The Art and Science of
Digital Compositing

Second Edition

THE ART AND SCIENCE OF
DIGITAL COMPOSITING

TECHNIQUES FOR VISUAL EFFECTS, ANIMATION AND MOTION GRAPHICS

SECOND EDITION

RON BRINKMANN

AMSTERDAM • BOSTON • HEIDELBERG • LONDON
NEW YORK • OXFORD • PARIS • SAN DIEGO
SAN FRANCISCO • SINGAPORE • SYDNEY • TOKYO

Morgan Kaufmann is an imprint of Elsevier

ELSEVIER

MORGAN KAUFMANN PUBLISHERS

Acquisitions Editor: Tiffany Gasbarrini
Publishing Services Manager: George Morrison
Project Manager: Mónica González de Mendoza
Assistant Editor: Matt Cater
Cover Design: Joanne Blank
Cover Images: See page xii for full credits

Morgan Kaufmann Publishers is an imprint of Elsevier
30 Corporate Drive, Suite 400, Burlington, MA 01803, USA

This book is printed on acid-free paper.

Library of Congress Cataloging-in-Publication Data
Brinkmann, Ron.
 The art and science of digital compositing / Ron Brinkmann.
 p. cm.
 Includes bibliographical references and index.
 ISBN-13: 978-0-12-370638-6 (pbk. : alk. paper) 1. Computer graphics. 2. Image processing—Digital
techniques. I. Title.

 T385.B75 2008
 778.5'2350285—dc22

 2007053015

ISBN: 978-0-12-370638-6

For information on all Morgan Kaufmann publications,
visit our Web site at www.mkp.com or www.books.elsevier.com

11 12 13 10 9 8 7 6 5 4 3

Printed in China

Contents

Cover/Interior Image Credits

Introduction to the Second Edition

In the years since the publication of the first edition of this book (1999), there has been a continued growth and flourishing of digital compositing in the worlds of film, television, gaming, and online content.

But even though a great deal of new *science* has been added to the toolbox available to digital artists, the fundamentals of compositing and, more importantly, the fundamentals of the *artistry* behind the process of digital compositing, has remained the same.

And so, as with the first edition, this new edition is still intended to be a foundation work—something that will give the reader a basic knowledge of digital compositing's underpinnings rather than concentrate on a particular piece of software. New tools will continue to become available that extend the artist's reach and (hopefully) make certain things easier, but the fundamentals are just as important today as they have been in the past.

What's New

If you already own or have read the first edition of this book, you're probably wondering what, specifically, is new for this edition. My original goal was to simply update the chapter that contains the case studies—to cover a number of more recent works and thus have the opportunity to discuss newer tools and techniques within the context of those case studies.

But as I was dealing with the acquisition of those various properties (a process that ultimately took well over a year, all told—traversing the bureaucracies of major movie studios is definitely not recommended for the impatient!) I found myself continually coming across areas that I felt could use a bit of an update in the main body of the text as well. Although the book was originally written in a fashion that I'd hoped would be reasonably obsolescence-proof, technology doesn't stand still and there were a number of areas that I realized could use further elaboration and some updating.

The new subtitle—*Techniques for Visual Effects, Animation and Motion Graphics*—is of course partially a way to make this book easier to find when one is searching for information on the web. But it also reflects the fact that this edition is even more focused on providing a set of practical, real-world concepts for working with images. Technology continues to advance but ultimately one needs to be able to *apply* that technology to solve a problem. And technology is ultimately (and even etymologically) all about knowledge of techniques.

In addition, the first edition was published at a time when color imagery still added a significant expense to a book. As such there were a number of concepts that I wasn't

able to illustrate as well (or at all) due to the limited number of color pages I was allowed. With this second edition that limitation has been lifted—the book is now full-color throughout—and I couldn't resist the temptation to update some of the old imagery and add a number of additional examples and diagrams.

As such we've now got over 600 photos and illustrations (more than 400 of which are new), added sections that cover rotoscoping, 3D/multipass compositing, and high dynamic range imaging, and there are 17 new case studies.

In my original forward to the first edition, I stated that I was writing the book I wish someone had handed to me when I was starting out in this industry.[1] With the ability to now include far more color imagery (and with the advances in digital photography making the general process of getting high-quality imagery *much* less painful), this new edition is the book that I wish I could have written in the first place.

A final minor change is evident in the appendices, which have been both updated and streamlined. Anything that is likely to be of a more transient nature (lists of companies involved in the creation of digital compositing software, for instance) has been removed from the book completely. Instead I have put together a website that will contain this sort of information as well as a variety of other things. This will hopefully allow me the ability to keep this information as up-to-date as possible. So please come visit at: **www.digitalcompositing.com**.

And in fact I would encourage everybody who is reading this book to visit the website at least once. I'm hoping to get a better idea of who is buying this book and so there is also a place on the site where you can tell me a little bit about yourself. This can be done anonymously but it will help me to understand a bit more about where and how the book is being used. I'm interested not only in typical visual effects application, but also in its use *outside* of this realm—scientific visualization, image analysis, gaming, virtual worlds, etc. A big "thank you" in advance to everybody who stops by.

I'd also like to point out that I do a fair amount of lecturing on the topics covered in this book. I'm always looking for an excuse to travel somewhere new, so if you are part of an organization that might be interested in having me come visit, please don't hesitate to get in touch with me about it.

[1] Concurrent with the writing of the first edition of this book a group of us were also putting together the **Shake** compositing application. And as the product designer for that software (continuing through the acquisition of the product by Apple) my primary design goal was, quite simply, to create a tool that *I* would want to use in production. Just about everything we did in Shake was driven by the same production-focused workflow as was driving this book. Fortunately most of the original development team had come out of production as well. Shake is no longer under active development (although it continues to be sold... at least for now) but it was certainly gratifying to see how the vast majority of high-end visual effects studios embraced Shake as a significant part of their production workflow.

The Real World

One of the more common questions I've been asked since the publication of the first edition of this book concerns exactly how all the information presented here relates to the "real world" of working in a production environment. Most importantly, how does one get started as a compositing artist?

As is often the case, there's generally not a single, well-defined path to this goal. But it almost always requires a bit of education (either in a formal academic setting or independent study) to the point where one can show a reasonable level of familiarity with the concepts discussed in this book and a reasonable degree of proficiency in at least one piece of digital compositing software. Usually this is demonstrated on the artist's **reel**—a DVD or webpage that contains clips of work they have done. The role of the compositing artist is a visual one and as such you'll be expected to have more than just a piece of paper to explain what you're capable of producing.

The clips on your reel may come from a variety of places—personal projects, class assignments, etc. In general, digital compositing is usually only a part of the work that is done when creating visual effects or animation. Conceptual and character design, 3D modeling, animation and lighting, live-action photography—these are all things that may be part of a given project. Everything on your reel should be something that you have personally worked on but, given the collaborative nature of this business, you don't need to have done every aspect of every piece on your reel. In fact, demonstrating an ability to work as part of a team is an excellent thing to underscore when you're looking for work. (Be prepared, however, to talk about exactly what you did or didn't do for anything you're showing.)

Once you start researching jobs in the industry, you'll find that the range of work that is expected from a digital artist can vary wildly. In a large visual effects facility things tend to be fairly compartmentalized in order to provide an efficient pipeline. Particular areas of expertise are focused on certain specific tasks. On the other hand, in a smaller facility things are often set up so that an artist will deal with several (or even all) aspects of the shot-production process. This is a trade-off that many professionals deal with constantly when making job decisions.

Working at a large facility has many advantages: The employment may be more stable because they generally have several shows going on simultaneously. You will have access to more resources and have a wider range of co-worker expertise to draw from. There will probably be a support infrastructure in place that can take care of things like file management, backups, organizational issues, etc., allowing you to concentrate more directly on a very specific task. And larger facilities tend to work more often on bigger budget, more recognizable projects.

On the other hand, a small facility may allow more freedom, with the ability to deal with a wider variety of challenges and to more directly interact with other disciplines in the production process. For instance, a junior compositor at a large facility will

rarely, if ever, be given the opportunity to spend time "on location" during principle photography or to talk directly to the director or cinematographer on a film. But at a smaller facility there is less of a hierarchy and more exposure to the full range of the process. It is also probably easier to get hired into a smaller facility and easier to advance more quickly to a level with additional responsibilities.

The hierarchy at a large facility can be quite deep. The following positions are typical of what one might find themselves doing over the course of several years in the feature-film visual effects business. The titles are somewhat arbitrary and will vary (as will the responsibilities) between different facilities.

1. *Technical Assistant (TA)*. Absolutely a "foot in the door" sort of position where job duties can literally include getting coffee or hand-carrying some artwork over to a different department. More typically, however, this job is specifically targeted to tasks that require some basic technical expertise—ensuring that data is backed up, generating videotapes or DVDs for clients or supervisors to view, etc.

2. *Rotoscoping or Paint Artist*. This role is very focused on producing high-quality rotoscoped masks (see Chapter 6) for a compositing artist to use or on using specialized digital paint tools on sequences of images to remove unwanted objects or clean-up artifacts generated as part of the compositing process.

3. *Digital Compositor*. The position that this book focuses on most directly—someone whose primary responsibility is combining multiple image sequences together to create a unified whole.

4. *Compositing Supervisor*. This person will oversee a team of compositing artists, generally offering both technical and artistic feedback in order to refine the shot as it is being worked on. Often supervises all aspects of 2D image production, including rotoscoping, paint, matte paintings, etc.

5. *Digital Supervisor*. Someone who looks over all aspects of the digital image creation/manipulation process. Thus, in addition to compositing, they would deal with 3D modeling, animation, and lighting.

6. *Visual Effects Supervisor*. The primary technical and creative lead on the visual effects team. Deals not only with the digital side of things, but also the actual image acquisition during principle photography.

Understand that the above list should by no means be seen as the path that is right for you. An alternate path might lead through **Production Assistant (PA)** all the way up through **Visual Effects Producer**, for instance. And there are many other positions, from **Technical Director** to a general **Digital Artist** who concentrates on color and lighting, that will need to employ digital compositing as part of a daily workflow. Learn about what you enjoy doing and what you are good at and also what you *don't* enjoy doing. Supervisory roles may have more "authority" associated with them, but they are also filled with a lot of work unrelated to actually creating images. Many artists have found

it far more satisfying to be in a purely creative role rather than to deal with schedules, budgets, interdepartmental politics, client handling, etc.

The types of projects available to a compositing artist are quite varied as well, each with its own particular advantages and disadvantages. Feature films, music videos, television commercials, title sequences, videogames, corporate videos, scientific animations, medical visualizations, webpage animations—these are only some of the areas where compositing may be employed. And each of these will also have its own advantages and disadvantages. Large projects—visual effects on a feature film, for instance—may have long production schedules where the artist will spend months on a single shot and years on a single film. Other types of work may involve a new project on a daily basis.

And of course there are any number of different routes to a particular goal. You may come from a programming background and start out writing code for in-house software tools and then decide you wish to move over to more of an artistic role. You may start out with an eye towards being a digital artist but then decide that the organizational and people-management aspects of producing are more interesting. Be aware of what roles are available and how they fit with your own skills and interests.

When starting out in this field it's extremely important to remember that, even though you may be an incredibly talented digital artist, part of working in production is the ability to work as a part of a *team*. No matter how good your reel of previous work is, supervisors and management want to feel comfortable that you are capable of being responsible, efficient and, quite honestly, reasonably pleasant to deal with. Production can be difficult and stressful—nobody wants to deal with personality issues on top of all that. If you're hired in as a TA or a rotoscoping artist, concentrate on doing that job as well as you can. Don't take the attitude that it's beneath you, don't constantly remind people that you really feel you should be given more senior work. If you demonstrate proficiency in a junior role, advancement will come naturally. And when you're given the chance to take on more responsibility, jump at it!

In terms of the specific content of this book, I'm often asked if a working compositor needs to know every single bit of information we'll be discussing? Absolutely not. And in fact much of the information in this book is here precisely so you (and I) *don't* need to have it memorized—so that it can be looked up whenever necessary. Having a broad understanding of the *concepts* behind compositing is much more important than knowing every specific technical detail (particularly for those things that will change as formats and standards evolve). Having a broad understanding of these concepts is also, in many ways, much more important than having proficiency in a particular package. Software will change (or be discontinued) and different facilities will require you to use different tools, but if you understand the way things work, you'll be well suited to whatever system you end up using.

Finally, one thing you absolutely should strive to do is to produce the best looking images you are capable of. Don't put the burden on your supervisor (or even worse,

your client) to tell you whether or not something looks good. Learn this for yourself and take responsibility for ensuring that you're satisfied with the work before showing it to others. Don't settle for "good enough." Learn your tools but also respect your art. And remember that any work you do that *is* substandard has the potential to be seen by a *lot* of people and may end up haunting you for a very very long time.

Fortunately the converse is true as well—well-executed artistry will be enjoyed by many future generations, and you'll always know that you were a part of it.

I'm also often asked for predictions about where digital compositing is heading in the future. And although it was tempting to write a section of this book dealing with exactly that, I quickly came to my senses—things are changing too rapidly for that to be anything but an exercise in rapid obsolescence.

But one thing is certain—the technologies and techniques that we think of as being primarily a part of "visual effects" are really becoming the tools of that will be used for *any* kind of sequential-image storytelling. Image manipulation has become the heart of postproduction, and knowledge of these concepts will benefit anybody who wants to work in that industry.

Acknowledgments

Although one might be tempted to assume that a second edition of a book would involve considerably fewer people than the first, it turns out that the number of people who contributed to the production of this book has, if anything, increased. Many of these people are listed here, but it's almost certain that many, many others who gave me ideas, information and inspiration are not, primarily due to the fallibility of my memory. To them I apologize, and hope that the fact that their wisdom is being propagated and utilized is at least some small consolation.

Thus, in no particular order, thanks to:

Nick Cannon, John Knoll, Kim Libreri, Dennis Muren, Ken Ralston, Eric Roth, Sande Scoredos, and Richard Weinberg. Nathalie Bergeron, Louis Cetorelli, Sandy Collora, Buckley Collum, Jamie Dietz, Garrett Johnson, Matt Plec, Peter Warner, and Mike Wassel. Edward Adelson, Páll András, Henry Bucklow, Steve Jurvetson, and Kyle Strawitz. Charles Boone, David Burns, Rory Hinnen, W. Scott Meador, Shawn Neely, Charles Roberts, Marc J. Scott, Dennis Short, and Mark Wilkins. Jerome Chen and Gary Jackemuk. Florian Kainz, and Rod Bogart. Scott E. Anderson, Sheila Brady, Gifford Calenda, Ed Catmull, Bill Collis, Jonathan Egstad, Sandra Lima, Alex Lindsay, Claudia Meglin, Tim Miller, Cliff Plumer, Lauren Ritchie, Dion Scoppettuolo, Mike Seymour, Al Shier, Jeanette Volturno-Brill. Tiffany Gasbarrini, Matt Cater, Monica Mendoza, and Sheri Dean Allen.

Thanks, generally, to the people and companies who contributed to the case studies (they're named more explicitly in Chapter 14), and especially to Brian Connor, who went above and beyond the call of duty with his wonderfully detailed *Revenge of the*

Sith write-up and the supplemental material for that on the DVD. Also a huge thanks to Dawn Brooks, producer extraordinaire, whose help with securing permissions from the studios for case study imagery was absolutely invaluable.

Thanks to Alex, Aundrea, Alyssa, Rachel, Anna, and Josh, because I would be a poor uncle indeed if I passed up the opportunity for them to see their names in print.

Finally, and above all, I have to thank all the digital compositing artists that I have had the pleasure of working with over the years, as well as the rest of the incredibly creative people in this industry who produce the fantastic images that feed and fill our imaginations. Keep up the excellent work!

<div align="right">

Ron Brinkmann
2008

</div>

DVD Note

A note about the DVD that is bundled with this book:
Although we have attempted to provide a digital equivalent for all the images that are discussed within the book, many of the studios have strict policies against distributing their imagery in a digital format. Fortunately we did manage to secure permission for a few of the case-study images and it is hoped that these will help to clarify some of the issues presented in those sections. Also included is a bit of additional footage (generously donated by fxphd and The Pixel Corps) that may prove useful in honing your matte-pulling techniques.

Introduction to Digital Compositing

An alien spacecraft hovers over New York, throwing the entire city into shadow. Massive armies converge on a battlefield. A giant ape faces off against a Tyrannosaurus Rex. And the Titanic, submerged for decades, sails once more.

Usually the credit for these fantastic visuals is given to "CGI" (computer-generated imagery) or "computer graphics," an attribution that not only broadly simplifies the technology used but also ignores the sizeable crew of talented artists who actually created the work. Computer graphics techniques, in conjunction with a myriad of other disciplines, are commonly used for the creation of visual effects in feature films. But the term "computer graphics" is broad and covers a wide variety of methods that rely on a computer to help produce images. Many of these methods are merely traditional methods that have been updated to take advantage of modern tools. In fact, even the typesetting of a book like this is now almost completely done using a computer, and as such this page could loosely be considered a piece of "computer graphics."

When dealing with computer graphics as used for the creation and manipulation of images, we will usually break the subject down into two primary subcategories: **3D graphics**[1] and **2D graphics**. The names indicate whether the work is considered primarily three-dimensional in nature, or two-dimensional. The first category, the "3D" work, involves creating a complete model of an object within the computer. This model can be viewed from any angle, can be positioned relative to an imaginary camera, and can generally be manipulated as if it were a real object, yet it exists only within the computer. Even though the way we are interacting with the object is still

[1] Do not confuse 3D imagery with stereoscopic imagery, a topic that we will also discuss in subsequent chapters.

based on a two-dimensional display device (the computer's monitor), the model itself is a mathematical simulation of a true three-dimensional object. This model can be lit, textured, and given the ability to move and change. Once a particular camera view is chosen and the color, lighting, and animation are acceptable, special software will **render** the scene to produce a sequence of images.

While the 3D aspect of visual effects seems to get a great deal of recognition, it is only one piece of the puzzle that makes up a finished shot. The other half of the visual effects process involves working with preexisting images, manipulating and combining them to produce new images. These images can be from just about any source, including rendered images produced by the 3D process. This process of manipulating existing images is identified as being "2D" work because of the flat, two-dimensional images with which it deals and because there is essentially no attempt to introduce any three-dimensional data into the process. Not every film that makes use of visual effects will include 3D work, but any time there is a visual effect in a film, you can assume that 2D work was done. It is the backbone of visual effects work, and the final, most important step in the creation of the desired imagery.

Even with a fully rendered 3D movie like Pixar's *The Incredibles*, 2D effects and tools are used to enhance and integrate the rendered 3D images. 2D manipulations have historically been accomplished via a number of different methods, as we'll discuss in a moment. But these days, most 2D work is done with the aid of computers, and the bulk of this 2D work is classified as digital compositing.

Definition

Digital compositing, as we are going to be discussing it, deals with the process of integrating images from multiple sources into a single, seamless whole. While many of these techniques apply to still images, we will be looking at tools and methods that are useful and reasonable for large **sequences** of images as well. Before we go any further, let's come up with a specific definition for what this book is all about.

> **Digital Compositing:** The digitally manipulated combination of at least two source images to produce an integrated result.

By far the most difficult part of this digital compositing process is producing the *integrated* result—an image that doesn't betray that its creation was owed to multiple source elements. In particular, we are usually attempting to produce (sequences of) images that could have been believably photographed without the use of any postprocessing. Colloquially, they should look "real." Even if the elements in the scene are obviously *not* real (huge talking insects standing atop a giant peach, for example), one must be able to believe that everything in the scene was photographed at the same time, by the same camera.

Although so far we've mentioned only a few big-budget examples of digital compositing being put to use, in reality you'll find digital compositing at work just about anywhere you look in today's world of media and advertising. Pull a magazine off the shelf and in all likelihood you will find that most of the art and graphics have been put together using some sort of computerized paint or image-editing program. Television commercials are more likely than not to have been composited together from multiple sources. Yet whether the digital compositing process is used for a business presentation or for feature-film special effects, the techniques and tools employed all follow the same basic principles.

This book is intended to be an overview that will be useful to anyone who uses digital compositing. However, you will probably notice that many topics, descriptions, and examples seem to approach the subject from the perspective of someone working to produce visual effects for feature films. This emphasis is not only due to the author's experience in this field, but also because feature-film work tends to push the limits of the process in terms of techniques, technology, and budgets. Consequently, it is an ideal framework to use in providing an overview of the subject. Additionally, it allows for the use of examples and sample images that are already familiar to most readers.

The title of this book, *The Art and Science of Digital Compositing*, was coined to stress the fact that true mastery of digital compositing includes both technical and artistic skills. As with any art form, the artist must certainly have a good amount of technical proficiency with the tools that will be used. These tools could potentially include any number of different hardware and software compositing systems. But one should also become knowledgeable about the science of the entire compositing process, not just specific tools. This would include everything from an understanding of the way that visual data is represented in a digital format to knowledge of how a camera reacts to light and color. Please remember, though, that all these technical considerations are simply factors to weigh when confronted with the question of "Does it look right?" The answer will ultimately be a subjective judgment, and a good compositor who is able to consistently make the decisions that produce quality images will always be in high demand.

The combination of multiple sources to produce a new image is certainly nothing new, and was being done long before computers entered the picture (pardon the pun). Although this book is about digital compositing, let's spend a moment looking at the foundations upon which digital compositing is built.

Historical Perspective

In the summer of 1857, the Swedish-born photographer Oscar G. Rejlander set out to create what would prove to be the most technically complicated photograph that had ever been produced. Working at his studio in England, Rejlander selectively combined the imagery from 32 different glass negatives to produce a single, massive print. A reproduction of this print, which was titled *The Two Ways of Life*, is shown in Figure 1.1. It is one of the earliest examples of what came to be known as a "combination print."

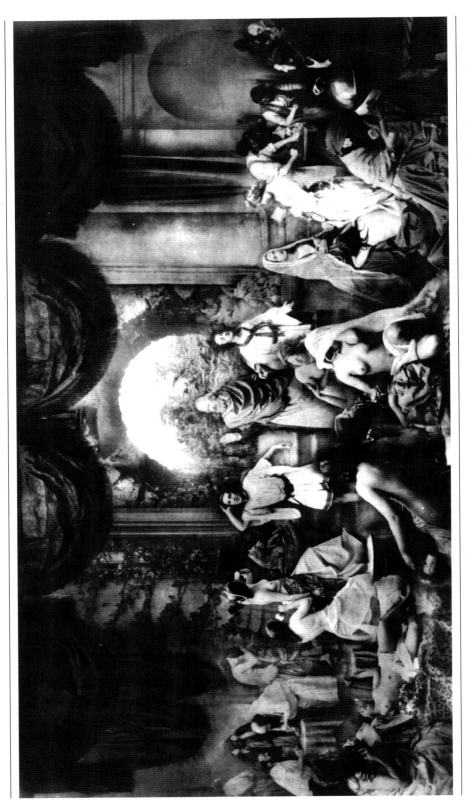

Figure 1.1 An early composite photograph, Oscar Gustav Rejlander's *The Two Ways of Life*. (Photo courtesy of the Royal Photographic Society Collection, Bath, England. Web site www.rps.org.)

Had the artist wished to capture this image on a single negative, he would have required a huge studio and many models. Even then, it is doubtful whether he could have lit the scene with as much precision or have positioned all the people in exactly the fashion he desired. Certainly it could have proven to be an expensive, time-consuming process. Instead, he painstakingly shot small groups of people and sets, adjusting each for the position and size that he would need them to be. In some cases, the only way to make them small enough in frame was to photograph them reflected in a mirror. Once the various negatives were created, the combination process involved selectively uncovering only a portion of the printing paper and exposing the desired negative to that area.

The scene that resulted from this complex undertaking was designed to depict the two paths that one may choose in life. The right side of the image represents the righteous path, with individual figures who illustrate Religion, Knowledge, Mercy, Married Life, and so on. The left side of the image depicts somewhat less lofty goals, with figures representing everything from Idleness to Gambling to Licentiousness to Murder.

Photography was only just becoming accepted as a true art form, but Rejlander's work was immediately recognized as an attempt at something more than the typical documentary or narrative photographs of the time. This is important to understand, since it points out that Rejlander used this combination technique in pursuit of a specific vision, not as a gimmick. There was a great deal of science involved, but more important, a great deal of art.

While *The Two Ways of Life* received quite a bit of recognition, it was also the subject of some controversy. Although part of this had to do with its subject matter (a Scottish exhibition of the work actually hung a drape over the nudity-rich left half of the image), the issue of whether or not such "trick" photography was ethical or artistically valid was continually raised. Eventually Rejlander himself denounced the practice, stating,

> I am tired of photography for the public—particularly composite photographs, for there *can be no gain*, and there is no honour, but cavil and misinterpretation.

Fortunately, the techniques continued to be used and refined even without Rejlander's support, and few people today consider compositing (at least conceptually) to be particularly dishonorable.

Motion picture photography came about in the late 1800s, and the desire to be able to continue this sort of image combination drove the development of specialized hardware to expedite the process. Optical printers were built that could selectively combine multiple pieces of film, and optical compositing was born. Many of the techniques and skills developed by optical compositors are directly applicable to the digital realm,

and in many cases, certain digital tools can trace not only their conceptual origin but also their basic algorithms directly to optical methodologies. Consequently, the digital compositing artist would be well served by researching the optical compositing process in addition to seeking out information on digital methods.

A number of early examples of optical compositing can be found in the 1933 film *King Kong*. The image shown in Figure 1.2 is actually a composite image that was created in the following fashion: The giant ape was photographed first—a 16-inch tall miniature that was animated using stop-motion techniques. This process involves photographing the model one frame at a time, changing the pose or position of the character between each frame. The result, when played back at normal speed, is a continuously animating object. After this footage was developed and processed, it was projected onto a large rear projection screen that was positioned on a full-sized stage. The foreground action (the actress in the tree) was then photographed while the background footage was being projected behind it, producing a composite image. This particular type of compositing is known as an in-camera effect, since there was no additional postproduction work needed to complete the shot. Other scenes in the film were accomplished using an early form of **bluescreen** photography (which we will discuss further in Chapters 6 and 12), where the foreground and background were photographed separately and then later combined in an optical printing step.

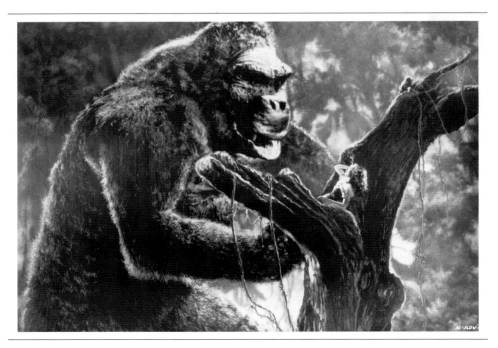

Figure 1.2 An early motion picture composite, from the film *King Kong*. (King Kong © 1933 Turner Entertainment Co.)

Nowadays, optical compositing has effectively been replaced with general-purpose computer systems and some highly specialized software, but the concepts have not really changed. Before we start our discussion of these software tools, let's take a look at an example of one of these digital composites. We won't go into a great deal of detail about this particular example just yet, but will initially use it to start presenting some of the common terminology used throughout the industry, as well as throughout this book.

Terminology

The example that we'll be dealing with is a scene from the feature film *James and the Giant Peach*, and is shown in Figure 1.3.

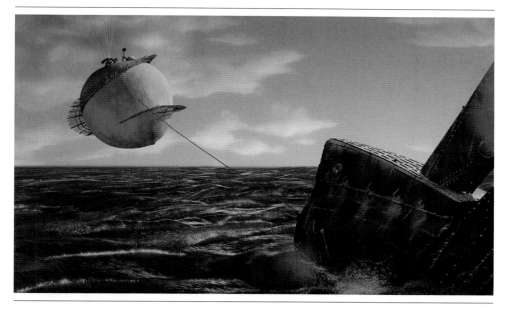

Figure 1.3 A composite scene from *James and the Giant Peach*.

This particular composite was created from a multitude of different original images. We usually refer to the individual pieces from which we create our final composite as **elements**. Elements in this composite include the following:

- The giant peach, shown as a separate element in Figure 1.4a. The peach is a miniature element, about a foot in diameter, and was photographed on a stage in front of a blue background, or bluescreen.

- The giant mechanical shark, shown in Figure 1.4b. This element is a computer-generated image, built and rendered as a three-dimensional model completely within the computer.

- The water, shown in Figure 1.4c. The water element is also computer-generated 3D imagery.

- The sky, shown in Figure 1.4d. This element is a hand-painted backdrop (painted on canvas) that was photographed as a single frame.

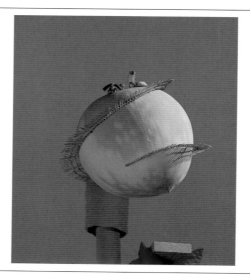

Figure 1.4a The giant peach miniature in front of a bluescreen.

Figure 1.4b The giant mechanical shark.

Figure 1.4c The water.

Figure 1.4d The sky.

Many other original elements make up this composite as well, most of them 3D elements. These include the reflections of the peach and the shark in the water, the smoke coming from the shark, shadows for the various elements, and spray and foam on the top of the water. Throughout the compositing process, additional elements

may be generated that are the result of some manipulation performed on an original element. Figure 1.5 shows such an element: a specialized image known as a **matte** that is derived from the bluescreen peach element and that will be used to selectively add the peach into the scene.

Figure 1.5 The extracted matte of the peach.

As you can probably tell, most of the elements that we've shown have had some sort of additional processing performed on them as they were added into the final scene. Such processing, which might be used to modify the color of an image or the size of an element in the frame, is done throughout the compositing process in order to better integrate elements into their new environment.

You will commonly hear elements referred to as **layers**, since the various elements are layered together to produce the eventual image. Original footage that is shot with a camera and transferred into a computer constitutes a subset of elements usually referred to as **plates**. Thus, the peach element in this example would be referred to as a plate. Typically, a synthetic image such as the water would not be termed a plate, nor would any intermediate elements that were generated during the process of creating a composite, such as the peach matte.

As you can see, there is little conceptual difference between the shot that was done for the 1933 version of *King Kong* and a digital composite such as the one we've just described for *James and the Giant Peach* (or in fact for the shot from the updated version of *Kong* that is discussed in Chapter 15).

Organization of the Book

This book will attempt to cover a range of topics related to digital compositing, from some basic concepts dealing with digital image acquisition and storage to specific aesthetic considerations necessary for producing a good composite. Initial chapters will provide enough background so that readers with only a basic knowledge of computers will find the book useful; in addition, there are a number of sections in this book that we hope even the most experienced professional will find useful.

The structure of a book such as this requires that the information be broken into well-defined categories. These categories (represented by chapters or sections within a chapter), while useful for organizational purposes, are ultimately somewhat arbitrary. The topics are all interrelated, and many discussions could easily have been placed into a number of different categories. To help identify related information, you will often find cross-references to relevant material that is located elsewhere in the book. The specific breakdown for how the chapters are organized is as follows:

- Chapter 2 describes characteristics of cameras and vision that must be understood in order to produce realistic, believable composites.

- Chapter 3 presents an overview of how images are represented digitally, including some discussion about the process of converting images from other sources into a digital format.

- Chapter 4 covers some of the basic manipulations that are possible with digital images. These include using image-processing tools that are designed to modify the color, size, and placement of elements within a scene.

- Chapter 5 takes this topic to the next step, with a look at the process of combining images or image sequences. This chapter is where the concept of a matte—an image that is used to selectively control certain combinatorial operations—is first introduced.

- Chapter 6 deals with these matte images in much greater detail—particularly with the methods that are commonly used to create and modify them.

- Chapter 7 is dedicated to concepts and techniques relating to imagery that changes over time, and to image manipulations that do the same.

- Chapter 8 looks at tracking, the process of analyzing and duplicating the motion of existing objects in a scene.

- Chapter 9 discusses a variety of methods that can be used to interact with the data, images, and software that you will be using.

- Chapter 10 is a broad overview of the various formats that might need to make use of digital compositing, from film to video to multimedia.

- Chapter 11 covers some important concepts that must be understood in order to work efficiently while still producing quality imagery—an area of great importance for any sizeable compositing project.

- Chapter 12 deals with some of the things that should happen before a composite is started, when the elements that will be used are being created.

- Chapter 13 rounds out a topic that we touch on throughout the book, namely, image and scene integration techniques, and gives some more specific suggestions.

- Finally, Chapter 14 goes into a bit more detail about certain topics that are of a more advanced nature and also touches on some disciplines that are related to compositing, such as digital painting, editing, and working with computer-generated 3D imagery.

- The last chapter of the book, Chapter 15, uses all this preceding information to take an in-depth look at a number of well-known scenes that were created via the use of digital compositing. It should give a sense of how the topics that we've covered can be applied in real-world situations.

The book also includes a few appendices that deal with specific topics in greater detail.

- Appendix A provides a summary of the tools that should be part of a reasonably complete compositing package, extending the list of operators that are specifically covered in the body of the book. This section should also prove useful if you need to evaluate the relative merits of competing pieces of software.

- Appendix B attempts to list some of the popular file formats that are used to store digital images for compositing purposes. This appendix also includes a more in-depth look at two of these formats, Cineon and OpenEXR.

- Appendix C documents some specific details about common film and video formats.

Although this book is primarily targeted at those who are actually creating digital composites, much of the information will also be important to individuals who need a more simplified overview of the subject. If this is the case, the following course of action is suggested.

1. In general, the introductory information at the beginning of each chapter gives a basic idea about what is contained in that chapter. If nothing else, read these introductions.

2. Chapter 2 is important for anybody who wants to understand the visual nature of the compositing process. It is not terribly technical and should probably be read in its entirety.

3. Chapter 3 defines a great deal of terminology. A basic understanding of the information contained in the section entitled "Image Generation" should be enough to make the rest of the book a bit more comprehensible.

4. Chapters 4 and 5 concentrate on specific tools, and as such may not be as relevant to someone who will not be involved with actual image creation. The section in Chapter 5 that discusses the concept of a matte is probably the only "must-read" section.

5. Chapters 6, 7, and 8 should be skimmed to get a basic idea of the concepts presented, but probably not much more than that is necessary. Chapter 9 is even less interesting to someone who will not be using any software directly.

6. Chapter 10 should probably only be looked at if there is a desire to understand a particular format in more detail. This may come up on a case-by-case basis.

7. Chapter 12 is specifically targeted to people who will be involved in the actual photography of the elements that will be used in a composite.

8. Chapter 14 is mostly composed of advanced topics, but the end of the chapter does touch on a few disciplines related to compositing that may be useful.

9. The final section of the book is the glossary. Although it is not something that should be read from beginning to end in one sitting, it should prove to be a valuable resource as one encounters unfamiliar terms.

Whether or not you actually have any formalized artistic training that should not deter you from learning the specific artistic skills that a good compositor (one who creates composites) uses on a daily basis. Part of this process involves learning the tools that are necessary. Just as a painter needs to understand the workings of pigments and canvas, a digital artist needs to have a technical understanding of the software involved. It is certainly possible to be an effective compositor without fully understanding all the technical issues that will be presented in this book. As with any other artistic discipline, experience and instinct can go a long way toward producing the final result. However, a basic understanding of the technology behind the tools can greatly improve the efficiency and problem-solving ability of even the best artists.

The rest of the art will come only with experience, although you will probably find that you are already well on your way. This is because you, and every other sighted person, have already spent a lifetime learning what reality looks like. The information may not always be consciously accessible, but the expert subconscious is surprisingly skilled at noticing when an image appears artificial or incorrect. This is both a blessing and a curse, since everyone else who will view your work will be similarly able to detect these problems. However, the ability to determine that there *is* a problem is the largest part of the process of realizing why the problem exists and learning how to fix it. Throughout this book we'll certainly try to point out the scenarios in which visual problems can arise. These problems will often involve well-defined artifacts— undesirable items in an image that are the result of the process used to create the image. But compositing problems can go far beyond specific identifiable glitches. Greater difficulties arise when trying to accurately duplicate the myriad of visual cues that would be present in a real image. These are the things that the subconscious is so

much better at perceiving, and this is why someone who creates composite imagery must become an artist. The same knowledge that a painter uses—from the interaction of light and shadow to distance and perspective cues—will be necessary to create a believable digital composite.

There is one final piece of business to be dealt with before we can continue to the rest of the chapters in this book. A disclaimer:

> Different people, countries, and software packages do not always use the same names to refer to particular tools, operators, or subjects. In addition, due to the need to simplify certain things, just about every statement we make could probably be countered with some exception to the rule.

This statement isn't given in order to protect the author from any mistakes he's made within the pages of this book, but rather as a warning to anyone just starting to learn about this field. In many cases, you will find similar or identical concepts referred to by completely different names, depending on what book you are reading or to whom you are talking. Digital compositing is still a very young, volatile discipline. As such, there are many areas within it that have not become terribly well standardized.

A glossary is provided at the end of the book that attempts to cover a wide range of terms as they relate to digital compositing. Throughout the body of the text, terms being introduced are printed in bold to indicate that you will find a definition in the glossary. There are certainly places in the book where we have made some arbitrary decisions about a particular term and its usage. It is hoped this will help, rather than hinder, the process of terminology standardization within the industry.

CHAPTER TWO

Learning to See

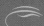

Before we begin looking at the technology that one can use to capture and manipulate images, it seems appropriate to get a better understanding of imagery in general—to look at how our eyes and our brains interact with the visible world. We also need to discuss the devices we have developed to capture a portion of the visible world— their characteristics and limitations.

Although most of us spend our whole lives looking at the world around us, we seldom stop to think about the specifics of how the brain perceives what our eyes see. Most of the time it immediately reduces everything to some kind of symbolic representation, and we never even stop to consider issues such as how the light and shadows in front of us are interacting. But at some point in the process of becoming an artist, one needs to move beyond this. To quote the poet/novelist/scientist Johann Wolfgang von Goethe[1]

> This is the most difficult thing of all, though it would seem the easiest: to see that which is before one's eyes.

[1] Although he is best known as the author of Faust, Goethe also published a book called *Theory of Colors*, which is an in-depth analysis of how the brain perceives color and contrast. He also wrote a poem called *The Sorcerer's Apprentice*, which inspired the composer Dukas to write a piece of symphonic music of the same name which, in turn, inspired the best-known segment from Walt Disney's *Fantasia*.

Goethe's not the only one who is aware of this issue. Here are a couple more quotes on the subject:

> I see no more than you, but I have trained myself to notice what I see.
> —*Sherlock Holmes, in Arthur Conan Doyle's*
> *"The Adventure of the Blanched Soldier"*

> Seeing is in some respect an art, which must be learnt.
> —*Sir William Herschel, the famous astronomer who,*
> *among other achievements, discovered Uranus and*
> *helped to prove the existence of infrared light*

"Seeing" is definitely something that can be learned (or learnt), and in fact is something that every visual artist from the beginning of time has had to learn. Digital compositing artists are no exception, particularly if they want to produce images that appear to be realistic and believable. Certainly digital compositing can be used to produce surreal or fantastic imagery, but one must still be able to believe that everything in the scene was photographed at the same time, by the same camera.

There are a number of excellent books that can help the artist to learn how to see. A couple of them are mentioned in the bibliography at the end of this book, and there are hundreds (if not thousands) of others that also cover the subject. But one must go beyond reading about it—one must practice it. Even if you don't take up sketching or painting, or even photography, you can always find time to better examine your surroundings, trying to understand exactly how the brain is interpreting the images it is seeing.

Ultimately, the more time you spend compositing, the more you'll learn about what things are important in order to fully integrate elements into a scene. There are a variety of techniques (and several tricks) that can be used to trigger the visual cues the eye is accustomed to seeing. Every image is a complex mixture of light and shadow, filtered through some sort of capture device and then interpreted by the human eye. In this chapter we will provide information that is directly applicable to the process of creating a composite image that feels natural and (within the constraints of what we are trying to accomplish), real.

Judging Color, Brightness, and Contrast

One of the most important things a compositor does when integrating elements into a scene is to balance everything in terms of color, brightness, and contrast. Different people's abilities to judge color can vary quite a bit, but it is not solely an inherited ability. Quite the opposite, in fact, having a good eye for color can be learned, generally through a great deal of practice.

Although the ability to judge color, brightness, and contrast is impossible to learn solely by reading about it, there are a few important facts that we can impart here to help with the process. The most important fact is that the perception of these things can be significantly affected by outside influences. The classic example of this principle is shown in Figure 2.1a.

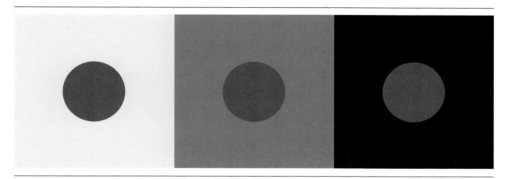

Figure 2.1a An example of simultaneous contrast.

Although the inner circle is the same color in all three cases, it appears to be brighter when surrounded by a darker background. Scientists who study perception know this phenomenon as the "principle of simultaneous contrast."

The same thing holds true with color imagery. A color will appear more vibrant and saturated when surrounded by complementary colors—red surrounded by cyan or green, for instance—and generally any color perception will be affected by surrounding colors, as illustrated in Figure 2.1b.

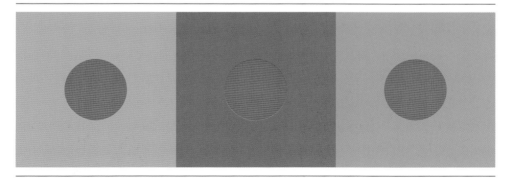

Figure 2.1b A similar phenomenon with color.

Simultaneous contrast is just one of many factors that can affect our ability to accurately judge tone and color. Perception of the overall contrast in an element or a

scene is also subject to the environment in which the scene is viewed—looking at a specific image while situated in a brightly lit surrounding environment will fool the eye into thinking that the image has more contrast than it really does. Similarly, images viewed while in a darker environment will appear to have less contrast. An even more extreme example is shown in Figure 2.2.

Figure 2.2 The checkerboard shadow illusion.

In this example,[2] the square labeled "A" is *exactly* the same color as the square labeled "B." This is extremely hard (perhaps impossible) to judge accurately and even when a bit of assistance is added as shown in Figure 2.3, where vertical bars of the same color help to "bridge" the space between the two patches, it is still quite difficult to believe.

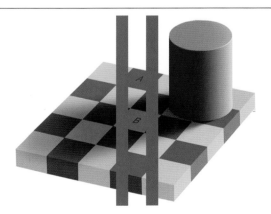

Figure 2.3 Checkerboard shadow with reference gray lines.

[2] Created by Professor Edward Adelson at MIT's Department of Brain and Cognitive Sciences.

Remember, these principles of color adaptability are wired into our brain's visual system and as such they are not necessarily something that can be overcome.[3] Therefore, it is important to at least understand them, in order to compensate when necessary.

Since the human visual system is so susceptible to environmental influences, one must do one's best to try to control that environment whenever judging color. Try to view different images in as similar a context as possible. If you are comparing two images on your computer's monitor, make sure that the surroundings, both on- and off-screen, are not biasing your judgment. Some people try to eliminate as much color as possible from their viewing area, to the extent of setting their screen background and window borders to a neutral gray. We have also mentioned that there are a number of digital tools for sampling the color of a specific pixel or a grouping of pixels. Knowledgeable use of these tools can be a tremendous help when trying to judge and synchronize colors between disparate plates.

Finally, it is important to realize that it is often impossible to completely represent the way an image will appear on a particular device if it is being viewed on a different device. Consider a digital image that will eventually be projected via film in a theater. Even if you have calibrated the monitor on your computer to represent colors as closely as possible to the way projected film would represent them, the two mediums are different and are almost certainly incapable of representing exactly the same colors. In the case of film, where there can be a significant turnaround time to actually see the final image after it is sent off to be filmed out and printed, it may be useful to generate a series of images that feature incremental alterations to the color or brightness of a reference frame. Essentially these images are all slight variations around the artist's "best guess" in the digital realm. This series of images (known as a **wedge**) will be sent to film and the final color and brightness can be chosen from the different options once they come back from the lab. The parameters that were used to create the chosen frame are then applied to the entire sequence, producing a final composite with the proper color balance.

Light and Shadow

It should go without saying that the most important thing to understand about the way we perceive the visual world is the interplay of light in a scene. Learning to understand the complexities of lighting, how it illuminates objects both directly and

[3] To make things more difficult, there is even evidence that *diet* can also influence one's ability to judge color. In a series of experiments performed by the U.S. government during World War II, researchers attempted to provide Navy sailors with the ability to see infrared signal lights with the naked eye. Through the use of foods rich in a specific type of vitamin A (and deficient in another, more common type), they found that the subjects' vision actually began to change, becoming more sensitive to the infrared portion of the spectrum. The experiment eventually ended, however, with the invention of electronic devices that would allow the viewing of infrared sources directly.

indirectly, is the fundamental principle on which everything else we'll discuss relies on. After all, without light, most images would be much less interesting!

But given the complexity of the subject, we're going to have to assume that the reader already has a reasonable understanding of how light interacts with objects in an environment, at least in a general sense. As such, we'll try to limit our discussion to a few basic principles, targeting the specific things that a compositing artist will be looking for when they begin to integrate elements into a scene.

And this is really one of the most fundamental aspects of a compositor's skill—the ability to understand how the lights in a scene are interacting and to understand how any new elements that will be added to that scene would also interact.

As such, it is important to keep a mental "checklist" of the various lighting characteristics to look for in a scene. In terms of direct lighting, these would include the *intensity* of the lights, the *color* of the lights, and the *location* of the lights. For direct light sources, these characteristics are fairly easy to quantify if you are standing in the scene itself (Chapter 12 discusses this a bit) but determining an approximate value for these characteristics simply by looking at an *image* of the scene can be significantly more difficult.

And really, the character of a light source is quite a bit more complex than these basic parameters would indicate. A fluorescent light bulb, a candle flame, or the sun overhead can all cast a light on a scene but the sun's light on a clear day is direct, casting hard consistent shadows whereas a fluorescent tube light casts a much broader light and consequently a less distinct shadow. The light from a candle is flickering and variable and the shadows will "dance" in unison.

Note too that we used the term "direct light sources" above. But further complicating any attempt we might make to fully understand the lighting environment that is present in a scene is the fact that light "bounces" off of all the objects in the scene as well, providing secondary (and tertiary, and so on) sources of light. This indirect lighting can be a significant contribution to the overall lighting characteristics of a scene.

The most obvious case of bounce lighting is a light source reflecting from a mirror or other shiny object. But just about everything in a scene will provide bounce light to some extent or another. A white wall provides a great deal of fill light on a subject, and someone standing on a sandy beach has a tremendous amount of light bounced back up on them from below.

The color of the object off which the light is bouncing will affect the color of the light as well. Consider Figure 2.4, if you look at the side of the figure that is closest to the red ball you can see that quite a bit of red light is coming back off of the ball to illuminate the wooden character. Figure 2.5 shows the same scene after we remove the red ball and a close-up comparison of similar areas is shown in Figure 2.6.

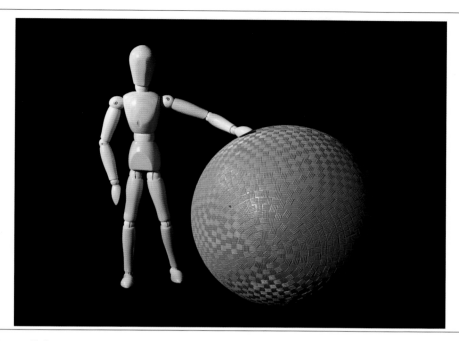

Figure 2.4 An example of colored bounce-light.

Figure 2.5 The same scene without the red object.

Figure 2.6a Detail of bounce-lit areas #1.

Figure 2.6b Detail of bounce-lit areas #2.

Although there are cases where a single object is causing enough bounce light-ing to be identified individually, usually the various sources of indirect lighting in a scene are a bit more random. Generically we will often refer to all the lighting in the scene that isn't coming from an identifiable source as being the **ambient light** in the scene.

Light doesn't always bounce, of course. It also passes *through* some materials, diffus-ing, diffracting, and casting irregular shadows. Even the atmosphere in a scene can modify the characteristics of a light. By the same token, the atmosphere itself will react to the light in a way that is worth mentioning. Figure 2.7 shows how dramatic this effect can be in certain situations.

Remember too that the light in a scene will often change over time. Clouds will move across the sky (and obscure the sun) or someone will open a door that spills in new light from the brighter room beyond it.

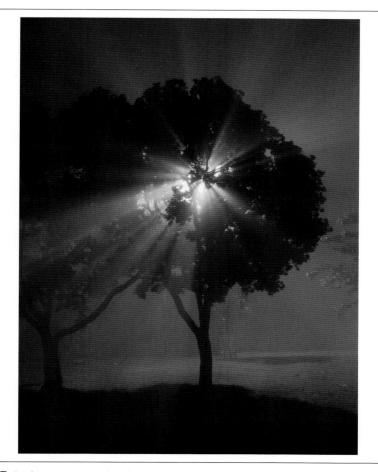

Figure 2.7 Lights interacting with atmosphere.

As we hinted at above, the shadows in a scene can provide some excellent clues to the character of the lights themselves. The size, density, and softness of a shadow is a direct result of the light that is causing it. The three images in Figure 2.8 show the same scene where the character of the light varies from being very direct (from a concentrated single source) to being extremely diffuse. This sort of variety can be found with both artificial lighting and outdoors with natural lighting (direct sunlight on a clear day versus a broad overall light when it is overcast, for instance).

A shadow's softness is also determined by the distance between the object that is casting it and the surface that is catching it. In Figure 2.9 we see that shadow grows more diffuse as the distance between subject and surface increases.

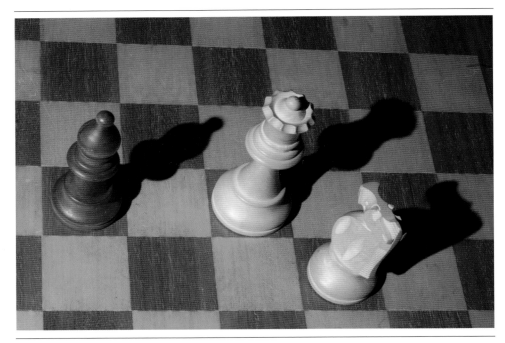

Figure 2.8a Shadow softness comparison—hard shadows.

Figure 2.8b Shadow softness comparison—medium shadows.

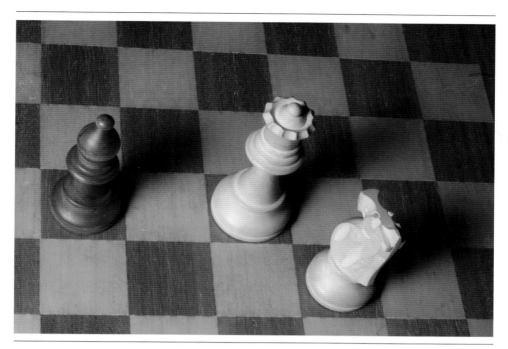

Figure 2.8c Shadow softness comparison—soft shadows.

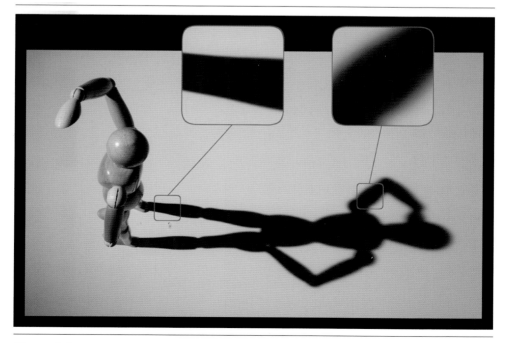

Figure 2.9 Shadow softness comparison—softness as a function of distance.

Shadows can also give clues about the other lights in the scene—ones that aren't causing the main shadow. If an area in shadow has a particular color cast, for instance, that color is, by definition, coming from one of the lights that isn't being blocked by the object casting the shadow and you now have a clue as to the color of that other light. Figure 2.10 shows a scene where there is a cyan light coming from the left of frame and a white light coming from the right. Note that the shadow being cast to the right is the result of blocking the colored light and thus it contains none of the cyan tint that is present in the rest of the scene.

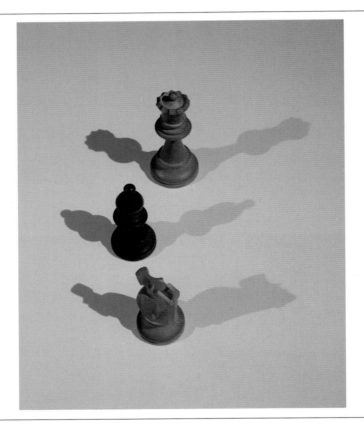

Figure 2.10 Shadows from colored light sources.

This image is also another excellent example of how our eyes can deceive us. Although the shadow area may *appear* to have a reddish tint, it is in fact a neutral gray. Our visual system's desire to immediately adapt itself to lighting conditions (in the same way that a page of this book will appear white no matter if we're standing in a room lit with blue-green fluorescent lights or one whose lights are yellow-tinted incandescents) means that the overall cyan light of the scene is perceptually shifted towards white and the gray area appears slightly pink accordingly.

The Camera

Not only do we need to learn how our eyes perceive the world around us, but, since we will probably be producing images that are designed to mimic those shot with some kind of camera, we also need to learn how the camera perceives the world around it. In other words, not only does the compositing artist need to learn how to see, he or she will also need to learn how a *camera* sees.

Much of this information will already be familiar to readers who are amateur or professional photographers. Basic photographic concepts are the same whether you are using a simple "point-and-shoot" camera or a professional motion-picture camera. There is no better way to understand how a camera works than to experiment with one. Reasonably priced still and video cameras are available now that allow the user full control over shutter speed, lens aperture, zoom settings, and low-light sensitivity, and there is no excuse for a compositing artist to not understand the fundamental principles of photography. Learn how these various parameters affect the way an image is captured and how it is that we are able to interpret the elements of a two-dimensional image as still having depth.

Resolution Limits

One of the most important things that you should remember when using a camera is that it is only capturing a *representation* of a scene. The resulting image will, it is hoped, look a great deal like the original scene, but the information in this image is only a subset of the original scene. First of all, it is obviously a two-dimensional representation of a three-dimensional scene. Moving the position of your head when viewing the image or walking around it will not give you the same information that moving about in the real scene would give, in terms of depth perception or of revealing objects that are occluded by other objects.

This image is also a subset of the real scene in terms of the amount of detail that is captured. The resolution of the real scene is effectively infinite—increasing the magnification or moving closer to an object in the scene will continue to reveal new information, no matter how far you go. The captured image, on the other hand, will quickly fall apart if it is examined too closely.

Consider Figure 2.11, a scene that features a great amount of detail. This was captured with a fairly high-end digital camera but even so, enlarging a small area of the image (as shown in Figure 2.12) will show that there is definitely a limit to the amount of information available relative to the real scene. Figure 2.13, however, was taken from a location much closer to this particular area of the cathedral, focusing on this same area. And of course the amount of detail we can capture is significantly more than what we can extract from the first image…an image which had captured a fixed subset of the information present in the real scene.

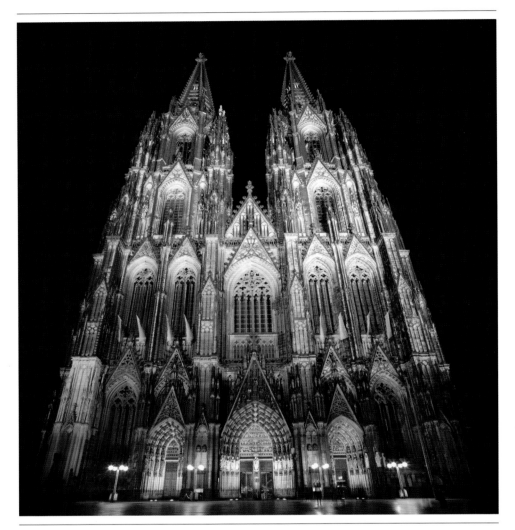

Figure 2.11 A high-resolution image of a cathedral.

Although this is probably so obvious as to barely be worth mentioning, this basic concept affects nearly every aspect of image manipulation. And the issue is certainly not limited to the level of detail in an image—we are also only able to capture a subset of the colors and luminance levels present in the original scene. For instance, areas that are above or below a certain brightness will be simply recorded as "white" or "black," even though there is really a great deal of shading variation in these regions.

These limitations are important to keep in mind as you are working with image data, as there may often be times when there is not enough captured information to effect the changes that a particular composite requires. We'll look at the ramifications of this in much greater detail in the next chapter.

Figure 2.12 An extreme enlargement of a section of Figure 2.11.

Figure 2.13 A close-up photo of the same section of the cathedral.

In addition to the dimensional, detail, and range limits that are inherent in a captured image, you should also become familiar with any idiosyncrasies of the device that you are using to capture these images. Whether you are working with film or video, artifacts of shutter and lens must be analyzed and usually mimicked as closely as

possible. If you are dealing with film (again, even if you are working on a sequence destined for video you will often find that your source elements were shot on film), you'll need to be aware of issues related to film stock, such as grain characteristics.

Even if you are not compositing live-action elements at all, most of these issues are still important. Just about any synthetic scene-creation process, from computer-generated images to traditional **cel animation**, will tend to use visual cues taken from a real camera's behavior.

Focus and Depth of Field

If you pay attention to the photographed imagery that surrounds you, you'll notice that it is rarely the case that every element in a scene is in sharp focus. A camera lens can really only focus at a single specific distance. (Your eyes too, for that matter, although the refocusing is such an unconscious thing that it generally isn't noticeable). Everything that is nearer to or farther from the lens than this distance will be at least slightly out-of-focus. Fortunately, there is actually a range of distances over which the lens can produce an image whose focus is considered acceptable. This range of distances is known as the **depth of field**. Figure 2.14 shows an example of a scene with a fairly shallow depth of field. The camera was focused on the figures in the center row, and all of the other toy soldiers feature a greater amount of defocus as their distance from this in-focus location increases.

Figure 2.14 An example of shallow depth of field.

There are no hard-and-fast rules about what constitutes "acceptable focus." The method used to measure the amount of defocusing present in an image uses something known as the circle of confusion, which is the diameter of the circle formed when an idealized point goes out of focus. Different manufacturers may vary slightly in their calibrations, but a fairly common convention is that an in-focus image will produce a circle of confusion that is less than 1/1000th of an inch on a 35 mm negative. In the real world, people depend on the manufacturer's markings on the lens, various tables (such as those contained in the American Cinematographer Manual, referenced in the Bibliography), or (most commonly) their own eyes to determine the depth of field for a particular scene and lens setting.

Incidentally, don't make the mistake of referring to depth of field as "depth of focus." Depth of focus is a very specific term for the distance behind the lens (inside the camera) at which the film should be placed so that the transmitted image will be in focus.

The depth of field for a given scene is dependent on a number of different factors. These include the aperture of the lens, the focal length of the lens, and the distance from the lens to the point of focus. Most composites (at least the believable ones) will require the artist to deal with elements that exhibit various degrees of focus, and it is important to understand the factors that determine the focus range in a given situation.

Probably the best way to get familiar with how depth of field works is to do some work with a still camera, preferably one in which you have control over the aperture and lens length. If you work with images that have limited depth of field, you'll notice that the farther away from the camera the focus point moves, the broader the depth of field becomes. In fact, if you double the subject distance, the depth of field quadruples: Depth of field is proportional to the square of the distance. You'll also notice that if you use a zoom lens, the smaller the focal length of the lens (i.e., the more "wide-angle" the setting), the greater the depth of field. The depth of field is inversely proportional to the square of the lens's focal length. Finally, notice that the larger the aperture you use, the shallower the depth of field becomes. Figure 2.15 shows the same scene as before, only we have changed from a very large aperture (f2.5) to a very small one (f32).

Let's look a bit more at the actual qualities of an unfocused scene. Take a look at Figure 2.16, which shows a well-focused scene. Now look at Figure 2.17, in which we've changed the focus of the lens so that our scene is no longer sharp. Note in particular what happens to the bright lights in the scene. They have not simply softened—instead, we have noticeable blooming and rather distinct edges. The characteristics shown will vary depending on the lens being used, as well as the aperture setting when the image was taken. As you can see, the defocused lights tend to take on the characteristic shape of the camera's aperture, in this case a hexagonal opening. (This shape will be different for different cameras and can also change as you change the aperture.) This image is an excellent example of how much a true out-of-focus

Figure 2.15 Broader depth of field.

scene can differ from a simple digital blur (one of the image processing operations that we'll cover in Chapter 4). Figure 2.18, which shows a basic **Gaussian blur** applied to Figure 2.16, is provided for comparison.

Another effect that occurs when you are defocusing a standard lens is that the apparent scale of the image may change slightly. (Changing the focus of a lens actually causes a slight change in the focal length of the lens.) This scale change can be particularly evident in situations in which the focus changes over time. A common cinematic technique to redirect the viewer's attention is to switch focus from an object in the foreground to an object at a greater distance. The amount of scale change from this "rack focus" is somewhat dependent on the lens that you are using, so if you are going to try and emulate it you'll ideally have access to some example footage that can help you to determine the extent of this effect for the lens in question.

Lens Flares and Other Lens Artifacts

In the real world, when a bright light source is shined directly into a lens, you will get a **flare** artifact, caused by overexposure of the film or image sensor and by multiple reflections within the various components in a lens assembly. Notice the term "lens assembly." A standard camera lens is actually a collection of specially matched lenses, all brought together in a single housing. This construction is the reason a lens flare has multiple artifacts instead of just a single one.

Figure 2.16 An in-focus scene.

Figures 2.19 and 2.20 show a couple of examples of what a lens flare can look like. Notice the diagonal row of artifacts in Figure 2.19. Each one of these is caused by one of the lenses in the overall lens assembly. You'll also notice that there is a noticeable hexagonal shape to some of the artifacts, which is again caused by the shape of the iris that forms the camera's aperture.

The most important thing to keep in mind about these lens flare artifacts is that they are specific to the *lens*, not the light source. Because of this, they are always the closest object to the camera. Nothing will ever pass in "front" of a lens flare (unless you have something inside your camera body, between the lens and the film), and any elements that are added to a scene with a lens flare will always need to go behind the flare. Of course, the light source that is causing the lens flare may become partially obscured, but

Figure 2.17 The same scene, now out-of-focus.

the result will be that the flare artifacts become dimmer overall, and conceivably change character somewhat, rather than that individual flare elements will become occluded.

Since lens flares are a product of the lens assembly, different types of lenses will produce visually different flares. This is particularly true with **anamorphic** lenses (which squeeze or stretch an image—we'll look at them a bit more in Chapter 10), which tend to produce horizontally biased flares. Compare the two different flares shown in Figures 2.19 and 2.20 again—the first is from a standard spherical lens, whereas Figure 2.20 shows a lens flare that was shot using an anamorphic "Cinemascope" lens. (This example was unsqueezed to show the way the flare would look when projected.)

The other thing to note with lens flares is that the different artifacts will move at different speeds relative to each other whenever the camera (or the light source) is moving. This is actually an example of motion parallax (which we'll discuss in just a second),

Figure 2.18 A Gaussian blur applied to the original in-focus scene.

caused by the different position of each element in the lens assembly. Figure 2.21 shows a series of images where the light source is moving through the frame. Note the changes that the lens flare goes through in this situation.

Take the time to examine a variety of real lens flares in motion. Notice that they are generally not "perfect," often featuring slightly irregular shapes and unpredictable prismatic artifacts, and tending to flicker or have varying brightness levels over time. These irregularities should not be ignored if you plan to add an artificial lens flare into a scene as a common problem with less-sophisticated software for generating these flares is that the elements may be far too symmetrical and clean.

Even if you don't have an explicitly visible lens-flare artifact, it's important to recognize that *any* light entering a camera will bounce around within the lens assembly and, as such, can still affect the image. Well-designed lenses can minimize this

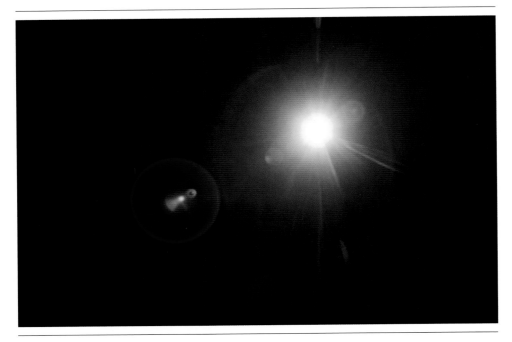

Figure 2.19 Lens flare example #1.

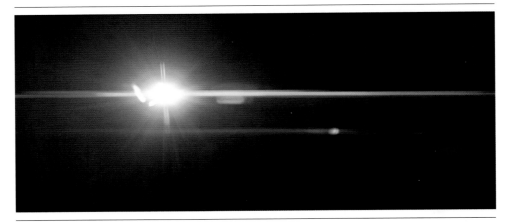

Figure 2.20 Lens flare example #2 (from an anamorphic lens).

effect but never completely eliminate it and thus it is something that the compositing artist will always need to take into consideration. Figure 2.22 shows two photos that were taken with the exact same exposure settings. The only difference between the two is that the image on the right has introduced an additional object (a lens cap) that is being held in front of the camera in order to block a light that is aimed at it. The illumination of all the other objects in the scene isn't changed by this—the lens cap

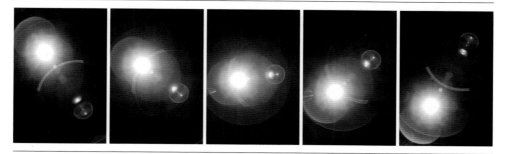

Figure 2.21 A series of images showing a moving lens-flare.

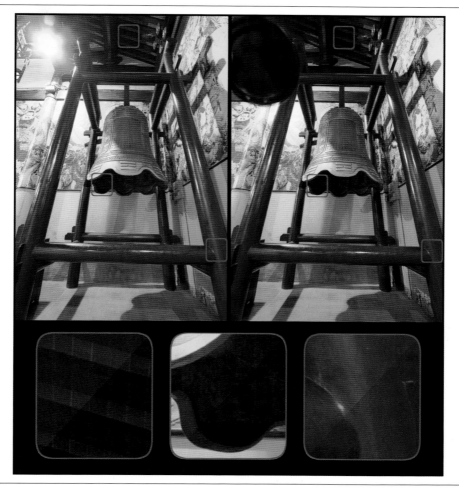

Figure 2.22 How a bright light will "flash" the blacks of an image.

is only an arms-length away from the camera—but nevertheless the captured image is still noticeably affected. Below the main photos are three inserts that compare (with a diagonal split line) the specific affect that this light-blocking has had on the images. As you can see, the light has "flashed" the image, lifting the black levels by a fair amount. Even lights that aren't directly visible in the image itself can have this affect—bright sunlight catching the lens at a glancing angle, for instance. You may not see the sun itself in the final image but a great deal of additional light can still have been introduced into the lens assembly and, consequently, into the captured image.

It is worth underscoring the point that lenses are never perfect and that there are a variety of other artifacts that may be visible—things like optical distortions, **chromatic aberration**, and even dirt or scratches on the lens itself.

Figure 2.23 An example of barrel distortion in a lens.

Lenses are generally designed to be **rectilinear**—to reproduce straight lines in the scene as straight lines in the resulting image of that scene. But some lenses are more successful than others in doing this. Figure 2.23 shows an example of a scene that was captured with a fairly wide-angle lens. In general it is much more difficult to get a perfectly rectilinear wide-angle lens and as we can see here the straight lines of the shelves are noticeably curved around the periphery of the image.

Awareness of this issue becomes particularly important when you are mixing footage from two different lenses or even more so if you are integrating CG elements (which tend to have the characteristics of being shot with "perfect" lenses). It may also become an issue when you are tracking the movement of objects in the scene (as we'll discuss in Chapter 8). Remember, the job of a compositor is not to create a perfect artifact-free image, it is to create a perfectly *integrated* image, and this integration will often include the matching of lens defects and other idiosyncrasies.

Motion Blur

When a rapidly moving object is recorded on film or video, it will generally not appear completely sharp, but will have a characteristic **motion blur**. This blurring or smearing is due to the distance the object moves while the film is being exposed (or the video camera is recording a frame).

The amount of motion blur is determined both by the speed of the moving object and by the amount of time the camera's shutter was open. All modern cameras have the ability to shoot at a range of different **shutter speeds**, giving the photographer/cinematographer the ability to control the duration that the shutter is open. This capability is important both for technical reasons—controlling the amount of light that reaches the film or sensor—and for creative reasons. Slower shutter speeds (and consequently longer exposure times) will result in a larger amount of motion blur, whereas faster shutter speeds will reduce or even eliminate motion-blur effects. Figure 2.24 shows two images of the same scene, but Figure 2.24a used a shutter speed of 1 second and Figure 2.24b used a speed of 1/640th of a second. As you can see, the characteristic of the falling water has changed dramatically.

Although these images were photographed with a still camera, video and motion picture film cameras have the same capabilities, albeit with a few limitations. The most important of these is that the shutter speed can never be more than the frame rate you are using to capture the image. Obviously if you are shooting at 24 frames per second (fps), the maximum possible shutter speed would be 1/24th of a second.

In a motion picture camera, the shutter speed is also specified in terms of the **shutter angle**, since the shutter itself is a rotating physical mechanism. The shutter rotates 360° over the length of a single frame, but can only expose film for a portion of that time. Generally, the duration of the shutter's opening is about one-half of the frame rate that was used to shoot the footage, and we would refer to it as being set at a 180° shutter angle. (This setting would correspond to a shutter speed of 1/48th of a second,

(a)

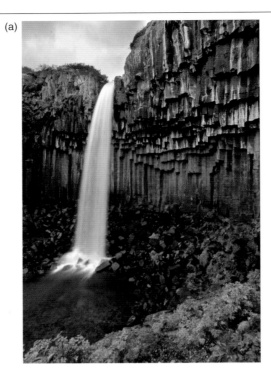

(b)

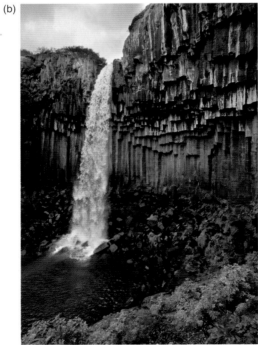

Figure 2.24b (a) A scene captured with a slow camera shutter. (b) The same scene captured with a fast camera shutter.

assuming we're shooting at the normal film rate of 24 fps.) This is a very useful piece of information. It means that, for a moving object, the film camera would only be able to capture about one-half of the object's movement. Consequently, the size of the motion blur on a single frame of an object will be approximately one-half the distance the object has traveled in that single frame. Since a compositor will often be called upon to take a static object and give it motion within the frame, this information can be used to help determine the proper amount of motion blur to apply.

Be aware, though, that although a 180° shutter angle is common, it is by no means universal. Although most motion picture cameras can only have their shutter angle set in the range of about 50°–200°,[4] video cameras do not have such limitations. Because they are not restricted by a mechanical shutter, many video cameras will allow the user to set shutter speeds at well over 1/1000th of a second. Slower shutter speeds (and consequently longer exposure times) will result in a larger amount of motion blur, whereas faster shutter speeds, particularly those available with video, will reduce or even eliminate motion-blur effects.

Figure 2.25 shows a falling object captured by a film camera with a 180° shutter angle. The ball was falling at a rate that was fast enough to produce a noticeable motion blur. Note that motion blur for images shot on film is symmetrical: The leading edge and the trailing edge of a moving object are blurred by the same amount. Contrary to popular belief, there is no in-focus leading edge with a trail of blur behind the object. This common misconception is probably the result of people looking at still images that were captured with flash photography, in which the shutter can be synchronized with the electronic flash to produce a trail.[5]

Depth, Distance, and Perspective

One of the most significant tasks that a compositing artist deals with is the job of taking elements and determining their depth placement in the scene. Taking a collection of two-dimensional pieces and trying to reassemble them to appear as if they have three-dimensional relationships is not a trivial issue, and a number of techniques are used in the process.

Because the elements that are being added to a scene were usually not shot in the same environment, there are a number of cues that must be dealt with to properly identify the elements' distance from the camera—primary visual features that allow the viewer to determine the depth relationship of various objects in a scene. These features

[4] **Motion-control cameras** are one of the exceptions to this rule, since they usually allow explicit control over the opening and closing of the shutter. There are also some specialized high-speed film cameras that treat the shutter differently, or at least are less reliant on the shutter since the exposure is determined more by a synchronized strobe.

[5] Either that, or it is the result of watching too many cartoons, which tend to depict motion by using a strong trailing blur.

Figure 2.25 Motion blur on a moving object.

include such things as object overlap, relative size, atmospheric effects, and depth of field. One of the most important features has to do with the way that **perspective** is captured by a camera, and thus we will take a moment to discuss this in greater detail.

Perspective and the Camera

Perspective relates to the size and distance relationships of the objects in a scene. More specifically, it has to do with the perceived size and distance of these objects, and with the ways in which this perception can be affected. Compositors need to be aware of these issues, since they will constantly be manipulating distance and size relationships in order to integrate objects into a scene. As with much of the material covered in the previous section, most of the following information can be found in any good photography book, usually in much more detail than we will go into here. But its importance is significant, and so we will try to give a quick overview of the subject and leave further research up to the reader.

Examine Figure 2.26—this scene was shot from a distance of about 16 inches away from the candles, using a 24 mm lens. Figure 2.27 was photographed from a much farther distance, about 4 feet, but using a longer, 85 mm lens. Notice the difference

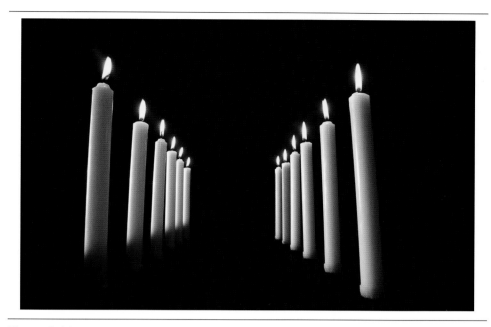

Figure 2.26 Candles shot from a close-up distance using a wide-angle lens.

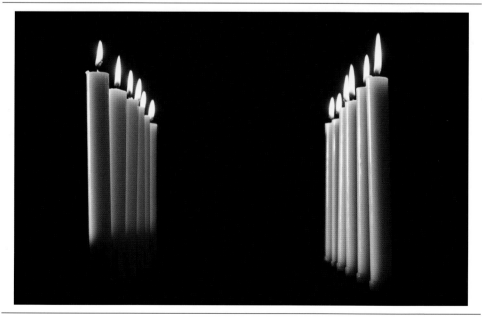

Figure 2.27 Candles shot from farther away using a longer lens.

in perspective between the two images. The apparent size and distance relationships among the candles in the scene are noticeably different—the candles seem significantly separated in 2.26 and much more tightly clustered in 2.27.

This difference in perspective is a result of the scene having been shot from two different *positions*. As we move towards or away from a given scene, the spatial relationships of the objects in that scene will seem to change, to be expanded or compressed. An extremely common misconception is that the perspective difference is due to the different *lenses* used to shoot the scene. While it is true that lenses with different focal lengths were used to shoot these two examples, it is best to think of lenses as simple framing devices that magnify a given scene by a certain amount. In this example, the scene in Figure 2.27 was magnified by an 85 mm lens so that the objects in the scene fill about the same amount of frame as they did in Figure 2.26, even though the camera is much farther away. But the lens itself did not contribute to the perspective change. Look at Figure 2.28, which was shot from the same distance as Figure 2.27, yet with the same 24 mm lens that was used in Figure 2.26. In particular, look at the area with the box drawn around it and notice that the objects have the same perspective relationship that is seen in 2.27. The lenses are completely different, yet the *perspective* is the same. This may seem like a trivial distinction at first, but ignore it at your own peril, particularly if you are the person who will be shooting different elements for a scene. This topic is discussed further in Chapter 12.

Figure 2.28 Candles shot from the same position as those in Figure 2.27 but with the same lens as used in Figure 2.26.

Objects farther from a camera begin to lose their sense of perspective: Their depth relationship to other objects is deemphasized. Thus, when you use a "long," or telephoto, lens, you will notice that the scene appears flatter and objects start to look as if they are all at approximately the same depth. This effect is due to the distance of the objects that you are viewing. In contrast, a collection of objects that are closer to the camera (and thus would tend to be shot with a wide-angle lens) will have a much greater sense of relative depth between them. Look again at Figures 2.26 and 2.27 and notice the effect that distance has on the apparent candle positions. Those in Figure 2.27 appear to have much less variation in their relative distances. They appear more flat, and their apparent sizes are very similar.

Strictly speaking, whenever discussing perspective issues such as this, one should always talk about the camera-to-object distance. But, in spite of the basic principles involved, it generally tends to be much more convenient to classify shots by the length of the lens used instead of the distance of the scene from the camera. The focal length of a lens is a simple piece of information, whereas the distance to the objects in a scene can be difficult to ascertain. Thus, we say that scenes shot with long lenses (which implies that they were shot at a greater distance from the subject) will tend to be more flat and show less perspective, and scenes shot with wide-angle lenses (implying proximity to the subject) will tend to show more perspective. We'll generally use this terminology and risk propagating the myth that the lens itself causes the change.

Depth Cues

Now that we have an understanding of how the perspective of a scene is affected by the distance from the camera, let's take a look at some of the other visual cues that our eyes use to help our brain understand an object's position in space. We'll call these depth cues, and will try to break them up into a few basic categories.

Overlap

The most basic cue that one object is in front of another is for the first object to overlap, or partially obscure, the second. This may seem to be such a basic piece of information that you may wonder how it can possibly help you to become a better compositing artist but remember, even though something may happen "automatically" in the real world, it won't necessarily do the same when you are building a synthetic scene. Thus, you will indeed need to be aware of the layering of objects in a scene, making sure that they overlap appropriately. Chapter 13 looks at how this and the rest of the depth cues that follow are used in the integration process.

Relative Size

Another cue that helps us to determine the placement of an object is the fact that the farther an object is from the camera, the smaller it will appear. This too is simple and obvious in theory, but in practice it can be deceptively difficult to determine the proper size of an object when it is being put into a scene. This is particularly true if the object you are adding is not something whose size is familiar to the people who

will be viewing the scene. Is that a medium-sized gorilla that's fairly close to the camera or is that a *really big* gorilla that's far away?

Motion Parallax

Motion parallax refers to the fact that objects moving at a constant speed across the frame will appear to move a greater amount if they are closer to an observer (or camera) than they would if they were at a greater distance. This phenomenon is true whether it is the object itself that is moving or the observer/camera that is moving relative to the object. The reason for this effect has to do with the amount of distance the object moves as compared with the percentage of the camera's field of view that it moves across. An example is shown in Figure 2.29. An object that is 100 m away may move 20 m in a certain direction and only move across 25% of the field of view, yet the same 20 m displacement in an object that is only 40 m away will cause the object to move completely out of frame.

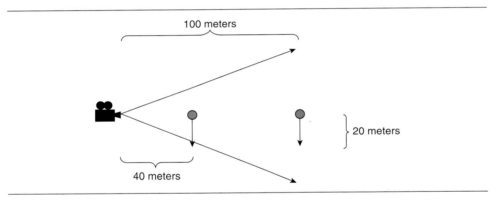

Figure 2.29 Motion parallax diagram.

Atmospheric Effects

One of the more subtle—and often ignored—depth cues has to do with the atmosphere in a scene. As an object moves farther away from the camera, the effects of this atmosphere will grow more and more pronounced. Atmospheric effects can include mist, haze, smoke, or fog, but even on the clearest days you will have atmospheric influences on objects in the distance. Air itself is not completely transparent, and any additional foreign gas or suspended matter will increase the opaqueness of the air.

Go look at some images taken on the surface of the moon, and notice how the lack of atmosphere makes even the most distant objects appear to have too much contrast. Shadows are far too dense, and in general it is extremely hard to judge the size and location of these objects. Even photographs taken from miles up appear to have been taken from a relatively low height, and the horizon seems far too near. Of course, part of this effect is because the moon, having a smaller diameter, does have a shorter

horizon, but this alone does not explain the effect, or the difficulty in judging the size of objects in the distance. It is primarily the lack of atmosphere that fools our perceptions.

Figures 2.30a and 2.30b both show good examples of atmosphere in a scene. Note the successive loss of contrast in the distant objects: The dark areas are lightened, and the image becomes somewhat diffused. In general, the darker areas will take on the color of the atmosphere around them. On a clear day, dark or shadowed areas on an object will take on the bluish tint of the sky as the object moves away from the camera (or the camera moves away from the object). This sort of effect becomes even more pronounced if the subject is in a fog or under water.

Figure 2.30a An example of how atmosphere affects an image as a function of distance.

For another example of how significantly atmosphere can help to define the distance of objects in a scene, consider Figure 2.31a. The land in the distance appears to be rather uniform—there is no real sense of relative depth between the various trees. However, if we look at the same scene photographed during a time when a heavy mist is hanging on the lake (Figure 2.31b) we can now understand that there is significant variation in object depths.

Depth of Field

Earlier in this chapter we examined depth of field as a general characteristics of the way a camera will capture an image. But it is also one of the cues that can be used to help understand the distance relationships of objects in a scene. Do keep in mind, however,

Figure 2.30b Another example of atmosphere in an image.

Figure 2.31a A scene without any atmospheric fog.

Figure 2.31b The same scene with a significant amount of fog.

that unlike some of the other depth cues the depth of field effect is symmetrical around the focus area. Thus, two objects may show the same amount of defocus but one can be 30 feet in front of your focus point and the other may be 30 feet behind the focus point. Fortunately there are usually other depth cues that can help to eliminate any ambiguity.

Stereoscopic Effects

There is a set of depth cues that we constantly deal with in our daily life, but that can't be captured by normal film and video. These are the significant **stereoscopic** cues that our binocular vision gives us. Although the overwhelming amount of compositing work isn't being done in stereo *yet*, it is certainly an area that is growing as more theaters adopt the ability to show stereoscopic films. Many live-action and most major CG-animated films are having a stereo version generated simultaneously with the more conventional format, designed to be shown via a specialized projector and (typically) polarized glasses to synchronize which eye is seeing which image.

Depth perception due to stereoscopic vision is based on the parallax difference between our two eyes. Each eye sees a slightly different image, whereby objects closer to the observer will be offset from each other by a greater amount than objects farther away. This effect is similar to the motion parallax described earlier, except that it occurs because the observer is viewing the scene from two different vantage points *simultaneously*. The brain is able to fuse the two images into a coherent scene, and at the same time it categorizes objects by depth based on the discrepancies between the two viewpoints.

Figure 2.32 A stereo image pair.

Figure 2.33 Stereo image pair—detail.

Figure 2.32 shows a scene as viewed from two cameras that were placed a typical pupil-distance apart. (Many people can "free fuse" these two images by slightly diverging or crossing their eyes in order to obtain a true stereoscopic view of the scene). If you examine the images you can see exactly how much the two images vary in terms of the overlap between different objects at different depths. Note how things that overlap significantly in one eye's view may not overlap at all when viewed through the other eye. This variance is highlighted in Figure 2.33, where we have

extracted a similar section of each image. These are exactly the cues that your brain will process automatically to generate a sense of depth.

Visual "Correctness"

We have just finished giving a great deal of detail about how light and imagery behaves in the real world. But it should be noted that as a compositor, you will often be walking a path that isn't always firmly planted in that same world. Very often you'll be asked to do what looks "good" even if it doesn't look completely "real." (For that matter you'll often find that reality itself doesn't always look all that real anyway.)

And this is really where the Science ends and the Art begins. Knowing when to deviate from reality is, of course, a very subjective thing, but it's certainly nothing that's specific to the world of visual effects or even filmmaking. Visual artists have been intentionally bending the rules for thousands of years, using tricks of color, perspective, and lighting to increase the drama of a scene or to make a specific point. Although we have become accustomed to a variety of lighting styles, look at some films with a fresh eye and you'll see that they are often filled with unmotivated light sources, for instance.

Ultimately you'll have to rely on your own judgment (or at least on the judgment of your supervisor or the director of the piece you're working on) to determine where rule-bending is appropriate. As you gain experience you'll learn to trust that judgment and realize that the ultimate rule which applies is this:

If it *looks* correct, then it *is* correct.

The Digital Representation of Visual Information

Digital compositing is, ultimately, about working with images. Before we can effectively discuss any of the basic tools of compositing, therefore, we need to build up a bit of background knowledge and vocabulary concerning how images are dealt with in the digital medium we are using. This is a large topic (and the chapter length reflects this!) but a core understanding of these fundamental concepts will make everything that follows much clearer.

For the topic of *digital* compositing, an obvious issue is how the digital image data is stored and represented. Although this topic could conceivably be extended to include everything from binary data coding to disk formatting, we try to present information that will directly affect the decisions a typical compositing artist will need to make on a regular basis. There are literally hundreds of different, reasonably well-defined ways to store an image digitally. But, in day-to-day usage, most of these methods have several things in common. Many of the concepts that are covered in the beginning of this chapter will be trivial and obvious to someone who has spent any time working with digital images, but it is suggested that you at least skim the sections because certain terms are introduced and defined that will then be used throughout the book.

Image Generation

Before we can discuss how image data is stored, we need to cover where the images come from in the first place. Although the digital compositor will eventually be dealing with images that have all been converted to some specific digital format, the procedures that were used to initially create or capture those images may vary quite a

bit. Elements that will be used for digital compositing generally come from one of the following three places:

1. *Hand-painted or human-generated elements.* These can range in complexity from a simple black-and-white matte to a photorealistic matte painting of a real or imaginary setting. Although in the past much of this type of artwork would have been generated outside the computer using more traditional painting methods, the advent of extremely powerful paint programs has made it far more common to hand-paint elements directly in the computer. An example of this is shown in Figure 15.3 in Chapter 15, a matte painting that was created for the film *Speed*, from 20th Century Fox.

2. *Computer-generated images.* Although no images are truly "computer generated" since their origin can eventually be traced back to a human being who defines a set of algorithms for the computer to use, this term (or its abbreviation, "CGI") is usually used to refer to elements that have been created or rendered using a specialized 2D or 3D computer animation package. In the *James and the Giant Peach* example from Chapter 1, the mechanical shark and the stylized water were both computer-generated images.

3. Images that have been digitized into the computer from some other source (typically film or video).

Breaking this topic up into three categories is extremely simplified—computer-generated elements may contain scanned or painted elements (used as texture maps, for instance), matte paintings often borrow heavily from other scanned sources, and live-action elements may be augmented with hand-painted wire removals or effects animations.

The first source of imagery, hand-painted elements, will be touched on throughout the body of this book as needed. We will not, however, spend a great deal of time discussing specific software or techniques.

The subject of how computer-generated (CG) images (our second potential source of imagery) are defined and rendered will also not be covered in great detail, although there are a few sections of this book (notably in Chapter 14) that give some suggestions about how to ease the integration of 3D elements into composited scenes.

Some excellent reference works already exist on both of these topics, a few of which are mentioned in the bibliography at the end of this book. Not only are there a variety of books that cover digital painting, modeling, animation, and rendering from a generalized perspective, but there are also specific "how-to" guides for many of the more common software packages.

The third source of imagery—scanned/digitized "live-action" footage—is still probably the most common source we deal with in digital compositing. There are a myriad of different formats that this source imagery can come from, some of them discussed in greater detail in Chapter 10 and Appendix C.

Understanding the methods that were used to generate a particular image sequence can be extremely important to a compositor. There are a number of distinguishing factors between CG elements and scanned live-action images in terms of how they are used in the compositing process. For instance, rendered CG elements can usually be generated with additional information that may be used to aid their placement into an existing scene. Information such as an additional matte channel (covered more in Chapter 5) or Z-depth information (Chapter 14) will allow the compositor to bypass or simplify several integration steps that are otherwise necessary when dealing with simple scanned images.

More importantly, there needs to be a recognition that digital images that are created from live-action sources are actually just bounded *samples* of the real-world scene. There is always a limit to the amount of detail and the range of color and brightness any given image capture technique can provide, a fact that should always be kept in mind as one is working with these images. We'll discuss this more in just a bit.

Pixels, Components, and Channels

Digital images are stored as an array of individual dots, or **pixels**. Each pixel will have a certain amount of information associated with it, and although it is still common to present a pixel as having a specific color, in reality there may be a great deal of additional information that is associated with each pixel in an image. But rather than taking the typical computer-graphics route of discussing all the possible characteristics of a pixel first and then looking at how these combine to make an image, we want to think of a color image as a layered collection of simpler images, or **channels**.

Digital images are, of course, a rectangular array of pixels. And each pixel does, of course, have a characteristic color associated with it. But the color of a pixel is actually a function of three specific **components** of that pixel: the red, green, and blue (usually simplified to R, G, and B) components.[1] By using a combination of these three primary colors at different intensities, we can represent the full range of the visible spectrum for each pixel.

If we look at a single component (red, let's say) of every pixel in an image and view that as a whole image, we have what is known as a specific **channel** of the complete color image. Thus, instead of referring to an image as a collection of colored pixels, we can think of it as a three-layer combination of primary-colored channels.

Consider an image such as that shown in Figure 3.1. The next three images, Figure 3.2a, 3.2b, and 3.2c, show the red channel, the green channel, and the blue channel of this sample image.

[1]There are many number of different ways to represent color, but because of its prevalence in the digital world we will primarily deal with the RGB model. A bit later we will talk about another model that represents color via hue, saturation, and value parameters.

Figure 3.1 A sample color image.

Figure 3.2a The red channel from our sample image.

Figure 3.2b The green channel.

Figure 3.2c The blue channel.

In this case, we've tinted the individual channels to reflect the color they are associated with, and it is convenient to think of the channels as being transparent slides that can be layered (or projected) together to result in a full-color image. But these channels can also be thought of as monochrome images in their own right. Consider Figure 3.3, which is the same image as Figure 3.2a, the red channel, but without any colored tint applied. This monochrome representation is really more accurate, in the sense that a channel has no inherent color, and could conceivably be used for any channel in an image.

Figure 3.3 The red channel from our sample image, shown as a grayscale image.

The reason for dealing with images in this fashion is twofold. First, single pixels are simply too small a unit to deal with individually; in general, compositing artists spend about as much time worrying about individual pixels as a painter might spend worrying about an individual bristle on her paintbrush. More importantly, dealing with complete channels gives a great deal of additional control and allows for the use of techniques that were pioneered in the days when optical compositing was being developed. Color film actually consists of three different emulsion layers, each sensitive to either red, green, or blue light, and it became useful to photographically separate these three layers, or records, in order to manipulate them individually or in combination. A digital image (also known as a bit-mapped image) of this type will generally consist of these three color channels integrated into a single image, but it should be clear that these three channels can be thought of as separate entities that can be manipulated separately as well.

Looking at the individual channels for the image in question, we can see which areas contain large values of certain colors, and it is easy to find the correspondence in an individual channel. For instance, the background of the image—the area behind the parrot—is a fairly pure blue. If you look at the red channel of this image (Figure 3.2a again), it should be obvious that there is essentially no red content in this area. On the other hand, the front of the head and the beak are areas with a good deal of red in them (yellow having heavy red and green values), which is also obvious when looking at the individual channels. Later we will see how manipulating and combining the individual channels of an image can be used for everything from color correction to matte extraction.

Spatial Resolution

A number of measurements are used to gauge the amount of information that is present in a digital image. The most obvious measurement is the number of pixels used to create the image. The larger the number of pixels that are used, the greater the **resolution** of the image. When we use the term "resolution" in this fashion, we are actually referring to the **spatial resolution** of the image. There are other types of resolutions, such as color or temporal (which will be discussed later), but the general convention is that the pixel count for an image is the primary measurement of the image's resolution.

A square image that is, for example, 500 pixels wide and 500 pixels tall has 250,000 pixels of resolution. Most images are not square, and thus it's generally more useful to speak of an image's resolution by giving the width and height in pixels.[2] The above example would be referred to as an image that is 500 × 500, or "500 by 500." Greater spatial resolution will allow one to reproduce finer detail in the image, but it will also increase the resources needed to deal with the image. And, as we saw in the last chapter, this resolution is ultimately only capturing a subset of the information that is available in the original scene. The image that we used for that example (Figure 2.11) was captured at a resolution of about 5000 × 5000 pixels, by the way.

Different media tend to work in widely different resolutions. At the low end, web pages may use images that are only a few hundred pixels wide. "Standard Definition" broadcast video, depending on the standards of the country in question, is usually in the range 700 × 500. Feature film work is generally done with an image that is approximately 2000 pixels wide,[3] though this can vary a great deal. The process of working with various resolutions and formats will be discussed further in Chapter 10.

Some of the highest resolution requirements come from the print industry. Although the terminology is somewhat different and images are often specified relative to their eventual output medium (i.e., using terms such as "dots per inch" or DPI[4]), the data requirements for large images can be substantial. For instance, a full (two-page) spread in a magazine such as *The National Geographic* will require an image that was

[2]This is in contrast to the digital photography world, where marketing has driven the industry to adopt a simple "Megapixel" number for measuring spatial resolution. An image from a digital camera whose sensor captures 4992 horizontal pixels by 3328 vertical pixels has a total of about 16,600,000 pixels or 16.6 Megapixels.

[3]Actually the number is usually the more computer-friendly 2048, and an image that is this wide is generally referred to as being a "2K" image. A 1K image is 1024 pixels wide, a 4K image is 4096.

[4]To clarify a bit more on this topic, as it seems to be a source of confusion for many people working with print images, Dots Per Inch is, in and of itself, *not* a measure of absolute resolution for an image. To say a digital image is "300 dpi" doesn't tell you anything about the number of actual pixels in the image, only that it has been digitally "tagged" with a specific instruction for the print device. To completely specify the image size using this convention, you'd need to provide the DPI measurement *and* the size at which it will be printed (i.e., "5 inches wide at 300 DPI," which would indicate that the image is 1500 pixels wide). Changing the DPI of an image doesn't affect the amount of information in the image (unless you resample the image at the same time), it merely controls how large the image will be once it comes out of your printer.

stored with a resolution of at least 4000 × 3000 pixels and fashion photographers regularly shoot at much higher resolutions than that, allowing them additional flexibility for postprocessing and higher quality should the image need to be reproduced in some extremely large format such as a billboard.

Bit Depth

Each component of a pixel can be represented by an arbitrary number of bits. A bit is the most basic representation of data within a digital system, and is capable of recording only two states. If we only have a single bit to represent a color, it would probably be used to specify either black or white. More bits will allow us a greater number of color variations, and the use of multiple bits for each component of an image is what allows us to store captured imagery with realistic color information.

The number of bits per component is known as the component's (and the channel's) **bit depth**.[5] The bit depth is actually a way of measuring the color resolution of a given image.[6] Just as a larger number of pixels in an image allows for finer image detail, so a larger number of bits allows for finer variations in color. As you will see, many of the issues we mentioned when discussing spatial resolution have counterpart issues when discussing color resolution. Another term for color resolution is dynamic resolution, referring to the greater dynamic range available when using a greater number of bits per component, and you will occasionally hear the term chromatic resolution as well.

Probably the most common bit depth for image storage is 8 bits per channel, which is also referred to as a "24-bit image" (8 bits each for the red, green, and blue channels).[7] Eight bits per channel means that each component of a pixel can have 256 (2^8) different possible intensities and the three components together can represent about 16 million (16,777,216 for the geeks) colors. Although this sounds like a lot of colors (most images will not even have that many pixels), it is often still not enough to reproduce

[5] Although you will often see bit depth defined in terms of the number of bits per channel, this definition is technically inaccurate, since the channel of an image refers to the full array of pixels that makes up the image. Theoretically, the number of bits per channel for a given image would be the number of bits per component multiplied by the spatial resolution of the image. However, since "bits per channel" is the more common term, we will consider it to be synonymous with "bits per component" and will use the two interchangeably.

[6] For the purposes of our discussion, we'll consider "color" to include shades of gray as well. Thus, the number of bits dedicated to reproducing the gray tones in a monochrome image can still be considered a measure of its color resolution.

[7] Incidentally, there is unfortunate confusion about some of this terminology in the personal computer marketplace. The video devices on early PCs were limited in their ability to display a great number of different colors. Many of them could only devote 8 bits *total* to the color specifier. To work around this limitation, they would use these 256 values to look up colors in an index of many more colors. Two different images might not need the same group of 256 colors, and consequently the palette was often dynamically allocated as necessary. Unfortunately, the correct terminology of "8-bit indexed color" was abbreviated in popular use to simply "8-bit color." When systems became available that could display a full 8 bits per channel, this then became referred to as "24-bit color." Throughout this book, we will always refer to an image's color resolution in terms of the number of bits per channel.

all of the subtle tonal variations that are captured with some analog imaging formats. Feature film work, for instance, generally represents digital images with at *least* 16 bits per channel, which gives us a palette of 281 trillion different potential colors. On the other hand, lower-end formats in which color gradations are less important may be able to work with even smaller color resolutions.

Figure 3.4 shows an original image that is using 8 bits per channel to represent the colors. Figure 3.5 shows that same image after being decimated to only 4 bits per channel.

Figure 3.4 An image captured at 8 bits per channel.

Notice the **quantizing** that arises—the noticeable delineations between various bands of colors, particularly in the sky and clouds. This phenomenon, also referred to as "banding," "contouring," or "posterization," arises when we do not have the ability to specify enough unique color values for smooth transitions between different shadings.

Strictly speaking, this noticeable banding should really be called a "quantization artifact." Quantizing itself is merely the process of assigning discrete values to samples taken from a continuous (i.e., analog) signal. This step is necessary in order to store an image digitally, and if it is done with enough precision, you shouldn't be able to distinguish the digital copy from the original. However, if you do not allocate enough data to store the sampled information, artifacts will result.

Figure 3.6 shows the same image yet again, only this time using just 3 bits per channel to represent the colors and only looking at the red channel of this 3-bit image. Here you can clearly see the 8 shades of red that are available to represent the colors in the image.

Figure 3.5 The same image when represented with only 4 bits per channel.

Figure 3.6 A single channel of the same image when represented with only 3 bits per channel.

There is a huge body of information about the proper way to choose the amount of data required to accurately represent an original image, but for the purposes of the artist trying to produce a quality image, the main issue is to use enough data so that visual artifacts aren't created, even after applying any necessary image manipulations. As we'll see in later chapters, one often finds that not having enough color resolution in an original image may only cause problems much later in the process, after many operations have been performed on the image.

Normalized Values

Since different images may be stored at different bit depths, and consequently would be represented by different numerical ranges, it is convenient to refer to the numerical value of a pixel as if the values had all been normalized to floating-point (noninteger) numbers in the range 0–1. Since a pixel with 8 bits per channel can have values in the range 0–255 for each channel, we would divide each value by 255 to come up with these normalized numbers. For instance, an orange pixel in an 8-bit image might have RGB values of (255, 100, 0). This pixel's normalized values would be specified as (1.0, 0.39, 0). By the same method, a 10-bit image (which can have a range 2^{10}, or 1024, values per channel) would have every value divided by 1023 to determine its normalized representation.

There are a number of reasons why this is a useful convention. First of all, it frees the user from having to worry about the bit depth of the source images that are being worked with. A good compositing system should be able to deal with images of a variety of differing bit depths and combine them easily and transparently.[8]

Additionally, math operations between images are made much easier. For instance, it is a standard mathematical concept that multiplying any number by 1 will not change the value of the number. If we multiply an image by another image, it is convenient that any pixel that is white (1, 1, 1) does not change the value of whatever it is multiplied by, and multiplying every pixel in an image by a pure white image (i.e., a constant value of 1) will leave the image unaffected.

Throughout this book we will use a floating-point notation for color values, thus assuming that an RGB triplet of (1, 1, 1) refers to a 100% white pixel, a triplet of (0, 0, 0) is a 100% black pixel, and (0.5, 0.5, 0.5) is 50% gray.

By normalizing digital values to the range 0–1, we have now also established a convention that works consistently at all bit depths. Note, however, that just because a system may display values as if they were floating-point numbers, there is a more specific definition of "floating point" that the compositing artist needs to be aware of. This is a slightly different way of representing color (and particularly luminance)

[8] Having said this, it is not at all uncommon to see values represented in the range 0–255 in many systems, particularly those that are only capable of working at 8 bits per channel. Sometimes, however, you'll still see systems use this 0–255 range even when they are processing at a higher bit depth!

that takes into account the fact that, in the real world, the concept of what is "white" is rather arbitrary and brightness levels don't have a fixed range they stay within. When we work in a system that can store pixel values in a true floating-point format, we may have pixel values that are greater than 1.0 and other values that are less than 0. This is extremely useful (and will be discussed in much greater detail in just a moment) but it does generally require a system that is capable of processing at a reasonably high bit depth. Also, even though any decent compositing system is now capable of working with floating-point data, most display devices—film or video—are not. They will still expect to receive integer data that is within a fixed range. Many file formats will also still enforce a truncated range and for these reasons a digital artist needs to understand the liabilities and benefits of a variety of representations.

Beyond Black and White

One of the biggest mistakes that the digitally trained artist can make comes from trying to think about the real world in digital terms instead of trying to view the digital world in real-world terms. As we have mentioned, it is important to recognize that a camera is only capable of capturing a limited sample of any given scene. This sample contains far less information than the scene itself, and consequently there are great limitations on how much manipulation can be done with it.

Consider the image shown in Figure 3.7. It features a scene with two obvious light sources. If you compare the image of the two light bulbs, you will see that the centers of

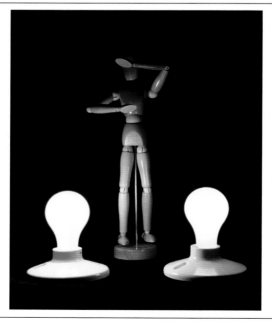

Figure 3.7 A scene with two light sources of different intensity. Both bulbs appear to have the same brightness when exposed normally.

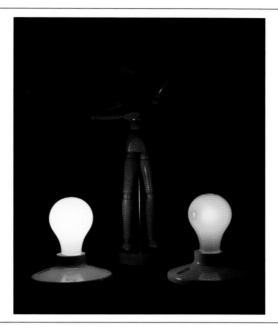

Figure 3.8 Reduced exposure reveals the difference between the two light sources.

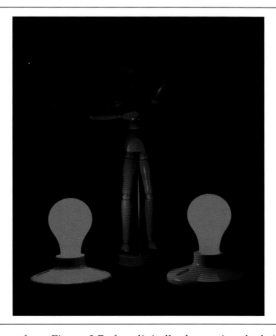

Figure 3.9 The image from Figure 3.7 after digitally decreasing the brightness.

both bulbs have the same apparent value. Both are "white," the maximum brightness that the film was able to capture. But in fact, these two lights are actually quite a bit different—the bulb on the left is a 100-watt bulb, the bulb on the right is only 25-watts. Theoretically, the higher-wattage bulb is putting out about four times as much light.

Figure 3.8 confirms this fact. The camera's aperture has been decreased so that the overall exposure of the scene is significantly reduced. The difference between the two light sources now becomes obvious, since the lower exposure prevents the lower-wattage bulb from overexposing the film and there is now detail visible in the center of the bulb. The 100-watt bulb, however, is still bright enough to expose to white.

This example underscores the fact that the terms "white" and "black" refer to very arbitrary concepts and are really only valid within the context of whatever system is being used to capture the image. They are also tied to whatever is being used to display the image. For instance, on a computer or video monitor, "black" can be only as dark as the CRT or LCD is when no power is being applied to illuminate it. Look at an unplugged TV and you'll realize that the screen is really not that black at all—more like a dark gray. By the same token, a "white" object on a monitor may look much less so if you compare it with an identical object being viewed in bright sunlight. All of the pictures in this book have their own limitations on the range of brightness they can properly represent—"black" is limited by how dark we can make the ink we print on the page, "white" is only as bright as the paper used to print the book.

A great number of digital compositing processes are built on the concept that black is represented by a digital value of 0, and white is represented by a digital value of 1. While this is, indeed, a very useful conceit, it does not accurately represent the way that the real world works, and there are times when we need to disregard this simplification. There is an inherent danger in making the assumption that the white or black areas in two different images can be treated as if they were equivalent values. Often you will find that white and black pixels should even be treated differently from the rest of the pixels in the *same* image.

Consider again Figure 3.7 as compared with Figure 3.8. If we attempt to modify Figure 3.7 digitally to produce an image that matches Figure 3.8, we can produce an image like the one shown in Figure 3.9.As you can see, although this has reduced the wooden character to an acceptable match, the areas that were white in the original have also been brought down to a darker value. Our digital tool is obviously not doing a very good job of mimicking what happens in the real world. Although the use of other digital tools and techniques may be able to do a slightly better job of preserving the brightness of the white areas in the image, we still have a problem with the detail in the center of the 25-watt bulb. If all we have to work with is Figure 3.7, we will never be able to accurately re-create the image that is shown in Figure 3.8, since the information in this portion of the scene has exceeded the limits of the system (in this case a piece of film) used to capture it.

The real world contains a *huge* range of potential luminance values,[9] covering several orders of magnitude. The average illumination of a sunlit scene, for instance, is approximately one million times greater than a moonlit one (and normal indoor lighting falls roughly halfway between the two ranges). And even within a fixed lighting environment, the objects *in* that environment can have a very wide range of values as well.

Fortunately the human eye is very adaptable to changes in illumination—not only is our retina capable of registering a broad range of luminance but the iris of the eye provides an additional method of controlling how much light the retina has access to.

Figure 3.10 A scene with a large range of illumination values.

Film emulsions and digital camera sensors aren't quite as flexible, at least not yet. The image in Figure 3.10 above was captured with a modern digital camera yet there are areas which fall far beyond the range that the camera's sensor can capture. Figure 3.11 is color-coded to make this even more obvious—red areas are those that the camera could only register as "white" and green areas are effectively black.

[9]Okay, in theory there's actually the possibility of an infinite range of luminance values but since there is a practical limit beyond which you'll be completely blinded or, eventually, incinerated, we'll consider the range that you're more likely to encounter on a daily basis.

Figure 3.11 Color-coded version of the same image showing over-exposed (red) and under-exposed (green) areas.

Now we can certainly change the settings on the camera to allow more or less light to hit the camera's sensor but understand that this will only *shift* the range that is being captured. Figure 3.12a shows the same scene with the exposure set so that four times as much light is captured—there is more detail visible in the shadow areas but at the same time far more of the image has blown out in other areas. Exposing in the other direction is shown in Figure 3.12b—now we can see some of the detail of the sunlit world outside of the window but the bulk of the scene is extremely dark.

Areas that exceed the exposure limits of film or video are a common problem even when there is no digital compositing involved. Trying to photograph a scene with a bright blue sky while still being able to see detail in areas that are shadowed can be a nearly impossible task. If you use an exposure designed to capture the color of the sky, the shadow areas will probably register as completely black. But if you increase the exposure in order to see into the areas that are shadowed, the sky will become overexposed and "burn out" to white. Digital compositing tools are sometimes used to solve just this problem. By photographing the scene twice, once for the sky and once for the darker areas, an **exposure split** (or **E-split**) can be used to combine the two images into the desired result. Figure 3.13 shows just such an example—it was actually created by merging the two images shown below it—Figure 3.14a and 3.14b. This is a very specific way to deal with a particular image situation but some more general concepts related to dealing with scenes that contain a large dynamic range will be discussed in the next section.

Figure 3.12a The same scene exposed to reveal more detail in the darkest areas.

Figure 3.12b The scene exposed to reveal more detail in the brightest areas.

Figure 3.13 An image that was created via the use of an exposure split.

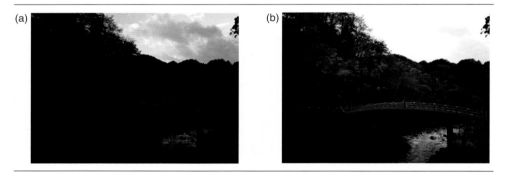

Figure 3.14 (a) Source image for sky exposure. (b) Source image for bridge exposure.

The important point for now, though, is that overexposed areas in any image should not be thought of as being "white" at all. Rather, any region that is at the maximum level of the system in question should really be considered to be *above* white. This is sometimes referred to as **superwhite**. Although we may have no way of measuring exactly how *much* above white the area really is, there are a variety of compositing situations in which the concept of superwhite (or superblack) can be put to use.

In Chapter 2 we described how an out-of-focus image of a very bright light source will look significantly different from a simple blur applied to an in-focus version of

the same scene. Some of the reasons behind the difference should now be a bit more obvious. Applying a basic blur to the in-focus image will merely average the "white" pixels (pixels with a value of 1.0) across many of the adjacent pixels. But these white pixels should actually be much brighter than 1.0, and consequently the amount of illumination that is spread by the blur should be increased as well. Because the bright areas in our digital image are limited to a value of 1.0, the amount of light that is spread is limited as well. In the real scene, the light source has no such artificial limits imposed on it, and there will be enough illumination coming from it to overexpose the entire range of its defocused extent. Instead of the soft-edged blob that is produced by our digitally blurred image, we have a noticeably defined shape.

It is not at all uncommon to treat overexposed (i.e., superwhite) areas of an image differently when dealing with them in a digital composite. These areas may be specific light sources, as shown in our lightbulb example, or they may simply be the part of an object that has a very strong highlight. For example, to better simulate the behavior of an out-of-focus light source while still using an ordinary blur tool, we might isolate anything that is a pure digital white into a separate image. Once we apply our blur to both images, we can add the isolated superwhite areas back into the scene at a greater intensity. This technique will help to simulate the fact that the real light source was far brighter that what our image considers to be white.

These last few paragraphs have touched on a few ways of working around the limitations of a framework where image data is lost due to under- or over-exposure of certain areas in a scene. But what we really want is a way to represent a much wider range of values and, ultimately, to capture these values as well. Let's look into that next.

Floating-point and High Dynamic Range Imagery (HDRI)

Consider Figure 3.15, a computer-generated image of a spherical object. Synthetic imagery like this isn't subject to the same limitations as a video camera or a piece of film in terms of only being able to capture a fixed range of luminance values. Internally our 3D rendering software can keep track of a far broader set of values, and lights can have just about any value, as is the case in the real world.

And when we want to represent the values of objects that are illuminated by these lights, we'll simply make use of some kind of floating-point representation where there is no inherent limitation on the range of numbers we can use. Earlier, we established the convention of normalizing black to 0 and white to 1.0 but the obvious progression from that is that we can now specify values *outside* of that range, even if our display device isn't capable of showing them to us in any sort of useful fashion. Thus, there's no reason why we can't have the value of a specific pixel go to 1.1, or 2.0, or even to 11.

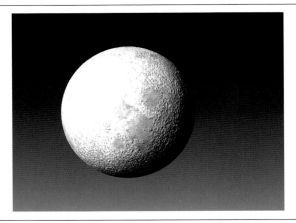

Figure 3.15 An image that was rendered into a floating-point image representation.

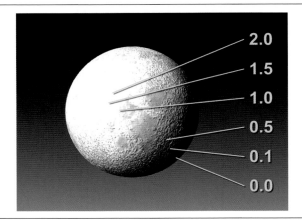

Figure 3.16 Labels showing the true values of different areas in the floating-point image.

In Figure 3.16 we've labeled a few different values on the object, showing exactly this principle. Although there is a large area that looks white as reproduced on the printed page (or viewed on a computer monitor), the digital file we're using to store this photo actually has much more information in that white area than what we can see. And in fact if we apply a simple mathematical operation to every pixel in the image, decreasing values to 1/2 of their original state (Figure 3.17) we can see exactly this. The textural detail that is actually present in the "hot" areas of the image now comes into view. By contrast, if the image shown in Figure 3.15 had been rendered to an image with a fixed range 0–1, decreasing it by the same amount would merely pull all of our white values down to a dull gray (Figure 3.18).

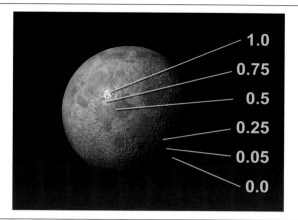

Figure 3.17 Floating-point image with values reduced by half.

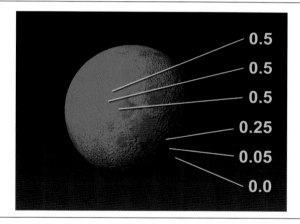

Figure 3.18 Fixed-point image with values reduced by half.

The ramifications of working in a floating-point mode (or, colloquially, "working in float") are significant and will be touched on throughout this book. At this point it is not yet the overwhelming standard for digital compositing work but it is almost certainly going to be so relatively soon.

Historically the reason that a full floating-point representation wasn't common was one of data size. To do a good floating-point representation you really want 32 bits per channel, which makes for rather large file sizes. (And of course if you double or quadruple the amount of data then it will take an equivalently longer amount of time to process the data when you start modifying it.) What makes a given representation "good," you might ask? In this case, it is simply making sure that you have enough precision to represent the range you are working with without causing any artifacts to show up. Earlier we saw how a low bit-depth image will start to show banding—there just weren't enough

individual colors in our palette to accurately represent the subtle gradations in the scene. If we're suddenly trying to store a much greater range of brightness values it should be obvious that we need to increase the amount of data we use to represent that range.

Images that contain a large range of brightness values are known as **High Dynamic Range** images or, acronymically, HDR images. The term is usually used for imagery captured from the real world but this isn't a hard-and-fast rule. Thus, while it would be reasonable to refer to the rendering in Figure 3.15 as an HDR image (and remember, we're talking about the digital file that contains this extended range, *not* the printed reproduction you see above) it is probably just as common to hear it referred to as simply a "floating-point image."

The two concepts, floating-point and HDR, are linked in many ways but they are definitely not synonymous. You can certainly store and work with images that are completely floating-point in their representation even if none of those images contain much of a dynamic range at all. A photograph of a uniformly-lit gray card will have almost no dynamic range—there are no bright or dark areas in the scene and everything will be of approximately the same illumination. But we can still represent that scene with floating-point accuracy. There are ways, too, that we could use 8 bits to store an HDR scene although it's generally not a very good idea to do so (and would likely be subject to terrible visual artifacts). Consequently, you shouldn't assume that just because you're not working with HDRI that you won't want to use a floating-point representation for your data. Because the real benefit of working in float is that you are much less likely to suffer significant data loss as your images undergo multiple manipulations. This will be touched on throughout the book, and further discussion on HDRI (both in terms of acquisition and manipulation) can be found in Chapter 14.

The HSV Color Representation

Up until now, we have specified the color of an image as being based on RGB components. This model, or **color space**, is certainly the most common way to represent color when using a computer, but it is hardly the only way. A particularly useful alternate method for representing (and manipulating) the colors of an image is known as the HSV color space. "HSV" refers to the hue, saturation, and value of a pixel.[10] In many ways, HSV space is a much more intuitive method of dealing with color, since it uses terms that match more closely with the way a layperson talks about color. When speaking of color conversationally, instead of characterizing a color as having 60% red, 2% green, and 95% blue, we would tend to say that the color is a "saturated purple." The HSV model follows this thinking process, while still giving the user precise definition and control.

The hue of a pixel refers to its basic color—red or yellow or orange or purple, for instance. It is usually represented in the range 0–360, referring to the color's location (in degrees) around a circular color palette. Figure 3.19 shows an example of such

[10] Variations on the HSV model include HSL and HSB, in which the third component is either lightness or brightness, respectively. HSV seems to be slightly more common with digital compositors, but just about everything we talk about applies equally well to these other models.

a circular palette. In this example, the color located at 90° corresponds to a yellow green, and pure blue is located at exactly 240°.

Saturation is the brilliance or purity of the specific hue that is present in the pixel. If we look again at our color wheel in Figure 3.19, colors on the perimeter are fully saturated, and the saturation decreases as you move to the center of the wheel.

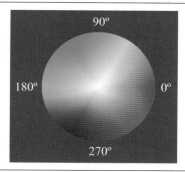

Figure 3.19 HSV color representation showing hue and saturation.

Value, for the most part, can just be thought of as the brightness of the color. Trying to represent this third component means that we need to move beyond a two-dimensional graph, and so you should now look at Figure 3.20. In this diagram we have chosen to map value along the third axis, with the lowest value, black, being located at the bottom of the cylinder. White, the highest brightness value, is consequently located at the opposite end. (This is, incidentally, only one method out of many that can be used to give a visualization of an HSV color representation.)

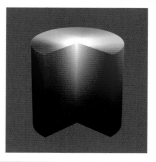

Figure 3.20 Three-dimensional color cylinder representing hue and saturation in the same fashion but with value mapped to the third axis.

Figure 3.21 shows our original test image represented as individual H, S, and V channels. Looking at the image in this fashion shows us, for instance, that most of the colors in this image are quite saturated and that the beak of the parrot is significantly brighter than the background.

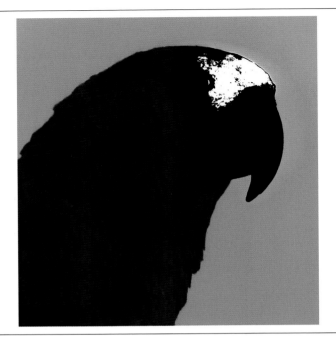

Figure 3.21a The hue component of our test image.

Figure 3.21b The saturation component.

Figure 3.21c The value component.

Even though we've talked about the HSV color space as an alternate method of representing data, it is generally not used to store images. Rather, it is much more commonly employed as a useful paradigm for *manipulating* colors. Chapter 4 has a bit more information on this concept.

The YUV Color Representation

Another color space that you may encounter—one that is very common when dealing with video technology—is the YUV[11] color space. In this case Y component represents luminance in a familiar fashion and the U and V components are used to represent "chrominance" values. The actual derivation of the two chrominance channels is a bit more obscure and not nearly as intuitive to an average human being—essentially they each represent a combined hue and saturation value for two different specific bands of color. Figure 3.22 shows the U and V components of a slice out of this color space (where the "Y" or luminance value is at 50%). As you can see, even trying to describe the colors that make up the two axes is difficult to do in a simple fashion using familiar terms. Figure 3.23 shows our test image broken out into separate Y, U, and V channels.

[11] And variations thereof—YIQ, YCbCr, etc. Although different broadcast standards actually use a variety of similar but different spaces (and YUV as it is formally defined is effectively obsolete), we'll follow the industry colloquialism of referring to all these related spaces as "YUV".

Figure 3.22 YUV color representation.

Figure 3.23a The Y component of our test image.

Figure 3.23b The U component.

Figure 3.23c The V component.

The YUV color space came about in the video world as a way to keep some backward compatibility with the original black-and-white video transmission specification (if U and V are removed then you have a standard B&W video signal). Fortunately most compositing systems have ways to deal with the conversion of YUV into something friendlier but it's important to be aware of the terminology, particularly since some video compression techniques make use of this representation.

Image Input Devices

As we discussed earlier, images that are intended to be used in a digital composite can come from a variety of sources. Those images that were originally created by nondigital methods will need to be scanned into the computer, or digitized, before we can use them. "Still" images—images that are not part of a moving sequence—may be simply brought into the system using a wide variety of single-image scanning devices. Flatbed scanners for print material are common, and slide scanners can be used to digitize images that were originally captured on negative or transparency film. Most of the imagery that we will work with when creating digital composites will be sequences of images, not just a single still frame. Sequences of digitized images will probably come from one of two places: either video or film.

All modern video cameras will convert their imagery into a digital representation as part of the image capture, but the format of this representation is a constantly changing landscape as manufacturers continue to introduce new technology. It is therefore quite possible that the compositing system you are using may not be able to read the image data directly and that there will need to be some sort of additional conversion step. This will certainly be the case if the data was recorded to tape, but even if the images were written directly to a hard drive there may need to be a translation into a more universal file format. Chapter 10 discusses format issues in greater detail.

Digitizing images that originated on film necessitates a somewhat different approach, and the use of a film scanner is required. Initially, film scanners were custom-made, proprietary systems that were built by companies for their own internal use. Nowadays, several companies (such as Arri and Filmlight) provide off-the-shelf scanners to whomever wishes to buy them.

The process of scanning a piece of film is conceptually straightforward. A light source illuminates the film from one side, and an array of sensors mounted on the other side captures the transmitted color. Depending on the device, the array is usually only a single pixel tall but wide enough to capture a full scan line, and the film moves slowly across this array each time a new scan line is captured. The rate at which a film frame can be scanned at high resolution will vary depending on the resolution you are trying to capture as well as the scanner itself—typical speeds can range from only a second or two per frame up to several minutes per frame.

If the intention is to transfer film directly to video, the scanning can be accomplished with a higher speed piece of equipment known as a **telecine** device. Telecine hardware

is usually capable of digitizing images in real time, running the film at a rate of 24 fps, but the quality is generally not as high as with a dedicated film scanner. In particular, the image may not be quite as stable. It is expected, however that the line between what is considered a telecine device and the higher-end film scanners will continue to become less distinct over time.

Typically, the original negative of the film is scanned, and then digital values are inverted to produce an image that looks correct. By scanning the negative, one is ensured of obtaining the highest possible image quality without suffering any generational loss from creating an intermediate print. The only disadvantage of this technique is that the original negative is essentially irreplaceable, and if it is somehow damaged during the scanning process, the consequences can be dire.

The science of how analog information (such as a piece of film or an analog video signal) can best be converted to a digital representation is a potentially immense topic. But, as we continue to mention, the important thing to remember is that the digitization of any image produces something that has a finite, limited amount of information associated with it. The only way to increase the amount of useful information in an image is to re-sample it at a higher resolution, and any additional processing that is applied to an image that has already been sampled can only decrease the accuracy of the data representation. Remember too that this data truncation can take place in multiple places, particularly if you aren't careful about your methodology. Something captured on film, for instance, is already a subset of the data from the original scene… digitizing this film can, at best, only capture as much detail as the film itself was able to hold in the first place.

Digital Image File Formats

Now that we have a digital representation of an image, presumably residing in the memory of the system used for the digitization, we need to store it in a file on the system's disk. There are a number of different file formats that one may choose to store an image. Each format has its own advantages and drawbacks, and as such there is no universally accepted standard format that everyone agrees is the best. File formats vary in their ability to handle a variety of important features, many of which are listed here.

Note that some formats, particularly those that are used to store sequences of images in a single file (such as Apple's Quicktime format), are really more of a *wrapper* that can be used to encapsulate a variety of different data representations. These representations are generally known as **codecs**, each of which will specify a particular way of encoding and compressing the data it contains. (The term "codec" is a portmanteau word combining the terms **co**mpression and **dec**ompression.) Thus an image sequence may be stored as a Quicktime movie file but encoded using a very specific codec that has its own unique characteristics. Codecs are often more manufacturer-specific than

stand-alone file formats. Most of the concepts discussed in this section will apply to codecs as well as to the more broad term "formats."

File Format Features

Variable Bit Depths

Certain file formats may be limited to storing images with only a limited or fixed number of bits of data per channel. Other formats are flexible enough that they can store image data of arbitrary bit depth. A good compositing system should be able to read files with different bit depths and allow the user to combine these images without worrying about the original bit depths.

Different Spatial Resolutions

Although most popular formats can be used to store images of any spatial resolution, certain formats (particularly those that are designed to represent only video images) may be limited to specific, fixed resolutions.

Compression

To limit the amount of disk space that is used by an image file, certain file formats will automatically compress the image using a predetermined compression scheme. Other file formats may allow you to explicitly specify the type of compression that you wish to use, and of course there are some formats that use no compression whatsoever. The next section gives some information about the different types of compression that are commonly used with image data and also discusses which types of images work well with which compression schemes.

Comment Information in a Header

Some image formats may allow for just about any sort of commentary to be stored with an image, whereas other formats may have a set of predefined niches for comments. Typical information would be the date/time an image was created, the name of the user or piece of software that created the image, or information about any sort of color-correction or encoding schemes that may have been applied to the image before its storage. Certain formats designed specifically for dealing with scanned film data (such as the DPX format) have a specific syntax for keeping track of how a specific scanned frame maps back to the original negative from which it was captured.

Additional Image Channels

In addition to the three color channels, there is often a fourth channel, the **alpha channel**, that is commonly added to an image when working in a compositing environment. Rather than contributing to the color of a pixel, it is instead used to specify the

transparency of various pixels in the image. (This channel is also known as the matte channel, and we will use the two terms interchangeably throughout this book.)

Beyond this, many file formats will allow for a variety of additional channels as well—for instance a Z-depth channel for determining the relative distance that any given pixel is from a certain fixed location. More information on these supplemental channels will show up in subsequent chapters.

Vendor-specific File Format Implementations

It should be noted that it is up to the vendor of a particular piece of software to follow the proper specifications for any file formats that they claim to support. There are dozens of examples where two different packages may both claim to support the TIFF file format, for example, yet neither package can read the TIFF files created by the other. Beware of these potential conflicts: It is always a good idea to double-check the entire pipeline that an image might travel before you embark on the creation of large amounts of data in a particular format.

We've included a list of the more popular file formats, along with some of their different characteristics, in Appendix B.

Compression

Because high-resolution images can take up a huge amount of disk space, it is often desirable to compress them. There are a number of techniques for this, some of which will decrease the quality of the image, others which will not. If the compression scheme used to store an image can be completely reversed (so that the decompressed image is digitally identical to the original) then the compression scheme is said to be **lossless**. If, however, it is impossible to completely recreate the original from the compressed version, then we refer to this as a **lossy** compression scheme.

As you will discover, there are almost always opportunities to trade quality for space efficiency. In the case of image storage, we may wish to sacrifice some visual quality to decrease the amount of disk space it takes to store a sequence of images. Fortunately, there are a number of excellent lossless methods as well. To get an idea about one of the methods used to compress images without loss of information, we will look at a technique known as run-length encoding (RLE). This is just one of many techniques—in fact a rather unsophisticated one that is becoming less and less common—but examining it will raise most of the typical issues one confronts when discussing image compression.

Run-length Encoding

RLE is a fairly simple technique, yet in the best-case scenario, the resulting compression can be significant. Consider the image in Figure 3.24, a white cross on a black background.

Figure 3.24 12 × 12 image enlarged to show individual pixels.

This figure is an extremely low-resolution image (12 × 12), enlarged to show the individual pixels. Also, to keep things simple, consider it to be a black-and-white image, so that we only need a single bit of information to determine a pixel's color. In this case, 0 will be a black pixel, 1 will be white. Thus, a numerical representation of this image would be as follows:

```
000000000000
000000000000
000001100000
000001100000
000001100000
001111111100
001111111100
000001100000
000001100000
000001100000
000000000000
000000000000
```

As you can see, we are using 144 characters in a simple matrix to accurately define this image.

RLE works on the principle of analyzing the image and replacing redundant information with a more efficient representation. For instance, the first line of our image above is

a string of twelve 0s. This could be replaced with a simple notation such as 12:0. We've gone from using 12 characters to describe the first line of the image to a 4-character description. Using this convention, we can encode the entire image as follows:

```
12:0
12:0
5:0, 2:1, 5:0
5:0, 2:1, 5:0
5:0, 2:1, 5:0
2:0, 8:1, 2:0
2:0, 8:1, 2:0
5:0, 2:1, 5:0
5:0, 2:1, 5:0
5:0, 2:1, 5:0
12:0
12:0
```

The total number of characters we have used to represent the image using this new notation is 104. We have reduced the amount of information used to store the image by nearly 30%, yet the original image can be reconstructed with absolutely no loss of detail.

It should be immediately obvious, however, that this method may not always produce the same amount of compression if a different image is used. If we had an image that was solid white, the compression ratio could be enormous, but if we had an image that looks like the following (Figure 3.25)…

Figure 3.25 12 × 12 image with alternating black and white pixels.

… then our same compression scheme would give the following results:

1:0, 1:1, 1:0, 1:1, 1:0, 1:1, 1:0, 1:1, 1:0, 1:1, 1:0, 1:1
1:1, 1:0, 1:1, 1:0, 1:1, 1:0, 1:1, 1:0, 1:1, 1:0, 1:1, 1:0
1:0, 1:1, 1:0, 1:1, 1:0, 1:1, 1:0, 1:1, 1:0, 1:1, 1:0, 1:1
1:1, 1:0, 1:1, 1:0, 1:1, 1:0, 1:1, 1:0, 1:1, 1:0, 1:1, 1:0
1:0, 1:1, 1:0, 1:1, 1:0, 1:1, 1:0, 1:1, 1:0, 1:1, 1:0, 1:1
1:1, 1:0, 1:1, 1:0, 1:1, 1:0, 1:1, 1:0, 1:1, 1:0, 1:1, 1:0
1:0, 1:1, 1:0, 1:1, 1:0, 1:1, 1:0, 1:1, 1:0, 1:1, 1:0, 1:1
1:1, 1:0, 1:1, 1:0, 1:1, 1:0, 1:1, 1:0, 1:1, 1:0, 1:1, 1:0
1:0, 1:1, 1:0, 1:1, 1:0, 1:1, 1:0, 1:1, 1:0, 1:1, 1:0, 1:1
1:1, 1:0, 1:1, 1:0, 1:1, 1:0, 1:1, 1:0, 1:1, 1:0, 1:1, 1:0
1:0, 1:1, 1:0, 1:1, 1:0, 1:1, 1:0, 1:1, 1:0, 1:1, 1:0, 1:1
1:1, 1:0, 1:1, 1:0, 1:1, 1:0, 1:1, 1:0, 1:1, 1:0, 1:1, 1:0

This change would be a bad thing, since we're now using 562 symbols to represent the original 144.[12]

The point of this example is not to prove anything specific about the RLE method (which is really rather archaic, having been supplanted by far more sophisticated methods in most cases), but rather to underscore the fact that not all encoding methods work well for all types of images. There are certainly more efficient methods for encoding images, and in fact there are far more efficient variations of the RLE scheme than the one shown here. Techniques such as this generally only work well for very specific sorts of imagery—typically synthetic computer generated images that don't contain a great amount of detail or tonal variation. On the other hand, RLE is generally a less effective method for storing images that come from an analog source like film since grain, noise, and other irregularities inherent in a natural scene will cause nearly every pixel to be different from its adjacent neighbors.

Lossy Compression

As mentioned previously, a process like RLE is lossless—no information is discarded when an image is stored in a format that uses this scheme. However, there are a number of formats that can compress the storage space necessary for an image by dramatic amounts as long as the user is willing to accept some loss of quality. Probably the most popular of these lossy formats is the one that uses a compression scheme defined by the Joint Photographic Experts Group. Generally, these images are said to be in JPEG (pronounced "jay-peg") format. The JPEG format has a number of advantages. First of

[12] All but the most basic RLE schemes are intelligent enough to deal with situations in which the encoding would increase the file's size. A final "sanity check" is performed after the image is encoded; if the encoded version is larger than the unencoded original, then the file will be written without any additional attempts at compression.

all, it works particularly well on images that come from film or video, in part because the artifacts it introduces are designed to be less noticeable in areas with some noise. In particular, JPEG compression attempts to maintain brightness and contrast information (which the human eye is very sensitive to) at the expense of some color definition. The format also has the advantage that the user can specify the amount of compression that is used when storing the file. Consequently, intelligent decisions can be made about the trade-off between storage space and quality.

Consider Figures 3.26a and 3.26b, both compressed versions of a high-quality original. Figure 3.26a has been compressed with a quality level that is considered to be 90% as good as the original, and Figure 3.26b compressed with a quality level of only 20%. When we examine the file sizes of the images that result from these compressions, we find that Figure 3.26a takes up about 1/10th as much disk space as the original, yet has suffered only minor visual degradation. Figure 3.26b is noticeably degraded, yet can be stored using about 150th of the space needed to store the original!

JPEG compression is by no means an ideal scheme for compressing every type of image. As mentioned earlier, synthetic or computer-generated scenes will tend to compress quite well using lossless schemes, and in fact the artifacts introduced by JPEG compression are often *most* noticeable on synthetic images. Look at Figure 3.27a as compared with Figure 3.27b. Figure 3.27a is a close-up of a section of an image that was compressed for storage using a fairly high-quality JPEG compression. When decompressed, we can see that noticeable artifacts around the edges of the text have obviously been introduced. The compression did reduce the file size, but the quality loss may be unacceptable. This is particularly true when you consider Figure 3.27b. This image was saved in the PNG file format, which can use a limited color palette and bit depth coupled with a compression scheme that is well suited to this type of image. Figure 3.27b actually takes up slightly less disk space than it took to store Figure 3.27a, yet appears to be far more accurate.

Chroma Subsampling

There's another little bit of nomenclature you may see in the video world that relates to a method of compression known as **chroma subsampling**. As noted earlier in this chapter, video is generally kept in a YUV (or similar) color space, where Y represents the luminance component of a color and the U and V channels specify chrominance values. But, as we've mentioned, the eye is generally much more sensitive to changes in luminance than in chrominance and so a reasonable method for limiting the amount of data needed to transmit a video signal is to reduce the amount of chrominance data relative to the luminance. For instance, we may choose to only store (or transmit) two chrominance samples for every four luminance samples. The terminology used to specify this sort of compression would be 4:2:2. And if we're only sending 1/4 as many chrominance samples as luminance, we'd refer to that as 4:1:1.

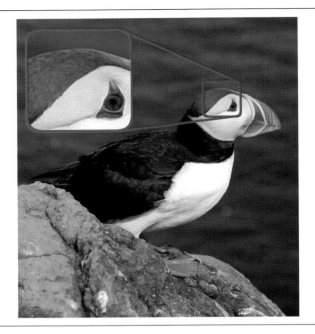

Figure 3.26a Image compressed using 90% JPEG quality.

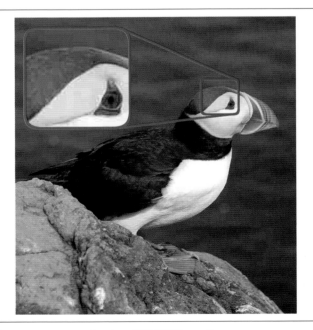

Figure 3.26b Image compressed using 20% JPEG quality.

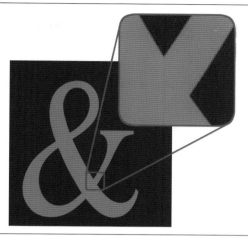

Figure 3.27a JPEG compression on a synthetic image.

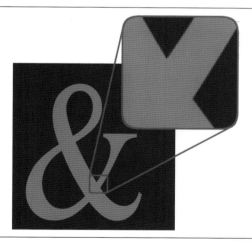

Figure 3.27b PNG compression on the same image.

4:4:4, then, is a full-quality signal and of course a 4:0:0 image would have no color information and would be a black-and-white image. It's primarily by convention that everything is related to the number 4, although generally you never see more than a few different combinations of these numbers. In particular, all you'll usually see is 4:4:4, 4:2:2, and 4:1:1. Others are possible—4:2:0 is still sometimes found, particular with PAL systems. Incidentally, 4:2:0 does not mean that there is no "V" component at all (which would effectively remove a whole range of possible colors). Rather, the U and V signal is only transmitted every other line in an alternating fashion. So you're really getting 4:2:0 compression on one line and then 4:0:2 on the next.

Image Sequence Compression

Formats that are designed to store *sequences* of images in a single monolithic file have additional ways to compress image data. Instead of storing every single frame in the sequence in the same way they can, for instance, use a specific frame as a sort of "master" and then subsequent frames will only need to record areas where they differ from that master frame. This methodology can result in significant reductions in data size when storing image sequences and can often be combined with other image-compression schemes as well.

The only foolproof method for determining the best possible compression scheme for a particular image or sequence of images is to do an exhaustive test. This goal is encouraged, certainly, but it should also be stressed that the blind pursuit of compression is not the best way to approach the issue of deciding on a file format. Ultimately, the amount of compression that can be obtained should only be one of many factors that one should take into account. The next section will encourage you to consider a multitude of issues before you make your decision.

Choosing a File Format

By now you've probably realized that there are no definitive guidelines that can help us determine exactly which file formats should be used for a given type of image. Certainly the content of the image is one of the things that we may consider when choosing a format, but the primary determining factor will be the actual scenario for which the images are being used. The only definable guideline is to choose the best compression possible that still produces the desired image quality. Although the amount of compression is an easily measurable quantity, the "desired image quality" is a bit more subjective. And this measure of quality is not purely tied to the final image—many compositing operations are particularly sensitive to compression artifacts. Bluescreen work, for instance, is often *much* more difficult if you are working with images whose storage/compression method reduced the color information in some fashion. JPEG compression, chroma subsampling, and a variety of video codecs can all be problematic in this situation as you are effectively blurring all your important color information across several pixels, including the boundaries between foreground and background.

If you are working in a situation in which quality is the top priority, then generally you will not want to use lossy compression schemes at all. You will want every image that you create to be as high quality as possible. But even if you know that your final output images are going to be something like JPEG or some compressed video format, it is probably a good idea to use a lossless format for all of the intermediate compositing work that you do. That way you will not be subject to quality loss each time you write out one of these images, accumulating artifacts with each step. Only convert to your space-saving file format once you have produced your final imagery, choosing the quality level that you find acceptable. Also, make sure you're not converting between formats unnecessarily as the conversion itself is often a lossy process.

Always be aware of whether the file format you are using is going to lose data, and don't be led into a false sense of security just because you think you are using a lossless format. Even if the format doesn't do any explicit compression, there may be some other factor that reduces the image quality. It may not support the bit depth that you need, for instance, which can translate into a huge quality degradation if you are not careful. This information is not always obvious, but a little research into the file format in question (and your software's support of this format) can prevent some catastrophic consequences.[13]

Depending on the type of system you are working with, there may be a 3rd consideration—the speed with which a particular format can be read and displayed. Compositing systems that are designed to play back sequences directly from disk in real time may only be able to do so because they are using an image format that is designed for this. Often this format (or codec, if you are working with a single file that contains a sequence of images) will be designed to trade off quality for the speed with which it can be decoded and displayed.

A number of other issues relating to this topic are dealt with in Chapter 11, "Quality and Efficiency."

Nonlinear Color Encoding

In addition to the standard data-compression algorithms mentioned earlier, there is a class of techniques that use a specialized color correction step before an image is stored in order to make better use of the bit depth available. Images that are modified in this fashion are often referred to as being stored in a **nonlinear color space** although the term "color space" is somewhat misleading in this case. In fact this process can be done independently of whatever true color space the image will be stored in and as such we will instead use the term **color encoding** for this sort of technique.

Although the topic is fairly complex, the basic process of converting an image so that its colors are encoded nonlinearly[14] is essentially quite simple. First, a specialized color or brightness correction is applied to the image. Then, the image is saved into a lower bit depth than the one in which it was originally stored. The lower bit depth obviously reduces the amount of disk space that is needed to store the image, while

[13] And, although anybody who has read this book certainly wouldn't make such a mistake, a surprising number of situations arise where artists or clients believe that merely by dubbing a low-quality tape to a higher-quality format you'll increase the quality of the material you have to work with. It's an anecdote told surprisingly often of how a visual effects facility would explicitly state a certain quality of tape as the method to be used to capture the images and later realize that everything had actually been shot on a lower-quality format and then just dubbed over to the requested medium.

[14] In this case the issue of linear versus nonlinear is purely relative to the original colors in the image. There is the more general concept of storing data "linearly" relative to the brightness levels in the original scene, but we'll save the discussion of that issue for later.

the specialized color correction helps to bias the data loss so that more "important" information (in terms of how humans perceive color and brightness) is retained.

There are a number of different scenarios that make use of nonlinear color encoding. In the video world this is the "gamma" with which an image is stored, while those compositors who work with film imagery will more commonly encounter files stored in a way that mimic the logarithmic response of film negative. To be sure, there are many scenarios in which you may never need to deal with nonlinear encoding issues, but both film and video make use of these techniques. Understanding them can therefore be extremely useful in certain situations.

A more precise description of the reasoning behind the use of nonlinear color encoding, as well as the proper way to work with (and even view) such images, is not a trivial subject. These issues, coupled with the consideration that many compositors will not need to deal with nonlinear data at all, has prompted us to reserve any further discussion of the topic for Chapter 14.

CHAPTER FOUR

Basic Image Manipulation

Now that we have a basis of understanding for the digital representation of images, we can start to look at methods for modifying these images. Most of the tools we will be discussing initially fall into the category of traditional **image-processing** operations.

Throughout this chapter, and really throughout the rest of the book, we will be discussing tools and procedures that modify images. It is extremely important to understand that these modifications do not come without a price. Of course it will take a certain amount of time to perform any given operation, which must be planned for. But more important is the fact that just about any image manipulation will ultimately degrade the image. In some cases this degradation will be slight, even imperceptible, but in others the problem can be extreme. A digital image starts with a finite amount of data, and each step in the compositing process can cause some of that data to be lost. The issue of how to recognize and minimize any image degradation is covered in much greater detail in Chapter 11, but you will also find related discussions throughout the book. Because the problem can occur at every single step of the process, it is not possible to present an overall solution. Rather, a good compositing artist needs to learn which operations (or combination of operations) are more likely to introduce artifacts or cause data loss.

We will certainly not be able to provide a detailed description of every possible image-processing operator, but will instead discuss several of the most common as well as those that best illustrate a specific concept. Most other tools are merely variations or combinations of the ones that we will be discussing.

Appendix A gives a short description of several more of these tools, and the bibliography lists some relevant books that are more dedicated to the topic.

We will first discuss single-source operators, that is, operators that take a single image or sequence as their input and produce a new, modified output. This process is in contrast

to what will be discussed in the next chapter, where we see how two (or more) different sources can be combined using multisource operators to produce a result.

Terminology

Throughout our discussion of various tools (in particular those which modify the color of an image), we will occasionally show graphs of how the pixels in the image are affected. Graphing the behavior of a function is a useful way of getting a more intuitive feel for how the image will be modified. Our graphs will all follow the format shown in Figure 4.1. Here, the *x*-axis represents the value of pixels in the original, source image. The *y*-axis is the value to which the pixel has been converted after our color-correction operator has been applied. Thus, an uncorrected image would look like the graph in Figure 4.1, in which a pixel that starts with a value of 0.5 would still have a value of 0.5 after the operation.

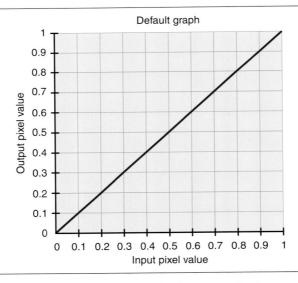

Figure 4.1 Graph of a look-up table (LUT) that leaves pixel values unmodified.

Let's assume that we take an image and multiply every pixel by a certain constant value. This is known as a "Brightness operation."[1] We'll start with the image shown in Figure 4.2.

[1] It seems that the more common an operation is, the more variations there are in the terms used to describe it. For instance, the operation that multiplies every pixel in an image by a fixed value is also various known as "Gain" or "Exposure," depending on the system that you are using. By the same token, the term "Brightness" may refer to some different type of operation, most common one where a fixed value is *added* to ever pixel in an image. Unfortunately there is no way that any book can cover all the possibilities and so the burden is on the reader to determine the terminology that is being used in the system they are working with.

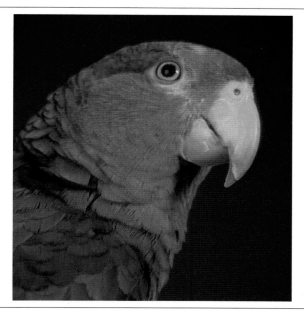

Figure 4.2 A sample color image.

The application of a Brightness of 2.0 produces Figure 4.3; the graph of the "Brightness 2.0" operation is shown in Figure 4.4. Examining the graph, we can see that a pixel value of 0.5 (midtone gray) maps to a pixel value of 1 (white) in the new image. In other words, every pixel is now twice as bright as it was before the operation. As usual, normal pixel values are assumed to range from 0 to 1, and any values that are pushed outside this range may or may not be **clipped**, depending on the compositing tool you are using. In our current example, any pixels whose values were pushed out of range were clipped, which is why any input pixels that were originally above 0.5 are now all equal to 1. Chapter 11 discusses the issue of data clipping in greater detail.

For some of the more simple tools, we also provide a brief equation to describe the operator. For these equations, we usually treat the entire image as if it were a single variable. In these cases, we use the following conventions:

I = Input image
O = Output image

Thus, $O = I \times 2.0$ would refer to our Brightness example, in which every pixel in the input image was multiplied by 2.0 to produce the output image.

Now that we have our terminology in place, we're ready to start discussing some of the basic image-processing tools we can use when compositing a scene. We will go over a number of different tools, but we will not yet discuss how these tools can

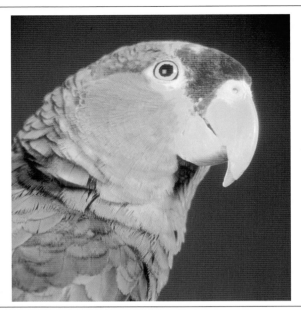

Figure 4.3 The test image with a Brightness of 2.0 applied.

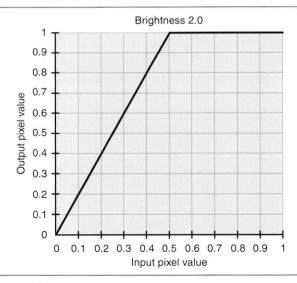

Figure 4.4 Graph of Brightness 2.0.

interact with one another or how they can be combined to produce a multiple-step compositing **script**. Also, unless otherwise noted, we'll be making the assumption that the images we're working with only contain pixels in the (normalized) range 0–1 and aren't being stored as floating-point data.

Single-source image-processing operations can be broken down into three basic categories: color manipulations, spatial filtering, and geometric transformations. Our example, the Brightness operation, would be considered a color manipulation, and we will discuss this category first.

Color Manipulations

As mentioned, we consider the Brightness operation that we've just covered to be a color manipulation. While the layperson might not consider an apparent brightness change to be a shift in color, we'll see that it is really just a simplified case of an operation that will produce a visible color change. Thus, in the image processing and digital compositing world, operations that affect brightness and contrast are all classified as color-correction tools. Brightness is a specialized version of a more general tool, called simply the "Multiply" operator.

RGB Multiply

The Brightness example had us multiply every pixel by a constant value to produce a new result. But if you recall from the last chapter, we often find it useful to work with digital images as a group of channels instead of whole pixels. If this is the case, we can actually apply a multiplication to each component of the pixel separately, and not necessarily equally. Thus, instead of multiplying each channel by 2.0 to create an overall brightness shift, we could apply a multiplier of 0.1 to the red channel, a multiplier of 1.25 to the green channel, and leave the blue channel unmodified (i.e., multiply it by 1). The result of such a procedure is shown in Figure 4.5. As you can tell, we've dropped the amount of red in the image significantly and boosted the green a

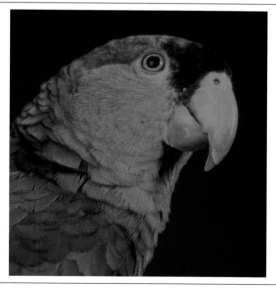

Figure 4.5 Result of RGB multiplication of (0.1, 1.25, 1) on test image.

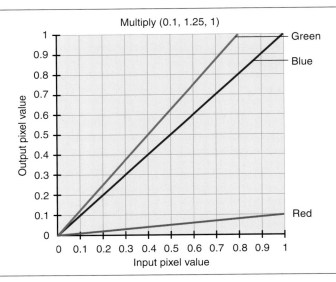

Figure 4.6 Graph of the (0.1, 1.25, 1) RGB multiplication.

bit, producing an image that is much more greenish blue than the original. The graph of the equivalent function is shown in Figure 4.6.

Most of the color-correction operators that we discuss can be applied either to all the channels of an image equally or to individual channels in varying amounts. When applied equally, the result will tend to be an overall brightness or contrast modification. When different amounts are applied to different channels, a visual color shift will usually take place as well. For the most part, our examples show the operators as they apply to the image as a whole, but you should assume that they can also be limited to individual channels as well.

Add

Instead of affecting the apparent brightness of an image by multiplying, we can instead add (or subtract) a constant value from each pixel. Consider the situation in which we wish to add a value of 0.2 to every pixel in the image ($O = I \times 0.2$). The resulting image is shown in Figure 4.7, with the graph shown in Figure 4.8.

Notice that, unlike the multiplication operation (which keeps the deepest blacks at the same level), the blacks in this example have gone to gray, or "washed out." The reason should be obvious: With the Multiply operator, a value of 0 will remain 0 when multiplied by any other number, and small numbers tend to stay small. In the case in which we add a value to every pixel, then even the pixels that start as 0 will end up being changed to whatever value we added to the image, in this case 0.2.

We've just discussed two different tools that can change an image to be brighter than it was to begin with. Phrases such as "make it brighter" are ambiguous at best, and it generally ends up being the job of the compositing artist to decide which tool would be

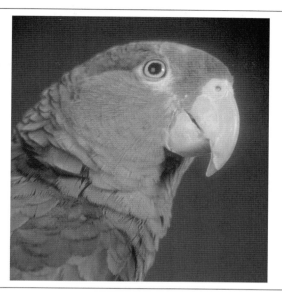

Figure 4.7 Result of adding 0.2 to every pixel in the test image.

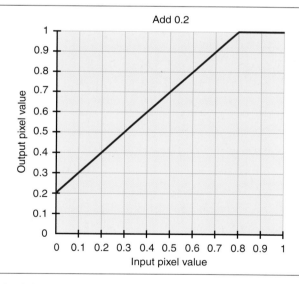

Figure 4.8 Graph of the Add 0.2 operation.

best for producing the desired result. Using a multiplication is probably more common, simply because the loss of rich blacks when using the Add operator is usually an undesirable artifact. However, you will notice that both of these tools will push pixels to pure white (a value of 1), causing bright areas of an image to look "blown out" or "burnt." Fortunately, there is another tool that is commonly used for making an image appear brighter, yet which doesn't exhibit the same sort of problems, either on the high or the low end. This tool is known as the Gamma operator.

Gamma Correction

The Gamma Correction operator uses the following exponential function:

$$O = I^{1/Gamma}$$

In other words, we raise the value of each pixel to the power of 1 divided by the gamma value supplied. If you have a calculator handy, you can see how different values of gamma will change the brightness of a given pixel. For instance, a pixel whose initial value is 0.5 will end up with a new value of 0.665, if a gamma of 1.7 is used.

The real reason why the Gamma operator is so popular becomes apparent when you examine what happens when you raise zero to any power: It stays at zero.[2] A similar thing happens when 1 is raised to any power: It stays at 1. In other words, no matter what gamma correction you apply to an image, pixels with a value of 0 or 1 will remain unchanged. The only effect that the gamma operator has will be on nonblack and nonwhite pixels.

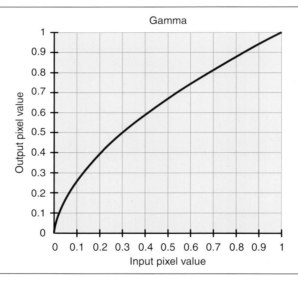

Figure 4.9 Graph of a Gamma 1.7 operation.

Don't worry too much about the math behind the Gamma Correction tool. Rather, examine the graph of its behavior. A gamma correction of 1.7 is depicted in Figure 4.9 in our graph format, and the effect on our example image is shown in Figure 4.10.

[2] The exception, of course, occurs when you raise anything to the zeroth power, which is defined as producing a result of 1. However, since applying a gamma value of 0 to the above equation would produce a divide-by-zero problem, the generally accepted convention is that applying a gamma of 0 to an image will produce a black frame.

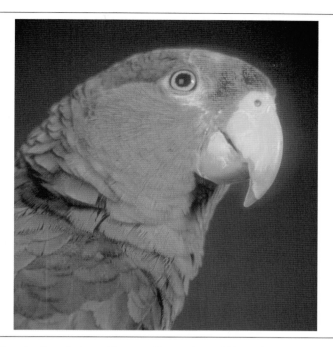

Figure 4.10 Result of applying a Gamma Correction of 1.7 to the test image.

As you can see in the graph, the endpoints of our brightness range remain fixed, mid-range values are affected the most, and the effect gradually tapers off as you reach the extremes. Examining the resultant image will show that it is primarily pixels that were of medium brightness that have been boosted. The image does indeed appear brighter, but there are none of the problems we've seen with earlier tools, where the blacks become washed out or bright areas are clipped to pure white. Not only does the image tend to look more natural, but there is also much less chance for the types of data loss that can plague other operators when working in a fixed-range color representation. On the other hand, if you are working with images represented in a floating-point space, the Gamma operator (depending on the exact implementation your software uses) may sometimes do things that aren't quite as intuitive. See Chapter 11 for an example of this.

Incidentally, please be aware that "gamma" is one of the most overused letters in the Greek alphabet. Ambiguity and confusion can arise because the term is commonly used to refer to a variety of totally unrelated nonlinear functions. Many other disciplines outside the image-processing field use the term, and even within the field of digital compositing, "gamma" may be used to refer not only to the specific image-processing operation we've just discussed but also to a nonlinear data encoding method, or even to the characteristic response of a piece of film or a digital image sensor to light exposure. Adding to the fun, this usage of the term is often looking at

the inverse of the function we describe above! But when working strictly with gamma as a color-correction operation, the convention is that applying a gamma correction between 0 and 1 will decrease the apparent brightness of an image and values over 1 will make the image appear brighter.

Invert

An extremely simple operator, yet one that will be used a great deal, is the Invert operator. The basic math behind the tool is merely

$$O = (1 - I)$$

In other words, every pixel is replaced by the value of that pixel subtracted from 1 (Figure 4.11).

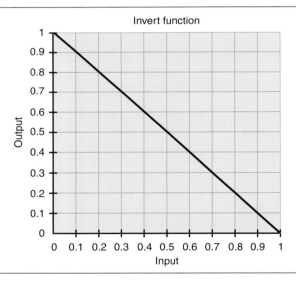

Figure 4.11 Graph of an Invert operation.

When working with color images, the result is an image that appears to be similar to the photographic negative of the original (Figure 4.12). Colors are converted to their complementary values, bright areas become dark areas, and vice versa. The Invert operator is also referred to as the Negate operator on many systems.

Although the need to produce the negative of an image may seem limited, a much more common use of the Invert operator is to modify images that are being used as masks or mattes. Such images are discussed further in upcoming chapters.

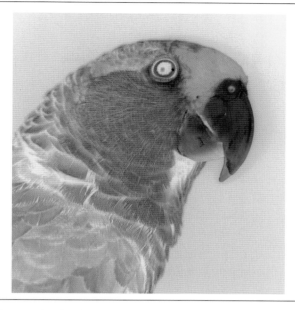

Figure 4.12 An inverted-color image.

Contrast

The Contrast operator is a tool for changing the brightness relationship between the upper and lower color ranges of an image. Increasing the contrast causes dark areas to get darker and bright areas to get brighter. Decreasing the contrast will bring the

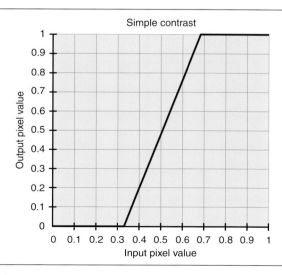

Figure 4.13 Graph of a simple Contrast operation.

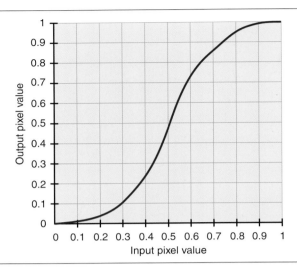

Figure 4.14 Graph of a smoother Contrast operation.

apparent intensity of lights and darks closer together. There is no universal standard for exactly how the contrast operator should be implemented, so we'll look at the graphs of a few different possibilities. A very rudimentary contrast could be implemented using a combination of the tools that we've already discussed. For instance, if we wanted to increase the contrast of an image, we could first subtract a constant value and then multiply the result by another constant. The graph of this (from the equation $O = (I - 0.33) \times 3$) is shown in Figure 4.13.

Contrast as applied in this manner is a less than ideal operator, since both the low end and the high end treat the image's data rather harshly. A better system is to apply gamma-like curves to the upper and lower ranges, as in Figure 4.14. This method tends to give a much cleaner image, particularly at the low and high ends of the brightness spectrum. Figure 4.15 shows an image that has been affected by the original contrast we showed in Figure 4.13, whereas Figure 4.16 was modified by our smoother contrast.

Ideally, our operator will also allow us to explicitly choose the boundary between what are considered the highs and the lows in the image, giving us a "biased contrast." In the graph in Figure 4.14 you'll notice that the point at which the curve goes from being concave to convex happens at exactly 0.5. Everything above 50% brightness is made brighter; everything below is made darker. This is fine if our image is relatively normal in its distribution of light and dark areas, but if the image tends to be very dark or bright overall, we may wish to adjust the midpoint where the transition occurs. Given a dark image, in which nothing in the frame is brighter than 0.5, we might want to set our bias point to be at 0.25 instead. If we didn't do this, then everything in the scene would become even darker, since all values fall below the threshold for what is considered the "dark" areas of the frame. Figure 4.17 shows a graph of a biased contrast in which the bias is set at 0.25.

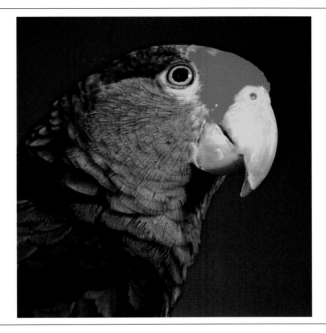

Figure 4.15 Test image with a simple Contrast applied.

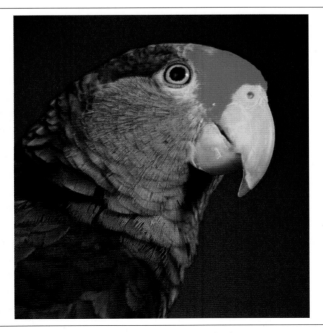

Figure 4.16 Test image with a smoother Contrast applied.

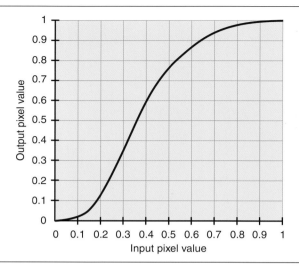

Figure 4.17 Graph of a biased-contrast operation.

Channel Swapping

There may be situations in which one actually wishes to reorder the channels that make up an image—placing the blue channel into the green channel, for instance.

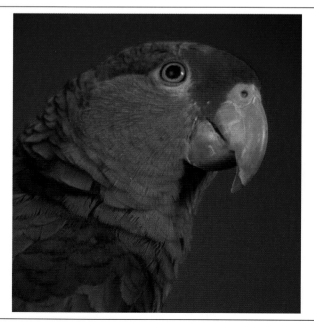

Figure 4.18 The test image after swapping the red and blue channels.

Simple reordering within the R, G, and B channels is not used a great deal, since it is a fairly brute-force and nonintuitive method of modifying an image's color but just for the sake of completeness, Figure 4.18 shows what happens to our image when we swap the red and the blue channels.

Although the process isn't commonly used as a color-correction, it can be quite valuable in other circumstances. Channel substitution techniques are, for instance, sometimes used as the basis for certain color-difference methods, as discussed in Chapter 6. They are also useful for moving data in and out of supplemental channels, such as the alpha channel. And usually this work is done in conjunction with some sort of expression language, which we will discuss later in this chapter.

HSV Manipulations

As mentioned in Chapter 3, there is an alternate way to represent the colors in an image, known as the HSV model. This model is particularly useful as a tool for color-correction, since it can be used to deal with concepts that would normally be very inconvenient were we limited to viewing color as simply a mix of red, green, and blue. For instance, affecting the saturation of an image merely by adjusting RGB values can be rather cumbersome, but using the HSV model allows us to directly access the saturation component, making manipulation trivial. An example is shown in Figure 4.19, in which the image's saturation has been reduced by about 50%. Dropping the saturation to zero would, of course, result in a monochrome (black and white) image.

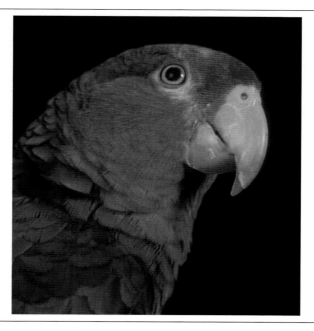

Figure 4.19 Test image with saturation reduced by 50%.

Incidentally, although tools that are based on HSV will effectively do a conversion to this new color space (and then back again when they're finished), the user generally doesn't need to see that. Rather, HSV modifiers simply present tools to the user that reflect the characteristics of that space.

Thus, since HSV usually represents hue in a circular fashion (as shown earlier in Figure 3.19), we can now "rotate" all the colors in an image by a certain amount. Figure 4.20 shows our test image after it was rotated by 180° through the color spectrum. You'll notice that every color in the image has been shifted to its complementary color, while still preserving the brightness and saturation relationships. (Compare this with the Invert operator we discussed earlier, which inverts colors but also the brightness levels).

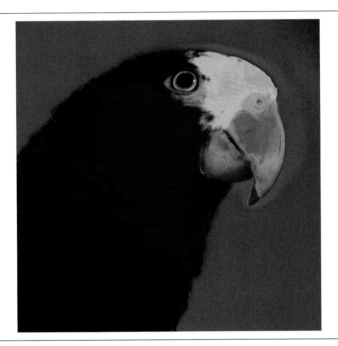

Figure 4.20 Test image rotated by 180° through the color spectrum.

Look-up Table Manipulations

We've shown a variety of graphs for various operators in the last several pages, where we plot the output color as it compares with the input color. But instead of merely viewing the results of an operation with such a graph, we ideally should be able to create a graph manually and then allow the software to apply this function to the image directly. In essence, the software will evaluate the value of the graph for every input value and determine what the corresponding output value should be. This input-to-output mapping is known as a **look-up table** (or a **LUT**), and consequently such a feature is usually called a LUT-manipulation tool. Such a tool can give

an extremely fine amount of control, even allowing specific color corrections across a narrow range of values. It will also often prove useful as a tool for creating and manipulating mattes. The sample image shown in Figure 4.21 has had all three channels modified by the set of curves shown in Figure 4.22.

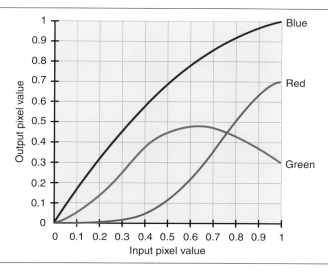

Figure 4.21 Test image modified by a look-up table (LUT).

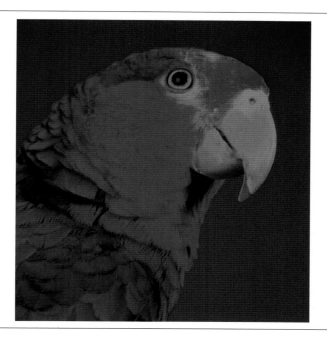

Figure 4.22 Graph of the LUT used to generate Figure 4.21.

This method of using user-defined curves to manipulate the colors of an image is not limited to merely modifying the brightness of certain regions in a given channel. Given a flexible enough software package, one can choose to arbitrarily modify one channel based on another channel. This operation can be particularly useful if you are able to include HSV color space in the mix. For instance, we may wish to modify saturation based on a particular hue. The diagram in Figure 4.23 shows a tool for performing this operation. The *x*-axis maps out the full range of hues available in an image, while the *y*-axis controls the relative saturation. In the example shown, the center of the *y*-axis is defined to be the point where saturation is unchanged. Pulling the curve upward will increase saturation, while moving it downward will decrease it. As you can see, we have chosen to desaturate anything that is blue, while at the same time we supersaturate a narrow range of green values. The resulting image is shown in Figure 4.24.

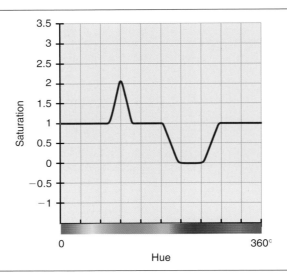

Figure 4.23 A graph used to show image modifications based on hue versus saturation.

The LUT concept that we have just detailed can be extended into a more complex tool known as a **3D Look-up**. In this sort of operation, the value of any given output pixel can be a function of more than one input color. Thus, instead of an algorithm where the red component of an output pixel is purely dependent on the red component of the input pixel, it could now be dependent on the red, green, *and* blue components of that input pixel. Complex 3D LUTs often become necessary in order to accurately map from one color space to another, for instance.

Expression Language

Finally, if all the other built-in techniques are not able to achieve the result you desire, a good compositing system should allow the user the ability to define arbitrary

Figure 4.24 Test image modified using the hue versus saturation graph shown in Figure 4.23.

mathematical expressions to modify the color of an image. This type of tool is essentially a simplified computer language with support for a wide variety of expressions and mathematical constructs. It should be robust enough that the user can create very complex expressions. Since this type of tool can vary widely between different packages, we will define a few basic conventions and then give some examples that follow those rules. This pseudocode should be easily translatable to a number of different systems. In general, the syntax for most of these manipulations is assumed to be C-like, and certain built-in keywords and functions are assumed to be predefined.

As was the case with the LUT manipulations, we will use this tool to modify the value of the channels in our image. But instead of creating a user-defined curve, the color change will instead be based on some sort of algorithm or equation. Let's start off with a very simple example, in which we modify the entire image by multiplying each of the R, G, and B channels by a constant value. In this case we'll modify each channel by 0.75. The expression for such an operation might look like this:

```
R = R × 0.75
G = G × 0.75
B = B × 0.75
```

The resulting image would be darkened by 25%. This isn't necessarily the best use of an expression language, since the identical result could have been obtained much more simply by merely applying a Brightness of 0.75 to the entire image.

Let's look at another example, one that produces a monochromatic image from the color source by averaging the three channels together:

$$R = (R + G + B)/3$$
$$G = (R + G + B)/3$$
$$B = (R + G + B)/3$$

A more proper expression, which takes into account the fact that the human eye perceives the brightness of red, green, and blue differently, would be obtained by the following:

$$R = (R \times 0.309) + (G \times 0.609) + (B \times 0.082)$$
$$G = (R \times 0.309) + (G \times 0.609) + (B \times 0.082)$$
$$B = (R \times 0.309) + (G \times 0.609) + (B \times 0.082)$$

Again, however, similar results could have been obtained by using other operators, in this case some sort of desaturation or monochrome effect.

Instead, consider a situation in which we wish to have a conditional requirement carried out by the expression. In particular, examine the next scenario, in which only the green channel is being modified. The red and blue channels remain unchanged:

$$R = R$$
$$G = R > G ? (R + G)/2 : G$$
$$B = B$$

For those of you unfamiliar with the shorthand syntax used in this expression, the English translation is as follows:

> If a pixel's red value is greater than its green value, then set the pixel's (new) green value to be equal to half of the sum of the red and green values. Otherwise (i.e. if the pixel's red value is *not* greater than the green value), leave the pixel's green value unchanged.

The result of the application of this expression is shown in Figure 4.25. As you can see, well-thought-out equations can quickly produce results that would otherwise have required the combination of several different methods.

Figure 4.25 Result of applying a conditional arithmetic expression to the test image.

Spatial Filters

So far, all of the image manipulations that we have talked about involved a direct mapping between a given input color and a given output color. This color mapping could be described by a simple function, and the only thing necessary to compute a pixel's output color was the equation and the original color of the pixel. Now we will look at a new class of tool that takes into account not just a single input pixel, but also a small neighborhood of pixels surrounding the input pixel. This type of tool is known as a **spatial filter**.[3]

Convolves

One of the most basic spatial filters is known as a **spatial convolution,** or simply a convolve. It iteratively considers a specific pixel, as well as a specific number of adjacent pixels, and then uses a weighted average to determine the value of the output pixel. This group of pixels that will be considered is known as the **kernel**, and is usually a square group of pixels that has an odd number of rows and columns. By far the most common kernels are 3×3 and 5×5, but there are occasions where larger kernels

[3] The term "spatial filter" is actually rarely used in the digital compositing world. Very often you will see packages try to group the operators that we discuss in this section under either color-correction tools or geometric transformation tools. Since they do not really fit into either category, we have decided to refer to them in a manner that is consistent with most image-processing books.

may be used. As we said, the convolve operator uses a weighted average of the existing pixels to determine a new pixel value. To control this weighting, we define a specific **convolution filter** that is used for the computation. This filter is the same size as the kernel we plan to use and contains a series of different numbers in the shape of a square matrix. The numbers in this matrix will dramatically affect the resulting image.

Although usually the compositing artist won't need to do much more than choose a specific filter from a list of options and then allow the computer to apply the convolve process, we'll take a moment to look at an example of how the math is actually applied for a simple 3×3 kernel. Feel free to skim this if the equations are starting to cause an uncomfortable feeling in the pit of your stomach.

We start with the following matrix:

$$\begin{matrix} -1 & -1 & -1 \\ -1 & 8 & -1 \\ -1 & -1 & -1 \end{matrix}$$

Think of this as a mask that will be laid over our source pixel, where the source pixel is aligned with the center of the matrix and each of the eight neighboring pixels is aligned with its positional counterpart. We then multiply each pixel by the coefficient with which it is aligned. In this example, the value of every neighboring pixel is multiplied by -1, and the source pixel itself is multiplied by 8. Now we add together all of these nine values to get a new number. This number becomes the value of our new pixel in the destination image. (Numbers above 1 or below 0 are clipped.) This process is repeated for every pixel in the source image until we have created a new image, point by point.

If we consider a section of an image whose pixels have the values shown on the left in Figure 4.26, applying the convolution filter we've just discussed will produce the results shown on the right. The particular filter we applied in this example is one that is designed to detect edges in an image. As you can see, it produced a bright pixel wherever there was a transition area in the original image, and produced dark pixels wherever the source image had a constant tone. To see this more clearly, examine the result of applying this same convolution filter to a larger image. Figure 4.27a is our original image, with some very high-contrast transition areas. Figure 4.27b is the resulting image after applying our edge-detection convolve.

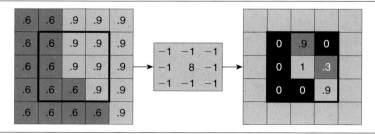

Figure 4.26 A convolve operation.

Figure 4.27a A high-contrast image.

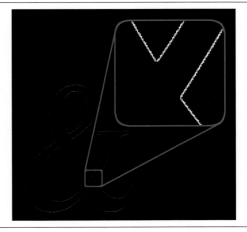

Figure 4.27b Image after applying an edge-detecting convolve.

There are a large number of different convolution filters that are commonly used for processing images. A few more of these will be mentioned in a moment, but you will probably need to consult a book on image processing if you are looking for a specific effect. Most compositing software will also come with a large number of prepackaged filters already implemented. In fact, you may not even find a convolve operator directly available in the compositing package you are using. Rather, you'll only have access to some (much friendlier) tools that make use of convolves "behind the scenes." For instance, edge-detection methods are quite useful in a variety of compositing situations and as such most such operators will feature a number of additional useful parameters for fine-tuning the result. A few edge-detection variations are shown in Figure 4.28.

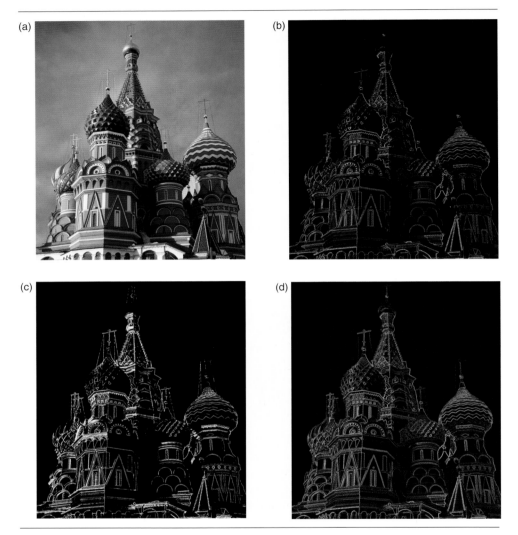

Figure 4.28 (a) Sample image and (b, c, d) various edge-detection algorithms applied to that image.

Blurring

There are many different algorithms for blurring an image, all of which produce slightly different results, but the basic concepts remain the same. The colors from neighboring pixels are partially averaged with the current pixel to produce a new image. Visually, the end result is an apparent reduction in sharpness.[4]

[4] You may also hear the term "low-pass filter" used as a synonym for a blur operation, particularly if you're hanging out with people who have an image-processing background.

Probably the most common blurring algorithm uses a simple convolve. For instance, a 3 × 3 convolve using the filter

$$\begin{matrix} \frac{1}{9} & \frac{1}{9} & \frac{1}{9} \\ \frac{1}{9} & \frac{1}{9} & \frac{1}{9} \\ \frac{1}{9} & \frac{1}{9} & \frac{1}{9} \end{matrix}$$

will result in a slight blur, as shown in Figure 4.29. Using a larger kernel, and thus averaging a larger area together, can cause a much greater amount of blurring, albeit at the expense of speed. Convolve-based blur algorithms can be extremely slow, particularly for large amounts of blur.

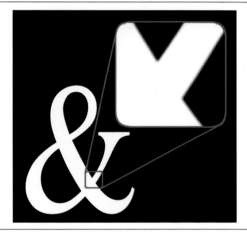

Figure 4.29 A slightly blurred version of Figure 4.27a after applying a 3 × 3 blurring convolve.

There are a variety of different convolution kernels that will produce a blurred effect when applied to an image, each with slightly different characteristics. You may sometimes see reference to a "Gaussian Blur," which is a blur that has a specific "look" that is generally considered to be smooth and natural. There are also a number of more complex algorithms that can emulate the look of these convolution-based blurs but in a much more efficient fashion, particularly for large blurs.

Also be aware that certain blur algorithms can animate very poorly. Visual steps between blur levels can be noticeable, causing blurs that change over time to be unacceptable. As usual, you may want to test the particular system that you are working with to see if it suffers from these problems.

Finally, although simple blur algorithms are often used to simulate the effects of an out-of-focus lens, a visual comparison between a "real" defocus and a simple blur

will show decidedly different results as we saw in Chapter 2. A section of that comparison is shown again, below, in Figure 4.30.

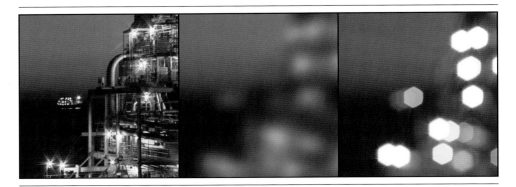

Figure 4.30 Detailed comparison of (from left to right) an original image, a synthetically blurred version, and a true out-of-focus.

There are actually two primary distinguishing factors here. The first is the overall character of the defocus, which is actually unique to the specific lens that is used to capture an image. The hexagonal nature of the way the light blooms is one aspect of this but even the darker areas have this same sort of characteristic built in. (Photographers refer to the specific aesthetic characteristics of the out-of-focus areas that a lens produces as the "bokeh" of that lens.)

The second issue here is related to the issue of dynamic range that we looked at in the last chapter. The lights in the original scene are actually significantly brighter than what the film was able to capture—those areas in the image that are white should really contain more "energy" than what we see. In the real world, changing the lens so that the image is out-of-focus will cause the energy from those bright lights to spread outwards and even though the surroundings may be quite a bit darker, the brightness of these lights will be enough to continue to overexpose the film over a broader area. But in our digital image we are spreading pixels that are artificially dimmed—clipped to white—and as they are averaged with their neighboring darker pixels the result is an intermediate gray color. This is a perfect example of where a high dynamic range image would be useful to more accurately model the way the real world works.

Most compositing packages feature tools (either natively or available as plugins) that attempt to more accurately model the look of an optical defocus, taking areas that are above a certain brightness and allowing them to "bloom" more appropriately. If you don't have such a tool you may still want to explicitly treat highlight areas differently when you blur something. Isolate them as a separate layer (using some of the keying techniques we'll talk about in Chapter 6), blur them by the same amount as the rest of the plate, and then *brighten* the blurred result before layering them back into the scene. This won't give you quite the same effect as what a dedicated defocus operator

can accomplish but it's generally better than allowing your highlights to blur out to a gray tone.

Sharpen

Given the fact that we can blur an image, it seems that one should be able to sharpen an image as well. To a certain extent this is possible, although the most commonly used method is really somewhat of a trick. The Sharpen operator actually works by increasing the contrast between areas of transition in an image. This, in turn, is *perceived* by the eye as an increased sharpness. Sharpening can either be done by using a convolve with a filter such as

$$
\begin{array}{ccc}
-1 & -1 & -1 \\
-1 & 9 & -1 \\
-1 & -1 & -1
\end{array}
$$

or via other techniques, such as **unsharp masking**. It doesn't really matter which specific mathematical technique you use—the principle is the same, as illustrated by the simplest-case scenario discussed next.

Figure 4.31a shows an extremely enlarged look at an edge in an image—in this case a straight-line transition from dark gray to light gray. Figure 4.31b shows the same area after some sharpening has been applied.

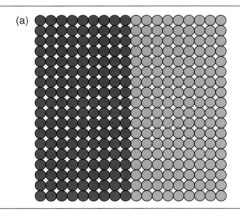

Figure 4.31a Close-up of a Sharpen operation on the original edge.

If we create a graph based on the values of a horizontal slice of the original image, it would look like Figure 4.32a, whereas Figure 4.32b corresponds to Figure 4.31b. (Remember, this is a very enlarged example—most of the time the effect of your sharpening along an edge will occur over only a few pixels.)

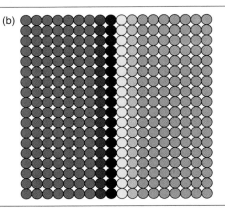

(b)

Figure 4.31b The same area after applying Sharpening.

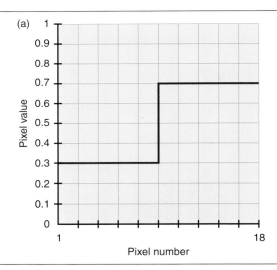

Figure 4.32a Graph of the brightness values along a horizontal slice from Figure 4.31a.

Notice the boosted contrast at the transition juncture, the bright area gets slightly brighter, the dark area slightly darker. A good sharpening tool should let you choose the amount of the sharpening, as well as the extent of the sharpening. If we happen to be using a convolve to do our sharpening, increased sharpening amounts would be produced by increasing the weights of the coefficients in our matrix, and an increased extent would be produced by using a larger matrix.

Figure 4.33 shows a comparison of various levels of sharpening when applied to a real image. On the left, the inset marked "a" is the original, unmodified image. Inset "b" has had a slight sharpening applied, with subtle but noticeable results. Finally, the third inset ("c") has had a far greater amount of sharpening applied, to demonstrate the type of

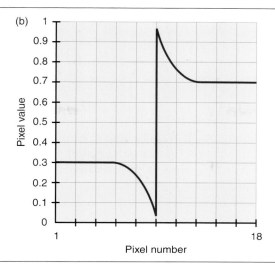

Figure 4.32b Graph of the brightness values along a horizontal slice after Sharpening has been applied.

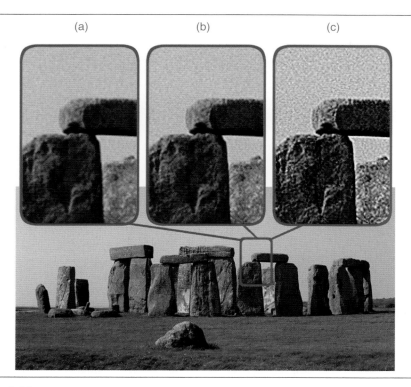

Figure 4.33 A comparison of various levels of sharpening: (a) No Sharpening. (b) Medium Sharpening. (c) Excessive Sharpening.

problems that can show up if this tool is used too aggressively. Now that you are familiar with what sharpening is really doing, it should make sense that oversharpening will cause you to see noticeable **ringing** along strong transition areas, such as the edges of the stones against the sky in the example. You should also be able to see that the sharpening has increased the amount of apparent grain in the image—an artifact that would be even more noticeable if it occurred on a sequence of images.

Keep in mind that these sharpening tools can never actually create or restore lost information. There is really no "real" detail being added to the scene, only the perception of it. The trick only works up to a certain point, and results can often include undesirable artifacts.[5] As an example of this, consider Figure 4.34a which shows a bit of detail from an image where the lens has been set slightly out-of-focus. Figure 4.34b shows the results of sharpening this out-of-focus area. Although it does indeed give the perception of being slightly sharper, it is still decidedly less sharp (with less detail) than what we see in the original (Figure 4.34c).

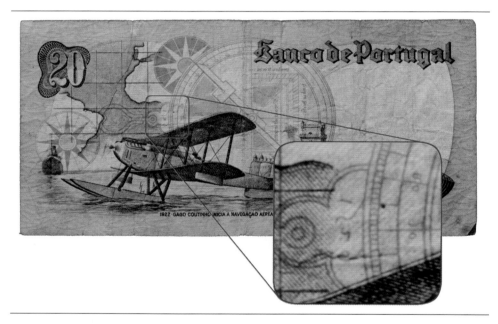

Figure 4.34a A slightly out-of-focus image.

As with the Blur operator, there are a number of more advanced algorithms for increasing the apparent sharpness in an image that go beyond what a simple convolve can give us. In particular, tools that can adaptively apply sharpening based on some

[5] Having said that, there *are* actually a number of algorithms that are being developed that can do a much more sophisticated reconstruction of the original scene based on a specialized defocused image. Expect these to become more and more available as time goes by.

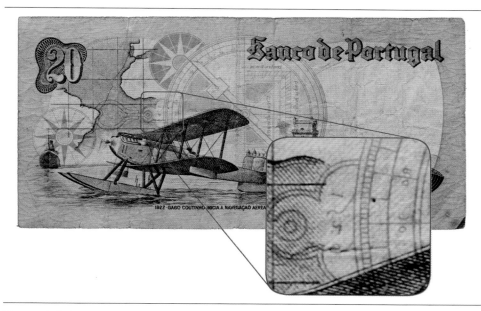

Figure 4.34b Sharpening applied to Figure 4.34a.

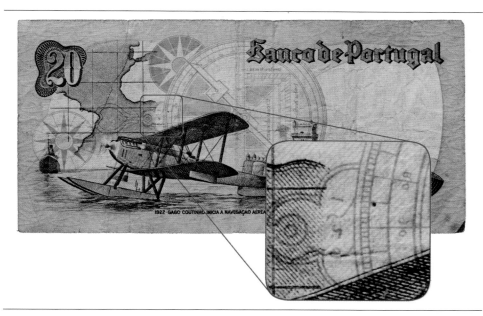

Figure 4.34c The original scene from Figure 4.34 shot with a properly focused lens.

sort of edge or feature detection can prove quite useful as they can usually give the perception of greater sharpness without introducing as many artifacts.

Median Filter

Certain spatial filters do not use a specific weighted matrix to determine the way pixels are averaged together. Instead, they use other rules to determine their result. One such filter is the **median filter**. Quite simply, it ranks all of the pixels in the kernel in terms of brightness and then changes the value of the pixel in question to be the same as the median, or center value, of this ranking. The net result is that the median filter does an excellent job of removing single-pixel noise artifacts, while causing only a slight reduction in the sharpness of the image.

Figure 4.35 is an image with some noticeable noise spikes—small bright and dark spots. Figure 4.36 is the same image after the application of a median filter.

Figure 4.35 An image with some noticeable noise spots.

As you can see, the bulk of the noise has been eliminated. Applying the filter again in a second pass would probably eliminate the rest of the noise. This process does not come without a price, however, since each time a median filter is applied the image will be slightly softened (as is visible in the enlarged area). For this reason, median filtering is usually applied only within a certain threshold. The only pixels that will be replaced with the median of their neighbors are those pixels that vary by more than a certain amount from the original image. Areas that do not have any noise are not changed, and the overall image suffers far less softening than a normal median would produce.

Figure 4.36 Figure 4.35 after applying a median filter.

As with most image-processing operations, you should consider both the details as well as the overall look of the image when viewed at a normal viewing size. In this case, for instance, the loss of detail isn't extremely noticeable in the full image, at least relative to the obvious decrease in the undesirable noise spots.

Geometric Transformations

The next class of operations we will be discussing all fall under the category of geometric transformations, or simply "transforms." A transform operation causes some or all of the pixels in a given image to change their existing location. Such effects include **panning, rotating, scaling, warping,** and various specialized distortion effects. We'll first consider the three simplest transformation effects: Pan, Rotate, and Scale.

Whenever we talk about moving images around, we must realize that they have to be moved relative to something. It's easiest to just consider that the image is being moved relative to some predefined frame. In most day-to-day compositing work, the first thing we tend to do is define our working resolution, and everything is moved around inside of this frame. What we call a working resolution is typically the resolution of the image that will be produced once we are finished with our compositing operations.

For the purposes of the next few examples, let's assume our working resolution is 1200 pixels wide by 900 pixels tall. Let's also assume that the input or source image that we'll be dealing with in these examples is a slightly smaller resolution, say 900 × 600. There is at least one more item we need to know about the system we are working in, namely,

what is considered the origin of our system. In other words, what part of the frame is considered to have the (x, y) location of $(0, 0)$. This point may vary between different software packages, but the most common assumption is that the origin is located in the bottom left corner of the frame. Thus, our example image when placed (without any additional transformations) into our working resolution frame is shown in Figure 4.37.

Figure 4.37 An image placed in the corner of a larger frame.

Panning

Let's say we wish to apply a simple translation to the image, offsetting it in both x and y. Such a translation is usually referred to as a PAN.[6] In this case, we will pan the image by 150 pixels along both axes. The new image produced is shown in Figure 4.38, with the original image more or less centered within the frame of our new output image.

What happens if we move the input image 700 pixels in x instead, causing part of the input image to be moved beyond the borders of our working resolution? The result will usually be something like what is shown in Figure 4.39a. However, the issue of what is done with the rest of the image that has moved out-of-frame is dependent on the compositing system that is being used. On most systems, the rest of the image will be cropped, or discarded. Any additional transformations to this image will be

[6]As usual, different software and artists may refer to these operations using different terminology. Some people would call this a simple reposition, or "repo." The term "pan" would then be reserved for a reposition that animates over time. Rather than have a term that is dependent on whether the effect is applied over time, we have decided to refer to either a static or a dynamic reposition as a "pan."

performed with the truncated image, and any portion of the image that was moved out of the working area will be unrecoverable. A few systems are able to deal with this problem in a more robust fashion, allowing the off-screen information to be preserved so that it can later be brought back into frame if needed. There is also a common

Figure 4.38 Image from Figure 4.37 panned by 150 pixels along both axes.

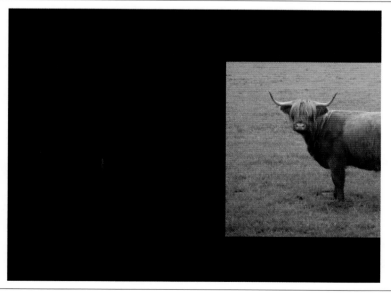

Figure 4.39a Image panned so part of it is off-screen.

option in most systems that lets the user specify that the image "wraps" around to the other side of the frame, as shown in Figure 4.39b.

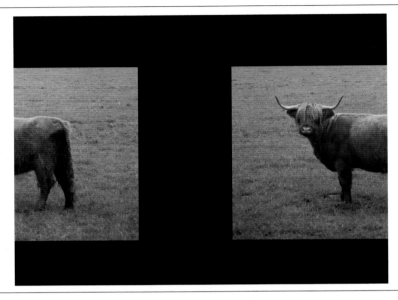

Figure 4.39b Image panned the same amount but with wrapping turned on.

This wrap-around mode is often used when you want to move some fairly nondescript background over a reasonably long period of time—a bit of landscape that's seen outside the window of a moving car, for instance. Figure 4.40a shows an image that has been specifically created to wrap in this fashion without showing any seam or discontinuity. Figure 4.40b shows the same image after panning it by a fair amount horizontally.

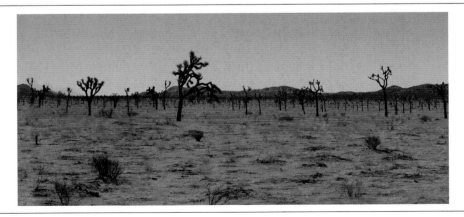

Figure 4.40a Image created specifically for seamless wrap-around.

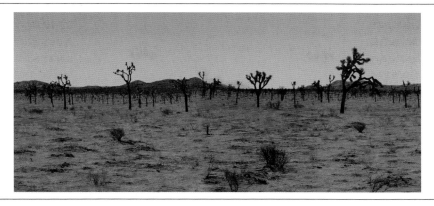

Figure 4.40b Wrap-around image panned sideways.

Rotation

Let's ROTATE an image now. The two parameters needed to control a simple rotation are the amount of the rotation (usually specified in degrees) and the center of the rotation. Changing the center of rotation can dramatically affect the result. Compare Figure 4.41a and 4.41b. Both images have been rotated 30° clockwise, but in the first the center of rotation was the origin, (0, 0), whereas in the second the image was rotated about a point that is approximately its center (indicated with the red arrow).

Figure 4.41a An image rotated 30° clockwise around the origin.

Figure 4.41b Image rotated the same amount around its approximate center.

Scale

Now we will look at the case of **scaling** an image. Again, if your compositing system supports it, the ability to scale around a user-defined point is useful. Figure 4.42a and 4.42b shows an image scaled down by 50% (or scaled by 0.5) around the same two origins that we used for our rotation examples. If for some reason your compositing system does not support scaling around a user-defined origin, don't be too concerned, since it is really just a shortcut that can easily be duplicated by panning the resulting image into the position we desire.

Although this example shows an image scaled by the same amount (0.5) in both x and y, we can certainly scale nonuniformly instead, say by 0.3 in x and by 1.2 in y. Note that we can also "flip" or "flop" an image by scaling it by -1 in the x or y direction, respectively (although most packages will have these available as explicit operations). Remember that flipping an image is not the same as merely turning it upside-down (i.e., rotating it by 180°). Instead, flipping produces a mirror image along the x-axis. This can be very useful when faking shadows or reflections in a composite. Figure 4.43 illustrates the difference between an image that is flipped (4.43a) and one that is merely rotated (4.43b). Figure 4.43c shows an image that has been flopped.

Figure 4.42a An image scaled by 50% around the origin.

Figure 4.42b Image scaled by 50% around its approximate center.

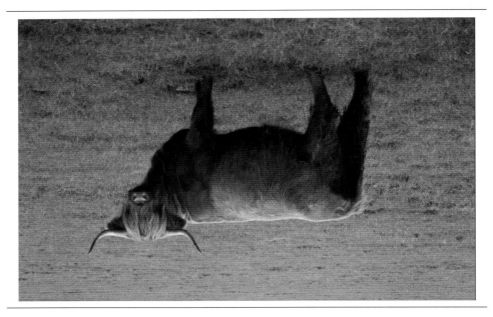

Figure 4.43a Flipped image.

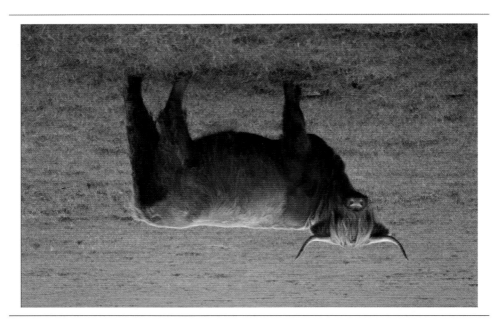

Figure 4.43b Image rotated 180°.

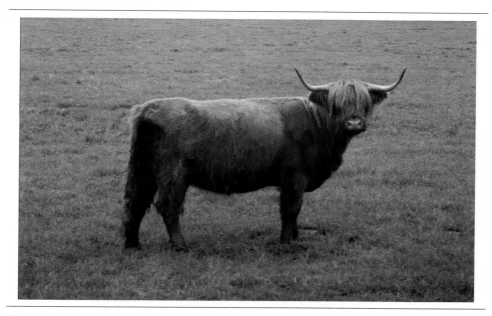

Figure 4.43c Flopped image.

3D Transforms

So far we've confined our discussion of various transformations to what are considered to be 2D transforms. We can also choose to rotate an image as if it were being moved about within a 3D environment. Various perspective effects will consequently be introduced. Without going into great detail to define the information needed to extend our discussion into this third dimension, let's just look at a simple example of transforming an image in 3D space. Figure 4.44 shows an image that has been partially rotated around the *x* (horizontal) axis. You can see the obvious perspective effects, whereby foreshortening causes the bottom of the image to be compressed and the top of the image to be enlarged.

Even if your compositing system doesn't support the concept of perspective transformations, it may support something known as "corner-pinning," in which the user can manually reposition the four corners of an image to create any arbitrary tetrahedron. The end visual result should be similar. In general, most 3D transformations can be emulated using 2D transforms.

In point of fact, it is often easier to use a Cornerpin operator than a true 3D transformation in many cases. One of the most common visual effects shots is to replace the content of a computer or video monitor with a different bit of imagery, for instance. Figure 4.45 shows just such a situation—a scene featuring a computer monitor, the appropriate Cornerpin image transformation applied to our example image, and the result composited over that monitor.

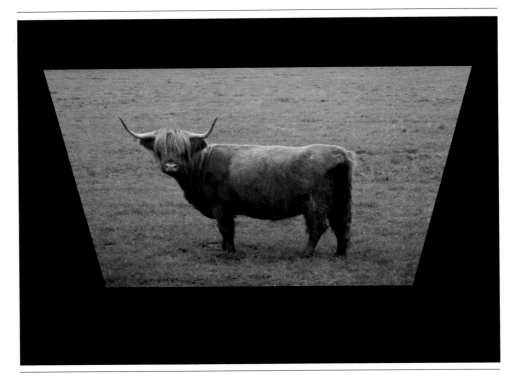

Figure 4.44 3D rotation around the *x*-axis.

Figure 4.45a Element with perspective that we wish to match.

Figure 4.45b Image cornerpinned to match the perspective in Figure 4.45a.

Figure 4.45c Figure 4.45b composited over 4.45a.

Warping

An even more sophisticated method of distorting an image is known as warping. Conceptually, it is easiest to think of warping as if your image were printed on a thin sheet of flexible rubber. This rubber sheet can be pushed and pulled by various amounts in various areas until the desired result is obtained. Image warping is usually controlled by either a grid mesh or a series of **spline curves**.

Although warping is a powerful tool for manipulating images to obtain effects that would otherwise be impossible, for illustrative purposes we will use it for a slightly less serious result. Consider Figure 4.46, which shows our sample image with a grid lain over the top.

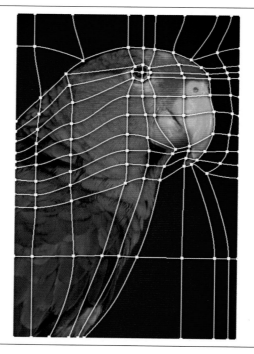

Figure 4.46 Warping: Sample image with a warping grid laid over it.

To control the warping of this image, we will manipulate this grid and the corresponding warp will be applied to the image. Thus, if we stretch our grid as shown in the right half of Figure 4.47, the resulting warped image would be similar to that

Figure 4.47 Grid before and after distortion.

shown in Figure 4.48. Later, in Chapter 5, we will also touch on the technique of **mor-phing**, a sophisticated combination of warping and dissolving between two images over a period of time.

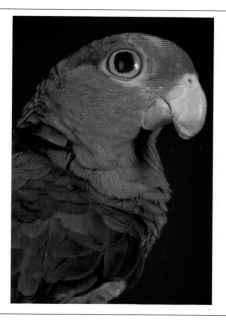

Figure 4.48 Resulting warped image.

Using a spline to control a warp is similar, although it allows the user to only concentrate on the areas that need to be affected and can often be much quicker to use. Figure 4.49

Figure 4.49 Source-and-destination splines for a similar warp.

shows a set of source (blue) and destination (red) splines that would be created to effect a warp on a portion of our parrot image and Figure 4.50 shows the outcome. As you can see, the process gives the same result but with much less manipulation.

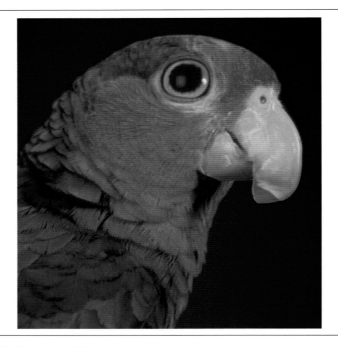

Figure 4.50 Spline-warped image.

Expression Language

Just as we saw with the color-correction tools, the ideal compositing system will allow you to resort to mathematical expressions to define warping parameters. The syntax will follow the same format as we defined for our color-correction example, only now we will be dealing with X- and Y-transformations. The degenerate case, in which we are merely mimicking something simple like an X-translation, could be represented as

$$X = X + 30$$

This transformation would shift every pixel to the right by 30 pixels.

More complex equations can easily be extrapolated. For instance, using a periodic function like sine, we can create a wavy offset:

$$Y = Y + 50 \times \sin(X \times 0.02)$$

In this example, the sine function returns a value between 0.1 and 1 depending on the value of X. The multiplication by 50 magnifies the effect so that pixels are offset in the

range -50 to 50. (Multiplying X by 0.02 before passing it to the sine function will control the frequency of the wave.) The result of this warp operation is shown in Figure 4.51.

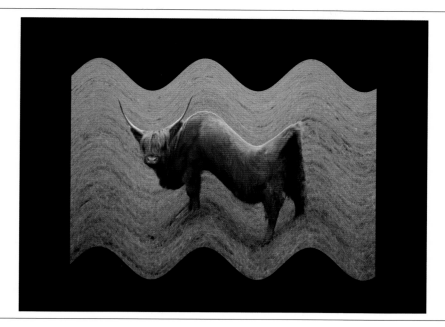

Figure 4.51 Warping operation performed using a mathematical expression.

Filtering Algorithms

Every time a geometric transformation is applied to an image, there is a step in which the computer samples the original image and creates a new one. Within this step, there is a choice of what type of **filter** will be used to produce the new image.[7] Consider the situation in which we want to scale an image down to one-tenth its original resolution. There are a number of ways that we could go about this. We could simply use every tenth pixel, for instance. This technique is a very simple filter, generally known as an **impulse filter**. It is a very fast method of reducing an image, but unfortunately not a very good one, since it completely ignores 90% of the data that makes up the original image. Think about the worst-case example of how this can be undesirable. If pixel number 1 and pixel number 11 in the image are black, but pixels 2–10 are white, our scaled-down image would use a black pixel to represent the new pixel number 1, even though the average value should be much closer to white. Better filtering algorithms look at all of the pixels in the original image and selectively average these

[7] From a mathematical point of view, these filters are essentially the same as the spatial filters that we have already described. However, their implementation here is different, and the compositing artist will use them differently.

pixels together to obtain a new pixel that more accurately reflects the data in the original image.

Choosing a specific filter is not just something that we do when scaling an image down (or up). Every geometric transformation (from a rotation to a warp) will use some kind of filter to compute the resulting image. Presumably, your compositing system will allow you to choose a specific filter for most geometric transformations. (If it doesn't, it is probably time to get a new compositing system.) Advanced systems may give you a variety of different filters to choose from by name, whereas less-sophisticated systems may just limit your choices to simple options such as "low-quality" or "high-quality."

Different types of filtering can produce vast changes in the quality of the resulting image, particularly when dealing with a moving sequence of images. For instance, when animating a pan be sure to choose a filter that is able to deal with increments of less than a pixel. Such a filter, known as one with **subpixel** accuracy, is designed to prevent your image from popping to whole-pixel boundaries as it moves—a visual artifact that is surprisingly noticeable, even when working at high resolutions. On the other hand, if you are using a geometric transformation to merely reposition an image (i.e., without any scaling, rotation, or animation), then you would be better off choosing a filter that does not resample, but instead preserves the original data exactly.

Although the perfect filter does not exist, there are a variety of different filters that are typically used with image-processing algorithms. The following list mentions a few of the filters that would normally be available for image resizing, with a look at the pros and cons of each. A resizing filter can act in the same fashion as a sharpening operator, where subtle application will appear to increase sharpness but at the risk of introducing ringing artifacts. Other resampling filters may introduce noticeable softness into an image or may result in aliasing. Higher-quality filters are more expensive in terms of memory and CPU usage, not surprisingly; therefore you should be aware of what type of filter you are using for a given operation. The use of a lower-quality filter for intermediate test work may be justified, as long as you intend to switch to a higher-quality one for the generation of your final imagery.

- The **impulse filter** is the fastest method for resampling an image, since it will sample only a single pixel in the original image to determine the value for a given pixel in the new image. It is also known as a **Dirac filter** or a **nearest-neighbor filter**. Although fast, it generally produces a significant amount of aliasing in just about any situation. In general, it should only be used when the need for speed is paramount.

- The **box filter** is of slightly better quality, but still tends to produce a lot of artifacts. When scaling an image up in size, it will result in a boxy look.

- The **triangle filter** considers slightly more area when resampling, and is used a fair amount as a quick method for resizing an image for viewing purposes.

- The **Mitchell filter** is a good balance between sharpness and ringing, and is often the best choice when scaling an image to a larger resolution.

- The **Gaussian filter** is a common filter that is virtually free of aliasing or ringing artifacts, but tends to introduce noticeable softening in the image.

- The **sinc filter** does a very good job of keeping small details without introducing much aliasing. It is probably the best filter to use when scaling an image from a larger resolution to a smaller.

(Any recommendations are merely guidelines of course—you should experiment with the actual image you are using to see if the results are acceptable for the situation you're in.)

Figure 4.52 shows a comparison of three of these filters when used to scale up an image (sections taken from the same image we used in Figure 4.34c) by a large amount. In this case the Gaussian filter on the left will produce an image that appears slightly soft, the sinc filter in the middle introduces a bit of local contrast to help the result feel sharper, and the impulse filter on the right is simply a pixel replication. At this magnification the differences are reasonably obvious but for most effects work you won't be doing such extreme scale increases. In those cases the distinction may be much more subtle (although subtlety is often exactly what a shot needs!)

Figure 4.52 Detail from an image, resized using (from left to right) Gaussian, Sinc, and Impulse filtering.

Figure 4.53 shows the same filters being used to scale up a simple test image (shown at the top) that features a sharp transition between a dark gray patch and a light gray. In this case we have (from top to bottom) Gaussian, Sinc, and Impulse. We've also graphed this transition (Figure 4.54) for all three filters in the same way we did when looking at the sharpening earlier in this chapter. Looking at this, it is easy to see that the sinc filter is doing something extremely similar to that sharpening filter—increasing local contrast in areas of transition.

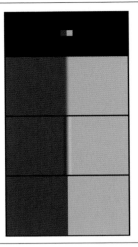

Figure 4.53 A simple two-tone image scaled up using (from top to bottom) Gaussian, Sinc, and Impulse filtering.

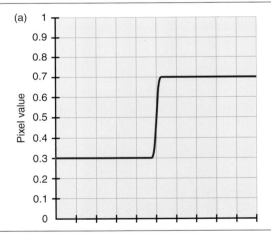

Figure 4.54a Graph of a cross-section from the image resized using a Gaussian filter.

There are a number of other algorithms that may be used when resizing images in order to obtain specific results. For instance, when enlarging a digital image for printing there are tools that will selectively add a slight bit of fractal noise into the result, which will appear to increase the detail that is present in the image. (This particular method, however, doesn't always animate well.) There are also ways to take advantage of multiple exposures of a single image in order to build a larger image with more information than a single frame could provide. This is now common when resizing (for instance) standard-definition video up to high-definition (HD) resolution—using the information from multiple frames to produce a higher-quality new frame at the larger resolution.

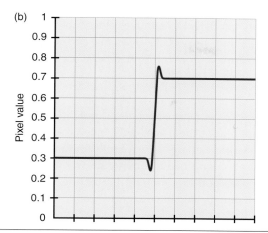

Figure 4.54b Graph of a cross-section from the image resized using a Sinc filter.

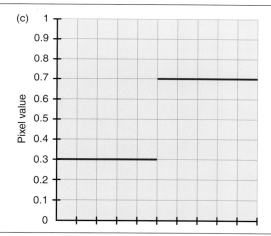

Figure 4.54c Graph of a cross-section from the image resized using an Impulse filter.

The most important point to take away from all this, however, is that no matter what methods you use to resize an image, you'll always be limited by the amount of data you started with. As we saw back in Chapter 2 (Figures 2.11–2.13), resizing is no substitute for capturing more detail in the first place. This should be kept in mind even when dealing with the localized resizing that warping tools introduce. A large distorting warp entails the same resolution requirements as a large zoom-in would require, at least in that specific area of the image—take another look at Figure 4.50 and you'll see that the eye of the parrot, which is now more than twice as large as the original, has gone noticeably soft. For this reason, if you know in advance that you are going to introducing a significant warp into an image, you would be well-served to try and obtain the original imagery at a higher than normal resolution. This is part of the reason

why fashion photographers regularly shoot at extremely high resolution. Most glam-our photos are certainly retouched to remove undesirable lines and blemishes. But significant localized warps may also occur—eyes and eyebrows are repositioned, lips are enlarged to make them appear more full, and general body contours are modified.

Motion Blur

Once you begin applying your transformation tools in a fashion that causes something to move over a period of time, you'll also need to deal with motion blur. As we saw in Chapter 2, real-world cameras take a finite amount of time to capture an image and if the object being photographed is moving during that capture period, the image will show some blur based on this motion. Emulating this with digital transformations is critical to producing believable imagery.

The way that different systems create motion blur varies—less-sophisticated transform algorithms may only be able to emulate motion blur through the use of sub-frame sampling. In this case, the software will render multiple iterations of the moving object and then blend them together using some sort of averaging. Figure 4.55 shows a 2D element that has been animated using a simple transformation.

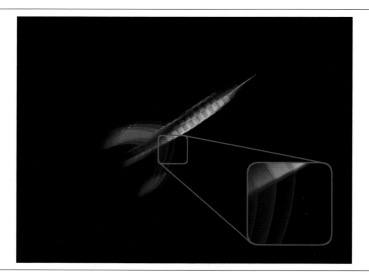

Figure 4.55 A transformed image rendered with simple motion blur applied (sampled five times).

Motion blur has been created for this element by sub-sampling the movement five times to produce a single frame. Not only is the effect less than pleasing but it also took five times longer to render than a single nonblurred image would. To increase the quality we could render even more samples (Figure 4.56 uses 20 samples) but this will be even slower. More sophisticated motion-blur algorithms will use some sort

of **adaptive sampling** method where the sub-frame calculations are only done where necessary. This will decrease the amount of time it takes to calculate motion blur at a particular quality level and it becomes much more practical to have a high-quality motion blur like the one shown in Figure 4.57.

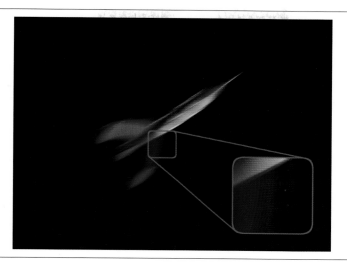

Figure 4.56 The same motion-blurred transformation but with motion blur sampled 20 times.

Figure 4.57 Motion-blurred transformation using adaptive sampling.

Decreasing the quality level with these method will also tend to give a more pleasing result as the sampling is more random that with pure frame-blending. Figure 4.58 shows the same amount of motion blur as Figure 4.57 but at a lower-quality level.

This lower-quality sampling took about half as long to calculate yet would probably still look acceptable when seen as part of a moving sequence (particularly if it's being added to a piece of film that already has some grain present).

Figure 4.58 Motion-blurred transformation using a lower-quality setting for the adaptive sampling.

As with most things in our digital world, we aren't restricted to the same physical limitations that a real camera might have. Thus it is certainly possible to use an artificially long shutter to exaggerate the effect. Figure 4.59 shows exactly this.

Figure 4.59 Motion-blurred transformation using an artificially long shutter.

As we saw with a regular blur, motion blur is also something where the higher dynamic range of the real world must be considered. Figure 4.60 shows a scene where

Figure 4.60 A scene featuring objects with bright (overexposed) highlights.

Figure 4.61 The same scene shot with a moving camera, introducing motion blur.

several objects are reflecting extremely hot highlights back to the camera. If we photograph this same scene while the objects (or camera) are moving, these hot highlights will still remain blown out to white even though they are motion blurred (Figure 4.61). Applying a synthetic, postprocessed motion blur can easily lose those highlights (as shown in Figure 4.62) and so once again you will either need to do some additional work to regain them or capture imagery with a higher dynamic range.

Figure 4.62 A postprocess transformation applied to Figure 4.60 with motion blur. Note the loss of the hot highlights.

Finally, although any decent compositing package will offer the ability to apply motion blur (of some sort) on basic image transformations, it is still much less common on other sorts of transformations—warping, for instance—and you may need to resort to various tricks to achieve the result you are looking for.

Basic Image Compositing

Now that we've taken a look at a number of different methods to modify a particular sequence of images, we can start to discuss the manipulated combination of *multiple* sequences. This process, combining two or more image sequences, is the true heart of digital compositing. It requires the use of special operators that are capable of dealing with more than a single input sequence, and so we will refer to these operators as "multisource operators." As was the case with our discussion of basic image manipulation tools, we will only take an in-depth look at a few of the most important image-combination tools. There are numerous others, and a bit more information on several of them can be found in Appendix A.

Multisource Operators

As we did in the last chapter, we'll provide simple equations for some of these operators to better define them. So, again, we'll use "O" to represent our output image and, since we'll now be dealing with more than one input image, we'll use the labels "A" and "B" for these.

Add

We'll start this discussion with one of the most common multisource operators. It is also one of the simplest, and we'll refer to it as simply an Add. If you recall, in the last chapter we discussed a single-input Add operator that added a constant value to each pixel in an image. Although we'll be using the same name for the multisource operation we're about to discuss (following typical nomenclature within the industry), the context of where and when they will be used should hopefully leave little room for confusion.

Adding two images together involves, not surprisingly, the addition of each pixel in the first image to its corresponding pixel in the second image. Figure 5.1a and 5.1b show the two source images we will be using to illustrate some of our multi-input operators.

Figure 5.1a Sample image "A" to illustrate compositing operations.

Figure 5.1b Sample image "B" to illustrate compositing operations.

Combining these two images using an Add produces the image shown in Figure 5.2. As you can see, the result is roughly similar to a photographic double exposure.

Using our standard notation, the Add multisource operator would simply be represented as:

$$O = A + B$$

Figure 5.2 Add of the two source images.

A and B are our two source images and O is the resulting image.

A number of the basic mathematical single-source operators, such as Subtract or Multiply, have dual-input equivalents—let's look at another.

Subtract

The Subtract operator causes every pixel in image A to be subtracted from its corresponding pixel in image B. Quite simply,

$$O = A - B$$

Note that Subtract is not a symmetrical operator. The *order* in which the two images are specified is important to the result. Be aware of which multisource operators are symmetrical and which are not, since it will determine whether or not you need to be concerned about the order in which you combine images. Thus, $(B + A)$ equals $(A + B)$, but $(A - B)$ does *not* equal $(B - A)$.

This is shown in Figure 5.3. Figure 5.3a is the checkerboard subtracted from the parrot, Figure 5.3b is the parrot subtracted from the checkerboard.

By default the Subtract operator will either clip all values that go below zero or (if you are working in a floating-point environment) produce negative values. It is also useful to be able to specify that the operator return the absolute value of the result, in which negative numbers are converted to positive. The absolute value method is particularly useful for difference matting, which we'll discuss in Chapter 6. A subtraction that returns the absolute value of the result becomes a symmetrical operation, so you no longer need to worry about the order of the two image sequences that you specify.

Figure 5.3a Subtract: A − B.

Figure 5.3b Subtract: B − A.

Subtracting one of our source plates from the other with the "absolute value" option turned on produces the result shown in Figure 5.4.

Incidentally, before we go any further we should note that many of these operators may not look particularly useful (or visually pleasing) based on the examples we're providing. In actual practice, you may find that they tend to be used in very specific circumstances, sometimes only in conjunction with additional matte channels (which we'll talk about in a bit). But for the sake of completeness we'll show most of them as they apply to our two example sources anyway.

Figure 5.4 Subtract A − B with the absolute value of the result.

Mix

A Mix is really a specialized version of the Add operator where we do a bit of basic image manipulation first. Specifically, it is the weighted, normalized addition of two images. In other words, the two images are averaged together, often with one of the images contributing a larger percentage to the output. Figure 5.5 shows the result of mixing 75% of image A with 25% of image B.

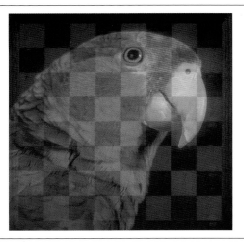

Figure 5.5 Mixing A and B.

The equation for such a mix, where "MV" refers to the mix value (the percentage of the first image that we will be using), is as follows:

$$O = (MV \times A) + [(1 - MV) \times B]$$

To "dissolve" from one image to another over a given period of time, one merely animates the mix value so that it initially displays 100% of image A and then eventually displays 100% of image B.

While all the operators that we have just discussed are certainly useful in a variety of situations, they really do not give us the impression that any sort of layering has occurred. There is no sense that certain portions of one image are actually occluding anything in the second image. To accomplish this, we need to introduce the concept of a matte.

The Matte Image

Combining different image sequences needs to be a process with as much control as possible. We need to be able to limit which portions of the various images will be used, and which will not. We need to be able to control the transparency of the various layers so that they don't completely obscure everything that they are covering. And we need to have a method for defining and controlling these attributes that is intuitive and consistent with the rest of the image processing we will be performing. This is what the matte image gives us.

First of all, understand that a matte image is not different from any other image, in terms of the data used to represent it. It can generally be treated and manipulated in exactly the same fashion as other images, but it is considered to have a different purpose than those images. Instead of providing a visual representation of a scene, it is more like a utility image used to control individual compositing operations.

Mattes are used during compositing when we only wish a portion of a certain image to be included in the result. You may also hear the term "mask" used when referring to mattes, and it is not uncommon to find the two terms used interchangeably. For sanity's sake, we will try to limit the use of the word "mask" to refer to a general image that is used to control or limit certain parameters in an operation, such as a color correction.

To complicate things even further, both "mask" and "matte" may also be used as either nouns or verbs. The terms can refer to the image used in the process of protecting or excluding a section of an image, or they may refer to the process itself. Consequently, we may "matte out" a section of the foreground so that the background is revealed, or we may "mask off" the bottom third of an image when we color correct it so that the correction doesn't affect that area.

Mattes are generally considered to be single-channel, grayscale images. There is no need for three separate channels, as there is when specifying color, since the transparency for any given pixel can be described by a single numerical value in the range 0–1. Many systems and file formats support single-channel images, whereas others will simply place a copy of the same information into all three channels of an RGB image. While this method is redundant (and can waste disk space), it does sometimes

provide a simpler model for both the user and the programmer.[1] Ideally, the compositing system will store a single-channel matte image as efficiently as possible, yet still allow the compositor to treat it as if it were a normal RGB image when necessary.

Depending on the software package you are using and the file format you have chosen, a matte can also be bundled along with a three-channel color image as a discrete fourth channel. When the matte image is part of a four-channel image, it is known as the **matte channel** or **the alpha channel**.[2] In the next section we will discuss four-channel images in greater detail, but for this first example we will consider the case in which our matte is a separately stored image.

Let's look at a very simple example of how a matte image is used, given our original two images (Figures 5.1a and 5.1b) and a third matte image shown in Figure 5.6. We will use this matte channel to isolate or extract a portion of our foreground and will then place it over the background. The resulting image is shown in Figure 5.7.

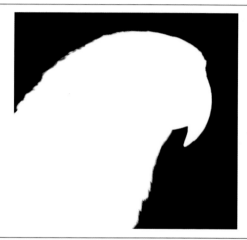

Figure 5.6 Matte for the object in image A.

As you can see, areas that are white (have a pixel value of 1.0) in the matte channel are used to specify that the corresponding area of the foreground image is to be kept at full opacity. This is said to be the "solid" area of the matte. Conversely, the black areas of the matte are used to specify that the corresponding pixels in the foreground image will be transparent, or effectively removed, when it is placed over the background.

[1] Matte images tend to contain large areas of identical pixels, usually black or white, and as such will compress dramatically using one of the better lossless compression schemes. Consequently, there is often less concern about the amount of disk space that is taken up by a matte image.

[2] The concept of a matte image that could be integrated as a fourth channel to a normal color image was developed and formalized by Ed Catmull and Alvy Ray Smith at New York Institute of Technology in the late 1970s.

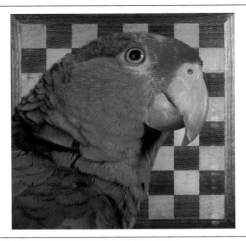

Figure 5.7 A combined with B through a mask (Keymix).

Intermediate gray levels of the matte channel provide a continuum of transparency, with brighter (higher-valued) pixels specifying more opaque areas and darker pixels specifying more transparent areas. The same behavior can be seen if we look back at the image from *James and the Giant Peach* that we discussed in Chapter 1. Figure 1.5 shows the matte that was used to extract the peach from Figure 1.4a in order to place it into the scene shown in Figure 1.3.

Intuitively, people understand this sort of layering as if the matte were a cookie cutter that removes all excess information from the foreground image. Once this cutout is created, the result is then pasted on top of the background.

Here's what really happens, mathematically, when we place image A (the foreground) over image B (the background), using image M as the matte for image A.

$$O = (A \times M) + [(1 - M) \times B]$$

This operation is sometimes known as a **keymix**, because it is actually using this third image as a "key" (yet another term, common in the video world, for a matte image) to determine how the two images are mixed together on a pixel-by-pixel basis. You can effectively think of it as being the same as the Mix operator that we discussed earlier, only instead of a fixed "mix value" that is applied across the entire image, there is a specific mix value for each *pixel* as determined by the matte image.

This example shows the matte images as being a distinct entity, completely separate from normal color (RGB) images. Any operation that is used to combine two images would need to reference the matte image as a third image in order to control varying levels of transparency. This need not always be the case if we are working with a system that supports four-channel images.

The Integrated Matte Channel

Very often an image will be stored with not only the three basic channels, but also a fourth channel for specifying the transparency of that image, effectively combining the matte channel with its associated color image. This fourth channel is known as the alpha channel or the matte channel.

But there is more to the process than simply attaching that matte channel to an image. Usually, when a fourth channel is added to an image, the color channels are modified as well, to include some of the information that comes from the matte channel. In fact, the standard definition of a four-channel image, at least in the world of digital compositing, assumes that the red, green, and blue channels have already been *multiplied* by the integrated matte channel. Such an image is referred to as a premultiplied image,[3] and it is typically the default type of image that is generated from a 3D rendering and animation package. (Occasionally there are situations in which you may have a three-channel image that has already been multiplied by an external matte. This too could be referred to as a premultiplied image, but this scenario is much less common.)

Figure 5.8 shows an image whose color channels are the result of multiplying Figure 5.1a by Figure 5.6 to produce a premultiplied image.

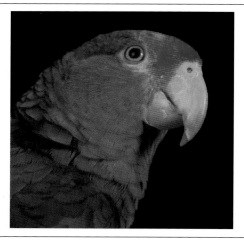

Figure 5.8 Premultiplied image, produced by multiplying Figure 5.1a by Figure 5.6.

As you can see, everywhere that the matte was black (having a digital value of 0), the color channels have become black, or 0. Wherever the matte was a solid white, the color channels are unmodified. Less obviously, in areas where the matte had some

[3] The premultiplied image (as well as a number of the multisource operators that can take advantage of a premultiplied image) was first described in a classic paper that Tom Porter and Tom Duff presented at the 1984 **SIGGRAPH** conference.

intermediate gray value, the corresponding pixels in the RGB image have been darkened by a proportional amount.

The utility of this four-channel image will become more evident as we discuss some additional tools, particularly the "Over" operator, in just a moment. But the bottom line is that we now have a way of representing the attributes of both color *and* transparency in a single image.

Let's extend the notations we use to describe our operators a bit more to reflect this new concept. For any image A,

A_{rgb} = The RGB channels only.
A_a = The alpha, or matte channel, only.
A = All the channels (be there three or more) of the image.

We will also occasionally use "M" whenever we need to denote an image that is used exclusively as a matte channel. Such an image should generally be thought of as a single-channel (grayscale) image.

For instance, since the Add operator we looked at originally behaves the same with either three- or four-channel images, there is no need to mention any specific channels in that particular equation, and it should be obvious that in actuality,

$$O_{rgb} = A_{rgb} + B_{rgb} \quad \text{and} \quad O_a = A_a + B_a$$

Now we have a common language that we can use to discuss some of these concepts, we can finally take a closer look at one of most common tools for selectively combining two images—the Over operator.

Over

If you've done any compositing at all you've almost certainly used the Over operation.[4] But even if you feel you are very familiar with using Over for compositing, it is worth understanding the exact algorithm that is used, since a number of problems can be diagnosed when you are armed with this knowledge.

The Over operator is specifically designed to layer a four-channel image over another image. It is effectively the same as the Keymix operation that we looked at a moment ago, only simplified to take advantage of the integrated matte channel.

Thus, instead of the Keymix equation where the following occurs:

$$O = (A \times M) + [(1 - M) \times B]$$

[4] Although it might not have been labeled as such. Since it is such a standard method for combining images, some packages never even use the term "Over"—it is simply the "Normal" or default behavior for image layering.

We can simplify the first part of the equation (the "A × M") and just use the four-channel premultiplied image instead. In our example, this was already shown to produce the intermediate image shown in Figure 5.8, with the mask still contained in the fourth (alpha) channel. (And in fact the existence of the Over operator is exactly *why* we want to have images in a premultiplied format—it saves us a step when it comes time to composite the image and it makes the image itself more understandable when viewing it—black is assumed to be transparent.)

We're not done with that matte channel yet, however—we also need to invert it (Figure 5.9) and multiply that with the background image. This multiplication effectively produces a new intermediate image with a black hole where the foreground

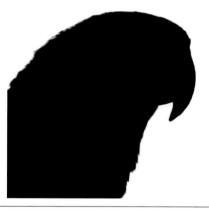

Figure 5.9 Inverted matte image for use in the Over process.

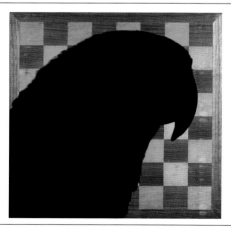

Figure 5.10 Background modified by multiplying by Figure 5.9.

will go (Figure 5.10). To complete the process, these two intermediate images are then added together, creating the final output, which we already saw in Figure 5.7.

This example underscores an important point about most image-combination tools. They are often just a group of even more simple operations applied sequentially. If you find yourself trapped on a desert island with a compositing system that has only a limited number of tools, you will usually be able to recreate a large number of more complex tools as necessary. And in fact you might find it useful to do exactly this with the Over operator as a quick exercise, since it will probably give you a much more intuitive grasp of the tool than equations on a page can.

Writing out the process of our Over operation in equation form with our foreground image being a premultiplied image complete with auxiliary alpha channel, we have:

$$O_{rgb} = A_{rgb} + [(1 - A_a) \times B_{rgb}]$$

Note that the color channels of the output image are independent of the background image's matte. However, the output image's matte channel is composed as follows:

$$O_a = A_a + [(1 - A_a) \times B_a]$$

We could also write the simplified equation for all four channels as

$$O_{rgba} = A_{rgba} + [(1 - A_a) \times B_{rgba}]$$

Everything works quite well here, producing a nice clean composite. But be aware—this only works this well because the Over operator is assuming that you are feeding it a premultiplied image for the foreground. However, if you *don't* use a premultiplied image or if you are working with some other operator that is assuming that your image *isn't* premultiplied, all sort of confusion can result. This will be discussed in much greater detail later in this chapter, as it can be a problematic issue in many compositing situations.

Additional Operators

Many of the additional multisource operators that we'll look at next can also take advantage of images that carry an auxiliary alpha channel. As such, we'll modify our two source images a little bit in order to make things a bit easier to understand. Specifically, we'll be using a premultiplied version of the parrot image so that the color channels will be as shown in Figure 5.8 and the matte channel for that image would be what we showed in Figure 5.6. We'll also reposition the checkerboard a bit relative to the parrot as shown in Figure 5.11a. As expected, the matte channel for the checkerboard would be as indicated in Figure 5.11b. Just to be clear, the result of placing the premultiplied parrot Over the repositioned checkerboard would be as shown in Figure 5.11c.

Figure 5.11a Sample image B repositioned.

Figure 5.11b Matte of repositioned image.

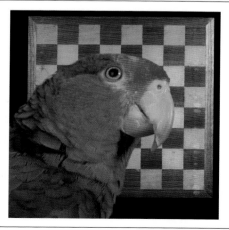

Figure 5.11c Image A over image B.

Multiply

The multiply operator is an extremely simple one—merely multiplying two images together to produce the result. Specifically:

$$O = A \times B$$

It doesn't require integrated matte channels but if they exist they will also be multiplied with each other. Although simple, the Multiply operator isn't really used very often as the effect isn't all that pleasing. Part of the reason is that it tends to produce a rather dark result as shown in Figure 5.12. The reasons for this are obvious if you think about it for a second—assuming we are working with a fixed range 0–1 for each pixel, multiplying two values that are less than one together will produce a value that is even smaller.

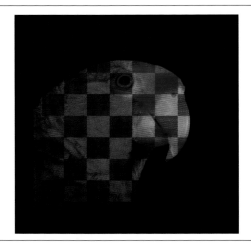

Figure 5.12 Image a multiplied by image B.

It is, however, extremely important as a way of combining images with mattes, as we've already seen. To create a premultiplied image you'll need to be able to multiply color channels with matte channels appropriately and any compositing package will give you a Multiply operator that is capable of doing this. The matte channel that results from multiplying our two source elements together is shown in Figure 5.13.

Screen

The Screen operator also doesn't require any integrated matte channels but gets a lot of use due to the fact that it works very nicely when simulating the effect of adding light to a portion of an image. It is actually still a multiplicative operator, only we perform the additional step of inverting both images before multiplying them together, and we then invert the result. Thus:

$$O = 1 - [(1 - A) \times (1 - B)]$$

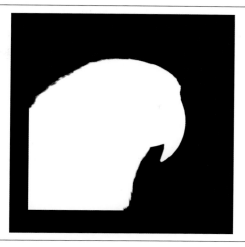

Figure 5.13 Matte channel of Figure 5.12.

Which, unlike the Multiply operator, will produce a result that is lightened in many areas as we can see in Figure 5.14. Dark areas in the background plate are brightened by lighter areas in the foreground image but bright areas in the background image are relatively unaffected by the foreground. (The relative strength of the Screen effect can be controlled by modifying the brightness of either the foreground or the background element prior to combination.)

Figure 5.14 Using the Screen operator to combine image A and B.

In fact, the Screen effect tends to mimic exactly the characteristics of reflections on a shiny but transparent surface such as a piece of glass. You'll find yourself using the

Screen operator constantly to put reflections on building or car windows, for instance. A nice example of this can be put together with the images we used to illustrate the Cornerpin operator in Chapter 4.

Figure 5.15a shows the original example—note how it feels somewhat artificial due to the lack of any kind of reflection on the glass face of the monitor. If, however, we Screen the images together (with an appropriate adjustment to the brightness of

Figure 5.15a Transformed image placed over a background.

Figure 5.15b Transformed image screened with background.

the original monitor reflection) we have a much more satisfying composite (Figure 5.15b). This effect is even more apparent if the image we are adding to the scene has a good amount of darker areas. Figures 5.16a and 5.16b show the same comparison with such an image.

Figure 5.16a Another example—layering without using Screen.

Figure 5.16b Layering elements using the Screen operator.

Maximum and Minimum

The Maximum (or Max) operator will combine two images and give a result that is the maximum of the two source images for each pixel that is being compared. The Minimum (or Min) operator is, obviously, the equivalent in the other direction. Applied to our two source images we can see the effects as shown in Figures 5.17a (Maximum) and 5.17b (Minimum).

Figure 5.17a Maximum of A and B.

Figure 5.17b Minimum of A and B.

They are most useful when you want to combine only the bright or dark areas of one image with another. For instance using a Min to place a dark object over a light one or, as shown in Figure 5.18, adding a bright object to a darker area using the Maximum operator. Max and Min are also often used when combining matte images.

Figure 5.18a A foreground element.

Figure 5.18b A background element.

Figure 5.18c Using Maximum to combine the two elements.

In

There are certain multisource operations that require *only* a matte image for the second input. (The matte image can either be a single-channel image or the alpha channel of a four-channel image.) The In operation is one of these. As you can see from the equation, it pays no attention to the color channels in the second image, even if it is a four-channel image:

$$O = A \times B_a$$

When we describe the use of the In operator, we usually say we are placing image A *in* image B; the result is an image that consists of only the areas in image A that overlapped with the matte of image B. An example of this is shown in Figure 5.19. On the left, we see our foreground In the background, and on the right is our background In the matte of the foreground.

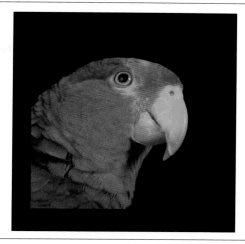

Figure 5.19a A In B.

Figure 5.19b B In A.

Out

The Out operation is the inverse of the In operation—it results in a new image that consists only of pixels from image A that did not overlap the matte of image B. We say that we're looking at A "outside of "B."

$$O = A \times (1 = B_a)$$

This is illustrated in Figure 5.20—the parrot outside of the checkerboard's matte on the left and the checkerboard outside of the parrot's matte on the right.

Figure 5.20a A Outside of B.

Figure 5.20b B Outside of A.

Atop

As mentioned, many image-combination tools can be used in tandem to produce new tools. Most of these combinations are given different names by different software vendors, so we will not attempt to list them all. But to give an example, we show a fairly common one, usually referred to as an Atop operator. It places a foreground Over a

background, but only in the area where the background has a matte. We say we are placing the foreground "Atop" the background.

O = (A In B) Over B

Figure 5.21 shows the parrot Atop the checkerboard on the left and the checkerboard Atop the parrot on the right.

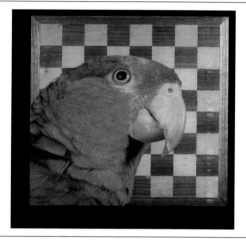

Figure 5.21a A Atop B.

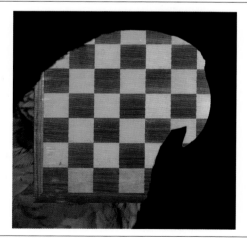

Figure 5.21b B Atop A.

Although most of these image-combination operators are really just very simple mathematical calculations that work with images and mattes, more complex operators

certainly exist. A few additional operators are included in Appendix A. Later in this chapter we'll look at the process of doing a **morph**—a tool that combines the animated warping of two images over time with a controlled dissolve between the two sequences.

Masks

There are times when we wish to limit the extent of a certain operator's effect. A particularly useful method for doing this involves the use of a separate matte as a control image. Whenever a matte is used in this fashion, it is usually referred to as a **mask**. In essence, the use of masking with a single-event operator implies a multisource scenario, with the original sequence as the first source and the mask as the second. Just about any operator should be something that can be controlled by an external mask, and so we'll look at a fairly simple example.

Consider the matte image shown in Figure 5.22. Let's say we wish to decrease the saturation of our original parrot image, but we want to limit that attenuation as a function of this mask. The result of this is shown in Figure 5.23, where we used a saturation value of 0. If we hadn't used a matte to limit this operator, the entire image would have gone to monochrome, but instead the desaturation was only applied where the mask allowed it to be. In the areas where the mask was completely transparent, the resulting pixels remained unchanged. Where the mask was solid, or white, the full

Figure 5.22 A mask image.

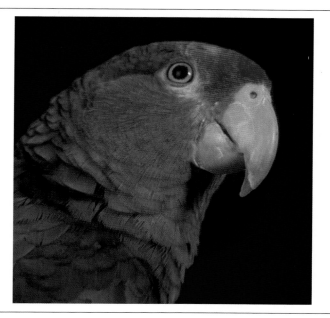

Figure 5.23 Image with saturation controlled by the mask.

attenuation could be applied. In any areas where the mask had intermediate gray values, the desaturation was applied by a proportionally smaller amount.[5]

Although the ability to use a mask to control or limit an operation is something that is available as a built-in capability on any modern compositing system, it is worth remembering that it can also always be accomplished explicitly, using some of the image-combination tools that we have already discussed. You would first apply the effect to the entire frame and then use the mask to isolate the proper area and combine it with the original, unaffected image. And although masks may be treated as "special case" images in some packages, they are ultimately just images and can generally be manipulated with all the same tools that you would use to manipulate any other images.

As we have seen with several previous operations, certain behaviors may be different if you are working in a system that allows for floating-point image representations. In terms of masks, the assumption is usually made that the image is in the range 0–1 as described above. But if you have a mask image that contains areas of, for instance, superwhite (values above 1.0) the results may be surprising. For this reason you may wish to ensure that your masks are explicitly clamped to the range 0–1 before using them to limit an effect.

[5]Depending on the software you are using, the logic of how the mask is used might be reversed—transparent areas of the mask would cause the effect to be applied by a larger amount and vice-versa. Don't be too concerned by this as any compositing package that supports masking will almost certainly provide an easy way to invert either the mask or the logic being used (or both).

Compositing with Premultiplied Images

It is extremely important to understand exactly what type of image (premultiplied or not) your system's compositing operators expect. Some operators assume that they will always be dealing with premultiplied images; others may require the image and matte to be brought in separately so that they can be recombined during the operation in question. If you do not use the proper type of image, you run the risk of introducing a wide variety of unacceptable artifacts.

This can be a great source of confusion, primarily because in certain situations this multiplication step is done automatically but in other situations (or when using different software packages), the process must be dealt with explicitly by the user. In fact, it is safe to say that concepts related to premultiplication (and the ramifications of working with premultiplied images) are some of the most misunderstood issues in the realm of digital compositing. In other words, pay attention here.

Let's look at some different scenarios related to working with premultiplied images. We'll use an example based on the Over operator, but the same problems can show up with other tools as well. The matte in our example is intentionally very soft-edged, since this is the most problematic situation.

Consider Figure 5.24, the image that we will use for our foreground. It features a dog standing in front of a gray wall. Figure 5.25 is a soft-edged matte to extract the dog from the scene. Figure 5.26 shows the background image that we will be using. It features the same wall (shot from an identical camera position), only with a cat standing in front of the wall. You'd be surprised at how often visual effects techniques are used to place two animals (or actors) that can't get along into the same scene.

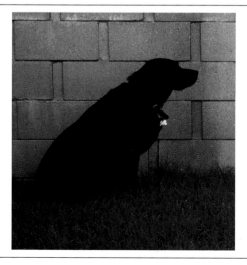

Figure 5.24 A foreground element.

Figure 5.25 A soft-edge matte for the foreground element.

Figure 5.26 A background element.

If we premultiply our foreground image by its matte, the result is shown in Figure 5.27. Now, if this result is placed Over the background in a system that assumes that the images you are providing are all premultiplied, the proper result is obtained, as shown in Figure 5.28. The soft edges blend well with the background and there are no noticeable artifacts.

Figure 5.27 Foreground multiplied by the matte.

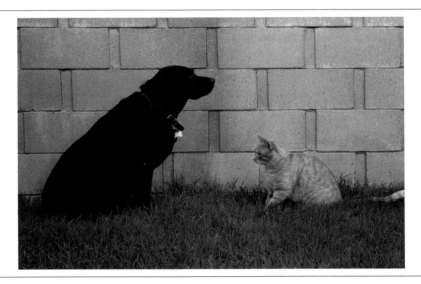

Figure 5.28 Premultiplied image (Figure 5.27) placed over background image (Figure 5.26) in a system that assumes all images are premultiplied.

However, if we combine Figure 5.24 with Figure 5.26 *without* premultiplying the color channels, we have an image that will *not* be handled properly, assuming our Over operator is expecting a premultiplied image. The result of placing such an image over the background is shown in Figure 5.29. Note that the foreground element, in areas where its matte is supposed to be 0, is still contributing to the result. If you were to

check out the math of what is happening, you'd see that in those areas of the result image, it is exactly as if we had simply added the two images together.

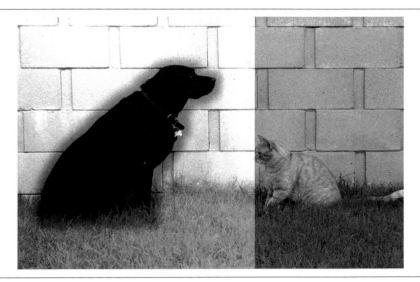

Figure 5.29 Unpremultiplied image (Figure 5.24) placed over the background image (Figure 5.26) in a system that assumes all images are premultiplied.

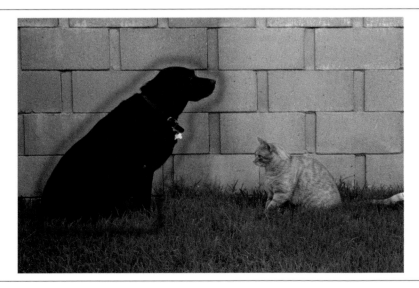

Figure 5.30 A doubly premultiplied image composited over the background. A dark halo is produced along the matte's edge.

Equally damaging problems can occur in the other direction, that is, if we feed premultiplied images to an operator that is expecting to combine the image with the

matte itself. Such an operator will automatically multiply the image by its matte channel, even though this has already been done in a normal premultiplied image. In this situation, we have effectively multiplied the image by its matte channel twice, thereby darkening all areas of soft-edged matte. The result of such a mistake is seen as a dark halo around the foreground, as shown in Figure 5.30. (And in general these clues are quite useful when it comes time to figure out why certain problems are showing up in a composite—edges that seem too bright or too dark are classic signs of a premultiplication problem.)

Although the preceding examples (which featured broad areas of partially transparent matte) resulted in some very obvious problems, we'll take a final quick look at how the problem manifests itself in a composite with a more typical matte. Figure 5.31 shows a portion of the composite from Figure 5.7—on the left we see the correct composite but the image on the right is what we end up with if we have double-premultiplied the foreground before compositing over the background.

Figure 5.31 Premultiplication with the original sample images—proper (single) premultiplication on the left and double-premultiplication on the right.

Even if we have properly synchronized our image types with what the operators are expecting, further image manipulations can also introduce artifacts. One of the more common places these will occur is when we are trying to color correct images that have already been premultiplied.

Color Correcting and Combining Premultiplied Images

Whenever we premultiply an image by a matte, there is a very specific brightness relationship between the pixels in the color channels and the pixels in the matte. Systems that assume you are working with premultiplied images will rely on this image/matte relationship; consequently, the brightness of any color channel can no longer be modified without taking the alpha channel into account (and vice versa). Thus, any time you apply a color correction to a premultiplied image, you run the

risk of producing a new image whose matte/image relationship is no longer "legal." If you look at the math that is used when we premultiply an image by a matte, it should be obvious that the brightness of any given red, green, or blue channel in such an image can never exceed the value of the alpha channel. This can sometimes be used as an indicator that there has been some kind of operation performed on the image after the premultiply occurred. The result of compositing with this image will vary, depending on the extent of the change made to the different channels, but generally it will manifest itself as a slight brightening or darkening of the composite in areas where the foreground matte was semitransparent. More extreme changes to the color or matte channels will obviously result in more extreme artifacts.

A particularly common problem will occur when some color correction has been applied to a premultiplied foreground image that causes the blacks in the scene to be elevated above a value of 0. Now, even though the matte channel may still specify that the surrounding field is black, the RGB channels will have some small, often visually undetectable, value. The problem will show up when one attempts to layer this element over a background. The resultant image will show a noticeable brightening of the background in the area outside the foreground's matte. (An example of this sort of thing is shown in Chapter 13.) As one becomes a more experienced compositing artist, artifacts like this become the clues that let one track down exactly which layer in a composite is causing a problem. In this case, the clue is the fact that the background gets brighter. As you can imagine, it may be very difficult to determine if this problem exists, since at first glance an improperly modified image may appear perfectly correct.

Because inevitably you will find yourself with the need to color correct premultiplied images, there is usually a tool on most systems to temporarily undo the premultiplication, at least in the critical areas of the image. We will refer to this tool by the rather

Figure 5.32 The result of redividing a premultiplied image (Figure 5.27) by its own matte channel.

unwieldy name of "Unpremultiply." Essentially, the tool redivides the image by its own matte channel, which has the effect (except in areas where the matte is solid black, or 0) of boosting the areas that were attenuated by a partially transparent matte back to approximately their original values. An example of this is shown in Figure 5.32, which is the premultiplied image from Figure 5.27 after redividing by its matte. (Areas where the matte was equal to 0 have been set to be pure white.) Although this is obviously not a completely perfect recreation of the original image, it restores enough information in the edges so that appropriate color corrections can be applied.

If your system does not have an explicit tool to perform this operation, you can try using some other tool to simulate it. For example, if there is a simple expression language available, you can modify the image so that

```
Red = Red/Matte
Green = Green/Matte
Blue = Blue/Matte
```

Once the image has been unpremultiplied, any necessary color corrections can be applied without fear of corrupting any semitransparent areas. The result should then be remultiplied by the original matte channel, which will restore the element to one whose image-to-matte relationship is correct.

For slight color corrections, or when using images that have very hard-edged mattes, you may get perfectly acceptable results without going through this process. As usual, use your best judgment (and, as always, if it looks correct, then by definition it *is* correct). But if there is any doubt in your mind, or if you are having problematic edges, you may want to take a moment and compare the results of performing your color correction before and after the image is multiplied by the matte.

By default, all the major 3D packages will render elements that have been premultiplied by their matte channel. As we've seen, this is not always the ideal scenario and in many situations may actually be counterproductive. Assuming that the 3D element is perfectly ready for integration into the scene, having it delivered already premultiplied by its matte channel will be fine. But often this isn't the case. You may want to determine if there is some way to override this premultiplication behavior in the 3D package, so that you can have unpremultiplied images available for your compositing work. This ability will be particularly important if you are in a situation in which you will be performing a good deal of color correction on the 3D element.

There are also some compositing packages that attempt to insulate the user from needing to deal with whether or not an image is premultiplied. The term "attempt" is used intentionally here, as it is not uncommon for there to be situations where such systems still don't do the proper thing and may even leave the user without the necessary tools to fix the issues. Most experienced compositors like to have the ability to override any default behaviors should the need arise.

Luminosity and the Image–Matte Relationship

When working with four-channel premultiplied images and using the Over operator, there is an additional effect that can sometimes be useful. It involves selectively manipulating the alpha channel of the image to *intentionally* modify the image-to-matte relationship. This operator is often referred to as a "Luminosity" tool.[6] By decreasing the value of the alpha channel before placing an object over a background, the object will appear to become brighter in the result. In addition, the background will become more visible through the foreground element.

An example of this effect is shown in Figure 5.33. In this case, the matte channel for the foreground image was multiplied by 0.6 before being placed over the background. In fact, as the matte channel is decreased towards 0, the result becomes more and more like an Add operation instead of an Over. This can be proven by examining the equation for Over again. If the matte of the foreground object in a premultiplied image is set to 0, the Over operator will produce the same results as an Add.

Figure 5.33 The matte channel of the premultiplied foreground image was multiplied by 0.6 prior to compositing over the background.

[6] The other common name for this on many systems is the "Opacity" operator, even though this name is less descriptive of the visual result this tool produces.

Having a specific operator for this sort of effect is less important than understanding the principles behind it. Selective manipulation of the image-to-matte relationship when layering images together can be used to deal with any number of situations. It is not uncommon to modify the matte channel slightly to affect the brightness of

Figure 5.34 A source foreground image (and its matte channel) for illustrating Addmix.

Figure 5.35 Several Addmix variations.

a partially transparent edge—helping to better integrate wisps of blonde hair into a bright background, for instance. Many systems will provide an operator (often known as an "Addmix") that contains special lookup curves for modifying the image-to-matte relationship in areas where the matte is partially transparent. Figure 5.35 shows a series of images where a glowing "orb" is placed into a scene. (Figure 5.34 shows the original element and its matte channel). All the variations in Figure 5.35 were produced by manipulations in the Addmix operator.

Morphing

In Chapter 4 we briefly looked at tools that can be used to warp, or distort, an image. Earlier in this chapter we covered some image-combination tools that can be used to dissolve between two different images over a period of time. Although both of those processes are used quite often by themselves, there is also a combination process that uses both techniques to implement a very specialized transition between two different images. This process is known as **morphing**.

Morphing, in theory, is really quite simple, although the process of creating a good morph can be very time-consuming. It is essentially a two-step process, though the steps will not necessarily occur sequentially. Morphing is considered a specialized transition not only because of the complexity of the tools that are used, but also because it really only works effectively if the two elements that are involved in the transition have some reasonably similar characteristics in common. It was developed, and is still primarily used, as a method to make it appear as if one object were physically transforming into another.

The first step in the process is to identify which key features in the first element will correspond to features in the second. Consider the example images shown in Figures 5.36 and 5.37. Let's attempt the classic morph scenario, in which we wish to make the monkey appear to transform into the lion over a series of frames. For the first step of the morph, warping tools are used to generate two new sequences of images. The first sequence consists of the monkey being warped over a period of time so that its shape is as close as possible to the second image. Selected frames from such a sequence are shown in Figure 5.38. At the same time, a second sequence (of equal length) is generated that consists of the second image being warped so that it ends up looking as much as possible like the first image. Note that we are attempting to synchronize key features, such as the eyes and the mouth, as well as the overall shape of the two objects. Once these two new sequences are generated, the second sequence is reversed, so that it starts with an image that is distorted to match with the original plate of the first. This sequence is shown in Figure 5.39. As you can see, the lion at the beginning of the sequence has been warped to look as much as possible like the monkey and the monkey sequence ends up with the monkey being warped to fit to the features of the lion.

Figure 5.36 Morph example source image.

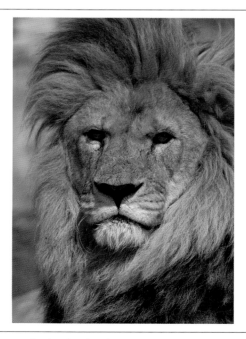

Figure 5.37 Morph example destination image.

Now that we have the two sequences, the final step is to simply dissolve between the two over a period of time. If everything works correctly, the result should be a visually pleasing transition between the two. Although the fully warped images shown in Figures 5.38 and 5.39 do not look particularly attractive by themselves, the dissolve transition will, one hopes, cause these excessively distorted images to be mostly obscured by their less-distorted counterparts. Selected frames from the final morph transition are shown in Figure 5.40.

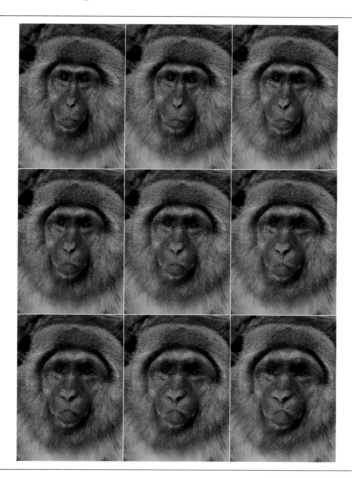

Figure 5.38 A sequence of images showing the morph source image warping over time to match the destination image.

In reality, the dissolve step is usually more than just a uniform mix between the two plates. Rather, the same controls that are used to define the warp parameters can also be used to selectively dissolve different areas of the image at different times. Thus, the dissolve for the eyes might occur early on in the morph, while the mouth from the second plate might not be revealed until the end of the morph. Figure 5.41 shows

Figure 5.39 Morph destination image warped to match the source.

a side-by-side comparison of the same frame in the morph sequence only in the second instance we have chosen to dissolve the nose/snout area earlier. The reasons for doing this are generally artistic (although at times it can also be useful to hide warping flaws)—having more variety in the timing of different dissolves will feel much more organic and pleasing.

Of course if we were doing a "real" morph (i.e., for a paying client), we would almost certainly want to isolate the effect so that it was only occurring on the animals, and *not* showing any transition in the background. For this reason most pure morphs of this sort are shot on bluescreen in order to make it easier to isolate that background.

The other huge difference between the morph we have just shown and one that you would tend to find outside of a book is that we have only shown the process being done on two *still* images. In reality you would be dealing with moving footage and so

Figure 5.40 The final morph transition between the two elements.

the alignment of the warps would need to take this into account. This extends back, again, to the shooting of the original plates. Morphs between two humans aren't too bad because the actors can be directed to move in a synchronized fashion. But a morph such as this one could prove to be quite a challenge for the cinematographer who is trying to capture two animals that are posed and moving similarly.

Although this example is a very typical use of morphing technology, many of the morphs being done today are not nearly as noticeable. For instance, a morph can be used to transition from a famous actor to his stunt double just before a dangerous stunt occurs, giving the impression that the actor performed the stunt instead of the double. These "hidden morphs" are extremely common—most morphs being done today, at least in high-end work, are of this less explicit type.

Figure 5.41 Morph comparison frame with different dissolve timing in parts of the image.

There are a number of additional factors to consider when creating a morph, but the process is primarily one of careful attention to timing and detail. Very few elements will have correspondence points that are completely obvious, and most morphs will require additional compositing or paint work to produce a perfect result. It should also be reiterated that the warping process is prone to a number of different artifacts—motion blur and lack of resolution must both be kept in mind.

Matte Creation and Manipulation

In the last chapter, we introduced the concept of a matte image and gave some examples to show what an important role these images play in the digital compositing process. But unlike most other images that you will be dealing with when compositing elements together, matte images are not scanned into the computer from some outside source. Rather, they are almost always generated *within* the computer, often as a part of the compositing process. There are many different methods used to generate mattes for compositing, just as there are many ways that a matte image can be used. As mentioned, 3D rendering software will almost always be set up to produce a corresponding matte channel for the image that is being generated. But for all other images, the compositing artist will generally be tasked with the creation of an appropriate matte.

The process of generating a matte for an object is referred to by a variety of terms, reflecting the fact that it is a constant and ubiquitous part of the compositing process. You may simply "create a mask" for an object or "extract" the object from an existing scene. If the process you are using is largely procedural, you tend to hear terms such as **pulling a matte**, and **keying**.

"Keying" is actually a broader term, in that it is often used not only to describe the process of creating a matte but also to include the process of combining one element with another. Thus, you might "key" a bluescreen element over a background.

There is also a historical basis for the dual terminology—the term "matte" came out of the film/optical world and "key" comes via video. As the two disciplines have effectively grown together into a single set of technologies, we'll use whichever term is most common for the scenario being described.

An example of a situation that would require a very simple matte would be a split-screen composite. This is a situation in which (for example) the left half of the image

comes from one source and the right half of the image from another. The matte would be a fairly simple shape that defines the boundaries of the split—often just a straight line that separates one plate from another. Such a matte is easily created using simple paint or shape-generation software.

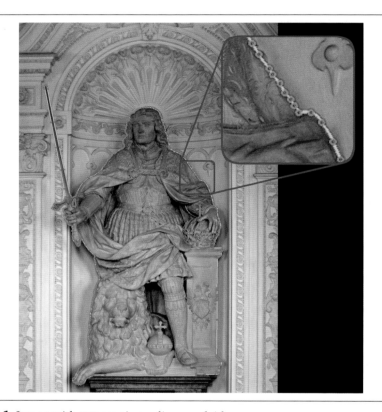

Figure 6.1 Image with rotoscoping spline overlaid.

More often, however, we need to place an object whose outline is much more complicated into a scene. We need a matte that accurately represents the boundaries or outline of the object and that fully encloses all solid areas of the object's interior. Typically we'd generate such a matte via the use of some kind of spline-based shape generator. An example of this is shown in Figure 6.1, where the statue that we want to extract from the background has been indicated by the hand-drawn spline[1] that is overlaid on that image. As you can see in the enlarged view, the spline is defined by a fairly large number of points in order to accurately reflect the boundaries of the object we wish to extract. The matte that is generated with this spline is shown in Figure 6.2.

[1] The shape itself is controlled by the individual points that define it, known variously as **control points**, **control vertices**, or simply **CV**s. There are a variety of different flavors of splines that may be used in the process of matte generation but the general concepts remain the same no matter which you are using.

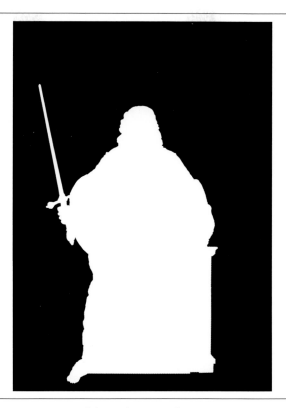

Figure 6.2 Matte image generated from the rotosplines.

It is also conceivable that such a static matte could be created via some sort of digital paint tool. But even with an unmoving subject it can be difficult to accurately draw or paint something that properly captures the desired edge qualities (such as transparency and softness) of a given object. As such, it is often useful to employ certain software algorithms, discussed later in this chapter, to help isolate an image from its background.

When compositing sequences of images, situations involving static mattes are fairly rare. Far more often we find the need to create a matte for an object that is moving within or through the frame. We require the use of a moving matte, or **traveling matte**. There are two approaches we can take to generate these mattes. The first would continue the methods we've talked about already, that is, hand-drawing a matte for the object in question but doing so over every frame of our sequence. This process, known as **rotoscoping**,[2] is still employed quite frequently, although rarely as a completely frame-by-frame operation.

[2] The rotoscope was a device patented in 1917 by Max Fleischer to aid in cel animation. The term is now used generically to refer to the process of creating imagery or mattes by hand on a frame-by-frame basis.

Ideally we will be able to take advantage of techniques that are more procedural in nature—semiautomated processes in which some initial parameters are determined that are capable of extracting a matte, and then the software is allowed to apply these same parameters over a sequence of images.

Rotoscoping

Rotoscoping is often one of the first jobs that an aspiring digital compositor will be given when taking a position at an established visual-effects company. Although it is not generally looked upon as the most glamorous of work, the fact of the matter is that it is an extremely important part of the production pipeline and is often the key factor in the success or failure of any given shot. If you are a novice compositor who is hoping to obtain a paying job in this industry, getting familiar with the techniques of good rotoscoping may be the single most important step you can take (second only to buy a copy of this book, of course).

Although the term "rotoscoping" was originally used to describe a workflow that needed to occur on every single frame of a sequence, it has since evolved to be a more general description of a process that includes procedural or algorithmic assistance wherever possible. More specifically, it typically refers to the process of creating a matte image for a specific object in a scene by defining a spline shape at certain key-frames of the image sequence and allowing the software to **interpolate** that shape for the intermediate frames.

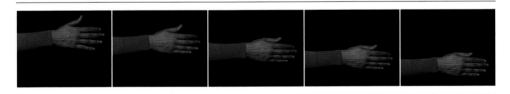

Figure 6.3 Image sequence—an object moving across frame.

Consider the image sequence shown in Figure 6.3. We have an image that moves across the field of view over the course of several frames. Let's go ahead and create a single **rotoshape** for frame 1 of this sequence—Figure 6.4 shows us this frame with our rotoshape spline overlaid on top of the original image and Figure 6.5 shows the actual matte image that this spline will generate.

Now let's move to the last frame and move all the points of our spline to the appropriate locations in order to define this new position as shown in Figure 6.6. Note that we're not drawing a new spline, we're moving all the points of the original one so that they all have a new *position* at this point in time. By doing this, the software we are using will now be able to interpolate the spline's position on intermediate frames. Let's see how well this is working by taking a look at a frame halfway through the

Figure 6.4 The first frame of Figure 6.3 with overlaid spline.

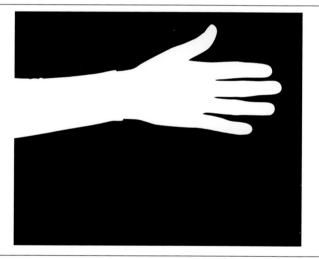

Figure 6.5 Matte image generated from the rotospline.

sequence and see how well the interpolate spline fits—Figure 6.7 shows this. As you can see, the fit is rather imprecise, due to the fact that the hand didn't actually move at a constant speed between the first and last frame. Additionally, the outline of the hand itself changed—the fingers and forearm were all moving by different amounts relative to the rest of the hand. These are all typical situations, and most rotoscoping work will feature far more movement than what we're looking at here.

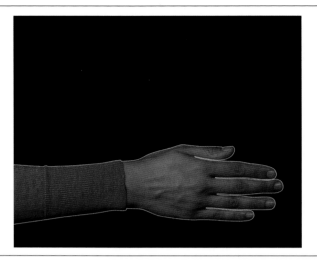

Figure 6.6 Last frame of the sequence with overlaid spline.

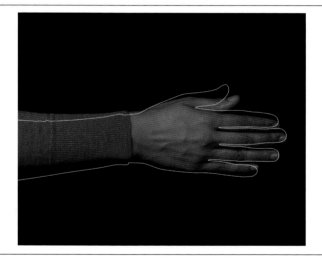

Figure 6.7 Middle frame of the sequence with the interpolated rotospline overlaid.

But the solution is simple—we'll start to refine our animated shape by manually adjusting the spline on this intermediate frame as well. As soon as we do this, the interpolation changes and the fit for other frames where we *haven't* set a specific keyframe will still become more accurate. We continue this process, iteratively looking at other frames that are halfway between any two keyframes until we have a moving shape that accurately reflects the image we're matching to. Note that we generally won't be doing this work on *every* frame (hopefully not!) but rather only on enough frames to get a matte that fits properly. If this scenario featured a shot of a more typical length—dozens or hundreds

of frames long—the movement of the object between individual frames would be slight and the interpolated shapes would be much more accurate. You would find that on many frames only a few of the control points would need to be modified rather than every point on the shape and in fact on many frames there might be no additional refinement necessary whatsoever. This is exactly the point of interpolated rotoshapes— trying to minimize the amount of human effort necessary to get an acceptable result.

Techniques

Deciding how to approach a particular rotoscoping job is a self-contained challenge in its own right—different types of footage will dictate different approaches. Generally you'll want to make sure you look at the entire sequence first and think about exactly how your spline(s) will need to evolve over the course of that sequence. Are there overlapping objects that will require separate splines? Is the object that you are extracting obscured at times (and if so, do you need to generate a separate mask for the obscuring object?)

Figure 6.8 A figure walking.

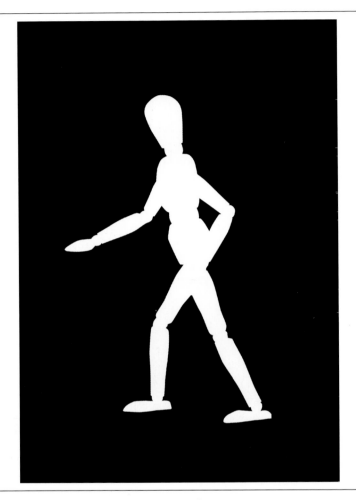

Figure 6.9 A rotoscoped matte for the walking figure.

Consider Figure 6.8, an image where our subject is posed in such a way that a portion of the arm overlaps with the body. If all we need to do is to create a matte for this single image (as we see in Figure 6.9), we might easily generate a shape like that shown in Figure 6.10. But what happens if we're dealing with a sequence of images where, as the figure walks, the arms will swing back and forth, not always overlapping the body in the same way. The rotoshaped "hole" formed by the elbow and body doesn't easily transform into something useful once the character moves. Better, then, would be to create a shape that acknowledges the existence of the figure's arms and legs as separate entities. There are different geometries that can accomplish this but often it is easiest to just create separate shapes for individual "objects" (even if they are somehow attached) and move them separately.

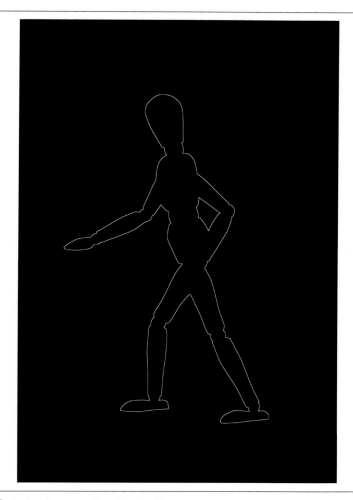

Figure 6.10 A simple rotospline for the figure.

An example of this is shown in Figure 6.11, where we have two shapes, one for the body and another for the arm. The rendered image will still give the same result (what we saw in Figure 6.9) but this configuration is much easier to deal with once we start moving splines about. Most good rotoscoping tools, for instance, will allow you to manipulate the arm as a separate entity, rotating it at the shoulder until it is in approximately the correct location before manipulating individual points. (And of course for those times where two objects do overlap, you needn't be at all exact for any area that is already covered by another rotoshape.) Some roto packages will go even further, allowing for hierarchies of objects in a sort of mini-animation scenario. Thus the body could be moved and the arms, which are parented to it, will come along but they can also still be manipulated independently.

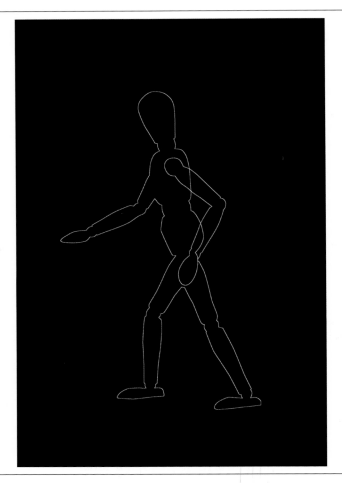

Figure 6.11 Multiple rotosplines that separate moving elements.

The overall rotoscoping process may also change based on the amount and type of movement in the subject. In our original example above we did the first frame, then the last, and then refined the "interior" frames as necessary. But this only worked well because of the fairly linear nature of the movement and the fact that the hand really didn't change its position all that much over time.

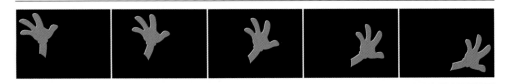

Figure 6.12 Image sequence of simplified hand moving.

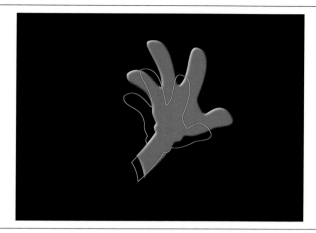

Figure 6.13 The middle frame of the sequence and the interpolated rotospline.

To better understand the issues with this, take a look at Figure 6.12, a simplified version of our original example. In this situation, where the hand rotates significantly over time, the same process wouldn't work quite as well. If we roto (yes, the term has become a verb in our industry) a shape for the first and last frames of this sequence and then look at the halfway point (Figure 6.13), we'll notice something strange—the shape is noticeably smaller than the actual footage requires. What's happened here? Although it might not be intuitive at first, it turns out that the software has done exactly what it always does—it has interpolated the halfway location for each point. We can confirm this by drawing a few lines to check our sanity, as shown in Figure 6.14.

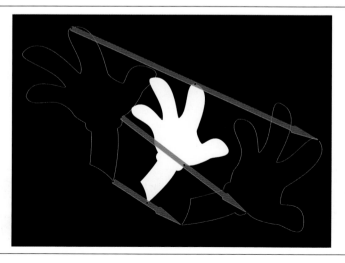

Figure 6.14 Illustration of why the spline doesn't fit with simple interpolation.

Although your rotoscoping software may include some higher-level tools that allow you to apply transformations to individual shapes as whole entities instead of individual points (something that can indeed be extremely useful in many cases) the bottom line is that it is often more effective, particularly when rotoscoping objects that are moving in a more organic fashion, to start at the beginning of the sequence and then move forward at well-defined intervals instead. For instance, for a 120-frame sequence, you might start at frame 1, then move to frame 20, then to frame 40, and then continue in 20-frame increments until you reach the end of the sequence. Then you can go back to refine as necessary, probably looking at every 10th frame in the sequence and then every 5th, etc.

You may also find it more efficient to do the initial first pass through the sequence using a fairly small number of points and then refine as necessary. There is often a delicate balance between how much detail to put into a spline when you start versus how much you'll have to spend modifying things as you refine. And, as always, many of these decisions will also be driven by the specific tools that you are using. Some packages, for instance, allow you to have a different number of control points on your spline over a period of time, other packages won't allow for this. This will definitely affect how you work, particularly if you have an object whose outline varies in complexity over the length of the sequence. In such a case you would ideally only have a small number of points when the shape is simple but could then move to a larger number of points as it grows more detailed.

Look at the "sequence" shown in Figure 6.15a and 6.15b, where the shape could be represented with far fewer points in the beginning than at the end. If we are forced to use an equivalent number of control points throughout, the density at the first frame will be much greater (and thus the work will be more time-consuming). Figure 6.16a shows a rotoshape for 6.15a that is being forced to use the same number of points as is needed in Figure 6.16b.

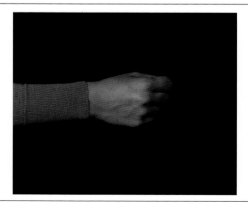

Figure 6.15a An object with a simple outline.

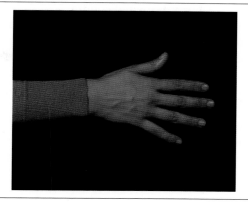

Figure 6.15b An object with a more complex outlilne.

Figure 6.16a Rotospline for Figure 6.15a.

Figure 6.16b Rotospline for Figure 6.15b.

Consistency, in terms of which control points on the spline "attach" to specific areas of the object, is also an important consideration to keep in mind. In Figure 6.17 we've labeled several points on the spline in order to better understand how they change over time (some rotoscoping tools include this sort of capability for just such a purpose). As you can see in Figure 6.18, the points are shifting relative to the hand's geometry—point 1 starts its life on the tip of a finger and ends the sequence in the trough between two fingers. The results of this can be rather tragic—take a look at Figure 6.19 to see exactly what sort of animation results if we try to interpolate between these two states!

Figure 6.17 Spline for first frame of the sequence with numbered points.

Figure 6.18 End frame with numbered points again—points don't correspond with the same locations as in Figure 6.17.

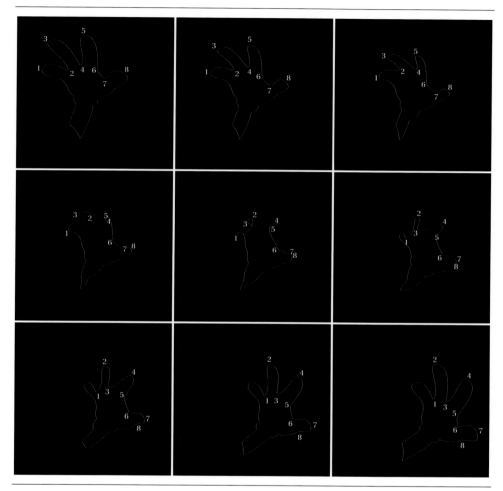

Figure 6.19 Automatic interpolation between Figures 6.17 and 6.18.

This might seem to be an obvious and simple problem to avoid (and in this particular example it probably is) but with a real-world scenario where objects that are far more complex are changing far more dramatically over far greater periods of time, things can quickly grow confusing.

Motion Blur

One of the most difficult things to deal with when rotoscoping to produce a matte for a moving object is the motion blur that may be present. In the real world this motion blur is effectively seen by the camera as an area of transparency since the background behind the object was obscured for only a portion of the image capture time. Figure 6.20 shows an example of this—the moving hand reveals the dark background behind

it. And thus when the subject is moving fast enough (or the camera's shutter is slow enough) to produce a noticeable motion blur on the object, your rotoscoped matte will need to reflect this.

Figure 6.20 Object with motion blur (over a featureless background).

There are a few different methods to achieve this. Some rotoscoping tools will allow you to explicitly define a soft edge for the shape, either uniformly (which isn't particularly useful in this case) or on a per-point basis. This method will at least give the artist the ability to manually introduce some kind of soft edge that attempts to emulate what the image is showing.

An even more convenient solution (although it's best to have both) is having the capability built into your rotoscoping tool to automatically compute an appropriate amount of motion blur based on the movement of the shape. Figure 6.21a and 6.21b shows two frames from a sequence. Figure 6.22 shows a motion-blurred matte

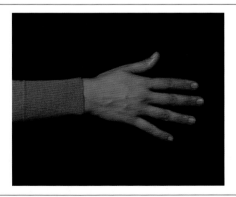

Figure 6.21a Example for motion blur—start frame.

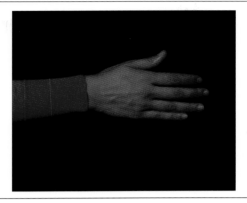

Figure 6.21b Example for motion blur—end frame.

Figure 6.22 Rotoshape with rendered motion blur.

that was automatically generated for an intermediate frame after rotoscoping the sequence. Note that this effect is much different than the overall motion blur you might be able to achieve using a simple transformation operator—the blur here is very specific to the movement of the object itself.

If we have a motion-blurred object over a reasonably neutral background, it's fairly easy to use our blurred rotoshape to extract that object. It becomes much more difficult, however, if the blurred object is over some background with a lot of detail. Figure 6.23 shows such a scenario—any soft-edged matte that includes the area of motion blur will also include some detail from the background of the scene.

Figure 6.23 Motion-blurred object over a complex background.

Limitations

Rotoscoping is usually *not* considered a generalized solution to the problem of how to generate a mask for an object in a scene, primarily due to the variety of situations that it is unable to address effectively. The issue of partial transparency we've just discussed is one problem. Another is the fact that it is nearly impossible to use a spline-based rotoshape to isolate extremely fine detail such as hair or fur—the number of shapes or control points needed would quickly become prohibitive.

Additionally, although most people are capable of creating a shape that does a reasonably good job of isolating an object on a single frame, a variety of problems will become visible when looking at the results across a sequence of frames, where slight discrepancies in spline placement can suddenly be visible as areas that flicker or "crawl."

Finally, of course, there is a significant manpower cost to rotoscoping. Many hours can be spent extracting a matte for an object using these techniques (objects that move or change shape a great deal may end up needing a key defined for nearly every frame, for instance) and, as mentioned, the results may still be less than desirable.

Given the fact that rotoscoping techniques are not well suited to all these situations, an additional set of tools have evolved that are better targeted to these problems. Tools that are more procedural in nature and that use the actual content of the image to drive their results.

Procedural Matte Extraction

We will briefly touch on a number of different methods that may be employed to procedurally extract a traveling matte from a sequence of images. The efficacy of these methods is highly dependent on the image in question, and often you will find

it necessary to try a number of different tools before obtaining a result that you are happy with.

The best methods of extracting a matte for an object rely on the fact that we (usually) know in advance that we are planning to place the object in question into a different scene. Consequently, we can choose to photograph this subject in a manner that greatly simplifies its matte extraction. Typically, this involves the use of a special background that is placed behind the subject we wish to isolate. This background (or **backing**) should be a uniform color, ideally a color that is not significantly present in the subject itself. The exact choice of what color to use will be determined by the extraction technique that will be employed, but historically the most common color (and the one about which the process was effectively formalized) was blue. Thus, the process of shooting in front of any colored background is sometimes generically known as **blue-screen photography**. Not all of the extraction tools we will discuss rely on a uniform backing, however, and many of them can be used to help extract mattes for objects that were not shot with any special attention or intentions. We will look at these tools first.

Keying Based on Luminance

One of the most common methods used to extract a matte for a given item is based on manipulating the luminance values in a scene. This is usually known as **luma-keying**[3] and involves the application of some basic image-processing operators to choose the luminance values that one wants to include or exclude from the matte.

The technique is generally most useful when the feature you wish to extract from the scene is significantly brighter or darker than the background from which you wish to separate it. The ideal case would be a bright object shot over a black background, but you'll find that there are often situations in which the brightness difference between foreground and background is enough to extract a decent matte.

Consider Figure 6.24, simply converting this to a monochrome image (Figure 6.25) will give us a single channel that could conceivably be used as a matte directly. However this would cause any areas that weren't bright white to be partially transparent once we did the composite (Figure 6.26) and that's probably not what we're looking for. You can also see that the dark background behind the skull in the original image is still showing up in the composite as well.

What we really want is to use something that gives us more control over which luminance values in our monochrome image are pushed to white and which values are pushed towards black. Most compositing packages have tools that are specifically designed for creating lumakeys, although even a simple contrast adjustment on the original monochrome image (an example is shown in Figure 6.27) is often just as effective.

[3] The terms "luma-keying" and "chroma-keying" (which we'll look at in a minute) both come from the world of video, where color video signals were already separated into discrete luminance and chrominance components.

Figure 6.24 Object in front of a dark background.

Figure 6.25 Luminance of Figure 6.24.

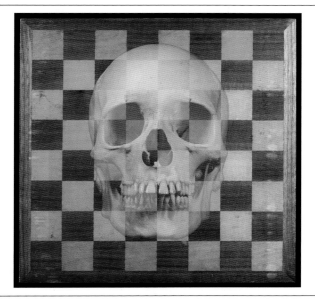

Figure 6.26 Using matte from 6.25 to composite Figure 6.24 over a background.

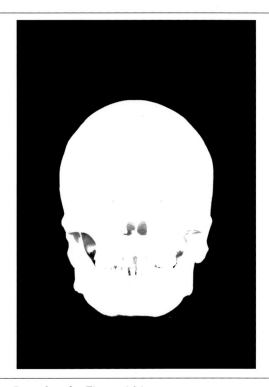

Figure 6.27 A better Lumakey for Figure 6.24.

As you can see, we now have something that could easily be used as a crude matte, and additional digital manipulations could continue to refine the result. When we use this new matte to layer the two images together (Figure 6.28) the skull now appears to be much more solid. It is obviously far from perfect—no distinction is possible between areas that should be considered transparent and those that should merely be considered black, for instance—and at this point we'd really probably want to make use of an interior **garbage matte**, which we will discuss in a moment.

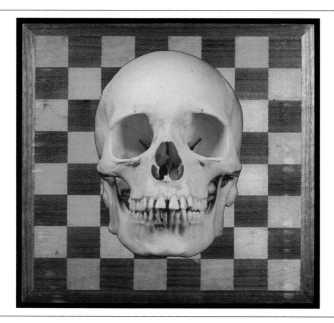

Figure 6.28 Using matte from Figure 6.27 to composite over a background.

Keying Based on Chrominance

Chroma-keying is a bit more sophisticated, but it still makes use of some of the basic tools that we discussed in Chapter 4. In the case of a simple chroma-keyer, the process is to pick a certain range of colors or hues and to define only the pixels that fall within this range as being part of the background. Generally, a good chroma-keyer will have additional tools that let you specify not only a specific hue range, but also a particular saturation and luminance range to further control the matte.

Consider Figure 6.29, the sky, although it contains a fair amount of tonal variations, is a reasonably unique color relative to the rest of the image. A chromakey generated from this sky is shown in Figure 6.30. To better understand the range of values that the Chromakey has selected for this particular matte, look at the colorwheel shown in Figure 6.31a. Applying the same Chromakey tool (with exactly the same settings) to this image will produce the matte shown in Figure 6.31b. You can see that we have

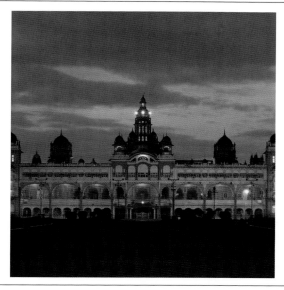

Figure 6.29 Image to be used for chroma-keying.

Figure 6.30 Chroma-keyed matte for sky.

selected blue values with a range of saturations and that there is a "falloff" in all directions, giving us a softer edge in areas of color transition. (Although the color-wheel only allows us to show values that vary in Hue and Saturation, there was also a limited range of brightness values that were chosen to get the key we needed.)

Figure 6.31a A sample color image.

Figure 6.31b Matte of selected region of Colorwheel.

As you might imagine, now that we have a tool that is capable of isolating a specific color, we can now look into the most popular procedural matte extraction—an object in front of a bluescreen. Consider Figure 6.32, we now have our subject placed in front of a nice blue background and using a simple chromakey we can easily extract a matte for that object and place it over a new background, as shown in Figure 6.33. The advantage of this method relative to the lumakey that we showed a couple of sections earlier should be obvious in that we can now make a distinction between areas that are dark but still part of the foreground (such as the inside of the nose) and the true background that we wish to remove. On the other hand, in this particular example we also have the issue of the black base that the skull is sitting on—since it isn't blue it, too, will be considered a foreground object and won't be removed by the chromakey process.

Figure 6.32 Bluescreen element.

Figure 6.33 Bluescreen object chroma-keyed over a background.

A good chromakey tool can obviously be used to pull a matte from a bluescreen or a greenscreen, but it is only one method that can be used for doing so. Don't confuse it, for instance, with the color difference methods that we'll discuss later.

The Color Difference Method

One of the most popular (and effective) methods for procedurally generating traveling mattes is known as the **color difference method**. This method was developed and patented in the 1950s by Petro Vlahos as an *optical* matte extraction process, and was first used in a major theatrical production for *Ben Hur* in 1959. The steps used, which involved selectively combining the different color records (or channels, to use digital terminology) of a piece of film to produce the resulting image, can be easily converted into equivalent digital formulas. We will describe the basic steps here so that you can get a better idea of exactly how the technique is applied, but understand that this will be a very simplified version of what can potentially be expanded into a much more complex process.

The first thing that we should mention is that the color difference method is not just a matte-extraction tool. It is actually a combination of steps that includes matte extraction, color correction, and image combination. Although the matte-extraction step will produce a matte that could be used in other situations, the basic definition of the color difference method must include all of the steps to be complete, and so we will describe the entire process in this section.

Assume we are working with an image shot on a blue background. The first step in the color difference method involves the creation of a new image in which this blue backing is suppressed to black. This is done by selectively substituting the green channel for the blue channel in every pixel in which the existing blue component has a greater intensity than the green component. In other words, for each pixel,

>**If** Blue > Green
>**then** New Blue = Green
>**else** New Blue = Blue.

An example of this process is shown below. Figure 6.32 from last section is our original bluescreen element, and Figure 6.34 is the result after applying the operation we've just described. Since the green channel should have a value of 0 in areas of pure blue backing, the primary result of this substitution is an image in which the blue background has gone to black. Additionally (and in some ways more importantly) anything in the foreground that has a heavy blue component (i.e., blue or magenta areas) will also be modified. Although this effect is a problem if there is any blue coloration in the foreground that we wish to keep, it is primarily a benefit in that it will neutralize any blue spill—blue lighting from the backing that has inadvertently fallen onto the foreground. This step, known as "spill suppression," is usually applied with a few more parameters than we have just described. Additional thresholds are added so that there is control over exactly how much blue is removed and to compensate for any change in

brightness that the channel substitutions might cause. The use of spill suppression to better integrate an object into a scene will be discussed again in Chapter 13.

Figure 6.34 Color Difference Spill Suppression step.

The second step in the color difference method involves the creation of the matte itself. This is simply a matter of subtracting the maximum of the red or the green component from the blue component. It is this difference between the blue channel and the other channels that gives the technique its name. To restate the step mathematically:

Matte = Blue − Maximum(Green, Red)

This operation will actually produce what we would normally think of as an inverted matte—the foreground area is black and the background area is white. This result is shown in Figure 6.35.

We now simply multiply this inverted matte with our intended background—a step that results in a background with a black hole in the shape of our foreground element. The final step would be to add our modified foreground to this intermediate background, producing an integrated result. As you can see, the final steps of this process are identical to the way that the Over operator works.

Figure 6.35 Color Difference Matte Creation step.

Of course, the steps described are merely a basic template for the process. If you were to apply these exact steps to any given bluescreen image, the chances are high that you would not be terribly happy with the result. Even in our example image, which features an extraordinarily good bluescreen, you'll note the matte created in Figure 6.35 is less than perfect—the areas that should theoretically be pure white are only about 70% white. In practice you would want to have additional control over the various steps as they are being applied in order to deal with such issues. You would adjust the relationships between the channels, thresholding certain values and multiplying others, until a visually acceptable result is obtained for the final composite. This type of control is exactly what a more advanced color difference tool (such as the Ultimatte system, described in the next section) would allow.

The color difference method always involves shooting the foreground object we wish to isolate in front of a uniform-colored backdrop. What's more, this method works best when the backing is a pure primary (red, green, or blue) color. Its effectiveness is greatly reduced if the backing is less pure. Chroma-keying tools have an advantage in this respect, in that they are not biased towards any particular hue. If you are

confronted with an image that has an off-color background, these tools may be a better choice. Having said that, you may find in certain situations that pre-correcting your background color before attempting to extract a matte can prove beneficial—adjusting (for example) an odd shade of green so that it becomes more "pure." (Keep in mind that this doesn't mean you must then use the color-corrected image for the actual composite—this would only be done in order to get a better matte image.) This trick is usually of limited value, however, as anything that moves the color of your background towards a specific hue will probably also move your subject towards that same hue, leaving you with colors in the foreground that are difficult to extract due to their similarity with the background color.

Incidentally, because the color difference method relies on the *relative* values of the channels for keying, it may sometimes be more forgiving of uneven lighting on the backing. A shadow that falls on a bluescreen will decrease all three values by about the same amount and thus the difference between (in the case of bluescreen) the green and red channels will still be roughly consistent.

In theory this means that the color difference method is better when dealing with unevenly lit screens than a purely color-based keyer such as a chromakey. In practice, given the variety of additional tools that can be brought to bear no matter which tool you are using, it's not really appropriate to give a blanket endorsement to the color difference method to the exclusion of all others when dealing with unevenly lit backings.

As a side note, if you're shooting on film but planning to work and deliver on video, there are some additional things to keep in mind. For non-effects footage you'd normally just set up your telecine to produce an image that "looks good" on video, ignoring the fact that you're almost certainly throwing away some information that was present in the original film negative (which has a much greater latitude than typical video standards allow). This is typically not a problem if all you're concerned with is the final appearance of the footage on video. But if you're transferring blue- or greenscreen footage, you're also presumably going to be pulling a *key* from this footage and the extra information present on the film negative might be extremely useful. Consequently it is often appropriate to transfer the footage slightly differently for these shots, knowing that you can do the final color balancing as part of the compositing process instead. For instance you may want to make sure you're not introducing any extra contrast that would push bright areas to clipped whites or dark areas to pure black. In fact you may even want to transfer with a *decreased* contrast, which can help to bring a larger amount of data from the original negative. Another option that might be useful would be to transfer the footage twice, using the second pass to obtain an image that is better for matte-pulling.[4]

Chapter 12 looks a bit further into some bluescreen/greenscreen issues, particularly from the perspective of why you might choose one color over another.

[4] Be careful with this though—you can't always assume that the **registration** of these two transfers will be completely accurate—and if they're not, your matte won't line up correctly with the "beauty" pass.

Difference Matting

In theory, if you have an image that contains the subject you wish to isolate, and another identically framed image that does not contain the subject, subtracting one from the other will produce an image that consists of information only where the subject was present. This process is known as **difference matting**.

In practice, slight lighting discrepancies, shadows, and grain make the difference between the two images unpredictable and the results less than perfect. Difference matting is thus usually not considered a complete solution, but rather as a very useful first-pass method that can then be cleaned up using other methods. Since a difference matte requires two separate images with the same lighting and camera setups, it is a limited tool, and using it to produce a traveling matte from a sequence of images would require either an unmoving camera or some method of perfectly synchronizing the camera movements between the two plates.

In spite of these limitations, difference matting is an extremely useful tool in certain situations because it can be used to extract a matte from just about any background. Consider the example image shown in Figure 6.36 as compared to Figure 6.37. As you

Figure 6.36 An object in front of a background.

can see, the carving is present in the first image but not the second, yet everything else is identical. If we subtract Figure 6.37 (which is known as a "clean plate") from Figure 6.36, the result is shown in Figure 6.38. While this is by no means a perfect matte, it is not a bad starting point, primarily because the background regions have all gone to black. A bit of additional digital manipulation can now be used to produce something that is more acceptable. Figure 6.39 is a matte generated from such manipulations, and Figure 6.40 uses this matte to place our original object over a new background. This example does a good job of showing both the capabilities and the deficiencies of this method. It should be stressed, too, that this is about as ideal a case as possible, given the fact that it was shot under well-controlled camera and lighting conditions.

Figure 6.37 The Clean Plate version of Figure 6.36.

Specialized Keying Software

Above and beyond the standard matte-extractions techniques described above, there are also a number of custom software tools that are designed explicitly for this purpose. Due to the specialized algorithms they employ, these custom packages can often produce far better results or (something that can be equally important) produce results that are just as good in a much shorter period of time.

Figure 6.38 Basic image subtraction of clean plate from sample image.

Figure 6.39 Difference matte for sample image.

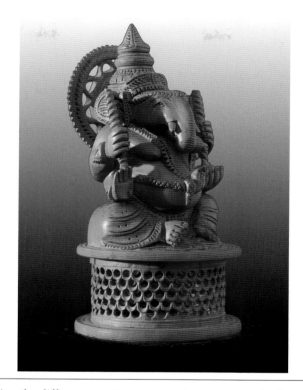

Figure 6.40 Using the difference matte to composite over a new background.

The value of these custom packages lies not only in their excellent matte-extraction tools, but also in the methods they use to integrate an element into a scene. Color correction, spill suppression, and edge treatments can all be dealt with when using these packages. Of the packages in question, one of the best-known is the set of tools provided by the Ultimatte Corporation. Ultimatte was actually founded by Petro Vlahos, the creator of the color difference method, and the Ultimatte software and hardware that it provides are extremely evolved versions of that process.

Yet another common tool for matte extraction and bluescreen compositing is the software known as Primatte. This software is essentially a very powerful chroma-keyer, allowing the user to choose a large number of different chroma values at the same time from which to key, effectively pushing and pulling the boundaries of the selected color volume.

A third popular commercial keyer is the Keylight module, which is primarily a color-difference keyer as well.

All of these specialized keying tools are available as adjuncts to a variety of different compositing packages, either bundled as part of the standard distribution or purchasable as an added-cost plug-in. Some also have a stand-alone version.

Many complete compositing packages will also provide their own custom keying and matte-extraction tools based on some of the color techniques we have already discussed. Depending on the implementation, these tools can range in quality from barely acceptable to extremely powerful.

And generally these dedicated keying solutions are all designed to deal with more than just the creation of a matte channel. They are, just as we saw with the discussion of the color difference method, intended to provide complete solutions to the problem of extracting an image from a bluescreen and then layering it over a new background.

There are now a number of tools becoming available that are able to extract a matte for an object based on *motion* rather than *color*. Using **optical flow** techniques (which we'll look at further in Chapter 7), these tools can actually determine the outlines of an object based on its motion relative to its background. Note that this technique is obviously limited to situations where you have a sequence of frames and where there actually *is* relative motion between the object you are wishing to isolate and the background. (This relative motion can be due to the object moving, the background moving, or just from the camera moving, causing a parallax shift between foreground and background). The best of these tools use both motion *and* color information to produce their results.

Ultimately, no single tool or technique is necessarily "better" than another. Each can be useful in a particular situation, and the choice of which tool to use will often be determined by a number of tests. Some packages or techniques work better for some images and worse for others, and it can be very difficult to predict this in advance. One can never have too many keying options!

In real-world compositing situations, you will generally find yourself using a combination of the techniques described above, often pulling different keys for different areas of your subject, rotoscoping where appropriate or necessary, and then combining all of these pieces as part of the compositing process. Many less-experienced compositing artists will spend a great deal of time trying to use a single tool to create a "perfect" key, laboring under the misconception that the process of pulling a matte off of a bluescreen should be a simple one-step process. This is true so rarely that it is definitely the exception rather than the rule. Even the best tools can have problems with certain images, and typical production situations often deliver plates to the compositor that are less than perfect in terms of evenness, graininess, and freedom from objects that are not intended to be seen in the final composite.

Matte Manipulations

A typical matte extraction usually involves several steps, a great deal of interactive testing, and often requires that specific tools be used for specific problem areas. It is

not uncommon to create several different keys for different areas of an image and then "split" these all together to get an acceptable result.

You may also find that whatever tools you use to extract a matte will need to be modified at different points in time. Unavoidable changes to the backing's illumination (such as an inconsistent light source) may require that the settings be animated throughout the duration of the sequence on which you are working.

Checking the Solidity of your Matte

Even though a matte may, at first glance, appear to be appropriate in terms of where it is solid (white) and transparent (black), you should always double-check this if you've used any sort of procedural tools to extract this matte from an image. There are a number of factors that can conspire to make it hard to see artifacts in your matte, including the fact that the eye will often have trouble discerning pixels that are just *slightly* less than white or *almost* pure black. The result, once the actual composite takes place, is that you will have areas where the transparency of the foreground element wasn't exactly what was expected.

A quick way to help your eye detect these problems is to temporarily apply a color-correction operation such as Brightness to the generated matte and then increase and decrease the luminance while looking for problem areas.

Also, if you are working with images that are higher resolution than your monitor is capable of displaying in its entirety, chances are good that you're looking at an image that is resampled in some fashion from its full resolution. And the filtering that is part of this resampling may be throwing away pixels that are problematic. Make sure to zoom into your image so you are seeing all the detail that is there.

It's certainly much easier to find this sort of problem if you check your matte right away, rather than to wait for it to show up in the composite itself so it never hurts to quickly apply a temporary brightness or gamma operator to a matte just to make sure everything is as expected.

Garbage Mattes

Very often one will use **garbage mattes** to help simplify the process of creating a clean matte. A garbage matte is a loose-fitting shape (usually created with the same tools used to do more complicated rotoscoping) that is designed to address specific problem areas, and will almost always be used in conjunction with a more exact matte. Garbage mattes should be quick and easy to create; usually they will have very little to do with the edges of the object in question. By definition, their purpose is to remove any obvious "garbage," or extraneous information. This garbage will usually be something exterior to the chosen foreground subject, such as a piece of rigging that is hanging into frame or a defect in the bluescreen itself. It is sometimes referred to as a

hold-out matte, for obvious reasons. The matte shown in Figure 1.5 (back in Chapter 1) was actually created with the aid of a garbage matte similar to the one shown in Figure 6.41, below. This matte, in conjunction with some standard keying software, was used to quickly remove the undesirable objects that are visible in the original bluescreen plate.

Figure 6.41 A sample garbage matte.

Figure 6.42 shows that original plate with the garbage matte overlaid on it, in order to better understand the relationship between the two. Note that the shape need not be at all exact since we're merely interested in removing objects that cannot be extracted using standard bluescreen techniques.

Figure 6.42 Garbage matte overlaid on a bluescreen element.

Garbage mattes can be used to explicitly *include* a portion of an image as well, such as areas that would otherwise be problematic due to a luminance or color similarity with the backing. For the example shown back in Figure 6.28, our luminance-based key was unable to distinguish the dark areas inside the skull from the black background. An easy way to solve this issue would be to draw a quick shape to define an inner solidity and use this to modify the matte before the composite takes place.

Thus, Figure 6.43a is a lumakey-generated matte, Figure 6.43b is our quick internal matte (also known as an **inclusion matte**) and Figure 6.43c is a matte that was generated by

Figure 6.43a New (more subtle) Lumakey for Figure 6.24.

Figure 6.43b Interior garbage matte for that Lumakey.

combining the two. Because our inclusion matte takes care of most dark areas within the interior of the skull, we can actually allow the lumakey to pull a "softer" matte, and thus our resulting composite (as shown in Figure 6.44) can have more transparent edges (although at the expense of some unwanted transparency around the chin area).

Figure 6.43c Lumakey + Garbage Matte.

Figure 6.44 Composite using the Matte from Figure 6.43c.

Thus we see that it is not uncommon to create both an inner and an outer garbage matte for many compositing scenarios. This underscores a particularly salient point:

> The most important thing that any automated matte-extraction technique will give you is a high-quality edge. Everything that is not an edge may very well be something that can be addressed with far less effort using other techniques.

Edge Mattes

Since it is usually the edges that we spend the most time with when working on a matte, it is extremely useful to have a way of limiting certain operations so that they affect *only* these edges. One of the best ways to limit these operations is by using yet another matte, usually referred to as an **edge matte**. An example of an edge matte for the peach from Figure 1.5 is shown in Figure 6.45. As you can see, this is a matte that is solid only along the edges of an element and is transparent elsewhere. It can be created either directly from an image or, probably more commonly, from another matte. For instance, if we pull a very high-contrast matte for our foreground element, we can then use an edge-detection algorithm to define only the edge. In this situation, the original matte we pull should be as hard-edged as possible, since edge-detection algorithms will work more effectively with this scenario. Then, depending on the edge-detection tools you have available, you may need to do some additional processing to create a thicker edge.

Figure 6.45 Example of an Edge Matte.

Edge mattes are worthwhile for a number of reasons. First of all, when coupled with a few simple operations they can be used to create a very accurate inner and outer

garbage matte. They can also be very useful as a mask for controlling additional effects that are used to help with the integration. For instance, one could use an edge matte to more easily control the softness or transparency of the foreground's edges. Or a soft edge matte might be used to help with spill suppression around the edges of the foreground element. There may even be occasion to use an edge matte to apply effects *after* the layering is finished. It may be worthwhile, for instance, to apply a slight blur along the edge where the foreground and background meet once they have already been composited together. When done sensibly, over the width of only a few pixels, this can look much nicer than simply blurring the edges of the foreground element before creating the composite.

Combining Mattes

Instead of using a single technique to create a single matte, it is often the case that a number of different mattes are generated, each targeted to a certain portion of the image. For instance, certain settings may pull an excellent matte around a character's hands, yet these same settings may produce absolutely unusable results on hair blowing in the wind. A second pull may be tuned to deal with the hair, and the matte image that this produces can then be manually combined with the matte that works well on the character's hands.

Combining these mattes will require finesse in and of itself. Since the different settings will produce different edge qualities, a hard-edged split will tend to show this transition area. Instead, you will probably need to use an additional matte with a soft transition edge to split the different procedural mattes together.

Image Processing on Mattes

Since a matte image is really just like any other image, it means that we can use our standard image-processing operators to modify these mattes as needed. We already discussed this a bit when we looked at the lumakey, where we used a combination of operations to tune a matte. No matter what method we use to extract a matte, procedural or manual, there may be times that we wish to tweak that matte by a slight amount—to expand it or shrink it or soften the edges a bit. This practice is perfectly acceptable, but is abused so consistently in the industry that we want to be very careful about recommending it. *Postprocessing a matte to soften edges is not a substitute for pulling a proper key in the first place.* Even though some of these techniques can modify mattes so that they look acceptable at first glance, significant loss of detail may have occurred. This detail may have been something that could have been preserved had a bit more time been spent tuning the original matte-pulling parameters instead of quickly resorting to postprocessing the result.

Having said this, we'll now assume that you have spent the time necessary to convince yourself that the matte you have pulled is the best possible using the tools you have available. If this is the case, yet your matte still does not feel acceptable, then it

may be time to resort to other tools. We'll mention a few of the more typical problems that are seen with mattes that are procedurally generated and then suggest some possible remedies. These are only suggestions, and may be totally inapplicable to your particular situation. In fact, many of these suggestions could easily cause more problems than they solve, depending on the matte in question.

Remember that any changes you make to the matte channel must also be reflected in the RGB channels if you are already dealing with a four-channel, premultiplied image. Do not simply blur the matte channel of a four-channel image, or you will most likely end up with a noticeable matte line when you go to composite your element over a background. Instead, you should make your matte modifications before any sort of premultiplication or, as a last resort, unpremultiply your image, manipulate the matte and then re-premultiply to get a new image that has an appropriate image–matte relationship.

We will assume that you are working with matte images that are separated from the RGB images and consequently will not remind you of the matte–image relationship for every situation in which it may be applicable. But, unless you are very careful, many specific matte manipulations will simply be trading one problem for another.

Noise Artifacts

It is not uncommon to find that a particular matte pull has some undesirable "holes" in it—small pixel-sized areas where the matte is partially transparent. These holes are often caused by grain or noise in the foreground element—grain that contains enough variance so that certain particles have coloring identical to the backing. (This is particularly common with bluescreen elements.) The ideal way to eliminate this sort of thing is with the use of garbage mattes, but if this is not practical, you may be able to apply something like a median filter, which will remove single-pixel anomalies.

Another technique for dealing with excessively grainy bluescreen elements is to apply a very slight blur to the original bluescreen element, extract a matte from this blurred element, and then use this extracted matte in conjunction with the original bluescreen plate. By slightly blurring the bluescreen plate, the most egregious grain or noise will be toned down, and a cleaner matte can then be pulled. However, we don't actually want to have a softened foreground element in our scene, so we revert to the original, unblurred element for our image. This can be combined with our clean matte to produce what one hopes is a better composite.

Incidentally, there are often situations where a few small holes in the foreground matte are not going to be particularly noticeable. If the background is not significantly brighter or darker than the foreground, the holes will reveal something that is fairly neutral and innocuous. They will, at worst, appear to be a bit of grain on the element. Use your own judgment on this, and do make sure your background doesn't change significantly over the course of the shot. Those "unnoticeable" holes in the matte are going to suddenly become a much bigger problem as soon as your foreground character walks in front of a bright light, for instance!

Figure 6.46 Original mask with detailed close-up.

Figure 6.47 Dilated version of this mask.

Hard Edges

Attempts to create a solid matte for the subject while completely removing the backing area will often involve a distinct threshold between the two areas. This can, as a side effect, produce a fairly hard edge to the matte. This is usually undesirable, since in the real world, even very sharp objects will have a slightly soft edge when viewed from a distance. The simple solution is to apply a slight blur to the matte channel, although by doing so you run the risk of introducing a matte line, since a blur will typically spread both outward and inward. You may end up doing some additional processing on the matte after the blur, to alleviate such problems. If your matte was too hard only in certain areas, you should use some sort of mask to control the blur, or limit its extent to only areas that are problematic. As mentioned earlier, the use of an Edge Matte may be exactly what is needed here.

Poor-Fitting Mattes

Very often we will find the need to slightly increase or decrease the coverage of a given matte or a portion of a matte. Many compositing packages will provide tools for doing this directly, using algorithms typically known as Dilate and/or Erode. These increase or decrease the relative amount of dark and light pixels in an image. Figure 6.46 shows a close-up of a small portion of a matte; the result after applying a simple Dilate tool is shown in Figure 6.47.

If your software does not have an explicit Dilate/Erode tool, you can usually come up with fairly similar results by using a combination of other operators. For instance, to dilate a matte, you can apply a very slight blur to it and then use an additional brightness or gamma to manipulate the medium-gray pixels that are created. There are many number of additional scenarios that might require explicit modifications to a matte. Some later chapters of this book will look some more at specific considerations that should be taken into account when creating a matte for an object.

Time and Temporal Manipulations

Although everything that we have discussed up to this point is related to the topic of digital compositing, most of it would also fit just as well into a book about using computer-based paint or image-editing programs. We have talked about a variety of tools for combining and manipulating images, but primarily have looked at these tools only as they are applied to a single, static image. The focus of this chapter is to move beyond the single-frame mentality into a discussion about how the concepts that we've been discussing apply to a sequence of images.

Certainly a good deal of what we have already discussed is easily understood in terms of a moving sequence. Just about any compositing package (and even some paint packages) will allow you to apply the tools we have discussed to a sequence of images. But the reason digital compositing must be treated as a separate issue from simple digital painting is that techniques that would be perfectly acceptable when dealing with a single image become not only cost ineffective but sometimes completely unusable when the need arises to produce a sequence of images.

Before we go into more detail about methods for dealing with image sequences, let's take a moment to discuss the difference between viewing a single still image and a sequence of them.

Apparent Motion

The eye has a natural ability to perceive movement when shown a sequence of still images, assuming that the rate of viewing is high enough and the distance any given object moves within the scene is small enough. This illusion is known by a variety of names, including "stroboscopic motion," the "phi phenomenon," or simply "apparent motion."

There is a common misperception that the reason we can see motion when viewing a succession of unmoving frames is that the human eye has a tendency to continue to transmit a signal to the brain for a few moments after the image is removed from view. This phenomenon is known as **persistence of vision**. Persistence of vision does explain why we do not see flicker when viewing a sequence of images at a high enough rate, particularly with a medium such as film or video, in which is a brief moment between each frame when the screen is actually blank. Persistence of vision will eliminate flicker only if the rate at which images are displayed is high enough. Film running at 24 fps is actually too slow to completely eliminate flicker; consequently, theatrical motion picture projectors are designed so that they show each frame twice, running at a rate of 48 fps. (Some projectors even show a frame *three* times in quick succession.) Even a rate of 30 fps is not really enough to completely eliminate flicker, which is part of the reason why video was designed to show two interlaced field images at a rate of 60 fps instead.[1] (The idiosyncrasies of interlaced video will be discussed in greater detail in Chapter 10.)

However, it is really a combination of both apparent motion and persistence of vision that allows us to be fooled into believing that we are seeing a moving scene when shown a sequence of still pictures. Apparent motion can actually happen at extremely slow frame rates, although generally a rate of about 16 fps is considered a reasonable minimum. This was the rate used for most of the original silent films.[2] Both the rate at which one views a sequence of images and the rate at which that sequence of images was acquired are important factors in digital compositing. We need to be aware of both, so that we can not only judge movement, but also because of the greater storage and processing requirements that arise when the number of frames increases.

Temporal Resolution

Just as is the case when dealing with a single image, in which we have a certain number of pixels to work with, when dealing with a sequence of images we will have a certain fixed number of these images, or **frames**, to work with. The more frames that are sampled over a given period of time, the greater the amount of information we have about the scene and the motion within it. In essence, this is yet another way of increasing the resolution of our imagery. We will refer to this as the **temporal resolution** of a sequence.

For the time being, let's assume that the images we are dealing with were captured at the same rate as that at which they will eventually be displayed. This rate is equivalent to the temporal resolution of a sequence and is usually measured in frames per second, or simply **fps**.

[1] And, generally, the brighter the source material the higher the frequency needs to be in order to eliminate the perception of flicker. That'd be the Ferry-Porter law, in case you were curious.
[2] Interestingly, the reason that the standard speed for film projection was increased to 24 fps was primarily to improve the sound quality for the new "talkies."

Most current feature films are captured and displayed at a rate of 24 fps. This is actually a fairly slow rate, bordering on the limits of the eye's ability to perceive flicker. Many artifacts, such as the distracting "strobing" one gets when the camera pans quickly, are often more pronounced in film than when dealing with higher-speed media.

Video in the United States is considered to run at a rate of 30 fps, although this is somewhat of a simplification, as we'll describe in Chapter 10. Various other countries may have different video standards: PAL, for instance, which is the video standard used in much of Europe, specifies a rate of 25 fps.

Other specialized film formats, such as the one known as Showscan, are designed to be captured and played at even greater speeds. (In the case of Showscan, the rate is 60 fps.) The advantage of a format that is designed to display frames at a higher rate relates to the perceived increase in the "realism" of the experience for the viewer. The artifacts caused by a low temporal resolution (such as flicker, strobing movement, and noticeable grain) are all minimized. High-speed formats are usually coupled with increased spatial resolution as well, to give a much more satisfying image. The disadvantage of high-speed systems from a digital perspective is that they require significantly more data for any given amount of time. Even if you choose to scan and store your images at a similar spatial resolution as you would for regular film, the fact that the projection speed is 60 fps instead of 24 means that you need more than twice the amount of storage space for the same length shot.

Frames, once digitized, are usually numbered sequentially for the sequence, although often they will not necessarily be used exactly the way they were created. Two sequences of images need not be of the same length to be combined, and they need not be combined with their frame numbering, or even their acquisition rate, synchronized.

It's also important to understand that footage may be acquired at one speed but played back at a different one. This is exactly how slow-motion is typically done with film—the cinematographer will shoot at, say, 48 fps, knowing that when this footage is played back on a standard projector in your local theater it will be running at only 24 fps. The result is that everything will now appear to be moving at half of its original speed. This of course works in the other direction as well. Time-lapse photography may shoot at extremely low-frame rates—one frame an hour, maybe even less—in order to get the effect of time passing incredibly quickly. Incidentally, there was a period of time where video cameras were incapable of shooting slow-motion at all but this limitation has largely disappeared.

Temporal Artifacts

As mentioned, there are certainly a number of issues that start to become problems once we are dealing with sequences of images instead of just a single frame. Some of these problems, such as the large amount of data that must be managed, are reasonably well defined. If we want to work with 100 frames instead of just one frame, the

amount of disk space will probably be about 100 times greater (assuming we're not using some specialized compression scheme). But there are other problems that arise as a result of our moving image. Many of these problems will fall into the category we refer to as **temporal** artifacts. The definition of this term should be fairly obvious— it refers to some visually noticeable problem that is a result of viewing moving images over time.

Very often you will find yourself putting together a composite and testing a number of different frames in the sequence. Each individual frame may look perfect, with nothing to belie the fact that it is actually a composite. With full confidence you process the entire sequence and take a look at what you've done. However, once you look at the result at the proper speed, everything falls apart. Matte edges crawl, objects moving around the scene are jerky and irregular, elements flicker, and you realize that a composite is more than just a collection of stand-alone images.

The eye is very sensitive to small movements. This is almost certainly a survival trait, a way of sensing danger in one's surrounding environment. Any sudden anomaly in the field of view, any unusual motion, will trigger a warning somewhere in the back of the brain. Unfortunately, this means that many small artifacts that are unnoticeable with a single image can become dramatically more visible when viewed as a sequence. Just about any movement can be a problem if it is not smooth and regular. An object's edge that does not have good frame-to-frame continuity due to an irregular matte will become immediately obvious when played at speed. Small changes in the rate of movement—accelerations and decelerations—will be noticeable and distracting. There is no single magic solution to these problems. The compositor should constantly view short sequences, not just single frames. Every effort should be made to ensure that techniques are smooth and continuous over time, and always make sure that you look at the complete moving sequence before you show it to your client or supervisor.

Now that we're aware of some of the problems that can arise when working with image sequences, let's go ahead and look at some of the ways we can work with and modify the timing aspect of image sequences. The next section will cover some general-purpose methods for modifying the speed of an image sequence. The reader should also be aware that a very specific timing conversion—the conversion between 24-fps film and 30-fps video—will be covered in Chapter 10.

Changing the Length or Timing of a Sequence

Whenever a sequence of images is captured, there is a certain rate associated with it, and this rate determines the number of frames that are captured for a given shot. The person capturing the images may have some control over the rate at which they are shot, but once a particular event is captured it will have been recorded using a specific number of frames. If, for some reason, the number of frames proves to

be inappropriate for the desired shot, it will be up to the compositor to modify the sequence so that it is useful.

A number of tools and methods exist that can be applied to a sequence of images to modify its length or **timing**.[3] The most simple method entails the removal of certain frames from the sequence in order to produce a new sequence. For instance, we may wish to use only the first 120 frames of a 240-frame sequence. Or we may use some range of frames from the middle of the sequence, say frames 100–200. Note that choosing a continuous range of frames out of a larger sequence will certainly give you a shorter shot, but it does not actually change the speed of the action in the shot. Say we have a 100-frame sequence of images that shows a ball rolling from the left side of the frame to the right. At frame 1 the ball is just entering the frame; at frame 100 it is just exiting. If we need a shot that is only half of this length (50 frames long), then using only frames 1–50 from this sequence would seem to fit the criterion. But the new shot will be that of a ball that starts at the left frame line and rolls only to the middle of the screen. The action of the shot is quite a bit different, and the ball itself still appears to be rolling at the same rate.

Instead of this, let's say that we need a 50-frame shot in which the ball's action is the same: It should still be seen to enter and exit frame over the course of the shot. The simplest method would be to reshoot the scene and just roll the ball twice as fast (or run the camera at half of its normal rate). This is often the best solution, but may be impractical for a number of reasons. As we'll see in many other places in this book, the "simple method" for solving problems (reshooting the scene) is often not an option, which is why digital compositing becomes necessary in the first place. So, let's assume that we are not able to reshoot our scene and therefore need to come up with a solution that makes use of the existing frames.

The most basic method for increasing the apparent speed of the action in a sequence of frames is to remove, or "drop" selected frames. For instance, if we wish to make the sequence appear to be twice as fast, we could just remove every other frame. In our rolling ball example, we will be left with 50 frames, but they will contain the full action desired (the ball rolling from left of frame to right), and consequently the ball will appear to be rolling at double the original speed. By the same token, if we wish to change a sequence so that things appear to be moving twice as slow, we can double every frame. Unfortunately, these methods often result in a new sequence in which the

[3] "Timing" is yet another potentially ambiguous term, particularly if you work in the film world. Film, when being developed and printed, goes through a color-correction step that is known as "color timing." In conversation especially, you may find people abbreviating this term and referring to the "timing" of a shot when they are discussing its color balance. Usually the context of the discussion will make it obvious whether they are talking about color or temporal issues, but not always. Fortunately the alternate term "color grading" seems to be gaining a bit more traction.

action doesn't appear quite as smooth as it should. The eye can perceive the artificiality of the process. In the case in which we double the speed of the sequence by dropping frames, for instance, we may see a noticeable strobing or jerkiness in the motion. This effect is due in no small part to the fact that, had the moving object actually been traveling at twice the speed, the camera would register a larger amount of motion blur.

In many situations, the lack of motion blur can be compensated for by adding a subtle blur to the shot, although you may find that it is necessary to restrict the blur to the proper areas of the frame, depending on the type of action. For instance, if the camera is unmoving and all the action is coming from an object moving across the frame, then any additional blur should be applied only to the moving object.

Slowing down the action in a scene by doubling frames is also subject to visual artifacts. In this situation, since the motion is effectively being reduced from (in the case of film) 24 fps to 12 fps, we are approaching the threshold at which apparent motion no longer works. The brain may start to realize that it is seeing individual images instead of a scene in motion.

Depending on the software available, there are a number of methods to help alleviate some of the artifacts inherent in simply doubling or dropping frames. One of the most common methods involves selectively mixing, or averaging, frames together. Let's look again at the case in which we wish to have a sequence move at twice its original speed.

Figure 7.1 shows a sequence of original frames (which we've also numbered sequentially in a fashion that will hopefully make it easier to understand exactly what is going on). Instead of *dropping* every other frame, we will instead do a 50/50 *mix* between every pair of frames to produce a new frame. Our new sequence would be as follows:

1&2, 3&4, 5&6, 7&8, 9&10, 11&12, …

Thus, our new first frame is composed of both frames 1 and 2 of the original sequence, averaged together. Frame 2 is a mix of frames 3 and 4, and so on, as shown in Figure 7.2. This method produces a sequence that is half of the length and visually twice the speed of the original. It has the additional benefit of producing images that will appear less artificial—the process of mixing two frames together essentially gives a crude approximation of a motion blur effect for objects that are moving. This can be seen in the rocket moving through frame—it has a (very) rough similarity to certain types of motion blur we looked at in Chapter 4.

The ability to produce a new sequence by mixing together additional frames becomes even more important when you need to create sequences that are not whole-number multiples of the original sequence. Consider a situation in which we want to increase the speed of the animation by only 50% instead of 100%. Using an intelligent averaging tool, we can produce a sequence whose frames consist of the following:

1&2, 3, 4&5, 6, 7&8, 9, 10&11, 12, 13&14, 15, …

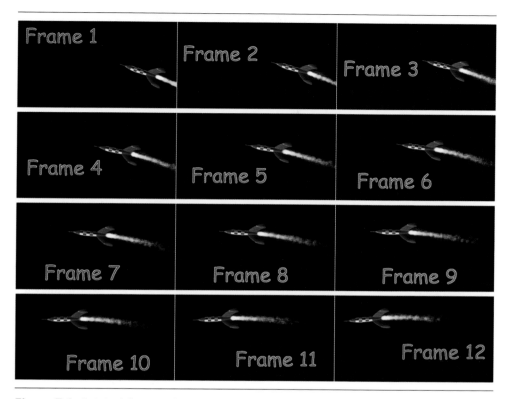

Figure 7.1 Original frames of an image sequence.

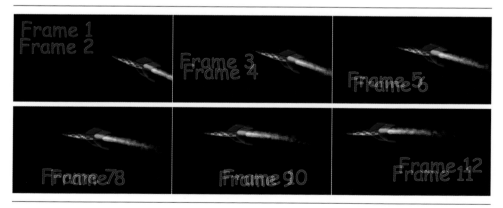

Figure 7.2 Frames averaged together to double their speed.

This is shown in Figure 7.3 but as you can see this gives us a situation where some frames are a mix of two frames and others are not—potentially yet another source of temporal artifacts since the eye may notice a strobing as frames alternate between sharp "whole" frames and softer mixed ones. Figure 7.4 shows an alternate averaging

that may appear a bit less artificial. Most of today's compositing systems will allow the user to control the exact mixing algorithm in some similar fashion, although the preferred method for generating new frames (which is replacing blending entirely) will be discussed in a moment.

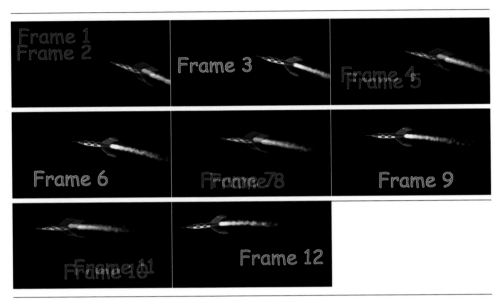

Figure 7.3 Frames averaged to cause a 50% speedup.

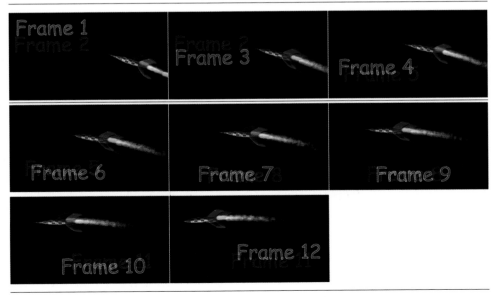

Figure 7.4 Another version of Figure 7.3, using a more pleasing blending algorithm.

Most systems will also give the compositor a variety of ways to specify the actual timing changes as well. You may, for instance, either enter a compression ratio (e.g., "reduce speed by 33%") or specify a frame-range mapping (e.g., "change the timing so that frames 1–8 of the new sequence are composed of frames 1–12 of the original sequence"). While these "linear" speed changes are useful for giving an overall speedup or slow-down in a sequence, very often we'd like to *vary* the speed-change of our imagery over the duration of our shot. In this case we'll need to use some kind of a curve-based control that allows for an explicit mapping of source-to-destination timing.

An example curve is shown in Figure 7.5 for a 100-frame sequence. The horizontal axis shows the source frame number, the vertical axis shows the "new" frame number that we want to map that to. For this particular curve, then, we would be retiming things so that the first part of the sequence will play back at the same speed as the original (frames 1–20 are all unchanged) and then the sequence will speed up so that by the end the clip is moving at twice the original speed.

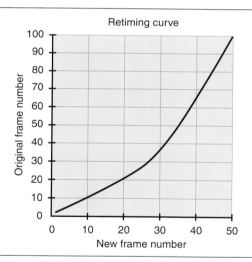

Figure 7.5 Example of a curve that can be used to control retiming.

Although we thus far been looking at retimed frames using frame-blending methods,[4] it's clear that these are all rather crude approximations of what we really want to accomplish—generating new frames that accurately represent what the camera would have seen had it been used to capture the footage at the desired frame rate in the first place. Fortunately many compositing packages now provide even more sophisticated tools for modifying the timing of a sequence of images. Based on a technology known

[4] Although certainly the images we're showing here are rather extreme given the small number of frames we're working with in these examples. If we were retiming a shot that was several hundred frames, the results of frame averaging would be much more subtle.

as **optical flow analysis** these algorithms can analyze the motion of individual areas (or even pixels) within an image over a period of frames.

Consider the sequence of frames shown in Figure 7.6—a plane moving relative to the ground beneath it.

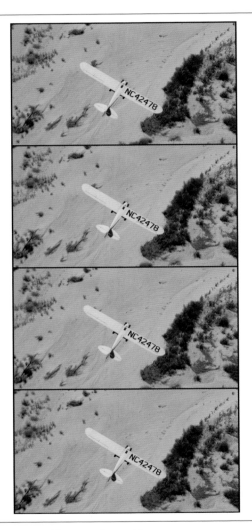

Figure 7.6 Image sequence with a moving subject.

Figure 7.7, then, shows an "optical flow" analysis for how the individual pixels change between the two middle frames of this sequence. This particular method for representing the calculated motion uses color to represent areas that are moving at different speeds relative to each other and in fact we can see that the background (in yellow) has a clear motion in one direction for the bulk of the image and the plane

(in blue) has a different motion vector. This image also underscores the primary issue that tends to come up when dealing with optical flow analysis, namely the difficulty of determining movement in areas where one object occludes another. Thus the mix of additional colors around the border of the plane itself—the technology (or at least the current state of it as of the writing of this book) does not always give us perfect information. Fortunately, even this level of analysis can produce extremely high-quality results.

Figure 7.7 Optical flow vectors for a frame of the sequence shown in Figure 7.6.

Using a combination of this flow information along with some selective interpolation and warping of the actual image can be used to produce new intermediate frames without the need to use any frame-blending. Figure 7.8 shows an image that is a mix of the two previous images—the result we would obtain if we resorted to frame-blending techniques to slow down an image sequence by 50%. Figure 7.9 is the intermediate image that was generated using optical flow techniques instead. Although this process can be fairly compute-intensive, the increased quality of the result is almost always worth it.

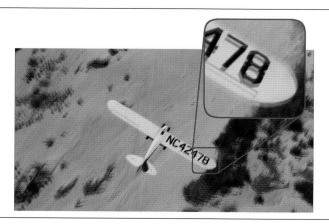

Figure 7.8 A simple mix between two frames.

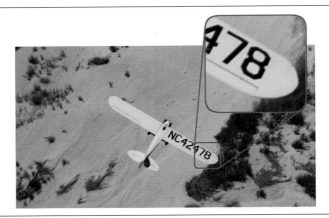

Figure 7.9 Optical flow interpolation between the two frames.

Keyframing

Now that we have discussed some of the ways that we deal with sequences of images in our compositing system, let's go to the next step and discuss how the various tools that we defined in earlier chapters are extended to work on these sequences. Digital compositing is based on the notion that just about any sort of manipulation you may use to produce or enhance a single image can then be similarly applied to a sequence of images. This is not to say that such an application is necessarily trivial, and certain techniques, such as those involved when using a digital paint system, do not easily translate from a single image to a sequence.

Even with tools that can just as easily be applied to a sequence of images as to a single frame, we will soon realize that instead of applying the same settings to our entire image sequence, we will want to modify certain parameters so that they change, or animate, over time. This raises the question of what the best way to animate these parameters would be. Obviously it could be quite painful to manually specify a different value for a particular effect on every frame of our sequence. Fortunately, there is a better way—a way that makes the job of animating values over time a relatively painless task. This technique is known as **keyframing**. Keyframing is a process in which, instead of explicitly defining a value for every frame of the sequence, the artist chooses certain "key" frames, assigns values to those frames, and then allows the computer to interpolate the values for the remaining frames. This interpolation will create values for the frames that fall between the existing frames we've chosen and that will appear to make smooth transitions as we move through time.

Most books on computer animation techniques will give a great amount of detail about the process of using keyframe animation, but for the purposes of our discussion we will work with a simple example that explains the basic concepts. We'll look at how we might use keyframe animation to vary the brightness of an element in order to

properly integrate it into a scene. Consider the case of an actor shot on bluescreen who is walking towards the camera. Let's assume that we've already done a wonderful job of pulling a matte for the actor, using some of the techniques discussed in Chapter 6. Now all we need to do is make sure that his illumination level is appropriate to the background plate in which he's supposed to appear. The only slight difficulty is that the plate dictates that he is walking from the far end of a shadowy corridor into a well-lit room. The bluescreen element was shot with constant lighting, so obviously we'll need to deal with animating the brightness of the character as he walks towards the camera. (Note: Animating the brightness of an element to simulate a change in lighting is common, but not ideal. A better composite would result had the element actually been shot correctly, with lighting that mimicked the background plate, but as every compositor will discover the "ideal" scenario isn't all that common in the real world.)

Using basic keyframing techniques, we'll start with determining a proper brightness for the character at the first and last frames. At frame 1, we determine that applying a brightness of 0.4 to the foreground produces a pleasing, visually integrated result. At frame 300 (after he has completely entered the well-lit room), we decide that a brightness of 1.1 is most appropriate. By default, our software will probably linearly interpolate these two values to determine values for the intermediate frames. (There are a number of different ways to interpolate data between control points. We'll look at another in just a moment.) Figure 7.10 shows a graph of the linear interpolation between our keyframes.

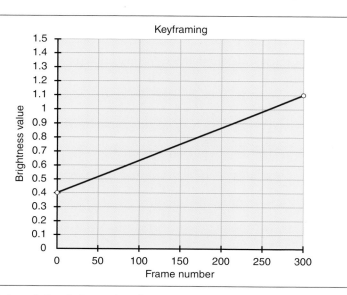

Figure 7.10 Interpolation between two keys.

As you can see from the graph, at frame 150 (halfway through the sequence), the software has chosen a value of 0.75 (halfway between 0.4 and 1.1). Unfortunately, when we go look at frame 150, we notice that the actor has still not entered the room and

consequently appears to be too bright for the scene. On closer examination, we realize that the actor doesn't enter the room until about frame 200, and should therefore remain fairly dark up until that point.

We then go back and look at a few more frames and determine proper brightness values for those frames. Figure 7.11 represents a graph of those new values, where we have added keyframes at frames 200 and 250.

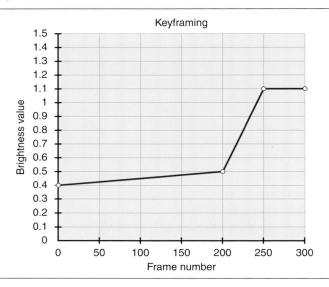

Figure 7.11 Interpolation with four points using linear interpolation.

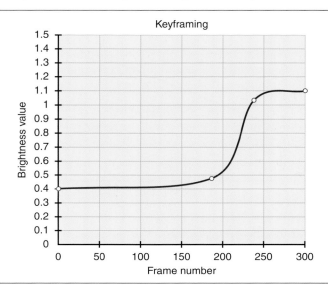

Figure 7.12 Interpolation using smooth curves.

Looking at this graph you can see how the foreground element's brightness slowly increases as the actor approaches the room. Then, as he steps through the doorway (which occurs at about frame 220), there is a more rapid increase in brightness, lasting a few frames. Finally when he is fully in the room, where the lighting is constant, the value essentially levels off for the rest of the sequence.

Now, given the fact that these brightness changes aren't really quite as sudden as our graph indicates, we'd probably want to use a different interpolation method than what we're showing here. Figure 7.12 shows the same number of keyframes used to create a smoother spline with this alternate method. We'll look at more curve-related concepts in Chapter 9.

This situation is, of course, a very simple example of how a single parameter might be animated over a range of frames. More complex projects will involve animated parameters for many different layers.

There are a number of different ways to animate a parameter over time. Instead of using keyframes, we might simply use an equation, or we may import data from an outside source. If we are animating the movement of an object, it might be simpler to draw the motion path of the object and then control the speed at which the object moves along that path. Not all software will support all methods, but usually the same results can be achieved using a variety of techniques.

Image Tracking and Stabilization

If you examine the history of visual effects in feature films, you'll notice that the vast majority of older composites, be they optical or digital, occur in scenes in which the camera isn't moving or zooming. This setup is known as a **locked-off camera**, and for many years it was almost a mandatory requirement for visual effects shots because it was extremely difficult to synchronize multiple elements in the same scene if their camera moves weren't exactly the same. However, it is often not possible, or even desirable, to use a locked-off camera. Multiple shots without camera moves can become boring and lifeless, and with today's sophisticated audiences may even cause the viewer to *expect* a visual effects shot.

Much of this problem went away with the invention of the **motion-control camera**, which gives the camera operator the ability to repeat any given camera move multiple times. A background plate can be shot with a motion-control (or "moco") camera move, and then at a later time the foreground element can be shot with the same move. Motion control has a number of disadvantages, however, including the fact that it requires setting up a good deal of extra equipment (such as camera dollies rolling on a pre-laid track). It also tends to be limited in terms of what type and speed of moves it is capable of performing. In many cases motion-control equipment can also be fairly noisy while in use, thus limiting its acceptability when shooting scenes with dialogue in them.

And motion control really only solves part of the problem anyway—it can deal with situations where you need to synchronize scenes in terms of the camera's movement but it doesn't do you any good if you want to synchronize the movement of something you're adding to a scene with the movement of some object in the scene that already has its own movement.

To address both of these issues we can now turn to a collection of techniques that we will group under the umbrella term of **tracking**. At its most basic, tracking is the process of selecting a particular region of an image and determining that region's movement over time (i.e., on a sequence of images). Once the information about the movement of a region (or group of regions) is obtained, a variety of operations (which we'll discuss in a moment) can be applied much more effectively.

As we've seen with many other digital compositing tools, even a process such as tracking is something that was possible to do within a traditional optical compositing system, although the time it took to manually track an object was considerable, requiring a skilled, patient operator to accurately hand-track an object (frame-by-frame) into a scene. Today's digital tools make it much easier to deal with this—a great deal of work has been done to automate the tracking process[1]—and almost all compositing packages now include the ability to exactly determine the movement of a particular feature over a sequence of images.

Make sure, however, that you don't rely on automated tracking algorithms to the point where you don't explore other ways to solve a problem. Many an inexperienced compositor has gone to his or her supervisor claiming that something is "impossible" to track, only to be shamed when a more experienced veteran will then sit down and *manually* track the object or scene—applying an explicit transformation a frame at a time "by eye" until a successful track is achieved.

Tracking an Element into a Plate

There are a variety of situations in which tracking can be used, but probably the most common is when you need to synchronize the movement of an object you are adding to the scene with something already in the scene. The object in the scene may be moving, or the camera may just be moving relative to the object.

Consider the sequence of images[2] shown in Figure 8.1. We'll use this image sequence as our example footage to help us explain the specific steps that are involved when tracking an element into a scene.

These steps will vary somewhat depending on what software you are using, but the concepts are fairly universal and the tools for automatically tracking a certain region of an image are all based on the same basic principles. Let's say we intend to add an object into the scene that appears to be attached to the front of the ship as it moves through the frame. First, you choose the feature in the image that you wish to track. (The next

[1] Tracking as an automated process was actually developed by the U.S. Defense Department to aid in missile guidance. See, once in a while the government actually *does* do something useful.

[2] Even though we're using computer-generated images for this example in order to illustrate the point as clearly as possible, in a real production environment it's relatively rare to find yourself called upon to track a CG element. This is because generally you'll have a more programmatic way to extract the exact movement of an object directly from the animation package you're using.

section gives some suggestions on how to go about choosing a feature that will track effectively.) Specifying the feature is done by choosing a particular region of an image, usually by drawing a bounding box. An example of this is shown in Figure 8.2, where we have placed our box so that it outlines a small outcropping on the bow of the ship.

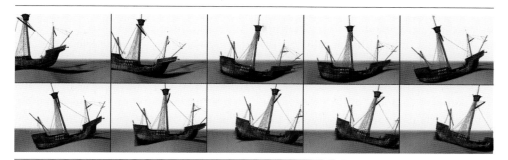

Figure 8.1 An image sequence with a moving object.

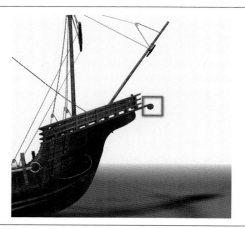

Figure 8.2 Choosing an area to track using a bounding box.

This region will now be used as a pattern that the software attempts to locate in all the other frames in the image sequence. Let's assume that you specify this region while looking at the first frame of the sequence, as shown in our example. The tracking software takes this reference region from this frame and begins by comparing it with the same location in the second frame. But not only does it compare the sample with the same location in the next frame, it also compares it with regions that are slightly offset from the original location. For instance, it pans the source box by one pixel to the left and does a similar comparison. Then it pans two pixels to the left and does the comparison. Every time it tests a new offset, it keeps a record of how much that tested area deviates from the original sample. Eventually, after doing an exhaustive search, there

will almost always be a region that matches far better than any of the other tests with the original pattern. This region is then accepted as the new location of the feature in frame 2. For instance, our tracking software may have gone through its exhaustive search and concluded that the best match[3] with the original region from frame 1 occurs when it moves the sample two pixels to the right and three pixels down. To properly match this movement, the element you are adding into the scene will need to be moved by an equivalent amount—two pixels to the right and three pixels down. Usually this movement is done automatically by the tracking software, once it determines the proper new location. The value of this new location is also entered into a table that keeps track of the movement of our pattern for every frame that we are tracking.

The software can now move on to frame 3, repeating the same process of searching for a pattern match with our original region. Eventually these steps are performed on every frame of the sequence, generating a move for our new element that corresponds exactly to the movement of the region that we have selected to track.

As you can imagine, this can be a fairly time-consuming process, particularly if the computer needs to search for pattern matches over a series of very high-resolution images. To make the process more efficient, there is at least one more region that the user is asked to define before the software begins tracking. This region is known as the "search area" and is also usually specified with a rectangular indicator, larger than the first and surrounding it. This box limits the area that the tracking software needs to consider on the subsequent frames in order to obtain a pattern match. Limiting the search area in this fashion speeds up the tracking process significantly, since areas of the image that are outside the search area are never examined. Just as the choice of what feature one wishes to track is not an exact science, so too is the choice of how large a bounding box should be drawn to define the search area. Some of these considerations will be looked at more thoroughly in a moment.

Although the example we have given discusses the process as if it were only testing areas that are whole-pixel offsets from the original, in actuality a good tracking system will exhaustively check subpixel offsets as well. Very few things will conveniently move a whole-pixel offset between every frame, and the ability to track accurately at the subpixel level is critical to obtaining a good result. Also, although we have only been discussing situations where a region is tested against *offsets* from the original position, most good tracking algorithms will also compare against size and rotational changes as well.

Choosing the Feature to Track

Probably the most important thing that experienced trackers have developed an instinct for is how to choose the right area to track. The first step of this decision-making

[3] Incidentally, the algorithms used to determine what exactly constitutes a "match" can vary quite a bit between different pieces of software; consequently, the accuracy can vary quite a bit as well.

process is to visually examine the entire sequence with which you are working. There are a number of reasons for this step. Obviously, one of the primary reasons has to do with the fact that you are looking for a feature that remains visible throughout the necessary duration of the shot. If the feature you are tracking becomes obscured or leaves the frame, you will need to expend some additional effort dealing with this problem, as described in the section entitled "Human Intervention."

Secondly, you are looking for a feature that remains fairly constant in terms of its shape and color. The tracking algorithm will usually be trying to find something that matches the original sample, and if the pattern changes over time it will no longer be such a match. Fortunately, there are methods for tracking objects that vary over time. Generally they involve choosing to periodically update the sample region you have chosen, replacing the original pattern with the most recent successful match. This change needs to be fairly gradual for the algorithm to deal with it, and a sudden, drastic change in the region that occurs over only a few frames will probably still cause the tracker to lose the region in question. Depending on the situation, this process of redefining the sample pattern may occur any number of times throughout the duration of the shot. As usual, the degree to which this process is automated will depend on the software that you are using.

Not only do we need to worry about the visibility and constancy of our region over the length of the sequence, but we also need to make sure that the area we've chosen to track moves in a way that is appropriate for the element we are adding. In our example, we chose to track the tip of the ship because we were planning to attach an object to this point. But we don't always need to track the exact attachment spot, as long as it does not move *relative* to that desired location. In other words, tracking some other feature on the front of the boat would probably also give us data that were reasonably accurate. But the farther away from the actual attachment point we move, the less accurate the data becomes, since these areas are moving differently. If you look at the example images in Figure 8.1 again, you can see that the rear of the boat is actually rising as the bow is descending. Obviously, if we wish to attach something to the front of the boat, it would be useless to track the back of the boat.

Finally, there are some specific visual characteristics that we look for in the region that we are choosing to track. Generally, you will want to pick a high-contrast area, with noticeable variations in color and brightness. Certain software or scenarios may work better if you preprocess your element to increase the necessary qualities. Usually this entails some kind of overall contrast manipulation in an attempt to emphasize specific features that you would like to use as a tracking target. Be careful not to emphasize undesirable artifacts (such as noise) at the same time, or you may actually decrease the accuracy of the resulting track. And grain or noise can be a problem in and of itself—a slight blur can reduce grain although just removing the blue channel (substitute the cleanest channel in its place) may be more effective. Compositing algorithms generally are already doing a bit of this preprocessing in the background but they don't have the benefit of being able to adapt to the specifics of the imagery being worked with.

The feature you choose to track should have variations along as many axes as possible to minimize the chance of the software coming up with a false match. For example, choosing a region like that marked as A in Figure 8.3 could prove to be a problem, because all the test regions that lie along this section of the mast look extremely similar to the original sample and will probably cause the software to be unable to accurately lock to a particular point. The region marked B has the same problem in a different direction; if you attach an object to this point, you will probably notice that your object slides up and down along this diagonal. A much better area to choose would be something like that shown in choice C, where movement along any axis would be unique.

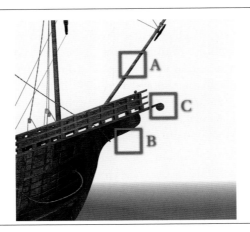

Figure 8.3 Three possible tracking locations.

If you know ahead of time that you intend to track something in a scene, you may even be able to add something to the scene that will be easier for your tracking software to identify. By placing specific tracking markers or **witness points** into a scene, you will be assured that there are high-contrast, uniquely shaped references that the software can track to. Ideally, you will be able to place them in locations that will not be obscured or suffer problems with lighting variations. Depending on the scene, these witness points may or may not need to be removed from the final shot. They may be covered by the new element that you are tracking into the scene, or they may be innocuous enough (such as strategically placed props in a scene) that they can remain. If you do need to remove them, the tracking data they provide may simplify the process of tracking a neutral piece of imagery to cover them.

Limiting the Search Area

Another important reason to examine the entire sequence ahead of time is so that we can get a rough idea about the maximum amount our feature will move between any two frames. This information is important because it will help us to choose

a search area that is no larger than necessary. This choice is generally a trade-off, since searching a too-large area will result in the search taking far longer than necessary, but choosing too small a box runs the risk of not including the proper area in certain frames. For features whose motion relative to the camera is fairly small, your search area box can also be fairly small, but if you are tracking an object that is moving significantly between every frame, then you'll need a wider search area (and consequently the tracking process will take longer).

Ultimately, you don't want to spend a great deal of time worrying about the size of this search area. It's better to err on the side of caution and choose a search area that is larger than you think necessary. These days, tracking algorithms are fast enough that the extra time it will take to search an overly large area will probably be negligible.

Human Intervention

Although most people would like to think that tracking an area in a scene is a completely automatic process—pick a region and the computer will do the rest—this is rarely the case. There are any number of reasons why the software may not be able to track certain things properly. Consider the case in which something else in the scene moves to obscure the object you were trying to track. Suddenly there is nothing in the search area that even remotely matches your sample. It need not be something as drastic as having an object move in front of our area of interest. Something as simple as a quick shift in lighting in the scene (a light being switched off or a surface catching a reflection) can confuse a tracking algorithm. Film grain may even cause enough variation between frames to introduce inaccuracies.

It is not uncommon for problems like this to show up several times during the process of tracking an area through a sequence of images. Generally, one has two choices. If the problem only happens for a few frames, you may be able to just manually enter in your best guess for where you think the feature would be on those frames. It will be much easier to make this guess if the object's movement is smooth and predictable. Erratic movement that varies significantly on every frame or a feature that is obscured for a larger period of time will require a second method. In this case you should try to choose a different point in the scene from which to continue your tracking, making sure that the new region is moving equivalently with the original region. Sophisticated software will usually be able to make a transition to this new point with little or no difficulty, but on some systems you may need to manually deal with the offset in the tracking data that happens when you switch points. Usually this intervention merely involves subtracting a constant X and Y offset from each frame's data after the changeover occurs.

More advanced tracking algorithms are now available that can greatly assist in the process of choosing points to track. These tools will analyze an entire sequence of images and provide an indication of which features are consistently distinctive and visible throughout a range of frames and thus would be better candidates to track. This sort

of capability not only makes it easier to find a good candidate point, it generally eliminates the need to limit the search area as well. However, there may still be a number of situations where there just aren't any good candidate points that span the necessary range of frames and so you will still need to switch points over the duration of the shot.

Using Tracking Curves Manually

Although most software will allow you to simply specify the element you wish to attach to the feature in question and will automatically deal with tracking and moving it, there may be times when you need to interact with the tracking data directly.

Once a feature has been tracked, your software should have in storage a sequence of either pixel locations or pixel offsets for every frame of the shot. Some software returns the data based on the absolute pixel position of the image you tracked; others return the data as relative offsets from your original position (now defined to be [0,0]). Ideally, you have some way of examining a curve that is a plot of this data. This visual test can immediately show any gross problems or mistrackings that have occurred. For instance, Figure 8.4 shows a graph of the X movement that the tracking software has calculated for an object. The chances are high that the tracker encountered some problems around frame 40, indicating that you may wish to either retry the tracking or manually intervene. Of course if your software is fast enough or your composite is simple enough, it may be just as quick to look at the actual result of your object tracked into the scene. This is obviously the ultimate test—and things that might appear reasonable in a graph of the tracking solution will be visibly incorrect once you look at the result.

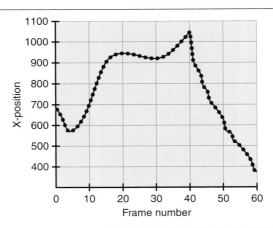

Figure 8.4 Graph of tracking curve with potential problem.

Instead of having the software automatically apply any tracked movement to an element, you may wish to do it yourself. In this case you will need to attach the

movement curves to a general pan operator explicitly. By doing so, you will have additional flexibility, and you can easily modify the data first or use it in conjunction with a secondary move.

Tracking Multiple Points

So far, we have talked only about one-point, or single-point, tracking. It is capable of giving us the X and Y position for a single point on an image so we can attach an element to it or stabilize the image based on that point. Single-point tracking only gives us enough information to deal with simple, overall positional changes.

If, instead, we track two points in a scene, we now have enough information to accurately reproduce any rotational changes that occur between the two points. What's more, by measuring the change in distance between the two points, changes in scale for a given object can also be computed and mimicked. (Again, most systems would automate this process, but if not, you could also compute this information manually.)

Taking this concept even further, four-point tracking gives enough information to calculate simple warps that mimic perspective shifts. We can track the four corners of a moving object and lock an image or element inside those points, often creating a perfect match for any transformations caused by object or camera moves. And of course the utility of tracking is not limited to just a few points—many systems allow an arbitrary number of tracking points to drive (or assist with) various other compositing processes such as rotoscoping, procedural paint, warping, and morphing.

If you are having trouble getting a good track, particularly if this is due to a plate with heavy grain or the area you are tracking has some inherent random movement (tree leaves, for instance), you may be able to compensate by using multiple trackers on the same general area and then averaging the results together. For example, if we wish to add something to the scene (a helicopter, perhaps) shown in Figure 8.5, it might

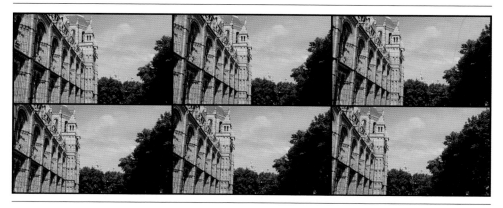

Figure 8.5 Image sequence captured with a moving camera.

make sense to use the three tracking areas shown in Figure 8.6 and then average them together to get a motion path that gives a good approximation of the camera movement without any movement artifacts that might be present in any single section of leaves. (Of course in this example you would probably be better off just tracking the building, but not all plates have a completely static object readily available.)

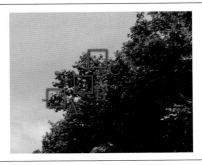

Figure 8.6 Multiple tracking boxes on the reference object.

Stabilizing a Plate

Tracking techniques can also be used when one needs to **stabilize** a sequence of images before they are used within a composite. This need tends to arise most often when the sequence was originally intended to be locked off but something happened during the shoot that compromised that intent. Any number of factors could conspire to produce such an "unstable plate." The camera might have been bumped or jarred while the film was rolling, a strong wind may have caused a slight wobble, or there may have been mechanical problems with the camera itself that caused the normally stable registration of the film as it moves through the gate to be less than acceptable. In this situation, the motion of the plate itself is tracked and analyzed, and then the unwanted movement is removed.

To do this using feature-based tracking tools, we still begin by tracking some feature in the frame to determine its motion over time. But instead of choosing a moving object in the scene, we will choose an object or feature that we believe is supposed to be stable and unmoving. By tracking this allegedly stable point, we can determine how far it deviates from a locked-down condition. Now we can take the resultant data and invert (negate) it so that we can move the plate in the opposite direction on each frame. We are effectively subtracting the plate's natural motion from itself to produce a new plate that no longer moves. (Again, applying our tracking curves in this fashion is assuming that our software isn't being used to automatically do this process for us. And in fact any compositing software that includes general tracking tools will almost certainly include a prepackaged "stabilize" function.)

A modification of this technique can even be used to remove high-frequency jitter from an otherwise desirable camera move. Consider a tracking curve such as that shown in Figure 8.7. We can see that the motion has a lot of small, erratic moves over time, yet there

is also a large overall camera move. In this situation, where we are looking at the X-translation curve, we see that the high-frequency noise is moving by up to 20 or 30 pixels in X, whereas the overall curve covers a range of nearly 600 pixels over the 60 frames shown. If we want to remove only the high-frequency artifacts, we need to create a curve that does the same basic overall move but has none of the noise. Figure 8.8 shows such a curve.

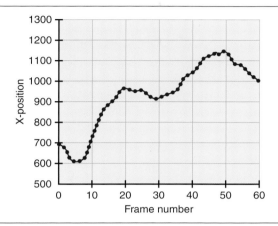

Figure 8.7 Tracking curve with high-frequency noise.

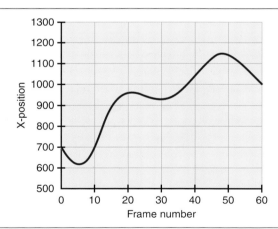

Figure 8.8 Smoothed tracking curve (noise removed).

Depending on your software, you can either create this second curve manually, matching the overall move as much as possible, or use your software's built-in tools for smoothing a curve to remove high-frequency noise. In either case, once this new, smooth curve is available, we subtract it from the original. (Essentially, we subtract the value of the curve at each frame from the value of the original curve at that frame.) The resulting curve is shown in Figure 8.9; it is now a curve that contains only the unwanted high-frequency noise from the original.

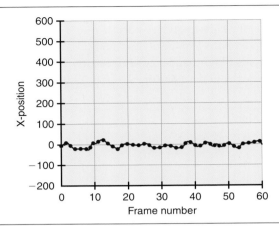

Figure 8.9 Noise-only curve.

If we invert this curve and use it to pan the original plate, we will end up with a plate that still has the required move yet doesn't exhibit any annoying extra jitter.

One thing to be aware of when stabilizing a plate—any time you reposition the frame you'll effectively be moving some of the image out-of-frame and consequently you'll have a situation where your image no longer completely fills the frame of your working resolution. For example, look at the 4-frame sequence shown in Figure 8.10.

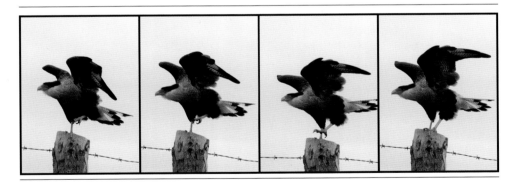

Figure 8.10 4-frame sequence that has an instability.

The third frame of the sequence has a noticeable problem—the camera was inadvertently repositioned for a moment. A simple stabilization will allow us to move this errant frame back into the proper place relative to its neighbors but when we do so, there are now some black "edges" that have crept into frame. Figure 8.11 shows this—our repositioned frame relative to the final frame of the sequence. You can see that the post is now in the same position in both frames but it is "cut off" on the bottom—the information wasn't there in the original image.

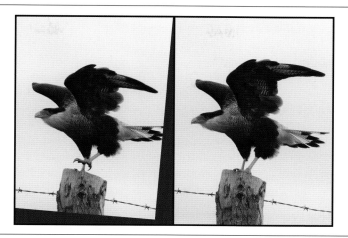

Figure 8.11 Repositioned third frame.

Depending on the source material we have a few different options for how this might be dealt with. We could, for instance, take part of the image from the previous frame and composite it back into this frame in the areas in question. As long as this area doesn't change significantly between the two frames (which is the case here) we'll be fine. But this solution may not be quite as clean if the background changes noticeably between frames. Additionally, if we're doing a stabilization that affects a large number of frames this process could be rather tedious. And even in this example we'd need to do something about the tip of the bird's tail that is cut off by the edge of the frame.

The other common solution to this sort of thing is to zoom the *entire* sequence slightly, "pushing in" so that any black edges which were created by the stabilization's reposition are scaled out-of-frame. Figure 8.12 shows our new sequence where we've done this. This solution has its drawbacks as well as you're losing a bit of resolution and

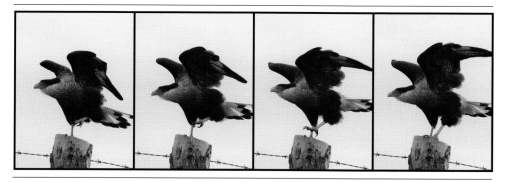

Figure 8.12 The new sequence after zooming in to remove black edges.

slightly changing the framing that the cinematographer originally chose—someone will have to decide if these trade-offs are acceptable.

Camera Tracking

Up to this point we have primarily discussed tracking techniques that relate to specific features in an image. But there is another class of tracking that we will call **camera tracking**. This technique makes use of sophisticated algorithms to analyze the entire frame over a sequence of images and, based on the motion of multiple objects in the scene relative to each other and to the camera, will derive the movement of the camera itself. It will effectively produce an exact match, in a virtual 3D space, of the original move that the camera used to shoot the scene went through.

The availability of packages that are capable of reconstructing the movement of the original camera has made things much easier in many areas. Now that this information is available, inserting an object into a scene with a moving camera is almost as easy as placing it into a scene with a locked-down camera. 3D objects can be rendered with perfectly matched camera moves and 2D elements can be placed into the proper position, either within a 3D animation and rendering package or (if your compositing software supports a 3D environment) as part of the compositing process itself.

It should be noted, however, that although knowing the exact information about how the camera moved can be extremely useful, it is does not always provide *all* the information needed to place an element into a scene. In particular it is only sufficient if the camera movement is the *only* movement in the scene that we are worried about. It is perfectly suited to a situation where we want to place a building in a landscape that was shot with a moving camera but if we wish to place a rider onto a horse that is already galloping through this landscape then we still need to derive information about the motion of the horse using feature-based tracking techniques. But even in this situation our knowledge of the camera's movement may prove useful—assisting feature-based tracking tools by removing the extra variable of the camera movement.

Incidentally, it's worth being aware that lens distortions can sometimes cause tracking problems, so if you have tools to remove lens distortions you may want to preprocess the source imagery first using those. This is rarely an issue with feature-based tracks but can become a much bigger problem if you are trying to re-create a 3D camera. Fortunately most 3D camera solvers provide tools to deal with distorted plates.

It should also be obvious that the process of stabilizing a plate as discussed in the previous section will be significantly easier if we have a good reconstruction of the actual camera move. In fact, most camera-tracking tools have a very simple set of controls for smoothing out the movement of a camera or completely removing it.

Interface Interactions

Although all digital compositing systems share the same basic concepts and algo-rithms, the method by which a user interacts with the system can vary widely. This interaction is primarily determined by the **user interface** that is provided with the software in question. These days, this user interface is typically a graphical front end to the tools, and hence is usually referred to as simply the **GUI** (graphical user inter-face). It would be pointless (and impossible!) to try to discuss the specific quirks of all the various interfaces out there, so instead we will attempt (somewhat arbitrarily) to define certain user-interface categories, discuss the different philosophies behind various working methods, and then spend some time looking at basic tools that have similar equivalents on all common platforms.

Because the process of digital compositing is an interactive one, requiring extensive feedback at every step of the way, it is very important that your compositing software does not hinder your efficiency. Certainly a great deal of this ease of interaction will have to do with how experienced and familiar you are with the particular paradigm that your software employs. Just about any system, including a completely text-based command-line compositing system, can be used to produce high-quality images. But the best systems recognize that the operator's time is a significant cost factor in pro-ducing imagery, and consequently will provide as many tools as possible for optimiz-ing the process.

We will break user-interface-related issues into two primary categories. The first is the more complex of the two and deals with how a compositing artist combines and controls the various tools that were discussed in Chapters 4–8. The second cat-egory encompasses the use of specific tools for viewing and analyzing images and sequences of images.

Different software packages may have extremely different methods of interacting with certain tools. Even the hardware that is used may be different—keyboard, mouse, tablet, and sometimes even specialized control devices may all be employed in various fashion. But the concepts *behind* the hardware are well defined and vary little from platform to platform. These concepts are what we will focus on in this chapter. The most important are related not to the interfaces used for specific tools, but rather to the overall working methodology that the software allows you to develop— the workflow.

Workflow

Up to this point, we've primarily treated the various image manipulation and combination tools as if they were isolated entities. In other words, we have mostly discussed how a single operator affects a single image. In the real world, the compositing process is one of applying combinations of these tools, each modifying some aspect of the image sequence until the final, intended imagery is produced. There may be situations in which dozens or even hundreds of these tools are used. To see an example of this, examine Figure 15.27 in Chapter 15, which is a graphical representation of all the operators that were used to produce a single specific shot for the movie *Titanic*. Each box represents a single operator, and the overall structure and grouping of the boxes is based on the order in which these operators were applied. Essentially, these numerous discrete operators were combined in an intricate fashion to produce the complex, custom-designed machine that was needed to produce the finished shot. For the bulk of our discussions in this chapter, we will try to use slightly less complex examples than the one shown in Chapter 15.

Whether one is working with a large, complex composite or a small, simple one, the general workflow is essentially the same. The flowchart in Figure 9.1 covers the basic steps. Note that this process is fairly recursive, since newly created image sequences will often be treated as source elements for the next step in a composite.

Let's look at the individual steps as they occur. In step 1, the images with which we will be working are imported into our system. Files of various types may be brought in, and, depending on the software that you are using, there may be a need to do some specialized processing to format the images in a particular way. (Chapter 10 discusses format issues in much greater detail.) Certain compositing systems may require you to preformat the images so that they can be rapidly stored and retrieved from a special area of the disk, for instance. Other systems will simply keep track of the image sequences' locations in a general file system and will read images into memory as needed. To speed up the interactivity of the process, software may let you work with low-resolution **proxies** of the original frames and/or allow you to use dedicated graphics hardware for some of the processing. These options are discussed in a later section of this chapter.

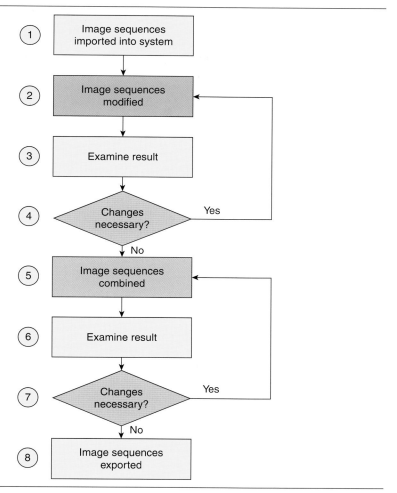

Figure 9.1 Flowchart of the typical compositing workflow.

In step 2, we start applying the image-processing operators such as those we discussed in earlier chapters. This process could include any number of color corrections, geometric transforms, or spatial filters—everything from gamma corrections to blurs to rotations.

Now we take a look at the result of the operations we've applied to the sequence and decide whether we're satisfied with the result. This is step 3, the "visual feedback" step, which may cause us to return to step 2 for additional adjustments. We may bounce back and forth between steps 2 and 3 several times until we have a result with which we are happy. (Understand that you do not necessarily need to decide on all the image-processing operations that you will use before you start to combine images. Most systems will allow you to add additional effects to the original layers as necessary, although

your flexibility may be more limited with certain types of systems.) Also, although the steps are represented as single boxes in our flowchart, in a real composite we may go through these same steps with any number of original source sequences.

At some point we will need to combine some of these modified sequences, using tools such as those discussed in Chapter 5. This process is represented by step 5 in our diagram and is immediately followed by an analysis (usually visual) of the result. Once again we go into a feedback loop, with potentially a large number of iterations in which changes are made and the results are examined. In this case, we have the added complexity that the changes may need to be made to the operator that combines the images (step 5) or to one of the original image modification tools (step 2).

The flowchart obviously represents a *very* simplified view of the process. The actual method of interacting with your compositing package will depend heavily not only on the specifics of the user interface, but also on the basic paradigms your software uses. A distinction between different systems that is worth mentioning, although perhaps mostly from a historical perspective, is whether or not your system is designed primarily to create a set of instructions that describes the *entire* process for a given composite or if it is designed to iteratively build up new elements interactively without keeping track of the steps that went into the making of those elements.

The Evolution of Interactivity

In the earliest days of digital compositing (and image processing in general), the tools had little or no real interactivity. The list of instructions for how a sequence of operations would be applied to a set of images would be driven by text-based scripts (effectively a specialized programming language), would include no GUI, and would provide no immediate visual feedback for any image processing that was being done. You would set up the process, execute the script, and then come back later to see the result.

Meanwhile in the world of video production, the hardware used to manipulate and combine analog video streams was also evolving to include more and more compositing-like functionality. For these systems, everything was designed to occur in real time—mixing, color-correcting…even keying. But generally this specialized hardware could only do one thing at a time. You would need to play your original videotape, pass the signal through the box that does a color-correction and then record the modified version to another tape. And then if you wanted to mix this new color-corrected element with yet another bit of footage, you'd play the two videotapes through a hardware mixer and record (on a third tape) the result.

Technology eventually allowed much of the tape-to-tape process to be replaced by reading and writing to a hard drive and additional systems evolved that would allow the operator to set up (and visually tune) a few specific compositing operations, processing them (depending on the speed of the system being used) in real time (or nearly so). These systems (sometimes referred to as online compositing systems)

could be used to build up very complex composites, but the workflow was much the same as with the original hardware-based video tools: Fairly compartmentalized operations were performed on a sequence of images (a "clip"), the result was computed and written to disk, and then the next set of operations would be performed. If changes were requested by the client, it would often require the operator to go back to one of the beginning pieces of video and manually re-do almost exactly the same steps a second (or third or fourth) time.

Script-based compositing systems continued to evolve as well, adding a wide variety of complex compositing tools as well as better, faster and more intuitive ways to interact with the system and visualize what the results of the process will be. As visual effects became more and more complicated and the demands on a compositing artist grew, the advantages of a script-based approach become even more apparent. Extremely complex scripts could be built up and, most importantly, easily modified. (Relative, at least, to the amount of work it would be to do so with an online system.)

Naturally the more complex a script grows, the more time it will take to compute the result but since this approach gives a well-defined set of instructions, it was much easier to enlist additional machines on the network to help with the process. The compositing process is already dealing with a series of individual frames and thus it is quite simple to send a script off to a "render farm" of several separate computers, each computing a single frame at a time and sending the result back to a central location. (In a large facility this render farm may consist of *thousands* of machines). This "batch" processing could, if enough machines are thrown at a problem, allow a script-based compositing system to equal or sometimes even surpass an online approach.

Of course what we really want is the best of both worlds—something that leverages hardware acceleration for processing wherever feasible and appropriate yet still allows for the flexibility and iterative workflow of a script-based system. And this is generally the case today. Systems that were traditionally considered "Online" (such as Autodesk's Flame product), now feature the ability to describe a complete composite as a batch script, which can then either be rendered immediately or distributed in a more batch-like scenario. At the same time, compositing systems like Adobe's After Effects or Apple's Motion can do much of their compositing in real time, allowing for a level of interactivity that was previously only available with an online system.

Thus the distinction between "batch" and "online" are effectively of historical interest and in fact those terms are rarely heard today. Even the concept of a compositing script may not be exposed to the operator—there is simply a specific project that is being worked on and all the details of the steps to be applied are kept within that project. But behind the scenes there is still a list of instructions being built up. As you add various compositing operations into your project they will be added to the list in an appropriate fashion and be available for modification as needed. And, because we're somewhat old-fashioned, we've continued to use the term "script" in various places throughout this book to refer to this list of instructions.

In terms of workflow, one tends to switch back and forth between viewing the entire range of frames that your composite features, watching the footage in motion, and concentrating on a single point in time (or a few key ones) in order to build up the logic of the script that is applied across the entire range of frames. This can greatly speed up the process of building up any sort of reasonably complex composite since the operator isn't waiting for the full clip to compute, only a single frame.

What we really want, obviously, is a system that is capable of applying all of the image-processing operations we specify at a speed that is faster than the time it takes us to move our mouse over to the "play" button. But, as with most areas of computing, that goal will remain forever out of reach since faster systems only breed the ability to tackle more complex processing.

Methods of Representing the Compositing Process

The heart of any discussion about interface interactions is a look at exactly how our compositing software presents the list of instructions that are used to generate our final imagery. First, let's define a few conventions here so that we can better discuss large compositing scripts—we'll walk through the creation of a very simple composite and specify a few terms and conventions as we go along.

We begin with two source sequences, labeled "Foreground" and "Background." Our goal is to combine the two images so that the foreground is over the background and the two sequences are well integrated. Let's say that the foreground image is initially in the wrong location so a Pan operation is applied to it. The background needs to be defocused a bit, and so a blur layer is added to that. We also decide that the background is a little too bright, and so a brightness modifier is added as well. Finally, the modified foreground is layered over the modified background.

There are any number of ways to formally define this process. We could use an interface known as "English," since it is presumably something that most readers of this book are familiar with. To describe this process as succinctly as possible in English, we might say:

> Read in an image sequence labeled "Foreground", apply a Pan of 10 pixels in X and 5 pixels in Y to that and then place the result of this operation over the image sequence that is created when you read in a sequence labeled "Background", apply a blur of 4.0 to it, and apply a brightness of 0.8 to that.

As you can see, the English language is not necessarily the best tool for describing compositing operations. The above description is fairly wordy and is probably not as precise as it should be, since the brightness of 0.8 could easily be interpreted as needing to be applied after the Over operation occurs.

Now, if we were to represent this process using a simple text-based compositing system, the syntax might look something like this:

```
Output = Over(
              Pan(
                  Foreground,
                  10, 5),
              Brightness(
                      Blur(
                          Background,
                          4.0),
                      0.8))
```

For those of you who are accustomed to working with a compositing system that has a nice GUI, this may look like a crude and cryptic way of representing a simple compositing script. But it certainly contains all the important information. We can see that a Pan of (10, 5) has been applied to the sequence called "Foreground." We can see that a Blur value of 4.0 has been applied to the "Background" layer, and then a Brightness value of 0.8 is added above that. Finally, the Over operator takes the two sequences and combines them.

And in fact if you look "under the hood" of most modern compositing systems you'll find some sort of syntax exactly like this to describe the project you're working on. But for all but the most masochistic it's not something that we're going to want to interact with directly, at least not without exhausting all other options first. So let's look at something more practical, something that actually uses a graphical representation.

Layer Lists

Consider now Figure 9.2. In this case the same set of operations is shown, but in "stack" format. We've included small **thumbnails** of the two elements we're using to make it easier to recognize individual layers—something that is common once we begin to look at workflows graphically.

Figure 9.2 A simple layer list.

Also referred to as a **layer list**, the vertical positioning in this model describes the hierarchy, with the "Over" being implied by the location of the foreground above the Background/Blur/Brightness group. Note that in this particular view we no longer are able to determine the exact parameters for the different operations that are being used—the *amount* of blur is not indicated, merely the fact that there *is* a blur. This is also not uncommon for a list like this—we are more interested in the overall structure of the compositing process rather than the specifics.

Of course there does need to be a way to see (and modify) the actual parameters that are being applied—depending on your system you might be able to, for instance, reveal the controls by "expanding" a specific layer as shown in Figure 9.3.

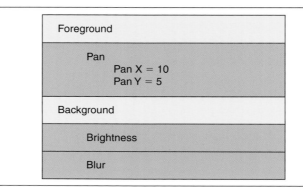

Figure 9.3 Simple layer list with expanded parameters.

This is purely illustrative of course—your system, if it supports a layer list as a way of viewing a set of compositing operations, is likely to include a far more sophisticated set of tools for viewing and manipulating parameters.

While a stack of operations is a reasonably intuitive way to represent a simple composite, the greater complexity of many real-world composites can soon prove to be a bit less so. Let's consider yet another method for representing our example process.

Trees

Take a look at the diagram shown in Figure 9.4, which is yet a third way of representing a compositing script—using a hierarchical "tree."

Each box in this tree is usually referred to as a "node" of the graph. The flow of this particular graph is from top to bottom. That is, when the operations are executed, the first nodes that are evaluated are those at the top of the graph, and then the operators below that are evaluated, and so on, until the final node, at the bottom of the graph, is executed. Some systems will have a convention that the image data flows in a particular direction—right to left or top to bottom—other systems may simply use

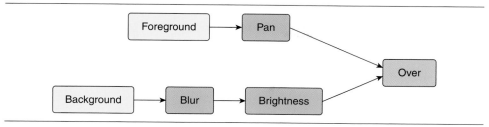

Figure 9.4 Simple compositing script represented by a hierarchical tree.

arrows on each connection line to indicate the direction of the process. For the rest of the examples in this chapter we'll use whatever layout fits best on the page but will always show the dataflow via the use of connecting arrows.

For most people, Figure 9.4 is far more intuitive than the other representations. It quickly shows the complex relationships between the images and operations in an easy-to-read format. More importantly it scales much better than a layer list does in terms of being able to represent increasingly complexity. Consider a tree as given in Figure 9.5.

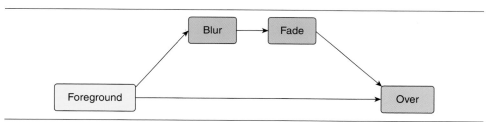

Figure 9.5 Compositing tree with recombining branches.

This depicts a scenario where we're taking an element, blurring it slightly, fading the result so that it has partial transparency and then laying that back over the original element. (Which is a common trick if we want to give an object a bit of a glow.) Representing this is easy enough in our tree view but in a layer list we'd have to represent as in Figure 9.6.

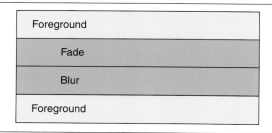

Figure 9.6 Layer-list equivalent of Figure 9.5.

Which does indeed represent the correct logic but it implies that there are actually two copies of the "Foreground" layer. Not a huge problem with a small script like this but suppose instead of having a single entity for our Foreground we had a complex 50-layer composite—we wouldn't really want to duplicate all of those layers twice in the list. This is one of the fundamental areas where a layer list becomes cumbersome—any time you have elements that branch into multiple paths before recombining. Even if we only have a few additional operators, as shown in Figure 9.7 (which we've laid out vertically), we can see how the layer-list makes it seem as if we have many more (Figure 9.8).

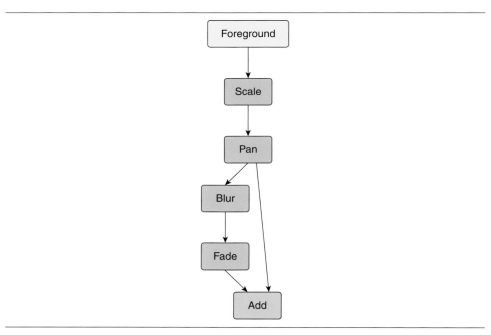

Figure 9.7 A more complex compositing tree.

Note, too, that while we've changed the combinatorial operator to be an Add instead of an Over, this isn't shown in the layer list. Since image combination operations in the list are implicit rather than explicitly shown, you would need to look deeper into a parameter list to determine exactly what is being used.

There may be a variety of additional viewing options available within your tree view. For example, some software may allow you to explicitly name each node or to attach notes to the diagram. Or we might want to color-code the different nodes based on some sort of classification system as we've already been doing in our examples. (In this case we've tinted file-loading operations yellow, used blue for basic image manipulation operators and green for combinatorial operators). This sort of thing is

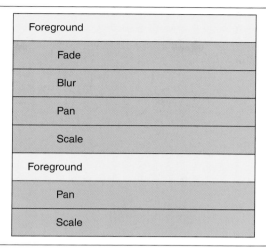

Figure 9.8 Layer-list equivalent of Figure 9.7.

done for more than just aesthetic reasons—providing cues that allow the compositing artist to quickly understand as much information as possible about a given script can be extremely beneficial as scripts grow to significant complexity, particularly if someone else will also be modifying parts of the same script.

Again, we must stress that this particular tree view is merely one of many possible ways to look at this kind of data: Your interface and mileage may vary. Most good compositing systems will give the user a multitude of different ways to view the data that is being manipulated, allowing the choice of which method is most efficient for a given person or situation.

Take a moment now to look again at the script shown in Chapter 15. This is a large script, but not unprecedentedly so. Composites produced for film, where attention to detail is critical and the increased resolution allows for a huge number of relatively small elements, can easily take months to set up and finesse.

Compressed Branches

As you can imagine, it can quickly grow difficult to keep track of where individual nodes are located in a large compositing script. This certainly underscores the importance of organizing your data efficiently and naming your nodes coherently and consistently. There are, fortunately, some other tools that can make the task a bit easier. One of the most important is the ability to select a portion of a graph and "compress" it, that is, to replace it (visually) with a simplified representation.

Consider a tree like the one shown in Figure 9.9. As you can see, our foreground image has several image-processing operations layered on top of each other. Let's say

that we've precisely tuned these layers to where we want them and that we no longer want to worry about them as individual objects. We can select the five layers and group them as a new compressed layer, which we'll call "FG fixes." The simplified graph would look like Figure 9.10.

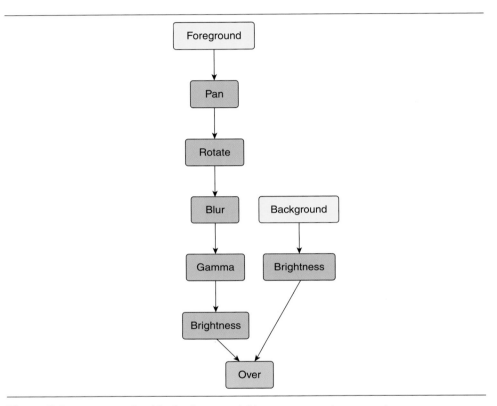

Figure 9.9 A script with a block of sequential image-processing operations.

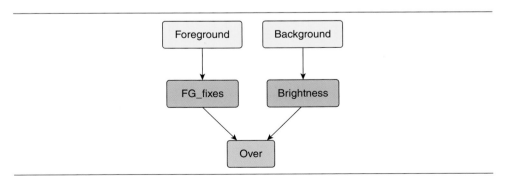

Figure 9.10 Grouping the block of operations as a single entity.

As usual, remember that not all software packages may support this sort of functionality, and even if they do, the paradigm may be different. If your software doesn't support this type of grouping directly, you can sometimes accomplish a similar effect by the use of precomposites, discussed more in Chapter 11.

The example graph shown in Figure 9.9 is also very "atomic" in the sense that specific transformation operations like Pan and Rotate are shown as separate items. In reality most compositing software will feature operators that consolidate common transformations (at least Pan, Rotate, and Scale) into a single tool. This is not always the case, however, and in fact it is not always desirable. In many ways the whole point of having a complex compositing graph is exactly *because* it gives an accurate map of exactly what is happening in a composite. Additionally it will make it easier to access specific parameter when they need modification without having the distraction of a large set of variables. For this reason many compositors prefer the ability to represent items with a great deal of granularity and will eschew systems that don't allow them the option to see things in this fashion. The ideal scenario is the ability for the operator to choose the fashion that data is displayed depending on their needs at any time.

Timelines

While the tree-based graph is very useful for viewing complex scripts, there is one piece of information that such a display does not address well, namely, the timing relationship between nodes, particularly for image sequences that are offset in time relative to one another. To better represent this information, we will use a timeline graph instead. The timeline lets us lay out the various events not only relative to each other, but also to an absolute time. Depending on what sort of work you are doing, you may find it useful to display the units of this graph in a few different formats—in common real-world units (such as seconds or minutes), as video timecode, or simply as individual frames. If you wish to display your timeline with real-world units, your system will need to know what the frame rate of your output medium will be—24 fps for standard film, 30 fps for NTSC video, and so forth. We will show all our time-related graphs with the units representing frames.

When dealing with layers from a timeline point of view, we are really only interested in two pieces of information: the length of the image sequence in question, and the starting point of this sequence. (A third useful piece of information, namely, when a sequence ends, is obviously an easily computed byproduct of the first two.)

Consider the case in which we want to have an object not appear in the scene until several seconds have elapsed. Perhaps the object is an explosion that is only 48 frames long, and it needs to begin after our background has been running for about 100 frames. Figure 9.11 shows a way in which we might represent this scenario.

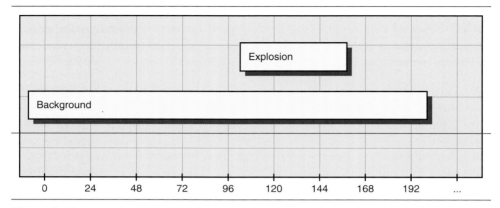

Figure 9.11 A simple timeline graph.

As you can see, we have a representation of our two layers, as well as a scale at the bottom of the diagram that shows us an absolute range of frames. The layers that we have available are positioned relative to this scale, so that their starting points and their lengths can be accurately measured. This sort of view gives us a great deal of information at a quick glance. We can see the relative length of the two sequences—how the background is about 200 frames long and the explosion element is 48 frames long. We can also see that the explosion won't be used until about frame 100. This information would be far more cumbersome to determine using any of the other display tools that we've discussed so far.

The timeline view is useful in a variety of different situations and should be considered an essential adjunct to the standard node-based view of a script. Not only is it useful for viewing information, but it can also be used for manipulating the script as well. For instance, to change the point in time at which a certain layer appears, you

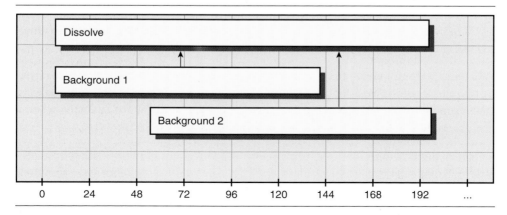

Figure 9.12 Timeline graph showing a dissolve between two image sequences.

could simply grab the layer in the timeline view and drag it to the desired starting frame. The timeline view makes it much easier to visualize and manipulate operations that involve a transition between two different layers. A dissolve between two different sequences can be indicated as in Figure 9.12, and adjusted by simply sliding the second layer so that the amount of overlap is of the desired duration.

At some point, of course, the functionality of a timeline graph can effectively grow to mimic that found in a dedicated editing package. And in fact there are many packages out there that serve as both an editing and a compositing package, although generally their functionality is concentrated in one direction or the other.

Curve Editors

As we've discussed in several earlier chapters, there are situations in which it will be convenient for the user to define a curve to control some aspect of a composite. This curve may represent a variable that changes over time, or it may represent a range of values in a look-up table. No matter what the eventual use of such a curve will be, there are some basic tools that are used for creating and manipulating curves. We usually call a group of such tools a **curve editor**, and we will present an example that uses many of these tools in a fairly standard layout. Some form of curve editing is available in most graphic packages. We will not go through the concepts in a great deal of detail, other than to define some basic terms and to highlight specific features that should be present in an above-average editor.

Take a look at the examples shown in Figure 9.13. The graphs show a number of curves that represent variables, which change over time. Thus, the *x*-axis represents time and is measured in frame numbers. The *y*-axis represents the value of the variable in question. A curve that is not based on time, such as a LUT curve, would have differently labeled axes, but would otherwise be dealt with in exactly the same fashion as a time-variant curve.[1]

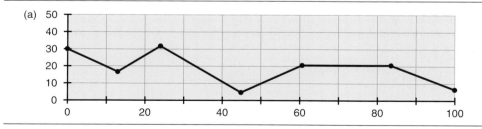

Figure 9.13a Various curve types: Linear interpolation.

[1] Frame-based curves will usually limit you to nonfractional frame numbers, whereas other variables that can be controlled via a curve may not need such a limitation.

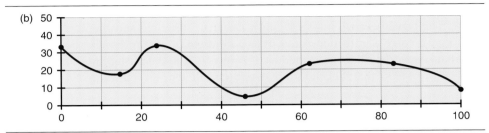

Figure 9.13b Spline interpolation.

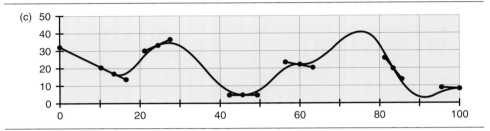

Figure 9.13c Hermite spline interpolation.

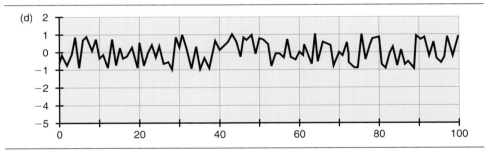

Figure 9.13d Function-based curve.

We are primarily concerned with a curve editor's ability to create, modify, and view a curve or group of curves. More specifically, a good curve editor should allow us to do the following:

- View multiple curves in the same window for direct comparisons. Multiple curves should be easily distinguishable, ideally through the use of color coding.

- Zoom in and out of a curve, scaling the *x*- and *y*-axes nonproportionally as needed.

- View the specific numerical *x*- and *y*-value at any location along the curve.

- Label individual curves with unique, user-defined names so that data can be better organized.

- View the control points on a curve and be able to directly access their specific numerical values.

- Create and manipulate individual control points.

- Insert and delete control points in an existing curve.

- Choose the type of interpolation used between control points. There are a wide variety of potential interpolation techniques, and different packages may vary slightly in what they offer. Figure 9.13a shows a curve with simple linear interpolation—the control points are connected with straight-lines. Figure 9.13b uses the same control points, but interpolates with a smoother spline curve instead. Figure 9.13c uses a particularly powerful type of spline (usually known as a "Hermite spline") that *allows* one to control not only the position of the control points but also the tangents of the curve as it passes through these control points. These tangent controls are represented as additional "handles" that sprout from each control point.

- Create a curve based on a mathematical equation. The equation language should support standard functions as well as the ability to create a curve using random numbers within a given range. An example of this is shown in Figure 9.13d, a curve that is defined to be a random value between 1 and −1.

- Combine and manipulate curves based on mathematical expressions. This can work in a number of different ways—either a new curve is generated from the expression or the existing curve is maintained and the modifying expression is stored with it.

- For example, we may want to take a curve which defines some fluctuating values and tie it to two different effects. The range of values for the curve is fine for the first effect, but the second effect may need a much larger range. In such a situation, we should be able to mathematically define a new curve that is simply a constant value multiplied by our first curve. This is shown in Figure 9.14, where the bottom curve is our first curve and the top curve is our second. Notice that every value in the top curve is five times greater than the equivalent value in the lower curve for any given point in time. Ideally, the second curve will still reference the first, and should we manually update the original, the second curve would automatically change as well.

- Apply arbitrary smoothing to an irregular curve. A number of different algorithms exist for smoothing a curve and removing unwanted noise or spikes. Figure 9.15a shows an unsmoothed curve, while Figure 9.15b shows the smoothed equivalent. Chapter 8 touched on some situations in which this capability is useful although there are many others.

- Append two curves together to create a new curve. Ideally this operation includes the ability to apply some kind of smoothing to the connection point to prevent abrupt changes in value.

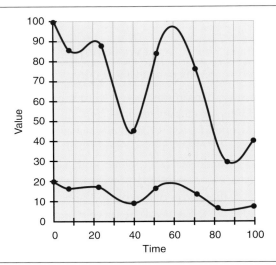

Figure 9.14 Defining a new curve (top) mathematically based on an existing curve (bottom).

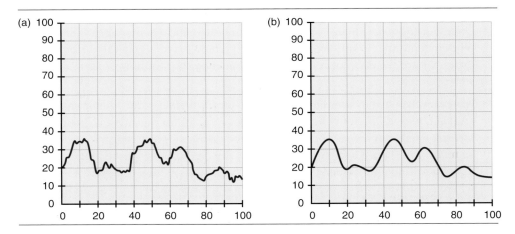

Figure 9.15 Curve smoothing: (a) Original curve (b) Smoothed curve.

- Read and write a curve from or to a file on disk in a simple ASCII format. There is no industry standard for how a curve should be represented, but as long as the format that is used is text based and well documented, it is usually a trivial task to modify curves taken from one editor so that they can be read by another.

- Resample a curve to produce a new curve with a different number of control points. This capability is useful for a couple of reasons. First, you may wish to convert a simple curve that is defined by only a few control points into a curve that has a control point for every frame. This curve could then be written to a

file and exchanged with any other package or device that works on a frame-by-frame basis—anything from a 3D animation system to a motion-control camera. It is also useful to do the reverse, that is, to import a curve that is defined by an explicit value at every frame and convert it to a simpler representation that uses fewer control points. This curve will then be much easier to manipulate, as well as requiring less memory to represent it.

Working with Proxy Images

If you are working on a computer that is not capable of displaying the images with which you are working in real-time at full resolution, or if you do not wish to spend as much of your time waiting for the computer to process intermediate test images, you may wish to work with lower-resolution proxy images instead. A **proxy image** is a lower-resolution equivalent of the image that you are working on—something that can be worked with in the same manner as the full-sized frames you will eventually be using but that can be processed much more quickly. The proxies are created either on the fly, as needed, or are precreated (manually by the user or automatically by the software). Working with proxy images usually requires (or at least implies) that you have some kind of batch-processing system available. The theory is that you can do the majority of your compositing work in low resolution; once you have taken it as far as possible, the steps you have defined will then automatically be converted and applied to the high-resolution equivalents. Some final tweaking will probably need to be done to deal with any unexpected problems that were not visible at low resolution, but the hope is that most of the work can be accomplished at low resolution in a much faster time. Note that a decreased-resolution proxy can also include a decrease in bit-depth—halving the amount of data by moving from 16-bits to 8-bits, for instance. Be careful with this sort of thing, however, particularly if you are working with floating-point images as the behavior of many operators can change quite a bit if you change from this mode back to one with a fixed range of brightness values.

To best take advantage of the proxy image method, your compositing system should be **resolution independent.** This term means that the system can take a script created for low-resolution (proxy) images and apply it to the high-resolution equivalent images, while still producing the expected imagery.

Resolution independence is not as simple as it sounds, since a great number of image-processing operations are normally specified in units that are pixel dependent. Something as simple as the parameters for a pan, for instance, are usually given in pixel units. If we specify a 200-pixel horizontal move for an image that is 400 pixels wide, we move that image by half its own width. If, however, we convert our script to high resolution, that same 200-pixel move applied to an image that is 2000 pixels wide will only move the image a fraction of its own width. A resolution-independent system either automatically converts the units to the new scale when we change our working resolution or simply represents all its operators in resolution-independent units

in the first place. A pan, for instance, could be specified as a percentage of the image's width instead of as an absolute number of pixels. If you do not have a resolution-independent system, you can still work with proxies—you'll just need to do the conversion yourself. Knowing which operators need conversion can be tricky. Any operator that physically moves an element by a specific pixel value will usually need converting, but element scaling will not. Rotations will probably need the location of the center of rotation converted, but the angle of rotation would remain the same. Convolution-based effects such as simple blurs will need to be converted, but color corrections will not.

Most compositing systems will, at the very least, produce temporary low-resolution proxies to speed the interactivity of testing. This feature is different from a fully functional resolution-independent system, but it still can be very useful. It may be limited to single-image test frames, for instance, but will still allow you to preview certain operations at this lower resolution and interactively tune any necessary parameters before applying them to the full-resolution original.

There is another method for increasing the interactivity of a compositing system—the use of video cards that contain on-board graphics acceleration. As graphics cards have grown increasingly more powerful, many compositing systems now do some of their operations entirely within these subsystems. These cards are particularly well suited for doing real-time transformations and general color-corrections. There are limitations to exactly what these cards can do, however, so usually the compositing software will be using a combination of hardware and software rendering to produce the imagery that is shown on-screen. And generally there is a dedicated software renderer for final output, which allows for consistent rendering regardless of the capabilities of the hardware. But there is no doubt that the trend towards providing systems that are as interactive as possible through the use of hardware "proxies" will continue to grow. Ultimately the desire would be to have a system where *every* operation can be performed in real time but of course the complexity of composites and the resolutions involved will undoubtedly continue to grow as well so it is unlikely that there will be a system anytime soon that is completely real time for all operations.

Image Viewing and Analysis Tools

In this section we will talk about a variety of ways to get information about the images with which one is working. This information is often visual in nature—certainly the most basic thing one can do with an image is to look at it—but there are also other tools that can be used to provide numerical or statistical data about an image. As usual, different compositing systems may vary significantly in the way their tools deal with certain things, including the ability to view and analyze images. But the basic concepts are consistent throughout the industry, and consequently most of what we describe in this chapter will be available, in some form or another, on just about any basic compositing system. The processes and tools we describe will be

useful throughout the compositing process. Before any operators are applied to an image sequence, you will need to know as much as possible about the images you will be using, and during the process you will constantly need information about the results of the various steps.

When it comes to viewing images, always keep in mind that the image you see represented on your computer screen is by no means guaranteed to accurately represent the way the image will appear in its final form. At the end of the day, it is only by viewing your imagery in the format and medium for which it is eventually intended that you can be absolutely certain of what it will look like. Thus, if you are creating images for film, you must see them on film before you can be sure they are correct. While care should be taken to ensure that all viewing devices are calibrated to a consistent standard, don't assume that an image that looks acceptable on your computer monitor will look the same when it is displayed via a different method, even if that monitor is properly calibrated to some standard. In fact it is often impossible for a particularly device to be able to represent what will be seen on another device with 100% accuracy because usually two different devices will not even be able to represent the same range (gamut) of colors. For instance, a particular shade of saturated yellow may be something that a piece of film can display without a problem but an LCD display simply cannot. Some compositing systems will at least be able to give you an indication (overlaid on the image in some fashion) of areas that are not being accurately displayed relative to a chosen output medium.

Image Viewers

Certainly the most basic tool is one that can display a single image. It should allow the user to view individual channels of the image, including the alpha, Z-depth, or any other auxiliary channels. You should be able to zoom in and out of various areas of the image to see more detail and ideally this "zoomed-in" view will not introduce any extra filtering operations on the image that might mislead you. If the image you are viewing is of a greater resolution than your computer's monitor, your viewer should allow you to see a portion of the image at a true one-to-one pixel ratio and to down sample the image so that you can see the entire image on your screen.

As you make iterative changes to your images, you will often need to do a detailed comparison between various trials. The best way is to be able to view the two images either by rapidly flipping between them or by interactively wiping or mixing back and forth between them.

If you are working with images that are stored in some sort of nonstandard color encoding, you may also find it useful to be able to apply a compensating LUT to the image when it is viewed. This LUT is strictly for display purposes: The data in the image is not changed; rather, the color conversion happens only in the viewing tool, for the benefit of the viewer. Chapter 14 discusses this concept further.

Not only will you want to view a single image, but most of the time you will also want to be able to look at a *sequence* of images, ideally at a fast enough rate so that they appear as moving footage. Generally this is simply an additional capability of the standard image viewer that is imbedded within your compositing application but the capability may also be available as a tool that runs in a separate window. This type of viewer is often known as a **flipbook**, a term that goes back at least as far as the days of traditional animation, when one would quickly "flip" through a stack of sequential images to check the motion. The abilities of most flipbook tools are very tied to the hardware capabilities of the system you are using and also to the format of the images that you wish to view. You may find, for instance, that for certain images you will need to be able to load most or all of the sequence into main memory and thus the length of the clip that can be displayed will be limited by the amount of memory you have on the machine. Large images will mean that the system can display a shorter sequence, and smaller images will allow a longer sequence.

If you are using a flipbook that requires all images to be loaded into memory and you want to compute the amount of memory needed to display this sequence, don't assume that you can simply look at the size of the images that are stored on disk. Flipbooks (and image viewers in general) will generally need to uncompress an image before displaying it, and if your image file uses any compression then this size will not give you an accurate estimate. What you can do, usually, is to compute the amount of memory required by simply multiplying the width of the image (in pixels) by the height of the image (in pixels) by the number of bits per channel that your flipbook uses by the number of channels that the flipbook will be loading by the number of frames you will be viewing. This gives the total number of *bits* that it will take to load the given sequence, so divide by 8 to get the number of bytes.

Some flipbooks may convert the images to a lower bit-depth for display purposes which may make sense visually (since many monitors can only display 8 bits per pixel anyway) but limits your ability to get accurate feedback about specific values contained in the original imagery. The number of channels to be loaded (assuming your flipbook can load auxiliary channels at all) will depend on whether or not you wish to view the matte channel, the Z-depth channel, etc., at the same time.

Not all flipbooks/viewers require the entire sequence to be loaded into main memory. If your system has a fast enough disk array (relative to the size of images you are viewing) or the images themselves are kept in a format designed for fast access, or both, you will be able to stream images directly from disk, consuming far less main memory. Not surprisingly, as images get larger the ability to play them back at a reasonable speed becomes more difficult. You will almost always want to view your sequence at the same speed as that at which it will eventually be used, but you may find that your system is unable to keep up with this rate if using full-resolution images. Usually this problem can be solved by displaying lower-resolution images

instead. Consequently, you will need to determine on a case-by-case basis whether the particular test you are working on is something that you want to see at the proper speed or the proper resolution. A good flipbook tool will give feedback about whether it is able to maintain the speed you have chosen.

Most of the features discussed for a single-image display should also be accessible for the flipbook display. You should still be able to zoom in and out of the moving sequence, view specific channels of the moving sequence, interactively compare sequences, and view a sequence with a specialized LUT in place.

In addition to a variety of different viewing modes, you should be able to get some numerical or statistical information concerning the images with which you are working. You will certainly need to be able to determine the spatial resolution of an image, as well as its bit depth. Be aware that just because an image is contained in a file with a particular bit depth does not mean that that image actually has information commensurate with that bit depth. An 8-bit image can be saved in a 16-bit file format, but doing so does not actually create any new information.

Other information may or may not be available, such as the average color in an image, or the high and low extremes. This information will be useful in a number of situations, particularly those in which we are attempting to synchronize the colors and contrast between two images. Even more useful than an overall analysis of statistics is the ability to analyze specific areas of the image, a topic we will discuss next.

Pixel or Regional Information Tools

There are times when you would like to determine information and detail about a subregion or even a particular pixel of an image. Most software will allow you to turn on a mode in which you can point to an area of an image and get feedback about the exact x- and y-coordinates that your cursor is indicating. You should also be able to determine the RGB value of an individual pixel or get some type of average value for a region. This information can be used to help with color-correction decisions or to check the solidity of a matte. Ideally, you will even be able to select the average color from an area and paste that value into a variety of different tools.

Another example would be when we are integrating a new element into a scene and we want to ensure that the darkest and brightest areas of that element match well with that scene. If we have a tool that gives us a numerical indication of these extremes for the background image then it will be much easier to color-correct the foreground element to match. Figure 9.16 shows an image with a region selected for analysis and the Minimum, Average, and Maximum pixel values for this region. The Min, Max and Average values for the entire image are also shown.

This analysis tool should be able to work on sequences of images, of course, and ideally the data from this tool can then directly drive other parameters. A classic example

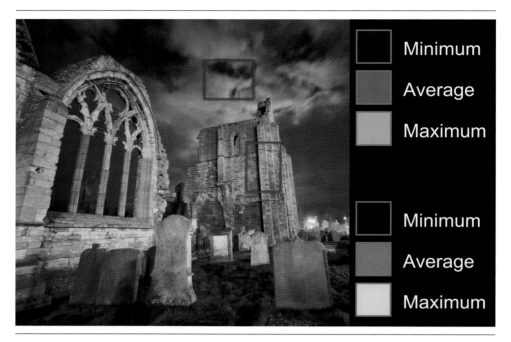

Figure 9.16 Image with regions selected and Minimum, Average, and Maximum values shown for those regions.

would be when one needs to add a new element into a scene that features some sort of inconstant light sources—a flickering candle, for instance. Analyzing the brightness fluctuations of that candlelit scene can produce a curve that then directly drives an equivalent brightness fluctuation on any additional elements we'll be placing into the scene.

If you are viewing an image whose spatial or color resolution is greater than that of your display, be sure that any feedback tools you are using are providing information about the original image and not the proxy you are viewing. It is not uncommon, for instance, for nonprofessional viewing tools to simply return values from the image that is displayed on the screen, instead of looking back to the original image. If the original image was scaled to fit on your monitor, or if your tool is reading color values from an 8-bit video card, then the values returned from this image will be inaccurate relative to the original file. Many times your image may also have had some sort of color modification applied for viewing purposes, either explicitly or automatically (i.e., a gamma correction or some kind of color profile). Again, make sure you know whether the pixel values you are reading are coming from the original image or from the modified one.

Further statistics about an image can be determined using a specialized graph known as a histogram, which we will discuss next.

Histograms

A histogram is a way of displaying a plot of the number of pixels for each given brightness value in an image. Consider the color image shown in Figure 9.17a and the 4-bit, single-channel image (shown in Figure 9.17b) that was derived from it. With only 4 bits to represent the color in the image, each pixel can have one of 16 possible values.

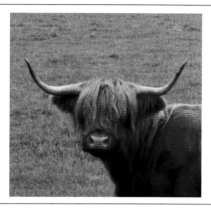

Figure 9.17a An 8-bit color image.

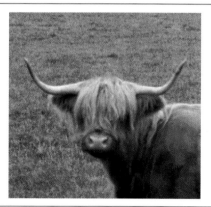

Figure 9.17b A 4-bit, single channel image.

The graph shown in Figure 9.18 is a histogram of Figure 9.17b. As you can see, there are a large number of pixels that have medium-gray values, but relatively few pixels that are pure white or pure black. In fact, we could go so far as to tell that there are about 95,000 pixels with a value of 0.6 (60% gray), but only about 375 pixels with a value of 1.0 (pure white). The point of a histogram, however, is not to derive such specific statistics, but rather to examine overall data trends for the image.

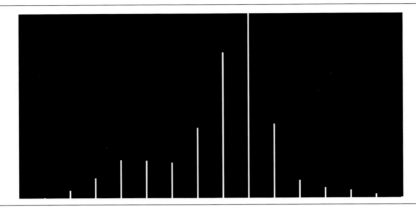

Figure 9.18 Histogram of Figure 9.17b.

Figure 9.19 shows the same type of histogram for the full 8-bit color image, in which all 256 possible intensity values are graphed for each channel. This histogram presents a normal distribution of values, indicative of an image that was exposed and reproduced fairly normally.

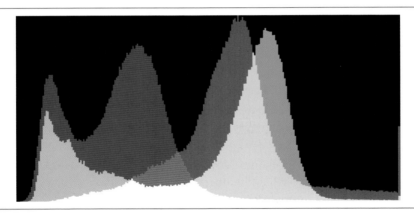

Figure 9.19 Histogram of Figure 9.17a.

A histogram tool can also be useful for determining if an image has been artificially modified and if data has been lost. Unlike the uniform pixel distribution in Figure 9.19, Figure 9.20 gives a strong indication that the image has had some kind of image-processing operation performed on it. The sharply clipped region at the high end of the palette is almost certainly an artifact of some unnatural data truncation.

Determining whether an image has been digitally modified is one of the most useful pieces of information that a histogram can provide. Most color corrections, for

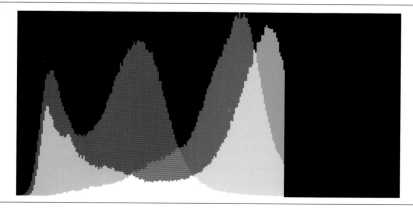

Figure 9.20 Histogram with a truncated range.

instance, tend to create an image that has a less even distribution of colors, which will show up as noticeable gaps in an otherwise normal histogram. To understand why, think about the situation in which we apply a brightness of 2.0 to an image. This operation will multiply every pixel by 2, producing an image in which all the values of every pixel must be an even number. There can be no pixels with an odd value, and consequently the histogram will look something like that shown in Figure 9.21.

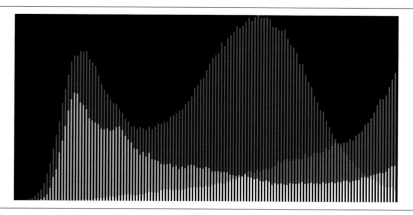

Figure 9.21 Histogram with no odd values.

Images that have been resampled from their original bit depth can also be detected via the use of a histogram. As mentioned earlier, if we create an 8-bit image from a 4-bit source image, we still really only have 4 bits of information present. Standard image-statistic tools will tell us that the image is an 8-bit image, but by examining a histogram of the image we would again see something like that shown in Figure 9.18. In this case, the regularly spaced gaps in the graph exist because the subtle color

gradations that would be available in an 8-bit image were absent in the original 4-bit source. Although the difference between a 4-bit image and an 8-bit image is usually visible by viewing the color image directly, the difference between an 8-bit and a 16-bit image is much more subtle. Determining the "true" (or at least the original) bit depth will require the use of a histogram or some other analysis tool.

There may be a variety of other image-analysis tools available in the compositing system you are using. Waveform monitors, vectorscopes, and even tools that can show your image plotted within a three-dimensional color space can all be useful for helping the artist to better understand the exact nature of the images they are working with and to graphically indicate what sort of changes to an image might occur if certain operators are applied.

Film Formats: Media, Resolution and Aspect Ratios

Generally (we hope), when you set out to create a composite, you do so with the intention that it will be viewed via some specific medium. Whether you are providing images for broadcast video, a website, video games, or a feature film, you will need to have information about what the specific requirements are for that medium. In other words, you will need to know about the **format** that is being used.

Notice the usage of the term "format" here. It is another of those wonderfully ill-defined words that is extremely context dependent. In Chapter 3 (and Appendix B) we discussed digital image **file formats**—specific methods for storing digital images on a disk. This certainly may be part of the information required, assuming it is acceptable to deliver digital images directly. But more often the term "format" is used in the broader sense, referring to the specifics of the physical medium needed to capture or display the images being dealt with. Thus, film, video, HD, 35 mm, IMAX, and so on would all be considered formats that we might deal with during the process of digital compositing. Some of the formats we just mentioned are subsets of others, which is part of the reason why it is so difficult to precisely determine what one is referring to when discussing the format. Also keep in mind that many formats may have different characteristics depending on whether you are talking about capturing imagery or if you are talking about displaying images. Care should be taken to ensure that all parties involved in the conversation are actually referring to the same topic.

In an attempt to organize the information presented in this chapter, we'll group the formats we discuss into three distinct categories: film, video, and other. Although this is an arbitrary classification system, there are certain basic traits for each category that make such a system worthwhile. This chapter will look at a variety of different formats within these categories, while keeping in mind that the point of this discussion

is to present an overview that covers, in as simple a fashion as is possible, the information that is most pertinent to digital compositing.

In an ideal world, we would be able to provide a simple table of different formats and the spatial resolution, color resolution, and aspect ratio for each of them. This is, unfortunately, an impossibility. First of all, there are so many different formats, and variations on these formats, that the task would be prohibitive. For any given format we often find that there is not really a definitive standard, but rather (at best) a group of standards, any of which you can choose and still claim to be following "the standard." This trend seems to be particularly prevalent in the video world.

Second, many of these formats represent images as **analog** data, and digitization methods will vary based on the hardware used for the conversion. Much of this hardware is manufacturer specific and is not subject to any particular standardization whatsoever. In other words, a piece of hardware can be built to sample an analog image at just about any resolution, and thus it is impossible to assign a specific resolution to a specific analog format. Only by knowing the characteristics of the hardware being used in your particular situation you can know with certainty the resolution of the format in question.

Due to the issues mentioned, we will tend not to give specific numerical values for the formats discussed, except as an aid to illustrating a concept or when a reasonably clear, simple standard exists. Nor will we go into great detail about any specific formats themselves, concentrating instead on the more important task of covering the basic concepts related to formats. Appendix C has also been provided as an additional format reference. It attempts to diagram some common formats that are used when working with film and video, and gives a bit more detail about typical digital representations of these formats. Much of this information is highly susceptible to changing technology, which is part of the reason that it was placed in an appendix rather than in the main body of this book.

Ultimately, this chapter will talk about formats on several different levels, some analog and some digital. We will discuss the pipeline of imagery as it moves from the original recording medium through the digital realm (where we perform our compositing work) and back out again. Of course our primary concern (since this is a book about digital compositing, not about the myriad of different moving-image systems that exist in the world today) is how these sequences are used in the digital realm.

There are a multitude of different film formats and (depending on how you choose to define "format") probably an even greater number of video formats. Some of these formats are analog, but even when dealing with a source that is considered to be digital (such as HD video), you'll find that the methods used to represent this digital data may be quite different from what we use to represent a frame within a computer. Fortunately, once an image has been taken from its original medium and format and converted into a digitized image that we are ready to composite with, the terms for specifying its format become much easier.

In fact, we usually only need to identify two specific parameters when detailing a digital image's format (at least in the context we're discussing here): the resolution (spatial, color, and temporal) and the **aspect ratio**.[1]

Aspect Ratio

We have already (in Chapter 3) discussed the concept of an image's resolution, which is simply the number of columns and rows of pixels in that image, the amount of data dedicated to color information for each of those pixels, and the number of these frames that are captured for a given period of time. The **aspect ratio** of an image provides additional information about the proportions of an image. This information can, in some situations, be even more important than the specific pixel resolution of the image.

The aspect ratio of an image is generally considered to be the width-to-height ratio of that image.[2] Note that when one is speaking of a ratio, the term is unitless. It will have the same value no matter what specific units of measurement are used. Consider the image shown in Figure 10.1.

Figure 10.1 Image with a 2:1 aspect ratio.

The aspect ratio of this image is 2:1. (When speaking, we say "two-to-one.") As mentioned, it doesn't matter what units we use to measure this image when determining

[1] Really we should also consider the *color space* that the image is stored in as a part of the format but we'll ignore this issue for the time being.
[2] But, of course, you can also find instances in which the aspect ratio is given as a height-to-width ratio instead. We'll consistently use width-to-height in this book, but don't assume that everyone else follows this convention.

its aspect ratio. If you get a ruler, you will find that the width of the image is approximately 12 centimeters and the height is half of that, or 6 centimeters. We would be correct in saying that the aspect ratio is 12:6, although in general we usually simplify everything by dividing both numbers by the smallest number so that we have a ratio that is relative to 1.[3] Divide both numbers in 12:6 by 6 to get 2:1. If we had measured the rectangle in inches instead of centimeters, we'd have an aspect ratio of 4¾:2⅜, which again simplifies to 2:1. Often, if we've already simplified the aspect ratio so that it is relative to 1, we don't bother including the ":1." Thus, a 1.85:1 aspect ratio will usually be specified as just 1.85.

If an image is already in digital form, then instead of measuring the sides with a ruler, we can simply divide the width of the image in pixels by the height, in pixels, to determine the aspect ratio. An image that is 2048 × 1024 will thus also have an aspect ratio of 2:1.

The aspect ratio of an image may seem like a redundant piece of information. After all, if we already know the width and height of our digital image, why bother to divide these to get the aspect ratio? The reason is that our digital images are usually just intermediate steps in the process of producing final imagery. That final imagery may not necessarily be formatted the same way that our intermediate images are. It may not need to be the same resolution as the intermediate resolution with which we've chosen to work. It may not even be a digital format, and thus the concept of a specific pixel resolution would be meaningless. More important that final imagery may be intended for display via a method that distorts or modifies the width-to-height ratio of the source image. Consequently we need a unitless, media-independent method of discussing formats, and the aspect ratio will help to provide that.

Nonsquare Pixels

Although we've just finished telling you how to determine the aspect ratio of an image by dividing height into width, we will now look at some situations in which this may not give you the true aspect ratio of the format that you are using. This situation arises when your output medium does not display images in the same fashion as your intermediate compositing system displays them. More specifically, we are concerned with display systems that modify the width-to-height relationship of the images that we send to them.

When we give the aspect ratio of an image, we usually try to refer to the aspect ratio of the image as it will eventually be viewed. Both film and video have formats and situations in which the aspect ratio of the displayed image is different from the original digital image. We often refer to such systems as having nonsquare pixels. In this

[3] Once again, there are always exceptions. The aspect ratios for various video devices are more commonly given as whole-number ratios. Thus, the standard NTSC television aspect ratio of 1.33:1 is often referred to as 4:3, and a common HD television specification HDTV specification calls for an aspect ratio of 16:9.

situation, "nonsquare" indicates that the width and height of the pixel are not equal. Its shape is rectangular rather than square. (Actually, it's probably oval rather than round, but nobody ever uses the term "nonround.")

This width-to-height relationship of a nonsquare pixel can also be represented as an aspect ratio. To distinguish it from the aspect ratio for the entire image, we call it the **pixel aspect ratio**.[4] On a normal computer's monitor (assuming it is adjusted properly), the width of every pixel is the same as its height, and we say that it has square pixels. Its pixel aspect ratio is 1:1.

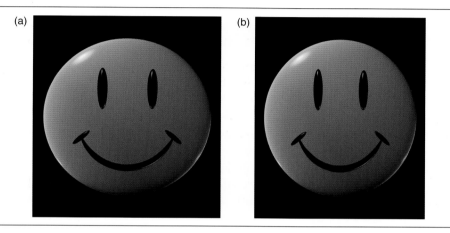

Figure 10.2 (a) Sample image featuring a round object. (b) Image as viewed on a D1 digital video monitor with a pixel aspect ratio of 10:11.

Do not confuse the pixel aspect ratio with an image's aspect ratio. The aspect ratio of an image can be (and usually is) a completely different number than the pixel aspect ratio of the pixels that make it up. For instance, the generally accepted standard for analog video images (in the United States' NTSC broadcast standard) is a pixel aspect ratio of 10:11. The pixels are slightly taller than they are wide. If the individual pixels are stretched, then obviously the entire image will be stretched as well. Thus, if we were to digitally create an image that has a perfectly round circle in the center of it and then send this image directly to NTSC video without any additional modification, the circle would appear as an ellipse. For example, Figure 10.2a shows an original image created within the computer. It is perfectly round. Figure 10.2b shows what this image would look like if it were viewed on a standard-definition video monitor. It is, in fact, stretched by 11/10ths vertically. Depending on the software and hardware that is being used, you may need to manually scale your image before sending

[4] Just as was the case with an image's aspect ratio, you will occasionally run across documents that give the pixel aspect ratio as a height-to-width ratio rather than width-to-height.

it to video in order to compensate for this discrepancy. Many systems will automate this step, however, so be sure you know how your particular setup behaves.

Some of the same situations can occur if we are working with film formats that involve optically distorting an image. Since images sent to film will no longer have identifiable pixels, instead of referring to these formats as having nonsquare pixels, we usually just call them **squeezed** formats. Formats that represent images with distorted aspect ratios are also commonly referred to as **anamorphic** formats. "Anamorphic" is a term borrowed from the art world that literally describes a distorted image that can be restored to its original shape. (Historically, it involved an artist painting a wildly distorted image that would only look correct when viewed as a reflection in a specially curved mirror.) In a later section of this chapter, we'll go into greater detail about some of the problems associated with anamorphic images when compositing them digitally.

Deciding on a Resolution When You Have an Aspect Ratio

Depending on your specific needs, the format of an image may be specified via resolution, aspect ratio, or both. If someone specifies that the images you should produce for a particular video game should have a resolution of 1920 × 1080 pixels then you have enough information to do the work. But if you are going to be producing images for film, the only information that the client may give you is the aspect ratio of the images he or she desires. The reason for the lack of a specific resolution again has to do with the fact that film is a nondigital format, and as such it can be sampled, or digitized, at whatever resolution our hardware allows. The client may have little or no interest in the specific resolution, as long as the resulting image is acceptably sharp and has not suffered from any distortion of its proportions.

For instance, you may be told that you need to produce images with a 1.85 aspect ratio. It is then time to make a decision about the specific resolution that is necessary. This decision may be based on a number of factors, including practical considerations such as available disk space and processing power. Working at a resolution of 2048 × 1107 will produce an image with a 1.85 aspect ratio, but so will an image with a resolution of 185 × 100. However, if we were to transfer our 185 × 100 image back to film, we would probably be unhappy with the quality of the results, since we started with such a low resolution. It is almost as much of a problem if you decide to work at too high a resolution, since you will be confronted with unacceptable storage and computational requirements. Of course the decision about what resolution to use for a given aspect ratio is most often determined (or at least influenced) by the hardware that will be used to scan or output the images, since such devices typically have certain fixed resolutions that they use for the various film sizes available.

As we've said, once an image sequence is converted to a digital form, the format is easily understood. But the process of doing the conversion, and the decisions that need to be made during that conversion, bear further discussion.

Format Conversion Pipeline

Let's look at the various stages of the compositing process where an image's format is important. The flowchart in Figure 10.3 gives a basic pipeline that will occur for every image sequence that is to be used in a composite.

Step 1 is where the source imagery that we will be using in our composite is first created. These may be images generated entirely within the computer, such as rendered 3D imagery coming from a specialized animation package, or they may be images shot on film or video.

What happens next is determined by whether the source images are already in a digital format or if they were created via an analog method. If the source material is analog—a piece of film for instance—then we proceed to step 2. An analog-to-digital conversion occurs, and a specific digital format (a resolution and a bit depth) is chosen at that time. This step is the first situation in which we need to start thinking about image formats and aspect ratios. Video images may or may not already be in a digital format, depending on the hardware available, but either way we will probably need to do some sort of conversion due to aspect ratio as well as resolution issues.

If the source images are already digital (having been created by a digital camera or a 3D animation system, perhaps), there may be no need for any further conversion. However, for whatever reason, we may still want to alter the format of this imagery—possibly to produce a new, lower resolution that will make better use of our available disk resources. In some situations, we may even need to go through an additional format conversion for images that were originally digitized from an analog source. This is potentially an undesirable thing, simply because it would have been more efficient to choose the proper format for the original analog-to-digital conversion instead of wasting the time it takes for a second conversion.

Other chapters of this book provide slightly more information about step 4, so we won't discuss it here other than to note that it is certainly conceivable that not all the image sequences that are being used in our composite will be in the same format. This possibility will be discussed further in a later section.

Steps 5 and 6 reverse the processes from steps 2 and 3. The digital images are, if necessary, converted to yet another digital format—one specific to the eventual output medium. This step is the least likely to be necessary, since one will usually choose to work in a digital format that is the same as the desired output format. Finally, in step 6 (assuming our final images need to be in some analog format) the digital-to-analog conversion takes place. This new analog format may not necessarily be the same form as the original images.

We've gone through a scenario in which a number of different format changes occur. Remember that every digital-to-digital format change generally entails resampling the data and consequently will result in a slight loss of image quality. Avoid all unnecessary format changes wherever possible so that you will not suffer from this quality degradation.

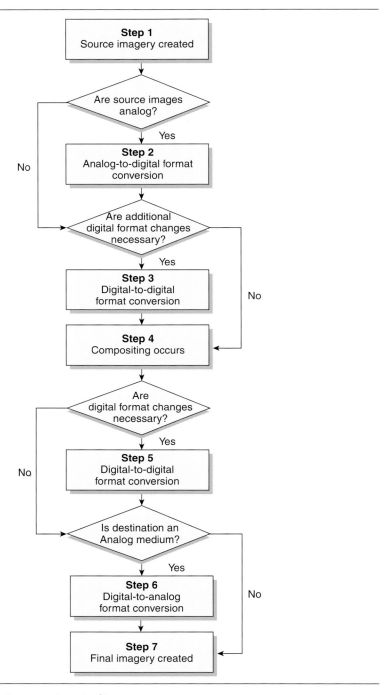

Figure 10.3 Format conversion pipeline.

The process of compositing is certainly much simpler if everything is created digitally and the intended final medium is also digital. None of the analog conversions are necessary, and a standard working resolution can be decided upon and maintained. Conceivably there will be no format changes necessary at all. The more complicated scenario occurs when our source and/or destination material is an analog medium, such as film. Not only do we need to deal with the analog-digital-analog conversions, but (particularly in the case of film) we will also probably need to be aware of a myriad of different physical formats that are in use throughout the industry.

Digital compositing is not the only discipline that needs to deal with format conversions. Conforming a feature film so that it can be viewed on video is a common example, one that can be particularly cumbersome if the original film footage was shot in some widescreen format.

The next section gives an example that follows the pipeline we've just detailed. Although it primarily uses a scenario based on film, it is suggested that you read through it even if you do not plan to do any film work yourself, since it touches on many format issues that are important no matter what the medium involved.

A Format Conversion Example

To get a better understanding of the format-conversion process and typical decisions that need to be made, let's run through the pipeline from Figure 10.3 while considering a piece of film as our source material.

The first question that one might ask about this film, particularly if one is dealing with the process of scanning the film into the computer, concerns the format of the film. Once again we must deal with the imprecision of the term "format." We already know that it was shot in a film format, as opposed to video. Let's also say that it was shot in a 35 mm film format, the standard for feature film work. Finally, to be as precise as possible, we find out that the film was shot in a 1.85 aspect ratio 35 mm film format. We now have the information that we need for deciding how this film will be digitized.

Notice that this particular format, which would usually just be referred to as "1.85 format" (pronounced "one-eight-five format"), gives us a specific aspect ratio for our images. Not all formats have the aspect ratio so conveniently mentioned by name, and you would instead need to consult a chart such as that shown in Appendix C. The aspect ratio is mentioned for this particular format because the camera actually captures more image than is necessary—the extra image will simply be masked or blocked when the print is eventually projected for the screen. Specifying the format (and thus the aspect ratio) lets everyone know that the shot was filmed with a specific framing and that the extra image will not be used. Consequently, when we go to scan this piece of film, we can choose to scan only the area that will be shown in the theater. For the sake of this example, we will do just that, although in the real world we would probably decide to scan the entire frame of the negative just in case we need to use some of the extra image.

Figure 10.4 Film frame with 1.85 framing indicated (in yellow).

Figure 10.4 shows a frame of the film for our shot. You can see the full image that has been captured, as well as a box that is drawn (in yellow) to indicate the standard framing for a 1.85 format. If you measure the width of this box and divide it by the height, you will come up with a ratio of 1.85:1, as expected. The usefulness of the aspect ratio should be starting to become apparent. Film, like any analog source, has no inherent resolution in the purely digital sense.[5] You can subdivide it as finely as you wish and you will always end up with new unique values. It is only when we sample it into discrete packets (i.e., pixels) that it is useful to define it in terms of its resolution. In other words, the digital resolution is determined only when we actually scan the film into the computer. Depending on the hardware we use, we can sample it at a fairly low resolution (such as that used when a standard-definition telecine operation occurs), or we can sample at very high resolutions—4000 lines or more.

Let's say that we choose to sample the frame so that we end up with a resolution of 3448×1864. As we've indicated, this resolution is somewhat arbitrary, subject primarily to the abilities and limits of the available scanning technology. You will notice, however, that the aspect ratio of our new digital image is the same as the area we've scanned in our original film image, 1.85:1. We could just as easily have chosen to scan at 1724×932, which would have given us a lower resolution but still kept the same aspect ratio.

Now let's assume a worst-case scenario: For whatever reason, someone decides that our resolution of 3448×1864 is not what we should use for the bulk of our work. Perhaps someone sat down with a calculator and realized that the amount of disk space that is available won't be enough to store our entire shot at this resolution. (A 3448×1864

[5] There are, of course, ways of measuring the "resolution" of a piece of film, but this quality is distinct from a digital resolution. A print or negative's resolution has to do with the fineness of the grain particles that are in the emulsion and ultimately with how much detail can be resolved when looking at certain test charts.

image stored in the Cineon file format, for example, will take up approximately 26 megabytes of disk space per frame. As you can see, high-resolution film images can have significant storage requirements.) Consequently, the decision is made to convert all our images to a lower resolution. Let's try something more reasonable—something about 2000 pixels wide. We'll be conventional and use 2048 pixels. There's nothing particularly magical about using 2048 instead of simply 2000, unless you happen to have a compositing system that prefers such a number (yes, there are, or at least there used to be, some that do), but it's somewhat of a convention to use computer-friendly numbers like 2048. Given our 2K width, and since we know that we need to maintain our 1.85 aspect ratio, we do a little math, divide 2048 by 1.85, and come up with a new resolution of 2048 × 1107. This gives us a more manageable image size as well, since we're only dealing with about $1/3$ as much data. We've just gone through step 3.

We could just as easily (at least on paper!) have gone back to step 2 and rescanned the film instead, going directly to our 2048 × 1107 resolution. Whether one would choose to do so would probably be decided by real-world considerations such as the accessibility of the scanner or the time available. In this particular situation, one would almost certainly just reduce the already-digitized images, since it would be faster and the image quality would be comparable.

Now that we have our images converted to the digital format that we desire, we can spend time working on the actual composite, producing a whole new sequence of images. These new images will be the same format as the images that are being used to create them, 2048 × 1107.

Eventually it will be time to get our completed digital composite back to film. To make sure that our example covers as many scenarios as possible, let's say that the company that we were planning to use for our **film recording** (the process of getting digital images back onto film) has announced that it is getting out of the business and won't be able to help us. So we call up a different company, only to be told that they don't like to have images at 2048 × 1107 for creating 1.85 format 35 mm film. They ask if we can convert the images to a resolution of 1828 × 988 before we send them over. We wish we had known about this sooner, since it means that not only are we going to spend time resizing a whole bunch of images, but also that we could have probably just done the entire composite at this lower resolution since we're dropping down to that resolution now anyway.

But there's no time to cry about it now—the deadline looms. So we go ahead and convert the images to the new resolution, which corresponds to step 5 in our pipeline, write them to some storage device (or just put them on a high-speed network), and send them over to the film recording company. This company now feeds the images to their film recording hardware, which converts the digital images back to visible light, exposing them onto a piece of film negative. The image is properly placed within the film frame, and, if we care to take the time, we can go back and measure the shape of the resulting image to confirm that the width-to-height ratio is still 1.85 to 1.

This example is a fairly simple one in that it didn't really discuss any issues related to how formats might change between acquisition and delivery or working with multiple formats at the same time. Some of this will be looked at later in this chapter. It also doesn't touch on the issue of color-space conversions that may occur when moving between formats. Different display devices will vary in the gamut of colors that they are able to display and to obtain the best representation of the color in the original scene you will need to understand the characteristics of both your capture device and your display device (while ensuring that any intermediate work you do within your compositing system doesn't compromise the data as well).

There are also a number of situations in which you may chose to shoot with a format that has a higher resolution (spatial and/or color) than your intended delivery format in order to have extra image information with which to work. Chapter 12 discusses the process of creating elements and includes a section entitled "Choosing a Format," in which some of the factors that dictate format choices are presented in greater detail.

At any rate, now that we have a basic idea of how imagery may go through a variety of format changes during the compositing process, we'll spend a few sections getting an overview of some of the more common formats that a compositor may encounter.

Film Formats

Although over the course of the past 100 years there have been numerous different film formats available, we will try to narrow this list down to a few of the most common. This section will not, as a rule, give detailed measurements for the formats—this is done for a few specific formats in Appendix C—but rather will attempt to give the reader a sense of how the different film formats are dealt with, the relative quality of the different formats, and any idiosyncrasies inherent to each format. It's also worth keeping in mind that there are really two different sets of measurements that we might be dealing with when talking about film—the acquisition format and the projection format. Generally the two are synchronized but this isn't always the case—slight discrepancies may exist.

And of course for any given pipeline, the capture may be digital and the projection analog, or vice-versa. At least for a little while longer. Given the speed with which digital capture and projection are being adopted in the feature film production world, the rest of this section runs the risk of becoming largely irrelevant within the next few years. Once that is the case, hopefully it can at least be enjoyed as a bit of an historical footnote.

Most film systems today are designed to project images at a rate of 24 fps. There are a few exceptions to this, which we will describe on a case-by-case basis. The color resolution of a piece of film is, as with the spatial resolution, somewhat dependent on the

hardware used to digitize the imagery. However, due to the large dynamic range of film, any decent scanner is designed to scan at more than 8 bits per channel. As of the writing of this book, the most common file format used to store scanned film imagery is the DPX format which uses 10 bits per channel, although the OpenEXR format is being utilized more and more.

Any given piece of film, as we've mentioned, can be scanned at a variety of different spatial resolutions, but these resolutions are at least partially determined by the physical size of the film that is being scanned.

The standard way to specify the size of a piece of film is by measuring its width in millimeters. This width is also known as the **gauge** of the film. By far the most common gauge for feature film work is 35 mm, so we'll start our discussion with a look at this standard.

Common 35 mm Formats

Not only is 35 mm the most common film format used for theatrical release, it is also, not surprisingly, the most common film format used for digital compositing work. As you will see, 35 mm is not really a single, well-defined format. In fact, there are a number of different formats that fall under the general category of "35 mm," and it is important to realize that the specific gauge of the film itself does not completely determine the size and shape of the image that is actually captured on that film.

The basic 35 mm frame is shown in Figure 10.5. Every frame of standard 35 mm film is bordered on each side by four of the perforations used to move the film through the camera. These perforations are often called "perfs," and consequently the 35 mm format is sometimes referred to as **four-perf**. Along the left side of the film, between

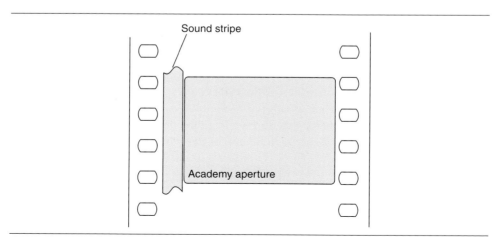

Figure 10.5 Basic 35 mm frame showing Academy framing.

the perfs and the image itself, is a narrow area reserved for the soundtrack of the film. This is known as the sound stripe. [6]

The area of the negative that is usually exposed when shooting standard 35 mm feature films is indicated by the light gray rectangle in the diagram. Note that this framing, which excludes the sound stripe, has an aspect ratio of 1.37—it is generally referred to as the **Academy aperture**.

Imagery that is exposed with this framing will not necessarily be projected with the same framing. Instead, it will generally be masked for theatrical presentation to conform to one of the more popular projection standards. Since the Academy aperture framing is the most widely agreed-upon standard for 35 mm work, we will try to point out how some of the different film and video sizes compare with the Academy frame in terms of absolute resolution. Appendix C also contains a chart showing this resolution comparison for a variety of formats.

Although the sound stripe area will be filled when the film is eventually projected, it is not something that necessarily needs to be protected when shooting the original negative. It is not uncommon, therefore, to remove the mask that blocks this area from exposure in order to capture a larger image. There is also some space above and below the Academy framing that can be used as well. Taking advantage of this extra area, which is called the **full aperture** (sometimes also referred to as the **camera aperture**), will result in a frame with an aspect ratio of 1.33. Simply by using this larger area, one is able to capture an image that is about 30% larger than normal Academy aperture. Certain formats make use of this extra area as an intermediate step before the final print is made, and it is not uncommon for visual effects elements to be shot "full-ap" to reap the benefits of a higher-resolution image. An example of the full aperture framing is shown in Figure C.1 (in Appendix C), as well as for the rest of the 35 mm formats we will be discussing.

1.85

An aspect ratio of 1.85 is by far the most common framing for movies that are shown in the United States. (In Europe, a 1.66 aspect ratio is more common, and in the rest of the world it varies between the two standards.) Projecting an image that was shot with normal Academy aperture in a 1.85 format is simply a matter of placing a mask in the projector that blocks a small amount of the image—usually along the top. The cinematographer has planned for this framing from the outset, and thus will not have allowed anything important to occur in the top of the frame. A diagram of 1.85 framing was shown in Figure 10.4.

[6] The standard sound stripe is designed to store an analog soundtrack. To maintain backward compatibility with the huge number of older projection systems in the world, the newer digital soundtrack methods were forced to find some other place to locate the sound information. There are a number of different, competing standards—some use the area between the perforations, while others use the margin of the film outside of the perfs.

Super 35

The Super 35 format ignores the space normally reserved for the sound stripe and uses most of the full-aperture area of the negative to capture the desired picture. This picture will eventually be projected with an aspect ratio of 2.35, but only after some intermediate steps.[7] These steps are used to reformat the captured image into a different standard, usually Cinemascope (which we'll discuss in a moment), and consequently Super 35 should be considered primarily a format for acquisition, not projection.

Cinemascope

The **Cinemascope**[8] format (also known as simply **C-scope)** is an anamorphic format that has been designed to capture images that are squeezed by 50% along the *x*-axis. This squeezing is done in order to capture a wider field of view while still using as much negative as possible. We will be using the Cinemascope format later in this chapter to illustrate some of the concepts related to working with nonsquare pixels, and will discuss the process it uses to capture this squeezed imagery in more detail in that section. Cinemascope images are intended to be projected so as to produce an image with an aspect ratio of 2.35. However, due to the two-to-one squeeze of the captured images, the aspect ratio of a Cinemascope image on a piece of film is approximately half of that, about 1.2:1. (The reason it is not exactly half has to do with the masking applied to the projected image to force it into a 2.35 aspect ratio).

There is another 35 mm format that we will discuss in a moment, known as the **Vistavision** format. Due to the particular characteristics of this format, we have chosen to cover it in the "Specialized Film Formats" section instead, for reasons that will become obvious.

16 mm Formats

Generally the various standard 16 mm film formats are not used very often in digital compositing. This is probably due mostly to cost issues: If a filmmaker has the money to digitize and manipulate film footage, he or she is probably able to afford shooting in a 35 mm format. These days lower-budget productions will tend to work with some format of digital video rather than 16 mm although occasionally it is used for stylistic or aesthetic reasons. It is also more commonly seen in countries where the digital video solutions are less available or cost-prohibitive.

[7] Technically, "Super 35" can refer to a variety of formats that use the full aperture for their exposure, but in practice, Super 35 is used almost exclusively to produce images that are intended for projection in a 2.35 aspect ratio.

[8] The term "Cinemascope" is actually the name of a specific widescreen anamorphic format that 20th Century Fox developed in the 1950s. However, it seems to have become a generic term for the 2.35 anamorphic format that is now primarily created using **Panavision** lenses.

16 mm film is occasionally enlarged to 35 mm for theatrical release, usually when a studio decides that a low-budget film is worth giving a wide distribution. In situations such as this, it is certainly possible that digital techniques might be employed to fix specific problems that may be unsolvable by other means, and it is conceivable that original 16 mm negative will be scanned for compositing work. Another place where 16 mm film is used is as a source for television commercials. In this situation, however, the images are generally transferred directly to video via a telecine device. Thus, the resulting resolution and aspect ratio of the images produced will depend primarily on the video equipment you are using. Figure C.2 shows the size of the basic 16 mm frame, relative to the other formats. It also includes a box indicating the size of a Super 16 frame. The Super 16 format extends the frame into the standard 16 mm sound stripe area, resulting in a larger image. Both of these formats are still quite a bit smaller than even the standard 35 mm Academy framing, and will only be able to capture about 25% of the resolution.

Specialized Film Formats

There are a number of less common film formats that are usually reserved for special situations. These formats are generally designed to produce much higher-quality imagery via the use of a larger exposed negative. Large-format films require the use of cameras that are much bulkier, more expensive, and generally less reliable than standard 35 mm cameras, and as such their use is limited. These larger formats will sometimes be used as intermediate steps in the production of a standard 35 mm print, or they may be part of a "special-venue" presentation that is capable of directly displaying large-format films.

Again, the improved availability of high-resolution digital cameras is making these formats increasingly rare.

Vistavision

Vistavision (or VistaVision) was originally developed by Paramount studios in the 1950s as a proposed new widescreen format. As mentioned earlier, the process actually makes use of standard 35 mm film stock to capture imagery. However, in order to increase the resolution of the frames that are captured, specialized cameras that run the film sideways through the camera (instead of vertically) are used.[9] The 35 mm frame now limits the height of the image instead of the width, and consequently the camera can expose an area of the negative that is more than twice as much as that exposed with standard 35 mm film photography.

Although it never really caught on as a mass-distribution format, Vistavision was used for a time as a method for capturing high-quality negatives that were then optically reduced to standard 35 mm prints. Even this usage eventually became less and

[9] The Vistavision negative is actually formatted in the same way that a 35 mm still camera exposes its film.

less common, and after the early 1960s Vistavision was effectively obsolete as a mass-market system. However, the lure of a larger negative was enough to inspire visual effects people to start using the format again, and consequently it was used for a while (and may still be occasionally) as a method for capturing visual effects elements at a greater than normal resolution. Figure C.1 shows a Vistavision frame. Compared with the standard 35 mm Academy aperture, a Vistavision negative exposes about 2.7 times more area. The Vistavision format is often referred to as **eight-perf** because the area captured by a single frame spans eight film perforations.

65 mm

A wide-gauge film that is run vertically through a special camera, 65 mm is used not only for visual effects work but also occasionally as a source for films that will be presented in 70 mm.[10] 65 mm is also widely used as a format for a number of different special-venue situations. One of the most common of these is the **Showscan** method, which captures images at a rate of 60 fps instead of the normal 24, resulting in a dramatically improved image in which grain is nearly undetectable and flicker, or strobing, is virtually eliminated. Since a single frame spans five perforations of the 65 mm negative, it is also known as "five-perf." A five-perf negative will capture an image that is about 3.6 times larger than the standard Academy aperture.

IMAX

Another system that uses a 65 mm negative to capture its image is one created by the Imax Corporation. It runs the film horizontally through the camera and projector in the same fashion as Vistavision, producing an extremely large negative. Each frame spans 15 perforations of the 65 mm film, creating a negative that is more than ten times larger than a standard 35 mm Academy exposure. A size comparison can be seen in Appendix C's Figure C.2. Although this format is most commonly used when capturing imagery for IMAX productions, the basic 65 mm, 15-perf format is not really "the IMAX Format." Rather, IMAX is a complete system that includes image capture on 65 mm, 15-perf negative, projection from 70 mm, 15-perf prints, and carefully calibrated projectors, screens, and sound systems. Strictly speaking, one should only refer to "65 mm, 15-perf" when describing this format, but colloquially it is simply called "IMAX."

Digitizing some of these special formats via a high-resolution scanner will result in images that require an extreme amount of data for every frame of the image sequence. This problem may be even be further compounded by the fact that some of these

[10] You may see your local movie theater advertising a film as being "shown in 70 mm." This is a specification for the print being shown, not the size of the original negative that was used when shooting the footage. Ideally a 70 mm print was originally shot with some large-format negative, but there are no guarantees that this is the case. These days it is much more common that the original footage was shot with a standard 35 mm format and then optically enlarged to fit onto a 70 mm print. This results in a brighter, less grainy print, although it will still have less definition than something that was shot with a large-gauge negative.

formats are also used to capture stereoscopic imagery by using two cameras to photograph a scene. This stereo imagery essentially doubles the amount of information that is created for every frame.

Video Formats

Video is, in many ways, an even more ill-defined category than film, particularly since film technology has more-or-less ceased to evolve. New methods to capture, display, and store "Video" footage, however, are being introduced almost constantly and there is no end in sight for this process. Additionally, there are multiple different standards, many still being defined, for video storage and for video broadcast. Given these facts, the rest of this section also runs the risk of becoming substantially out of date within the next few years.

But for now we will attempt to define some broad categories, without delving into an inordinate amount of detail about how video works. Again, there is a bit more information given in Appendix C for those who are interested.

Unlike film, where one can easily grasp exactly how the image data is stored by simply holding the medium up to a light source, video is a fairly complicated subject. Before we can even begin to discuss specific video formats, we need to define a number of additional concepts.

Originally video was also an analog (albeit electronic) format. Its resolution for purposes of digital compositing work was primarily dependent on the hardware used to digitize the footage. Nowadays, however, most video is shot directly as digital footage and thus has a bit more regularity in terms of the various resolutions that are available. However "video," in all its various incarnations, does have a few unique characteristics (relative to general digital imagery) that need to be considered.

Fields

Although a frame of digital video still consists of a rectangular array of pixels, the way these frames are displayed to the viewer requires further explanation. When a video image is streamed to a display device, it is generally sent one row at a time, building up to an entire image. These rows (sometimes referred to as **scan lines**) will, in a fraction of a second, fill the screen with the entire image, which will then be replaced in a similar fashion by the next frame in the sequence.

A system that displays each successive line in a video image sequentially is known as a **progressive scan** format and this is almost certainly the way that most video will eventually be carried in the future. But there are also systems (and indeed all analog video systems such as NTSC) where a different method is used. Instead of displaying each subsequent line sequentially, every *other* line of the image is displayed first, creating an image that is the proper height but with only half as many scan lines. Every

other line is, thus, blank. Immediately after this initial image is displayed, the remaining scan lines are displayed in the same fashion, creating a second image composed of the alternate lines. Essentially we have two images displayed immediately after each other to produce a single frame. Each of these half-frames is known as a "field image," or simply a **field**. Each field is displayed for half the frame rate of the format with which we are dealing, so in the case of NTSC video (which runs at 30 fps), each field is displayed for 1/60th of a second.

Formats that use two fields to define a single frame are known as **interlaced** formats, and an image composed of two fields is known as an interlaced frame. Although this technique may seem a bit inelegant, it was created out of technical necessity. The limitations of CRTs and broadcast bandwidth, coupled with the need to prevent flicker via a reasonably rapid refresh rate[11] all contributed to the development of this standard. Although some of these issues are no longer a consideration given today's technology, limited bandwidth in certain systems (as well as historical compatibility) means that interlaced formats are still commonly used.

With digital video, the format specification generally includes an indication of whether or not the image is designed for interlaced or progressive display. Thus the term "720p" indicates video that will display 720 lines of resolution in a progressive fashion while "1080i" indicates that the 1080 lines of the image will be displayed as two fields (each with 540 lines).

Most compositing systems are set up so that the user can ignore the interlaced nature of video. Typically, the hardware that converts the video stream into a digital RGB image will be able to automatically interlace the field images together to produce a single normal frame. But there may occasionally be situations in which one wishes to deal with the distinct fields explicitly, and it will depend on the capabilities of your individual system whether or not this is possible.

Packages with this ability will allow the user to **deinterlace** a frame into two half-height fields and work on the images individually. This process will of course produce twice as many images. Usually one can choose whether or not to simply treat them as vertically squeezed anamorphic images or just temporarily resize them to full height. The advantage of working with field images instead of full frames has to do with the increased temporal resolution. Motion artifacts, particularly for elements that move quickly across the frame (horizontally), are significantly reduced.

Figure 10.6a shows two frames of an animated sequence in which a ball is moving across the screen, left to right. The same animation rendered to fields is shown in Figure 10.6b. Remember that even though the field images appear to be squashed in

[11] There was also the consideration that vacuum tubes would suffer from interference if they were scanned at a rate that differed from the frequency of the electrical system powering them. This is the reason why the NTSC system runs at 60 fields per second to match the 60 Hz of the US power grid versus the 50 fields per second of the PAL system, matching the 50 Hz of the European power grid.

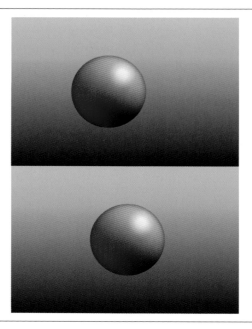

Figure 10.6a Two frames of an animated sequence.

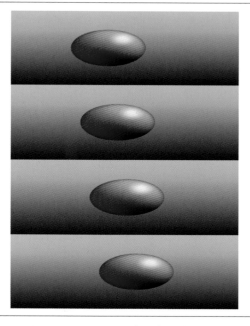

Figure 10.6b The same animation represented as four-field images.

our digital image format, they will be full height when displayed as a field image on a video monitor. As you can see, since we have twice as many images for a given time period, we can represent the movement more accurately. The result will be an animated element that has less flicker, or strobing, when viewed. On the other hand, we're actually dealing with less spatial resolution—each field image would have half as much detail as its full-frame counterpart.

Once you have finished working with the field images, your system should allow you to reinterlace them to produce a new full-height frame. Figure 10.7 shows what these new frames would look like. This result might appear strange if you are looking at only a single frame, but remember that this is really an artificial way of viewing these images. They will appear perfectly correct when viewed at the proper speed on a normal video display system. In fact, if you were to examine an interlaced frame from video of a live-action ball thrown across the screen at the same speed, you would see exactly the same sort of interlacing characteristics.

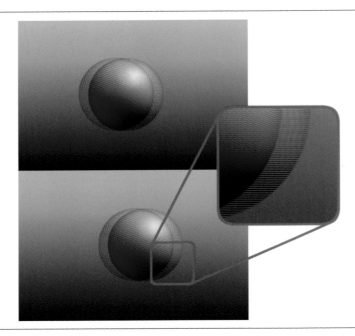

Figure 10.7 Field-rendered images from Figure 10.6b interlaced to produce two complete frames.

Color Resolution

Analog video signals have historically been sampled at 8 bits per channel when converting to digital as this was both quick and generally enough data to accurately

capture all the information in that signal. The standards for digital video, however, continue to evolve and most specifications now provide the ability to sample at either 8 or 10 bits per channel. Video also continues to use various color subsampling techniques like those we discussed in Chapter 3.

Gamma

Anyone who has worked with video imagery from a technical perspective has probably been exposed to the concept of video's "built-in" gamma. The gamma correction that becomes part of a video image during capture is actually a form of the nonlinear color encoding that we briefly mentioned in Chapter 3. It is primarily used as a way to maximize the available bit depth in an image, although it is also related to the way that a video display device (such as a television) converts a signal into an image. A complete discussion of this subject is beyond the scope of this chapter, and you should consult the more detailed coverage that is given in Chapter 14 if you desire additional information.

For the purposes of this section, it is sufficient to understand that standard video images include a gamma correction that is applied when the images are acquired. Typically this means that the video camera used to shoot a particular image applies this gamma correction before the image is written to tape or disk. For all the different video formats we discuss (including HDTV), the standard gamma that is applied is 2.2.[12]

The fact that all properly stored video images have a built-in gamma of 2.2 means that if they are transferred without modification to a digital RGB image in a compositing system, they will appear to be too bright. You may need to apply a compensating gamma of 0.45 (1/2.2) to bring them back into the normal range. Don't do this blindly, however. Make sure that whatever hardware you are using to convert video signals into digital images isn't automatically applying the inverse gamma, which is becoming the common practice.

Common Video Formats

Now that we've provided a bit of background on the basics of video, we can touch briefly on the specific formats that are commonly used throughout the world. As mentioned, we're in the midst of a transition from Analog to Digital in terms of broadcast standards but the basic formats for the standard-definition resolutions are pretty much the same. We'll just give some basic numbers here, mostly to point out

[12] Some of the standard documents for the PAL format actually specify a gamma of 2.8, although this generally seems to be ignored.

some things that related to the idiosyncrasies of the analog versions and will reserve a more in-depth look for Appendix C.

NTSC

The most common video format from a historical perspective is **NTSC**, the standard defined by the National Television Systems Committee. It is the video standard in the United States, as well as in Canada, most of Central and South America, and a few Asian countries.

NTSC is designed to display images with 525 lines of resolution at 30 fps.[13] It is an interlaced format, so in reality it is displaying field images at the rate of 60 per second. With NTSC, the first field contains all the even-numbered scan lines, and the second field contains all the odd. This is referred to as the **field dominance** of the format. NTSC, as mentioned earlier, is a squeezed format, and a pixel that is converted to an NTSC image will have an aspect ratio of 10:11. The aspect ratio of the full NTSC frame is 4:3.

PAL

The **PAL** video format was developed by Germany and is used throughout Great Britain, parts of Europe, several African and Asian countries, and Australia. It is designed to carry images with 625 lines of resolution, displayed at a rate of 25 fps, or 50 fields per second. PAL is the opposite of NTSC in terms of field dominance, since field 1 contains all the odd-numbered scan lines and field 2 has the remaining even lines. The aspect ratio of a PAL image is also defined to be 4:3 (the same as NTSC), which, given the fact that the vertical resolution of the format is different, implies a different pixel aspect ratio. In this case, it turns out that any square pixels that are sent to a PAL monitor will have an aspect ratio of 59:54—they will be slightly squeezed vertically.

SECAM

SECAM is a much less common format, developed by France and used in parts of Europe and Africa. Like PAL, SECAM is an interlaced system designed to run at 25 fps, carrying 625 lines of resolution. Unlike NTSC or PAL, SECAM is rarely used as a video storage format, or even as an intermediate format for editing. There is significantly less support for this format in terms of hardware, and generally most work in countries in which SECAM is the broadcast standard will use PAL as their primary format. The video signal will be converted to SECAM only when it is being broadcast.

[13] The official specification for NTSC playback defines the speed as 29.97 fps. The 30 fps is a fairly safe approximation for this discussion but there are certainly times where you will need to be aware of the true rate.

HDTV

HDTV is a somewhat general-purpose term for High-Definition Television—actually a set of standards for formats that carry significantly more resolution than those discussed above. (Which, collectively, are considered "Standard-Definition" video.) Being a much more modern standard, HDTV really has no historical analog equivalent so you will only need to be concerned about the digital version.

HDTV, being a collection of format descriptions, has provisions for either interlaced images or progressive scan. Most of the medium-resolution HDTV formats are progressive scan, but the high end of the specification also describes an interlaced HDTV format. HDTV is, mercifully, defined to be a square-pixel format, and has provisions for both 8 and 10 bits of color precision. It is considered to carry a built-in gamma of 2.2.

The most common HDTV resolutions that you will encounter in practice are probably 1920 × 1080 (either interlaced or progressive) and 1280 × 720 (usually always progressive).

Other Formats

Although we have just described several common formats related to film and video, as the range of devices and methods for viewing image sequences increases there will continue to be more and more "formats" that a compositor may need to deal with. These formats will vary in spatial and color resolution, aspect ratio, compression methods and general file formats. Every introduction of a new video camera seems to include some potential format variation as manufacturers attempt to balance data capture speeds with quality and features. One thing is certain, resolutions will continue to increase for some time. There is, for instance, already a format being proposed by NHK of Japan (labeled Ultra High-Definition Video, or UHDV) that provides a resolution 16 times greater than HDTV.

Working with Nonsquare Pixels

If you are working with formats that utilize nonsquare pixels, there are some special considerations that you will need to take into account. To illustrate some of these concepts, we'll use the most common anamorphic film format, the Cinemascope format. Everything we'll discuss applies equally to squeezed film or video, but we've chosen the Cinemascope format for our example because its two-to-one squeeze is the most dramatic and thus illustrates the concepts quite well.

Cinemascope footage is shot using a lens that compresses the image by one-half along the *x*-axis. If you examine a piece of film that was shot with a Cinemascope lens, you will see that everything in the frame appears to have been squeezed so that it is half as wide as normal. When it comes time to project this strange piece of film in a theater, another special lens (that makes everything appear twice as wide as normal) is used, and the image appears correct once again.

When planning to digitally composite images that were shot in this format, there are a few different routes one can take. Initially, your elements will probably have been scanned exactly as they appear on the negative. We say that they have been "scanned squeezed," and if you look at a frame of this on your computer it will indeed appear squeezed. Now, it is possible that you may choose simply to do your work directly on these squeezed images. When dealing with less extreme squeezes, such as video, this is a common scenario. (The caveat comes when it becomes necessary to rotate a squeezed element—we'll discuss this in a moment.) Working with squeezed Cinemascope elements can, however, be visually distracting, and properly judging movement is a skill that may take some time to develop. (Horizontally moving objects will appear to be moving half as fast as they normally would, yet vertically moving objects are going at the proper speed. Diagonally moving objects are particularly hard to judge intuitively.)

In an ideal world, the best way to deal with these squeezed Cinemascope images would be to immediately unsqueeze them—that is, scale them nonproportionally to restore their proper aspect ratio. In practice this method has drawbacks, in that you either must halve your y-resolution (thereby losing 50% of the information you just scanned) or must scale your image by two times in the x-direction (thereby doubling the amount of data to deal with, even though you haven't really created any extra sharpness or detail in your image).

The best solution is to find a compositing system that is capable of displaying the images as if they were in an unsqueezed format, while still processing the data in a squeezed format. Such a system uses either software or hardware to let you view the images as if they have been unsqueezed for all the tests that you are doing, yet still keeps and processes the images at their original resolution when producing the final composite. A well-designed system will be able to do this with little or no additional processing overhead.

Incidentally, we often refer to systems with the ability to do this temporary unsqueeze as being able to display nonsquare pixels. Don't assume that this means that the individual pixels you see on your computer's monitor will become squeezed or stretched. If you were to take a magnifying glass and look at these pixels, each would still appear to be properly proportioned. It's just that the system has applied a simple geometric transformation to nonproportionally resize the image so that it appears the same way as it will in its final form. The underlying image data has not been modified; it is only the *display* of these images that goes through this temporary process.

Most image processing and compositing operations will work just fine when applied to squeezed images. Simply layering of one squeezed element over another is no problem (assuming they are, of course *both* squeezed, and by the same amount), and things like color corrections will behave identically whether or not they are applied to squeezed imagery. But certain processes can be very problematic and will require special attention. Consider the issue of rotation.

Figure 10.8a shows the squeezed-image representation of a circular object placed in a standard Cinemascope frame. In this case, the extreme squeeze of this format has produced an image that is much narrower than it is tall. If we immediately send this image back to film and view it with the proper lens on our projector, it will appear round again, as shown in Figure 10.8b.

Figure 10.8a A circular object as represented in a standard Cinemascope film frame.

Figure 10.8b The image from Figure 10.8a as it will be projected.

But let's say we wish to rotate this squeezed element by 90° before pasting it over a squeezed background. Figure 10.9a shows what this rotation would look like if we had ignored the squeezed nature of the image and simply rotated it using our normal methods. If you think about it for a second you'll already realize that something's wrong here—the element no longer looks half as wide as it does tall. In fact it's quite the opposite, and Figure10.9b shows the result when we project it. We have suddenly generated an element that is drastically distorted, probably not the result we were looking for.

Figure 10.9a Circular, anamorphically squeezed image from Figure 10.8a rotated 90° without first unsqueezing it.

Figure 10.9b Figure 10.9a as it will appear when projected, showing unwanted distortion.

To avoid this problem we would need to first unsqueeze the element, rotate it, and then resqueeze it along the *x*-axis. The result of this process would produce the image shown in Figure 10.10a. Projecting *that* image gives us something like what we see in Figure 10.10b—much better. Although these examples are extreme enough to produce very obvious problems, many times you'll be dealing with much smaller rotational values and the distortion will be equivalently less. Figure 10.11 shows the result of only rotating Figure 10.8a by 5° before unsqueezing. You can still see that something is wrong but it is much more subtle and would be even more so if it wasn't happening on a perfectly round subject. The best advice, then, is to double-check everything if you are working with nonsquare pixels in order to ensure that these sorts of problems don't sneak into your final result.

Most spatial filters such as blurring will also need to be treated differently if you are working with squeezed elements. Thus, blurring a squeezed element by an equivalent

Figure 10.10a The proper rotation of Figure 10.8a, taking into account the 2:1 squeeze of the anamorphic image.

Figure 10.10b Figure 10.10a as it will appear when projected.

Figure 10.11 Figure 10.8a rotated 5° and then unsqueezed.

amount in x and y will result in an unsqueezed element that appears to have too much blur along one axis. If you have access to a blur algorithm that allows you to control both the vertical and the horizontal blur, you can adjust the relative amounts to compensate for any image squeeze.

The best compositing systems will usually be able to automate these tasks, allowing you to specify a working aspect ratio either for a specific operator (like rotation) or for the entire compositing session. The system will then automatically deal with the related issues, performing the unsqueeze/resqueeze process when rotating squeezed elements or transparently adjusting any other parameters for operations that require it.

Keep in mind that these issues can arise whether you are dealing with film or video. Because the amount of squeeze that is typical for video is much more subtle than for film, it is easier to overlook the fact that you are working with squeezed images. Many video systems automatically unsqueeze elements when transferring them from video to the computer and back, meaning that you will run into problems if you apply an additional unsqueeze. As always, be aware of the idiosyncrasies of your particular system.

Converting and Combining Formats

We've tried to give a very broad overview of the wide variety of formats that you may encounter. Depending on your particular situation, you may never need to deal with most of these formats. On the other hand, you may find yourself working on a composite in which you need to combine several different formats at the same time. Usually this doesn't present much of a problem, since the different images can just be scaled as needed. A mixture of squeezed and unsqueezed images will obviously require you to determine a working aspect ratio and then to conform everything to that standard. There may even be times when you wish to combine film and video in the same image.

You may also be required to output to several different formats as part of what you deliver. And this support for multiple formats is more than just a file-format conversion. Consider the case where the different formats have significantly different aspect ratios—for instance if you have material that was shot in a 16:9 aspect ratio but needs to be displayed at an aspect ratio of 4:3. In this situation there is an aesthetic decision to be made for how the imagery is converted. We generally cannot simply resize the first image to fit into the aspect ratio of the second since this would introduce an undesirable squeeze to the image.

Consider the image shown in Figure 10.12. This is the full frame of the image that we looked at earlier, and it has an aspect ratio of 4:3. Creating wider aspect ratios of this image are easy enough—we can simply crop some area off the top or bottom. Figure 10.13a shows a 16:9 extraction from the original and Figure 10.13b shows a 2.35 extraction. (Both of these examples were extracted from the center of the image, also known as **center extraction**.) Already we can see that certain decisions need to

be made when converting from one aspect ratio to another. We are obviously throwing away image data and consequently the nature of the image changes. Particularly with the more extreme 2.35 extraction we have produced an image that isn't nearly as well framed as the original. We could certainly choose a different extraction—Figure 10.13c is also a 2.35 extraction but at least it keeps all the blades of the windmill in the frame and might thus be considered more acceptable.

Figure 10.12 An original image with a 4:3 aspect ratio.

Figure 10.13a A 16:9 extraction from Figure 10.12.

Figure 10.13b A 2.35 extraction from Figure 10.12.

Figure 10.13c A different 2.35 extraction, with better framing of the subject.

It gets even more interesting if we need to convert from a wider format to a more square one. If, for instance, we had shot this image originally on High-Definition video it would look much like what we saw in Figure 10.13a—an image with a 16:9 aspect ratio. If we now want to convert it to a 4:3 format, we could crop data from the sides of the image instead, giving us something like we see in Figure 10.14.

But, again, this has caused a fairly significant change to the image. It may not be particularly problematic in an image such as this, but consider the scenario of a widescreen image where two characters are speaking to each other while standing at either side of the frame. Cropping a less-wide aspect ratio image out of this source may very well remove one, or even both, of the characters—probably not what the director/cinematographer intended!

Figure 10.14 A 4:3 extraction from the 16:9 frame in Figure 10.13a.

Figure 10.15 Letterboxing the 16:9 frame to produce an image with a 4:3 aspect ratio.

There is another method that can be used instead, and it involves scaling the entire image down to fit into the frame we need to work with and then padding the extra areas with black. This second method is typically known as **letterboxing**, and an example of taking our 16:9 image and placing it into a 4:3 frame using this method is shown in Figure 10.15. All of the imagery from the original frame is there but the picture is smaller and we now have black bars at the top and bottom.

Since this method, too, isn't always desirable there is actually a third technique that comes into play. Known as **pan and scan**, this method creates an *animated* crop region that moves back and forth over the frame as appropriate. In the case we're looking at, the crop might start showing a 4:3 crop from the left half of the image (shown in Figure 10.16a) and, over a period of time, will move to the framing shown in Figure 10.16b. The success of this technique is extremely dependent on the nature of the original footage. When done well it can be nearly invisible, giving the impression that the original camera operator was moving the camera in such a fashion when the footage was originally shot. But many shots will already have a camera move that can conflict with any additional pan and scan or happen too quickly to be appropriate for such a process.

Given these issues, many films are intentionally shot with multiple delivery formats in mind. Framing will often be done a bit more "loose" (wider) so that there will be more options when converting to a different format. For instance, often a film will be photographed with the intention to project in a widescreen format but the camera will actually capture additional (unimportant) image at the top or bottom or both. These extra areas will still need to be free from the typical lights, stands and cables found on a film set and as such they are referred to as "protected" areas of the image. In many cases, animated films will even be rendered to the largest necessary format, allowing for eventual scaling and resizing into the various distribution formats.

Converting Between Film and Video

Although this chapter gave a number of examples of how formats might be converted throughout the compositing process, there is a particular conversion that bears further scrutiny: the film-to-video conversion and its reverse, video to film. This conversion is problematic primarily because of the different frame rates that the formats in question use, particularly when converting between NTSC video at 30 fps and standard film at 24 fps.

In Chapter 7 we discussed some general-purpose methods for converting between different frame rates, but the specific conversion between film and interlaced video occurs often enough that a well-defined standard process has emerged. It involves taking a film frame and converting it to two fields of video, and then taking the next film frame and converting it to three fields of video. This alternating creation of two

Figure 10.16a A pan-and-scan 4:3 extraction from the 16:9 frame—start frame.

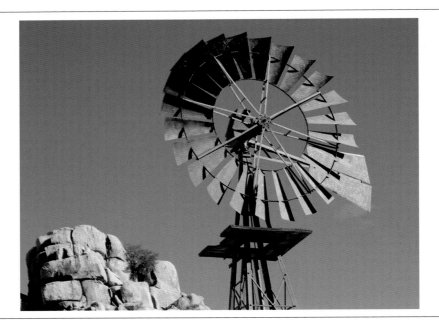

Figure 10.16b A pan-and-scan 4:3 extraction from the 16:9 frame—end frame.

and then three fields in order to synchronize film timing to video (NTSC) timing is known as a **2:3 pulldown**.[14] A diagram of this process is shown in Figure 10.17.

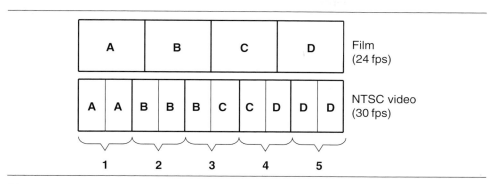

Figure 10.17 The 2:3 pulldown conversion.

Film frame A is used to create both fields of our first video frame. Film frame B is used to create both fields of video frame 2, and also the first field of video frame 3. Film frame C is then used to create the second field of video frame 3, and also the first field of video frame 4. Finally, film frame D is used to create the second field of video frame 4 as well as both fields of video frame 5. As you can see, 4 film frames will make up exactly 5 video frames, and thus 24 film frames will make up 30 video frames.

Converting between film at 24 fps and PAL video (25 fps) can be done in one of two ways. The simplest method is to do a straight frame-for-frame transfer between the two, so that any given film frame corresponds directly to a certain video frame. This will obviously change the speed of any motion in the footage that is being transferred, but the speedup is only about 4% and is fairly subtle—subtle enough that the simplicity of the process makes it worthwhile. (Not to mention the fact that any movie that is transferred to video for television broadcast will be 4% shorter, giving more room for commercials!) But if a more accurate transfer is needed, a 25th video frame will need to be generated from the 24 film frames. Merely duplicating one of the frames would be visually noticeable, so instead two additional video fields are created, one from the 12th film frame and the other from the 24th.

These frame-rate conversions are usually accomplished by special telecine hardware that deals with both the digitization of the film and the pulldown. The process of going from video to film is much less common, but would follow the same logic for the speed change, in this case deinterlacing video fields in order to produce film frames. For the case of NTSC to film, the process is known as a **2:3 pullup**.

[14] This is pronounced "two-three pulldown." You may also hear it referred to as 3:2 pulldown, which theoretically indicates that the first frame is converted to three fields and the second frame is converted to two. In practice the terms are usually used interchangeably.

If film is being shot with the sole intention of transferring it to video, then the film camera can often just be adjusted to shoot at the appropriate frame rate, 30 fps or 25 fps, and any pulldown conversions can therefore be avoided. Many film cameras can actually be set to shoot at exactly 29.97 fps to perfectly match NTSC's rate.

Although the use of pulldown and pullup techniques to convert between frame rates is still fairly common, it is rapidly being displaced by more sophisticated methods that use optical flow technologies. As mentioned in Chapter 7, these tools can analyze the motion of all pixels in an image and create intermediate frames based on selective warping. The same sort of algorithms can also be extended to deal with field-to-frame conversions in a much better fashion.

Quality and Efficiency

The intent of this chapter is to now take a step beyond the basic processes involved in digital compositing and to start discussing how to apply all our tools to produce the highest-quality images in as efficient a manner as possible. In fact these two topics—quality and efficiency—are so co-dependent that it makes sense to discuss them together, in the same chapter.

Even though we are taking the time to devote an entire chapter to the topic, we hope that you have already noticed a number of quality and efficiency issues that were raised in earlier chapters of this book. In fact, many of the examples will touch on concepts that have already been covered elsewhere, allowing us to explore the issues more fully and, ultimately, to fully indoctrinate you into the obsessive mind-set that the best digital artists practice on a daily basis.

Quality

In an ideal world, there would be time and budget enough to produce perfect composites for every job on which you work. After all, nobody gets into the business of digital compositing without having some kind of desire to do quality work. Unfortunately, the people *paying* for the work may not be as interested in the quality as they are with some other aspect, such as speed, quantity, or cost. The term "quality" is certainly subjective. Most compositing work allows for a great deal of personal aesthetics to be brought into the mix, and ultimately this book will never be able to fully identify exactly what constitutes a quality image. But there are certain absolutes of quality that can be identified. In particular, any technical artifacts or imperfections that are independent of artistic judgments will need to be addressed.

There are any number of these potential defects—aliasing artifacts, contouring, mis-aligned mattes, animation glitches, scene-to-scene discontinuities, mismatched colors,

data clipping, and so on. Some of them (such as color mismatching) might bridge the categories of artistic and technical problems, whereas others are clearly a problem by any objective measure. The determination as to what is considered to be acceptable quality for a given job may ultimately be someone else's decision, but please don't rely on others to find technical flaws for you!

Efficiency

There is an old (rather cynical) adage which states that, given the categories of speed, cost, and quality, you can only have two of the three options. Fortunately, efficiency is an excellent way to cheat this rule and produce high-quality composites on time *and* on budget.

Efficiency is a matter of maximizing your available resources. No matter what your scenario, whether you are compositing a single frame on the obsolete PC in your basement or you are using thousands of CPUs to put together a 5000-frame composite for the next Hollywood blockbuster, your resources will always have a limit. The understanding of this limit, or, more properly, the understanding of the numerous limits that each piece of your compositing toolkit has, is the first step towards understanding where efficiencies can be introduced. Very few processes are inherently efficient, and it is up to the compositing artist to modify his or her methodologies so that he or she is able to produce work within the necessary time and budget.

Even though efficient working methods will save time and money, there is no reason why they should cause any loss of quality. In fact, many times we find that careful attention to producing an efficient compositing script will actually result in a higher-quality image than one generated from a hastily created script.

Production Methodologies

In some ways it is impossible to teach someone exactly how to choose the best method for a given job, since every job is different. However, it is possible to discuss commonly observed problems and impart some sense of things that should be avoided. We will concentrate on things that can be done to make a compositing script more efficient, while being as certain as possible that we are not degrading the image in any way. The discussion will include not only the actual compositing operators used, but also issues related to disk, CPU, and memory usage. Many times we can only give general guidelines, since certain things will depend on exactly what software and hardware you are using to complete your task.

For most of the discussions about efficiency, we'll be talking about methods to increase the productivity of the software and hardware that we are using. But determining the most efficient method for creating a composite involves not only weighing the amount of processing time the computer(s) will need to spend on a particular

composite, but also estimating how much of the operator's time will need to be spent to set up the process. Compositing artists, whether working alone or as part of a larger team, need to remember that they have a certain cost associated with the time they spend on a project—and that these costs are just as real as the cost of the computer's time. You will constantly be making decisions that trade off the amount of time you can spend on a problem versus the processing time it might take to solve it in another fashion.

Many problems can certainly be solved by brute force. You may find that you can spend 20 minutes quickly setting up a process that will then take 8 hours to run on the computer. Or you could spend an hour setting up a much more elegant and efficient process that will only take the computer 2 hours to process. How do you decide which path to take? There is no definitive answer, of course. If it's the end of the day and you know that nobody will be using your computer overnight anyway, you'll probably choose the solution that takes less human time and more computer time. If, on the other hand, it's the beginning of the day and you need to produce imagery by that afternoon, the time spent setting up a faster-running process will be worth the investment. This may seem like common sense (and if you're an experienced compositor it had better be!) but it is always important to remember that just about any process will have these sort of trade-offs.

The ability to consistently make these sorts of decisions (often referred to as **production sense**) is something that generally only comes with a fair amount of experience, but we can certainly discuss a number of the issues involved. As mentioned earlier, we always want our quest for efficiency to be driven by our quest for quality. Consequently, let's start with a look at how even the most simple compositing process can be susceptible to drastic image-quality problems if one is not careful.

Minimizing Data Loss

There is a popular misconception that working with digital images means that one need not be concerned with decreased quality whenever a multitude of image manipulations are applied. This is such a pervading fallacy that it must be refuted immediately; in a large bold font:

> **"Digital" does not imply "lossless."**

Now if you've been paying any sort of attention while reading the previous chapters this should come as no surprise but we'll go ahead and flog the topic a bit more. Certainly, digital compositing is a much more forgiving process than the optical compositing process, in which every step can cause significant generation loss. But even in the digital realm, data loss is generally something that can only be minimized,

not eliminated (hence the title of this section). Just about any image processing or compositing operation loses some data. There are a few exceptions to this rule, such as channel reordering or geometric transformations that don't require resampling, but in general even the most innocuous operation will, at the very least, suffer from some round-off error. Unfortunately, whether this data loss will actually affect the quality of your composite is nearly impossible to predict in advance.

Whenever we begin a composite, we have a fixed amount of data available. All of the images that will be used are at the best resolution (spatial, chromatic, and temporal) that we are able to justify, and now the process of integrating them begins. Note that we talk about the "best resolution we are able to justify." What does this mean, and how do we decide such a thing? The bottom line is that we should try to work with the least amount of data necessary to produce a final result that is acceptable. Once again we're walking the fine line between having enough data to produce the quality we desire without having to process more pixels than is necessary. Choose too low a spatial resolution and you will have an image that appears soft and out-of-focus. Choose too low a chromatic resolution (bit depth) and you may start to see quantization artifacts such as banding and posterization. Even if the original source images appear to be of an appropriate quality level, once they are processed by multiple compositing operations these artifacts may show up.

The tempting solution might be to start every composite with very high-resolution images. But if our final result is intended for playback at a resolution of 640 × 480 pixels, we would be foolish to process all the intermediate steps at 4000 lines of resolution. Instead, we would probably choose to initially reduce all the elements to a resolution of 640 × 480 and then work directly with these images instead. As long as we pay attention to the various steps, we should be fine working with the lower resolution, and we will certainly have reduced the amount of time and resources necessary for the work. The trade-off decision about what resolutions are necessary must be made for every composite, although often it may make sense to standardize to a set of particular formats in order to reap the benefits of consistency and predictability.

There are no guarantees or formulas that let one definitively determine if a specific input resolution is high enough for a given composite. But not only will choosing an excessively high resolution cause a great deal of wasted man- and CPU-hours, it still will not guarantee artifact-free images. It is actually quite simple to produce a compositing script that causes data loss even if the input images are high resolution and at a reasonably high bit depth. This was briefly touched on in Chapter 3 but we'll give another example here to underscore the point. Consider the images shown in Figure 11.1, where we have an original image, a 2nd image that is the result of applying a brightness of 2.0 to that first image and then a 3rd image which was created by applying a brightness of 0.5 to the second. This was done using a 16 bit-per-channel workflow that can only keep track of color values in the normalized range 0–1. As you can

see, a significant amount of data was lost—anything in the original image that was above a mid-tone brightness ends up clipped to grey. A graph of the result of this two-step operation is shown in Figure 11.2 and we can see that all the information in the brightest parts of the image has been clipped to a uniform value of 0.5.

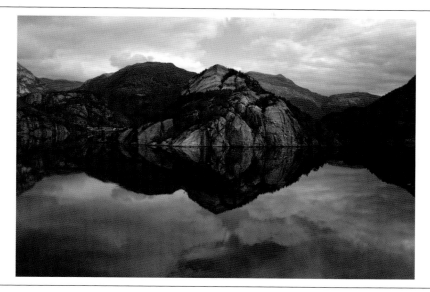

Figure 11.1a An original source image.

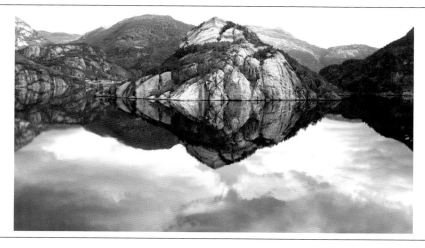

Figure 11.1b Figure 11.1a after applying a brightness of 2.0.

Figure 11.1c Figure 11.1b after applying a brightness of 0.5.

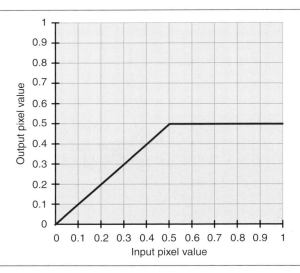

Figure 11.2 Graph of the data loss as a result of the two operations described in Figure 11.1.

Any time we need to layer multiple operations on top of each other, we must be aware of what can happen to the data in terms of overflow and round-off, particularly when working in a non-floating-point system. In certain situations your software may be smart enough to analyze multiple color corrections like this and consolidate

these expressions into a global, more precise algorithm. (In the example just given, the two color corrections would cancel each other out.) This ability to automatically consolidate similar operators can make a huge difference in image quality and, in many cases, can even increase the speed of your compositing session because redundant operators are eliminated. As usual, the best advice is to test the behavior of the system yourself so that you know exactly what to expect. The ability of software to automatically deal with this sort of thing is very useful, but as you will see elsewhere in this chapter, an intelligent compositing artist can usually modify a script to avoid these problems in the first place and will be able to introduce efficiencies that an automated system cannot.

Although the example was designed to show data loss when information is pushed outside the range of what your compositing system can handle, similar loss can occur anywhere if you are not working with enough precision. This possibility raises the issue of exactly how a given compositing system maintains the data with which it is working.

Internal Software Accuracy

In the previous section we looked at an example of data loss that can occur when working with an integer-based data representation. Specifically a system where there is a minimum value of 0 for the darkest possible value of a pixel and a maximum value of 1.0 for the brightest possible value. But, as mentioned in Chapter 3, the ability to represent image data with floating-point values[1] is a much better option.

Unfortunately, not all systems are capable of a full floating-point pipeline. There may be certain operators that are not floating-point compliant (which will mean that information passing through these operators will be truncated to the range 0–1) and even if the compositing system itself is fully floating-point, 3rd party "plugins" may not share the same extended-range model. As this can be a significant source of data loss, it is important to be aware of the internal accuracy of all the components in your system.

On the other hand, there have been a huge number of digital composites done using fixed-range 16 and even 8 bit-per-channel images that look perfectly acceptable. And in fact 8-bit images can be visually indistinguishable from 16- or 32-bit images, particularly if the image contains the noise, grain, and other irregularities that are inherent in a digitized image from an analog source such as film or video. But rarely will we simply input an image and then immediately send it to its final destination. Rather, we will add multiple layers of image processing operations, color corrections, image combinations, and so on until we come up with our final result. It is during this multitude of additional processing that greater bit depth becomes useful. Each

[1] Although the typical bit depth used to represent a floating-point image is 32 bits per channel, this is not an absolute requirement. A 16-bit floating-point is also used in places and is sometimes known as "half precision floating-point." The OpenEXR file format (discussed in Appendix B) can represent values in this fashion, for instance. Some graphics cards can also work at this precision.

step will cause a minute amount of data loss (at least), and eventually this loss will start to manifest itself visibly if there is not enough color information available. Limited-bit-depth systems may be perfectly acceptable for simple composites without a large number of elements or processing steps, but once we need to push things to the extreme, they can rapidly fall apart.

Of course working at higher bit depths does not come without a cost. Double the precision and you double the amount of data that needs to flow through your system, which can slow things down and require more memory. Although the trade-off is usually worth it (particularly with the ongoing advances in processor speeds and decrease in memory costs), some systems will still allow you to select the accuracy that is used to compute some or all of your compositing operations. Be aware too that some systems may automatically choose the processing accuracy based on the images that are being fed into it. For instance, if your image is only an 8-bit image, the system may assume that any further operations can also be done at 8 bits. Generally these assumptions can be overridden.

As mentioned earlier, the advantage of working in a floating-point system is not just to ensure higher precision. Rather, it becomes necessary if we wish to represent images in a fashion that is more accurate relative to the way that the real world works, where there is no upper limit on the brightness a scene can have. From a workflow perspective, there are some other key differences between an integer and a floating-point system. The compositing artist needs to worry less about any data clipping that might occur when extreme color corrections are applied to an image. For instance we can now double the brightness of an image and not lose all the data that were in the upper range of the image. A pixel that started with a value of 0.8 would simply be represented with a value of 1.6. For purposes of *viewing* such an image we will still usually represent anything above 1.0 as pure white, but there will actually be data that is stored above that threshold. At a later time we could apply another operator that decreases the overall brightness of the image and brings these superwhite pixels back into the "visible" range. The same thing holds true, of course, for pixel values that dip below 0, although the analogy with the real world is less apt since ultimately there IS a minimum amount of light that any scene could have (the complete absence of photons) and there is really no equivalent to a "negative" illumination value.

It should be noted that many compositing operators may also behave less predictably (or at least intuitively) when working on data that is outside the range 0–1. Consider the "gamma" operator that we first looked at in Chapter 4. If we have an input pixel value of 1.1 and a gamma of 0.4 then the output pixel will have a value of 1.27. This might be unexpected to someone who is familiar with the normal-range behavior of the gamma operator where a gamma of less than 1.0 will tend to darken the image. And indeed every pixel in the image with a value between 0 and 1 *will* still grow darker, but everything above the value of 1.0 will be *increased* instead. A graph of this is shown in Figure 11.3.

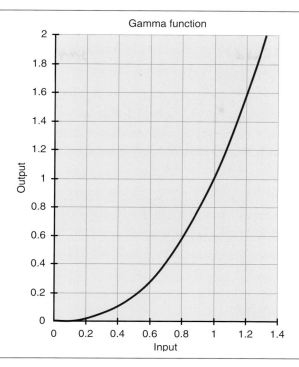

Figure 11.3 Graph of applying a gamma of 0.4 to an input range 0–1.4.

Even more problematic may be the behavior as our input value increases or our gamma value decreases. If we have a pixel with a value of 4.0 and apply a gamma of 0.2, the output pixel value will be over a thousand! Negative numbers may introduce even stranger results.[2]

Masks may also behave differently when working with floating-point images, particularly if the mask itself contains values outside of the 0–1 range. Some compositing systems will automatically clamp mask values, others may not. (And in fact it may not always be desirable to do so.) Thus, you may want to make sure you explicitly clamp any image before it is used as a mask, either by limiting its range or by converting it into a non-floating-point image. Because each compositing system is different there is no way to predict exactly what behavior may show up when you apply any given operation on a floating-point image. Even things like sharpening

[2] If we use the definition of gamma given in Chapter 4, for instance, all negative values would be converted to positive values once the gamma is applied. Since a compositing artist would likely find it both unintuitive and disturbing for all of their superblack values to suddenly become superwhite after applying a gamma operator, many systems modify the rule so that negative input values return negative output values. Even so, the results are likely to surprise someone if they are transitioning from a traditional fixed-range system.

or resizing an image may introduce unexpected results. Once again it is up to the compositing artist to be aware of the specifics of the system being used.

Consolidating Operations

The purpose of this section is to discuss situations in which certain compositing scripts can be modified in order to eliminate unnecessary operators. Whether a given operator is necessary will not always be an objective question, but initially we will look at scenarios in which two operators can be replaced by a single operator without any change to the resultant image whatsoever.

Figure 11.4 A simple script for applying a brightness of 0.5 to an image.

For instance, let's take the extremely simple case of an image with a brightness effect applied to it as represented by the diagram in Figure 11.4. In this example, we have applied a brightness of 0.5 to the original source image. Let's say that we look at the resultant image produced by this script and decide that we need the brightness decreased by another 25%. There are two paths we could take: Either we add a second Brightness operator with a value of 0.75 (Figure 11.5a), or we modify our existing brightness tool and decrease it by an additional 25%. Doing the math, we take $0.5 \times 0.75 \times 0.375$. This route is shown in Figure 11.5b.

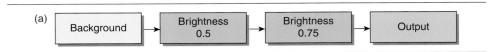

Figure 11.5a Two options for modifying the brightness of an image. Using two separate Brightness operators.

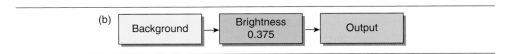

Figure 11.5b Using a single, consolidated Brightness operator.

Perhaps it is obvious that the preferred method would be to recalculate the proper numbers and modify the existing brightness effect. This will leave us with a simpler script, and the process may even run more quickly since it is only processing a single operation instead of two. This is a very simple example—once your script begins to have more than just a few layers, these sort of decisions can become much less obvious.

Whenever one is creating a multiple-level compositing script, it is dangerously easy to add a new operator every time a modification is necessary. Before you add another layer to a script, stop to ask yourself if the layer is truly necessary, or if the same (or a visually similar) effect can be accomplished by modifying one of the existing layers. Compositing scripts have an uncanny ability to grow excessively, and unless great care is taken to simplify whenever possible, you will end up with a script that is not only incomprehensible, but also full of image-degrading problems.

Our ability to simplify the previous script relied on the fact that we knew that two Brightness operators could be "folded" together. Since the Brightness operator is merely a multiplier, this consolidation is straightforward. One cannot always assume that this is the case and in fact certain operators can't be combined in the same fashion. For instance, replacing two identical sharpen operators in a row with a single operator that specifies twice as much sharpening will actually give a slightly different result (although usually the difference isn't enough to worry about, as we'll discuss in just a minute). If you're not sure you can get away with it, do a visual check.

Many compositing systems are able to analyze scripts and automatically simplify the math before they run the process. On such a system, you might in fact not have any significant speed difference between the two examples we showed in Figure 11.5. Such automatic optimization can only go so far, however, and to rely on it will inevitably produce code that is less efficient. Even the best optimization routines will probably be limited to producing images that are exactly what would be produced by the unoptimized script. A good artist, however, can look at a script and realize that two layers can be consolidated to produce an extremely similar, but not identical, image. The decision can be made to accept the slightly different image in the interest of a significant speed increase. But please, be careful not to compromise image quality in blind pursuit of the most efficient script possible!

Let's look at a slightly more complex example to discuss other areas that can be simplified. Consider the compositing script shown in Figure 11.6. We have a foreground element with several effects layered on it, and a background element with a few different effects on it. The first branch is then placed over the second.

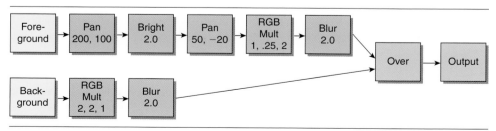

Figure 11.6 A more complex compositing script involving two different source elements.

Close examination of the script will reveal obvious inefficiencies. First of all, there is a Pan operator on the foreground element in two different locations, each offsetting by a certain number of pixels. These pixel offsets can be added together to produce a new, consolidated offset value, as follows:

$$(200, 100) + (50, -20) = (250, 80)$$

Also, we have both a Brightness and an RGB Multiply in our script. If you recall the definition of Brightness, you'll remember that it is effectively the same as an RGB Multiply, except that the same value is applied to all three channels equally. Therefore, we really have two different RGB Multiply operators, the first of which applies a multiplier of (2.0, 2.0, 2.0) to the image, and the second of which applies a multiplier of (1.0, 0.25, 2.0) to the image. These two operators can be multiplied together to consolidate their values, producing a new RGB Multiply of (2.0, 0.5, 4.0). Finally, the Blur operator on both images is the same value, so we can simply move it after the Over, so that it only needs to happen once, instead of twice.[3] We've just eliminated three operators, producing a faster, more comprehensible, and higher-quality script, as shown in Figure 11.7.

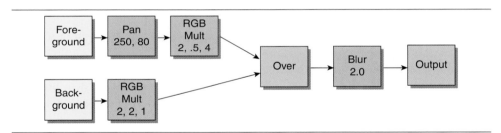

Figure 11.7 Consolidation of operators to create a simplified version of the script from Figure 11.6.

Now, let's assume that your supervisor takes a look at the sample test image your script produced and tells you that it looks twice as bright as it should. The tempting solution would be to simply apply a Brightness of 0.5 to the top of the script, after the Over, as shown in Figure 11.8. However, a much better solution, particularly in light of how much we're boosting the image in some of the earlier steps, is to go back and modify the RGB Multiply on both elements before the Over, again consolidating our correction into the existing operators. Thus, the script becomes as shown in Figure 11.9.

[3] Strictly speaking, this particular rearrangement will not produce an identical image. However, the trade-off in speed will be considerable, and in fact it is generally considered visually better to blur two elements together instead of blurring them separately and then combining them. Thus, this is a good example of a consolidation that would probably not be caught by an automatic system, but that would be obvious to an experienced artist.

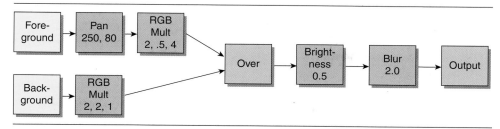

Figure 11.8 The script from Figure 11.7 with an additional Brightness operator.

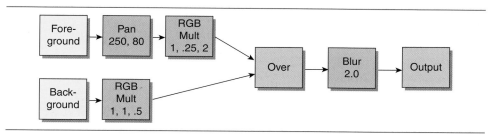

Figure 11.9 The script in Figure 11.7 with consolidated operators.

Of course not all scripts have such obvious places where you can simplify, but situations such as the one presented in this example will be quite common. What's more, when working on a large, multilayer composite, you should always keep an eye out for places where you can rearrange things to produce even greater efficiencies. Ideally this will be done before you fine-tune the composite, since this will give you more flexibility to change things without worrying about the effect on a "signed-off" element. Understanding the math behind various operators is important if you wish to make educated decisions on layer consolidation. Remember that the result produced by multiple operations will often be order dependent, and simply changing the order of two operators could radically affect the output image.

Recognize that there are always trade-offs for how long it may take to simplify a script compared with the time it may take to run the unsimplified version, but know that ultimately, if you are careful to think about efficiency every time you modify your script, you will be far better off once it grows to a huge size. Be aware of the entire process, not just the particular step with which you are dealing.

Incidentally, if you think that the relentless pursuit of simplified scripts is a bit too obsessive, consider the fact that even medium-complexity scripts can include dozens or even hundreds of different layers and operators. Again, refer to Figure 15.27 in Chapter 15 for an excellent example of a real-world script. Although large, it is actually a very clean script, produced by an experienced compositor. There is little if any room for additional efficiency modifications. Imagine how a script for a scene of this complexity would look if it had been produced in a more haphazard manner, without careful attention to issues of speed and quality!

Region of Interest

One of the most important things a compositing artist can do to increase productivity is to make sure that compute resources aren't spent on unnecessary calculations. We've discussed a few different ways to avoid excess computation, but one of the best methods is to utilize a **region of interest (ROI)**. An **ROI** is a user-specified rectangle that can be used to limit certain compositing calculations to within its boundaries (often temporarily). Using the ROI to limit calculations is done primarily as an intermediate step in a composite, that is, when one desires to concentrate on tuning a particular area of the full image.

Very often you may find yourself in a situation in which you have balanced most of the composite to your satisfaction, but there is a small area that needs more work. By specifying an ROI that surrounds only this small area, you are allowing the computer to deal exclusively with the pixels you choose. No extra CPU time will be spent to compute portions of the image that you do not need to modify. A well-implemented ROI can produce a huge increase in compositing speed. Complex composites may have a number of elements that fall outside of any given ROI, and the compositing engine will be able to completely ignore these elements when working only within the ROI. Ideally your software will let you interactively define and redefine the ROI as needed, but if it is not this flexible, or does not explicitly support ROI functionality, you may still gain similar benefits by pre-cropping the elements to a region that features the area in which you are interested. You can tune your parameters with this lower-resolution image and then apply the values you prefer to the original uncropped composite. Be sure to go back and test the full image once you have tuned the area defined by the ROI, since there is a chance that something you did may have affected an area outside of the ROI.

Many of the better compositing packages are also able to use a similar calculation-limiting feature known as a **domain of definition**, or **DOD**. A DOD is usually defined within any given image as a bounding box that surrounds nonzero pixels. For instance, if you render a small CG element inside a fairly large frame, the rendering software may include information in the file header that specifies a rectangle that surrounds the element as tightly as possible. This DOD can then be used by the compositing software to limit calculations in the same way as the ROI. While both the DOD and the ROI are used to limit calculations, they are not the same thing. The DOD is generally an area that is automatically determined by a piece of software, based on the information in a specific image. The ROI, on the other hand, is chosen by the user and may be redefined as needed.[4]

[4] The terms ROI and DOD are often used interchangeably or, more commonly, ROI is used to refer to both concepts. But in the interest of trying to standardize the grammar within the industry, we'll make the distinction as stated.

Working in a Networked Environment

While the bulk of the high-end film compositing work being produced these days is done at facilities with hundreds or even thousands of computers on a network, many smaller shops, even single-person operations, now have access to more than a single stand-alone computer system to help store data or process imagery. The physical connections between these machines will vary quite a bit, but there are certain guidelines that can help you deal with a group of networked computers as efficiently as possible. Generally, the network between any two computers will be much slower than the local disk drives on those machines.[5] As such, it usually makes sense to be aware of where your files reside. Although the goal of most good networks is to present a file system that behaves similarly whether files are local or remote, it is important to be able to distinguish between local and remote files. Ideally, if you are trying to get feedback on your composite as you are tuning parameters, you will have the source files local to the computer at which you are working. If this is impractical due to disk limitations on the local system, then you may find it worthwhile to make local copies of certain files that you are spending a large amount of time accessing.

A number of other considerations need to be kept in mind when working in a networked environment, but since they are not strictly compositing related, we will not go into much more detail. Suffice it to say that issues related to data sharing, concurrency control, and bandwidth maximization should all be considered.

Disk Usage

Disk space is another limited resource that you will need to keep an eye on. Throughout this book we've discussed a number of things that can help with managing disk space, including compressed file formats, single-channel images, and the use of proxies. But you should also be constantly looking for opportunities to discard data that is no longer necessary. If your source images started at a higher than necessary resolution, you may be able to immediately downsize them to your working resolution and remove the originals. Any tests that you generate that are outdated by a newer test should probably be removed as soon as possible.

It will at times be important to estimate how much disk space will be used when a new image sequence is computed. This calculation is particularly critical if your system is creating images while unattended, since a suddenly full disk can have catastrophic consequences. You should always make sure that you have enough disk space available for a sequence before you create it. There are a number of ways to estimate this, but usually the simplest is to create a single frame and then multiply the amount of space it uses by the number of frames that will be in the final sequence.

[5] This is not always true, however. Well-funded facilities can afford to put high-speed networks in place that greatly diminish the access speed difference between remote and local files.

Be careful if you are working with compressed file formats, because the test frame that you generated may not be an accurate indicator of the file size for every frame in the sequence. Compressed files can vary considerably depending on content, and as such should only be considered as an estimate for what the average file size will be. If you are greatly concerned about this issue you may want to precompute several different frames throughout the sequence and see if there are major size differences.

You may also find yourself in a situation in which you have computed a low-resolution proxy image and now want to predict how much space the full-resolution equivalent will consume. Remember that the size difference will be proportional to the change in both the horizontal and the vertical resolution. A common mistake is to assume that doubling the resolution will result in a file size that is twice as large. In reality, doubling the resolution means that you are doubling both the X and the Y resolution, thereby producing an image that will be four times larger.

There is a maxim that "Data expands to fill the available space." Working with multiple image sequences is an excellent way to prove the validity of this statement, and you'll quickly find that your resources seem insufficient no matter how much space you have available. But efficient disk usage usually boils down to constantly monitoring the existing space and making sure that image sequences that are no longer necessary are removed from the system as soon as possible. Probably you'll want to back up most images to some form of long-term archival storage so that they can be recovered if needed. In an environment where disk space is at a premium, you may find that temporarily archiving files and then restoring them to disk as they become needed is an ongoing process instead of one that occurs only when a shot is completed.

Precompositing

In any environment in which resources are limited, you may find that a trade-off can often be made between compute resources and disk resources. Consider the script again from Figure 11.9 earlier in this chapter. If we are thinking about this script as a batch process, we are assuming that there are two image sequences on disk (Foreground and Background) that will be read when we run the composite. Our five operations (the Pan, two RGB Multiplies, the Over, and the Blur) will be applied in the proper order and a new image sequence (which we're calling Output) will be produced and written to disk. But there is nothing to prevent us from breaking this script into a set of smaller composites. We could, for instance, create a smaller script that only takes the foreground element and applies the Pan and the RGB Multiply. We would then write this new sequence out to disk and name it something like New_FG. This process is diagrammed in Figure 11.10. This new sequence is called a **preliminary composite**, or simply a **precomp**. To use this precomp, we now need to modify our original script to reflect the fact that we have a new element, as shown in Figure 11.11.

This technique might seem to be somewhat of a waste of disk resources, since it required creating an entire new sequence on disk, yet ended up with a script that still

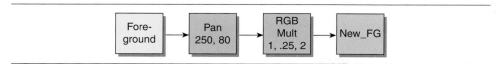

Figure 11.10 Creating a precomposite for the foreground element of Figure 11.9.

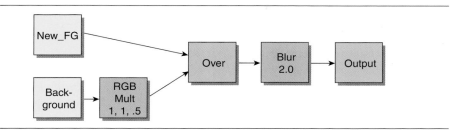

Figure 11.11 A new script that incorporates the precomposited element.

produces exactly the same result. If we only run our script a single time, then this evaluation is true. But the nature of most compositing work is that the same sequence of operations will probably be run several times, with only minor changes each time. Perhaps we're not sure about the quality of the blur that we're applying, and so we run the script several times, slightly modifying the blur parameters each time. Even though we're not actually changing the parameters for the other operators, we're probably still recomputing their result every time we run the script. By precomping our New_FG layer, we will not be recomputing the Pan and the RGB Multiply every time we run our script. In effect, we have traded some disk inefficiency for some gains in CPU efficiency. Our new script should run more quickly now that we have removed two of the operators.

Of course, the trick to all of this is deciding exactly when it makes sense to precomposite a portion of a script. Generally, you only want to precomposite something once you're reasonably sure that the operators that are being applied are not subject to change. If, for some reason, we realized that the pan we had applied to our foreground was incorrect, we would be forced to go back and rerun our precomposite before we could then rerun our main composite. There are no right or wrong answers when it comes to precompositing. Operations that are very compute intensive are good candidates for precompositing once you have a reasonable assurance that the parameters will not need to be modified.

Precompositing is also often used when a script grows too large for a piece of hardware or software to deal with it effectively. Extremely large scripts may require a great deal of memory. If the memory on a given system is limited, then you might want to break your large script into a number of smaller, more memory-friendly scripts. In a sense, most online compositing systems are really producing numerous precomps at every step of the process. By not having any batch capabilities, they are forced to

precompute a new sequence whenever a new operator is added, and any modification to earlier layers will require manually retracing the same compositing process.

If you do decide to produce intermediate precomps, remember that they should be stored in a file format that has support for the quality that you feel you will need. It may be tempting to use a format that includes some lossy compression, or works at a lower bit depth, but doing so will potentially introduce artifacts that become more pronounced as additional effects are added to the imagery.

Many of the benefits of precomping can also be had if your systems features the ability to **cache** intermediate images. A cache is a more automated method of storing images that represent some portion of a compositing script without requiring the user to explicitly write files to disk. Using a set of heuristics, the compositing system can identify intermediate images that may be worth saving, at least temporarily, and hold these in memory or on disk in anticipation of their re-use. Consider again Figure 11.11. If the user is iteratively modifying the Blur operator to try and find a desired value, the system might recognize that caching the image produced by the Over operator will eliminate the need to recompute everything "upstream" of the blur every time a blur value is changed. This, then, can significantly increase the interactivity of the experience for the duration of the user's work on that operator. Robust caching systems can have a dramatic effect on how responsive a system feels and are a key feature when a compositing script grows to any reasonable size.

CHAPTER TWELVE

Creating Elements

Visual effects photography, the process of creating the plates that will be used in a composite, is an art and science unto itself. So far we've been able to touch on only a few basic guidelines, but in this chapter we will try to provide a few more recommendations, while fully acknowledging that these will mostly be useful for fairly standard situations.

Although we'll spend the bulk of this chapter discussing things that *should* be done during plate photography, let's make it perfectly clear that it's very likely that many of these things probably *won't* happen. Normally it is the job of the visual effects supervisor to see that plates are shot as well as possible, but the realities (and costs) of location shooting often make it difficult or impractical to ensure that every detail is covered perfectly. Frankly (and unfortunately), it really is sometimes cheaper to just "fix it in post," and the chapter following this one will go into greater detail about specific techniques that can be used to compensate for less-than-perfect elements.

This chapter is by no means an attempt to teach basic cinematography. We'll discuss issues specifically related to visual effects cinematography, and assume that the reader already has access to other resources that cover the essentials of the broader field. The information in this chapter will be presented for two reasons. The first, obviously, is to help anyone who will be photographing elements for use in a composite. But it is also presented for the benefit of those individuals who will be working on the digital side of the process, so that they can better understand the various problems that can come about during a typical plate shoot.

The primary job of a visual effects cinematographer is to ensure that all the elements that he or she photographs for a given shot are appropriate for integration with each other. The goal is to think ahead as to how these elements (including the primary

background plate) will be put together and to do everything that is possible to minimize the amount of postprocessing that will need to be done on these elements.

Incidentally, although we will be primarily discussing things from the perspective of live-action photography, many of the issues discussed in this chapter are equally applicable to the generation of CGI elements. A 3D artist is effectively the digital equivalent of the cinematographer and utilizes techniques that are essentially the same as those used when doing real-world photography.

Lighting

Probably the most important thing that one must do when adding an element into a different background is to make sure that the new element appears as if it is being affected by the same lights that are illuminating that background. This process ideally starts when the background element itself is first being photographed, and takes the form of careful attention to the details of the lighting in the scene. Whether you are planning to integrate elements shot with bluescreen, synthetic CG images, or are just going to soft-split two plates together, it is critical that the different pieces look as if they were lit with the same lights. As the most common scenario usually involves shooting a background plate first and then later shooting additional elements that will be layered onto that plate, it is usually worth taking the time to create some kind of lighting diagram for the scene in question. This diagram may be nothing more than some basic notations about the placement of the main lights in a scene, or it may be a complete blueprint for the stage and all the lights (and cameras) that were used.

As mentioned in Chapter 2, there are a number of identifiable characteristics of the way lights affect a scene. In particular, the following items should be noted when shooting the background:

- Identify the *location* of the various light sources in the scene. If you are on a set, you can (usually) easily identify the exact placement of every light that would affect an object in the scene. If you are shooting outdoors, identify the position of the sun (if in the daytime) or any artificial light sources that may be present. This information is necessary not only to help duplicate the same lighting on any subsequent elements, but also to help you keep track of the direction in which the shadows in a scene should be cast. Many times you will find that you need to recreate shadows from scratch, and you'll be thankful that you at least have some idea about the direction in which they should fall.

- Identify the *brightness* of the individual lights in the scene. There are light meters that can give numerical readings for each light's power output, but it may be acceptable to simply note the relative brightness of various lights—light A is twice as bright as light B, for instance. Again, if you are on a set, the various lights in the cinematographer's arsenal will probably all be well defined. Consequently, you can note that light 1 is a 10 K spotlight, light 2 is a 5 K, and so on.

- Identify the *color* of the lights in the scene. Certain standard filters, or gels may be used to modify various lights on a set, and these can be recorded in your notes easily. Otherwise, subjective judgments will have to suffice. Remember too that different types of lights can produce drastically different colors, even when they aren't explicitly modified by gels or filters. A fluorescent tube-light is much more cyan than an incandescent bulb, for instance.

- Finally, take note of the *quality* of the various lights in a scene. This measurement is by far the most subjective, and takes into account such things as how "hard" or "soft" a light is. Hard lights cast sharp-edged shadows and will produce high-contrast areas. Softer lights (which come from a broader light source) produce softer edges on the shadows and decrease contrast. If you're outdoors, consider your daylight quality and notice whether it is overcast or clear.[1]

In the real world, light sources are not always idealized point sources. Not only can they be hard or soft, but objects between the source and the subject can cause irregularities and nonuniformity. This "dappled lighting" is something that you would see if you were standing beneath a tree, where the leaves all contribute to an uneven light pattern. On a stage, it is common to place shadow-casting objects in front of the light source to reproduce this type of look. These objects are known as **cukalorises**, or **cukes**. For instance, if you are planning to shoot an element that will be inserted into a scene taking place beneath a tree, plan on using something to simulate the necessary leaf shadows.

Although taking note of these four basic parameters—location, brightness, color, and quality—for each light source will give you a rough idea of the lighting in the scene, as we have discussed previously the lighting at any given location is much more complex due to all the indirect lighting that is going on. This sort of thing is constantly overlooked, since it is usually fairly subtle and can be easy to forget about. But indirect lighting can, at times, significantly alter the look of a scene or the elements in that scene. Note any surfaces that bounce a great deal of "fill" light on a subject and keep track of the color of this bounced light. For instance, a red curtain in a scene (whether the light is coming through it or bouncing from it) will tint that light with a reddish color, and therefore you should plan for any later element that might be shot for insertion into this scene to have a bit of red light illuminating it from the proper direction. Bounce light, unless it is coming from a very shiny mirror-like surface, will be softer and more diffused than direct light.

[1] It's probably also worth mentioning here that CG lights aren't guaranteed to behave the same way that real lights do. For instance, the brightness of a light falls off according to an inverse-square relationship based on the distance from the light-source. CG lights don't all do this, which can mean that the compositor may need to need to compensate for unrealistic lighting of this sort.

Interactive Lighting

Many times you may find that the lighting in a scene changes over time. Do your best to keep track of inconstant or animated lighting (and the shadows that go with it!). Your background may contain a candle, or a towering inferno, or any number of other irregular light sources that you might need to keep track of. Be aware that duplicating this sort of inconstant lighting on all the elements in a scene can prove to be a difficult task. Ideally you want to synchronize things so that bright flashes occur at the same time on the background and the foreground, but with something that is completely random, such as flickering flames, this can be impossible. You may find that a combination of live-action lighting and some additional postprocessing work (which will be easier to synchronize with the fluctuating background) may give the best result.

When lighting effects are added to a scene—particularly lighting effects that fluctuate or are inconstant—they are often referred to as **interactive lighting**. This is a broad term, encompassing a variety of different situations. In some sense, just about any lighting could fall under this umbrella, since it interacts in some way with the elements in a scene, but the term is usually used when referring to lighting effects that are designed to mimic a specific, uniquely identifiable light source.

So far we have been discussing our lighting scenarios as if all the lights in the scene exist only in the background and will contribute to the illumination of any new foreground element. But in many situations, the reverse may actually be true. A highly reflective object placed into a scene will obviously cause the lighting on nearby objects to change, but the more extreme case would be if the element that you are adding to the scene is something that is self-illuminating (i.e., a source of light). If this is the case, you will most certainly want to modify the background plate to account for this, particularly if the element you are adding is something whose brightness fluctuates significantly. The best example of this situation would be some kind of pyrotechnic element such as an explosion. Nothing makes an explosion look more "pasted on" than if it doesn't actually cause anything else in the scene to light up!

Although it is sometimes possible to simulate interactive lighting in the compositing process, it is (again) generally more desirable to do so while shooting the elements in question. A simple compositing solution that could be used to add interactive light from an explosion into the scene might entail a general brightening of the background image, but this alone will usually look artificial since a real explosion wouldn't cause such a uniform effect. Instead, objects would cast shadows and the intensity of the light would fall off as the distance from the source increased. The best method would be to actually photograph the background scene with some sort of built-in interactive light that simulates the explosion. Of course, setting off a real explosion in the scene would be the most accurate method, but if you are able to do that, then you probably wouldn't need to do a digital composite! Instead of a full-sized explosion, something much more controlled, such as a flash-pot or even a manually controlled electric light, can be used. As mentioned earlier, the timing synchronization between foreground

and background lighting can be difficult, and you may need to manipulate both foreground and background to obtain the best results.

Matched Cameras

Almost as important as ensuring that the lighting on the elements in a scene matches the task of synchronizing the camera for all the elements. Usually this is the more simple task, since there are not quite as many variables to consider, but there are still a number of issues to be aware of. Let's again look at the case in which we initially shoot the background plate for the scene, and then later shoot the foreground element. The first thing you'll want to do is determine where in this background plate your foreground will eventually be located. You should have some idea about the size of the foreground element that you are going to add, and using this information we can start to decide on the camera placement and subject framing. We'll want to take the same sort of meticulous notes for our camera's setup as we took for our lighting setup, again so that we have enough information to recreate the background camera when shooting additional foreground elements.

- First of all, be aware of the camera's *distance* from the subject. This information is absolutely critical if you want the perspective on the composited elements to feel consistent. Try to get as accurate a distance measurement as possible. In many cases it is not necessary to be extremely precise, but at other times it may be quite important. Overall (as we've said many times before), you're better off having too much information than not enough. Incidentally, when measuring distance from a film camera, the convention is to measure from the film plane, not the front of the lens. This way, even if you have a different length or type of lens on the camera used for other plates, your measurements will still be valid. For convenience, many film cameras are marked somewhere on their body with a special symbol, a "ϕ", that indicates the position of the film plane. There is often even some kind of hook that can be used to attach a tape measure, since measuring camera-to-subject distance is something that the person controlling the focus on the camera will need to do as well.

- The next item of information that you should take note of is the *height* of the camera relative to the subject. Usually this is simply a matter of measuring the distance the camera is located above the ground, although if the ground is uneven or slopes drastically, you may need to try to obtain more detailed information.

- After this is done, determine the *orientation* of the camera, as it relates to tilt angles. Record not only how much the camera is tilted up or down, but whether or not there is any camera tilt along any other axis. Camera orientation is usually recorded in terms of yaw, pitch, and roll, as shown in Figure 12.1.

Figure 12.1 Yaw, pitch, and roll relative to the camera.

- Make sure you have a record of what *lens* was used to shoot the scene. At the very least, get the focal length of the lens; there may be times when you want to record the aperture (measured in terms of its **f-stop** or **t-stop**) as well. Although there may not be much that you can do about it, you should be aware that the marked focal length on any given lens may not be terribly accurate. Different lenses from different manufacturers (or sometimes even from the *same* manufacturer) can vary by as much as 5 mm from their indicated length. Situations that require extremely precise measurements may require calibration tests on the lens, or at least an attempt to use the same lens when shooting the various elements in the scene.

- Finally, you should keep track of any other camera settings that might affect the synchronization of the shots. In particular, try to ensure that the same shutter speed is used so that any motion blur is consistent, and make sure that you are shooting all the elements at the same frame rate. There may be occasions when you choose explicitly to shoot at a different frame rate than was used for the other elements, for example, if you wish the various elements to move at different speeds. Shooting at a higher-than-normal frame rate can also be done if you are unsure about the exact timing you will want for your element. It is, in many ways, analogous to shooting with a larger-format negative, in the sense that you are capturing a higher resolution (temporal in this case) than you may eventually use.

Keep in mind that many of the camera parameters that we've just mentioned can actually change throughout the duration of a shot. Although the use of a locked-off camera will make the issues of camera synchronization much easier, this is generally something that the cinematographer should choose to use based on a creative decision, not something that the visual effects process should dictate. If your camera does move throughout the shot, then every element will theoretically need the same camera move on it. Either plan on shooting the elements with a mechanical motion-control camera or be prepared to do a lot of tracking in postproduction to try to duplicate or synchronize the different motions. Also mentioned in our tracking discussion in Chapter 8 was the use of witness points that can be placed into a scene to give the tracking software some well-defined points from which to determine camera motion.

These points will be particularly important if there is nothing else in the scene that can be used to track the motion effectively. Although software algorithms for automatically extracting a camera movement based on the original footage are getting better and better, there are still situations where they will fail—don't rely on them to the exclusion of taking good notes.

Unfortunately, given the physical limitations that are inherent with plate photography, you may find that it is not always a simple matter to accurately create a foreground setup that perfectly matches the way that your background plate was shot. This is a typical problem one runs into when shooting on a stage or some other confined space where it would prove inconvenient to move the camera as far away from the subject as you would like. It may be tempting to simply use a wider-angle lens to compensate for the fact that you are closer to your subject. This is generally not a good solution, since the difference in camera-to-subject distance will cause a perspective discrepancy. It would be much better if you can come up with some other way to maintain the proper distance. Of course this may not be practical, in which case you will just have to live with elements that do not have perfectly matched perspectives. This may not be a huge problem, depending on the specific scenario. People tend to be less perceptive of perspective mismatches than they would be of a lighting mismatch, for instance. Additionally, Chapter 13 offers some suggestions that can sometimes be used to mitigate mismatches between elements.

There may be times when we can use the perspective/distance relationship to our advantage. An example of this is the situation in which you are shooting an element that will be fairly small in frame. Once you set up the proper camera-to-subject positioning, you can actually change to a longer lens and not cause a perspective switch. The reason for doing this is to capture a larger image of the subject, with greater resolution. (As we'll discuss in just a moment, the desire to capture elements with as much resolution as possible is a common occurrence in visual effects photography.) This particular trick means that you're putting the burden on the compositor to figure out the proper scale of the element, since changing the lens will increase the size of the object in frame. The correct scale should be easily determinable if you know the amount the lens length was changed, since the size change will be proportional.

The Reference Stand-in

No matter how much attention you pay to faithfully duplicating the lighting and camera setups for your background plate, you will find that it is extremely difficult to produce a new foreground element that is an exact match for one that was actually shot in that background. Your new lighting setup will always just be an approximation of the original. To help the compositor understand exactly how the foreground element differs from what the element would actually look like if it had been shot in the scene in question, a reference stand-in can and should be used.

There are primarily two different types of reference stand-ins. The first type is a stand-in object or person that attempts to mimic as closely as possible the element that will eventually be placed into the scene. Consider the case in which you are shooting a background and will later insert an actor who was shot on bluescreen. Depending on how much control you have of the situation, it will be very helpful if you can get someone who is approximately the same size, and who is wearing similar clothing, to stand in the scene long enough to shoot some reference footage. The better your stand-in mimics the object that will eventually be inserted into the scene, the better off you will be when it comes time to create the composite.

But what about a situation in which you don't know exactly what is going into the scene (because nobody has made a decision yet, for instance) or in which the object that is going to be inserted into the scene is something that you cannot easily duplicate (for example, some strangely shaped and textured creature that will eventually be created via the use of 3D computer animation)? In these cases, it is often useful to photograph a simple object such as a neutral gray sphere in the scene.[2] This will at least give you some idea about the placement, intensity, color, and quality of the lights in the scene. This object (often called a lighting reference) will also be useful if there will be any 3D elements created for the scene, since it will allow the 3D artists to place a duplicate object into their artificial scene and light it to match. This should produce a 3D element that is more likely to be easily integrated into the background, although it will all come down to the compositor when it is time to marry the two elements together.

Of course there's usually no reason not to shoot multiple types of reference, since it shouldn't take long or cost much—at least not compared with the cost of having to fix a grossly mismatched element in post. Generally you will need only a few frames of footage on these reference stand-ins, so the amount of film used will be negligible. Keep in mind that this reference footage will be just as useful to the person shooting additional elements as it will be to the compositor. Even the simple gray sphere can be brought to the bluescreen set and, when compared with the reference clip, used to help with the lighting setup.

Stand-ins are useful for more than just lighting synchronization. If you place a properly sized reference object into your background, it will help to ensure that the framing of the scene makes sense, and you will know how large the subject should be in the frame. At this point, you can also measure the camera-to-subject distance with more accuracy.

[2] When shooting lighting reference for use by 3D artists, it is also common to also shoot a shiny object, such as a large chrome ball, that can be used to better understand what reflections might be needed in the object that is added. A chrome ball can also be extremely useful in determining the location of some of the lights in the scene.

Clean Plates

Whenever you are shooting an object that you intend to eventually extract or isolate from its background, it is often useful to shoot what is known as a "clean plate." We discussed this briefly in Chapter 6, when we looked at the use of a clean plate to help create a difference matte for a foreground object. Theoretically, everything is identical between the two plates, with the exception of the subject object.

There are a number of uses for such a clean plate, but they tend to fall into two primary categories. The first use would be to help extract a matte for an object, as we've already seen. This use goes beyond simple difference matting, and many times you will find that bluescreen methods can benefit dramatically from the availability of a clean plate for a given shot. This topic will be discussed momentarily, in the section on lighting and shooting with a bluescreen.

The second primary use of a clean plate is as a source of image information that can be used to selectively remove or replace some unwanted portion of the foreground element. For instance, a wiring harness that is suspending an object or actor in midair can be removed by strategically pasting areas of the clean plate over the area where the wiring harness is visible. The clean plate gives us image information that would otherwise have been obscured by the wiring harness and allows us to restore it to the scene. Replacing a portion of a scene with a clean plate can either be accomplished via standard compositing techniques or (probably more commonly) by having a digital paint artist carefully merge pixels from the clean plate into the main plate.

Obviously this sort of technique works best when there is a perfect match between the camera, lighting, and exposure on both plates. Consequently, clean plates tend to be much more common whenever the camera does not move throughout the shot (or if there is a motion-controlled camera involved). But even if the camera does move, it may be appropriate to shoot a clean plate. Tracking tools can be used to add motion to this clean plate so that it properly matches the original camera move, effectively producing a new element that can be used for the techniques just described. Optical flow techniques can also be used to analyze a sequence of images and, either automatically or with some user input, generate a clean plate by "borrowing" image information from surrounding frames where certain areas of the scene are not obscured.

Film Stock

If you are shooting on film, be aware of the film stock that you are using, since different stocks can have significantly different characteristics. For instance, every stock is balanced so that it will accurately reproduce colors only when illuminated with a certain type (i.e., color) of light. Most stocks are balanced either for daylight or tungsten lighting, and if you use the wrong stock for your lighting conditions, you run the risk of producing imagery with a serious color skew. Yet even if you shoot a subject using a stock that is properly balanced for the lighting conditions (or if you make use of

colored filters to compensate), you will still not have a perfect color match. Ultimately, every film stock will have a unique response to light, and it will generally not match the response of a different stock. This is obviously a problem with visual effects work, where it is common to shoot a background element as an outdoor scene and then shoot the foreground element indoors, in front of a bluescreen. This situation almost always results in the need to manually color correct the foreground element by eye so that it fits better into the background scene.

Different-speed film stocks, even if they are balanced for the same lighting conditions, can also vary in their color reproduction. Higher-speed films tend to produce images that are lower contrast and have less saturation. What's more, the amount of grain that is captured by different stocks can vary considerably. Take a look at the images shown in Figure 12.2.

Figure 12.2 Grain comparison: (a) A highly sensitive, low-light film stock (Kodak 5289). (b) A slower-speed film stock (Kodak 5245).

Figure 12.2a is an extremely magnified section of a piece of film. This particular film (Eastman Kodak 5289) is a highly sensitive stock, well suited for use in low-light conditions, but it also a fairly grainy stock. Figure 12.2b shows the same amount of magnification applied to a different, slower type of film. Notice the significant difference in the amount of grain that is visible. Although we have magnified the film in order to show the grain as effectively as possible, it should be noted that the grain difference between two different stocks can be very noticeable even without any additional magnification.

In general, the faster, more light-sensitive films tend to be grainier, whereas slower-speed films show less grain. This is only a rule of thumb, however. Don't assume that you can take two film stocks with the same rated sensitivity and produce images

with matching grain characteristics. In fact, don't even assume that scenes shot on the same film will produce matching grain characteristics, since many other factors (such as exposure and development) will all affect the amount of grain present in a captured image. In practice this is not usually that much of an issue, and you can generally assume that similar stocks will produce similar grain, but you should be aware of the potential problems nonetheless. Incidentally, it is worth noting that the amount of grain can differ quite a bit between the different records (channels) in a film image. Figure 12.3 shows the red, green, and blue channels of Figure 12.2a. The blue record is characteristically the most noisy, the green record the least.

Figure 12.3 RGB channels of the film stock shown in Figure 12.2a.

Unlike some of the other issues we've discussed in this chapter, grain is not necessarily something that you should strive to synchronize between all elements as you are *shooting* them. Instead, the amount of grain captured with an element (and consequently the decision concerning what film stock to use) will be determined much more by the type of work that is to be done with these various elements *after* principle photography, once they are in the compositing process. This precept is primarily because it is much easier to add grain to an element than it is to remove it. Grain is easily simulated digitally, and the user can precisely control exactly how much additional grain is to be applied to a scene. If, however, the element is already very grainy, then removing the grain can be nearly impossible. Any attempts to remove grain will almost always result in a slightly softer image. For this reason, visual effects photographers usually try to use the least-grainy film they can get away with for the given lighting situation. Part of the reason to shoot elements with larger-format film (as we'll discuss in a moment) has to do with the desire to minimize the relative amount of grain captured.

There certainly may be times when you *do* wish to shoot elements with the same amount of grain. A simple split-screen effect, which involves virtually no additional processing, is a classic example of a situation in which you want the grain in both your original elements to match as closely as possible.

Filters

Cinematographers use a variety of filters to obtain certain effects for the footage they are shooting. These filters (as opposed to the digital filters that we discussed in Chapter 3) are usually a glass or plastic material that modifies the color or quality of the light that is transmitted through it. While they can be useful for normal photography, they can cause a number of problems when photographing elements for compositing work, particularly for bluescreen shots. Color filters are placed either on individual lights that are illuminating the subject or are placed on the camera lens itself, causing the overall color of the scene to be modified. Obviously, colored filters would affect the color of a bluescreen element, potentially causing the process of extracting a matte to be more difficult than necessary. Less obvious, however, are the problems that can be introduced when using certain **effects filters**. These filters, when placed on a camera, are designed to introduce artifacts such as diffusion or flares into a scene. Isolating a bluescreen subject will be made more difficult if it was shot with one of these effects filters in place because the scattered light from the filter can easily contaminate the foreground element.

If you know that an element is going to be dealt with digitally, you will be better off shooting it with a normal, unfiltered exposure. Overall color corrections will be easier to tweak, and any additional effects (such as diffusion) that are necessary to match a background plate can be added during the compositing process. There are even plugins available for many compositing packages that are designed to mimic the effect of standard optical filters, making the process of synchronizing elements much less complicated.

Choosing a Format

At first it might seem that choosing a format for the elements you plan to shoot would be a simple matter, given that the format in which you will eventually deliver the material is probably already determined. While it's true that format decisions for a particular production are often made even before the effects are considered, this does not necessarily mean that the effects elements will need to be shot in the same format. Even ignoring compositing, there are any number of examples in which the final, delivered format is different from the shooting format. Many television programs and commercials are still shot on film and then transferred to video. This is usually done to get a certain look, as well as to have some of the flexibility (such as an ability to shoot in extreme slow-motion) that video may lack.

When we are shooting elements to be used in compositing, one of the primary reasons to shoot with a different format is to gain additional resolution or (a byproduct of higher resolution) to reduce grain. Larger film formats such as Vistavision, 65 mm, or IMAX allow one to expose a bigger piece of the negative to the scene. Vistavision is more than twice as large as standard 35 mm film; 65 mm, and IMAX are even more so (see Chapter 10 as well as Appendix C for more details). With the larger negative, the grain size relative to the image captured is much smaller. If we scan and then digitally reduce the full frame from one of these large formats to our working resolution, we will have a nearly grain-free image. This result was particularly important when optical compositing was prevalent, since every optical generation introduced added grain into the scene. This reason alone was enough to rescue the large-format Vistavision cameras from obsolescence, at least for a while. Although increased grain is less of a problem with digital compositing, it still must be considered.

Shooting with a larger-format negative allows for flexibility in other areas as well. For instance, we can now zoom in to a portion of the image and not run the risk of revealing grossly magnified grain or noise. A two-times zoom into a Vistavision frame will result in a grain size that is the same as that on a standard 35 mm frame. Shooting in high-definition video will give you an image that is more than double the resolution in both directions than standard definition-video.

Of course there are a number of other factors that may influence your choice of format. Although from the compositor's perspective larger-format images are usually better, practical considerations such as the size or the availability of the equipment may prevail. Vistavision cameras tend to be more lightweight and compact than 65 mm cameras, for instance, and have the advantage of using a more standard stock and processing, but they are also usually much louder when operating, making them less suitable for scenes in which sound must be captured.

Also, be aware that if you are shooting two different elements for a particular shot with two different camera formats, some of your measurements will need to be converted to maintain equivalency of depth of field, exposure, and field of view. For instance, a 50 mm lens on a Vistavision camera will capture about the same field of view as a wide-angle 28 mm lens on a regular 1.85 format. And of course mixing different video formats, or even mixing film and video within the same shot, will mean that you need to be aware of how certain parameters translate between the different formats. Again, depth of field may vary significantly depending on the lens and film/sensor size that is being used.

Even if you are shooting with a standard 35 mm camera, you may be able to capture additional resolution. Although most film formats do not actually require the entire frame area on the negative, there is no reason why you cannot use this area to capture additional image information. Make sure that your camera is not automatically masking out picture information merely to frame the format. Instead, shoot without any mask and plan on cropping the extra picture later, as needed. You can always remove

unnecessary image in order to be efficient with your disk space, but will still have the ability to restore the additional information should it become necessary or useful.

It is also becoming more common to shoot larger-format video in order to capture additional image information. For instance, you may wish to shoot your elements using HDTV cameras instead of a standard-resolution video camera or to shoot at even higher resolutions if you are planning to deliver something at 1080 p. This is sometimes done even when no visual effects will be involved, simply because the larger frames can be used to produce high-quality images in multiple formats, extracting both NTSC and PAL framing from a larger master, for instance.

Of course the fact that a larger-format image will give you more data in both good and bad. We've discussed the advantages, but the disadvantage is that you end up with images that require additional storage space and processing power to be dealt with effectively. As mentioned previously, you should try to obtain *as much* data as is necessary, but *no more* than is necessary. This consideration will sometimes drive the desire to choose a smaller-than-normal format to capture an element that will be used within a composite. For instance, there may be times when it is appropriate to shoot standard-definition video elements that will be added to a film scene. An obvious example would be an element that is intended to be used as a "burn-in" on a video monitor in a given scene. This scenario is not uncommon, and it should be obvious that there is no need to have a resolution greater than video if the result will need to look like video eventually anyway.

But video elements could also potentially be used if they are only going to fill a fraction of the frame. The resolution of a standard-definition video frame relative to your film frame can easily be computed. If you are working with film images that have been scanned at a resolution of about 2000 pixels, then you really only have about three times the horizontal resolution of video. If you plan to add an element into the scene that will be less than one-third of the width of the frame, then using a video-resolution source would theoretically mean that you are not losing any resolution. Be *very* careful if you plan to do this. Although the spatial resolution of your video element may be acceptable, other factors may not. Remember that video generally has less color fidelity than film, so be sure that the lower chromatic resolution will not be a problem, and be sure that the video frame rate will not cause your element to appear to be moving at the wrong speed. Even if you ignore color resolution and frame rate issues, the bottom line is that video just looks different than film. Consequently you will probably need to process the video imagery quite a bit (adding grain, adjusting contrast, etc.) before it fits acceptably into the scene.

Lighting and Shooting with Bluescreens

As with the rest of this chapter, this section is not intended to be a comprehensive discussion about how to light and shoot a bluescreen. The topic is significant, and there

are so many variables involved that we will only be able to touch on some of the most basic issues. Continuing the precedent that was set in Chapter 6 (when we were discussing matte-extraction techniques), we will once again use the term "bluescreen" as a generic term for all uniformly lit, single-color backgrounds. Thus, unless otherwise specified, everything we discuss would apply equally well to a greenscreen scenario.

We've already covered the basic principles of how to synchronize lighting between different elements. Bluescreen elements are no exception to those principles. Lights should hit the objects in the scene from the same angle, have the same apparent intensity, and be of the same color as they are in the background. While this sounds easy in theory, in practice it is probably the most often violated rule in bluescreen photography, which may be due in part to the issue of duplicating outdoor lighting in an indoor setting. As mentioned, this is a common situation with bluescreen shoots, wherein the background is an outdoor scene and the foreground is shot later in front of a bluescreen on a sound stage. It is a particularly vexing problem since there is really no way to accurately duplicate the perfect single-source lighting that comes from the sun on a clear day. Another problem is the difficulty of judging the lighting on an element when it is placed in front of a bright blue background: The eye tends to see the background as a light source, even though it will be removed and neutralized in the final composite. Don't assume that the blue spill that is hitting the subject from behind will look the same as a normal backlight. In an ideal shooting scenario, the foreground object is lit first, and only after it is correctly matched to the background plate should you start to light the bluescreen backing. Again, don't forget to duplicate any colored bounce light that should be affecting your subject.

To obtain the best matte-pulling results when using a bluescreen, the bluescreen itself must be as uniformly lit as possible. The brightness of the lighting should be consistent across the entire screen, with no hot spots, shadowed areas, or color differences. This almost always means that we will need to introduce additional lights into the scene to illuminate this backing. You should obviously try to direct the lights at only the backing, and avoid having these lights cast additional illumination on your subject, but in practice, this is not always easily achieved.

Remember everything that reflects light is effectively a light source and a bluescreen is no exception. The blue backing will always reflect a certain amount of additional light onto the foreground. This effect is known as **blue spill** and is a constant problem with bluescreen shots. Blue spill on the subject not only causes the lighting to be wrong, but also makes the job of pulling a matte off this subject much more difficult. Since the spill areas now have similar coloration to the blue backing we're trying to remove, most keying software will have a hard time distinguishing these heavily contaminated foregrounds from the bluescreen itself. It is a common practice to add some yellow lighting onto the subject in order to nullify any blue spill (yellow being the complementary color to blue). This practice has fallen into disfavor, however, since once again it is adding lights to the foreground element that were not present in the original photography of the background.

One of the most basic things you can do to prevent blue spill from contaminating the foreground (and to prevent set-lighting from contaminating the bluescreen) is to ensure that the foreground is as far as possible from the backing as separating screen from subject will attenuate the bounced screen-colored light. This is fine if you have a great deal of space, a very large backing, and the ability to light this large backing uniformly. If this is not the case (and it usually isn't), you'll need to be much more careful with lighting the scene.

Figure 12.4 shows a small figure in front of a greenscreen. In this case we've chosen to keep the subject itself relatively unilluminated in order to better see exactly what the reflected light from the background is doing to that object. Note the significant amount of green light that wraps or "spills" onto the figure around its edges. Figure 12.5 shows the same figure but instead of placing it in a location that is relatively close to the backing, we have moved our greenscreen much further away from the subject. Not only is the spill significantly less, there is an added benefit of evening out many screen imperfections due to the fact that they are now partially defocused. There is still some spill of course—the rather shiny "hand" on the left side of the screen is at an angle that reflects a good amount of the light from the background and could be problematic when putting together a composite featuring this element.

Figure 12.4 An object placed near to a greenscreen backing.

Figure 12.5 The same object with the greenscreen further away.

Since the primary source of spill in a situation like the one shown in Figure 12.4 is from light that is hitting the object from the side rather than directly from behind, the act of moving further from the backing is effective primarily because it reduces the size of the screen relative to the subject. A similar result can be achieved simply by decreasing the size of the screen itself. Figure 12.6 shows exactly this—the screen is the same distance from the subject as it was in Figure 12.4, only we are now using a much smaller screen—one that is much closer to the size of the subject itself. This has, again, eliminated much of the greenscreen bounce that was coming from the edge of the screen and consequently decreased our spill by an equivalent amount.

Although it might be tempting to assume that the best scenario for shooting bluescreen would then be to only use very small screens, in practice this is almost always not going to be possible. Rarely will you be able to get agreement from the actors to never move away from a specific location nor will your cinematographer ever agree to lock down the camera.

The question of whether or not to light your bluescreen element so as to preserve shadows is very situational. A good matte-extraction tool should be able to bring a shadow along with the foreground image. But the shadow itself may not be appropriate, because the surface on which it is cast may not match with anything in the background plate. This topic will be discussed more in the next chapter, where we cover integration techniques.

Figure 12.6 A much smaller greenscreen, placed at the same distance as the one in Figure 12 .4.

Figure 12.7 Detail of spill areas on all three greenscreen scenarios.

Bluescreens are usually lit from the front, but there are also semitransparent screens that can be lit from the back. The choice is mostly determined by practical considerations: Rear-lit screens are generally more expensive and require more floor space to implement. But they can be very nice if you would otherwise have a hard time lighting your element without introducing unwanted light onto the backing.

The exposure (brightness) of the bluescreen relative to the foreground subject will vary depending on the subject itself, but the general rule of thumb is to expose the backing to a fairly neutral brightness. This will usually end up being about the same exposure as the foreground, although the latitude of most digital matting tools will often allow you to get away with a slightly underexposed bluescreen. This may make the matte slightly more difficult to pull, but will help to eliminate blue spill.

Of course, as with just about every aspect of the plate-photography process, there are always compromises that must be made. In the case of a subject on bluescreen, you will often be trading a perfectly exposed backing for more accurate lighting on the subject. This is usually a worthwhile trade-off, since there are a number of techniques that can be used to compensate for a nonuniform backing. But trying to compensate for an improperly matched foreground element can be next to impossible. And, given the fact that many compositing shots rely solely on rotoscoping techniques to create a matte for an object, doing a little bit of roto to deal with a poorly lit bluescreen isn't all that much of a burden.

We have already discussed the utility of shooting a clean plate whenever possible. This step will be particularly useful when shooting bluescreens, assuming (as before) that your camera will not move during the shot. Packages such as Ultimatte support the ability to read an additional clean plate of the bluescreen (shot without any foreground subject) and will then use it to compensate for any inconsistent lighting on the backing or any imperfections in the screen itself. Clean plates, when used for this purpose, work best if the amount of grain present can be minimized. The typical method for accomplishing this is to shoot several identical clean plates and average them together to produce a less grainy result.

Earlier we suggested that you try to avoid the use of filters when photographing elements that will be used in a composite. This is absolutely critical when shooting bluescreen elements. Colored filters can affect the difference between foreground and background coloration, and effects filters (such as fog or diffusion filters) will cause edges to soften and light to bleed from background to foreground.

Bluescreen shoots should almost always be done with as neutral a camera setup as possible. This includes ensuring that no additional processing is being done on the image as it is being captured, as may be the case with a video camera. Many video cameras have a built-in **detail generator** that can be used to increase the sharpness of the image that is captured. While this can be useful for normal photography, it can cause a great deal of pain when working with a bluescreen element. If you recall, digital sharpening is simply a method of increasing the contrast around transition areas.

Since the transition between foreground and bluescreen is usually much more dramatic than it would be between the foreground and the real background, the resulting sharpening of this edge will introduce an undesirable matte line around your foreground object. Always turn off this sort of processing when shooting on video or when transferring film to video via a telecine process.

Certain types of film stock can also introduce this type of problem. Film stocks that are designed for extreme sharpness will actually undergo a photochemical process that produces a similar edge artifact. Most film stocks also tend to be sharper in the blue and green records than in the red record, which can cause a slight magenta halo when working with a bluescreen.[3]

Bluescreen versus Greenscreen

Whenever the decision is made to shoot an object in front of a uniform background for the purpose of matte extraction, the first question that arises will usually be about the color that should be used for the backing. And usually this choice boils down to bluescreen or greenscreen. There are a number of different trade-offs involved in this decision, and we will discuss some of them here, but you'll find that there simply are no definitive answers for the bluescreen versus greenscreen debate.

The traditional backing for procedural matte-extraction shots is colored blue, and has been used at least since the 1920s as a method for producing traveling mattes for black-and-white photography. Greenscreens really didn't become popular until the 1960s,[4] and were initially much more common in the video world. This precedence probably occurred because video was a less expensive format in which to experiment, and consequently greenscreen's viability was proven sooner in that format. These days, both methods have been used countless times with both film and video to produce excellent composites, and the process of working with either color is straightforward and essentially identical. But there are certain factors that should always be considered when making the decision about which color to use.

By far the most important aspect of the decision has to do with the foreground subject itself, and any colors contained in it. Any similarity between a color in the foreground object and the backing will potentially introduce difficulties. Thus, if your foreground object has some saturated blue in it, you will probably want to use greenscreen. Conversely, if it has any bright green content, you should lean towards bluescreen.

The reason that redscreens are seldom used is the heavy red content of most flesh tones. Since traveling matte shots usually involve people, this immediately makes the

[3] There are also film stocks, such as Kodak's SFX 200T, that are specifically designed for bluescreen and greenscreen work. They feature a more equivalent sharpness between the various channels and attempt to minimize any edge enhancements.

[4] Greenscreens really only became feasible with the development of "day-glo" green paints. Before this, it was not a simple matter to inexpensively produce a bright, saturated green surface.

redscreen a less desirable choice. You will sometimes find redscreens used if the subject is not a person, and many model and miniature shots use a specialized redscreen process.

If there are no saturated blues or greens in your foreground, or if there are both, you will need to base your decision on other factors. A list of a number of these factors follows. As will become immediately evident, just about any argument in favor of a particular color can be countered with an argument in the opposite direction, and ultimately experience can be your only guide.

- Greenscreens will usually require less light than bluescreens to get an acceptable amount of illumination, in part because film and video are more sensitive to the color green than they are to the color blue. Using less light makes for a less expensive shot and will also help to reduce the risk of spill contamination.

- The most common spill-suppression technique used with greenscreen shots involves a partial substitution of the blue record into the green record. This technique is discussed in greater detail in Chapter 13, but the net result is that the substitution of the noisier blue channel into the green channel will increase the overall amount of grain in your resulting image. Thus greenscreen shots, particularly those that are already being shot with higher-speed film, can be prone to excessive grain problems. The problem is not nearly as great with video as it is with film, and greenscreen work is still quite a bit more common in video compositing. This issue is also much less of a problem with some of the newer, less grainy film stocks.

- On the other hand, the fact that the blue record is more grainy implies that any matte that is based on a bluescreen will be slightly noisier and more prone to holes than an equivalent greenscreen matte.

- Another consideration may be the specific color of the hair and skin that is being shot. Bright yellow hair will have a higher green component, and extremely black hair can appear almost blue. One school of thought also holds that darker flesh tones tend to have a slightly higher blue content, a fact that would tend to indicate that a greenscreen is more appropriate. This theory has never been rigorously tested, however, and the extreme variability between different individual's skins probably makes this a somewhat uncertain principle.

- Bluescreen shots may be more problematic if shooting outdoors, since the overall ambient light from a clear blue sky can give your subject an overall blue cast, which may make keying the subject more difficult. However, it also will be easier to get a purer blue color in your backing, whereas a greenscreen could be contaminated by this blue skylight.

- If your foreground element is to be composited into an unsheltered outdoor setting, the presence of a little bit of blue spill may be less noticeable than green spill, since it could be justified as coming from the blue sky. This would

tend to favor a bluescreen setup. If, instead, your foreground element is to be surrounded by a large amount of green foliage, you may want to use a greenscreen. Thus, it is worth noting that sometimes the color content of the background may also be important in the choice of bluescreen versus greenscreen.

As you can see, there are a number of factors, many conflicting, that can drive the decision about what colored backing to use. Some cinematographers will even admit that they avoid greenscreens simply because they don't like the color and would rather spend the day standing in front of a calm bluescreen instead of an unsettling green one! With all these different variables to take into account, it is not possible to make an overall recommendation regarding the choice of screen color. But there is one definitive recommendation that can be made, particularly if you haven't done a great amount of bluescreen shooting in the past, and that is to shoot as much test footage with your specific scenario as is reasonable. Not only should you test different screen colors (there are even a number of different shades of blue or green that are available), but you should also test various exposures on these screens. You'll also find that different software may be better suited to a particular situation, so you will probably want to do some tests with whatever different digital tools available.

Shooting Order

There can be very little general-purpose advice given for how to shoot elements, since such advice requires explicit knowledge of how the element being shot is going to be used. But there is an excellent rule of thumb for the order in which the various elements that will make up the composite should be shot: Always shoot the least controllable element in a scene first. Once this first element is captured, the other elements can then be adjusted to compensate for anomalies in the first plate. As usual, this is much easier said than done. Very often you will find that several of the plates will have things in them that are less than controllable. Usually when you are planning for a bluescreen composite, you try to shoot the background first, particularly if it is an outdoor scene, in which you have less control over the lighting due to time of day and weather. The foreground can then be synchronized to the desired take. But if you are putting a live actor into a miniature or 3D scene, it may make sense to shoot the bluescreen element first, particularly if there is a moving camera involved.

Of course, sometimes you may find yourself in somewhat of a dilemma, since you may need to shoot the foreground element first, without the luxury of knowing exactly how the background element will be lit. At times, you can only use your best guess. Be sure to keep track of what lighting is used when shooting the foreground, in the hopes that you can modify the lighting in the background to be as consistent as possible.

Additional Integration Techniques

In an ideal world, the person responsible for shooting plates will light and photograph any foreground element in exactly the same way as its corresponding background element, and your job as a compositor will be miraculously simple. (And in this same mythical world the 3D artist would be delivering perfectly matched elements as well.) Don't count on these miracles happening very often. Instead, you will probably find yourself using a variety of different techniques to modify the foreground (or background) so that the two integrate as well as possible. Throughout the book we have attempted to describe how the various tools in question can be used to better integrate elements into a specific scene. This chapter is designed to round out this subject, address some of the most common issues, and provide some suggestions that aren't covered elsewhere. Of course, every shot has its own problems, and no book can cover every scenario. The true test of a good compositor is his or her ability to come up with efficient and creative solutions to issues that fall outside the boundaries of common, well-defined problems.

A number of visual characteristics that we discussed in Chapter 2 ("Learning to See") will be mentioned again in this chapter in order to give suggestions about what kinds of methodologies can best be used to simulate these characteristics in a digital composite. We have effectively come full circle, to the point where you can apply everything you've learned about the way the real world behaves, using the digital tools that we have been working with, to produce the final beautiful result that we are striving towards.

Several of the considerations we discussed in the last chapter as being important during the principal photography stage will also now be referenced in our discussion

of digital postproduction. In fact, you'll notice that many sections in this chapter are direct counterparts to similarly named sections in both of these earlier chapters.

If you have skipped the last chapter, because you thought you would never be involved with the actual photography of the elements, go back and read it now. It will give you a much better idea of what the foreground and background relationship should look like and will help you to identify where the discrepancies exist. Identifying a problem is the biggest step you can take towards finding a solution. And thus (assuming that there is no longer the opportunity to reshoot anything to correct any faulty plates), it's time to start working on the integrated combination of all your elements, using whatever methods you have available.

The types of elements that will need to be integrated into a scene fall into two broad categories—live-action and CGI. Most of the issues that we'll discuss apply to the integration of any elements (CGI or live-action) but there are a number of additional concerns that are specific to live action elements (whether they were extracted via procedural keying or manual rotoscoping techniques) that we'll deal with as well. And of course with CGI you usually (but not always!) have the luxury of being able to re-render the element in question if the integration work becomes too extreme to handle in a compositing environment. Thus we'll generally be looking at things from the live-action perspective and save any further discussion of CGI for the "Working with CG Elements" in Chapter 14.

As in previous chapters, we tend to discuss topics in the framework of a simple two-layer composite—a foreground over a background—and allow the reader to extrapolate to more complex scenarios. It should also be noted that properly judging whether an element is acceptably integrated into a scene will often require that you view the scene as a moving sequence, not as a single frame. The characteristics of a scene may change over the length of a shot, invalidating any tuning that was done for just a single point in time—clouds will move across the sky (and obscure the sun), fog will waft into the scene or creep across the ground, or someone will open a door and light will spill in from the brighter room beyond. Simultaneously, certain features, such as film grain or motion blur can only be accurately judged by looking at moving image.

For the most part, we will not attempt to recommend specific tools or operators that should be used when dealing with a particular integration problem. There are too many tools and too many ways to use these tools for any kind of meaningful discussion to take place. Experiment with the tools you have available, and learn how they behave when using different types of imagery. For instance, although the Over operator is common to a large number of compositing packages, don't make the mistake of assuming that this is the operator that must be used when someone requests that a foreground be placed "over" a background. Many different tools can be used to place an object into a scene, and many objects, particularly those that are semitransparent or self-illuminating, will be easier to integrate if something other than a standard Over is used.

Scene Continuity

Throughout the book we have primarily discussed the integration of elements within a specific shot. But rarely will this shot exist in a vacuum. It is very important to keep in mind that not only should every element within a shot be consistent and well integrated, but also every shot should match or "cut" properly with the surrounding footage in the scene or sequence. In this context, scenes and sequences refer to groups of shots that are all part of the same narrative and that will most likely to be viewed at the same time. A common problem in visual effects work is a shot that may be well balanced as an individual entity but, when viewed in the context of the entire sequence, stands out like a sore thumb because of problems with overall color timing, grain levels, or lighting. Always view your work in context before considering it to be finished.

Certain minor differences and inconsistencies between shots in a sequence can often be dealt with by using some kind of overall correction that is applied to the final shot. When working in film or video, this can even be done by the **colorist**, a person who is given the job of looking through the entire work and adjusting color, brightness, contrast, and tonality so that continuity problems are minimized. The amount of change that the colorist can effect depends on exactly what sort of system is being used (photochemical versus digital, in the most extreme example) but don't rely on them being able to correct problems that should be dealt with by the compositor!

For the rest of this chapter we will go back to primarily discussing things from the perspective of a single shot, but always keep in mind that your work will also need to hold up when placed within the context of a multiple-shot sequence.

Color and Lighting

Of all the problems that must be dealt with when putting together a composite, one of the most difficult is the proper tuning of color and lighting for all the elements so that they feel well-integrated. There generally is, almost by definition, no perfect reference for how a particular object *should* look in a scene since we are almost always inserting something that is different from anything else already in the scene. And of course you can't truly even separate the concepts of "color" and "lighting," as they are inextricably intertwined. The color of an object (at least in terms of what our eye or camera sees) is largely determined by the color of the light that is falling on it.

For most integration scenarios, the problems should really be looked at from two different perspectives. The first would be to consider things from a real-world point of view, attempting to understand how the lighting of one element (usually the background) would affect any other elements if they were to be placed in that same environment. But there is also the purely digital perspective to keep in mind, where actual numerical values for colors can be measured directly. Neither method is complete without the other of course, as you are ultimately using your knowledge of the first to manipulate things in terms of the second. Ultimately the only objects that are truly

being dealt with are pixels, channels, and other collections of data. This data is used to *represent* objects and lights, but at some level the representation is inaccurate, or at least limited.

So we'll look at things from both the sides, starting with the theoretical lighting situations and then eventually moving on to purely digital issues. Other related issues will also be covered.

Lighting

As discussed in the last chapter, synchronized lighting between elements is probably one of the most important factors in a good composite. Unfortunately, unsynchronized lighting can often be an extremely tough problem to fix, and trying to tie together images whose lighting doesn't match can at times seem almost futile. Of course if the overall intensity or color of the lighting on your element does not match with the scene a color correction might be sufficient, but this is rarely the case.

Of the four primary lighting factors (direction, intensity, color, and quality), having an element that is lit from the wrong location is usually the worst scenario to be confronted with. If you are lucky, you may find that certain "easy" fixes may work. For instance, you may have a situation with strong sidelight coming from the left in the background, and strong sidelight from the right in the foreground. Assuming there's nothing in the scene to give away the trick, simply flop (mirror along the *y*-axis) one of the elements. (Remember, as long as you don't introduce a continuity problem with another shot, it is just as valid to change the background as the foreground.)

More complex discrepancies will require more complicated solutions. In the worst case, you may find it necessary to isolate highlights that occur in inappropriate areas and do your best to subdue them, while selectively brightening other areas of the subject to simulate new highlights. This isolation of certain areas is usually accomplished by using a combination of loose, rotoscoped mattes, and some specific luminance keying for highlights or shadows.

The *quality* of the light in a scene can be difficult to quantify, but fortunately it is also less noticeable than some of the other mismatches. Distinctly mottled lighting can be dealt with via the selected application of irregular, partially transparent masks to control the placement of some additional light and dark areas. If the lighting in a scene, and on an object, is not consistent over time (including the presence of interactive light in the scene), you will need to do your best to conform your foreground's fluctuations to the background's. In some cases it may be as simple as adding a fluctuating brightness on the foreground that is synchronized to the background. In other situations you may need to have articulated mattes controlling the light so that it only falls on certain areas.

Taken to the extreme, very complex interactive lighting can be achieved by duplicating your foreground element as a neutral-color 3D model and applying CG lighting to it.

This new element will include brightened areas that can be extracted and applied to the original 2D foreground element. The same techniques can also be used to manipulate a change in lighting direction, providing a set of control masks to apply appropriate brightness changes. An example of this is shown in the *King Kong* case study in Chapter 15.

In a situation where the foreground element that you are adding into the scene is actually *producing* light, you'll also need to modify the background plate appropriately (assuming that this interactivity wasn't taken care of when the plate was shot). Objects in the background should be illuminated by varying amounts, keeping in mind that the intensity of the light should fall off as the distance from the source increases.[1] Objects in the background should cast shadows on each other as well, and you should at the very least try to create some mattes to simulate shadows and use these to brighten the scene less (or not at all) in these areas.

Light Wrapping

Indirect lighting is also something that needs to be considered when you're putting together a composite. As we have said before, *every* object in a scene is effectively a light source, bouncing light onto the other objects in the scene. A camera (or your eye) has no way of making a distinction between photons that are generated via incandescence, for instance, and photons that reach the sensor after being reflected from another surface.

We can use this fact to help us better integrate objects into a scene even if we aren't specifically modeling light-sources. One such method is to take some of the colors from the background plate and "wrap" them around the new foreground element.

Consider the statue element (Figure 13.1) that we originally isolated from the background in Chapter 6. If you, for some reason, feel the overwhelming urge to relocate such a statue into the middle of a cow pasture you may find the significant difference in lighting environments to be problematic. Given the background shown in Figure 13.2, simply placing the statue over it results in the rather unsatisfying composite shown in Figure 13.3. But a few additional steps can make a world of difference.

First, let's generate a new mask based on the matte of our original foreground element. This mask[2] (shown in Figure 13.4) is designed to let us isolate only the edges of the original image. Next, we'll create a new foreground element that has been

[1] Light actually follows an "inverse square" law for falloff—the attenuation of the light increases based on the square of the distance from that light. Rarely do you need to be this precise, however, and producing something that "looks good" is usually sufficient.

[2] Created by multiplying the original mask by a blurred, inverted version of itself.

Figure 13.1 An element extracted from its background.

Figure 13.2 An image to be used as a new background element.

Figure 13.3 A simple composite—Figure 13.1 Over Figure 13.2.

Figure 13.4 A specialized mask used to isolate the edges of Figure 13.1.

modified to contain colors from the background we'll be integrating it with.[3] This color-modified image is shown in Figure 13.5.

Figure 13.5 The original foreground element, color-corrected using hue and saturation from the background image.

Finally we'll use the edge-matte from Figure 13.4 to mix this colorized image with the original before combining it over the background. The result is shown in Figure 13.6.

While far from a "perfect" composite (we'd probably want to do some more detailed color corrections to the original statue image to modify the warm light that is illuminating it, for instance) it does feel more "integrated" with the environment than our first attempt. A detail of this is shown in Figure 13.7, where we can see how this technique successfully approximates the sense that green light is bouncing off of the grass and relighting the statue.

Although this procedure isn't really all that accurate a representation of what is happening in the real world, it's a fairly simple way of removing obvious color mismatches

[3] In this case we blurred the background and then substituted the hue and saturation from that image with the original hue and saturation of the statue.

Figure 13.6 A new version of the Figure 13.3 composite, now with light-wrapped edges.

Figure 13.7 A comparison of detail from Figure 13.3 versus Figure 13.6.

between foreground and background without requiring significant color-correction to that foreground element. And of course light that is coming from behind an object *does* wrap around that object to an extent—take a look back again at some of the greenscreen examples from the last chapter if you need to be reminded of this fact. Ultimately, though, the point here is not to show a specific technique so much as to describe general concepts—in this case using one image to modify the color of another and the use of masks to concentrate on important areas like object edges. A more thorough

composite might, for example, involve spending more time on the mask we're using, balancing the effect more appropriately in areas such as the sword or the face.

Shadows

A common mistake made by novice compositors is to forget or ignore the fact that an object should cast a shadow (or several) on its environment. Any time you add a new element into a scene, you should think about how the lights in the scene would affect this new element, which includes the fact that the new object would *block* some of these lights, causing shadows to be cast. Whenever you apply these shadows, be sure to match other shadows in the scene in terms of size, density, and softness.

Part of the reason why shadows are so often forgotten can be attributed to the fact that many bluescreen plates are lit so as to intentionally remove shadows. Shadows that fall onto a bluescreen can make it difficult to easily extract the foreground object (particularly when using less-sophisticated traveling-matte methods), and so they are often considered undesirable when lighting the setup. Whether there is a shadow available or not, many methods of extracting an object from its background do not allow this shadow to be brought along, at least not without additional effort.

Even if you are able to extract an object's shadow from its original background, it may prove useless due to the lighting of the scene or the shape of the ground where the shadow is cast. In many cases you may decide to create a shadow yourself. It is often acceptable to simply manipulate the matte of the foreground element and use it as your shadow element. This method is fine if your shadow falls onto a fairly smooth surface, such as a floor. But if your shadow needs to be cast onto irregularly shaped terrain, you may need to create something more specific to the scene. Perhaps you can warp a flat shadow so that it fits, or you may need to go so far as to manually paint an appropriate shadow. Whatever you use, remember that it will need to change over time if your element (or the light striking your element) is moving.

Once we have the element (usually a matte) that we will be using to define our shadow, the most common way to actually create the shadow effect is to use this element as a mask to selectively modifying the shadowed area. Remember that a shadow is not simply darkening an area uniformly, it is really the result of *some* of the light in the scene being blocked. Other light sources (potentially just light bouncing from other objects in the scene) will still be partially illuminating the area in question. And remember that when an object blocks a colored light-source, creating a shadow for this object would mean that you only want to remove the light that is being blocked.

Take a look at Figure 13.8, part of an image we originally looked at in Chapter 2. We can see that the shadow cast towards the right by the chess piece is not a darker blue but rather a more neutral color because only the blue light has been removed. Figure 13.9 demonstrates this visually—Figure 13.9a shows the result if we use a matte to simply darken the image. The shadow doesn't match any of the other shadows in the image. On the other hand, in Figure 13.9b we have used the mask to color-correct the background plate to more accurately match the other shadows in the scene.

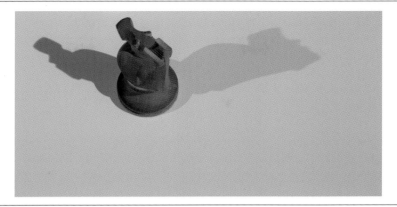

Figure 13.8 Shadows cast from colored light-sources.

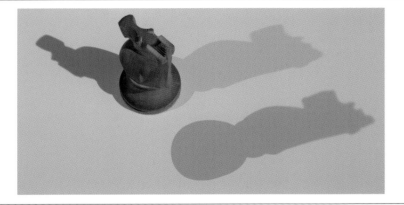

Figure 13.9a Artificial shadow created by simply darkening the plate.

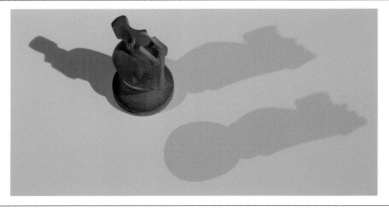

Figure 13.9b Artificial shadow created by selectively color-correcting the plate.

Take note, too, of other artifacts that the light in question may have produced. For instance if your original image has noticeable highlights or bright areas of specularity, these may need to be dealt with explicitly. The worst-case scenario is if your original image has images that have blown out to pure white. If a real shadow had fallen on this object, those highlighted areas would be brought back down to a value that would show detail, whereas simply darkening them would only leave you with a uniform gray color.

Given that a shadow is the *absence* of a particular light source, it makes sense that two objects casting a hard, distinct shadow onto a surface will not necessarily produce a darker shadow where those shadows overlap each other. This is shown in Figure 13.10. As you can see, the area where the shadows overlap is the same density as where they do not overlap, because both objects are obscuring the same light source—either object is enough to completely obscure that light. Even though their shadows overlap, there is no additional darkening needed in the intersection. This might seem obvious on paper, but in a real-world compositing situation we could conceivably be manipulating the two shadow objects as separate elements, and thus the brightness decrease from the shadow masks could easily be inappropriately doubled if the layers were applied sequentially.

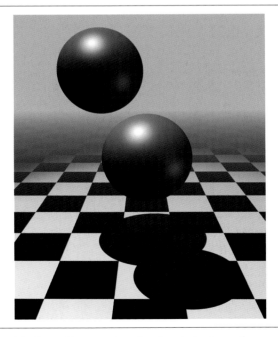

Figure 13.10 Two objects casting overlapping hard shadows from a single light source will not produce a darker shadow where the shadows overlap.

Soft, diffuse shadows will behave differently, since they are not blocking a particular light but rather are shielding an object from a broader or more global source. This is the case with the lighting from an overcast sky. In this situation, not only will your shadows be much softer (and only occur when objects are in closer proximity to a surface) but they can actually produce different densities in areas of overlap.

Objects that are in extremely close proximity (or that are touching each other) will block most of the light, even if it is a fairly diffuse source. For this reason we often include a special **contact shadow** in such situations. The classic case is where a character's feet touch the ground—even if you already have an overall shadow for the object, you may want to add an additional bit of shadow just around the area where the objects make contact.

Multiple light sources will produce even more complex shadows. Theoretically, every light that is hitting an object will produce some sort of shadow, but this is often impractical to simulate within a composite. There may be a light source that is significantly brighter than the rest, and you can take your shadow cues from this alone, or there may be a need to add a few shadows, each the result of a particular source.

Digital Color Matching

Although we have talked about the importance of matching the lights and shadows in a scene, in the digital realm all we have to work with are the numerical measurements of these lights and shadows. Instead of adjusting a light on the set, we will be confined to working with image processing operators that can adjust brightness, contrast, and color. Even if all the elements that are to be integrated into a scene were shot with identical lighting setups, the resulting digital image files may not be properly matched. Many of the conversion steps that the images go through as they are digitized can introduce inconsistencies, including color or brightness shifts. At some point the issue of how the elements were created becomes less important, and you will need to concentrate on synchronizing the digital values as these elements are added to a scene.

Consider the case of the darkest areas in an image. These areas are usually referred to as the "blacks" of the image, and may be found where there are heavy shadows, or merely in areas where the object that was photographed is extremely dark. Rarely are the darkest parts of a photographed scene completely black, and if you want to add something to that scene you should make absolutely certain that the darkest parts of your new element aren't any darker.

Mismatched black levels are one of the most common problems you will find with composited imagery. This is due in part to how difficult it can be to accurately judge relative brightness in the darker areas of an image. The problem is compounded even further by the fact that you will often be viewing the images in a fashion that is different from how they will eventually be displayed. As mentioned in Chapter 9,

your computer's monitor (even if it has been carefully calibrated) can still only give an approximation of what the final image will look like on film or video. Subtle black-level mismatches that your monitor is unable to display may become suddenly noticeable when the image is transferred to its final format. Even if you do have the opportunity to view your images in what you think is their final format, don't assume that you have nothing else to worry about. Ultimately you can never be certain what will happen to your images once you are finished with them. For instance, it is a very common practice to slightly boost the brightness of film images when they are released on video/DVD or for digital distribution, due to differences in the dynamic range of home viewing devices. Suddenly, areas that looked to be of uniform blackness can reveal hidden detail, including compositing artifacts!

For a visual example of this, consider Figure 13.11. This is a composite—the rocket was placed over the star-field background. Within the limits of our display device (the chapter of this book) the composite appears to be without artifacts. But in reality the black levels don't match perfectly well. Figure 13.12 shows the same image but with a brightness boost applied to it. Now we can see that a rough rotoshape matte for the spaceship has suddenly appeared! The color-correction was enough to bring the subtle difference between black levels into a range that is more visible to the human eye and the artifact shows up. This sort of thing is extremely common if you look at video transfers of older movies that feature miniature model spaceships. The transfer to video applied enough of a boost to the mismatched black levels that the composite no longer holds up.

Figure 13.11 An image shown with the intended exposure.

Fortunately, there are some very simple methods that can be used to help judge how well the black levels are matching. The first, and easiest, is to simply boost the brightness of the composited image you have created. This will obviously be a temporary

Figure 13.12 Figure 13.11 with gamma-boost applied—the garbage matte becomes visible.

step, since you presumably have already created an image that is the proper brightness, but it can quickly reveal problems that would otherwise be undetectable. By taking a few moments to create an image that is much brighter than necessary, you will move the darkest areas into a range where slight tonal variations will be far more noticeable. There are a few different ways that you can accomplish this temporary brightness shift. You can certainly just apply an additional brightness to the image itself, creating a new image for viewing purposes. On the other hand, it may be easier to adjust the brightness of your computer's monitor instead. Make sure that you can easily return to any calibrated settings that may have been in place on this monitor! Many software packages will even allow you to load a specialized look-up table that will be applied to every image that is displayed. This method is usually best, since the LUT can be quickly turned on or off as needed.

Most compositing tools will also include the ability to digitally sample values from different regions of an image. By carefully sampling appropriate groups of pixels from areas that should be equivalently dark, you will be able to obtain a numerical confirmation that the levels match to within an acceptable threshold.

Although we have only discussed black-level matching so far, the concepts obviously extend beyond this. Many of the same issues hold true for the brightest parts of a scene, and care should be taken that the white levels match as well. Typically there is less of a problem with compositors not matching their highlights, partially because, even with darker images, whites can often reach 100%.

Most importantly, of course, is ensuring that the colors of the element being added *to* the scene are appropriate for the illumination *in* the scene. A blue object will, obviously, have digital values that read as more purple if it is placed into a scene with

blue lighting. Matching blacks and whites is a good first step (generally what you want to do before moving on to color) but the real trick is to come up with ways to accurately determine how much color correction needs to be applied to the object. And this is usually done by analyzing clues in the scene itself. Flesh-tones, for instance, can be a great indicator if you can match your foreground character to someone already in the background plate. Look, too, at objects that have known colors (shades of gray are particularly handy) and adjust accordingly between all elements.

A histogram or some other image analysis tool can also be useful in this situation, allowing you to quickly see the relative distribution and range of colors in the foreground and the background. You'll want to look at your foreground element after you've extracted it from its background and color-corrected it to where it is a reasonably close match to what you think you have in the background and then adjust things if you see radical discrepancies. Of course the two histograms will never match exactly but general trends can often be discerned.

At the end of the day, of course, you will be matching a variety of different values between elements. Colors and contrast ranges may all need adjusting, and although there may be some analysis tools that can help you to determine numerical correlations between specific areas, your final decision will always be based on your own aesthetic judgments. As always, if it *looks* correct, then it *is* correct.

Spill Suppression

Along with all of the issues already discussed, bluescreen and greenscreen plates feature the additional joy of having to deal with the *extra* lighting introduced by bounce-reflection from that screen. No matter how carefully the foreground character was lit, there will always be a bit of blue colorization that comes from the backing.

As we have already discussed, the process of placing a bluescreen element into a new background involves several steps. We looked at a variety of different methods for accomplishing the matte-extraction step in Chapter 6 and at that time also touched a bit on a basic spill-suppression processes that is a part of the color difference method that first originated in the optical compositing world.

If you recall, the spill-suppression step of this process involves the selective substitution of one channel into another. In the case of a bluescreen, we selectively use the green channel as needed. The most simple version of this step compares the blue and green component for every pixel in the image. Whenever the blue component exceeds the green component, the value of the green component is also used to replace the current blue value. An example of simple spill suppression is shown in Figure 13.13.

Figure 13.13a shows our original bluescreen element, which was intentionally shot with a bit of blue spill, particularly in the mannequin's hair, to emphasize some of the issues we need to discuss. Hair, especially blonde hair, is widely recognized as one of the most difficult things to composite when working with bluescreen imagery.

Figure 13.13a A bluescreen element.

Figure 13.13b Simple composite of Figure 13.3a over a new background.

If we extract a matte for the mannequin and place it directly into the background scene (as shown in Figure 13.13b), you can still see quite a bit of blue contamination on the foreground. But if we apply a spill-suppression technique before the composite is performed, a more pleasing (but hardly perfect) result is obtained. This is shown in Figure 13.13c.

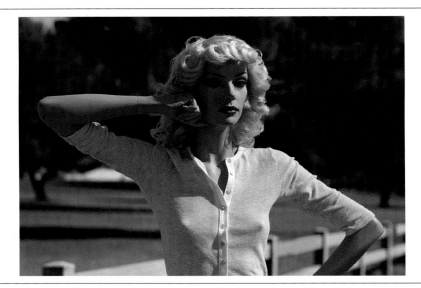

Figure 13.13c A composite where the foreground element has had spill-suppression applied before compositing.

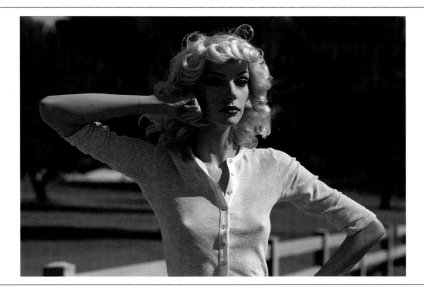

Figure 13.14 The foreground object photographed in the actual scene (not a composite).

For comparison purposes, take a look at Figure 13.14. This is not a composite—the mannequin was actually photographed standing in front of the background. Examination of fine details (such as the hair) as well as the overall color balance will give you some idea of the issues that can arise when attempting to produce a composite that properly matches with reality. As you can see, the spill suppression that we used can

certainly neutralize the blue in the "spill" areas, causing them to become a gray tone. But this technique will usually not be able to distinguish the difference between blue *spill* and blue *objects*, with the result being that certain things that should remain blue will be inadvertently affected. You can see this, for example, in the shirt the mannequin is wearing—it has a blue tint that is inappropriately neutralized by the general spill-suppression step. The typical solution is to either explicitly isolate such elements (via specific procedural or manually generated mattes) so that they are not affected by the spill suppression, or to manually color correct them back to the appropriate tone.

Incidentally, using channel substitution as a spill-suppression method can, in some situations, have additional drawbacks as well. One of the more significant occurs primarily when working with greenscreens. The same logic we used to suppress blue can be used to suppress green, merely by substituting green for blue and blue for green in the spill-suppression equation. Thus, anywhere the value of the green channel is greater than the value of the blue channel, use the value from the blue channel instead. But this technique can be more problematic with greenscreen because of the relative amount of noise that is present in the various layers of motion picture film. You'll recall that the blue record is significantly more grainy than the green channel. And thus using a larger amount of this noisier blue channel to replace the green channel can increase the overall amount of grain by a noticeable amount. Whether or not this effect will be a problem is very dependent on the situation. If you are using slower, less grainy film or shooting on high quality video (where the relative noise between the blue and green channels is quite a bit less), this may not be a significant problem. If you are explicitly limiting the spill-reduction to a relatively small area, you can also probably get away with applying a slight degrain or blur to the blue channel before doing this substitution. And of course if there is very little green spill to suppress in the first place then very little channel substitution will take place and, again, there may not be an issue.

Also, remember that any algorithm which simply *removes* green or blue from "spill" areas in an image will be darkening those areas as well. This is a bigger problem with greenscreens given the fact that the green component contributes a great deal more to the luminance of an image than does blue. But in either case, any despill operation should probably be accompanied by a compensating brightness increase in those areas. This may or may not be something that your despill algorithm does automatically.

The simple channel substitution we've looked at here is only one of many techniques for dealing with blue spill. There are a variety of variations on it—selectively mixing in different ratios of alternate channels where appropriate. You'll rarely be called up on to do such explicit channel-mixing by yourself, however. Most compositing packages feature several tools that can be used to remove or decrease spill while causing less of an effect on the overall balance of the image. Some of these tools are based on channel substitution concepts, others are not, relying on more standard color-correction methods such as selective desaturation. And just about any dedicated keying software, whether it is available as a plug-in across many platforms (i.e., Ultimatte, Primatte, Keylight) or proprietary to a specific compositing package, will feature tools for far more advanced spill-suppression tools than we can discuss here.

As you can see, spill is particularly problematic in edges that are composed of extremely fine detail (such as hair blowing in the wind). The individual hairs are so small that they should really be considered partially transparent in many cases, and you'll have to modify things accordingly. In fact, it is sometimes better to not even try to approach these areas as a layering operation at all. Rather, use the matte you have generated for the wispiest of these areas to simply apply a color-correction to the background instead. Slightly brighten the background if you are dealing with blonde or brightly lit hair or tint the background darker or more brown for brunettes. An example of this is shown below.

Figure 13.15 shows a section of the image where we've used a mask (Figure 13.16) that was derived primarily from the red channel of the original bluescreen element to color-correct the background. (In this case we corrected the background towards a yellow-golden color that is similar to what we find in the blonde hair-highlights.) Now we can pull a much more "severe" matte for the bluescreen foreground—one

Figure 13.15 Selective color-correction of the background based on a mask.

Figure 13.16 The mask used for the color-correction in Figure 13.15.

that eliminates much of the spill-contaminated blue areas of the hair. Figure 13.17 shows the matte we're using for this, along with the resulting image after having been premultiplied by that matte. Of course the elimination of blue-contaminated hair has also eliminated much of the fine detail in those same areas but that's not a problem since our new background plate (Figure 13.15) already has that detail from the color-correction step. Now if we take the premultiplied image from Figure 13.17 and place it over that background, we have a much more pleasing composite.

Figure 13.17 A matte that eliminates heavily spill-contaminated areas and the premultiplied image that results from using this matte to extract the object from its original background.

Figure 13.18 shows this composite (on the left) as compared with the same result we originally obtained back in Figure 13.13c. Remember, this method is very specific to the problem at hand—applying those same steps to other portions of this same image would probably end up looking *worse* than what we had in Figure 13.13c.

Figure 13.18 The composite created using selective color-correction on background compared with the original spill-suppressed composite from Figure 13.13c.

The bottom line on any of this is to realize that bluescreen compositing is rarely accomplished via the use of a single keying operator. It is far more common to use a multitude of different techniques that are combined together in different areas to achieve a pleasing result.

Atmosphere

When it comes time to add a distant object into a scene, you will almost always want to modify the element to simulate the effect of atmosphere. Once you're in a digital environment, this atmosphere is often just done with a bit of color-correction, selectively applied to account for the distance involved. It can be as simple as decreasing the contrast in the element, but usually you'll be better off if you concentrate on the dark areas of the image. Distant objects can still produce hot highlights, but their blacks will always be elevated as they move away from the camera. They will also usually take on some characteristic color or tint, depending on the ambient light and the color of the atmosphere itself. You may want to use pixel and regional analysis tools to numerically determine the value of any dark areas in the background plate that would be at the same distance as your new element.

Atmosphere may also introduce **diffusion** into the scene, an effect that causes some of the light to be scattered before it reaches the viewer or camera. This effect can also be the result of certain filters that are placed on the camera itself. Diffusion is not the same thing as a blur or a defocus. Only some of the light is scattered, and there will still be detail in the image. Diffusion tends to cause a halo around bright light sources and will often also elevate the blacks. In the digital world, an excellent method that is often used to simulate diffusion is to slightly blur the image and then mix it back with the original image by some small amount, probably mixing brighter areas in at a higher percentage.

These methods are enough for uniform atmospheric effects but if the atmosphere is something more distinctive—some well-defined tendrils of smoke, for instance—things can get more complicated. You will probably want to make it seem as if any new elements you are adding to the scene are behind, or at least partially within, this smoke. You may be able to pull some kind of matte from the smoke—based on luminance most likely—and use it to key some of this background over your new foreground element. This method will only work if your background is fairly dark and/or uniform. If the camera is locked off, try averaging a series of images together to create a new element. Averaging the smoke together will remove distinctive details and will give you something that can be used as a clean plate. This plate can then be used with difference-matting techniques to better isolate the smoke, producing a new element that can be laid over your foreground and will roughly match the existing smoke in the scene (one hopes). You'll probably find that once you've created the difference matte you'll want to clean it up a bit, possibly blur it, and so on. The good news is that in most cases the foreground smoke won't need to be an exact match for what's already in the scene to be able to fool the eye. Given this, it may be just as easy to get footage of similar smoke shot on a neutral background and layer that over your element. In a situation such as this, you'll probably end up wanting to put this new element over

both foreground and background, though not necessarily at the same percentage. The major disadvantage of this solution is that, in order to make it seem like the smoke is well integrated, the overall amount of atmosphere in the scene will increase.

Camera Characteristics

As discussed in Chapter 2, understanding how a camera sees the world (including the actual capture medium, be it film or a digital sensor) is a key factor in being able to produce believable composites. And, just as we saw with color and lighting, the topic should be looked at from both a real-world and a digital perspective.

Camera Mismatches

If you recall, when shooting a foreground and a background as separate elements we ideally want to use cameras that are consistent in terms of location, lens, and orientation relative to the subject. Plates that were shot with mismatched cameras can be difficult to identify via a purely visual test, since the discrepancies are often subtle and hard to quantify. Once again the importance of good notes, which can quickly identify the existence of a mismatch, becomes obvious. Consider Figure 13.19, which gives

Figure 13.19 The view of a subject when seen from a fairly high angle.

an idea of the perspective in a scene when photographed from a certain position. Now look at Figure 13.20. We've moved the camera so that it is much lower than it was in the first image. Although the perspective is noticeably different for the two camera positions, the basic information that is present in the two images is fairly similar. If this building is a separate element, judicious use of certain geometric transforms may be able to modify Figure 13.20 so that it appears to have been photographed from nearly the same perspective as Figure 13.19.

Figure 13.20 The view of the same subject from a much lower position.

Consider the four-point distortion, or "corner pinning," that is indicated in Figure 13.21—the red border gives a good indication of the general transformation that has occurred. If we place this modified element over the background (as shown in Figure 13.22), the apparent perspective feels much closer to the scene shown in Figure 13.19, at least in terms of having removed the noticeable foreshortening contained in the original image.

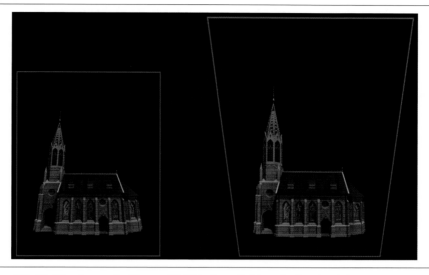

Figure 13.21 The image in Figure 13.20 before (left) and after (right) using a corner-pin transform to approximate the perspective seen in Figure 13.19.

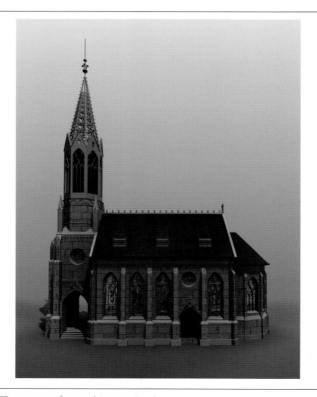

Figure 13.22 The retransformed image in the scene.

Using a two-dimensional transformation to correct a 3D discrepancy is known as a **perspective compensation**. Of course this was a fairly simple scenario, and we had the enormous advantage of having a reference image to help us determine the appropriate amount of transformation to apply. But at the very least, the example serves to illustrate that it is possible to at least partially compensate for elements with inappropriate perspective. Some specialized warping might be able to produce an even closer match, although the task would not be trivial, and you would run the risk of introducing artifacts that are more disturbing than the original problem. This sort of compensation can only be taken so far. Figure 13.23 shows the building from a much different angle. A whole new face of the building has been revealed, and obviously no amount of image manipulation would be able to transform Figure 13.20 into a reasonable match for this new image.

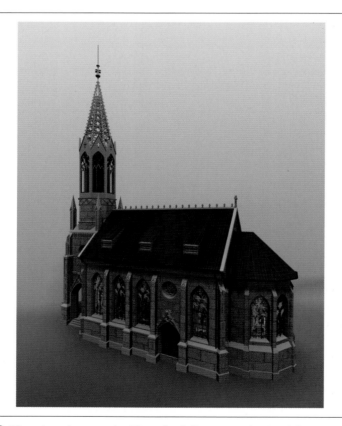

Figure 13.23 The view from a significantly different angle. Modifying Figure 13.20 to approximate this perspective would be extremely problematic.

Since it is the camera-to-subject position, and not the lens, that determines perspective, two elements that were shot with different lenses will not necessarily cause

a great problem. Assuming the camera was in the proper position, a different lens should result in nothing more than a scaling difference. As long as you have enough resolution to resize the element without introducing artifacts, your only problem will be determining the proper position and size for the element. While this is not trivial, it is usually far less difficult than having to compensate for perspective discrepancies. Of course, the chances are good that if the wrong lens was used, the camera position/ distance was modified to compensate, and you therefore will be back to dealing with perspective issues.

As mentioned, the problems with a composite that includes these sorts of mismatches are hard to identify, but will still be noted by the subconscious expert. When questioned, people will say that the shot "feels wrong," that the elements just don't quite "fit" into the scene. If you don't have shooting notes that can help you to determine the nature or extent of the problem, you'll need to pay particular attention to any objects in either element that can give clues concerning what the lines of perspective are doing, in order to better align the two plates.

Camera Movements

The nature of effects photography historically required that the elements of a composite all be shot with an unmoving, locked-off camera. While this made for easier composites, it didn't really make for interesting (or believable) cinematography. In Chapter 8 we looked at tracking tools that can help determine the move that a new element will require if it is going to be placed into a scene that was shot with a moving camera. Nowadays, this is far more common than requiring a locked-off camera. Tracking can also be used to synchronize two elements that both have camera moves, even if the two moves are not similar. Understand, however, that two different moves implies that the camera-to-subject relationship will not be exactly the same for both plates. Some of the perspective compensations that we discussed in the last section may need to be applied to one or both of the elements in question.

Another method that is often used to introduce camera movement into a shot is to add the move *after* the composite is complete. In this situation, all the elements would ideally have been shot with an unmoving camera, and the composite would initially be put together as a locked-off shot. Once the shot is finished, an additional digital pan could be applied, giving the sense that a camera was moving across the scene, following some piece of pertinent action within the frame. Strictly speaking the effects of such a move will be incorrect in terms of parallax effects—closer objects won't necessarily move more relative to the more distant ones and the scene may end up feeling slightly "flat." Often you can get away with it, or you may be able to break up this plate into a few different layers and move them by a slightly different amount.

The camera move need not be a sweeping pan or zoom. Instead, you may find it necessary to add some sort of minor camera bounce or shake to your shot to match surrounding footage. A subtle move such as this will often be enough to take the curse

off an otherwise static shot, hiding the artificiality of its origins. There may even be times when a defect in the shot that would be fairly difficult to correct explicitly can be covered by a strategically placed camera shake. Obviously there would need to be some sort of justifiable motivation for such a shake, but assuming it is warranted, this ploy could save a great deal of work.

If the move that needs to be added to a shot is fairly large, then you may need to work at a larger-than-normal resolution so that the push-in won't cause unwanted softness. If the move is small, then a slight push-in will probably be unnoticeable even if you are already working at the same resolution as the rest of the surrounding shots.

The shot from the film *Speed* that is discussed in Chapter 15 makes use of some of these tricks, adding a two-dimensional pan to an otherwise locked-off shot in order to heighten the excitement and action in the scene.

Scale and Perspective

When you are adding multiple elements into a scene, be careful that their relative depth cues are consistent. Unlike the real world, in a digital composite it is possible to accidentally create a scene in which object A moves in front of object B, which moves in front of object C, which in turn moves in front of object A. This sort of contradiction can conceivably happen with several of the different depth cues.

If you are placing a true foreground element into a background scene, this may be a nonissue, since your foreground will overlap everything else in the scene. But if your "foreground" element is actually located somewhere in the midground of the scene, you may need to isolate objects in the background plate that can be used to partially or occasionally occlude the new element. You may also simply add elements that are truly in the foreground.

In some situations there may be additional data (such as set measurements) that can help with the process of sizing an object, but all too often one must arbitrarily scale the element to what one hopes is an appropriate size. Learn to use other objects in the scene as clues to relative size and position. Even if there are no objects in the scene that are the same size and distance from camera as the new element, you can often look at several nearby objects and mentally extrapolate the proper scale for the new object.

Again, be aware of the overall perspective of the scene when doing these estimates. This will become even more important when you need to deal with objects that move towards or away from the camera. In this situation, you may even need to animate the scale of the object. The amount of scale change will be determined not only by the speed at which the object is moving, but also by the perspective in the scene. If the scene was shot with a long lens, the apparent size increase/decrease will be less extreme than it would be had it been shot with a wide-angle lens.

Note that generally we will usually need to make use of several depth cues (such as atmosphere and depth of field) simultaneously in order to properly place an object at a specific depth. This is particularly true in the visual effects world, where one is often called on to integrate elements whose scale is something with which we're not normally familiar (such as a giant flying saucer hovering over an entire city). In situations such as this, you may find that certain cues such as relative size are almost meaningless, and things such as overlap and atmosphere take on a greater importance.

Focus

We gave a bit of information in Chapter 2 about how depth of field is affected by the lens and subject distance and if you actually have access to this information you may be able to use it to help determine the proper amount of focus for various objects that are being placed into the scene. Most of the time, however, the primary depth-of-field clues that you will have available are the other objects in the scene, and these can be a guide for your element's degree of focus. If there is nothing in the background that is the same distance from camera as your foreground element, you will need to make an educated guess, which is when some of the information discussed in Chapter 2 can be used. For instance, now that you understand about the relationship between aperture and depth of field, you can assume that a scene shot with less light was probably shot with a larger aperture, and consequently that the depth of field is narrower.

The most common method for simulating an out-of-focus element in a digital environment is to use some kind of blurring algorithm. While this is often perfectly acceptable, it is really a compromise solution. As we discussed in Chapter 2, a true defocus has a number of well-defined characteristics—characteristics that go beyond the look obtained by using a simple blur. Ideally, your compositing package will provide you with tools to help simulate a more accurate defocus, including some facility for highlight blooming, scale changes, and even depth-of-field effects.

If you need to add depth of field to an existing scene, you may be able to use a gradated mask to selectively defocus objects that are farther in the distance. If your scene is a synthetic, CG image, a Z-depth image (discussed more in Chapter 14) may be used to determine the amount of defocus each area will receive.

It may seem obvious, but remember that an out-of-focus object should have an edge softness that is appropriate to the overall softness of the object. Creating an appropriate edge tends to be most problematic when pulling a matte on a soft or motion-blurred object, since the thresholding used by certain keyers may produce a harder-than-normal edge. Either work on your key some more or (if you can get away with it) just add a bit of additional blur to your new edge.

If you need to add an element into a scene that features a rack focus, you should plan on spending some time synchronizing the timing of your new element's defocus. Since there are currently no real tools for measuring the "amount" of defocus in a generic scene, the compositor will need to visually match the timing of the focus

change as closely as possible. This can be difficult: Individual frames may appear to be matched properly, but once the effect is seen in motion, the illusion may fall apart.

Depth of field can also be a powerful cue for setting the scale of an object since small objects will usually be shot fairly close to camera (and consequently the depth of field can be much narrower). For instance if you look back at the image in Figure 2.14 you'll immediately have a sense that the scale of the objects in the scene are fairly small. Introducing an artificially small depth of field into an image can trick us into having the same experience. Consider Figure 13.24. To most people, their first perception of the truck in the scene is that it is some kind of miniature. Figure 13.25 shows the original image, where the truck appears normal-sized. Given the fact that the visual effects artist will often be placing objects into scenes that are intended to representing something of a different size—Miniatures that need to appear full-sized or actors that need to appear miniaturized—it is worth being aware of this perceptual issue.

Figure 13.24 An image with a very shallow depth of field, giving the impression that it is a photograph of a miniature object.

Figure 13.25 The original image with the normal depth of field.

Motion Blur

If you wish to place a moving object into a scene, and that movement is something that *you* created (either as a 3D element or with a 2D transformation), you should plan on motion blurring your element. Most high-end systems allow motion blur to be added to a 2D move or rendered with the 3D element. If your system does not provide a true motion-based blur, you may have to resort to using some kind of directional blur or smear. It may not be quite as accurate (the tool may be unable to create a blur that curves along the object's path, for instance), but in many cases it will be enough to fool the eye.

As mentioned in Chapter 2, different types of cameras and camera settings can greatly affect the amount of motion blur that is captured with an image. While cameras will always have a limit to the range of shutter speeds they can use, most software that is designed to simulate motion blur will have no such restrictions. At times this may be useful to create a desired special effect, but usually you should do your best to analyze any reference material you have for the scene in question so that your depiction can be physically accurate and consistent.

If your original element already has some motion blur associated with it, be aware that changing the movement of this element will introduce a visual discrepancy that may be perceptible. For instance, adding vertical movement to an object that only has horizontal movement (and horizontal motion-blurring) would produce imagery that might appear somewhat strange. While there are certain algorithms that can sometimes remove motion blur from an element, they are not common and are limited in their scope. Ultimately, your only choice may be to apply additional motion blur that properly matches the new move and hope that the effect isn't too damaging to the already-blurred image.

Lens Flares

It is often desirable to introduce some sort of lens flare when creating a scene with bright light sources that were not present in the original elements. Be careful with this effect, as it has become somewhat overused in much of the CG imagery being created these days, but don't be afraid to use it where necessary, as sometimes it can play a very important part in making a scene look correct.

As mentioned earlier, a common problem with some commercially available lens-flare software is that it tends to produce elements that are far too symmetrical and illustrative. Instead of relying on these packages, you may wish to shoot real lens flares over a neutral (probably black) background (as was done to create the examples in Chapter 2) and use these as separate elements.

Unfortunately, if you have a moving camera (or the light source that is causing the flare is moving relative to the camera), simply compositing a static lens flare onto a scene will not produce the proper characteristics. In this case, you will have to try to match the way a real flare would behave. There are a number of ways to accomplish this. You can shoot a real lens flare with a similar camera move or, even better, with a motion-controlled match-move. You can use a commercial lens-flare package that is able to automatically move the various flare elements relative to one another after you've tracked the light source's movement across the frame. Or you can simply manually create some visually appropriate motion for the various static flare elements. These techniques all have their good and bad points, depending on the situation. Remember that lens flares will usually have similar characteristics throughout a given scene. Examine the surrounding footage so that you can create a flare that fits with the other shots in the scene.

There may also be times when you have a background plate that already has a lens flare in it, and you need to composite a new object into this scene. In this case you'll need to come up with a way in which the new object can appear to be *behind* the flare. (Remember, lens flares are never occluded by other objects—they simply fade out as the light-source is hidden from the camera.) This task can be quite difficult, since the flare is almost always semitransparent. You may be able to key a basic shape for the flare, but you'll probably end up with some detail from the background as

well. The typical solution is to apply additional flare over both foreground *and* background. While this will increase the apparent brightness of the flare, it will help to integrate the elements without showing an obvious difference between foreground and background. Of course if the new element you are adding to the scene actually does obscure the light source that is generating the flare, you really should remove that flare. This is not a fun task—hopefully you can find image data from surrounding frames or have access to a clean-plate image of the scene.

Finally, remember that *any* bright light-source that is hitting the lens of a camera (even at an oblique angle) will affect the image, flashing the black levels to a certain extent (as we saw in Figure 2.22). Thus if you are adding a new element into a scene, you should determine if there is anything in the scene that could cause this effect and modify your new elements accordingly. As usual, make sure you examine other objects in the scene for clues as to how much work you'll need to do in this area.

Film Grain and Sensor Noise

We've already discussed how visual effects photographers who are shooting on film will tend to try to capture most imagery with as little grain as possible, under the assumption that it can be added in post as needed. The same principles also hold true for scenes that are shot digitally—always try to minimize the amount of noise that your sensor is adding to the scene, usually by using a high quality setting and making sure that you have enough light in the scene. (And since it would be really tedious to fill the next few paragraphs with the phrase "grain or noise" repeatedly, we'll just use the term "grain" as a generic term for both.)

But if your background plate was shot with a different film stock than what you're using for your visual-effects work, you will probably need to be adding an appropriate amount of grain to your elements before they are placed into a scene. Conceivably, an overall grain pass can be applied to the finished composite, assuming that *all* the source elements were equivalently grainless. Forgetting to add grain to an element is a common novice mistake when integrating rendered 3D images into a scene, causing the CGI element to appear far too "clean" for the rest of the image. (Incidentally, a little bit of grain added to a CG element can also do a wonderful job of eliminating the contouring or banding artifacts associated with limited-bit-depth CG images.) Even two different live elements may not have the same amount of grain or noise, owing to different film stocks, cameras, exposure levels, development processes, and any operators that may have been applied.

A number of compositing processes can add to or enhance the grain in an element. Sharpening, for instance, can dramatically emphasize the grain in an image, as can a large contrast adjustment. If you plan to digitally enlarge an element, be warned that your grain will enlarge as well, possibly giving the image a blotchy look. As discussed earlier, some spill-suppression techniques can affect the amount of grain in a bluescreen/greenscreen element.

Note too that grain isn't something that affects all areas of an image equivalently. Look at Figure 13.26 (shot with a digital camera), which, if you examine the close-up detail shown in the bottom-left, appears to be relatively noise-free. However, if we boost the brightness of this image (as shown in the bottom-right corner), we will see that the darkest areas of the scene actually have a significant amount of sensor noise in them. Thus the same issues we discussed in the "Digital Color Matching" section would apply in a similar fashion here—make sure that not only do your blacks match in terms of brightness levels, they should also match in terms of grain characteristics. Because, again, you can never be certain what the transfer to some other format might do to reveal artifacts that were previously hidden.

Be aware of processes that *remove* grain as well. The most common process would be any sort of blur algorithm, but various other filters, such as the median, can also

Figure 13.26 Example of the grain/noise that is typically present in the darkest areas of an image.

cause a decrease in the amount of visible grain in the treated element. When using these sorts of operators on a background that originally contained grain, you will often need to add grain back into the element after you have performed the operation. Remember—grain and noise are functions of film/sensor and not the lens—a completely out-of-focus image will still have the same amount of grain in it as the properly focused equivalent. This can be seen in the following example (Figure 13.27). On the left is a fairly noisy image, in the center is the same scene, photographed with the same camera settings, only intentionally shot out-of-focus, and on the right is an artificial digital defocus applied to the original in-focus image. Although the digital defocus looks reasonably close to the actual out-of-focus image, a closer look (Figure 13.28) will show that there is a significant difference between the two—the algorithm that creates the defocus effect has also removed all of the grain from the scene.

Figure 13.27 Comparison of an in-focus, an out-of-focus and digitally "defocused" image.

There are times when some element in a scene may not really need to be a sequence of images, since there is nothing moving in the element. If you decide to use a repeated single frame as an element, you will still probably have grain in the scene, only it will not change over time. This will almost always be even more noticeable than not having any grain at all. If possible, you should try to acquire a very short sequence of images instead of a still frame and then loop this sequence repeatedly to achieve the necessary shot length. This solution assumes that you can obtain a sequence that doesn't contain any object motion that would betray the trick being used. You'll ideally want to use at least 16 frames or so to make sure that persistence of vision can't detect the repeating grain patterns.

Figure 13.28 Details from Figure 13.27, showing how digital defocusing (on the right) removes grain that would be present had the image been naturally out-of-focus.

Another common solution to the problem of "frozen grain," particularly if you can only get two or three identical frames, is to average these frames together to produce a single, grainless image. Moving artificial grain can then be reapplied as needed. This technique is preferred if you need to enlarge the element in question, since you can add your grain after the enlargement so that the grain itself does not appear to change size.

Tuning grain to match another image is a somewhat subjective process. Try to notice both the size and the density of the grain particles, as well as the amount of color and brightness variation. Ideally, whatever software you have for introducing grain will allow you to control these various parameters. Many packages now include the ability to specify a particular film stock and will automatically apply what it considers to be the proper grain characteristics to match that stock. Be very cautious when using such tools, since there are so many factors beyond the specific film stock that can affect grain—these "presets" won't know about any abnormal exposure or development that might have been used, nor will they know to compensate if the element in question already has some grain present. For that matter, you can never be certain that the information about the stock to which you will be matching is accurate. Tools that can actually *analyze* the grain in an image are also available and solve some of the above issues to a greater or lesser extent. But the bottom line is that you should never apply an automatic grain-generation tool without visually checking the result to see if it is appropriate.

If your compositing system does not have the ability to create grain explicitly, you can always take some raw film stock, give it a slight exposure (a process known as **flashing**), and then scan the result to use as a grain template. A sequence of these images can be looped and combined with your grainless images to introduce the proper grain. Be sure to use a film stock that is appropriate for the situation, and realize that

the same warnings we gave about using prepackaged grain generators apply in this situation as well.

Grain should be judged by looking at moving sequences, not just still frames. In a single image it will be much more difficult to judge the quality of grain, particularly if the scene contains a great deal of random detail, since it may not be obvious if a particular spot is from detail or grain. Grain should also never be judged when looking at a proxy image. Any filtering that is done to resize an image for proxy use will greatly affect the grain, sometimes increasing it (particularly if using a fast, rough filter) and sometimes decreasing it.

Finally, remember that grain is one of the most important issues to consider when examining scene continuity. In the days of optical compositing, a cut to a shot with noticeably more grain was almost a dead giveaway that there was a visual effect involved. These days, it's probably as likely that you'll provide a shot that has too *little* grain to match the surrounding shots.

Advanced and Related Topics

Throughout this book we have looked at a wide variety of topics related to digital compositing. For most of these discussions, an attempt was made to provide a reasonably complete coverage of the topic given the limited amount of space available. To be sure, this entailed a fair bit of simplification in certain areas, particularly when you consider the fact that many of the chapters in this book could easily be expanded into complete books themselves.

This chapter will now take the time to go into a bit more detail about certain things that were only alluded to in earlier chapters, including concepts that the average compositor may not need to deal with regularly and/or that are somewhat more advanced in their application.

Certain other topics that are related to (but not necessarily an integral part of) digital compositing will also be covered in this chapter.

The Digital Representation of Images, Revisited

Let's look back for a minute to some things we originally introduced way back in Chapter 3 (The Digital Representation of Visual Information). In the interest of keeping the information in that chapter at a fairly nontechnical level (and to a manageable length) we presented certain concepts in a relatively simple fashion. But in order to better understand the true ramifications of how we need to work with data in the real world, it makes sense to revisit some of those items and examine them in a bit more detail.

One of the most important concepts first discussed in Chapter 3 was the fact that our cameras are only able to capture a fraction of the range of light in many scenes. And while this, sometimes, may not be a problem (since our display device may not be able to display as great a range anyway), if we really want the ultimate in flexibility

and quality for the images we are manipulating, we would ideally be able to work with images that feature a much higher dynamic range.

High Dynamic Range Imaging

We've touched on the concept of HDRI in several places throughout this book but given the fact that this is almost certainly going to be a concept that is used for nearly *all* image manipulation at some point in the future, it bears further examination.

Generating floating-point HDR data via a CG rendering pipeline is usually quite simple—generally just a matter of specifying a few options at render time. As such it is now more the rule than the exception when working with CG images that might undergo any sort of postprocessed manipulation. It will allow the compositing artist to darken a CG element without fear of losing the highlights that are present, unlike the scenario you would find with a fixed-range data representation. It also makes many filtering operations behave much more realistically, as now areas that are very bright will retain the appropriate amount of "energy" when defocused, for instance.

But unfortunately these benefits aren't quite as common yet with live-action footage, due to the fact that most cameras (be they video or film) are still very limited in the dynamic range they can capture. Let's delve a bit more into the concept of dynamic range and how it applies to various capture devices.

Dynamic Range in Film and Video

Any image capture device has a fixed limit for the range of brightness values it is capable of grabbing at a specific point in time. For instance, a typical[1] video camera (be it standard or high definition) will generally be able to capture about 5½ "stops" of latitude, where a stop is considered to be a doubling of brightness.[2] In other words, anything in the scene that is more than 50 times brighter[3] than the darkest area that you are exposing for will be in danger of saturating to pure white.[4] Let's look at a graph of this relationship to understand it better (Figure 14.1).

[1] At least as of the publication of this book—circa 2008.

[2] Measuring dynamic range in stops comes from the photography/cinematography world, where people tend to think in terms of the way their camera behaves. Opening up the aperture of a camera by one stop will, by definition, allow twice as much light to reach the film or sensor. Engineers and scientists tend to use different terms and units for measuring the dynamic range of electronic devices but we're here to make pictures so we'll stick with the terminology you'll hear coming from *this* community.

[3] Remember, each stop indicates a *doubling* of brightness. If our darkest value is "1" then doubling that 5 times will get you to 32 and doubling it again will get you to 64. A nice in-between number to use as an approximation is 50.

[4] The dynamic range for professional digital video cameras, particularly those that are now being employed in situations where film would normally have been used, are considerably better than standard video and this is an area where significant advances continue to occur. You can also get a greater dynamic range out of your digital still camera by shooting a "raw" format if it is supported, since this will record the full range that the sensor is capable of capturing.

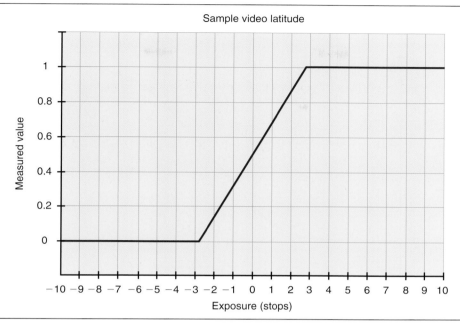

Figure 14.1 Graph of the response of a video sensor to light.

The *x*-axis, labeled "Stops," is a measure of the intensity of light hitting the sensor. The center point of this, arbitrarily set to 0, could be considered a light value that is recorded as neutral gray. Our digital video sensor returns a value of 0.5 (normalized in the range 0–1). If we reduce the light by one stop (i.e., decrease it to half the previous value) our sensor will return a value of about 0.3. By the time the light decreases by 3 stops, our sensor is no longer capable of registering any illumination and returns a value of 0. The same thing happens as we increase the light hitting the sensor and, as we've said, anything that is more than 5.5 times brighter than what the sensor considers to be 0 will have reached the limits of the sensor and will be registered as white, or 1.0. As you can see, a digital sensor like we have in a video camera (or a digital still camera) responds very linearly to the light that reaches it. If twice as many photons hit this sensor, the value returned will be twice as high, up to the point where the sensor reaches saturation.

Film, on the other hand, is a much different beast in terms of the way it responds to light. Figure 14.2 shows an example of this. Although film doesn't return a numerical value directly the way a digital sensor does, we will instead measure how transparent the developed negative is and convert that into the same normalized set of values. You can see that as we approach the limits of the curve we don't suddenly hit "black" or "white" in nearly the same way. Rather there is a gentle roll-off on both ends.[5] Increasing the exposure from 3 stops over neutral to 4 stops doesn't give the same relative increase as from stops 1 to 2.

[5] This, incidentally, is similar to the way your eye/brain interprets brightness as well.

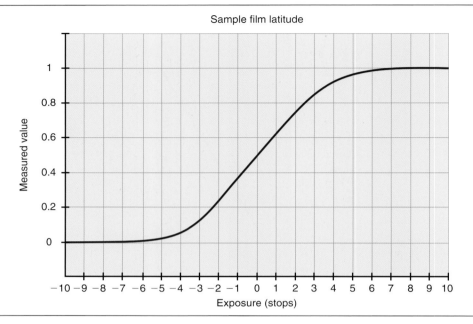

Figure 14.2 Graph of the response of film to light.

This nonlinearity is one of the reasons why characterizing the dynamic range of a piece of film is a little less rigorous and why you'll *never* get a straight answer to the question "what is the dynamic range of film." The convention is to consider the portion of the curve that is fairly linear and consider this the "usable" latitude[6] of the film in question. So in our example graph we have approximately eight stops of dynamic range. But really we have a little bit more on either end—it's just not behaving in quite the same fashion. This is one of the biggest reasons why film and video just look different—the way the medium responds to light at the extremes and film's ability to capture more detail in the shadows and highlights.[7]

The dynamic range of film will vary quite a bit depending on the stock being used (and the way it is exposed and processed). But it tends to be quite a bit higher than traditional video—quoted values range from anywhere between 7 and 11 stops for common stocks although if you consider the total range of sensitivity there could easily be a few stops more where you will be able to distinguish detail. Black and white stocks can be even higher.

[6] You'll probably hear the term "latitude" used as a synonym for dynamic range. It is, in fact, the traditional film term for the same concept but tends to imply that we're taking into account some kind of approximation at the high and low end as we're describing.

[7] Of course video isn't really quite as easy to measure as we've indicated either. Rarely do digital sensors return a pure "black" at the low end—rather it is the point where the inherent noise of the sensor overwhelms any detail at that exposure level.

So, what's the point of having greater dynamic range? Do you really need it? Sometimes. It all depends on what you're trying to photograph and how you plan to use the imagery.

One of the primary technical tasks that a director of photography is responsible for is making sure that the image being captured (be it on film or video) falls within a range of values that the camera can record. So if they're shooting video they'll make sure that the brightest areas of the scene aren't more than about six stops brighter than the darkest areas. (Except, of course, for the areas that they *want* to show up as pure black or blown-out white.) They'll set up their lights accordingly, filling in the shadows or dimming down the key lights as needed. This is easy enough on an indoor set where all of the light in the scene can be explicitly controlled but the same thing holds true when shooting outdoors. Even though it can be difficult to directly dim down the sun, you can always pump a bit of extra light into the shadows, bringing the overall brightness of the scene up but the *relative* brightness of shadows-to-highlights to fall within a much smaller range. (And this is yet another reason why, although it might *seem* to be easier to shoot outdoors in natural light, it is often much more convenient to just shoot on a sound stage where all of the lighting is well-controlled.)

Of course it would be nice if we could just capture the full range of a scene (or at least a much greater range of it) without having to haul in a bunch of extra lights and then be able to adjust things appropriately in the comfort of a postproduction environment. And in fact this is one of the major advantages of the traditional film pipeline, where the negative that is created in the original photography has a much greater sensitivity range than the prints that will be produced from it. This feature is what allows so much flexibility in the printing process: The extra range in the negative means that the brightness of the print can be increased or decreased by fairly significant amounts without losing detail in the bright or dark areas of the image. We take advantage of this in the digital realm because it is the negative that is used when we digitize the image.[8] The full brightness range will be captured even though we won't necessarily be able to see all of that range when a final print is made. But film is still limited in the dynamic range that it can capture. Ideally we'd like to go even further.

Capturing HDRI

The easiest way to capture HDRI is, of course, to have a camera that is directly capable of doing so. Technology marches on and the luminance range that digital sensors can recognize/record will only continue to increase.

But there are also some interim methods that can be used to acquire extremely HDR images, particularly for use as background elements or textures that will be applied to 3D objects. The most common of these methods is to shoot multiple images of a scene, varying the exposure across a range of values. Figure 14.3 shows an example of this—five different exposures of the scene we originally looked at in Chapter 3.

[8] Even though we scan the negative, we immediately invert the values digitally so that the image appears to be a normal "positive" when we are working with it.

Figure 14.3 Five different exposures of a scene.

These images can now be combined (using specialized software designed for this purpose) into a single image that contains a huge dynamic range. We'll want to store this image in a file that has sufficient bit depth to maintain all of this information, of course. Although we could conceivably store an HDR image in an 8-bit file, the "steps" between individual brightness levels would be so great as to be extremely noticeable. And so it is a good time to mention again that while floating-point data representations don't necessarily imply that you have HDRI, you generally don't want to be working with the latter without the former.

This technique of combining multiple exposures is, obviously, rather limited in terms of exactly where it can be used. It requires that there not be anything moving in the

scene and that the camera be similarly unmoving. But for getting a good sample of a high-contrast scene, it can be quite useful.

Working with HDRI

Once we have an HDR image, then we're faced with the issue of what exactly we should do with it. In many situations we may not want to do anything explicitly with it at all. Rather, we'll simply use it in our composite in the same way we'd use any other image, but with the added benefit that we can confidently increase or decrease the brightness values of that element without the visual artifacts that might show up in a lower dynamic range image.

There may, however, be times that we want to bring more of the image into a range that can be viewed on our output device. Remember, most display devices—a computer monitor, a television, even the print film that your local theater will run through the projector—are fairly limited in terms of the dynamic range they can display. And so even if we have captured a broad dynamic range from a real-world scene, we'll need to put that range back into an image that is appropriate for how we're going to view it.

The process of modifying an HDR image so that most or all of its range can be viewed on a limited dynamic range device is known as **tone mapping**. Let's tone map the HDR image we created from the five exposures above so that it is easier to view and understand on the limited dynamic range device (known as "paper") that you're looking at right now.

The simplest method is just to scale the intensity range of the entire image into something that can be shown on the pages of this book. The brightest values will map to a digital value of 1, the darkest to a value of 0, and everything else will be somewhere in-between. The result of such a mapping is shown in Figure 14.4. But this is a rather unsatisfying solution—while we can see detail throughout the image, it looks rather low-contrast and flat. This makes sense if you think about it for a moment—only the darkest of darks will appear "black" but other areas in the scene that are almost as dark will now need to be seen as gray. The same is true in the whites.

Instead we could choose some arbitrary dark value (but one that isn't necessarily the absolute darkest value in the image) and define that to be "Black" and at the same time choose some fairly bright (but not the brightest) value in the image and define that to be "White". Everything else would scale between the two values. The process is known as choosing a **black point** and a **white point** and is a very common process. Figure 14.5 shows the result of modifying our original HDR image based on certain black and white points—choosing a range that is still larger than what the camera itself could capture but isn't nearly the full range of the HDR file we generated by combining five separate exposures. This is still not a particularly pleasing image—it still feels a bit low-contrast and at the same time we've lost some of the details in the highlights (particularly in the window) that we know exists in the original scene.

Figure 14.4 Simple tone mapping of the full range of values contained in a high dynamic range image of the scene from Figure 14.3.

Figure 14.5 Another simple tone mapping with a different white and black point.

What we're really hoping to get, presumably, is an image that looks like it has a nice tonal range but still does a better job of representing all of the data that is available in the scene.

The problem boils down to the simple fact that there is really no way to display an HDR image on a lower dynamic range device without modifying the image in a way that no longer matches the way light behaves in the real world.

And so what we'd need to do is employ some specialized image-processing techniques that are designed exactly for this purpose. Techniques that can, for instance, determine which portions of the image are significantly brighter than their surroundings and to specifically decrease the brightness of only those areas, for instance. More sophisticated algorithms will take into account issues of saturation, edge transitions, and various theories of human perception. Figure 14.6 shows a more pleasing extraction from the original HDR image.

Figure 14.6 A more sophisticated tone mapping.

The person doing the mapping will make decisions about what brightness ranges are considered important, at what point the threshold for "white" or "black" should be set, which areas of the image should be emphasized, etc. They will be, ultimately, attempting only to make the result "look good," ignoring any technical correctness in the process.

But it is important to understand that this final method is effectively abandoning any attempt to accurately represent the way that light behaved in the original scene—it has now firmly entered the realm of a subjective process. Whether or not this is something you need to worry about is completely situation-dependent. If you are planning to integrate this imagery into a shot or scene that didn't go through a similar process then you need to carefully examine the result to make sure that there is no visual discrepancy between the two. If, on the other hand, you are solely interested in producing a pleasing image then it is perfectly justified.

Color Reproduction

Moving beyond the issues related to accurately represent real-world *luminance* levels in a digital image, we also need to take a closer look at how *colors* will map between the real world and the digital one. So let's talk a bit more about how exactly images are captured, stored, and viewed … and what happens to the colors of those images as they pass through this process.

The process itself would seem to be fairly simple. We have, basically, the following stages:

1. The original scene.
2. That scene is recorded by some capture device (film or some kind of digital camera).
3. The captured data are digitized and stored on disk (as an image file).
4. The image file is sent through some kind of display device (a computer monitor or a printer or a variety of other options).
5. Someone views the image.

This is theoretically quite a simple process. One would intuitively assume that the viewer in Step 5 would see an accurate representation of the original scene from Step 1. But in reality this is almost certainly not the case. We've already discussed how the range of brightness values that we can capture is often far less than what was in the original scene.

But we've also got to deal with the fact that we can't rely on the *colors* in the scene staying the same through all of the steps along the way. Why? Because both our capture device and our display device will have characteristics that introduce these sorts of color changes.

We already showed (in Figure 14.2) that a piece a film negative has a very specific response to different brightness levels, and just measuring values from a piece of exposed negative would absolutely *not* provide numbers that corresponded directly with the values in the original scene. It should come as no surprise, then, that film's response to color will also have a very idiosyncratic behavior. Video cameras (or digital imaging sensors in general) all have their own unique characteristics as well, and those

from different manufacturing processes can vary quite a bit. As a result we will find that photographing a piece of fabric that is a particular shade of green (for example) on two different types of cameras will probably end up recording a completely different digital value in the file that is generated.

When it comes time to view the digital image, the same issues are again introduced. We now not only have to deal with any color shift that the *capture* device introduced, we also have to be aware of what the *display* device is doing. Because such devices—film or CRT monitors or LCD displays or printer paper—will also introduce their own color shifts to the data in question.

Thus, in order to view an accurate representation of the colors in the original scene we would need to apply some sort of color lookup (as we discussed in Chapter 9) before viewing the image—a lookup that would compensate for both the color shift that the capture device introduced as well as for the color shift that the display device will have.[9] This is typically how things work in a color-managed workflow these days. Images are stored with a description (or **profile**) of how they were captured and display devices have similar profiles that describe any color shifts that they will introduce. Both profiles are taken into consideration when it comes time to view or print an image.

The problem with all of this is that most display devices are still incapable of displaying *all* the colors that the human eye can see. Common print film (of the type used in your local movie theater) isn't capable of displaying extremely saturated yellows, for instance. But we'll try to do the best we can, and the best way to do this is to at least ensure that the data are stored as consistently and accurately as possible.

Linear Light Representations

While storing images in a scene-referred fashion is useful in that it provides us a common baseline for all captured images (independent of the device used to capture them), there is one further bit of terminology that we need to discuss: The topic of representing light (and specifically objects that are illuminated by light) in a *linear* fashion.

So what exactly does "linear" mean then, in this context? Specifically we're talking about ensuring that the digital representation is linear relative to the original light in the scene. Thus if you had two identical objects in a scene only one of these objects was illuminated by a light that is twice as bright as the other, the digital value of the brighter object should also be double the digital value of the darker object. As with so many other things related to this subject, one's first intuition would be that this would

[9] The other option would be to apply this lookup to the image itself *before* storing it. Then the image could be viewed directly, without the need for any additional color correction. Of course the problem with this scenario is that our image is now really only suited for display on a specific device. (Images stored in this fashion are described as being **output referred**). Which is fine if, for instance, we're preparing images that we know will only be broadcast via a standard television signal. But it's not a good general-purpose way of storing an image.

be the default but as we saw with the graph of film's response to light, this isn't always the case. It's generally not even the case with video, in spite of what Figure 14.1 might imply, because video images are usually stored with an additional color correction (a gamma correction) applied. We'll talk about why this is done in just a moment.

Another common misconception is that images which are stored with a linear-light representation (or, colloquially, **linear images**) will look visually correct when viewed on your computer's display. This is also generally not the case, since your display device isn't normally set up to display linear images directly either. Computer monitors have their own display characteristics.

Generally the compositing artist will be best served by always working with images that represent light linearly relative to the real world. We'll talk about the reasons for this in just a moment as well, in the section that discusses Nonlinear Color Coding, below.

Scene Referred

Although the process we've just described (directly storing the color values that the capture device sees) has the advantage of making the *capture* fairly simple, it is hardly ideal. A better general-purpose method would be to remove any color shift that the capture device has introduced, storing the images with values that are directly related to the measured values of the scene itself. These images are said to be **scene referred** and the fact that they contain a much more accurate representation of the original scene makes it much easier to be more accurate when it comes time to display this image on a variety of different devices.

To produce truly scene-referred data, therefore, our image-acquisition device will need to be characterized to determine exactly how it captures color.[10] Of course even if a device is properly characterized it will still have a limited range of brightness and color that it is capable of capturing, relative to the real world. But within that range the colors saved to disk will be accurate relative to the original scene, and any two devices that can produce scene-referred data should be accurate to each other within their respective ranges. This can be quite useful if, for instance, one wishes to mix footage shot with different cameras or even a mix of film and video.

Properly *viewing* scene-referred data still requires that we apply a lookup to compensate for the characteristics of the display device, and our eyes of course.

Going back to the discussion of HDR…Given that our desire to capture HDRI is driven by an attempt to more accurately model the way light is represented in the

[10] There are a number of factors that make it effectively impossible to do a *perfectly* accurate characterization of any given image capture device. They range from the issue that every lens you put on a camera will also introduce a slight color-shift to the fact that digital sensors will behave slightly differently depending on room temperature to the (much bigger) issue of how our 3-channel RGB representation of color is really just an approximation of spectral nature of light in the real world. But getting a *reasonably* accurate characterization is much simpler and well worth the effort.

real world, the advantage of also keeping this information in a scene-referred format should be obvious. Not all HDR images are necessarily captured or stored as scene-referred nor do all scene-referred images contain HDR data. But they are both becoming much more common and eventually the accuracy and usefulness of scene-referred data will cause it to be widely adopted. The OpenEXR file format specification (discussed in Appendix B) is designed specifically to deal with HDRI and it also mandates that all data should be kept in a linear, scene-referred color representation.

Working with Limited Bit Depth

As we have discussed several times already, working with a digital-image representation of a real-world scene is filled with compromises. One of the most significant of these has historically been the limited bit depth that was used to represent these images. Although things are obviously moving towards a standard of full floating-point, HDRI, we're not there yet. And as such there are a variety of different methods that have evolved to deal with these more limited (typically 8 and 16 bit-per-channel) color resolutions—to simulate a greater dynamic range or to better use the limited color palette available.

We have chosen to place a discussion of these topics in this late chapter with the hope that the reader may not need to deal with them very often, although this may be a bit optimistic in the short-term. Classifying certain concepts as "advanced" when in fact they are typically used on lower-end systems may seem a bit strange but ultimately they are exactly that—methodologies that add to the complexity to the compositing process yet which really provide less flexibility and quality than simply working at a higher bit depth and with a floating-point data representation.

White Point and Black Point

Given a limited bit depth, we may still want to be able to use certain concepts that a floating-point workflow would normally give us. Chief among these is the concept of values that are above "white" or below "black". To do this, there is a technique that involves choosing a slightly smaller range of values to represent our "normal" black-to-white span while still keeping a bit of extra room above and below those values. In this situation, a specific, nonzero numerical value is defined to be black, and another value, not quite 1.0, becomes white.

Note that this is effectively the same thing we described several sections back where we talked about choosing a white point and a black point from an HDR image. In this case we're just starting with a much smaller range but we're still choosing a subset of that range to display in the result.

For instance, we might arbitrarily define black as having a digital value of 0.1 instead of exactly 0. Similarly, we might say that our white point will be considered to be anything at or above the digital value of 0.9. By treating these points as if they were the limits of our brightness range, we effectively create a bit of extra room at the

top and bottom of our palette. The values that fall outside the range defined by our white and black points are, once again, often referred to as superwhite or superblack. Understand that the process of choosing a white point and a black point does not necessarily change the image itself. Initially they are simply values that we need to be aware of. It is only when we actually convert our digital image to its final format that the white and black points have an effect on the image.

Let's say we are sending our image to an analog video device. In this situation, instead of the normal mapping that we usually apply when sending images to video, the conversion is done so that any pixel in our digital image that has a value above or equal to our white point will be displayed at the full brightness that the video device is capable of. In effect, our white point is now truly "white," at least within the limits of our video system. The same thing will be true for the black point: All pixels at or below this value will be as dark as is possible. A diagram of this conversion is shown in Figure 14.7.

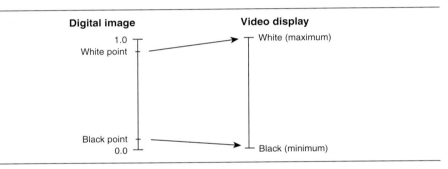

Figure 14.7 Mapping white and black points to an analog video display device.

In a way, the use of a white and black point when working with image data provides some of the benefits of a floating-point HDR system without the need for the additional computational resources that such a system would ordinarily require. Of course there are disadvantages as well, including the fact that the bulk of our compositing work is being done with a slightly smaller range of values (the range between the white point and the black point). This constraint will reduce the number of colors that are available to work with, and consequently may be more likely to introduce certain artifacts.

Once again we'll need to deal with the fact that we can't view these images directly and get an accurate feeling for how they'll appear in the final output stage and so we'll still need to use some sort of LUT or profile as part of our viewing process. The net result is that the white point will actually appear to be white, since it is being mapped to the brightest value that our computer's monitor is able to display. At the same time, the black point will be mapped to the darkest value that is possible.

At the risk of complicating this discussion even further, it should be noted that some video systems already have built-in white and black points. Values above a certain

threshold are considered "illegal" and will be automatically clipped to an acceptable level, as will values that are too low. With NTSC video, for example, the range of legal values is between 16 and 235 (out of the 0–255 range that 8 bits gives us) or, normalized to the range 0–1 as is the convention throughout this book, the white point is at 0.92 and the black point is about 0.06. Intermediate systems may make use of this fact, using certain out-of-range values for special functions such as keying.

Nonlinear Color Encoding

If you've ever worked with video from a technical perspective (or have read Chapter 10 in this book) you are undoubtedly aware of video's "built-in" gamma. It is one of the more annoying things that one will need to deal with in the compositing world because it is often subtle enough to go unnoticed in many situations, only to later prove to be a huge headache. Film has an equivalent headache—the fact that many film images tend to be captured and saved with a color encoding which matches the way the negative behaves but requires additional manipulations before we can properly deal with it. And both of these issues came about for the same reason—a desire to store imagery in a fashion that will minimize the amount of data necessary to keep an acceptable image.

In Chapter 3 we looked at a few different methods that can be used to reduce the amount of storage space a given image will consume. Most of these compression schemes, while mathematically quite complex, can be used quite easily, without ever needing to understand their inner workings at any great level of detail. But the technique we'll be looking at now is different in that it actually modifies the colors of the image as part of the process—it involves the use of nonlinear color encoding.

Conceptually, the best storage format would be one that keeps only the useful information in an image and discards everything else. Of course, what actually constitutes the useful data in an image is difficult, if not impossible, to determine precisely. In high-end work our ideal scenario is of course to assume that *any* information is useful and we shouldn't discard anything. But when we are in situations where we need to reduce the amount of data we are working with, certain techniques can help us to choose ways to discard data that are less likely to introduce visual artifacts.

We already discussed one such technique in Chapter 3 when we looked at JPEG encoding, which assumes that color information is less important than brightness information. But JPEG is a fairly lossy format and rather unsuitable for high-end work. Another fairly drastic method that could be used to reduce the space requirements for an image's storage would be to simply reduce its bit depth. Reducing an image from 16 to 8 bits per channel will halve the size of the image, but obviously throws away a great deal of potentially useful information. If, on the other hand, we properly *modify* the data before discarding some of the least-significant bits, we can selectively preserve a good deal of the more useful information that would otherwise be lost. In this situation, our definition of "useful" is based (at least partially) on the

knowledge of how the human eye works. In particular, it is based on the fact that the human eye is far more sensitive to brightness differences in the darker to midrange portions of an image than it is to changes in very bright areas.

Let's look at an example of how this principle can be applied when converting an image to a lower bit depth. We'll look at the extremely simplified case of wishing to convert an image that originated as a 4-bit grayscale image into a 3-bit file format. Once you understand this scenario, you can mentally extrapolate the process to real-world situations in which we deal with greater bit depths.

If our original image starts as a 4-bit grayscale image, we have 16 different gray values that we can represent. It should be obvious that converting this 4-bit image to a 3-bit storage format will require us to throw away a great deal of information, since our 3-bit destination image has only eight different grayscale values. The most simple conversion would be merely to take colors 1 and 2 from the input range and convert them to color value 1 in the output image. Colors 3 and 4 would both become color 2; 5 and 6 would become 3, and so on. This mapping is shown in Figure 14.8.

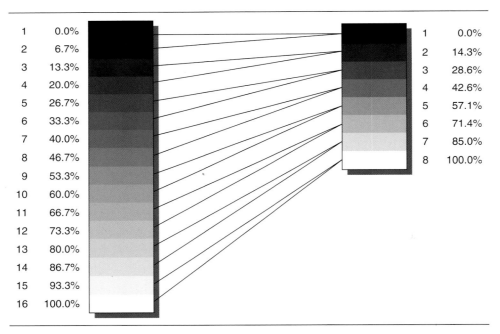

Figure 14.8 Linear mapping of 16 to 8 colors.

A graph of this conversion is shown in Figure 14.9. The horizontal axis represents the value of the original pixel, and the vertical axis plots the resulting output value for the pixel. The dotted line shows the generalized function that would apply no matter how many color values we are dealing with. As you can see, this function is completely linear, and this conversion would be called a "linear encoding" of the image data.

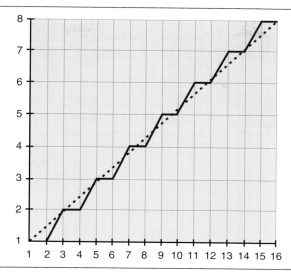

Figure 14.9 Graph of the linear color conversion. The solid line shows the actual mapping, the dotted line shows an approximation of the function that would accomplish this conversion.

The disadvantage of this linear method is that it ignores the fact that the human eye is less sensitive to differences in tone as brightness increases. This principle is difficult to demonstrate with only 16 colors, particularly with the added complexity of how the various brightness levels are reproduced on the printed page. But consider if we had 100 evenly spaced grayscale colors to choose from, ranging from black (color number 1) to white (color number 100). You would find that, visually, it is almost impossible to distinguish the difference between two of the brightest colors, say number 99 and number 100. In the darker colors, however, the difference between color number 1 and color number 2 would still remain noticeable. This is not merely due to the human eye being more sensitive to particular brightness levels, but also to the fact that the eye is more sensitive to the amount of *change* in those brightness levels. In our 100-color example, a white value of 100 is only about 1.01 times brighter than color number 99. At the low end, however, color number 3 is twice as bright as color number 2.

Since brightness differences in the high end are less noticeable, a better way to convert from 16 to 8 colors would be to try to consolidate a few more of the upper-range colors together, while preserving as many of the steps as possible in the lower range. Figure 14.10 shows an example of this type of mapping. In this situation, any pixel that was greater than about 80% white in the source image will become 100% white in the destination image. Pixels that range from 60% to 80% brightness become about 85% white, and so on. Figure 14.11 provides a graph (solid line) of this mapping, as well as an approximation (dotted line) of a function that would accomplish this conversion. As you can see, the function is no longer a straight line, and consequently this would be considered a nonlinear conversion.

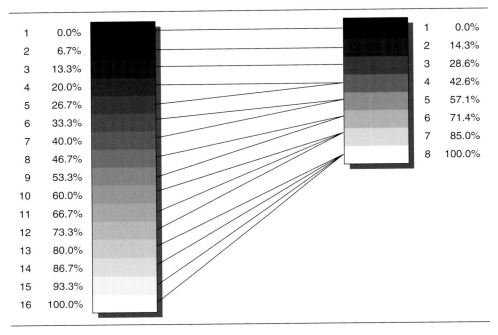

Figure 14.10 A nonlinear mapping of 16 to 8 colors.

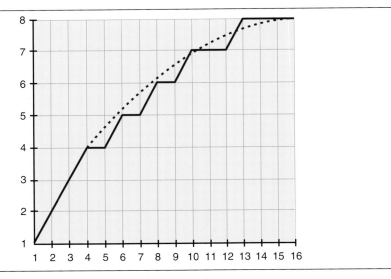

Figure 14.11 A graph of the nonlinear color conversion.

Because this conversion actually modifies the colors in an image, it produces a result that is visually different from the original image. If we were to view this new image directly, it would appear to be far too bright, since we've shifted midrange colors in the original image to be bright colors in our encoded image. To properly view this

image, we would either need to reconvert to its normal representation or modify our viewing device (i.e., the video or computer monitor) so that it simulates such a conversion. An image that has had its colors modified for storage purposes can be said to have been converted to a different color space, although in actuality a color space is a much broader term that can encompass a variety of different models for representing color. And in fact a nonlinear encoding such as we have just discussed could conceivably be utilized within any of these models. As such, we'll use the term color *encoding* rather than color *space*, although it is quite common in the industry to refer to an image that has undergone this encoding as being stored in a **nonlinear color space**.

The reason for applying a nonlinear encoding before storing an image is the same as for any other compression scheme—the desire to store information as efficiently as possible. But the conversion of an image from linear to nonlinear is not, in itself, a compression technique. All we are doing is taking a series of input colors and mapping them to a different set of output colors. There is no explicit mathematical compression as in the run-length or JPEG encoding schemes that were discussed previously. It is only when we convert the image to a lower bit depth (or convert it from an original analog signal) that it is actually compressed, and significant amounts of data are then removed. Thus, it is useful to think of this conversion as a two-step process. The first step is simply a color correction, nothing more. The result of this color correction is that certain color ranges are consolidated so that they take up less of your color palette, thus leaving room for the other, more important ranges to keep their full resolution, even when reducing the number of bits used to store a given image. But until we actually store the data into a file with a lower bit depth, very little data are lost, and the process is reasonably reversible. Of course, it is usually not very worthwhile to apply this color correction without lowering the bit depth, since the color correction by itself does not actually reduce the file size. A 16-bit image with the colors represented nonlinearly will be the same size as a 16-bit image with colors represented linearly.

The second step of the conversion is where we decrease the bit depth, and consequently discard a great deal of information. Once we truncate our 16-bit file to 8 bits, the image that has been converted to a nonlinear encoding will have a distinct advantage over its linear counterpart: It is using its 8 bits to hold more "important" information. When it comes time to linearize the data to work with it (and you will almost always want to do so), we will ideally convert it back to a higher bit depth before we start modifying things. But once this is done, the nonlinearly encoded image will have lost far less of the visually critical detail than the image that remained linear throughout the bit depth changes.

Working with Nonlinearly Encoded Images

If we had an unlimited number of bits per pixel, nonlinear representations would become unnecessary. However, the usual considerations of available disk space, memory usage, speed of calculations, and even transfer/transmission methods all continue to

dictate that we attempt to store images as compactly as possible, keeping the minimum amount of data necessary to realize the image quality we find acceptable.

Unlike most of the more traditional compression techniques, however, it is very easy to view (and work with) nonlinear images directly. And because nonlinear encoding is really only a color correction, *any* file format can be used to store nonlinear data. This can be one of the most confusing issues that arises when working with images that are stored nonlinearly as there may be no way to determine if an image has had a nonlinear encoding applied other than to visually compare it with the original scene. *Most* of the time an image file will be able to store a tag in its header file but this isn't always reliable. Certain file formats may be *assumed* to hold data in a particular fashion but a format by itself cannot *enforce* a particular encoding.

Nonlinear encoding is useful in a variety of situations, and whether you work in film or video, you will probably be dealing with the process (at least indirectly). Although it may be possible to remain fairly insulated from the topic given the increased sophistication of software and hardware systems, you should still understand where and why the process is used and needed. Let's look at a couple of situations in which it is typically employed. We'll start with the video world, where a nonlinear conversion known as a "gamma correction" is often used. We looked at the gamma function a bit in Chapter 4. If you compare the graph for the gamma operation (from Figure 4.9) with the simple nonlinear encoding function that we demonstrated in Figure 14.11, you can see that the basic shapes of the curves are quite similar.

Video Gamma

Typically (at least when dealing with traditional video where images are stored in an 8-bit representation), video images are captured and stored with a built-in gamma correction of 2.2. This correction is part of the image capture process, when analog images that enter the camera's lens are converted to numerical data and stored on tape or disk. In a sense the camera is performing a nonlinear conversion from the dynamic range that the sensor is able to capture to the limited bandwidth of a video signal. The visual result is that the image is made brighter, but the important issue is that the high end has been compressed in order to leave more room to represent low-end colors. Standard video display devices are actually nonlinear in their response, so if we send these images directly to video, the monitor will, by default, behave as if an inverse correction had been applied, thereby producing an image that appears correct. But if we want to view these images in the digital world so that they appear to have a brightness equivalent to the original scene, we will need to compensate for this gamma correction.

There are two ways to perform this compensation. The first is to simply apply another gamma correction, the inverse of the original, to restore the images to a linear color representation. In this case, a gamma of 0.45 (1/2.2) would be used. This is the process (or at least part of the process) that we would use if we plan to actually work with the images and combine them with other linear images. But if we simply want to

view the images, it may be easier to adjust the viewing device (the computer's monitor) so that it is darkened by a gamma of 0.45.[11] This adjustment will display the images at the proper brightness without the need to preprocess every frame. As we mentioned earlier, certain viewer tools will make it even easier, allowing you to load a specialized color table that modifies the way that images are displayed on the system's monitor.

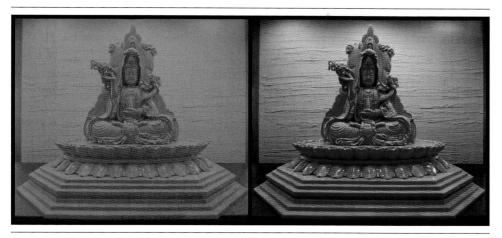

Figure 14.12 An image represented with a nonlinear ("Log") color encoding compared with the same image viewed normally.

Film Imagery

For film images, a more complex nonlinear color encoding is often found, on which is dictated by the way that film stock responds to varying exposure levels. A common file format used to store film images is the **DPX** file format (and a subset of that, the **Cineon** file format) which includes a specification for conversion into a "logarithmic format." A logarithmic curve is again similar to the curve shown in Figure 14.11. If you work with Cineon or DPX files, you will deal with both white and black point mapping as well as this nonlinear color encoding. The Cineon file format is discussed in a bit more detail in Appendix B, and an example image using Cineon encoding is shown in Figure 14.12. On the right is an image that is presented in with a normal, perceptually correct color representation and on the left is the Cineon-encoded equivalent. As you can see, the Cineon image appears a bit flat and washed-out, which is typical for this sort of encoding—it is (just as we saw with Figure 14.4) a direct result

[11] Although we state that you should "darken your monitor by a gamma of 0.45," this does not necessarily mean that you should explicitly set your monitor's gamma at 0.45. Rather, you will need to first determine what monitor settings are needed to give your monitor a linear response and then apply the adjustment on top of that setting. Different systems will have different (often poorly documented) controls for adjusting the monitor to respond linearly to a video signal, and consequently there is no way that we can tell you exactly what setting should be used.

of the fact that the Cineon file contains a much higher dynamic range than what our viewing device is able to display.

Linear versus Nonlinear when Compositing

Earlier we mentioned that you generally want to work in a linear-light representation when it comes to doing actual compositing work. Although you may have chosen to *store* images in a nonlinear format, you will almost always want to convert these images back to a linear representation before working with them because of the way in which color correction, resampling and compositing operations behave when confronted with nonlinear data. Consider the image shown in Figure 14.13, which is an example of a simple color correction in which the red, green, and blue channels have been multiplied by constant values of 0.8, 1.1, and 1.1, respectively.

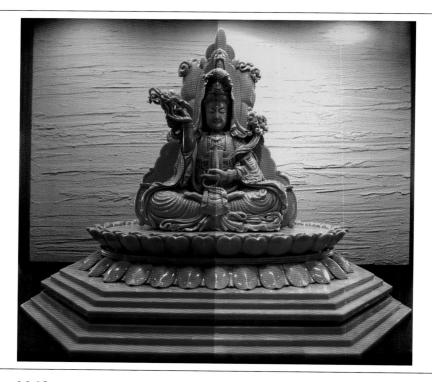

Figure 14.13 A color correction applied to an image in a linear representation (left) and one that was stored in a nonlinear fashion (right).

The left side of the image was corrected with the image kept in a linear color representation, and comparing any pixel with the original image will show a red value that has been reduced by 20%. The right side of the image, however, was first encoded into a nonlinear color representation (in this example we used the Cineon specification), and

then the same multiplication was done. Once the color correction was applied, the image was restored to a linear encoding. As you can see, a fairly slight color correction on a linear image has become rather drastic when applied to a nonlinearly encoded image. In particular, notice how the midtones have changed quite a bit more than the darker areas of the image. This same sort of thing would hold true if you did the same comparison with an image that had been stored with a video gamma correction applied, although to a lesser extent. It also holds true with many other operators—resampling behavior changes, for instance, as do blurs. Figure 14.14 shows a similar comparison—the right side of the image had a gamma correction applied before the blur and then a compensating inverse gamma applied after the blur. The left side of the image had the same blur amount applied but without any change in color encoding during the process.

Figure 14.14 Blurring an image stored in a linear representation (left) and one that was stored with a gamma correction applied (right).

This behavior can be particularly vexing when working with bluescreen elements—attempts to reduce blue spill may result in undesirable shifts in flesh tones, for instance, if you are not working with linear images. Even the simplest image-combination tools (including the Over operator) can produce different and technically incorrect results when they are used on nonlinear images, causing undesirable color shifts in, for example, soft edges when compositing. The further you move away from linear data in your

compositing workflow, the more likely you are to experience issues where semitransparent objects (such as the edges of a premultiplied image) begin to show artifacts and generally you will find that things begin to look more and more artificial.

Although there are certainly compositing operators that do *not* have this problem (a simple crop, for instance) and there can be situations where one is able to effectively work directly with images that are stored nonlinearly,[12] in general the compositing artist would do well to heed the following warning:

> Color correcting or compositing images that are representing light with a nonlinear encoding can easily produce undesirable, unpredictable or incorrect results. In general, always linearize your images before manipulating or combining them.

Conclusions

So what can we take away from all of this? In terms of data manipulations, we really do want to ensure that all image processing takes place in a linear, scene-referred color space and that we have enough bit depth available to support that. No matter how we choose to store our data on disk, we want it to be properly converted into this linear representation when we work on it and then we need to be able to accurately convert it to any other data storage representation when we are done. What this really requires, then, is that all of the applications in the production pipeline have the ability to fully manage the color image data that flows through them. This includes not only proper decoding as files are being read or written but also tools for properly *viewing* this imagery as it is moves through various representations.

Unfortunately this is still generally not a common scenario. Many (perhaps most) of the tools we use in day-to-day visual effects production do not allow for such a color-managed workflow and as such we find that every facility needs to set up a pipeline that is specific for the tools they are using. Hopefully things will get better.

3D Compositing

Digital compositing has, historically, been considered a "2D" discipline. The term reflects the fact that all the elements that are being brought together are two-dimensional images. They may be a *representation* of a three-dimensional object or scene but they have been captured (or rendered) by a device (or an algorithm) that reduces them to a flat, 2D image.

But much of your work as a compositor will be to ensure that the images you produce feel as if they were taken from a view of a three-dimensional scene. Objects in your composite will need to reflect the effects of perspective, occlusion, atmospheric

[12] Mathematically, applying an Add on a logarithmically encoded image is very similar to the result obtained by applying a Multiply on the equivalent image stored as linear data, for example.

depth-cues, etc. And although many of these things can be done using two-dimensional tools, there are times where it is much easier to use tools that are naturally three-dimensional in nature, similar to those tools that are used by 3D artists.

Compositing within an environment where images can be manipulated in a third dimension is often referred to as "3D Compositing" or (reflecting the fact that it still actually has limitations that are not there in a true 3D environment) "2½ D Compositing." There's not really an industry-accepted convention for the exact terms that are used and so for the rest of this book we'll just use the less-cumbersome term 3D Compositing.

We have already discussed a few things related to this. In Chapter 4 we looked at spatial transformations that included the third dimension, for instance. But that sort of transformation was still basically just a way of distorting an image to mimic the effects of perspective—the result would still be layered back onto other images in a two-dimensional environment.

However, if we move our compositing tools into the context of a three-dimensional representation, a number of things become much easier. For the purposes of this discussion, we'll define this three-dimensional environment to be a place where every element has an inherent position not only in x and y, but also in z. In other words, it has a location in space that is defined by its distance from other objects in the scene—a distance that includes a depth component. More importantly, there must also be the concept of a *camera* in this scene—the viewpoint from which we will see all the elements that we are dealing with.

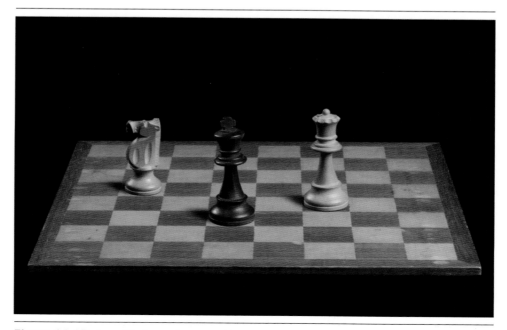

Figure 14.15 A multi-element composite.

Consider the composite shown in Figure 14.15. It is a fairly simple composite—three foreground layers (the chess pieces) and a background (the board). But, unlike all the other composites that we've looked at so far in this book, this one is actually set up using a 3D environment. To give an idea of the true layout here, we've moved our 3D camera around a little bit to the side and modified the transparency on some of the elements and now (in Figure 14.16) it becomes evident exactly what is going on in this scene. The three pieces are flat elements, just as they would be with any composite, but in this case they exist in an environment that actually supports placement and movement not only in *x* and *y*, but also in a third dimension (generally labeled as the *z* axis).

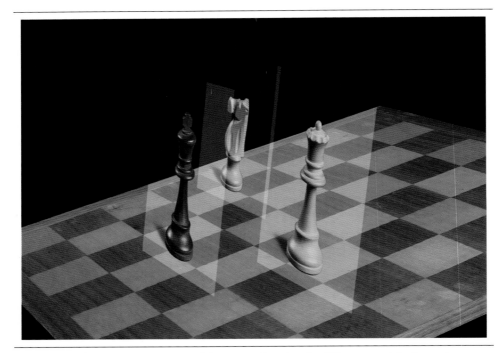

Figure 14.16 An alternate view of the scene showing the 3D nature of the layout.

If you're familiar with 3D animation and rendering you're probably accustomed to thinking of these objects as images (or "textures") applied to a flat rectangular surface. And of course we are applying not only RGB values but also an alpha value for transparency. These rectangles, or **cards** as they are usually referred to in this context, can be manipulated within this 3D environment, just as one would do within a full-featured 3D animation package.

There are some immediate advantages to having set up our scene in this fashion. First of all, each layer in the scene is automatically scaled appropriately for the distance from camera. Objects that are further from camera are smaller without the need for any explicit additional scaling on the part of the compositing artist.

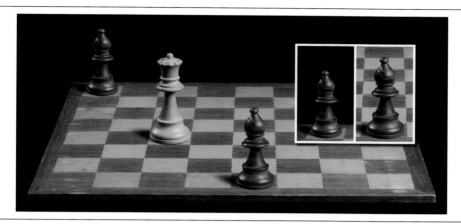

Figure 14.17 Two identical images that are placed at different distances from our virtual 3D camera.

Compare the size of the two identical pieces shown in the scene in Figure 14.17—obviously the one on the left is smaller (as we can see even better in the inset) but we didn't apply any *explicit* scaling to the element, rather we just moved that element farther away from the camera. Occlusion, too, will generally be handled automatically so you don't need to worry about the order in which the layering of the composite takes place. In our traditional compositing environment, if we wanted to start the scene with a knight in front of the king, partially obscuring it, and then over the course of the shot have it move so that it is *behind* the king, we would need to change the compositing order sometime during the shot. Knight *over* king would need to switch to be king *over* knight. You can imagine the additional complexity this might introduce into a script if we had hundreds of elements instead of just two! In our 3D environment, it is much easier—simply move the cards to their new position and the layering will be done correctly. The 3D compositing paradigm is explicitly set up so that the depth of objects (relative to the camera) will determine the order of compositing operations.

Simulating camera movement becomes much easier as well because we are now dealing with something that is designed to mimic the effects of moving a real-world camera. The sequence of images shown in Figure 14.18 reflects the effect of a camera moving from left to right. In a 2D compositing environment we'd need to animate each of the layers explicitly, ensuring that the more "distant" layers move less than those which are supposed to be closer to us. Again, in a 3D environment this all happens automatically—all the artist needs to do is move the camera.

Of course there are limitations and potential problems to be aware of as well. Objects aren't truly three-dimensional so the illusion can quickly be ruined if your camera (or card) moves so that the card is no longer reasonably face-on to the camera (as we saw in Figure 14.16). Most 3D compositing packages have the ability to force cards to always orient themselves to camera, although this too may introduce noticeable artifacts because

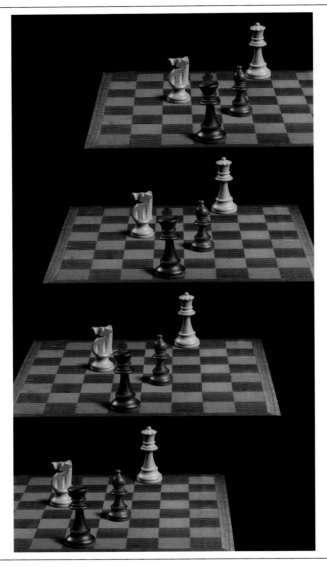

Figure 14.18 A sequence of images where the virtual camera is panning horizontally.

at some point you'll probably be expecting to see the *side* of the object in question. For most of the chess pieces in our example this isn't much of a problem since they'd appear about the same from that angle but the knight would obviously be incorrect. And of course there is no way to look at the top or the bottom of the pieces—they're just flatlander objects living in a three-dimensional world. This, ultimately, is where the limitations of this method are greatest—if your camera is going to move significantly relative to the elements in the scene you'll probably need to find other ways to deal with it.

Intersections are another issue, as shown in Figure 14.19. Then again, two intersecting objects would be problematic with 3D models as well, not to mention in the real world! And in fact intersecting cards can sometimes be used to enhance the illusion of three-dimensionality of otherwise flat elements. Consider the tree shown in the first frame of Figure 14.20. Rotating our 3D camera around it produces a distinctly unsatisfying effect.

Figure 14.19 The result of two intersecting image planes.

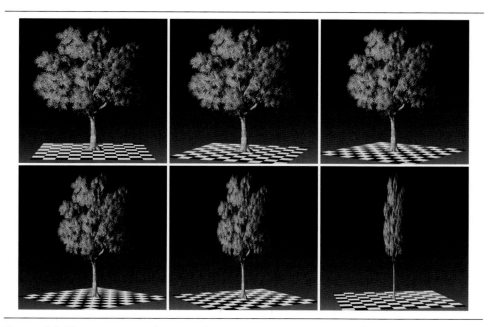

Figure 14.20 A sequence of images showing the result of rotating a virtual camera around a flat "card."

If, instead, we place *two* copies of this tree into the scene, set perpendicularly to each other and intersecting at the trunk (as shown in Figure 14.21) we have something that maintains a much more reasonable appearance even when viewed at a variety of angles (Figure 14.22). It's not necessarily something that would hold up under intense scrutiny, but probably acceptable if you're planning to use this trick to add some additional foliage in the distance.

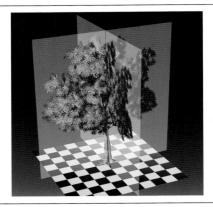

Figure 14.21 Placing two 2D cards perpendicular to each other to simulate a 3D object.

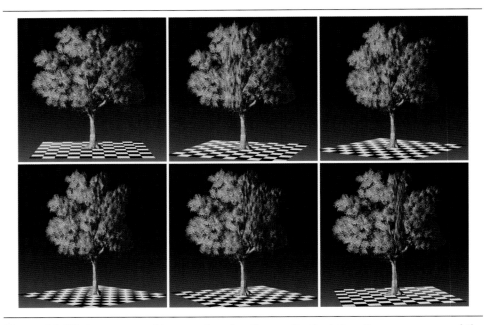

Figure 14.22 A sequence of images showing the result of rotating the camera around the two intersecting cards.

Another similar trick is to always orient your card towards the camera but to iteratively substitute *different* images on that card depending on the position of the camera. For instance, if your camera is in the region that is considered the "front" of the object being shown then you would use the image (texture) that shows the front of the object but at some point when the camera moves around the object a new image would be substituted on the card that shows the object from a slightly different view. This, of course, requires that you effectively have a view of your object from every angle that your camera might view it from. Again, this probably isn't the kind of thing that you'd want to use on an object you're viewing in close-up but it can be useful for background objects.

Different compositing systems will have varying 3D capabilities. Some may incorporate a significant amount of 3D functionality, including the ability to manipulate lights and shadows (specifically casting shadows based on the matte channel of the image), to apply atmosphere to the scene, and even to mix fully textured 3D objects in with the 2D cards. A specific trick that is particularly useful in 3D compositing is to map an image onto a curved surface (the inside of a cylinder or a sphere) in the distance and use that as the distant background of a scene. An example of this sort of setup is shown in Figure 15.77 in Chapter 15.

As software continues to evolve, more and more 3D functionality will become available directly from within the compositing environment—already the line between 2D and 3D has become much less distinct. Expect this trend to continue, particularly in the ways that CGI is dealt with in the compositing process.

Working with CG Elements

Throughout this book we have occasionally touched on some specific issues when it comes to working with synthetic, Computer-Generated 3D elements. The most notable of these is the easy availability of a perfect matte channel for any such element.

But in fact there are a variety of additional advantages that can come into play when working with CG. The most obvious is that the 3D artist has *far* more control over how the 3D elements will look before they are sent to compositing. Lighting and camera characteristics can be completely synchronized between all the different CG elements in a scene and even to a much greater extent between and live-action elements in the scene (including the background plate).

In theory it might be even tempting to assume that any CG element could simply be created in such a fashion that it can just "drop in," without any additional compositing tricks needed for integration. This is, of course, generally not the case due to any number of factors.

First of all, remember that an image from a 3D rendering package has been produced by a *simulation* of a camera, not the real thing. As such, real-world characteristics such as lens distortions or film grain may not be included and will need to be added during the compositing process. Remember too that the brightness range of a CG image may

be different from a live-action image. Very often a scanned film image will never have any digital values below a certain threshold, yet a digital image may actually have values down to zero. Integrating the two will require that the contrast range in the CG image be adjusted, boosting the blacks so that they match with the live-action plate.

But probably the biggest consideration when working with a mix of 2D and 3D is one of time and resources. Although hardware speeds continue to increase at a rapid pace, new rendering algorithms are always being developed to ensure that this hardware will never be fast enough. While extremely complex 2D composites can certainly take a noticeable amount of time to process, 3D rendering is almost always going to be far more expensive. Different situations can vary wildly of course but it is not at all uncommon to have scenarios where the 3D rendering required for a given shot will take 10–100 times more processing time than the 2D part of the job. As such it becomes much more cost-effective to try and do much of the work in the 2D realm, as long as doing so doesn't compromise the quality of the resulting image.

When working with CG elements there will always be situations in which one can choose to either modify the already-rendered element in the composite or to modify the color and lighting parameters in the 3D scene and then re-render the element from scratch. Deciding which route to take isn't always a clear-cut choice, however, and there are a number of variables that should be considered.

Within the 3D environment there is obviously much more control over how an object is lit than there is once it has been rendered into an image. Unlike in 2D, where changing the apparent direction of a light source can entail a great deal of effort, in the 3D world one can easily move and modify lights at will. Thus, any significant changes in lighting direction will usually require a re-render.

Changes in the overall color balance of an element, on the other hand, may be something that is done just as easily in the composite (and which can then save a significant amount of time). The difficulty in judging which route to take usually boils down to the fact that there is no good way to determine ahead of time if the 2D tools will be capable of effecting the changes that are needed. So usually you'll end up trying a few things first in 2D and then reverting back to 3D manipulations if the 2D progress seems to be ineffective or excessively time-consuming.

Working with 3D elements may also present some additional logistical problems when your 3D elements are being created by someone else. If you are dealing only with a collection of live-action plates, you know that the elements you are given will remain the same for as long as you are working with them. When integrating 3D, however, the situation may not be quite so stable. It is very common for the development of a particular 3D element to be something that is happening concurrently with the integration of that element into a scene, a process that has both benefits and drawbacks. The benefits are that it will give both the compositor and the 3D artist the ability to address problems by re-rendering as necessary. There may even be times when a

compositing script can be made more efficient by removing certain operations (such as a color correction) and applying a compensating operation to the 3D element itself as it is being re-rendered. Of course the significant downside to this process is that the compositing artist may spend a great deal of time balancing a particular element into a scene and then suddenly be confronted with a radically changed new element provided by the 3D artist. The only way to avoid this is to ensure that the communication between the 2D and the 3D artists is thorough and timely.

With the growing popularity of completely computer-generated movies, television shows, and theme-park rides, there is now a good deal of compositing work being done without any live-action elements involved. Although it is possible for an entire CG scene to be rendered as a single finished shot, experienced 3D artists will still tend to render more complex shots as a series of discrete layers and then composite these layers together into a final scene. This methodology allows the 3D artist to avoid time-consuming re-renders of large scenes when there is only a problem with a specific element. Instead, only the element in question will need to be redone, usually saving a great deal of time and resources.

One of the things that can greatly enhance the likelihood that the necessary changes to an element or a scene can be done in 2D rather than 3D is to set up your 3D rendering environment so that it can produce additional information about the element to aid in the compositing process. This additional information generally takes the form of supplemental images (or channels within an image), which are targeted at specific issues. The first of these additional images that we'll look at is the Z-depth image.

Z-Depth Compositing

Whenever a 3D database is created for the purpose of rendering a CG image, every object in the scene will have a specific color, material, and illumination assigned to it. When it comes time to render a scene from this database, each pixel in the image that is generated will correspond to a certain point on one of the objects in the scene. But there is more information in this database than just the color and lighting description of the scene. The spatial relationships of the objects in this scene are also very well defined. Every object in this virtual scene has a specific location in virtual space, and the 3D software is obviously able to determine these locations with great accuracy.

It makes sense, then, that we should be able to extract this information and put it into a form that is useful to the compositing artist. To accomplish this we'll use a technique known as **Z-depth compositing**.

Z-depth compositing (or sometimes just "Z-compositing") uses a special image that is explicitly created to quantify these spatial relationships, allowing us to incorporate depth information into the compositing process. Thus, in addition to the standard color image that is rendered for a scene, the 3D software will be instructed to also render a specialized depth image. As with a matte image, this new type of image requires

only a single channel to represent its data. But instead of using pixels to represent transparency information for the corresponding point in the color image, each pixel specifies the spatial depth location for each point.

The image that is generated is known as a **Z-depth image**, based on the typical axes that are used to measure space in a 3D coordinate system (x is horizontal, y is vertical, and z is depth). Depending on the tools you are using, this Z-depth image may be kept as a separate file, or it may be integrated with the color image as an additional channel. When integrated, it is referred to as the **Z-channel** or **depth channel** of the image. Consider the image shown in Figure 14.23a, a simple synthetic scene. Figure 14.23b is the corresponding Z-depth image for this scene.

Figure 14.23a A rendered CG scene.

Figure 14.23b The Z-depth image for Figure 14.23a.

We can choose to represent spatial information in a few different ways, but in general we are interested in the specific distance any given point is from some fixed reference point. This reference point may be an absolute location in our 3D space—usually the origin—or it may be relative to a given object, usually the camera. For the sake of

this discussion we'll consider the case in which we are only interested in the distance from the camera. Areas in the image that are closer to the camera are represented with brighter pixels; those that are farther away are darker.[13]

This depth image can be useful in a variety of ways. At its most simple, it can be used to modify the original image in order to add some depth-based atmospheric effect. Consider Figure 14.24 and the corresponding Z-depth image for this scene (Figure 14.25). Using the Z-depth image as a mask for mixing between the main image and a uniform gray-colored "fog" image will give the result shown in Figure 14.26.

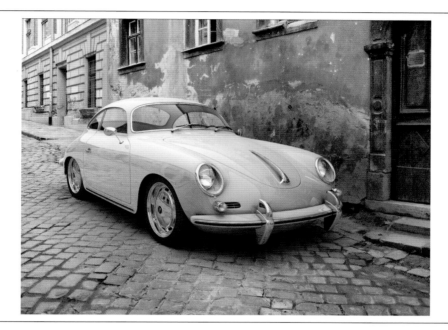

Figure 14.24 Another 3D scene.

But most software will allow us to use much more powerful tools in conjunction with the Z-depth image. Since we now have accurate information about the depth of the various objects in the scene, the process of determining occlusion can be automated. In a simple scene this ability may not save us a great deal of time, since we could have already generated a matte for the various objects and have manually determined the foreground/background relationship between anything new that we want to add to

[13] There isn't really any industry standard for exactly how to represent a Z-depth image in terms of what specific pixel values are used to represent a given distance from camera. Usually the 3D package will allow you to choose the range that will be represented by various values, but there may be additional issues. Maya, for instance, creates Z pixels using the formula $-1/depth$. Bit depth is also an important consideration with Z-depth images. Given the potentially huge range of distance values that might need to be represented (while still requiring a great deal of accuracy) it is generally best to use a floating-point image for storing this information.

Figure 14.25 The Z-depth image for Figure 14.24.

Figure 14.26 Using the Z-depth image from Figure 14.25 to modify Figure 14.24 in order to introduce fog into the scene.

the scene. But if our scene becomes more complex, automated Z-depth compositing can be incredibly useful.

Consider Figure 14.27a—also an image with a large number of objects in it at a variety of distances from the camera. If we have Z-depth information for this image as well (Figure 14.27b), depth-compositing algorithms can be used to combine two images and automatically determine the proper foreground/background relationships for

Figure 14.27a Some additional CG elements.

Figure 14.27b The Z-depth image for these elements.

each of the different objects in the scene. Figure 14.28 is the result of our Z-composite of Figures 14.23 and 14.27. This same step, had it been done manually, would have required a great deal of time to individually determine which objects should overlap.

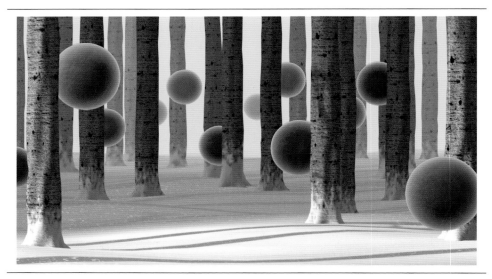

Figure 14.28 The result of using Z-depth compositing to combine Figure 14.27 with Figure 14.23.

While this is obviously a very powerful feature, it is important to recognize that there *are* several limitations to Z-depth compositing. The most obvious is that this Z-depth information is generally unavailable for any live-action elements (more on this in a moment), and thus Z-compositing is typically useful only when combining CG elements. But even within a wholly synthetic scene there are limits to the accuracy of this Z-depth information. Earlier we mentioned that each pixel in the Z-image will correspond to a point on a particular object. But this is not always the case. If we have a partially transparent object in the scene, the pixels for this object in our color image will receive color information from both the foreground (semitransparent) object as well as from any object that is behind this object. How do we assign a depth value for such a pixel? The short answer is, we can't, at least not usefully. We could choose to use the depth values of the foreground object (which is usually what is done), but if we tried to use this depth value to add a new, more distant object into the scene, our Z-compositing software would automatically put this new element behind the first object. But the first object, being partially transparent, is already showing a bit of the original background behind it. Thus, the foreground object would appear to be in front of the new element, but would still be revealing a bit of the original background.

An example of this problem is shown below. Figure 14.29a shows our scene, and Figure 14.29b shows the depth information for this scene. As you can see, the semi-transparent sphere is fairly close to the camera, and the checkered wall is farther away.

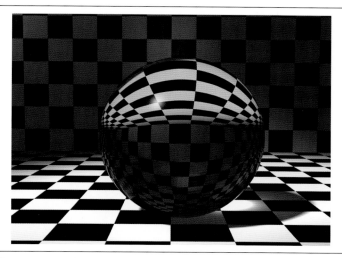

Figure 14.29a A scene featuring a transparent object.

Figure 14.29b The Z-depth image for Figure 14.29a.

Now, let's attempt to compose the object shown in Figure 14.30a into this scene. The depth information for this object is shown in 14.30b. Based purely on the depth information, a Z-composite would produce the final image shown in Figure 14.31. But this result is unacceptable. The final image should look like Figure 14.32, where the new object is still visible (refracted) through the foreground sphere. And there is really no way to fix this problem, short of re-rendering the scene as an integrated whole. Consequently, it is safe to say that Z-depth compositing will be problematic and in some cases even useless if you'll be working with transparent objects in the scene.

Figure 14.30a A new object to be introduced into the scene.

Figure 14.30b The Z-depth image for the new object.

Unfortunately, even if there is no explicit transparency involved, the edges of certain objects can sometimes cause a problem because most 3D objects are actually rendered with antialiased edges that effectively introduce a small amount of transparency in these areas. A pixel that is precisely on the edge of an object will get part of its color from the foreground object and part from the background but the Z-depth image will be forced to specify a given pixel at a specific depth. Consider the top half of Figure 14.33a, which is a close-up detail from the Z-depth composite we saw in Figure 14.28.

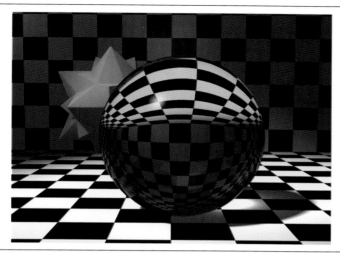

Figure 14.31 A Z-depth composite of the two images.

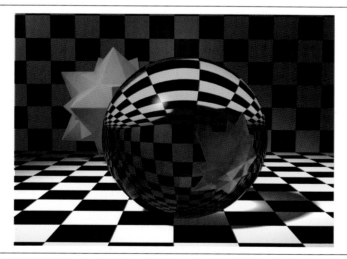

Figure 14.32 The complete scene rendered as a single image.

As you can see, the edges are very hard—they don't have any sort of transparency in them. Compare this with the bottom-half of the image, which is the result we'd get if we rendered the spheres and the trees together as a single scene instead of compositing them together using Z-depth compositing. The edges are much more believable. A bit of additional edge processing may help to alleviate any artifacts that are introduced, or a more general-purpose solution is to render all of the elements at a higher resolution, then perform the Z-depth composite and then scale the resulting image down to the final resolution. This sort of oversampling will produce a better result,

although obviously there is a processing cost associated with it. Figure 14.33b shows the result of doing this sort of thing—the elements were re-rendered at 4K resolution (4096 × 2304) instead of the 1920 × 1080 resolution of the originals and the resulting Z-depth composite was then resized back down to the working resolution.

Figure 14.33a Detail of the original Z-depth composite from Figure 14.28 compared with the same area rendered as a single image.

Figure 14.33b Detail of the Z-depth composite performed with higher-resolution source images.

Be aware, too, that any sort of operation that filters an image should really treat the Z-channel differently than the RGBA channels. Applying a blur to a depth map is really meaningless, for instance, because it can easily cause adjacent pixels of different depths to be averaged together, implying that we have effectively *moved* the portions of the object that those pixels represent in relation to their distance from the camera. This is almost certainly not what was intended. By the same token, remember that resizing images with most filters will resample and average several pixel values together. Which, again, might end up producing depth values that are an average of a near and a far object. You seldom want the outline of an object to be spatially located halfway between the foreground and the background! For this reason, if you are forced to resize Z-depth images you'll probably want to choose a filter that does a little averaging as possible.

Another inherent problem with the Z-compositing process is the fact that there are no standards for exactly what depth or distance corresponds to a particular brightness value in the Z-image. In fact there really cannot be any standard, since two different scenes may have wildly different distances from the camera. Usually when Z-depth images are rendered, one specifies a particular depth range that will be represented, and all pixel values in this image will be normalized for this range. But this range might be the equivalent of only a few meters of depth in one image, whereas another image may have depth values that would be measured in thousands of miles. It is not uncommon to spend some time normalizing two different Z-depth images to each other before they can be combined.

Precision and bit depth is also an issue. If your system is only using 8 bits to represent the Z-depth values, then you will only have 256 different depths that can be identified. 16-bit Z-depth images will be better, but the best systems use floating-point values, which provide for much higher precision as well as far more flexibility for the range of depth values that are used. In Figure 14.25, the Z-depth image was only rendered at 8 bits per pixel and there are some noticeable banding artifacts. Fortunately, we can get away with it in the fog example we showed because once it is incorporated into the composite the rest of the detail in the scene obscures most of the problems.

As we stated earlier, Z-depth compositing is primarily used with computer-generated images, since this is the only type of image for which accurate depth values can be automatically generated. But it is possible to occasionally make use of these techniques even when live-action is involved. Most commonly this is done by arbitrarily assigning a constant depth value to a particular live-action object and then integrating it with a synthetic element. If we create a Z-depth image for our live-action element, we can choose an overall depth for that object. Assigning a medium-gray value for the Z-image of our live-action element would cause the Z-depth compositing software to automatically place this live-action element about halfway back in our 3D scene. In certain situations, it may even be worthwhile to hand-paint a more detailed Z-depth image for a particular object. This will, of course, require someone who is skilled enough to determine the relative depths of the different objects in the scene, but the time-savings may be worth the effort.

In Figure 14.24 the background behind the car is actually a photograph of a real scene but since the wall and street could be represented by some very simple 3D geometry (and because we didn't need to worry about a moving camera when dealing with only a single frame to put into a book), it was easy enough to manually create a Z-depth image for the real-world element.

There are also tools that can (sometimes) procedurally extract some sort of Z-depth information from live-action footage by specialized analysis. Stereoscopic photography inherently contains some depth cues, and even a single camera view can give quite a bit of information if it is moving enough to introduce parallax shifts. Sophisticated software algorithms are able to analyze such imagery and can often produce useful depth information for the scene.

Multi-pass Rendering

We've just looked at a very specific instance of an additional image that can be generated to aid some aspects of the compositing process. But in fact there are an unlimited number of images that might be rendered out of our 3D package. Images that (like our Z-depth image) are designed to control or affect some specific aspect of the CG element we're placing into the scene. Generically, then, we'll refer to this concept as **multi-pass rendering** and we'll include any situation where the CG element is rendered as anything more than a single, complete 4-channel image.

At its most basic, of course, is the idea that any specific subcomponents of an object can be rendered as separate layers. For the car in Figure 14.24, for instance, we could have created renders for individual elements such as the windshield or the tires, allowing us to modify these objects independently from the rest of the car.

Just about anything might make sense to render separately, depending on the circumstances, and as mentioned above this might be done either for creative purposes or for efficiency. If the director wants to ensure that a CG character's eyes are bright and well lit (even if the lighting setup for the scene will occasionally throw them into shadow), then it might make sense to just render those eyes as a separate layer. If the cloth simulation you're using for a CG character's clothing is particularly compute-intensive or error-prone, you might want to render different items of clothing as separate elements, making it easier to re-render only what is absolutely necessary.

One of the most common things to render separately are the shadows that an object casts onto its environment. In this case if we look at our car composite *without* the shadows it will immediately give away the synthetic nature of the scene, as shown in Figure 14.34.

It would be easy enough to render a hard, directional shadow for the car here but the lighting cues in the scene tell us that it would be completely inappropriate—there's nothing else in the scene to indicate a bright, directional light source. Instead we'll use a softer shadow-rendering technique to produce what is known as an **ambient occlusion** layer, as shown in Figure 14.35. As you can see, this method (which is designed

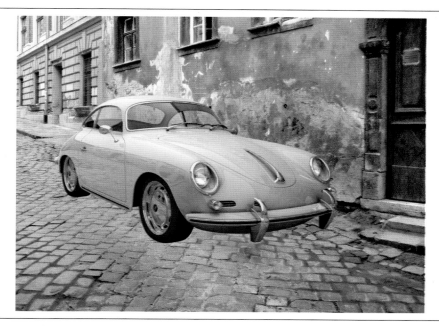

Figure 14.34 A CG element over the background without any added shadows.

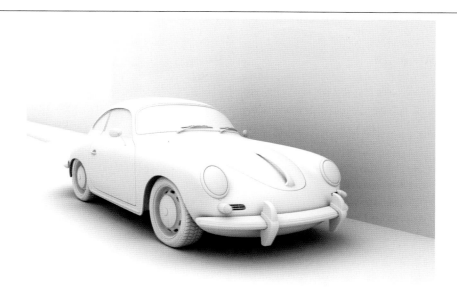

Figure 14.35 An ambient occlusion pass for our scene.

to more accurately model the way light and shadow interact with *all* the surfaces of an object and its surrounding environment) gives us nice soft shadows under the car, on the back wall, and over the car's surface. The nice thing about an ambient occlusion layer is that we can use it to increase the realism of the CG element as well as to integrate it with the background plate.

But let's look more into the rendering of the car itself and discuss some of the things that we might want to modify during the compositing process. The most common would probably be a desire to easily change the color of the car directly. Obviously an overall color correction isn't going to work very well since we'll be affecting the color of the *entire* car—the tires and the chrome and the glass—rather than just the painted portions.

We could render a mask element for modifying the painted areas of the car. Figure 14.36 shows just such a mask—notice that the reflective bits of the car are also included in this mask (albeit with slightly less opacity in places) so that our color correction will affect those areas as well. Figure 14.37 is the result of using this mask to modify the color of the original car again.

Figure 14.36 A mask for the painted areas of the CG object.

The result is better than modifying the entire car's color but still not quite right. Why? Because the reflections in the paint have also been tinted towards red and this isn't the way the real world works.

Figure 14.37 The result of color correcting the CG object using only the mask.

Figure 14.38 The object rendered without reflections.

To do this properly we really need to separate specific components of the lighting model into different images. Thus, in this case we want to separate the reflections into their own layer, as shown in Figure 14.38 (the car without reflections) and Figure 14.39 (the reflections themselves).

Figure 14.39 Reflections for the object rendered separately.

Finally we have all the tools we need to put together our composite. The car shown in Figure 14.38 is color corrected through the mask shown in Figure 14.36 and then the reflections are applied on top of *that*. The final result is then layered on top of the (properly shadowed) background.

Figure 14.40 is the result of all this and as you can see everything is now reasonably accurate to the way the car would appear in reality. And of course once we have all this set up it's easy to modify the color to be just about anything we want or, for that matter, to modify the reflectivity of the car as well. Figure 14.41 shows a few more iterations that can easily be generated from the layers we now have available.

There are really no standards for exactly how any given render might be broken apart—the choice is extremely situation-dependent, determined by the particular problems and challenges of the shot in question. You might have separate images for each individual light source, images for individual features of the object, separation of ambient, diffuse or specular components of an image's lighting, images that indicate the distance of the object from some other surface (the ground, for instance, making it easier to include some low-lying fog), and so on. Several of the case studies

Figure 14.40 A new composite where the object's base color was modified and then the reflections were added into the scene.

Figure 14.41a Another variation of the CG object created purely via compositing changes.

Figure 1.41b Another variation of the CG object created purely via compositing changes.

Figure 14.41c Another variation of the CG object created purely via compositing changes.

in Chapter 15 include examples of different types of multi-pass rendering. And certainly the images that are generated can evolve as work on a shot progresses—it's not uncommon for the compositing artist to get partway into the work on a shot and then request some specialized layer to be generated out of 3D in order to better expedite something.

Certain file formats allow for an arbitrary number of channels to be included within a single image file (notably the OpenEXR format, discussed in Appendix B). Bundling all these additional layers together can make it easier to keep track of everything since you're only dealing with a single file (per frame), but at some level this can also be counterproductive to efficiency since you may want to modify a single component without recreating the entire image.

Historically the process of creating and rendering 3D imagery has been a reasonably separate discipline from that of compositing. The 3D "color and lighting" artist would position and balance lights, change the color and properties of materials, and keep an eye on things like shadows and reflections.

But as you've seen here (and more so in several of the case studies in the next chapter), there is an increasing overlap between the work of a 3D lighter and what a compositing artist can do. This is due in part to an increased sophistication of compositing software, particularly in terms of its 3D capabilities. But it is also being driven by the fact that the artistic skill-set required to effectively integrate an object into a scene via accurate color and lighting is extremely similar to the skills that a good compositing artist has learned. Consequently, it is becoming more and more common to see facilities where the same individual will do both—3D lighting *and* compositing. This can bring a tremendous boost to both quality and efficiency since a single person will be in complete control over the process. They can choose whether something can be modified acceptably using compositing tools, whether it will be better to re-light and re-render in 3D, or they can choose the hybrid route, determining exactly what sort of additional information should be extracted from the 3D scene as used to finalize the 2D composite.

Related 2D Disciplines

In the very first chapter of this book, we alluded to the fact that there is 2D work that does not fall into the category of digital compositing. We will round out this chapter with a look at a few disciplines that share many things in common with pure digital compositing but should usually be considered as separate fields. The following processes share some conceptual similarities with digital compositing, and you will find that they are often used in conjunction with digital compositing as part of the overall process of producing a finished set of imagery. Depending on the size of the project or the team that is doing the work, the following items may be dealt with as completely separate processes or may be all wrapped together as one. This is also dependent on exactly what sort of hardware and software is being used as some packages can deal

(to a greater or lesser extent) with all aspects of a digital production pipeline whereas others may concentrate on only a very specific portion.

Digital Painting

The term "painting" still evokes the image of a brush and a canvas. Although there are digital tools that mimic this paradigm (usually with a stylus and a tablet), digital painting is far more than just a method for drawing colored lines into an image. In fact, digital paint programs offer a huge range of tools, many of them similar or identical in function to the compositing tools that we have discussed throughout this book. Even the most basic paint packages will allow the user to color correct an image, to apply geometric transformations, and to composite separate layers into a single scene. What's more, the "brush" that is used in digital painting is really nothing more than a series of composites that are applied along the path on which the brush moves. The effect will be limited to the extent of the brush size, and may be applied with soft edges around the periphery of the brush's path, but the operations should all be familiar. Simple painted brush strokes are usually just some kind of image processing, ranging from color correction to color replacement, but the brush can also be used to apply everything from blurring to localized warping.

Ultimately, the primary distinction between compositing and painting tends to boil down to whether or not the tools can be applied in an automated fashion to a sequence of images, instead of to a single one. Even this division is not foolproof, since there are a number of paint packages (most integrated within a compositing system) that can record a brush stroke on a single frame and then reapply that same stroke over a sequence. The attributes of the brush itself can even be animated over time. This sort of **procedural paint** functionality effectively allows single brush strokes, or groups of brush strokes, to be treated as individual layers in a composite. The strokes themselves are commonly recorded as splines so that their shape can also be manipulated to change over time.

Having a good paint program that can be used in conjunction with a good compositing system will prove to be invaluable. It can be used not only to create rough or detailed masks, but also to touch up any problem areas. Very few composites will be perfect, and the use of some final paint work to finish the image is a common practice. In fact, most of the situations that bring paint tools into the compositing process involve the need to explicitly correct problems, as opposed to actually creating new imagery. Often a bit of simple touch-up painting, even if it must be done to a sequence of images, will be far less time-consuming than attempting to redo the compositing process to fix the problem areas.

The use of digital paint tools is not restricted just to fixing artifacts of the compositing process, however. For instance, there is a whole class of work known as **wire removal** that is particularly well suited to a combination of painting and compositing techniques. Unlike the traditional compositing scenarios, in which the goal is to

add objects to a scene, paint tools often prove more necessary when the need arises to remove objects from a scene. Many times a photographed scene will inadvertently contain unwanted harnesses, ropes, or wires that were used as part of a stunt or a practical effect. It is not always possible or cost-effective to fully hide these items from the camera, and consequently digital tools may be employed to remove them from the scene. Since the process seems to be most often used to remove wires, the term "wire removal" has to a certain extent grown to be a generic term for the removal of undesirable stage elements from a scene. "Rig removal" is another common term that is broader in its scope. Certain vendors offer compositing and paint software that includes tools specifically designed to aid in the wire-removal process.

This type of fix-it work can range in complexity from something that may only take a few minutes to accomplish (if it is merely a matter of removing something from a few frames of a sequence) to shots in which complex and/or time-consuming techniques must be employed to achieve the desired result. In fact, certain wire-removal shots can end up being the most expensive shots in a film. These types of shots are almost always finished off with painting techniques, with careful attention to any areas that exhibit temporal artifacts when played at speed.

Digital techniques make it possible to remove things that would never have been considered feasible before. In one of the most extreme cases, a major motion picture[14] was approaching completion when it was discovered that a fictional electronics company whose logo featured prominently in the film had a name that was extremely similar to a real-world company. The real company was upset at the unflattering portrayal of the fictional company and was concerned that the public could confuse the two. The decision was made by the production to go through the entire film and digitally replace the company name and logo in every scene in which it appeared! This work certainly involved a good deal of traditional compositing steps, such as tracking the logo as it moved through various shots and compositing a new logo over the original. But there were also a huge number of shots in which the company name was painted out, frame-by-frame. Obviously this was an expensive, time-consuming project, although without the use of digital paint tools, the work could probably not have been done at all.

Editing

The editing process concentrates on the assembly of shots and scenes into a final product. As such, it tends to be primarily concerned with decisions about the length of individual shots and the order in which they will appear in a scene. But the editing for any given project will generally start before any compositing can begin and will continue after the final composite is delivered.

[14] Featuring a certain prominent actor who has since gone on to govern the state of California.

Modern editing, be it with film or video, tends to make use of digital image-manipulation devices that are conceptually quite similar to digital compositing systems. Elements are digitized into the system and can then be quickly reordered, compared, trimmed, and otherwise adjusted in order to better visualize how the final shot will look. The editor can make timing decisions by cutting the beginning or the end of a shot or by retiming footage in exactly the fashion that was described in Chapter 7. Transitions between scenes will also be dealt with by the editor, controlling the duration and timing of a dissolve, for instance.

Not only the editor will need to determine the length and placement of every composited shot, he or she will also need to determine which elements should be used for this shot. As such, it becomes very useful for an editor to be able to previsualize a composite while the elements are being chosen. To this end, many digital editing systems include a variety of tools for performing effects and composites. Once again, the distinction between compositing and editing is becoming difficult to define—many compositing systems combine the features that are necessary for both disciplines into a single package and many editing systems feature a wide enough range of compositing-related tools that it may be unnecessary to export anything to a separate compositing process.

For shots that *are* exported from the editing package for compositing and then brought back in, situations may often arise where the length of the shot changes after the composite has been completed. If the shot is shortened this isn't a problem, but if a *longer* shot is needed it can be more problematic. For this reason, it is not uncommon for editors to specify an effects shot that is longer than necessary, adding extra frames to the beginning and end of the shot. These **handles**, usually less than a dozen frames at either end will provide the editor with some additional room for adjustment once the composited shot is delivered.

The Digital Intermediate

Although feature films are (as of the writing of this book) still *primarily* projected on film, analog film-processing techniques for the intermediate steps are growing increasingly rare. In particular the process of doing the final color timing (aka color grading) of a film—ensuring that every shot matches in terms of color, brightness, and contrast with the preceding and subsequent shot—is an area where digital has supplanted optical. Regardless of the original source medium—film or video or even pure CG—a high-quality digital equivalent of the final material is prepared that can be viewed in its entirety. This is known as a **digital intermediate** (or DI) and is analogous to the "intermediate" step that is generated optically when working with a non-digital film production pipeline.

In the classic analog (photochemical) film pipeline, preparing a film for release to theaters generally goes through the following steps. The first thing to happen would be to strike a **rough print** from the original negative. This print is what the editor would

work with, cutting and splicing repeatedly as the edit is refined without fear of touching the original negative. Once the edit is "locked down" the original camera negative (sometimes referred to as the **OCN** or simply the "**O-Neg**") is cut according to this finalized edit, producing the master negative for the movie.

But if we wish to produce multiple prints for theatrical distribution (potentially thousands for a wide-release film) there are additional steps that must be taken. The original negative is considered too delicate to produce all of these prints directly—each print will introduce slight wear and tear on this one-of-a-kind original. Thus we need to create a copy of this negative (several, actually) that can be used to generate all of our **release prints**. In the photochemical film world a positive can only be created from a negative and vice versa, so to create a new negative from an original negative is a two-step process. First, an **intermediate positive** print (known as the "**IP**") is created. From this IP, *multiple* **intermediate negatives** are printed and these **IN**s will then be used to generate as many **release prints** as is necessary. By creating multiple INs we again are attempting to minimize the wear and tear on the film, producing higher-quality final prints.

In the above process, color grading is accomplished by modifying, on a shot-by-shot basis, the color of the light that is used to expose the IN as it is created. Control is fairly minimal—the colorist can only change the *overall* color of each shot by varying red, green, and blue values of that light but there is no way to do anything even slightly more sophisticated (to only affect a specific tone of blue, for instance) or to deal with things like contrast. (Although contrast *can* be manipulated to a certain extent via changes in the photochemical development process itself).

Introducing a DI into the workflow simplifies things a great deal, as now the original negative can be scanned and additional modifications performed directly on the digital data. Regardless of whether or not any visual effects or digital compositing work will be done on this data, the tools available to a **digital colorist** are extremely similar to what a compositor would be familiar with, particularly in terms of color corrections, filters, and masking. Although the specifics will vary depending on the system used, generally the colorist can easily affect color, contrast, and saturation, pulling keys as necessary to isolate the effect to certain color ranges. Additional sharpening can be applied, grain can be reduced, and even the overall framing of a shot can be modified by zooming in on a specific portion of the image. Many digital grading systems allow the operator to create masks (for selective color correction) via shapes or splines and even to use tracking techniques to move these masks over the duration of a shot. Of course extremely detailed work of this sort would generally be handed over to a visual effects artist/facility once it reached a certain level of complexity.

Once the DI is finalized, the data is sent to a film recorder which can then create as many new master negatives as is necessary. Release prints are then made directly from these negatives using the traditional optical development process. Films scheduled for digital projection will, of course, be encoded directly from the DI.

Color grading of a DI tends to be a very interactive process—the hardware/software system is generally designed to provide visual feedback immediately whenever possible and often the director and/or cinematographer will work directly with the colorist as the grading is being refined. Although theoretically a digital colorist with a standard compositing package could do the same work as a compositor at a visual effects facility, in practice the work of a colorist is limited to those things which can be done reasonably quickly. This is primarily due to the desire to ensure that sessions with the client are as interactive as possible and don't include an inordinate amount of time waiting for the operator or the software to perform a complex task.

The production of a DI is usually done at a facility that is dedicated to this task although in some cases larger visual effects houses may actually provide a full digital color grading for the entire film as part of what they deliver.

Ultimately the benefits of a DI are multifold. It skips several steps of optical printing, each of which introduces additional cost and (more importantly) causes degradation of the image due to generation loss. Having a full DI of the film not only makes the actual print production much easier and higher quality, it also allows other formats to be derived directly. Historically the video version of a film was telecine'd from the original film but now it is simply a matter of converting the high-resolution digital data from the DI into various video formats—NTSC, PAL, HD, etc. "Pan and Scan" can be applied at this point as well. It's not completely just a simple push of a button, however. Generally there is an entire second grading pass done on the DI to prepare it for the video version, due to the differences in the way colors are reproduced with the different viewing methods.

Finally, and perhaps most importantly, it allows the filmmaker a *much* greater degree of control over the final image, providing a set of tools for color, contrast, sharpness, and grain that are unavailable in the analog world. Of course it is only a matter of time before the entire "film" pipeline, from acquisition to projection, is fully digital for all but the rarest of cases. Certainly there have already been films that have been done this way and the obvious benefits will rapidly increase the adoption of this method.

Case Studies

This final chapter will now examine a number of digital compositing examples that are taken from the real world. We will attempt to give a sense of the diversity of work that is being created using digital compositing methods, and will discuss how the various concepts that we have presented in this book were used to create this work.

We've kept a few of the original case studies from the first edition—specifically the first six studies in this chapter. Although they are discussing the technology as it existed just before the turn of the century, the basic techniques are still valid.

The new case studies for this 2nd edition were handled a bit differently. To get a fresh perspective, we have asked people directly associated with the productions to tell us about the work they did in their own words. You'll quickly see that there are as many ways to approach the compositing process as there are people doing the work!

James and the Giant Peach

In Chapter 1, we used a number of elements from the film *James and the Giant Peach* to help define some basic digital compositing terms. This section will now describe the process that was used to actually prepare and composite these elements into the final shot shown[1] in Figure 1.3. As mentioned, the elements for this scene are a combination of miniatures and synthetic CGI.

The creation of the shot began with photographing the model of the peach itself. As you can see in Figure 1.4a, the peach was shot in front of a bluescreen so that it could be easily extracted and placed into its new environment. Careful attention was paid

[1] Rather than re-print these images we'll just refer directly back to the figures found in Chapter 1.

to the way that the peach was lit, since not only did it need to be appropriately lit for bluescreen extraction, but it also needed to match the other shots in the sequence in terms of lighting direction. The sequence features several shots in which the sun is visible, and all the shots in the sequence were planned in advance so that the location of the sun and the way the objects in the scene were lit would be consistent.

The peach in this shot is a model measuring about 1 foot in diameter. The characters standing on top of the peach are puppets that moved via **stop-motion animation**. This technique involves photographing the shot a single frame at a time, then repositioning the puppets by a minute amount before the next frame is shot. This process is repeated for the entire length of each shot; consequently, filming can be extremely time consuming. For a typical 5-second shot, filming can take days to complete, particularly if there are several characters in the scene, as in our example. The peach itself was also moved throughout the scene, in order to give the impression it is being restrained by the cable that runs into the mouth of the giant mechanical shark.

You'll notice that the peach was shot very large in frame, even though the element would be much smaller in the final composite. This was done to ensure that the compositor would have more than enough resolution for this element. There was no need to predetermine the scale of the peach in the original photography, since this could easily be done during the compositing process. The exact location of the peach and the framing of the shot did not need to be decided upon until the other primary elements in the scene (the shark and the water) were more completely realized.

The peach was extracted from the bluescreen using a combination of proprietary and off-the-shelf software, coupled with some spline-based garbage mattes. Spill suppression was primarily accomplished with the simple equation that was given in Chapter 6.

The background sky plate was also photographed on a stage as a separate element. It was a large piece of canvas and the clouds were airbrushed on by a scenic artist. The plate was shot locked off, and several identical frames were photographed so that they could be averaged together in order to eliminate film grain.

The rest of the elements in the shot are 3D computer-generated images. The obvious ones are the shark and the water, but there are a number of additional ones as well. The water was procedurally generated using some custom software that was written specifically for the show. It actually consists of three different layers: the basic water, the foam that caps the top of most of the waves, and a slight layer of spray that is emitted from the tips of these waves. The splash that can be seen in the bottom right corner of the frame was also created as a separate 3D element. The shark was rendered as a single image, as shown in Figure 1.4b, but the steam and smoke that comes from the shark's gills and dorsal fin were created as separate elements, as was the cable that runs between the shark and the peach. The movement of the shark and the cable were animated to match the movement of the peach described earlier.

The shot was assembled in the following manner. First, the peach and the sky elements (which had been digitized directly into the Cineon color space when they were scanned) were converted to a linear color representation. This would allow these plates to properly match with the CG elements. The sky plate was then given a slight animated move over the duration of the shot. This move is extremely small and subtle, designed to give the impression that the clouds are moving slowly across the sky. The water was added over the sky background, and some additional atmosphere was added near the horizon with the use of a simple gradient. The animated foam and spray elements were added to the scene as well.

Several tests were done to determine the proper placement of the peach, and it was then scaled and added into the scene. Obviously, spill suppression and color correction were performed in order to better integrate the peach into the shot. A couple of additional elements—a shadow element and a reflection element—were created to help with the peach's integration into the scene. Both of these were generated by creating a quick stand-in element for the peach in the same 3D environment in which the water was being created. This stand-in did not need to be terribly accurate or detailed, since it was only being used to create shadows and reflections, but it did need to be approximately the same size and color as the "real" peach. These two new elements were composited into the scene as well, adjusting their values until a visually pleasing result was obtained.

Essentially the same process was used for the addition of the shark to the scene. The shark itself was placed into the scene first. (Other shots in the sequence made use of Z-depth compositing for situations in which the shark was farther in the distance.) Once the shark was in the scene, a rendered shadow was added and the densities adjusted. Some initial tests were done with a shark reflection as well, but all the other elements that were being added obscured it to the point at which it was not worth the effort, and so it was removed. Other shots in the sequence did make use of these rendered reflections. A rendered line of foam and splashes was added to the areas where the shark intersected with the water, and a larger splash was created that synchronized with the action of the shark's fin slapping the water. Finally, the smoke and steam were added to the scene, after several adjustments were made to their transparency.

The last step in the process was to introduce some synthetic film grain into the scene. This grain actually needed to be added to all the elements in the scene. The CG elements obviously did not have any grain on them originally, and we have already mentioned that the grain was explicitly removed from the sky via multiple-frame averaging. But even the peach had become effectively grainless due to the amount of scaling that was applied to it. This scaling had the effect of averaging the existing grain together, reducing its noticeability significantly. Thus, the grain was applied as a single pass to the finished composite.

Speed

Visual effects are often used to increase the perceived danger that is present in a specific stunt. For the film *Speed*, a bus carrying a load of passengers needed to appear to jump over a huge gap in an elevated freeway that was under construction.

Figure 15.1 shows the completed effects shot in which this was accomplished. The bus, traveling at high speed, has just driven off the edge of the concrete and is soaring through empty space. In reality, the bus that was used in the stunt did jump off the edge of a road and fly through the air for a good distance. However, the danger was quite a bit less, since the ground was really only a few feet below the bus. A short ramp was built that duplicated the look of the gap's edge, and then the stunt driver was able to launch the specially reinforced bus over the edge.

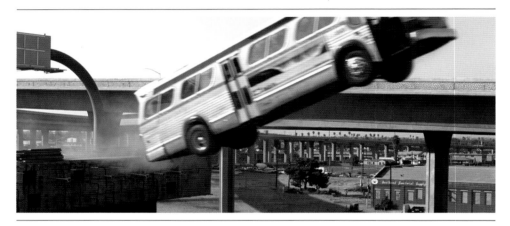

Figure 15.1 A composite image created for the film *Speed*. Images from *Speed* courtesy Twentieth Century Fox Film Corporation. © 1994 by Twentieth Century Fox Film Corporation. All rights reserved.

Figure 15.2 shows the original plate that was shot for this scene; you can see that the road actually continues beyond the edge of the ramp. The task of the compositor was to replace this road with a huge drop-off. To accomplish this, an artist created a digital matte painting of the ground below, detailing it with terrain and equipment that would be typical for a construction site (Figure 15.3). As you can see, the painting is designed to replace as little as possible. Fortunately, the scene was actually filmed atop an elevated highway, so the background off the edge of the road has an appropriate sense of depth and distance.

The plate was shot with this sort of replacement in mind. The camera angle was chosen so that the bus didn't actually cross over the road at any point. This setup allowed the painting to be placed only over the road and made it unnecessary to extract a matte for the bus. Shot with a locked-down Vistavision camera, the background plate

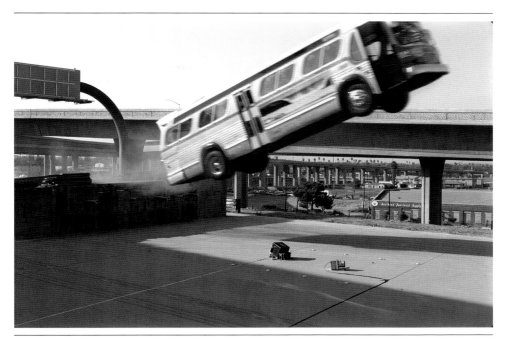

Figure 15.2 The original plate for this scene. © 1994 by Twentieth Century Fox Film Corporation.

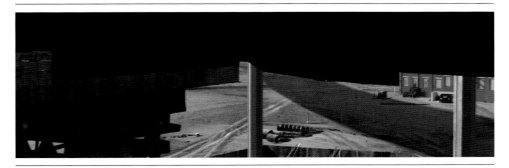

Figure 15.3 A digital matte painting created for this shot. © 1994 by Twentieth Century Fox Film Corporation.

was scanned at a high enough resolution that there was plenty of room to animate a slight camera move into the final sequence. The move was created to simulate the motion that a cameraman might have introduced were he or she is actually filming the scene. This included a less-than-perfect attempt to follow the bus as it is moving through frame. The pseudo-camera actually takes a moment to catch up with the bus immediately after it jumps, for instance.

Of course the painting, being a single frame, had none of the grain that was in the rest of the shot, so animated grain was added to the sequence of images that were produced from the painting. As is usually the case with adding grain to an element, it is essentially unnoticeable, but its absence would have been immediately apparent. A few pieces of computer-generated debris were also added to the final scene—unidentifiable objects that were heavily motion blurred and whose primary purpose was to cross over the split line between live action and matte painting. Such a trick helps to mask the split between the two and gives a better sense that everything is really part of the same scene.

Although the bus itself did not cross over the area that was to be replaced by the matte painting, some of the dust that was thrown into the air did. This caused a noticeable edge to appear at the juncture between the live action and the painting wherever the dust was heaviest. This problem only lasted for a few frames at the end of the shot, so the easiest solution proved to be a simple manual paint fix. The dust had very little character—it was mostly a haze that caused the apparent color of the roadway behind it to shift towards a brownish tint. By hand-tinting the appropriate area of the matte painting for the 10 or 12 frames at the end of the sequence, the noticeable split between painting and live action was easily hidden.

Independence Day

Spaceships and flying saucers have been a staple of visual effects work for almost as long as the craft has been in existence. For the film *Independence Day*, the challenge was to make these saucers appear to be more massive than anything previously depicted.

Figure 15.4 shows a finished frame from the film. The alien "Destroyer" spaceship is approaching the city of New York, and the size of the ship alone is enough to cause dramatic atmospheric disturbances.

Figure 15.4 A composite image created for the film *Independence Day*. Images from *Independence Day* courtesy Twentieth Century Fox Film Corporation. Image from *Independence Day* © 1996 by Twentieth Century Fox Film Corporation. All rights reserved.

Several different visual cues are used in this scene to convey the sense of the ship's scale. The fact that the ship fills the frame is one of these cues, but we will also discuss a number of others.

As is typical, the first step on the way to creating this shot was to capture a suitable background plate. Figure 15.5 shows a view of the New York City skyline from beneath the Manhattan Bridge. The inclusion of this massive bridge in the foreground was no accident, but rather a conscious decision designed to establish the sense of scale. Had the shot been framed so that there was no noticeable foreground object, the impact of the image would have been far less dramatic. Instead, it immediately becomes evident that the Destroyer is quite a bit larger than the bridge.

Figure 15.5 The original background place. © 1996 by Twentieth Century Fox Film Corporation.

A couple of factors made it fairly straightforward to produce the matte for the bridge. First, the sky is significantly different from the bridge, both in terms of color and brightness. In this situation, the compositor extracted a basic matte for the bridge, primarily by keying on luminance. The second factor that helped with generating this detailed matte is that the sequence was photographed with a locked-down camera. In this case it was a standard 35 mm motion-picture camera, shooting full aperture. The static camera meant that it was necessary to create only a single frame of this matte. Any problem areas that weren't addressed by the procedural matte pull could be touched up by hand, using a digital paint system. The work would need to be done only on a single frame, which would then be used throughout the entire shot.

Before this matte could be used to hold out the bridge for the sequence a stabilization pass was applied in order to remove a slight jitter that was in the original footage. This

jitter appeared primarily as a random vertical offset in each frame of the sequence. Although minor, it would have been enough to cause a misregistration between the image and the matte on many frames. The unwanted motion was analyzed and each frame was repositioned to compensate, resulting in an extremely steady plate that would match exactly with the single-frame matte.

The final depth cue that should be noted is the atmosphere in the scene. In this situation the atmosphere is more than just a tool to convey a sense of distance—it is actually part of the effect. The roiling clouds were created from two separate elements. The first element, shown in Figure 15.6, consists of the model spaceship mounted on a motion-control rig. The Destroyer moves slowly towards the camera as the shot progresses, revealing itself from within the clouds. The model of the ship was shot on a stage, with a smoke generator providing the first layer of clouds.

Figure 15.6 An element for the scene that features a miniature spaceship and a smoke effect. © 1996 by Twentieth Century Fox Film Corporation.

A second layer of clouds was shot in a **cloud tank**, a large water-filled glass enclosure. These "clouds" are actually produced by injecting a white, opaque liquid into the water in a controlled fashion. Underwater lights in the tank help to define the clouds, producing a more dramatic look. The result can be seen in Figure 15.7. Note that there is also an object in this plate that serves as a stand-in for the spaceship. Designed to mimic the basic contours of the more detailed model, the shape allows the clouds to move in an appropriate fashion and appear as if they are interacting with the ship.

To combine these two cloud elements into a single shot, a number of soft-edged mattes were hand-painted. These mattes allowed the compositor to selectively reveal

Figure 15.7 An element for the scene that was shot in a cloud tank. Note the stand-in object that is used for the spacecraft. © 1996 by Twentieth Century Fox Film Corporation.

portions of the two plates, and to control the amount of mix between them. Once the two layers were married together, they could be placed into the original background plate. In this case, some additional color correction was done to modify certain portions of the clouds. Several areas were tinted red, and the contrast was modified around the perimeter of the element. The leading edge of the cloud effect required specific attention.

If you examine Figure 15.7 closely, you will notice that there is a well-defined edge for the bottom of the clouds. The top of the clouds, however, does not feature such a clean edge. In fact, the surface of the water, seen from below, is acting like a mirror, and the top of the clouds are overlapping with their own reflection. This presented a problem, as the scene required the boundaries of the effect to be visible at the beginning of the shot. To create an appropriate edge for the top of the cloud-bank, the compositing artist simply used the bottom edge of the clouds and flipped the image. The timing of the footage was shifted—a different range of frames was used—and this became the top edge of the clouds. Since the top and bottom edge came from different points in time, it was not obvious that they had originally been part of the same element. A soft-edged matte was used to place this edge back into the scene.

As mentioned, the original background plate was photographed "full aperture." In fact, all photography for the film was done in the Super 35 format, where a frame with a 2.35 aspect ratio is extracted from the original negative and used to create the final widescreen print. (Chapter 10 discusses this procedure in greater detail.) As you can see when you examine Figure 15.4, a great deal of image information at the top and bottom of the frame is discarded when the final frame is produced. Using the

same technique that was discussed with the shot from *Speed*, the location of the 2.35 extraction was animated over the course of the shot, producing a slight camera move in the final scene.

The Prince of Egypt

As we saw with the imagery from *James and the Giant Peach*, compositing techniques are certainly not limited to live-action elements. In fact, digital compositing is now being used extensively in the creation of traditional **cel animation** as well. A scene from the Dreamworks film *The Prince of Egypt* will be discussed as an example, concentrating on the completed frame shown in Figure 15.8.

Figure 15.8 A composite image created for the film *The Prince of Egypt*. Photos from the motion picture *The Prince of Egypt*™ & © 1998 Dream Works L.L.C., reprinted with permission of DreamWorks Animation.

Before the existence of computers, cel animation consisted of drawing and painting individual elements that were to make up a scene directly onto a piece of transparent cellulose acetate. (This is where the term "cel" comes from.) These elements would all be placed together in a stack, layered so that the most distant elements were at the bottom. This group of elements was then photographed as a whole, creating a single frame of the sequence. This process was done repeatedly for subsequent frames, substituting different cells of animation and repositioning background layers as necessary.

In most contemporary 2D animation, the final photographic step has been replaced with digital methods. Each scenic element is digitized on a flatbed scanner, and these separate images are then combined as digital images. They are, in fact, composited together.

The use of computers has certainly simplified the process of combining layers, but it has also allowed the animation artists to create scenes with many more layers than would have been previously practical. Historically, shots with many layers were problematic for a number of reasons. First, keeping track of the movement that would need to occur on each layer could prove to be rather arduous. Each cel could require a separate move, and each move would need to be slightly different, depending on the theoretical depth of the element in question. There were also problems that could occur when too many cels were layered on top of each other. Because the material that a cel is made from isn't perfectly transparent, multiple layers of this material could start to show a noticeable color build-up. The bottommost layers would be affected by the color of the cels above it. For this reason, the person painting the cel would need to be aware of that cel's eventual position in the layered stack. He or she might even decide to use brighter paints for the lower levels, choosing colors that would compensate for the slight attenuation and yellow shift that the cels would introduce.

Figure 15.9 The primary background element. © 1998 Dream Works L.L.C.

All of the elements that are shown in Figures 15.9–15.16 (with the exception of Figure 15.10), originated as hand-drawn images. The scenic backgrounds originated as cel paintings before they were scanned to become digital elements. This process is also changing, gradually, as more and more of the traditional scenic artists are learning to use digital paint systems instead. For *The Prince of Egypt*, probably 99% of the scenic backgrounds were still created by artists working with traditional brushes and paints. But the studio's next production will feature a much more even mix of traditional and digitally painted backgrounds.

Figure 15.10

Figure 15.11

Figure 15.12

Figure 15.13

Intermediate layers of the multiplane composite. © 1998 Dream
Works L.L.C.

Figure 15.14

Figure 15.15

Figure 15.16 Intermediate layers of the multiplane composite. © 1998 Dream Works L.L.C.

The animated characters in this scene were created in a slightly different fashion. They originated as line art that was drawn a frame at a time on individual sheets of paper. Each frame was then digitized, producing a series of black-and-white line drawings. A digital "ink and paint" system was then used to complete the process.

Such a system is capable of converting these pencil sketches into strong outlines that mimic the look of a hand-painted cel. These outlines can then be filled with the appropriate colors. This process is hardly automatic—the artist will need to explicitly indicate many of the outlines, and will specify the colors that need to appear within these boundaries. But the software can often simplify some of this work. It can, for instance, automatically fill the same area over a sequence of frames, instead of requiring the paint artist to do this for each individual frame. Once the procedural work is completed, manual retouching will often be used to complete specific areas.

Multiple layers are used in traditional animation for a number of reasons, but primarily to save a great deal of time and effort. Backgrounds that do not change need only be drawn or painted a single time, while the more labor-intensive process of frame-by-frame animation will be limited to only those elements that need to change. But multiple layers can also be used to introduce a sense of depth in a scene through the simulation of parallax effects. This sort of **multiplaning** is created by moving the elements that are theoretically farther from the camera by a lesser amount than the elements that are near to the camera.

Figure 15.17 shows the scene composed within a proprietary scene composition package. This view allows us to see not only the ordering of the layers, but also the distance between the elements in our imaginary three-dimensional space. This information will be used to determine the appropriate multiplane effect for the scene. Thus the yellow, sun-filled sky is noticeably farther from camera than the other foreground elements, and will consequently show very little perspective shift as the camera moves. This same sort of tool can also be used to determine the proper placement of any 3D elements that will be added to the scene. Mixing CG with cel animation is becoming increasingly more common, and it is only natural that the artist would want to work with both types of data within the same tool.

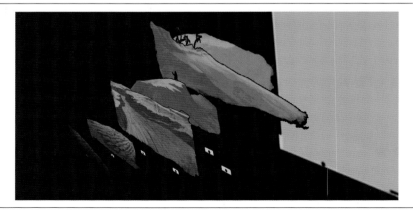

Figure 15.17 The layout of the scene, showing the depth relationships between the various elements. © 1998 Dream Works L.L.C.

Within this composite, a number of things were done to better integrate the separate layers into the scene. The layer that features Moses standing on the hilltop (Figure 15.14) was modified so that the edges of the character were slightly shrunk wherever they passed in front of the sun. This made it appear as if the light was actually wrapping around the element a bit, as it would if a live-action actor were to stand in front of an intense backlight. Another subtle effect was applied to some of the shadows in the scene. The shadows that the characters from Figure 15.15 are casting can be seen in Figure 15.16. These shadows were hand-drawn, but were not specifically designed to match with the contours of the background shown in Figure 15.12. To help with this interaction, an additional distortion was applied to these shadows to help them fall on the surface in a more realistic fashion. The distortion was based on the luminance of the ground—brighter areas would warp the shadows by a greater amount, darker areas would warp the shadows less. This slight distortion was enough to make it feel as if the shadows were falling onto a three-dimensional surface, instead of a flat piece of painted artwork.

A few different atmospheric layers were also added to the scene. One of these is shown in Figure 15.10. It features a couple of small dust-clouds that will surround some of the characters in the foreground. These clouds were generated with a procedural texture that could be controlled via a number of parameters within the composite.

Each sequence in the film was designed to feature a specific, limited color palette. This was not a decision based on a desire to limit the amount of data necessary to represent an image. Rather, it was an aesthetic decision that was made to help with the story telling. In fact, the images were usually represented with 16 bits per channel of color depth. This would prevent any quantization artifacts from appearing—a particular problem when one is attempting to display broad areas of similar colors.

A number of additional digital tools may be used to improve the quality of the final composite. One such tool modifies the images to introduce a pseudo motion blur to certain areas of the image. Using a sophisticated (and proprietary) algorithm to analyze the motion of objects over a series of frames, this tool can selectively blur the portion of the image that is moving significantly between frames. Since the original hand-drawn elements will typically have no motion blur, this technique can produce images with a much smoother feel to their animation.

The shot being discussed is a very quick scene in the final film. Consisting of only 64 frames, it would be visible for less than 3 sec. Unlike traditional visual effects work, where one often produces several additional frames of handle at the beginning and end of the shot, cel animation is almost always done exactly to length. Many of the shots in a major animated feature can easily cost more than $1000 per frame to produce, making any extra work a prohibitively expensive proposition. This same reasoning also drives certain shortcuts in other areas. For instance, hand-animated figures are not always created with 24 discrete frames for every second of animation. Instead, the artist will animate "on two's," producing only 12 distinct frames for each second. Each frame is then typically displayed twice in a row—a process that is now

usually dealt with in the compositing stage. This double-frame animation is not the problem it might be with live-action footage. First of all, the animator will choose which elements are appropriate for this treatment, usually confining it to slower-moving characters or objects. Additionally, this sort of timing has been used for nearly as long as cel animation has been in existence, and can be considered a part of the stylized look of this medium.

Budweiser Lizards Commercial

Although most of the shots discussed in this chapter are taken from feature-film composites, digital compositing is obviously used in a number of other situations as well. Television commercials are filled with digital effects, some of which can easily rival motion picture work in terms of quality and complexity. The two images shown in Figures 15.18 and 15.19 are from a Budweiser commercial. Figure 15.18 is the final composite that was created for one shot in the commercial, and Figure 15.19 is one of the elements used to create this composite. At first glance, this example might seem to be a very simple composite, requiring only a basic bluescreen extraction and a standard layering of the two elements together. But in reality there is far more to this shot.

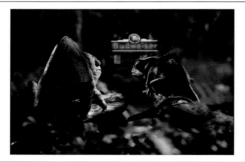

Figure 15.18 A composite image created for one of the Budweiser "Lizards" commercials.

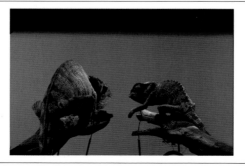

Figure 15.19 One of the bluescreen elements used to create the shot.

The lizards that are sitting on the branch in the foreground are actually small puppets. You can see the control rods that were used to animate the creatures by manipulating the movement of the various appendages. These rods obviously needed to be removed from the scene, and a combination of techniques was used to accomplish this. Since the rods would often pass over another portion of the lizard or the branch, there was more to the process than simply painting out the rod itself. Depending on the situation, the portion of the image that was covered by the rod was recreated either by grabbing a portion of a clean plate or by using image data from the same plate, but from a different point in time when the rod was not obscuring the area in question. Even though the camera was locked down for most of these shots, the rod would often cover a portion of the lizard that was also moving, making clean plates useless. In these cases, the motion of the moving area was determined with automated tracking techniques, and the "clean" area was pasted into the scene by using this tracking data to duplicate the proper move.

A great deal of the animation, or at least the timing of the animation, was also dealt with in the composite. Multiple **takes** of each scene were usually shot, each with slightly different animation and timing. Since all the puppetry was done by hand, it was common for different takes to be slightly different. When it came time to create the final composite, the artist was able to choose from several of these different takes to determine which one was most appropriate for the scene in question. In fact, the artist was not limited to choosing a single take for a given scene. Instead, different pieces from the various takes were pasted together to create the final element. For instance, the "performance" of the lizard on the left might have been better in one take, while the movement of the lizard on the right was less than satisfactory for that same take. The artist was able to pick the version that worked best for either lizard and then use a simple split-screen to bring the best version of both lizards into the same final scene. This process of mixing and matching different takes was actually done on an even more minute level. Using a combination of soft-edged garbage mattes and careful tracking, different body parts from the various takes could also be combined. Thus, the moving lips from a certain take might be combined with the tail motion from another. If you look carefully at the final element, you will notice that both lizards have appendages in different positions than they were in the original bluescreen element.

Once the final action for the foreground lizards was complete, additional integration was necessary to tie the scene together. Some basic color correction was applied, as well as many very specific manipulations that were designed to change the quality of the lighting. Using a series of animated garbage mattes once more, certain areas of each lizard were treated to increase the brightness of the highlights or to attenuate areas that should be in deeper shadow. Again, comparing the original bluescreen with the final image should show an obvious change in much of the lighting.

The background element was also heavily modified from the original scene. Since this scene is only one of a number of similar scenes from a number of different Budweiser commercials, there were opportunities to reuse certain plates instead of shooting a

new element. This scenario was taken advantage of as often as possible since it greatly reduced the time and expense of each new commercial.

In this case, the production had already shot a plate of a similar background, only with a Budweiser sign that was hanging crookedly. To reuse this plate, the artist simply extracted the crooked sign using a soft-edged matte and then rotated it to the appropriate orientation. Once repositioned, a bit of manual painting was required to touch up the area around the sign and hide the modifications. Once this was done, a single new frame of the background was ready. Since the background is unmoving in this scene, the single frame could be extended to last for the duration of the shot. The original background plate had been photographed in sharp focus, but this scene required the background to be slightly defocused. Executing this defocus produced an element without any noticeable grain, so a final step to recreate moving grain was performed before the foreground was placed over this new background.

Titanic

The image from the film *Titanic* that is shown in Figure 15.20 is actually only the end-piece of a long transition shot that marries together three different scenes. The shot actually begins with a completely different view—a close-up on the actress who plays the elderly Rose, one of the main characters in the film. The camera pans past her to

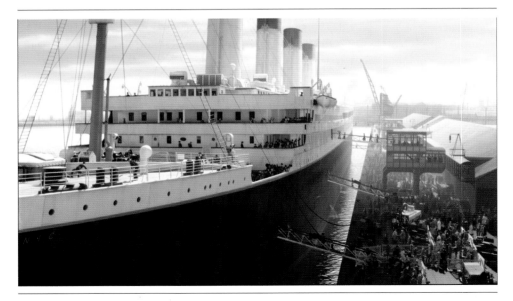

Figure 15.20 A composite image created for the film *Titanic*. Images from *Titanic* courtesy Twentieth Century Fox Film Corporation. © 1997 by Twentieth Century Fox Film Corporation. All rights reserved.

reveal a video monitor that is displaying the present-day Titanic—a hulking wreckage on the sea floor. This view expands to fill the frame, and the camera continues to move around the ship's bow, giving us a view of the rust-encrusted railing. Subtly the scene transitions to the day in 1912 when the ship was new and ready for launch. Hundreds of people are at the dock in Southampton, waiting to board, and others are waving from the lofty decks.

Literally hundreds of elements were used to create this scene, only a few of them are shown here. We will concentrate primarily on the process that was used for the creation of this final portion of the shot, since the compositing, tracking, and morphing that went into the beginning of the shot would be difficult to describe without the benefit of several more pages of illustrations. We'll start with the ship itself. Although the film made use of everything from full-sized set pieces to completely computer-generated models, the Titanic that is shown in Figure 15.21 is a 1/20th scale miniature. After photographing the miniature on a stage in front of a black background, a matte was extracted for the ship with a combination of luminance-keying and garbage mattes. This element was shot with a motion-control camera, applying the same camera move that was used to capture the beginning elements in the scene.

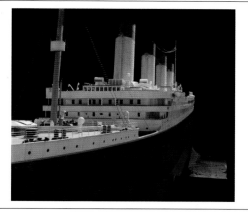

Figure 15.21 An element that features a miniature of the ship. © 1997 by Twentieth Century Fox Film Corporation.

The passengers and crew that are seen standing on the ship are all computer-generated characters. Created as carefully detailed digital models, these elements were rendered with integrated matte channels. The positional data that was used to drive the motion-control camera for the miniature shoot was also translated into a format that could drive the virtual camera, resulting in a perfect match with the miniature plate.

The sky behind the ship (Figure 15.22) is a matte painting, given life by the addition of a slight movement to the clouds and some animated smoke elements coming from

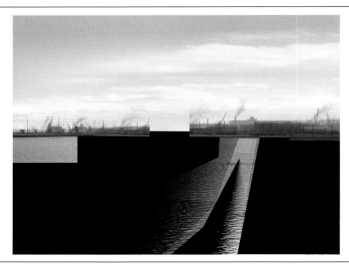

Figure 15.22 An intermediate element that contains computer-generated water and an animated sky. © 1997 by Twentieth Century Fox Film Corporation.

the factories' chimneys. The foreground water in this same plate is a completely synthetic, computer-generated element. It was partially attenuated in certain areas to account for the shadow of the ship, and was also rendered with the appropriate camera move.

The dock on the right side of the frame (as well as all the people standing on it) was originally intended to be photographed as another element with the same camera move. A full-scale dock set had already been created for a number of other scenes in the film, and theoretically a matching camera movement would allow this final element to be easily integrated with the other pieces of the scene. This scenario became problematic, however, when the sweeping camera movement that the director was looking for proved impossible to capture with the equipment that was available. Instead, the decision was made to replace the dock with a digitally created reconstruction.

The primary architecture of the dock consists of several CG buildings, all created in the computer to match the live-action set that is seen in the surrounding shots in this sequence. Rather than render the entire dock as a single image, a number of smaller elements were rendered separately in order to give more flexibility to the compositing artist. These elements ranged from buildings and gangways to crates and luggage. This strategy allowed the compositor to control the matting, atmosphere, and animation of these individual elements more explicitly. A few synthetic seagulls can also be seen circling the area. Figure 15.23 shows the result after combining many of these individual elements into a precomped intermediate element.

Since the dock was primarily a CG model, a basic Z-depth image was easily generated, providing a tool to aid with certain depth cues. This image is shown in Figure 15.24. It was used to reduce the contrast of the objects in the distance, adding atmosphere and an appropriate sense of distance to objects farther from the camera. A similar depth pass was generated for the Titanic itself, although in this case it was hand-painted.

Figure 15.23 A computer-generated dock element. © 1997 by Twentieth Century Fox Film Corporation.

Figure 15.24 An element used to control the atmosphere on the dock. © 1997 by Twentieth Century Fox Film Corporation.

Notice how even the darkest objects on the ship become a more neutral gray as they recede in the distance.

The characters populating the dock are a combination of live and computer-generated actors. Most of the actors that are closer to camera, and thus larger in the frame, are real. They were shot on a stage, standing on a greenscreen surface. Although the camera is moving throughout the shot, the actors were filmed with a

locked-down camera and then tracked into the plate. Since they are fairly far away, the shift in perspective is essentially unnoticeable. Rather than shoot a single plate with a huge number of extras, a smaller cast was chosen and photographed in a variety of different configurations that were designed to fit with the location on the dock where they would be placed. Approximately fifteen different clumps of foreground actors were used in this scene. Since these individual groups would all be fairly small relative to the full frame, the film footage was transferred directly to video using a telecine. This step saved both time and money, yet preserved more than enough resolution for this particular situation.

Figure 15.25 An element featuring people that were on the ship. © 1997 by Twentieth Century Fox Film Corporation.

Figure 15.26 An element featuring a group of people on the dock. © 1997 by Twentieth Century Fox Film Corporation.

The shadows for all these elements were handled and manipulated separately from the characters themselves. The shadows were first extracted from the greenscreen plates with a combination of automated and manual techniques. This gave the compositor the ability to color correct and process the shadows in a different fashion from the actual actors. It also allowed all the shadows to be combined into a single shadow pass that could be used to darken the dock in the appropriate places all at once. This eliminated any overlap problems that would have come about if the shadows had been applied individually.

An image of the compositing tree (from the "Nuke" compositing system) that was used to create this shot is shown in Figure 15.27.

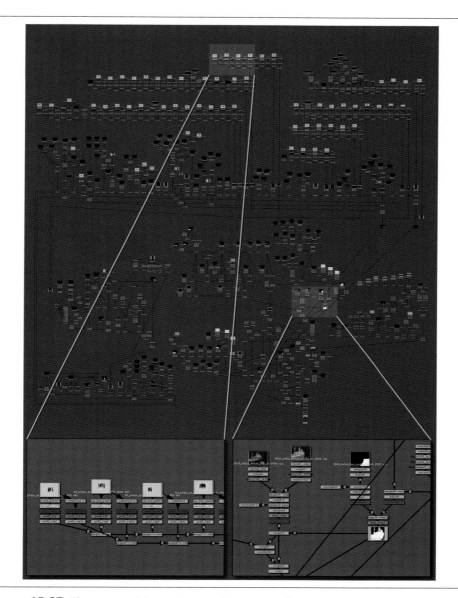

Figure 15.27 The compositing script used to create the image shown in Figure 15.20. Sections are magnified to show detail. © 1997 by Twentieth Century Fox Film Corporation.

A Gentlemen's Duel

Blur Studio is an animation and visual effects studio located in Venice, CA. Their 8-minute, HD-resolution short film A Gentlemen's Duel *can be found in its entirety on the DVD located in the back of this book. Sebastien Chort, who served as the CG supervisor for*

this piece, discusses the process of putting it all together. (The short film is included in its entirety on the DVD bundled with this book.)

Every year Blur organizes a contest for its employees where everyone is encouraged to submit proposals for a short film. The scenario which receives the highest number of votes by the management team is then put into production.

These short films allow the animation team to put together a fun project without the typical constraints of a demanding client, giving us a sense of creative freedom and the ability to try new looks, techniques, and pipelines that will eventually find their way into future (paying) projects.

A Gentlemen's Duel was one of these short films. It was a particularly challenging project compared to many of the other shorts that we have done—it required a large number of visual effects, it had many characters speaking, it included a character with fur, and it featured many different lighting setups.

The 3D production was done with a hybrid pipeline that used both 3DSMax and XSI, "glued" together with a number of in-house tools. The compositing was done primarily with Eyeon's Digital Fusion.

Every shot was generated with multiple passes coming out of the renderer, which were then composited together to produce the final image.

The simplest shots (those in the introduction) would typically only have about a dozen layers but as we got into the more technically challenging shots (such as the one we'll be looking at here) we would often find ourselves with more than 50 different passes to deal with.

Although the film had quite a large number of shots, things did break down into specific scenes, each with its own characteristics. Roughly we had the introduction, the fight (from an exterior perspective), an interior "cockpit" view during the fight, and the final sequence. To take advantage of this we developed a set of tools that would help to pipeline the process as much as possible (although the most complex shots were, unfortunately, also the ones that required the most custom work).

Our primary tool for automating parts of the shot production was something we called "Shot Change." The tool would essentially allow us to define a certain script as a "master" and then generate modified children of that script based on a set of inputs and parameters. We would specify the path that the elements for this new script would come from and they would be automatically integrated into the shot based on our consistent naming scheme. Additional data files were also generated by the renderer that could be used—frame ranges, for instance. Output paths would also be set accordingly and the tool was even capable of adjusting the shot length of the composite itself when the original 3D camera changed its output range.

The gain in efficiency that this tool gave us cannot be understated. With the large shot-count (135) and the large number of layers per shot (over 50 in some cases), even the time it could take to set up a new script by hand could be quite significant. The Shot Change tool automated much of this work, saving time and also reducing the chance for human error when dealing with dozens of similarly named files.

We also put together a tool that could be used to procedurally substitute in a set of higher bit-depth source images when we started to see banding in certain shots. Our default process was to render to 8-bit Targa files but wherever it became necessary we would render to a higher bit-depth OpenEXR file.

With all this in mind, let's take a look at a specific shot. It's one of the more complex shots from the short and we'll go through the process of how it was "built up" from back-to-front.

In terms of our workflow, we broke it down into four basic groups:

The far background

The "alley" of trees

The robots

A final FX pass.

The background was constructed from two elements—a sky painting and a horizon element that showed distant countryside and mountains. These two elements were combined to produce the basic background as shown in Figure 15.28.

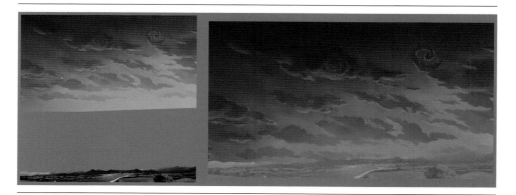

Figure 15.28 The Primary background precomposite, composed of a sky element and a ground element. Images from *A Gentleman's Duel* courtesy Blur Studio. © 2007 by Blur Studio. All rights reserved.

The alley of trees was then added, which included the foreground trees as well as a clump of more distant ones. At this point we are only introducing the ambient pass of these trees, which results in the image shown in Figure 15.29.

Figure 15.29 Adding two tree layers to the background. © 2007 by Blur Studio.

Next came the key-light pass for the trees, shown in Figure 15.30.

Figure 15.30 Adding a key light to the trees. © 2007 by Blur Studio.

Grass was added separately so that it could get a different color treatment as needed and then a big atmospheric fog was brought into the scene. The fog was done both via a Z-depth pass for overall color correction and with a specific ground-fog element that showed up in the distance. With all of these elements put together we now have a basic precomp for the background, as shown in Figure 15.31.

But before we go any further we need to color correct this element to get it to the final "look" we want for the scene. In this case there was a desire to boost the illumination in the sky and have it glow a bit, as shown in the image on the left side of Figure 15.32. At this stage we also added some blowing leaves into the scene.

At the same time we needed to modify things to achieve the golden sunset color that was consistent with the rest of the sequence. This overall color correction produces the image shown on the right in Figure 15.32.

Figure 15.31 Fog added to the scene, using a Z-depth pass and an explicit fog element. © 2007 by Blur Studio.

Figure 15.32 Color correcting the background. © 2007 by Blur Studio.

The robot passes are a little more complex, designed to give us a great deal of additional control over the lighting on the characters.

First we have an ambient pass for the two robots. Although they were rendered together into a single frame, we had a separate mask for each robot that we could use to color correct them individually whenever necessary. (Which was quite often—the fact that one robot is so much darker than the other meant that similar color corrections didn't always produce the desired result if applied equally to each character.) The basic ambient pass for the robots is shown on the left of Figure 15.33 and, on the right, after they have been color corrected and integrated into the scene.

Next comes a key-light pass (Figure 15.34), then a reflection pass and a rim-light pass (Figure 15.35).

The reflection pass was actually masked out by an ambient occlusion pass, which was also used to selectively dim the soft-shadowed areas of both robots. We also wanted

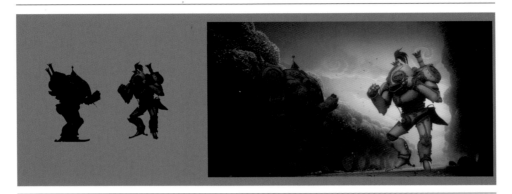

Figure 15.33 The ambient pass for the robots placed into the scene. © 2007 by Blur Studio.

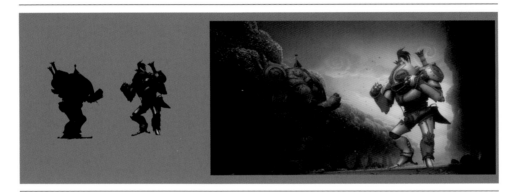

Figure 15.34 Addition of a key light for the robots. © 2007 by Blur Studio.

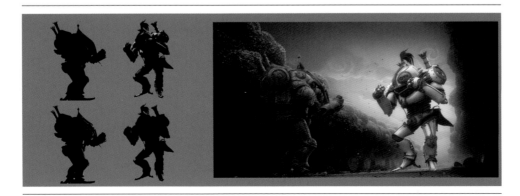

Figure 15.35 Addition of a Reflection pass and some rim lighting. © 2007 by Blur Studio.

to increase the specularity of just the foreground robot so we had a separate pass for that. Both of these are shown in Figure 15.36.

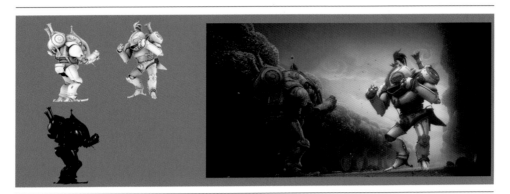

Figure 15.36 An ambient occlusion pass and some additional specular lighting on the foreground robot. © 2007 by Blur Studio.

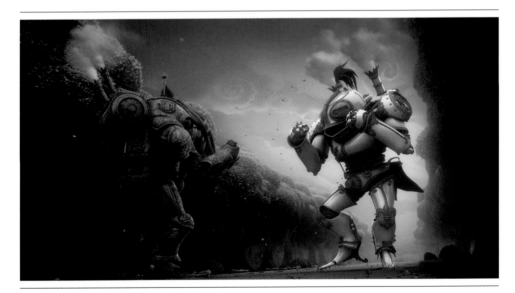

Figure 15.37 The final composite. © 2007 by Blur Studio.

The rest of the comp is made up of a few more FX layers (smoke from the boilers, some ground dust and particles, and a few additional foreground leaves). Final color correction was done selectively (using additional rendered masks). In an ideal world it would have been nice to go back into the 3D file and change the colors per layer in order to avoid some of the strong color grading we needed, but the schedule didn't really allow us the time to do everything so neatly. And fortunately nobody really sees the intermediate steps—what really counts is the final result, which is shown in Figure 15.37.

Battlestar Galactica

Zoic Studios has offices in Los Angeles, CA and Vancouver, BC. Kristen Branan, head of production for Zoic, discusses their work on a shot from the television series Battlestar Galactica.

Battlestar Galactica is an episodic television show that relies heavily on visual effects compositing to establish its general setting as well as to make specific story points. Fortunately certain types of effects recur on a fairly regular basis and so we were able to put in a production workflow into effect that is reasonably consistent for every episode.

The first step of the pipeline occurs as soon as we receive plates from production, where they are first evaluated for paint and rotoscoping issues. This is where we determine whether plates have excess information that needs to be removed before the final composite. This often includes tracking markers (some of which are visible as the triangles attached to the bluescreen on the far wall in Figure 15.38), green or bluescreen spill, wires, rigs, and matting. The roto artist paints out any unnecessary information using a combination of animated masks, 2D tracking, and simple paint strokes. Upon completion the plate is processed or rendered out as the "clean plate."

Figure 15.38 Bluescreen element. Images of *BattleStar Galactica* courtesy of Universal Studios Licensing L.L.L.P.

The next step requires the artist to create a matte for any green or bluescreen. Creating mattes is typically the most time consuming aspect of the 2D pipeline because it requires detailed edges, which need to blend-in with the background during the final composite. The best way to approach pulling mattes is to think in terms of black and white, since that's all the matte is going to be.

Usually a matte is pulled that focuses on edge quality over density, meaning that the matte may not be solid white throughout, but the edges of the matte are nice and

clean. This is the Soft Matte. The alternative is a Hard Matte, which is solid white internally but usually has "bad" or dirty edges.

The Hard Matte is then shrunk or eroded to reduce its size slightly and then it is added to the soft matte to fill in any internal density problems. Now that we have a reasonably solid matte with good edges, cleanup and roto of that matte as a whole is then done to get rid of any leftover artifacts—small holes that may still be present due to excessive grain in the original plate or other issues. This requires the artist to evaluate frame-by-frame, painting as needed to fine-tune the matte. The final matte for this shot is shown in Figure 15.39.

Figure 15.39 Extracted Bluescreen Matte. Courtesy of Universal Studios Licensing L.L.L.P.

The shot we're looking at is a set extension. For this shot in particular, the bottom side of the matte (where the floor of the real plate is to combine with the floor of the CG plate) may need to have additional feathering added to it so the two can blend seamlessly. This only applies to the ground plane as the walls in this shot do not connect with a CG wall.

While all of this work is being done by a compositing artist, a 3D tracker begins to determine the camera motion of the plate. Using the original pre-processed plate that includes all the tracking marker information, the artist is able to 3D track the scene and pull out the necessary information required to duplicate the camera motion in a 3D environment. This can then be used to place objects and set extension in the scene correctly, matching the camera's movements. A solid 3D track can make all the difference when compositing the final elements.

Once a good track is established, the 3D artist takes the camera information in the 3D scene and begins to place in any new 3D geometry and light the CG scene to match the original plate. Once this is done, they will render out several different passes of each object for the compositor to use. Each pass is a simple aspect of what makes up the object as far as color is concerned. Passes could include base RGB color (being the color of the object without any type of shading), shadows (whatever shadows the object casts on itself or on the ground), main key-light pass (the main highlight side of

the scene), and a fill pass (color with self-shading used only to fill in the shadow areas with ambient tones).

Since each of the passes were rendered by a camera whose characteristics were determined by the 3D tracking process, they should, in theory, line up exactly with each other and with the movement of the background plate. This will give the CG the appropriate parallax when the camera moves which will in turn help sell the fact that we're looking at a long hallway full of ships and tools. The compositor takes all of these rendered passes and combines them with the matte and the clean plate we created earlier and begins to put the scene together.

For this scene in particular, the main thing to match was the amount of ambient lighting there is in the foreground and the characteristics of the ground shadows. Most of the time, the main lighting effect or ambience comes from the CG artists, which lets the compositor concentrate on color correction and levels of blacks in the back plate. But since each element within the background CG has multiple layer passes related to lighting, it's ultimately the compositors job to manipulate each pass independently to finalize the desired look. Figure 15.40 shows the final background render.

Figure 15.40 CG background. Courtesy of Universal Studios Licensing L.L.L.P.

Once the desired look is reached as far as color and lighting is concerned for the CG, the compositor then concentrates on integrating the matte and making sure the edges are clean. They must blend with the background and the colors of the floor in the foreground live plate. This is why we spend so much time at the outset making sure that we have a good matte for the shot.

Once all the elements have been color corrected and all black levels match correctly, the depth of the hall is taken into consideration. The 3D artist, along with all their other passes, has exported a depth pass (Figure 15.41), which is just a simple black to white matte that travels from foreground to background (black to white) and encompasses all objects created in 3D.

Figure 15.41 CG background Z-depth. Courtesy of Universal Studios Licensing L.L.L.P.

This image allows the compositor to manipulate the depth of field and focus on the background objects, eliminating the need for additional roto and tracking. The nice part about having a depth pass is that one can color correct it directly to get the desired depth effect by experimenting with the overall levels of that depth image. This depth pass will also allow the compositor to add any smoke, distance-cued atmosphere, distant shadows (or even to simply turn the lights off at the end of the tunnel!). This final depth-related step will promote the fact that it is truly a very long hall filled with ships and other materials and not just a CG mockup. The final composite is shown in Figure 15.42.

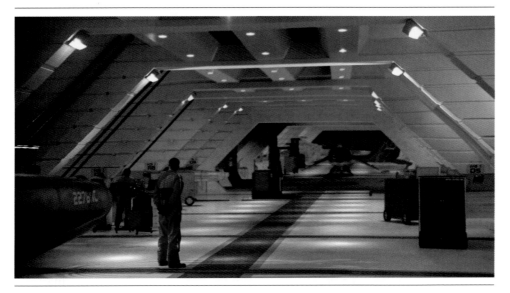

Figure 15.42 Final composite for a scene from *Battlestar Galactica*. Courtesy of Universal Studios Licensing L.L.L.P.

Carlton Draught "Big Ad"

Animal Logic is a visual effects and animation facility based in Sydney, Australia. Angus Wilson, senior compositor for the spot, talks about their work on the award-winning Carlton Draught "Big Ad" spot. (The full commercial is available on the DVD included with this book).

The "Big Ad" is an epic commercial incorporating huge crowds and grand landscapes captured in sweeping aerial shots. However, all these effects had to be achieved with only three days shoot time and approximately three hundred extras. (And most of them had left by the last day of shooting—only about 50 remained.)

The challenge was therefore to create the impression of a large choreographed crowd moving across the landscape, but without the benefit of such a crowd on-set. Normal crowd replication techniques, we felt, were not suitable for this project given the inaccessibility of the aerial shot locations and the need for such tight choreography and time limitations. We therefore decided to use "Massive," a CG crowd simulation software, to recreate the grand effects required.

The route chosen in the early stages of postproduction planning was to use Massive exclusively for the nine wide shots, to use standard crowd replication for one or two additional shots, and greenscreen for the final close-up crowd/pack shot. The sky and background (mountain) replacement was also going to be a large part of the compositing process.

As often happens with external location shoots, the weather varied over the three days. It was decided, in post, that we would keep some cloud detail but retain a bright sunshine feel throughout. After the initial telecine session, the compositors conformed the commercial in the Flame compositing system.

One of our next jobs was to enhance the look of each shot. Clouds and mountains were hand-drawn into the scene for early approval. The sunshine and brightness was sustained using a mixture of keys and animated garbage masks to lighten scenes in certain areas. Since much of the action took place against clouds, we kept some of the detail around the actor's heads to avoid the rather obvious composite of hair over a pure blue sky background.

When we achieved a consistent grade and the rough background layouts, we supplied the 3D department with clean background plates to begin the process of designing, tracking, and animating the crowd. Graded live-action shots were also supplied to them as lighting references.

Once work was under way in 3D, we then turned our attention to the mountain backgrounds. A considerable amount of time was spent compositing matte paintings (created in Photoshop) of mountains and sparsely clouded skies. In moving shots, Flame's 3D tracking software was used to create a realistic perspective, or parallax, on the 2D mountains and clouds. The compositors pulled keys from the skies and combined them with the hand-animated garbage masks to restore the original foreground hills back over the top.

As the compositors started piecing together the 3D Massive elements, it became apparent that the repetition of color across the aerial shots of the crowd was a problem. To overcome this, 3D supplied some random RGB passes of hair, clothes, and faces. This gave us the ability to easily grade selected individuals differently, and in doing so break up the uniformity of the group. We used another selective grading technique to make the logo on the aerial beer glass more legible by flattening the grade through a solid "Carlton Draught" mask, which had also been supplied by 3D. The element is shown in Figure 15.43.

Figure 15.43 A 3D crowd simulation. The permission of Foster's Group Limited to reproduce material from The Carlton Draught "Big Ad" is gratefully acknowledged.

One of the most challenging shots we encountered was the low-angle helicopter shot, flying towards the crowd (as illustrated in Figure 15.44). The entire shot was constructed in post. Firstly, a high-resolution scan of the ground was projected onto a basic 3D geometry in Maya. Additional background hills, mountains, and sky were created in Photoshop using a combination of graded film and digital stills taken on location. These were then composited in Flame using a matching 3D (Maya) move. Exporting a camera move directly from Maya to Flame proved problematic so we instead rendered a grid and tracked that.

Figure 15.44 A scene created entirely in post. © Foster's Group Limited

All of the extras in this scene were animated in Massive. As a final touch, dust elements were added over the top so that the 3D sat more comfortably into the environment.

As previously mentioned, only two traditional crowd replication shots were used in the commercial. One of these (as illustrated in Figure 15.45) was a wide tracking shot of a single line of actors running towards camera. There were many gaps behind them that had to be filled in order to create the effect of a much larger gathering. To achieve this, we pulled a 3D key from their red cloaks and patched the faces and hair in the same key. This technique was also used in another static camera shot of the red army. Using 2D tracking, we built up layers of men over the original shot until the gaps were filled and then keyed the original lineup back over the top so they remained in the foreground.

Figure 15.45 A crowd generated by replicating elements. © Foster's Group Limited

The final shot (as illustrated in Figure 15.46), once again required us to recreate the illusion of a large group when, in reality, there were only fifty or so extras at our disposal. We chose to use greenscreen here (Figure 15.47) since it was a close-up shot and the Massive models, by design, were not detailed enough to stand up to close scrutiny. There was also a big camera move and no motion control rig available on this occasion.

Figure 15.46 A final frame. © Foster's Group Limited

Although the scene was to feature the camera moving forward through the crowd as they raise their glasses, it was actually shot as a dolly *back*, with the actors *lowering* their glasses. Which was, of course, reversed in the final edit. Shooting it this way made it easier for the camera crew, and also gave the director more control over the framing of the final and all-important pack shot. However, it also meant that the beer bubbles were going down instead of up, leaving us with the job of tracking a new glass of beer over the old one.

Figure 15.47 The greenscreen element. © Foster's Group Limited

This shot was also previsualized in Maya, prior to the shoot, to establish the best spot to put the tracking markers and give the director the optimum greenscreen size. The tracking markers were placed on taut wires over the heads of the actors on the greenscreen background to minimize the fuss of their removal later on. It also provided us with accurate 3D tracking information for Boujou, the 3D tracking program used.

It was at this point that the VFX supervisor decided that the best formation would be in the shape of a triangle, with the point furthest from the camera. This meant we had the maximum benefit of the parallax captured in camera, using very few actors. The rest of the crowd was shot statically in pairs against greenscreen (changing their costumes between takes) and raising their glasses in "cheers." We tracked the shot in Boujou so the information would be compatible with both Flame and Maya. We then cropped the pairs into singles, created mattes for them and added body-shaped shadows. They were exported to 3D as RGB TIFFs, marginally over length, so that they could be moved, randomly distributed, and their timing slightly offset. They were then returned to 2D with combined matte and shadow passes. The layered precomp for these background actors is shown in Figure 15.48.

All these elements were finally composited together in Flame along with the Photoshop background. The original track was exported from Boujou to replicate the move on the mountains resulting in a flawless end shot—a fitting finale to this magnificent commercial.

Figure 15.48 Actors mapped onto cards and positioned in 3D space. © Foster's Group Limited

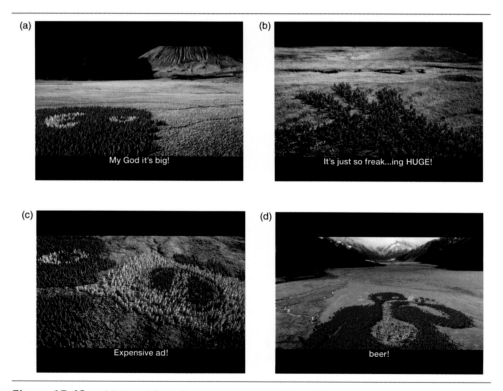

Figure 15.49 Additional final frames. © Foster's Group Limited

Chronicles of Narnia: The Lion, the Witch, and the Wardrobe

Rhythm and Hues is an effects, animation, and design studio based in Los Angeles, CA. Perry Kass, who was one of the compositing leads on The Lion, the Witch, and the Wardrobe *for R&H, takes us through the construction of a shot from the film.*

In a film that featured everything from centaurs to talking beavers, Rhythm & Hues was given the task of bringing the key character of Aslan to life. The shot shown in Figure 15.50 is the first time the viewer sees Aslan, who is created throughout the film as a completely computer-generated character. Aslan emerges from the shadows of an ornate tent, pushing the fabric aside as he walks into the sunlight to face full-frame into the camera. This shot is a grand entrance for a grand character and an excellent example of the quality and detail that went into Aslan's creation.

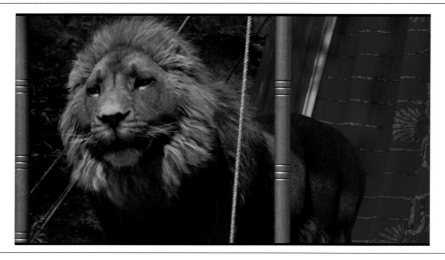

Figure 15.50 Final composite for a scene from *The Chronicles of Narnia: The Lion, The Witch and The Wardrobe*. Images of *Chronicles of Narnia: The Lion, The Witch, and The Wardrobe* courtesy of Disney Enterprises, Inc and Walden Media, LLC. © 2005 Disney Enterprises, Inc. and Walden Media, LLC.

The original plate (shown in Figure 15.51) shows that the tent itself was shot without curtains, as we knew ahead of time that it would be necessary to create the curtains in CG so that they would properly interact with Aslan. But the bottom of the curtains would also need to interact with the (live-action) grass on the ground and so this was one of the first things we had to deal with. Initial attempts to create this effect were done through the use of carefully keying bits of grass and creating rotosplined mattes that were pulled away as the curtain moved through the grass. After many attempts it was decided that this method was never going to be able to provide enough believable

interplay between the grass and curtains and thus we ended up augmenting it all with the addition of CG grass. This element would be properly displaced by the movement of the CG curtains passing over it and by the movement of Aslan's feet through it.

Figure 15.51 Original background element. © 2005 Disney Enterprises, Inc. and Walden Media, LLC.

Early in this shot, as Aslan is coming through the parted curtains, the interior of the tent is visible behind him. But because the tent in the live-action plate was shot without a curtain, the inside of the tent is illuminated with far more sunlight than it should have been receiving had there been a curtain (and a large lion) blocking the light.

Usually a selective darkening of the tent's interior could be done in the composite using tracked garbage mattes and color manipulation but because of the number of reflective surfaces inside the tent that were giving off bright highlights we chose instead to replace the interior with a matte painting. Highlights are always tricky and we've found that it's better to paint out the highlights than use compositing tricks on them whenever possible. A single de-grained frame of the original plate was sent to a matte painter who created an image that was more accurate to what the inside of the tent would have looked like with a minimum of light penetration. This painted frame was placed back into the plate and then tracked to match the camera motion of the plate.

As Aslan continues to walk, he passes behind a golden tent-pole and this presented another interesting challenge. The pole is naturally picking up colored reflections and lights from the other objects in the plate and these are particularly problematic along the edges because Aslan's presence in the scene should be visible in these areas. Simply using a rotospline to hold out Aslan would show an undesirable bleed of existing reflections and light wrap without showing any of Aslan's interaction and of course if the rotospline for the pole was adjusted to remove the reflections and light wrap, the pole would look "pinched in" whenever Aslan walked behind it. To achieve the final look in this shot, a key was made of everything that wasn't pole-colored

within the pole's rotospline matte. These pixels were desaturated and decontrasted to remove the variation in background influence, and then those same pixels were tinted towards Aslan's color to give the effect that Aslan was being reflected in the edges of the pole.

The general color and lighting on Aslan was fairly straightforward from the compositing perspective. We had a couple of different things we could use for lighting reference—a stand-in "stuffy" of the lion (Figure 15.52) and a mirrored ball (Figure 15.53) that gave us a general idea of the surrounding environment. Of course these elements were used by the 3D artists for their initial color and lighting but it's always useful to have this sort of thing available when compositing as well, even if it only provides a rough guide (as in this case) for general shadow and lighting direction. Looking at the Aslan stuffy plate, one can see the shadowing between the curtain and the stuffy as well as the red reflective glow on the stuffy from the curtain. The effect was mostly recreated in lighting (albeit more subtly because Styrofoam picks up more glow than fur would) but we were able to modify it slightly in later compositing steps. CG also gave us several different lighting passes that we could mix together as needed. Some of these are shown in Figures 15.54–15.57.

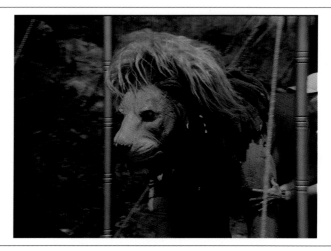

Figure 15.52 Stand-in object for lighting reference. © 2005 Disney Enterprises, Inc. and Walden Media, LLC.

As with most CG character integration into a live-action plate, a large portion of the time spent on this shot was dialing in and adjusting shadows. Mattes were created in lighting to represent the shadows that an object would cast on all other objects in the scene (e.g., one for the shadow of Aslan onto the curtain and another for the curtain onto Aslan). The mattes were a great start, but each one needed to be applied in a way that looked correct. This often meant multiple blur, position, and color adjustments for each of the mattes. Many of them also needed to have areas added or removed with rotosplines.

Figure 15.53 Mirrorball in background scene for lighting/environment reference. © 2005 Disney Enterprises, Inc. and Walden Media, LLC.

Figure 15.54 Lighting pass for the CG Character. © 2005 Disney Enterprises, Inc. and Walden Media, LLC.

Figure 15.55 Lighting pass for the CG Character. © 2005 Disney Enterprises, Inc. and Walden Media, LLC.

Figure 15.56 Lighting pass for the CG Character. © 2005 Disney Enterprises, Inc. and Walden Media, LLC.

Figure 15.57 Lighting pass for the CG Character. © 2005 Disney Enterprises, Inc. and Walden Media, LLC.

A couple of shadows were created completely in 2D by manipulating and offsetting a rotospline of a live-action object or the matte of a CG object. These types of shadows are always difficult because they usually look like what they are—a 2D offset shadow. For this shot, we tried to minimize that feeling by either skewing the matte slightly so that it was thinner at one end and fatter at the other, or by using a procedural texture to add some noise to the edge of the shadow (basically adding a random texture to the matte controller of a dilate node so that it would grow an inconsistent edge). As with the inside of the tent, shadows and specular highlights are incompatible, so we were careful to remove any specular hits where the shadow would be applied before working on the color of the shadow. Luckily, all the CG items in the shot were rendered with the specularity in a separate layer—so this was easy enough to do.

Other than the shadowing issues described above, the main work on Aslan occurred in two other areas. Both were mechanically easy but very sensitive to adjustments. The first was softening parts of Aslan so that he doesn't stand out against the live-action

plate. An overall diffusion (a slight blur cross dissolved with the original) was applied to the element and then specific areas were given extra blur to soften the fur a little more. An edge blur was applied after Aslan was put into the plate to set him into the plate better. And, of course, matching the grain in the plate helps any CG character feel like part of the shot. The second area of Aslan where we paid special attention was in the eyes. Since much of the life and personality in a character is read in the eyes, we were given a lot of direction in this area. Overall eye brightness, iris color, and eye reflection characteristics (opacity and blur) were the main areas that were adjusted and animated throughout the life of this shot.

Golden Compass

Digital Domain, located in Venice, CA, does everything from visual effects to commercials to animation and videogame development. Joe Farrell, the compositing supervisor on Golden Compass for Digital Domain, talks about the work they did for the show.

Figure 15.58 Final composite for a scene from *The Golden Compass*. Stills from *The Golden Compass* courtesy of New Line Productions, Inc. Photo by Digital Domain. © MMVII New Line Productions, Inc. All rights reserved.

As the postproduction work on *The Golden Compass* neared completion, we were approached by the film's production company to "spice up" the very object that the film was centered around – *the Golden Compass*. Several shots featuring this object (also known as an alethiometer) needed to be extended in order to help convey some specific

story points and generally the compass needed to be enhanced throughout the film in order to give it a greater sense of magical presence.

For this particular shot, the camera needed to fly up to and then *through* the alethiometer's complex face, passing a series of the underlying internal cogs and wheels, and then taking us into the mystical realm of truth-visions that the device allows. The compass itself needed to be replaced with a CG object whose internal parts could perform complex mechanical movements that the real-world prop wasn't capable of. Various symbols on the face of the compass would need to be illuminated at appropriate times and a series of bezels would light up and start a complex dance of rotations in sync with the alethiometer's hands. Some of the CG replacement elements are shown in Figure 15.59 but there were many others.

Figure 15.59 An intermediate element. © MMVII New Line Productions, Inc.

The shot's original camera move was an optical zoom done on-set, featuring the real-life compass prop. This real-world camera of course couldn't actually fly *into* the device and thus the shot ended much sooner the VFX supervisor wanted. We would need to extend the shot (making sure that the camera move felt smoothly continuous) and add the additional necessary elements.

The first step of this was to meticulously reconstruct the original camera move in 3D (using our in-house tracking software named, unimaginatively, "Track"). This zooming camera information was imported into the Nuke 3D environment along with a 3D model of the compass. The plan, then, was to re-project the original footage back onto stand-in geometry and then create a new camera move that was more appropriate for the longer shot we needed to deliver. As the new camera movement would effectively be adding an additional zoom-in on the plate, we made sure that everything was scanned at 4K resolution.

To generate clean (grain-free) plates to re-project, we rendered through a duplicate camera frozen at key frames. Since we had the original camera move we could easily use that information to *remove* that movement, and we could then compound groups of 10–15 of these frames into a single image. The new grain-free frames were retouched in areas that had become exposed due to the new moving camera.

The more complex objects like the lid and the face of the compass were projected onto detailed models imported from the fully reconstructed 3D compass. The human hands and the tabletop were projected onto extended bicubic cards that mimicked where the real hands were in 3D space. We could get away with this much simpler geometry (instead of completely creating realistic hands in 3D) because the new camera movement wasn't going to be significantly off-axis from the original path. The hand bicubics could, however, be slightly animated/deformed over the course of the shot to match the movements of the real hands. Figure 15.60 shows a side-view of this reprojection setup.

Figure 15.60 A 3D reprojection of the original element onto new geometry. © MMVII New Line Productions, Inc.

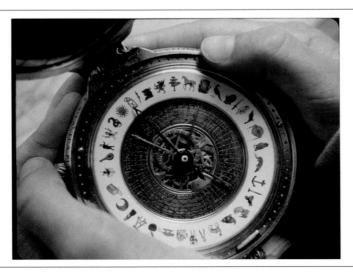

Figure 15.61 The original background plate. © MMVII New Line Productions, Inc.

The original plate for this shot was about 180 frames long, whereas the final shot ended up being over 700. An early frame from the original plate is shown in Figure 15.61, and you can already see that the framing is slightly different between this image and the final frame (Figure 15.58), due to the new camera position.

Once the new camera move was designed inside of Nuke, the camera was exported back to the 3D people who used it to render the internal workings of the compass that they had created. This included some amazing particle simulations (Figure 15.62 shows an example) driven by the movement and luminance of images from the "visions." These additional elements—many, many different layers—were then loaded back into Nuke and selectively blended together to create the final internal world of the alethiometer.

Figure 15.62 An intermediate element. © MMVII New Line Productions, Inc.

In this film there were a total of 9 complex alethiometer "vision" shots such as this one—shots that ranged from the opening prologue which was over 1500 frames long to more colorful and shorter shots of different story-points throughout the film. Digital Domain was also tasked with about 50 other compass enhancement shots which consisted of color corrections, glows, and chromatic lens effects to help enhance the mystical persona of this important artifact.

The Incredibles

Pixar Animation Studios is located in Emeryville, California. Sandy Karpman, the special effects supervisor for the show, talks about the work they did on The Incredibles.

At Pixar we had a history of rendering all of the shots in our animated features in one single pass. If an image required any changes, it would be re-rendered in its entirety. But as the "look" we were trying to achieve became more complex, and as we started

adding significant FX to our story-lines, we decided that it was becoming necessary to layer our renders and combine them using compositing.

The task of layering did not come easy to Pixar. We really prided ourselves on the idea of a "poke render"—a single-pass render that could be easily re-rendered as needed. Change the camera in the last days of the film, no problem. Change the main character's shirt color, fine. These changes would simply require an update to the asset and then all you need to do is "poke" the render button for those shots. No compositing file needs to be updated. No rotoscoping needs to be changed. Just one simple push of a button and any shot at any time by anyone can be rendered. It sounds so clean and easy.

This mentality was particularly interesting since the people who basically *invented* digital compositing are still working here at Pixar. Yet as a facility we tended to view the word "comp" as a four-letter word—and we have historically been a G-rated studio! *The Incredibles* finally broke that mold for us. It was our first PG-rated film and the first time that we used compositing techniques as an integral part of our workflow.

The shot shown in Figure 15.63 is one example of how we started using basic compositing in production. The story called for Jak Jak (the baby) to become "made of fire" while Syndrome (the villain) is attempting to escape with this kidnapped child.

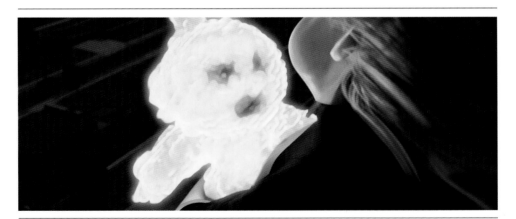

Figure 15.63 Final composite for a scene from *The Incredibles*. Images of *The Incredibles* courtesy of Disney Enterprises, Inc/Pixar. © 2004 Disney Enterprises, Inc./Pixar.

The background, Syndrome, Syndrome's interactive light, and Jak Jak (normal) were very basic renders. These could have been rendered a number of ways but we did them as separate layers that were combined upstream in the comp, serving as the new BG plate where we'd be placing our baby-made-of-fire (Figure 15.64).

We specifically chose to render in layers for those shots that featured some sort of FX—in this case the fire effect. It gave us the ability to more easily introduce or modify subtle blurs or blooms at the compositing stage instead of re-rendering things

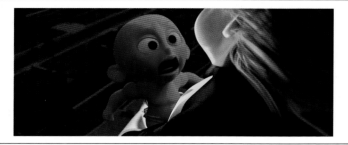

Figure 15.64 Background precomp, before fire FX are added. © 2004 Disney Enterprises, Inc./Pixar.

whenever changes are needed. The shots that have a non-moving camera can have the background set rendered only once, while the animated parts such as props and characters are rendered for each frame. Beyond the use of compositing for FX-based shots, there were also certain shots that were so complex (either in terms of requiring an unacceptable amount of memory or that would just take too long to render) that layering was really the best way to get a successful render.

We had some comping fun with the "baby-made-of–fire." We wanted to see facial features but did not want to write up some fancy or convoluted shader to do all of this at the time of render. The fire element started from a Maya-generated fluid volume simulation, as shown in Figure 15.65.

Figure 15.65 The rendered fire layer. © 2004 Disney Enterprises, Inc./Pixar.

To get the eyes and mouth we then rendered simple matte elements of the eyes, pupils, mouth, and tongue. We used those layers in the comp to combine the original fire element with an inverted fire element, which gave us the look of the mouth and eyes being hollow. We then used the tongue and pupils to darken the hollowed fire element even more. Before we re-applied the flaming eyes, mouth, pupils, and tongue, we ran those matte elements through a simple animated noise image that displaced things slightly. The eye/mouth mask is shown on the left side of Figure 15.66 and the "fire" version is shown on the right.

Figure 15.66 Mattes (left) to control the fire effect on the eyes and mouth and the results of this (right). © 2004 Disney Enterprises, Inc./Pixar.

Since the release of *The Incredibles* we have continued to expand our use of compositing as part of the general production workflow, making much more extensive use of it in subsequent films like *Cars* and *Ratatouille*.

I, Robot

Digital Domain, located in Venice, CA, does everything from visual effects to commercials to animation and videogame development. Lou Pecora, who was one of the lead digital compositors on I, Robot *for Digital Domain, talks about the work they did for the show.*

The general pipeline that we have developed at Digital Domain over the years makes heavy use of the multi-channel capabilities of Nuke (which was developed here at DD as our in-house compositing system). Unlike most other compositing systems, which only support the ability to pass 4 or maybe 5-channel images down an image pipe, Nuke can bundle a huge number of channels together and have them appear to the compositing artist as if they were manipulating a single element. This becomes extremely useful when dealing with multi-pass rendering because it allows us to add a single operation to a node-tree and have it affect dozens or even hundreds of layers.

For the final composite shown in Figure 15.67, our job was to take the background (shown in Figure 15.68) and add many robots into the scene, including the "hero" robot that is large in camera.

Each of these robots was actually rendered as multiple layers and assembled in the composite itself. Some of these layers are shown in Figure 15.69.

The layers in the image represent a combination of the standard lighting passes one would typically use in such a scenario but also several specialized "fix-it" passes that were added in response to specific issues that were showing up once we started getting the robots into various shots. Additionally, we needed independent, separate controls over the mechanical innards and the translucent shell, so each set of renders had individual passes for all of these components.

The top row in Figure 15.69 shows (from left to right) the standard reflection, diffuse, and specular passes for the mechanical innards of the robots.

The fourth item on the first row (labeled "d") is a "red light" matte pass for the innards, which we used to control the way the red light would be added to the image.

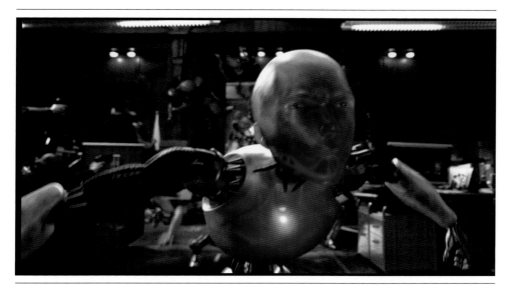

Figure 15.67 Final composite for a scene from *I, Robot*. Stills from *I, Robot* courtesy of Twentieth Century Fox. © 2004 Twentieth Century Fox. All rights reserved.

Figure 15.68 The original background plate. © 2004 Twentieth Century Fox.

We added this because we found that the red light effect required a lot of dialing—there was a delicate balance to get the light looking saturated enough but not letting it get too pink. The red response of film (being different than what we could see on our monitor) didn't help either, so we had the added challenge of trying to closely simulate what a filmout was going to do to this specific shade and intensity of red. This image is really used as three different masks, breaking out the red, green, and

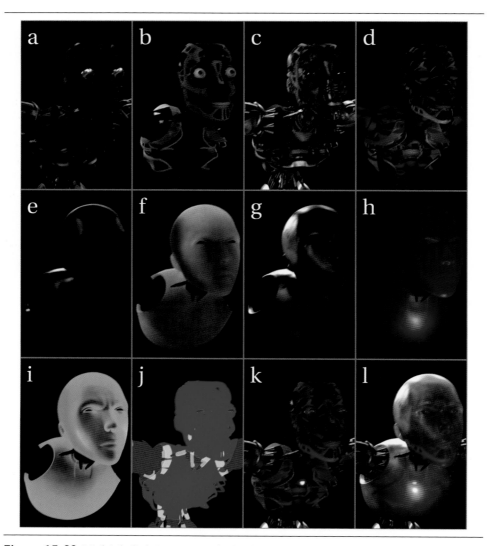

Figure 15.69 Multiple lighting passes for building the foreground robot. © 2004 Twentieth Century Fox.

blue components separately to allow for independent control over the key, fill, and "Boo" lights—the under-the-chin spook light.

Images "e–g" are the conventional reflection, diffuse, and specular passes for the robot's plastic exterior shell. Image "h" is again a red light pass for the shell component of the robot. In this case the red channel of this image was used as a matte for the general effect and the green channel was used for the light's hot core and low-angle "Boo" light that hits the face.

The bottom row starts with an interesting pass. In addition to a fairly standard Fresnel pass in the green channel, we had to add two specialized mattes that were dialed in

on a case-by-case basis. The red channel of this image is a cheek matte that we used to help prevent the "raccoon eye" effect that began showing up on a regular basis. The blue channel was primarily used in cases where the "lamb chop" effect was a problem. That's a fancy term for the robot looking too much like he had mutton-chop sideburns due to excessive shadowing in that area. This mask allowed us to better control the illumination on that area, helping to prevent the robot from looking too much like an extra from "Grease."

Next, in image "j," we have yet another matte pass. As we began getting away from look development robot turntables and into various shots where different angles and actions were being seen it became clear that we needed to be able to control the various pieces of the robot on a case-by-case basis. Parts that seemed to keep showing up in VFX supervisor comments as requiring additional tweaking drove us to create this element. For instance we found that the eyes and shoulders tended to go bright under certain conditions so a matte for these specific bits was rendered into the blue channel of this pass.

Image "k" is the overall "Red Light" pass that was turned on when good robots went bad. It would be mixed with (and controlled by) some of the passes from the first row of this image.

Then the last image is, of course, the final, assembled robot.

We used a custom Nuke "gizmo" (a collection of other nodes wired together in a sort of macro) that was affectionately known as "MakeBot" to break out all of these passes and provide the compositing artist with various controls over them to tweak the robot as necessary. It was effectively a customized re-lighting setup that appeared to the user as a single specialized tool.

Nuke's ability to deal with multiple channels per image stream was absolutely critical to the process. All of the layers came out of the renderer as standard 4-channel images: red, green, blue, and alpha. We then used a Nuke preprocess to take these various layers and combine them into a single OpenEXR file. That file contained all of the layers shown in this image and was fed directly into a MakeBot node that allowed specialized controls over specific aspects of the various passes. For instance, a slider control called "Pink Blocker" was what the artist would use to dial down the pinkness of the red light effect without needing to go in and specifically modify the various passes that were tied to that effect. As another example, we could tie the Fresnel pass to a chroma shift function, again defining a single slider in MakeBot that would actually perform several operations to turn up or down the chromatic shift effect that would happen towards the edges of the robot's translucent shell.

This approach gave artists control over aspects of the lighting that would traditionally be handled in the renderer and allowed for significant changes to be made in the composite rather than having to wait for a re-render from a lighter. It meant that VFX supervisor or director comments could be addressed very quickly which, in turn, gave us time to address *all* of the comments instead of simply running out of time.

A few more general notes about the shot: Once we had placed all of the robots in the scene and started looking at animations, we realized that the shot needed more tilt when the main robot jumps into frame. Unfortunately the set wasn't complete since we had never planned on using that part of the plate. So we painted an extension, put it on a card using Nuke's integrated 3D module, and let the tracked shot-camera do the rest.

There was also quite a bit of cleanup that needed to be done for this shot including removing the wires for the stuntmen and the big C-stand smack dab in the middle of frame where the main robot lands. There is also something that we just couldn't remove, and if you watch the completed shot you'll still see it. When the camera pans around and reveals the policewoman in the brown coat you can see that she is apparently struggling somewhat in her attempts to run towards camera. That's because the rig she was attached to—one that would eventually jerk her backwards in response to one of the robot's actions—was too tight and didn't allow her to move forward very quickly. There was really no way to remove that from the shot so we just got rid of the wires and harness and left her slightly strange movement in the scene, hoping nobody would notice!

King Kong

Weta Digital is a visual effect facility which (along with its sister company, the physical effects-focused Weta Workshop) is located in Wellington, New Zealand. Eric Winquist, who was the digital compositing supervisor for King Kong, *tells us about one of the shots they created.*

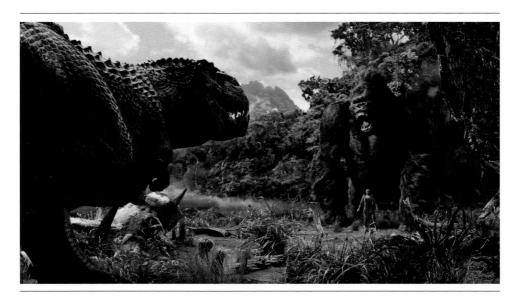

Figure 15.70 Final composite for a scene from *King Kong*. Stills from *King Kong* courtesy of Universal Studios. © 2005 Universal Studios. All rights reserved.

In the classic 1933 version of this beauty and the beast tale, Willis O'Brien did almost all of his groundbreaking compositing in-camera. Typically, the stop-motion ape was

painstakingly animated frame-by-frame on a set made up of multiple layers of miniature scenery, rear-projection plate photography and traditional matte paintings on multiple planes of glass to add depth to the scene.

In Peter Jackson's recent remake of the film, the technology used in creating the dense jungle sequences on Skull Island has advanced, but there are more parallels in the visual effects of the two films than you may think.

Here, we will examine one of the iconic scenes from the film: Kong's battle to save Ann Darrow from the jaws of a very persistent Tyrannosaurus Rex. In Jackson's version, the sequence takes us from a dense glade where Ann first encounters a Rex, through a narrow gully and into a rocky clearing. It is here where our large hero emerges to fend off the Rex, who has been joined by two others in its pursuit of a mid-day snack. The oversized wrestling match rages out of the clearing, over some rocky ledges, into an enormous vine-filled chasm and, finally, drops down into a marshy swamp. It is here where Kong finishes off the last Rex in an homage to O'Brien's classic sequence.

The basic pieces that comprise this shot are fairly similar to the original. The Ann element was photographed on a partial bluescreen set (Figure 15.71). Kong and the Rex are animated, this time with the aid of computer graphics, and rendered as shown in Figures 15.72 and 15.73. The background rain forest and sky is an oversized digital matte painting (Figure 15.74), and while not ultimately used in the final shot, the chasm walls and swamp floor were crafted as miniature elements and photographed with motion-control photography. There are also subtle helper elements to add scale to the scene, such as the small insects that can be seen intermittently flying around near camera and interaction elements such as water splashes and ground getting torn-up as the creatures tumble around in the environment.

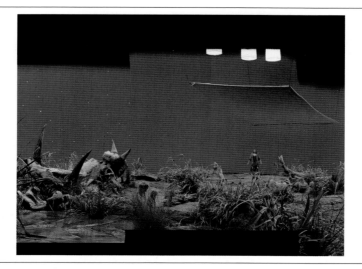

Figure 15.71 Original bluescreen element. © 2005 Universal Studios.

Figure 15.72 CG King Kong element. © 2005 Universal Studios.

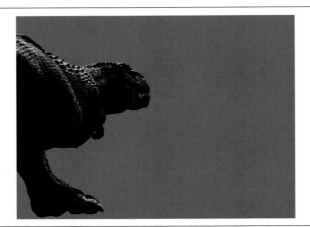

Figure 15.73 CG T-Rex Element. © 2005 Universal Studios.

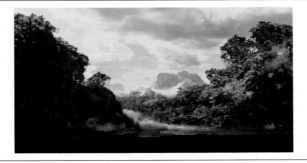

Figure 15.74 Background matte painting. © 2005 Universal Studios.

Biodiversity was something Peter wanted very much for Skull Island. The Greens department did what they could to dress the set with a good variety of living plants, but they were constantly struggling to keep that amount of foliage alive under the hot lights for the weeks that the set would be needed. As a result, some of what should have been lush green swamp plants wound up being yellowed and dying once they made it onto film. This issue, along with the fact that the live-action set ultimately comprised only a small piece of a much larger environment, led to the need to completely replace the set in many shots with a digital swamp floor.

In the case of this particular shot, the set worked out fine, so was used in its entirety as the FG element and was keyed with a combination of off-the-shelf keyers and procedural mattes, aided with articulate roto where needed. Because of the relative size of the actor in some of these plates, we had to scan the negative at 4K to try and squeeze every bit of detail out of the grainy film stock. Also challenging was the need to "relight" parts of the plate photography in post. Because the specifics of the environment hadn't been worked out at the time of shooting (as well as the difficulty of doing specific illumination on such a large set), the lighting in many cases was very flat. When it came time to integrate this plate with the high-contrast lighting situation that was worked out for the CG environment, Ann just didn't look right standing next to Kong. So a normals pass was rendered from matchmoved animation and was used to increase the brightness on her key side and darken down the shadow side to more closely match the lighting of the CG creatures. The stages of this process are shown in Figure 15.75.

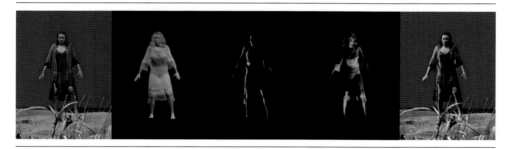

Figure 15.75 An example of using a CG stand-in to generate mattes for relighting a live-action element. © 2005 Universal Studios.

For Kong and the T-Rex, the 3D department delivered renders to compositors in OpenEXR format, newly adopted for this film at Weta. A camera Z-depth channel was included in these renders. The choice to move to this format was primarily based on its unlimited channel support and the disk space savings its compression offered while still containing the high dynamic range that a float linear format provides. The depth channel was frequently used for adding haze to the creatures for depth cueing, and often helper mattes were provided for dialing in the amount of organic debris in Kong's fur and the amount of reflection in his eyes.

The mid-ground wall elements were originally intended to come from a photographed miniature. This had been blocked out at the previs stage and was used as reference for the miniatures units. After seeing shots progressing into lighting, however, Peter decided that staging the battle largely against dark rock walls wasn't as visually dramatic as it could be and re-blocked the scene to be staged more against the bright vistas at either end of the chasm. Unfortunately, there was no time in the schedule to re-shoot the miniature plates, so digital versions of the swamp environment had to be created. This digital build consisted of the sandy ground terrain, a wide variety of ground-cover including foliage, dead logs, skeletons of other dinosaurs long since past and the two rocky chasm walls, both covered in lush vines, ferns, and other types of greenery. These were broken into logical passes for layering and then rendered as OpenEXR files, again with embedded depth channels to aid compositors in adding atmospheric haze. The basic midground element is shown in Figure 15.76.

Figure 15.76 Midground CG element. © 2005 Universal Studios.

When it came to the distant background, Peter wanted us to think of this environment as hourglass shaped. The battle takes place in the middle where two rock walls come together, but the arena opens up beyond that to mountainous, rain forest-draped vistas. Separate digital matte paintings were created for each end of the hourglass, broken into layers for sky, terrain, and atmosphere. These paintings were warped with procedural noise images through painted mattes to add subtle canopy sway and finer scale leaf flutter to the environment before being projected onto 3D geometry to allow for parallax and proper distortion of the image with the wild camera moves used throughout the sequence. Figure 15.77 shows an example of this projection.

Finally, each of the elements were brought into the composite and integrated with a library of high-speed bluescreen interaction elements to sell the contact with water,

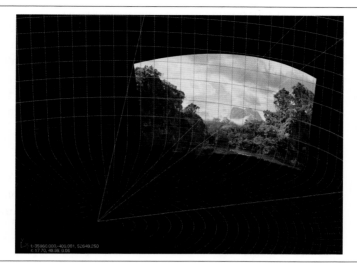

Figure 15.77 Matte painting projected onto a 3D surface. © 2005 Universal Studios.

ground foliage, and earth. These were mapped on 3D cards with a proprietary plugin so they would track properly with the camera move. Also added were a host of tiny insects (Figure 15.78) rendered with crowd simulation software to add even further scale and biodiversity to the scene.

Figure 15.78 A layer of flying bugs, including detailed close-up. © 2005 Universal Studios.

The end result of this work hopefully takes the viewer into a lush imagined world that still feels very real and pays tribute to one of the landmarks of early cinema, while at the same time updating the visuals for modern audiences.

A snapshot of the compositing script used to create this shot is shown in Figure 15.79.

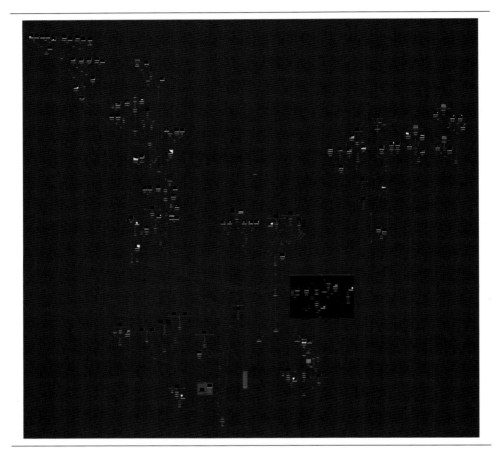

Figure 15.79 The compositing script used to generate Figure 15.70.

Lost

Kaia Inc is a boutique visual effects facility in Santa Fe, New Mexico. Spencer Levy discusses the work that was done on this shot from the pilot episode of the television series Lost.

In this episode that establishes the basic premise of the series, a commercial jet crashes on a remote desert island. On the beach we see the aftermath of the crash and the uninjured survivors are helping others. One of the jet engines remains attached to an overturned wing and the engine is still running. And suddenly one of survivors, getting too close to the intake, is sucked into the rapidly revolving blades. The succeeding shots show the explosive result.

There was a tremendous amount of work that went into the live set, including the massive effort of disassembling a Lockheed L-1011 and shipping it to Hawaii where

the series is being shot. But there were still a number of things that couldn't be done practically, and that's where visual effects needed to step in.

For the shot shown in Figure 15.80 (where we actually see the person as he is sucked into the jet engine) we needed to create an actively spinning engine turbine in CG and then integrate this with the existing action that was captured on-set. We needed to simulate the effect of tremendous suction from the engine pulling the man into it.

Figure 15.80 Final composite for a scene from *Lost*. Images from *Lost* courtesy Touchstone Television. © Touchstone Television.

A stunt man was outfitted with a harness and an attached cable, and this cable was routed to and through the hollow engine (which can be seen in the original plate shown in Figure 15.81). At the appropriate time (as he moved into the area that would be the intake airflow for the engine) he was jerked off of his feet and then pulled directly into the engine set-piece.

Figure 15.81 Original background plate. © Touchstone Television.

The CG elements for this scene included not just the spinning engine blades—we also needed to recreate the entire engine casing in 3D in order to have something for the other elements to interact with.

Kaia Inc's specialty is 3D visual effects and we rely heavily on our 3D capabilities even when compositing shots. An example of this was the creation of a mask for the jet-engine casing. Rather than roto frame-by-frame in 2D, we 3D tracked the scene's camera, built geometry to match a live-action element and rendered white over black. This methodology of using 3D to aid the 2D work is often more efficient because the computer does more of the work.

There are two types of 3D camera tracking; simple rotation and rotation with translation. Tracking shots where the live camera stays in place and just rotates are usually easier. Tracks where the camera translates, as with this shot, can be more difficult because of the parallax which shows up in various places in the scene. We use Syntheyes for 3D tracking.

We rarely get measurements from the set and rarely need them. As my drawing teacher said, "If it looks right, it is right." Your eyes are the only true measure of a shot. More important than measurements are tracking dots. These days what can be done with computer graphics are only limited by budget and schedule. One of the most difficult hurdles to overcome, however, is a shot without tracking dots. Ensuring that tracking dots are placed on-set can save many, many hours later in the postproduction process.

The work on the man being pulled into the jet engine started with basic 2D rotoing of the stunt man. Once he was separated from the plate we could continue and modify the live-action arcing motion of him flying into the engine, adding some rotation and scaling just before he comes into contact with the blades.

The wire-removal of the cable, like the rest of the comp, was done in Shake. We do most wire removal by selecting (rotoing) the area with the cable, blurring the edges of the selection mask, and then offsetting a clean part of the frame to cover the wire. This keeps the grain and lighting consistent.

The spinning engine blades were modeled and animated in Maya. The intensity and saturation of the 3D lighting was exaggerated in the original model to compensate for the eventual dulling effect of motion blur. (The element is shown in Figure 15.82.) Lighting and texturing in 3D should be done with an eye for compositing. Frames coming out of 3D should have lighting directions and colors that match the plate, but contrast and saturation should use the whole range. In the comp it is possible to do the fine-tuning—to match blacks and reduce saturation and contrast—so it is better to have more information available in the 3D render. You can always remove information in the comp, but it is much more difficult to add.

The final touch on this shot involved some additional integration with the environment itself. In the scene there was a pile of sand lying in front of the engine. We used particle animation in Maya to generate some additional sand that could be drawn

Figure 15.82 CG engine element. © Touchstone Television.

into the jet engine. It was animated to follow the shape of the hill it comes from and arch upwards into the engine (Figure 15.83).

Figure 15.83 CG sand element. © Touchstone Television.

A few notes on our general production pipeline.

We are typically very reluctant to incorporate new software into our pipeline. There is always a new piece of software getting attention but the time it takes to purchase, install, learn, work out the bugs, and be productive on it is rarely outweighed by benefit that the new functionality will bring. We use Maya for 3D, Photoshop for image-editing, Shake for compositing, After Effects for motion graphics, and Syntheyes for 3D tracking, all running in a Windows environment.

Visual effects are always up against budget and schedule and so we rely on a model that includes freelancers that can be added as needed. This allows us to get the perfect mix of skills for each project, while not carrying a large overhead between projects. Conceptually we think of our facility as a satellite system. There is a central hub with many individuals as satellites.

For this particular show, we were spread across two countries—The U.S. and Canada. The 3D tracking was done in Vancouver, BC, the modeling and animation in Victoria, BC, 2D tracking was done in Washington state, lighting and compositing in Santa Fe, New Mexico. The individual contributors needed to be self-sufficient and have good communication skills. They look after their own hardware and software and manage their own time as well. (And a fast Internet connection helps too!) Creating a system that works efficiently took some time to develop, but now the idea of everyone driving to one place to work seems almost ridiculous.

The Lord of the Rings: The Return of the King

Weta of course also did the bulk of the work on the entire Lord of the Rings *trilogy. Matt Welford, 2D sequence lead for* The Return of the King, *talks about one of the shots in that film.*

The boundaries of visual effects are constantly being pushed to their very limits and it is always satisfying to know that you are working on a project that is pushing these boundaries forward. *The Lord of the Rings* trilogy was a group of films that truly helped to push visual effects to new limits, not only in the technology but also in the way visual effects can be used to assist in the storytelling process.

For *LOTR* the Weta Digital visual effects team helped Peter Jackson create the complete world of Middle Earth. This required several years of painstaking work, utilizing every trick in the filmmaking book and the development of several more along the way. Weta went from old-school scale photography techniques, to state-of-the-art computer graphics capable of recreating the battle of hundreds of thousands of Orcs on the doorstep of Minas Tirith in Pelennor Fields.

By the time we get to the last installment of the *LOTR* trilogy, *The Return of the King*, we have already experienced a multitude of CG characters and densely populated environments. What was left for the concluding part of the trilogy was the final epic battle for Middle Earth on the barren lands of Pelennor Fields. Here we will breakdown a shot of Saruman's evil armies forming into ranks just before the battle begins. This all takes place under the watchful eye of Gandalf the White from within the walls of Minas Tirith. A frame from the final composite is shown in Figure 15.84.

If we break down this shot in its most basic form we have four sets of elements that were composited together to create what we see on screen. The Gandalf plate (Figure 15.85) was shot on the Minas Tirith set with a partial bluescreen that was set up to cover Gandalf at the end of the shot, but there was not a bluescreen to cover all the soldiers as the camera tracks up to its final position. The next element was a CG army that was created using Massive, the crowd simulation package developed at Weta Digital specifically for *the Lord of the Rings* trilogy. The environment was created from a 180° matte painting view that was projected through each shot camera, with a sky dome and digital ground layer. Finally there were fire, atmosphere, and smoke layers added to help created depth and subtle movement across the course of the shot.

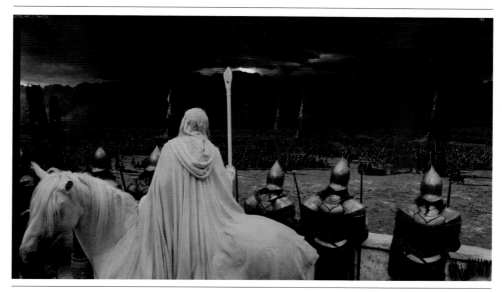

Figure 15.84 Final composite for a scene from *The Lord of the Rings: The Return of the King*. *The Lord of the Rings: The Return of the King* photos courtesy of New Line Productions, Inc. Copyright MMIII, New Line Productions, Inc. TM The Saul Zaentz Company d/b/a Tolkien Enterprises under license to New Line Productions, Inc. All rights reserved. Photo by Pierre Vinet.

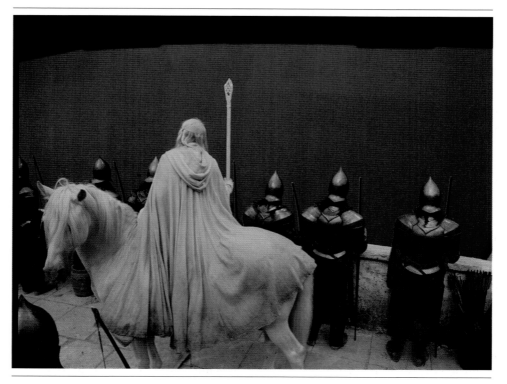

Figure 15.85 The foreground bluescreen element. © MMIII, New Line Productions, Inc.

Many of the sets for *LOTR* were built on an extremely large scale and Minas Tirith was no exception. These large sets brought along their own problems as well—in this case the bluescreen was only large enough to cover the end framing of the shot. This meant that for much of the shot the soldiers were against a bright overcast sky rather than a bluescreen, causing severe light-wrap around the soldier's helmets and weapons. Lighting that was inappropriate for the lighting in the final composite.

Wherever bluescreen was present we were able to key it using Shake's standard keyers. But we still faced the problem of extracting a matte for the rest of the shot where we had no bluescreen. This was initially achieved via a set of lumakeys and articulate roto mattes, but this only got us half the way there. We then needed to hide the light-wrap which we achieved with a combination of two methods. First we developed a proprietary Shake plugin to assist with problems like this—a tool that could extend colors outward from selected parts of an image. This could dilate parts of the soldier's colors over the light wrap edges to give more consistent edges, and where this did not work we also tracked edges back over the parts that still were too bright.

For the environment, the matte painting department created a 180° view of the distant mountains and blended it with a very dramatic cloud sky dome (Figure 15.86). This was then animated to add movement to the clouds and the erupting volcano of Mordor, and to create interactive lighting on the clouds from the volcano's glow. We then projected this dynamic **cyclorama** through the specific shot-camera to see the appropriate area of the cyc for our position within the scene. To complete the environment we needed to create the ground, which was developed in two layers. First a base layer was textured and rendered, and then a fur technique was developed to render a second layer that contained detailed clumps of animated grass. This grass-layer was composited over the base ground render to produce the precomp shown in Figure 15.87.

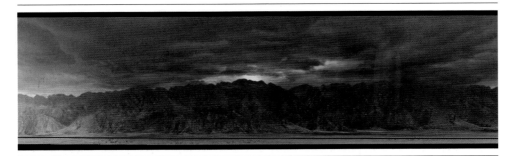

Figure 15.86 A matte painting element. © MMIII, New Line Productions, Inc.

The focus of this shot is the army waiting to attack outside Minas Tirith. The Massive crowd-simulation software allowed us to create large numbers of digital characters that could interact with each other and with their environment without the need to hand-animate every character. The 3D department delivered beauty passes of the Orc army, Warg Riders, and siege towers in our in-house file format "lif" (log iff format) at 4K.

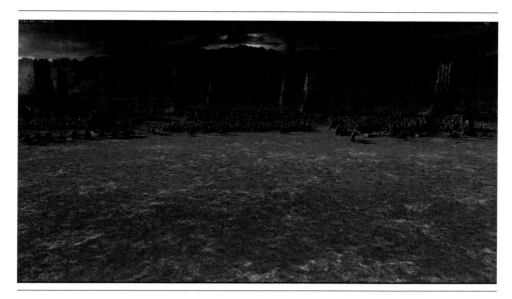

Figure 15.87 The background layer precomposite. © MMIII, New Line Productions, Inc.

They also rendered several helper passes to assist us in the composite. These included a secondary specular pass and a set of position depth passes. We used the specular pass to exaggerate specular highlights in certain areas of the Orc army, which helped distinguish each character so that we could read the number of soldiers in the ranks, rather than see groups of Orcs blend together. The other important pass was what we called a "position pass." This held three different depth layers: A global height depth, the height of each character or agent, and a world depth from the camera.

To help create the illusion of depth and scale of such a vast army we relied on a selection of smoke, dust, atmosphere, and fire elements that we had specifically shot for the battle sequences in the film. By taking the world depth position pass the compositors were able to depth-cue the army into the atmosphere. Then by using a combination of the world depth and agent depth, we were able to have the 3D renders walk through dust and ground interaction elements. The final pieces layered into this environment included many fire and smoke elements, which we often retimed to help sell the scale of these epic battle sequences. All of these 2D elements were tracked into the shots using our proprietary tracking export tool from Maya, which allowed us to export tracking information from any 3D scene to our compositing package to apply the necessary camera moves.

All of these pieces were brought together into the final composite using our primary compositing package, Apple's Shake. The composite was created with a neutral grade, which we delivered as the final composite. We then passed this to the color grading team who added the final primary grade for the theatrical release of the film.

The Orion Nebula from The Hubble Space Telescope

And now for something completely different. The tools and techniques that are used in digital compositing are certainly not only applicable to film or television productions. The Space Telescope Science Institute is funded by NASA and manages science operations for the Hubble Space Telescope. Zolt Levay (Senior Imaging Specialist) and Greg Bacon (Senior Animation Specialist) in the Office of Public Outreach at STScI take us through a case study of how these techniques can be used to gather and present massive astronomical data sets. Some of the terms may be unfamiliar (both the compositing terms and the general scientific ones!) but you'll see that the basic principles have much in common with compositing as it is discussed throughout this book.

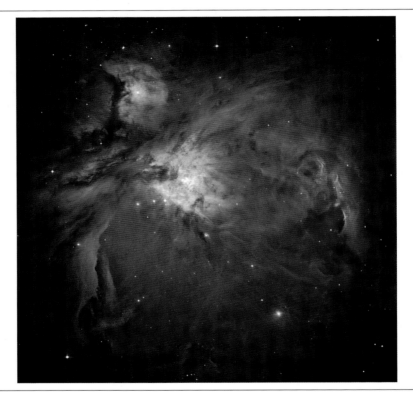

Figure 15.88 The final composite image of the Orion Nebula. Hubble Space Telescope images courtesy of NASA, ESA, M. Robberto (Space Telescope Science Institute/ESA) and the Hubble Space Telescope Orion Treasury Project Team.

Introduction

The Orion Nebula (M42) boasts iconic status as a heavenly body. It is one of the few deep-sky objects visible to unaided eyes[2] in the prominent, recognizable winter

[2] Albeit only to keen, young eyes at a very dark, clear site.

constellation Orion. The *Hubble Space Telescope* (HST) with its privileged vantage point above the obscuring atmosphere and a suite of up-to-date instrumentation obtained the most detailed images of the Orion Nebula to date. We describe here part of the process of producing a color composite image from the assembled Hubble data for distribution to the public, media, and astronomers. We discuss the practical challenges of working with over one billion pixels of high dynamic-range data.

An equivalent challenge was producing an image distinct from the gallery of existing photographs of this popular target, but not so unusual as to appear unrealistic. (Keep in mind that nearly all astronomical images of this sort are actually false-color images, where we can map both visible and nonvisible ranges of the electromagnetic spectrum to colors that are visible to the human eye.) We therefore will be making a number of subjective choices in this process, some of them purely for aesthetic reasons.

Roughly two products were generated with the final image—a large still-frame for web/print use and an animated video. The printed version was created in multiple sizes for various venues. The video was created to take you to specific regions of the image for a "focus view." It was published by our group directly but was also incorporated into other final productions; i.e., with music and narration.

At every step of the production, several goals were kept in mind:

- Create a visually striking image.
- Maintain a realistic overall appearance, in terms of tonality and color.
- Render coolest stars red, hottest stars blue.
- Represent the broad dynamic range contained in the data.
- Render the detailed structure inherent in the data.
- Stay honest to the data.

Note: Mention of specific hardware and software should not be construed as endorsement of a particular commercial product, manufacturer or vendor. Specific products were used in this project and are mentioned in this document to describe in detail how these tasks were accomplished. They are mainstream items used widely in the graphics industry and therefore the methodology of their use constitutes well-known paradigms useful in describing specific techniques for editing images.

Data from the Science Team

Data used as input to create the final presentation image was produced by the HST Orion Treasury Program Team at the Space Telescope Science Institute. The actual images were captured by the Advanced Camera for Surveys (ACS) Wide Field Channel (WFC) aboard the HST in October 2004 and April 2005.

The initial data consisted of 104 separate HST ACS/WFC "pointings." A pointing is a specific aim-at point for the camera, so we were actually looking at 104 different

locations in the nebula. Each of these would ideally overlap significantly with the adjacent ones although, as we'll discuss, this was not always the case. The resolution on each of these pointings was roughly 4000 pixels square (each derived from a side-by-side pair of 2048 × 4096 images that come directly from the CCD). In terms of real-world units, each pixel represents approximately 0.05 sec of arc in the sky.

Unlike the images produced by a "traditional" digital camera which uses filters to isolate red, green, and blue frequencies (and then combines them internally to produce an RGB image), astronomical images will often be captured using a variety of different "color" ranges from across the full spectrum of light. Filters are put in place that restrict the light reaching the sensor to a specific frequency range. The decision for which frequencies are eventually mapped to red, green, and blue in the final image is dealt with much later in the process.

For each of these 104 pointings, 5 different filters were used—4 broad-band and one narrow-band. These different exposures gave us information from a wide range of the spectrum, which we would then be using to create our color images. Thus we started out with over 500 individual images that we would be working with, or a total of around 8,320,000,000 pixels.

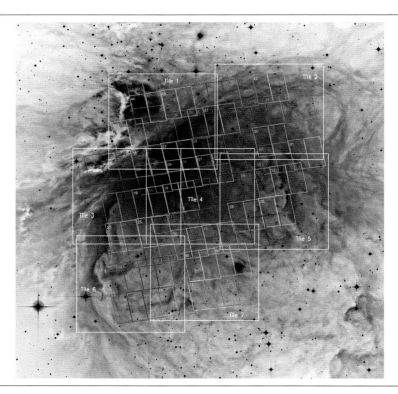

Figure 15.89 Distribution of the 104 ACS fields on the sky and the seven primary tiles that were constructed. © NASA.

We consolidated the 104 pointings into seven overlapping tiles, each 13,000 × 14,000 pixels in size. This was done using "Drizzle," a set of specialized code/algorithms that were built here at STScI specifically for combining multiple exposures offset by small (sub-pixel amounts).

Creating seven tiles (as opposed to one large image) was necessary due to hardware/software limitations (memory mostly).

The tiles were saved to disk using the FITS file format. FITS (Flexible Image Transport System) is the most common image file format used for astronomical data and allows for bit depth up to 32 bit floating-point. This gave us 35 new files to work with—each of the seven tiles had five different versions corresponding to the different "colors" that were captured.

Figure 15.89 shows a general mapping of what we have just described. The original 104 pointings are represented by the colored rectangles and the seven new tiles that were derived from those are outlined in white.

Preliminary Processing

Each of the 35 monochrome input files was converted from 32-bit floating-point data into an editable 16-bit image using a logarithmic scaling. As the ACS data was processed and calibrated consistently, the same intensity scaling parameters could be used for each tile and filter. Parameters were adjusted to produce a wide, smooth range of tones, maintaining detail in the brightest (highlight) and darkest (shadow) regions across all of the images. Figure 15.90 shows the resulting processed imagery. Images in each row represent data from the five different filters and the columns are the seven tiles that were created for each filter.

While there was a strong desire to keep the image at the native pixel scale coming from the camera, it rapidly became obvious that this would be highly impractical. Thus we reduced the image size by a factor of two in each dimension. All of the seven 16-bit tiles were combined and reassembled into a single mosaic—a 16-bit grayscale flat Photoshop document that was 32,567 × 35,434 pixels (total of 1.1 Gigapixels). Again there were five different versions of this due to the different filters used in the original capture.

Color Assignment

The most straightforward way to reconstruct color uses three images assigned to the three additive primary color channels—red, green, and blue. However, it is possible to make a color composite with more than three constituent images using a layering paradigm to assign individual grayscale images to specific hues. This is the method we used, ultimately choosing 4 primary hues—red, green, blue, and a reddish/orange.

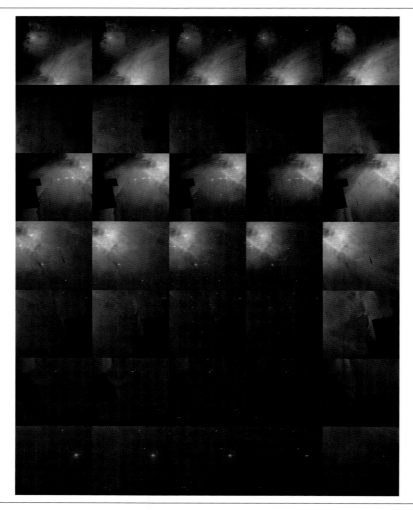

Figure 15.90 Images resulting from initial intensity scaling to 16-bit gray Photoshop documents, each 13,000 × 14,000 pixels in size. © NASA.

The specific color assignments for each of the five filters were as follows:

F658N (also known as Hydrogen-alpha) transmits a very narrow band of colors matching the brightest light of the element hydrogen shining in red light. The images produced from this filter were colored red/orange in the color composite.

F850LP (also known as z band) and F775W (also known as i band) transmit near-infrared light (wavelengths longer than the red light that we can see). The images from these filters were combined (averaged together) and assigned red in the composite.

F555W (also known as V band) transmits green/yellow light. The images from this filter were assigned green in the composite.

F435W (also known as B band) transmits blue light, and these images were assigned blue in the color composite.

The first draft of our color composite is shown in Figure 15.91.

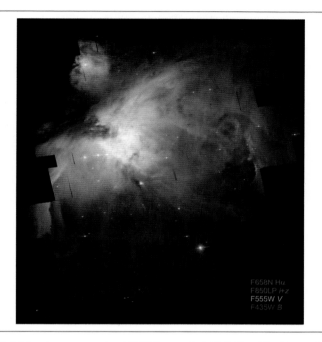

F658N Hα
F850LP *i+z*
F555W *V*
F435W *B*

Figure 15.91 Initial color composite (HST data only) 32,567 × 35,434 pixels. © NASA.

Replace Missing Data

Unfortunately the distribution of the original pointings was not designed to fill out a perfectly rectangular pattern, resulting in the ragged boundaries shown in Figure 15.91. There were also a few interior gaps in the data. We felt that a clean, rectangular composition would be more appropriate for a public presentation of the image and so we needed to make use of some additional imagery in order to fill out the borders of the image into a less distracting final result.

The science team provided another set of data to us—a wider (but less-detailed) view of the nebula—that we could use to fill out the boundaries and fill in the gaps. This data came from a ground-based telescope/camera at the European Southern Observatory (ESO) station in La Silla, Chile. It also came to us as several different color bands, in this case four of them. The filters were not exactly the same as from the Hubble data but matched closely enough when we lined up similar filters.

As with the HST data, each filter was scaled from the full dynamic-range FITS into 16-bit images. Slightly different scaling parameters were used for each image, though

log transform was used for all. The goal was consistent shadow and highlight values and overall tonal range among the four images used.

We then needed to combine the two sets of imagery. A mask was generated starting with all of the non-black pixels in each HST image. This mask was modified (manually retouched to ensure full coverage) to blend the two images smoothly. In addition, some brightness adjustments were applied to match the images where they overlap. Figure 15.92 shows (from left to right), the Hubble mosaic, the mask that was created for that and the broader-coverage ESO image.

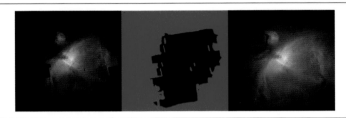

Figure 15.92 Initial HST mosaic (left), blending mask (center), and ESO image (right). © NASA.

Color Composite and Adjustments

The final color composite was made from the combined HST and ESO images, based on the initial prototypes with the HST data only. Brightness, contrast, and color balance adjustments were applied at this stage, both to the individual filter components and to the combined image. Masks were used to apply adjustments to localized areas with the result of preserving detail and maximizing local contrast across the image.

For practical purposes, the image was again downsized by two times in each dimension (to about 18,000 × 18,000 pixels) before applying substantial adjustments to improve the contrast and color. Again, masks were used to apply adjustments in selected regions to expand the overall tonal range. To further facilitate additional editing, the flat, 16-bit color composite was tiled into four pieces in a 2 × 2 array.

Cleaning and Restoration

Telescopes and cameras introduce certain well-known artifacts into astronomical images such as:

- CCD saturation "bleeding,"
- diffraction spikes,
- residual cosmic rays,
- internal reflections (primarily on the brightest stars in the ground-based image, due to light reflecting among the filters and other optical elements within the instrument).

Most of these were removed from the Orion Nebula image using standard digital editing techniques. Every attempt was made to avoid changing the character of the underlying image.

Examples of "cosmetic cleaning" on small sections of the adjusted color composite mosaic are shown in Figure 15.93. Along the top row we show three examples of observational artifacts: CCD charge "bleed," cosmic rays, and internal reflections. The bottom row shows cleaned versions of the same image sections.

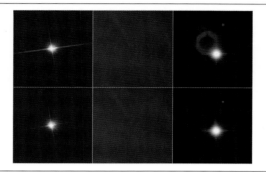

Figure 15.93 Examples of "cosmetic cleaning" on small sections of the adjusted color composite mosaic. The top row features examples of (left to right) CCD charge "Bleed," cosmic rays, and internal reflections. The bottom row shows the cleaned versions. © NASA.

Final Adjustments

After cleaning, some additional adjustments were applied, mostly to increase the overall contrast and to enhance detail in the shadows (while taking care not to lose detail in the highlights). A slight sharpening was applied to the final image. Care was taken to use the minimal amount in order to avoid introducing any sharpening artifacts. Finally, the overall contrast was enhanced slightly by inserting a copy of the image to which a moderate high-pass filter was applied at 60% opacity via a "hard light" layer blend mode.

The result of these final adjustments is shown in Figure 15.94. The intent was to enhance contrast throughout the image to make a "crisper" rendition but without sacrificing highlight or shadow detail or losing the overall sense of the very large range of brightness values inherent in the data.

Video Treatment

Now that we had a final still image, we needed to produce some something that could be used as a part of moving-image presentations. The flat, 16-bit color composite, which was tiled into four pieces, was used to create the movies. The single composited image could have been used, but we found the software to respond quicker

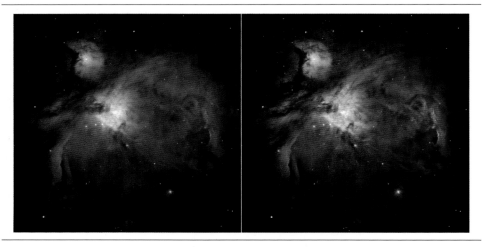

Figure 15.94 Comparison of original composite (left) and final color adjustments (right).

with smaller images, especially when focused in a particular region of the overall image. Proxy images were also used to get quicker feedback.

The four images were placed in the necessary positions relative to each other in the compositing package (in this case Apple's "Shake" software). Two-dimensional transformations were applied to move the image relative to a user-defined "viewport"—a window onto the larger frame. The duration of the movies as well as the choice of which areas to concentrate on were purely an aesthetic decision.[3]

Sin City

Hybride Technologies is a visual effects facility based in Montreal, Canada. Daniel Leduc, the visual effects supervisor and producer for Hybride on Sin City, talks about one of their shots from the film.

Shot almost entirely on greenscreen sets, the visual effects in *Sin City* yielded an authentic adaptation of a black-and-white comic book style. In the comic book, many of the scenes portray Marv, a principle character, as a silhouette against a plain background—either black on white or white on black. In the motion picture, the high-contrast black and white appearance of the comic book style is preserved consistently.

The shot presented in this case study features the use of greenscreen footage keyed into CG environments, matte painting, animated garbage masks, and compositing techniques. In remaining true to the comic book adaptation, these visual effects were concluded to be more of a stylistic achievement than a technical feat.

[3] Two of these clips are included on the DVD bundled with this book.

Sony's HDCAM SR video camera was used to capture all of the elements for the film. The footage was recorded at a resolution of 1920 × 1080 using the RGBA 4:4:4 10-bit option. This format greatly reduces many of the compression artifacts that were found in earlier versions of this camera, a critical issue when it comes to greenscreen keying.

During production, two HD monitors were used on the set, one for previewing the live camera action and the other for previewing the compressed black-and-white image, which provided an immediate sense of the lighting and shadow contrasts in the scene. The black-and-white preview of the live footage was handled using the controls on the output monitor, specifically the contrast, brightness, and gamma controls; this is similar to watching black-and-white TV.

In postproduction, color was added sparingly using compositing and garbage masks to isolate blood, fire, eyes, lips, and other key elements—mimicking the color used by the comic book's author/artist Frank Miller. Throughout the film, special attention was given to preserve the characters' facial expressions and eyes as illustrated in poignant scenes of the comic book.

In this scene we were trying to match, the comic book illustration has hardly any background at all and Marv and Stan are drawn with very hard edges around their backs. In the foreground, much of the characters' bodies are in shadow with the exception of bandages on Marv's face and arms and Stan's eyes (Figure 15.95). Under the supervision of the director and co-director, this scene was re-designed with a fuller background than the illustration but nonetheless respected the continuity of the preceding and succeeding scenes in the story.

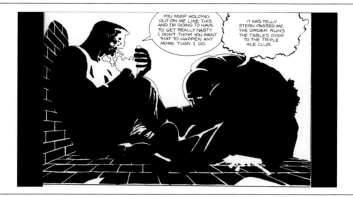

Figure 15.95 The reference image from the original comic book that the shot was designed to match. Stills from *Sin City* courtesy of Miramax Films © Miramax Films. All rights reserved.

Using a locked-down the camera, the scene was shot in front of a greenscreen with a lot of backlighting on the set to create the hard edge effect around the actors' silhouettes (Figure 15.96). In postproduction, the actors were keyed-in against a CG

background consisting of a long and narrow alleyway. In this particular scene, the contrast of blacks and highlights creates a shadow play below the characters' legs where only the shapes of Marv's handgun and pack of cigarettes are discernible in the foreground.

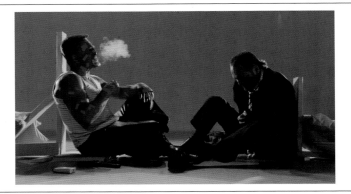

Figure 15.96 The foreground greenscreen element. © Miramax Films.

Of particular importance in this scene are the numerous bandages that Marv has on his body and how these bandages stand out so vividly white in the final result. To keep the high contrast of the image and to obtain a white result with the bandages, the actor had to wear fluorescent orange bandages. Otherwise the white bandages would have appeared grayed-out or even been lost in the shadow areas. On the set, an ultraviolet light was placed in front of Marv to brighten up the orange glow even further. The blacklight caused Marv's white tank top to have a blue cast, so color suppression and a garbage mask were used on the shirt during compositing.

The CG background (Figure 15.97) with the bricks and mortar was created with a reverse rendering technique in 3D. This was done to closely match the "reverse shadow" effect in the comic book illustration where the bricks are dark and the mortar between the bricks is very detailed, high-contrast, and bright. The CG result was then composited in a separate pass with the live footage. Several matte layers were used which included garbage masks of the actors' real shadows. These were keyed with varying levels of softness to achieve the final result.

The overall objective in this scene was to integrate the "negative of the shadow areas" using a lot of soft shading while adjusting luminance, highlights, and shadows, specifically in the regions where the mortar is in shadow behind Marv's and Stan's backs.

Mattes were generated for keying the background, for emphasizing the bandages on Marv's body, and for keeping the details of Marv's and Stan's facial expressions, particularly Stan's eyes. The final composite is shown in Figure 15.98.

Figure 15.97 The CG background element. © Miramax Films.

Figure 15.98 The final composite for a scene from *Sin City*. © Miramax Films.

Sky Captain and the World of Tomorrow

CafeFX, based in Santa Barbara, California, does feature film visual effects. Jeff Goldman, the digital effects supervisor at CafeFX for Sky Captain and the World of Tomorrow, *talks about the work they did.*

Sky Captain and the World of Tomorrow (WOT) was an entirely bluescreen shot film captured on High-Definition video (HD video). Though many different visual effects facilities worked on the various segments within the film they were all guided and tasked by World of Tomorrow Productions who had their own large team of digital artists on hand and also developed the look and pipeline for the entire film. Our work

at CafeFX involved a section of the film known as the "Nepal" sequence, which takes place in the highest, snowy reaches of the Himalayan Mountains—a location which we ultimately created through the use of digital matte paintings, 3D environments, and compositing. This particular shot example takes place in a makeshift airbase made up of period expedition tents on a frozen lake-bed.

WOT employed a dreamy, almost hand-colorized world which looked like the old, serial, adventure features it sought to mimic. The "WOT Look," as it became known, was important to the stylistic feel of the film. Keeping the look consistent between all the vendors was very important, and the WOT production team developed composite strategies, a recipe of sorts, that would allow everyone to develop results that visually occupied the same world. The use of bluescreen technology and digital compositing allowed the filmmakers to realize the hyper realistic world of their dreams without the need to build elaborate sets or travel to distant locations, while retaining the skills and abilities of real-world actors.

WOT was one of the first feature-length all bluescreen shows to be shot with HD video, and it had to be treated differently from a show shot on conventional film. The format had its own share of positives and negatives. On a positive note, the HD video didn't need to be scanned, as with film, and it was recorded in linear color space, as opposed to film's logarithmic color space. This negated a need for a response-curve conversion process to bring images into linear colorspace as would be used with Cineon scans. On the downside, HD video wasn't capable of the same exposure latitude as film. Due to the linear nature of the format, what we saw was what we got. If RGB values clipped at the high end they were gone forever, negating any need for floating-point calculations.

Compositing with HD video necessitated a different technical knowledge from film particulary in the realm of colorspace. WOT's HD video format utilized a 4:2:2 YUV colorspace (Sony HDCam 4:2:2), which meant that while the total resolution of the HD frame (1920 × 1080 pixels) was used to determine luminance values, only half the available resolution was used to describe the color portion. This resulted in an image that was sufficiently pleasing to the eye, but not as detailed and useful for the tools used in digital compositing. When converted to RGB colorspace for compositing, it resulted in an effective RGB colorspace of only 8-bits, however we worked with full floating-point calculations for the CG work and ultimately delivered 16-bit SGI files because production used a digital intermediate for color timing on everything for final release. That meant that while our bluescreen source material was only 8-bits deep, our CG work and composites could be at a higher bit depth. Due to the amount of image processing required on the source material to achieve the WOT look, the original 8 bits of data was modified so much that we ultimately took advantage of the higher 16-bit depth level.

We used a wide array of off-the-shelf compositing tools for WOT. Our primary compositing package was Digital Fusion, while After Effects was used on a handful of shots, as well. Aside from basic workflow mentality (Digital Fusion being node driven

and After Effects being layer driven), the mixing of the two packages never presented a problem. In fact, WOT Productions used After Effects pretty much exclusively for their in-house work. Because of this, the primary "WOT Look" recipe was devised in After Effects, and we had to match the methodology in Digital Fusion. A large part of the look that was developed in After Effects was accomplished with the use of an off-the-shelf diffusion plugin from The Foundry. Luckily, Digital Fusion's plugin architecture was compatible with After Effects plug-ins, so we were able to translate the After Effects methodology into a virtual replica within Digital Fusion by using the same After Effects plug-ins for both packages. At that point, working within the two packages was virtually identical from a technique point of view.

Several elements were used to construct the final shot, beginning with the primary background image (Figure 15.99). The first piece of this was a distant 2D matte painting developed in Photoshop utilizing bits of photographs of snow-covered mountain landscapes. In this particular sequence, matte paintings were used for distant backgrounds where 3D perspective shifting wouldn't pose a problem. This worked well for objects over a mile away. In this case, the dry lake-bed was ringed with a series of intermediately distanced short cliffs that were rendered individually in CG. This allowed us the flexibility to place them manually in static shots to help drive the shot composition.

Figure 15.99 A rendered CG background. Stills from *Sky Captain and the World of Tomorrow* courtesy of Paramount Pictures Corp. © Paramount Pictures Corp. All rights reserved.

The midground environment for this element was CG generated, from the snowy ground, to the expedition tents, to the miscellaneous props littering the camp. Much of the material was rendered in a single beauty pass, but as the shot progressed production wanted to experiment with different treatments for the foreground area of the camp. So, the foreground snow immediately under the plane was rendered as a separate layer, which allowed for faster experimentation.

Eighty per cent of the airplane was reconstructed digitally to match an on-set prop. Only the area immediately around the plane's cockpit was a live-action element. The

rest of it, from the tail to the ends of the wings, to the front cowling with propellor was a CG creation (Figure 15.100). The CG plane parts were carefully textured, color matched, and grained to blend seamlessly with the live-action section of plane. In this case, the plane was an independent element made up of a single, beauty pass layer and a ground contact shadow layer (Figure 15.101) for integration into the environment. All CG elements were rendered in floating-point colorspace using OpenEXR files to allow for wide latitude in image processing when necessary.

Figure 15.100 The CG plane element. © Paramount Pictures Corp.

Figure 15.101 A rendered CG shadow for the plane. © Paramount Pictures Corp.

The foreground, or live-action elements, were separated into three layers. Sky Captain and the live-action section of cockpit were one layer, Polly Perkins was another layer, and the three actors approaching from the distance were the third, though there were originally only two source plates provided by production; Sky Captain and Polly were on one (Figure 15.102) and the Sherpas were on another (Figure 15.103). This allowed for repositioning of the elements within the shot space. For instance, Polly Perkins would have been obscured by the CG wing in her original plate location, so she was repositioned

upwards to allow just enough of her to still be visible behind the wing. Similarly, the shooting stage was not deep enough to shoot the Sherpas at the desired distance, so they were shot separately with the anticipation of repositioning them in the composite.

Figure 15.102 The foreground bluescreen element. © Paramount Pictures Corp.

Figure 15.103 Additional bluescreen characters. © Paramount Pictures Corp.

The foreground compositing process included extracting the actors and relevant props from the bluescreen source footage. HD, again, proved a challenge to the keying process. In particular, the blue channel was highly compressed, due to the nature of the format, and riddled with compression artifacts. It became common practice to blur only the blue channel slightly in order to retain clean-keyed results. Similarly, a significant amount of grain removal was done to the plates to achieve a good key. The grain removal tool we employed sampled the image for existing grain structure in areas of the frame that were supposed to be a constant value (a clean section of bluescreen, for example), and then attempted to remove the differences between the grain structure and a theoretical constant value. The result was a smoother, more easily keyable image with little softening to useful edges. Once a satisfactory matte

was achieved, the result was then applied to the original footage to cut out the relevant RGB, thereby retaining the quality of the original plate.

A series of effects layers were then added to help bring the static shot alive with lighting changes and atmospheric effects.

- An animated, perspective-positioned cloud noise layer (Figure 15.104) was used as a mask to modify the luminance of the midground layer, simulating the subtle light-shifts on the ground caused by thin clouds passing overhead.

- A 3D fog pass was generated to allow for composite control of atmospheric haze with depth.

- Areas of the distant background and sections of the midground at the base of the tents were hand masked and filled with subtly shifting fractal noise layers to simulate low-lying ground mist.

Figure 15.104 A mask used to create cloud-shadows on the ground. © Paramount Pictures Corp.

Finally, layers of particulate snow developed both in 3D and within the compositing package were added to indicate a pending weather front. Digital Fusion's particle tools worked in 2½ D space, where particles could occupy full 3D space, as with a conventional 3D package, but were limited to generating flat sprites or point-particles as output. This was fine for particulate snow, and due to the simplicity of the system and calculations, it allowed us to populate shots with heavy numbers of particles for very little render overhead. But for shots that required elaborate camera moves, very specific particle movement, or object interaction, Lightwave 3D was employed to generate snow. In this particular shot, gently falling and drifting snow was achieved through Digital Fusion's particle tool, while subtle streams of particulate snow that get kicked up by wind and blown through the frame were generated by Lightwave 3D.

After all the layers were combined, black points and color values were matched to each other to create a visually balanced composite before going onto final finishing which involved the addition of the "WOT look."

After being approved by production, color was reintroduced with a technique that was developed by WOT's compositing supervisor. Originally WOT was envisioned as an all black and white feature, so much of the work pioneered by WOT Productions was developed around that assumption. Because of this, WOT Productions' workflow was a little different from our workflow at CafeFX. At WOT Productions, adding color meant adding another department to handle the work, so composites were usually completed in black and white first by one compositor, and then handed off to another compositor for color integration. CafeFX came aboard the project only after the decision to incorporate color was made, so we were able to save time by having one compositor finish a shot all the way through the black and white and color stages.

The basic color process to achieve the "WOT look" was as follows. As soon as the basic composite was finished (Figure 15.105) the result was desaturated to black and white (Figure 15.106). This allowed the artist to concentrate on achieving a good balance of values within the composites that was crucial to the look of WOT. Once everything

Figure 15.105 The primary color composite. © Paramount Pictures Corp.

Figure 15.106 The primary color composite made monochrome. © Paramount Pictures Corp.

was balanced in black and white a recipe of filters including black and white threshold glows (via The Foundry's Diffusion Filter) were used to achieve a soft, aged film look (Figure 15.107). This filter allowed us to not only glow the image, but it allowed us to limit the luminance range in which the glow was applied both at the high and low end independently. Highlights would glow out while dark areas appeared to burn in.

Figure 15.107 The monochrome composite with diffusion added. © Paramount Pictures Corp.

Figure 15.108 The final composite. © Paramount Pictures Corp.

The technique for reintroducing color was fairly complex, but essentially it involved tinting the black and white footage a particular color that was indicative of the mood of the sequence, then blurring a rough, full color composite to reduce detailed color rendition. The blurred color layer was then reintroduced to the tinted black-and-white footage using a combination of screen, color, and softlight operations which resulted in what appeared to be hand-applied washes of color. Facial tones, for instance, became monochromatically flesh colored, as opposed to conventional footage's wide array of color detail normally represented within a face. Since we were using the original plate color, very little hand roto was required. The final composite is shown in Figure 15.108.

Spider-Man 2

Sony Imageworks, based in Culver City, CA, has provided the bulk of the visual-effects work for all three Spider-Man movies. Here they discuss a scene from Spider-Man 2.

This 7-second shot from the fight scene on the side of a moving train between Spider Man and villain Doc Ock in *Spider-Man 2* is an excellent example of using nearly all CG effects and visual elements to create an action sequence that couldn't be filmed using real actors or practical locations. Because of camera angles above and on the side of a speeding train, as well as action elements which proved to be impossible (or impractical) to shoot with stunt people, the shot was digitally composed. For this shot, Chicago's elevated commuter train was transposed to Spider-Man's New York home. During the shot, Spidey (as he's affectionately called by the visual effects team) bursts through the window of the train, leaping onto the train's side to fight Doc Ock with his webs while Doc Ock's four tentacles grab at him, piercing the hull of the train. As a passing train approaches from the other direction, Spidey flattens himself back against the train to avoid being crushed.

While the original plan was to use primarily live-action footage of the train and place it in the created background, it became clear during preproduction that the background, train, and character elements for Spidey and Doc Ock would need to be all CG.

Background elements were created and lit digitally, after the visual effects team consulted the production designer for reference shots of individual buildings, and the director of photography for his desired warm, orange-y magic hour lighting for the shot. The background buildings, train tracks, and rails (Figure 15.109) were all rendered separately for maximum flexibility, then a depth pass was added to introduce depth of field into the background. The reflection of the tracks was lowered, and contrast was added to the foreground buildings, again to enhance depth of field.

The only live-action components were the passengers inside the train, who were photographed separately in front of a greenscreen and projected onto cards to appear as though they were inside the train (Figure 15.110). This option gave the filmmakers more flexibility in placing the passengers in the train as desired.

Figure 15.109 Background Element. *Spider-Man*® 2 lighting pass images courtesy of Sony Pictures Imageworks Inc. © 2004 Sony Pictures Inc. All rights reserved.

Figure 15.110 People in the train. © 2004 Sony Pictures Inc.

The train elements were separated into individual components: the train itself (Figure 15.111), the reflections of the passing buildings on the train, and the reflections of Spidey and Doc Ock as they wrestle on the side of the train (combined together to produce Figure 15.112). A diffusion pass was then layered over to blur reflections and add character's shadows. A dirt pass was added to dull down reflections and add realism to the depiction of the train.

Figure 15.111 Train diffuse layer. © 2004 Sony Pictures Inc.

Figure 15.112 Train reflection layer. © 2004 Sony Pictures Inc.

A matte pass was done next to fine-tune specific color aspects of the train – using the red channel for the wheels matte, the green channel for the windows and the blue channel for the metallic body. A reflective occlusion pass was then done to mask out building reflections when characters of Doc Ock and Spidey were in front of them. And an overall ambient occlusion pass was generated to refine the lighting on the train (Figure 15.113). Dirt and smudges were added to the windows.

Figure 15.113 Train ambient occlusion layer. © 2004 Sony Pictures Inc.

The train window composite was screened onto the train element, and broken glass (caused by Spidey's flight through the window) was added next. As the animated broken glass looked too motion blurred on the first render, the compositor made it more high-contrast and added highlights. A separate pass was done to mimic refraction in the small broken glass pieces. Character holdouts were added to place the characters in front of the broken glass fragments. A train depth pass was done next to make the train blur slightly as it recedes into the distance of the shot. All train layers were composited over the background elements. Train edges were blurred or softened with a light edge wrap to blend the train into the background.

In the shot, the characters of Spidey and Doc Ock were created entirely in CG. Actors Tobey Maguire and Alfred Molina were photographed using Light Stage technology, in which the reflectance field of the human face is captured photographically. The resulting images can be used to create an exact replica of a subject's face from various viewpoints and in changing light conditions. To gather the data for Doc Ock's face, for example, Molina was seated in a chair and surrounded by four film cameras running at 60 fps. Above his head was an armature that rotated around the chair with strobe lights that fired at 60 fps. At the end of 8 seconds, the visual effects team had 480 images of the actor's head in one position but in a variety of different lighting conditions.

The completed character animation was composited in at the next stage. Doc Ock's body, hair, tentacles, and clothes were all rendered as separate passes for better control. His clothing in particular proved most difficult to render because of the fast fight choreography, combined with the cloth's movements from the speed of the moving train. Another challenge to compositing these elements were Doc Ock's tentacles, which sometimes cross over each other. Reflection, ambient, and diffusion passes on the

tentacles were each done as a separate render; after blooming, which adds a lens flare effect, and color balancing was done, red and green LED lights on the tentacles' claws were rendered separately. The combined color pass for Doc Ock is shown in Figure 15.114 and the ambient occlusion pass for this character is shown in Figure 15.115.

Figure 15.114 Beauty pass for "Dr. Octopus." © 2004 Sony Pictures Inc.

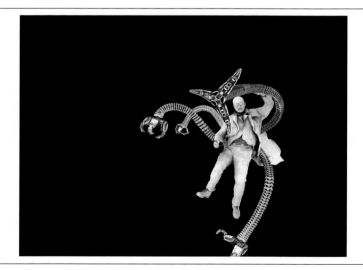

Figure 15.115 Ambient occlusion layer for "Dr. Octopus." © 2004 Sony Pictures Inc.

For the first stage of putting Spidey (Figure 15.116) in the shot, a general color correction was done, and then the blue and red colors of his suit were carefully matched

using photo reference shots. The blacks were lifted to avoid clipping and to match live-action plates used in the surrounding scenes. Again an ambient occlusion layer was generated to provide more realistic lighting and shadows (Figure 15.117).

Figure 15.116 Beauty pass for Spider-man. © 2004 Sony Pictures Inc.

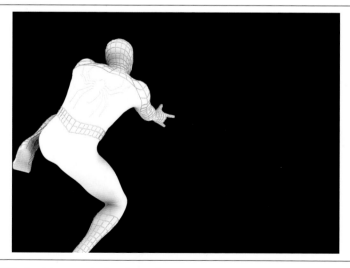

Figure 15.117 Ambient occlusion layer for © 2004 Sony Pictures Inc.

After Spidey's emergence from the inside of the train, he throws webs from his hands onto Doc Ock's tentacles and each character tries to pull the other off-balance. The compositor did a series of broad specular, tight specular, diffuse, and iridescent filtering

passes on the webs to give them the desired somewhat translucent look. Rotoscoping was used to create a specular hit traveling along each web based on lighting and camera angles. Blooming was added to highlight the web elements.

Depth of field was controlled globally by the use of a depth matte (Figure 15.118), selectively blurring objects as they recede into the distance. Finally, a subtle camera exposure change was added as the camera tilts up and down in the shot. Lens distortion was added to match the slight fisheye warping on the edges of the frame, to make the shot blend with others in the sequence. Blacks were lifted once more, and film grain was added to match the overall look of the film.

Figure 15.118 Z-depth layer for the final scene. © 2004 Sony Pictures Inc.

Figure 15.119 The final composite for a scene from *Spider-Man 2*. © 2004 Sony Pictures Inc.

Underworld: Evolution

Luma Pictures is a visual effects facility located in Venice, CA. Justin Johnson, the compositing supervisor for this piece, talks about their work on the film Underworld: Evolution.

Luma's compositing task on *Underworld: Evolution* required the completion of two hundred of the most difficult shots in the film. To get this done in the time we had available required us to scrutinize every aspect of our pipeline, finding ways to simplify and automate production tasks wherever possible. Specialized applications and methods were developed that eliminated human error while at the same time empowered artists with a fast and efficient workflow.

Multi-pass compositing was one these methods. Multi-pass rendering has always been used throughout the industry as a means to optimize production pipelines, or in some cases just to get things rendered at all. (It's not uncommon to find that an extremely complex CG shot which the rendering software is struggling with can be "fixed" by breaking it apart into smaller pieces and then reassembling the result in compositing.)

But the benefits of separating aspects of a render are numerous. One of the biggest reasons is to give the compositors the ability to adjust every aspect of a CG element in comp. Giving them this control greatly reduces the need for rerendering CG elements when something is not quite perfect. The faster that iterations can happen to a shot, the more feedback can be given, and the faster it can be made to look believable.

There are, however, varying points of view towards this multipass approach. There is a train of thought that says do as much as possible on the lighter's side of things, so that the compositor gets as few passes as necessary to successfully complete the shot. When management of a large number of passes and disk space are of concern, this viewpoint is quite valid. Another philosophy feels that it is better to give the compositor total control of the shot by giving them every minute aspect of a render so that it can be tweaked relatively quickly in the 2D world. It is crucial to find a balance between these two factors, thereby giving the lighter the tools necessary to allow them to push their renders as far as possible while still enabling the compositor to tweak everything.

The shot being discussed here is of Marcus, one of the main villains in the movie, who gets trapped behind a door while pursuing someone down a hallway. The actor was filmed without facial prosthetics and our task was to transform him into his vampire form. By the time we get to this shot in the sequence, Marcus has transformed enough that we are completely replacing the real actor with a CG version.

This shot is a great example of the types of passes generated by our lighting model. The following passes were used in this shot and generally represent some of the more common types of passes compositors used throughout the show.

Background: (Figure 15.120) The background plate was a matte painting created from the degrained original plate. We applied a matchmove to this that had been derived from exported camera animation from a 3D track of the original hand-held plate of

the actor doing his performance. Since this shot is effectively a fully digital shot there was no need to use a tracked camera, but as it is somewhat difficult to accurately simulate the intricacies of a hand-held camera we decided to use the track. Every bit of authenticity helps.

Figure 15.120 Background. *Underworld: Evolution* images courtesy of Sony Pictures Inc. © 2006 Sony Pictures Inc. All rights reserved.

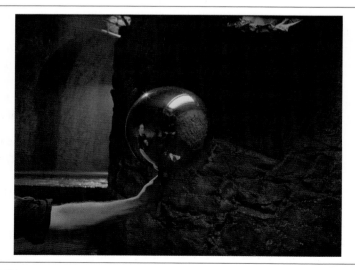

Figure 15.121 Reference Chrome sphere. © 2006 Sony Pictures Inc.

Reference: (Figure 15.121) For reference on this shot we received a scan of a chrome sphere that was filmed on-set in the approximate position that Marcus would be

standing. This was used to derive lighting direction. From this, the lighter could see that there had been a large diffusion screen placed above the actor and a rim light from back left. The scan of the chrome sphere also was used for creation of the IBL (Image Based Lighting) environment, which was part of the generation of the reflection and ambient passes.

Beauty: (Figure 15.122) The term "beauty pass" could mean different things depending upon what type of lighting model was being used. In this case, the beauty pass was used simply as a way for the lighter to check the integrity of their other passes. At first we were not even including this in the render output—everything that contributes to the full beauty pass was rendered separately and could be combined in the comp. However, the lighters eventually found it useful as an easy way to determine whether or not all passes rendered as expected. It was rarely ever used directly in the comp.

Diffuse: (Figure 15.123) Diffuse reflection approximates how light behaves after hitting microscopically rough surfaces. It basically represents the contribution of all lights to an element. Each individual light was separated into a different pass in order to give the compositor the freedom to control intensities and color of each light. The plate shown here is actually the sum of two passes—the key light diffuse pass and the rim light diffuse pass.

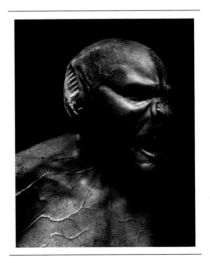

Figure 15.122 Beauty. © 2006 Sony Pictures Inc.

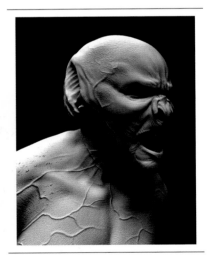

Figure 15.123 Diffuse. © 2006 Sony Pictures Inc.

Specular: Specular reflection is how a light will reflect off a smooth surface, in this particular instance the wet skin of Marcus. As with the diffuse, the specular component was separated for each light and what is being shown in Figure 15.124 is the sum of all lights in the scene. In general the compositing artist didn't need to make significant adjustments to the general lighting of the scene, more time was spent on the surface characteristics described below.

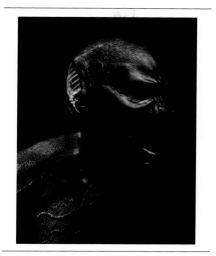
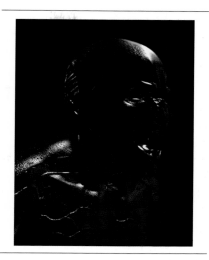

Figure 15.124 Specular. © 2006 Sony Pictures Inc.

Figure 15.125 Reflection. © 2006 Sony Pictures Inc.

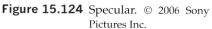

Reflection: (Figure 15.125) This pass represents the reflection of all surrounding objects, as opposed to the specular passes which reflect merely the lights. It was usually multiplied by the reflection and Fresnel values in the shader during the render. As the production proceeded, we found it helpful to leave these multiplications up to the compositor by including these values in the output of the render as matte passes. There was also a choice to have self-reflection and reflection occlusion included with this pass. For most of our needs we never used this.

Color: (Figure 15.126) The color map shown here is the fully transformed vampire color. There was also a human color pass that was not included here. In the case of the transformation shots we used vein maps and projected ramps to make the transitions between skin colors more interesting than simple fades. It also allowed for these transitions to happen in the 2D department, again avoiding the need for re-renders of 3D to deal with relatively minor timing adjustments in the transformation.

Ambient: (Figure 15.127) The ambient pass we worked with represented two types of information, ambient lookup and ambient occlusion. The ambient lookup aspect simulates the contribution of light bouncing around the environment in all directions. Ambient occlusion is based on the notion that less of this light will find it's way into the nooks and crannies of an object. Both of these values were generated by a shader solution called Image Based Lighting (IBL). We kept these two passes in the same image—ambient lookup in the RGB channels and ambient occlusion (which is a monochrome image) in the alpha channel. The ambient lookup pass is shown in Figure 15.127. Another method we used on this show is called Final Gather, available through Mental Ray, which behaves similarly to occlusion, but also provides color bleeding and UV-independent baking.

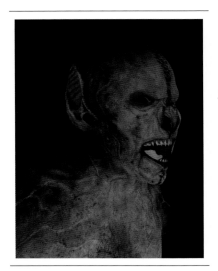

Figure 15.126 Color. © 2006 Sony Pictures Inc.

Figure 15.127 Ambient. © 2006 Sony Pictures Inc.

Alpha: Our master alpha matte (not shown) was placed in the "A" channel of the color pass and redirected wherever it was needed. This left the "A" buffer of every other pass open for additional mattes instead of including the same alpha in each pass.

Subsurface Scattering: (Figure 15.128) This is light that actually enters a translucent object (such as skin), bounces around a bit, and then exits. The way subsurface was handled for this show did not allow for each light to be separated. And so if there were any shots where the intensity of a certain light was incorrect or needed adjustment, there was no way to correct the subsurface pass except to re-render it with corrected values in the 3D scene.

Depth: (Figure 15.129) The depth or Z-depth pass is a matte pass that returns a value representing the distance from camera. We used a custom depth pass that was based upon the normalized values between clipping planes of the cameras. This depth information is used as a mask for color corrections and to apply things such as depth defocus.

Fresnel: (Figure 15.130) This is a pass used mostly to multiply against the reflection pass—to control how much reflection is visible to the camera based on the angle of the surface being viewed relative to the camera. Thus this pass represents the glancing angle of the geometry being rendered. If the surface normals are pointing directly at camera then a value equivalent to the specular roll off value (a rendering parameter) is returned. If the normals are perpendicular to camera a value of 1 is returned.

Additional Passes: As mentioned, there were a number of additional passes that might be generated for any given shot. Some of these would be used to control lighting characteristics (such as the mask shown in Figure 15.131 which would be used to give some

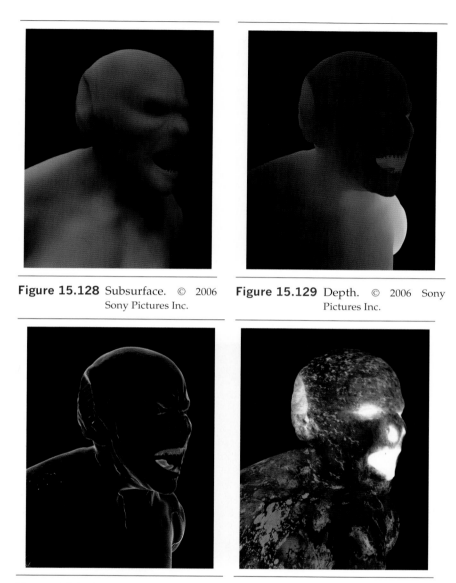

Figure 15.128 Subsurface. © 2006 Sony Pictures Inc.

Figure 15.129 Depth. © 2006 Sony Pictures Inc.

Figure 15.130 Fresnel. © 2006 Sony Pictures Inc.

Figure 15.131 Specular Breakup Matte. © 2006 Sony Pictures Inc.

"breakup" to specular and reflection areas) and other passes would be specifically to give control over some surface characteristics. Figure 15.132a, for instance, is rendered with a different set of veins kept in different channels of the image. The artist could, for instance, use the red channel as a mask to modify the veins that are on the character's torso. The alpha channel for this pass contains the fourth set of veins, as shown in Figure 15.132b.

Figure 15.132 Vein Mattes. © 2006 Sony Pictures Inc.

The final composite, then, is shown in Figure 15.133.

Figure 15.133 The final composite for a scene from *Underworld: Evolution.* © 2006 Sony Pictures Inc.

Since our lighting model is geared towards a multipass compositing pipeline, the number of elements per shot could have easily become unmanageable. There were anywhere from ten to as many as two hundred passes per shot. Giving the compositors all of this control was helpful, but a method had to be created to better allow the artists to deal with this large datasets. A stand-alone application was created to allow the lighters to communicate to the compositors when new renders became available and were ready to be updated into the comp. The compositors could then, at their convenience, choose to incorporate the new renders into their composite automatically without having to edit their scripts.

The composites themselves needed to be simplified as well. Every CG element in the show contained the same core group of passes, and therefore could be combined in a very similar way. Shots were first categorized into groups, such as, "werewolf," "wing,""fortress," etc. From there, template scripts for each type of shot were created. This ensured consistency throughout each particular sequence and reduced the amount of time it took to setup each composite. These templates, in turn, were at their foundations very similar to other templates. Once an artist became familiar with one of the templates, moving on to other types of shots was much easier, even for shots that were started by a different artist.

We also developed a method for easily rendering composites on the render farm. Due to the script-based nature of Shake (which was the compositing software we used for this show), we were able to eliminate the need for artists to manually change the version or output path for every render. The artists could simply choose the shot they wanted to render and send it to the farm with the click of a button. Full-resolution Cineons and jpegs were created along with video resolution quicktimes to handle the requirements of several different review processes.

Wallace and Gromit: The Curse of the Were-Rabbit

Wallace and Gromit: The Curse of the Were-Rabbit, is a stop-motion film created by Aardman Animation. The bulk of the digital visual-effects in the film were created by London-based Moving Picture Company. Stuart Lashley, the compositing supervisor for MPC on the show, talks about one of the shots they put together.

In this shot, Gromit (in an attempt to save Wallace from an experiment gone wrong) smashes the malfunctioning "Mind-o-matic" device, releasing Wallace from its grasp in an explosion of glass and electrical energy.

The aim for this shot was to create a spectacular shockwave explosion, which lights up the entire room, scattering shards of broken glass and dust in all directions. For comic effect it was decided that the more "over the top" the effect was, the better.

In stop-frame animation physical models and puppets are given the illusion of motion by photographing and repositioning them a single frame at a time. When these frames are played back in sequence, the puppets appear to be moving on their own. Because

the scene has to be completely static for each frame to be captured, any character or object that needs to appear to be flying, falling, or jumping through the air will need some sort of wires or rig to keep it suspended while the frame is being captured.

For the entire filming of this project, motion-controlled cameras were used for any shot, which required a camera move. The movement of motion-controlled cameras is completely motorized and controlled electronically using computer software. This allows the movement to be programmed in advance and, most importantly for this project, allows that movement to be accurately repeated any number of times. Which gives the cinematographer the ability to plan out the camera moves and have the camera automatically positioned for each frame before the moving objects in the scene are adjusted by hand. Using a digital "framestore" the animators had the ability to see their animation up until their current frame. At times they would make the decision to reanimate a part of the scene which would involve going back a few frames and repositioning the puppets and camera to pick up from that frame. Motion-controlled cameras make this process far less troublesome than a situation where the animator would be required to manually place the camera at a previous location.

The process of animating rotosplines for this project had to be approached in a slightly different way than normal as well. To start off with, most of the film was shot "on twos," meaning that each frame was captured twice, resulting in only 12 unique frames per second instead of 24. (Stop-motion animation is often done at 12 fps as it halves the amount of work required in what is generally a very time-consuming process. The visual result of animating this way is acceptable and consistent for the animation style, giving it a distinctive look.)

For this particular film, many shots would feature a mixture of twos and single-frame animation. When animating the splines for these shots the duplicate frames were first removed so that keyframes did not have to be placed on every frame of the roto animation. The same pattern of double and single framing was then applied to the finished rotoshape so it matched with the original animation.

Another slight difference compared to working with live action was the absence of any motion blur. This turned out to be an advantage when creating the roto shapes as all the edges were sharp and easily traceable. It is worth mentioning as well that on certain fast-moving shots motion blur was intentionally added by the animator using a technique called go-motion (as opposed to stop-motion). This would involve the use of a specially rigged character or background piece that was set up to automatically move (via computer-controlled motors) from one position to another. The camera would be set to a very long exposure time and while the shutter was open, the rigged character would be set in motion. This would give the impression of motion blurring on each frame.

The first job for the compositor on this shot was to remove the bits of wire that were used to suspend the parts of the broken Mind-o-matic as they fly through the air. This type of rig removal is frequently required throughout any stop-frame animation project.

In this case the rigs were removed by using a clean background plate—a plate which was shot using the motion-controlled camera so that both the animation frame and the clean-plate frame would line up exactly. It was then a reasonable simple job to paint through to the clean plate where necessary. For the few frames where parts of the rig pass if front of the animated objects or characters, the cleanup was done by cloning (again using paint tools) from other areas of the same image or from an adjacent frame.

Figure 15.134 shows three final frames from this sequence, featuring the glass housing before, during, and after the point of impact with Gromit's swinging wrench.

The electrical glowing rings inside the glass device—named "mindwaves" because they represented the manifestation of thoughts extracted from whoever is wearing the device—were created using 3D animation software and were styled to look like energy-emitting smoke rings. The actual render that was created in 3D consisted

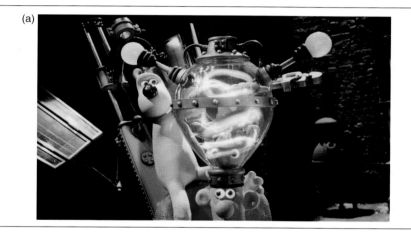

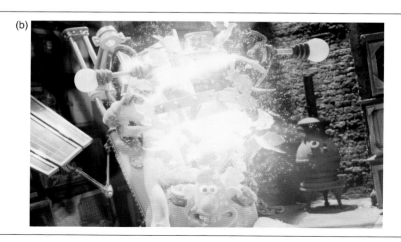

(c)

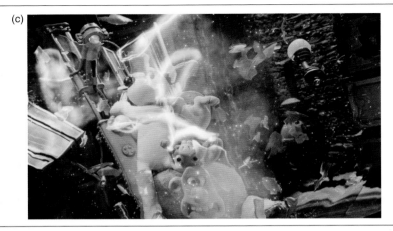

Figure 15.134 Composite images created for the film. *Wallace & Gromit: Curse of the Were-rabbit* images courtesy of Aardman Animations Ltd. © and ™. Aardman Animations Ltd. 2005. All Rights Reserved.

of the animated rings textured with very basic coloring (Figure 15.135) but with no special energy or glow effects added. These effects were all applied later in the composite, where the mindwaves were graded to have white-hot centers and colorful glowing edges. These same elements were also blurred and then added back to the image to give the effect of light emitting from them, illuminating the surrounding background plate. This was an important part of the integration of these mindwaves with the background—creating the impression that the light emitting from them was interacting with the surrounding physical objects in a realistic fashion. We achieved this by taking the luminescence of the existing scene and using that as a control channel to add additional colored light to the surroundings. In addition to using the luminescence channel as a matte, various spline roto mattes were created for all of the foreground characters,

Figure 15.135 "Midwaves" element for frame "a". © and ™. Aardman Animations Ltd. 2005.

as well as for the chair and apparatus directly behind them. This allowed the compositor to better control the amount of interactive light which fell on the surrounding objects and to create a greater sense of depth by having the illumination effect fall off as the object's distance from the source increased. These same mattes were also used to create some fake shadows on the rear wall and on the framework directly behind Gromit.

In this particular shot, the glass housing of the Mind-o-matic is physically present in the animated scene up until the point where Gromit hits it with the wrench. At this point the animator removed it from the scene (as in Figure 15.136) to allow for the digitally created glass to take over. The smashed glass was again created using 3D software textured in a way which closely replicated the reflective and refractive nature of the real glass (Figure 15.137). It was also animated in such a way as to make it look like stop frame animation—imperfections in the motion were deliberately added to give it that distinctive look. An additional touch when compositing the CG glass into the scene was to paint in some extra glints of reflected light to bring it to life a bit and add to the overall spectacle.

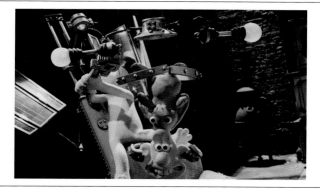

Figure 15.136 Original plate for frame "b". © and ™. Aardman Animations Ltd. 2005.

Figure 15.137 Broken glass element for frame "c". © and ™. Aardman Animations Ltd. 2005.

The energy explosion itself was done entirely in the composite and consisted of three main elements. The first of these was the bright radial flare of light, which happens at the moment of impact. This was created by taking the 3D mindwave pass, increasing the brightness a great deal and using a radial blur filter to give the impression of radiating light. In addition to this a practically shot lens flare was also added to help with the sense of photographic realism. As before, lumakeys and various roto mattes were used to create the interactive light and shadows needed help with the integration.

The second element of the explosion to be added was the expanding shockwave effect which follows the initial flash. This was done using a 2D animated and textured shape to drive a pixel warping filter which expanded the image slightly within the areas defined by the control shape. This produced a kind of refracting bubble effect.

The last element to be added to the explosion was the cloud of dust that gets left hanging in the air after the flash dies down. Because of the nature of the stop-motion process, organically moving elements such as this dust explosion, smoke, or fog could not be present in the scene at the same time as the animation was being done because the result would be a very erratically moving element and would look very unnatural. This meant that any scenes which required such elements had to be accomplished using visual effects. For instance, a number of scenes in this film required the addition of a dense hanging fog. In these cases fog plates were shot in real-time using the same sets, lighting, and motion-controlled camera moves as the animation plates so that the animated characters could then be extracted and composited into the live fog plates, giving the desired atmospheric result.

The dust element for this particular shot was a practical dust explosion shot over a black background (Figure 15.138). The element was retimed to match the pace of the scene, a lumakey was extracted and the result combined with a green tint to finish.

Figure 15.138 Dust element. © and ™. Aardman Animations Ltd. 2005.

Star Wars: Episode 3—Revenge of the Sith

Industrial Light and Magic is, of course, the company that George Lucas founded in 1975 create the visual effects for the original Star Wars film. In this final case study, Brian Connor, a digital compositor on Revenge of the Sith, *gives us a (very) detailed breakdown of the work he did on a shot from that film.[4]*

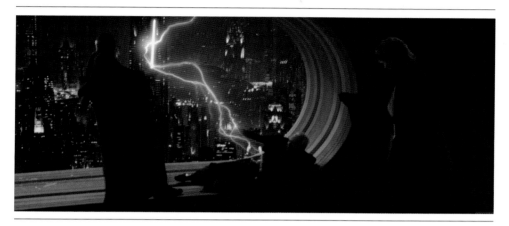

Figure 15.139 A final composite image from the film. *Stars Wars: Revenge of the Sith* stills courtesy of LUCASFILM LTD, © LUCASFILM LTD.

To those that do not do it for a living, digital compositing might seem as simple as A over B (except after C). For those of us that do, it can be one of the most arduous yet satisfying things on the planet. The process of layering all sorts of disparate imagery together and creating the illusion that it was all shot by one camera at the same time (while hiding all of the digital footprints behind this illusion) is an art form in and of itself.

The best compositors have developed a "good eye" by not being afraid to learn and listen to people who are more knowledgeable and/or more experienced than themselves. They understand that we are trying to emulate the reality that we all know through the lens of a camera. Knowing how the camera works by studying and replicating all of its wonderful attributes in the composite is why some composites look "real" and some do not. No wonder then that some of the top visual effects supervisors today are ex-cameramen from the traditional model and stage departments. This includes John Knoll, the main visual effects supervisor on all three prequels of the Star Wars saga.

In Episode 3, we find ourselves in the pivotal sequence where Anakin Skywalker is witnessing a battle to the death between Master Jedi Mace Windu and the now-exposed

[4]As an added bonus, Lucasfilm has generously allowed us to include all of the imagery related to this discussion on the DVD bundled with this book. This includes all of the original elements as individual files as well as several QuickTime movies. Also provided is the entire compositing script (built in Apple's "Shake" software) that was used to create this shot.

Lord of the Sith, Emperor Palpatine. While fighting a lightsaber duel, Palpatine loses his weapon and instead employs the unlimited power of the Dark Side—manifested as bolts of lightning—to keep Mace at bay.

For a good compositor, it is important to know what the "story point" of the shot is. That way you can intelligently add/subtract things to the composite to emphasize it. It's all about the story.

Breaking Down the Shot—ccm436

We'll be taking a look at the shot "ccm436." (Every shot in a production is given a name, generally based on some shorthand for the scene that it appears in.) Before we embark on the journey of creating shot ccm436, it is important that we first take a step back and analyze all of the different elements. As the saying goes, "Proper Prior Planning Prevents Problems." The elements that you receive for a shot may come from a variety of places and may not always "fit" together as well as expected. It is good practice to do a quick "slap comp" or "bash comp" to make sure all the pieces fit together. That way, strategies or workarounds can be identified and implemented early on to ensure the shot comes together successfully. That way, you have time to not just put it together, but to polish the pixels and make it look good.

There are probably more than 10 ways to do just about everything in compositing. Deciding ahead of time on the right strategy can sometimes prevent one from comping themselves into a proverbial corner. At Industrial Light + Magic (ILM), we typically try and layer a shot from the background to foreground. This method makes it conceptually easier to organize and to add photographic attributes like background "light wrap" onto a foreground object.

Take a moment and view all of the movies and/or stills for each of the elements listed below. Feel free to create a quick composite using your software of choice to see how everything fits together and don't forget to pay particular attention the duration of each element.

The basic list of elements is as follows:

The Background

- City cyclorama (also known as city cyc)—a digital matte painting.

- City cyclorama Z-Depth—the depth pass for the city cyc.

- CG traffic—rendered as multiple passes (ambient, diffuse, specular, etc.), including a separate "light panel" render for all the illuminated lights and interiors of the different vehicles.

The Foregrounds

- Bluescreen (bg)—a miniature set.

- Bluescreen (b1)—the take that will be used for Anakin's head and arms only.

- Bluescreen (b2)—the primary take, which will be used for Mace Windu, Emperor Palpatine, and Anakin Skywalker's torso/robe.

Additional Rendered Elements

- CG ledgeShards—rendered with a separate specular pass.
- CG brokenWindow—also rendered with a separate specular pass.
- CG lightning Elements—rendered in three pieces: the "Arc Bolts," the "Finger Bolts," and the "Saber Bolts."

Generic Elements

- Smoke for outside atmospherics.
- Smoke to breakup the user-created glows.
- Sparks for lightning hits.

Additional Elements

- The lightsaber rotoshape.
- Misc additional rotoshapes.

Being as astute as we are, we notice a few things after having examined all of the elements:

- The city cyc and all its associated elements are rendered oversized and need to be repositioned (translated) into position. This is done by a bit of trial and error, and is usually dependent on the position of the city cyc in surrounding shots. The final positioning was decided by the VFX supervisor as part of the daily review process.
- The Bluescreen (bg) miniature set element is only 24 frames long. This means we will have loop or "ping pong" those 24 frames.
- The Bluescreen (b2) plate is the main foreground for the actors and partial set. This plate is the "master" plate in terms of positioning for all the other elements in the shot. Looking at the bluescreen backing, it is pretty obvious that multiple extractions (keys) will need to be combined in order to get the final matte.
- The Bluescreen (b1) plate is an alternate take that will be used soley for adding a new head and arm to Anakin.

Note: In this day and age of digital manipulation, it is not uncommon for a savvy director to use different takes for each actor in a scene, "splitting" them together to form the final shot. It should come as no surprise then that the owner of ILM, George Lucas, takes it a step further and sometimes "creates" the best take of an *individual* actor by combining pieces from different performances. The b1 plate will be used to *replace the head* of Anakin in the b2 plate and *add a hand and arm*. For the two different elements actions to sync up, b1 will need to be slip-synced 8 frames so that frame 8 of b1 is frame 1 of the composite. So much for A over B! More on this later….

But Wait... There's More

In addition to replacing Anakin's head and adding an arm, the actual composition of the shot needs to be recomposed. The FX supervisor decided that there was too much dead space to the left of the shot, in essence, the right side was visually too heavy. To remedy the situation, it was decided that the shot be "blown up" or enlarged so that the action was more centered and balanced. This has the effect of focusing the viewer's attention on the storypoint of the shot, the reason for the shot's existence.

The Plan

We have examined all of the elements. Based on our examinations and extended conversations/confirmations with supervisors from various departments, we can now create a plan of action for each layer of the composite. With this shot, the actual production involved the work of several people. At a large facility like ILM we have the luxury of requesting help from different departments to assist with various pieces of the process. In this case we requested that someone provide assistance in creating the many articulated mattes that will be needed to complete the shot. (In a smaller facility you would probably end up doing this work yourself.)

Thus we submit multiple requests for the following articulated mattes (rotoshapes):

- A mask to remove the head and arms from the b1 plate for later use.
- A mask to remove the head from the b2 plate.
- An additional "helper" matte to aid in the extraction of Anakin's robe from the background.
- An additional "helper" matte to aid in the extraction of shadows on the floor.
- An additional "helper" matte to aid in the extraction of Anakin's feet.
- Miscellaneous mattes that will be used to split between the b2 and the miniature plate.

We will also submit a request to have dirt and dust removed from the bluescreen plates.

Creating the Background

The plan for creating the background is as follows:

1. Create a precomp (precomposite) of the background city cyclorama (cyc) using a Z-depth matte to color correct.
2. Create an animated generic Smoke element to add a heat ripple effect to distant buildings.
3. Combine the separate Traffic passes and integrate them to the city cyc. Color correct using the traffic's Z-depth matte to match the color of the city cyc.

4. Add the lights on the traffic. We can blur and reuse this element in various ways to create and add appropriate glows.

5. Reposition the entire city cyc and traffic precomp based on layout reference.

The City

The background for the shot is a large cyclorama image—what we called "city cyc" for short. The city cyc consists of oversized renders of the city planet of Coruscant—a place that makes New York City look like Lost Springs, Wyoming (Population: 1). At this point we only have a single, static frame of this background, which we'll still refer to as a "matte painting" even though it was constructed with a combination of painted and rendered elements. This image is shown in Figure 15.140.

Figure 15.140 The background city cyclorama precomp, without traffic. © LUCASFILM LTD.

We need to add several additional elements to this still frame to produce an animated background (which will actually be used in multiple shots in the sequence). Putting together, or "precompositing" backgrounds for this purpose can save *enormous* amounts of time. In this case, the background city cyc is rendered "oversize" so that it may be moved around in frame while maintaining its overall image integrity. As a compositor, you may be asked to precomposite a background to be used by multiple artists.

Usually a Z-depth matte is also created so that even though the city cyc is "baked" (i.e., all the buildings are combined into one image), an artist can still have some way to manipulate the image sequence with a grayscale matte. In this case the matte's intensity is based on the distance from the camera. Typically Z-Depth mattes are used to add atmospheric haze and depth of field. They can also be manipulated and used to isolate and affect specific areas as well. The depth matte for our matte painting is shown in Figure 15.141.

Figure 15.141 The background city cyclorama Z-Depth pass. © LUCASFILM LTD.

Atmosphere

If we look up at the stars we notice a slight twinkle. This, of course, is caused by the intervening atmosphere of the Earth. When viewing Las Vegas from atop the swanky Palms hotel, one can see a similar effect, in this case caused by heat trapped in the ground during the day and released into the cold night air.

This heat ripple effect will be used to add life to our static still of the city planet. Creating heat ripple is a relatively simple process and starts with some type of noise-based image. Procedurally generated grain is a form of noise that, when blurred, gets chunky. For our purposes, we do not want the "pattern" to be too large which means that only a slight blur is required. That coupled with some added contrast gets us most of the way there. The last thing needed is to animate the parameters of the grain until the size and speed "look right." This new element is then used to drive a "Displace" plugin/filter applied to the city cyc whereby the white parts of the control image "push" the image and the black parts "pull" creating the displacement.

Figure 15.142 The final animated smoke used to displace the city cyc. © LUCASFILM LTD.

Figure 15.142 shows an example frame of this noise (but of course you really should view the animated sequence on the DVD to get an understanding for the type of movement it contains).

Traffic

Figure 15.143 The RGBA traffic pass (with an area enlarged to show detail).
© LUCASFILM LTD.

What crowded city would be complete without its associated traffic? The traffic, like most renders these days, is rendered in multiple passes for maximum flexibility. When added together, the various amounts of each Ambient, Diffuse, Specular, and Reflectivity pass (among others) in sum constitute the lighting of the traffic. This allows the compositor, for better or for worse,[5] to "relight" the rendered traffic by manipulating the different passes. With renders that would otherwise take up to 12 hours a frame to compute, moving the relighting capabilities to the compositing step is an extremely important part of an efficient workflow.

As the objects move farther from the camera, they tend to lose contrast, saturation, and sharpness. Objects farther away also tend to take on the color of the surrounding environment sometimes referred to as atmospheric haze. The Z-depth matte allows us to mimic these "real-world" attributes.

Anything that is rendered usually comes out as a "premultiplied over black" image. We won't go into all the gory details here as, by this time, Ron has already defined exactly what a "premultiplied" image is. Suffice it to say, when color correcting a rendered image, we need to separate the traffic's color (red, green, blue) channels from its associated alpha (matte) channel. "Unpremultiplying" the image (dividing the color by the alpha) and *then* color correcting and/or adding haze allows it to be applied at full strength all the way to the very edge. Not doing so might cause premultiplication errors such as black fringing.

[5]"For better or for worse" because the image can be relit to such an extent that the technical director who created it may have a heart attack when viewing the modified result.

In a congested city planet, one would expect the traffic to have the typical turn signals and brake lights. The Light Panel pass should be added to the city cyc/traffic precomp.

In a city of lights and traffic, we need to create and add atmospheric glows. To create a convincing glow usually requires a "core" glow and a "soft" glow. The core is often very hot and is generally created by taking the primary Light Panel pass and blurring it slightly the soft glow is done by blurring the Light Panel pass even more with a Fade used to take down the intensity. We'll use similar techniques for all of our glows—for example, the infamous "lightsaber" is made up of a single-animated matte with various color corrections and blurs applied to it. More on that later...

Note: Elements representing the light emitted from an object are usually Added or Screened onto a background. When using one of these functions, it is important that we zero out or kill the alpha channel as it can cause "problems" later on.

Creating the Foreground

No background city would be complete without something happening in the foreground. Sure, the cities are pretty, but the shots exist in service to the story. The *ccm* sequence is where we find out how Emperor Palpatine gets disfigured, when Anakin officially turns to the Dark Side, and how Mace meets his doom.

Most shots in Star Wars Episode 3 feature elements that were shot against a blue- or greenscreen backing. Shot ccm436 is no exception. There are a total of three separate bluescreen elements that will make up the "foreground" for this shot. We will first extract the b2 bluescreen and make that our master plate for the other elements to match to in terms of position, rotation, and scale.

The b2 "Master" Bluescreen

Figure 15.144 The b2 "master" bluescreen plate. © LUCASFILM LTD.

Foreground B2 Plan

1. Paint out tracking markers of b2 plate.

2. Extend the robe to fix "edge of frame" issues.

3. Super-saturate the b2 plate to even out the uneven bluescreen, simplifying the extractions.

4. Create multiple extracted mattes for the "edges" and "core." Combine into one final matte for extraction.

5. Create articulated helper mattes to split between the B2 plate and the bg miniature plate (used to also remove Anakin's head).

6. Create articulated helper mattes to assist in the extraction of Anakin's feet.

7. Suppress the blue spill and color correct the plate to match the surrounding shots in the sequence.

Prepping the B2 Bluescreen

Figure 15.145 The b2 plate with tracking markers painted out and image extended for robe fix. © LUCASFILM LTD.

The first thing we need to do before pulling a matte is to cleanup and prepare the bluescreen. Doing so will enable us to get a better extraction faster. Using a paint program (or a paint module in our compositing package), we will start by painting out the tracking markers. An appropriate blue color could be sampled and used to cover these markers or (even better) we can find "clean" portions of the bluescreen and paint/clone those areas over the markers instead. The primary advantage of doing it this way is that we get matching grain for free, which will make it more consistent later on when we are pulling a key for this shot.

We will also (once we've finished the comp) end up repositioning this element to achieve a new framing. But doing so will cause "edge of element" issues with Anakin's robe in the b2 element. The missing part of the robe will have to be "repaired." This

can be done with a combination of compositing and paint. The widened frame with the tracking markers removed is shown in Figure 15.145.

Figure 15.146 The b2 "supersaturated" element. © LUCASFILM LTD.

Figure 15.147 The supersaturated element Added to the original b2 plate. © LUCASFILM LTD.

The second thing we can do to ensure a better/cleaner extraction is to "even out" an unevenly lit bluescreen. This can be accomplished (using our favorite keyer such as Keylight, Primatte, Ultimatte, or other proprietary keyer/method) by doing an initial "soft" extraction—one that gives us a matte, which has partial density in areas that are less-than-perfect blue. We Subtract that grayscale image from the original b2 element. This gives us a supersaturated "blue only" element (Figure 15.146) that can then be Added to the original b2 bluescreen. Adding the supersaturated element has the effect of *evening-out* the different areas of the bluescreen.[6] This new and improved bluescreen (Figure 15.147) will make life easier in the next section.

[6] At ILM we also have some proprietary tools for helping to blur the bluescreen areas a bit, the result of which can be seen by comparing Figures 15.145 and 15.146—notice the way the on-set fan has been blurred.

Procedural Extractions and the "Perfect" Matte

Creating a matte can be done in numerous ways. Procedurally generating a key or matte to be used to place an element "Over" a background is one of the most fundamental things we do in compositing. A common mistake is to think that a single procedural key/matte can be forced to create a matte that had both density in the interior *and* still have detail in the edges. A better approach is to create multiple extractions:

- An "edges" matte with a *soft* extraction that is solely to capture appropriate detail on object edges. This matte does not need to have density or be fully opaque—we're only concerned with getting good edges (with an appropriate bit of transparency) on the foreground objects. See Figure 15.148a.

- An "inner" matte with a *hard* extraction that is fully opaque. This matte is used to fill in the inner (inappropriately transparent) areas of the "soft" matte. See Figure 15.148b.

- A user-created rotoshape is needed to "take out the garbage" hence the name "garbage matte."

Figure 15.148a The soft "edges" matte. © LUCASFILM LTD.

Figure 15.148b The hard "core" matte. © LUCASFILM LTD.

- A user-created rotoshape can also be created to "hold out" the background. This matte is combined with the soft edge and the core mattes to add opacity to problem areas.

We do this multipass key pulling because usually we'll see that the finely detailed edges of a matte are compromised when "forcing" the inner core of the matte to be fully opaque. Creating multiple mattes and then *combining* them into a single "perfect" matte is the way to go. Our combined matte is shown in Figure 15.149.

Figure 15.149 The combined soft "edges" and hard "core" mattes. © LUCASFILM LTD.

Suppressing the Spill

Figure 15.150 The spill-suppressed and color-corrected b2 plate. © LUCASFILM LTD.

In any environment, light bounces off all sorts of surfaces multiple times. Naturally then, whenever a foreground is shot against a colored backing, bounce-light from the backing "spills" onto objects in the foreground. This spill must be removed or "suppressed."

Another common mistake is to try and do the spill suppression within the procedural extractor itself. As stated previously, the *ideal* matte is almost always a combination of multiple mattes. By the same token, it makes sense to treat the color and matte as two

separate things. That way, the spill suppression is not based on a matte but is applied to the entire image. This technique gives us a better spill-suppressed result overall.

Spill suppression using a variety of plug-ins and/or color expressions can be used to get rid of unwanted spill. Color correction to match the foreground plate into the background and/or surrounding shots can also be applied at this point. The RGB color must then be combined with the "final" matte or alpha. We currently have a separate RGB color image or "unpremultiplied" image and the final matte. To combine the two so that the matte cuts out the extraneous spill-suppressed RGB image, we need to multiply the RGB color by the alpha matte. We will combine our "perfectly" spill suppressed and color-corrected RGB, with our combined "perfect" final matte, giving a "perfect result."[7] This "premultiplied over black" element is now ready to be put over the background city cyc.

Using essentially the same procedures we can now either move on to extracting the bg miniature bluescreen or the bs1 head and arm bluescreen.

Note: Never, never, never blur the edges of your edge or final matte. If there are problems with your matte then you need to go back and redo the extraction. In fact, if your final matte is a bit "crunchy," sometimes a touch of "edge blending" on the foreground Over the background will solve all your "problems" automagically. Use with caution as nothing gives away a composite faster than blurred edges.

Figure 15.151 The spill-suppressed b2 plate combined with (multiplied by) the "final" matte. © LUCASFILM LTD.

The B1 Head and Arm Bluescreen
Foreground B1 Head and Arm Plan

1. Create multiple extracted mattes. One for the screen-left side of Anakin's head and another for screen-right side. Combine into one final matte for extraction.

2. Create an articulated rotoshape helper matte to fill-in the areas in-between left and right side head mattes.

[7] Your results may vary.

Figure 15.152 The b1 "head and arm" bluescreen plate. © LUCASFILM LTD.

3. Create articulated rotoshape to extract the arm.

4. Suppress the blue spill and color correct the plate to match the b2 "master" plate.

5. Slightly sharpen head color and multiply color by the matte.

6. Animate the head to match the size and position of the original b2 head and body.

7. Animate the arm to the b2 "master" plate until it looks "right."

8. Add matched grain to motion-blurred head and arm elements.

I am fond of saying that *"Once you have a matte, you're golden."* Though not the most eloquent of phrases, it holds true in most cases. For example, the final matte we made for the b2 plate can be repurposed to generate "Edge Wrap" from the "outside" city cyc precomp onto the edges of the foreground b2 plate. The same matte can be used for edge blending; used to constrain an interactive light effect we will discuss

Figure 15.153 The luminance-keyed matte that will be used for the left side of the head. © LUCASFILM LTD.

Figure 15.154 The keyed matte that will be used for the right side of the head. © LUCASFILM LTD.

Figure 15.155 The left side of the head isolated with a combination of a rotoshape and the matte from Figure 15.153. © LUCASFILM LTD.

Figure 15.156 The right side of the head isolated with a combination of a rotoshape and the matte from Figure 15.154. © LUCASFILM LTD.

later and in more detail. What we will do is use everything we have done for the b2 plate and reuse it for the b1 head and arm plate. This can be accomplished by simply copy/pasting what we have done thus far in our compositing tree, swapping out the b2 footage and using the new b1 elements, adjusting the procedural extractions and associated helper mattes, and *Viola!* We are 90% of the way there! It's all about efficiency. The more iterations we can do before the shot is targeted for completion, the better the Final result.

At this point we are only concerned with the extraction around Anakin's head and arms (since that's all we're going to be using from this element). Since part of his head is over the set piece (which is unevenly lit), we will have to, once again, create multiple extractions and combine them for the "final" head matte. The screen-right portion of his head will be done with a procedural extraction focusing only on those areas of his head. For the screen-left side of his head, we will do a series of lumakeys based on the red and green channels. Use of articulated (animated) rotoshapes will constrain the lumakeys to only the areas of interest.

For the arm, a rotoshape is all that is required to extract the arm off of the b1 plate. Once done, both the extracted and spill-suppressed head and arm elements will have to be hand-animated to match properly with the b2 plate.

(a)

(b)

Figure 15.157 (a) The mattes for the right and left side of the head combined together. (b) The "final" premultiplied head (shown composited over gray). © LUCASFILM LTD.

An important thing to note is that whenever we translate or move an image that image is resampled. If we resample an image too many times by animating, the image tends to soften. Knowing this, we can try and compensate for the loss of detail by "Sharpening" the RGB color *before* it is premultiplied with the combined mattes. Another trick is to reduce the amount of motion blur[8] usually added when translating. Finally, we need to add "Grain" back onto our now slightly motion-blurred head and arm elements that exactly matches the b2 plate in *each* red, green, blue color channel.

Figure 15.158 (a) The arm rotoshape. (b) The "final" premultiplied arm. © LUCASFILM LTD.

A final note: Animating body parts (or human movement in general) can be a very time-consuming process. What looks "right" to you may not to your supervisor(s). Iterations are part of the process that, in the end, will (hopefully) make for a better result.

bg "Miniature" Plate

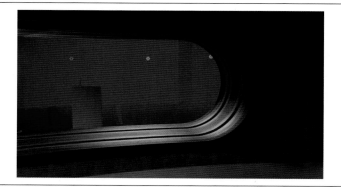

Figure 15.159 The bg miniature bluescreen plate. © LUCASFILM LTD.

[8] Normally the compositing software will add motion blur that is consistent with the amount of movement the object is undergoing. But in this case we are already introducing softness due to the resampling of the object so we can get away with using less than a "normal" amount of motion blur for this element. Instead of using the default 180° shutter setting, we dropped the value down to about 120° instead.

Foreground bg "miniature" plate Plan

1. Create multiple-extracted mattes and combine into one final matte.

2. Create a user-created rotoshape "helper" matte to help split the b2 plate over the bg miniature plate.

3. Suppress the blue spill and color correct the plate to the "master" b2 plate.

4. Reposition the bg miniature plate to match the b2 plate. Use a cornerpin to match the differences in perspective.

5. Lengthen the duration of the plate by repeating the 24 frames.

6. Make sure grain matches the b2 "master" plate.

Like we did for the previous b1 "head and arm" plate, we can reuse everything we have done for the previous extractions and color corrections. As before, this can be accomplished by simply copy/pasting; swapping out the footages; adjusting the procedural extractions and associated rotoshape helper mattes.

Since this plate is a "locked off" shot with no movement, our matte can simply be a rotoshape that can be used as a stencil to cut out all of the unwanted areas of the backing. The only problem is that the rotoshape we create would have to match the shape of the opening perfectly. Though this seems like the most efficient use of our time, using rotoshapes when a perfectly good backing is available actually works against us in terms of creating a "photorealistic" shot.

There are few things that the human brain is better at picking out than perfect lines and edges made using software. A tip that also generally applies to anything computer generated. As the saying goes *"There are no straight lines in nature."* With that in mind, we will use our favorite procedural keyer to extract the area inside the window so that we get all the nooks, crannies, and general imperfections for free. We can then create a rotoshape to remove "the garbage."

Figure 15.160 The bg miniature spill-suppressed and multiplied by the matte.
© LUCASFILM LTD.

Now that we have a matte, we need to spill suppress and color correct the bg miniature sequence. Again, we should start with the same spill suppression and color correction we used for the previous two plates. This gets us most of the way there and requires less time. Do we see a pattern emerging yet?!

We can now multiply the spill suppressed/color-corrected color with the extracted matte. This gives us our premultiplied over black image that is now ready to be repositioned and placed over the combined b2 and b1 plates.

Using position/scale/rotate allows us to get the bg "miniature" plate lined up as close as possible to the b2 "master." Using a Fade, we can temporarily make the bg miniature plate semi-transparent. This will help us line the two plates up more easily and interactively. As we notice, the bg "miniature" plate will need a slight cornerpin adjustment to compensate for the difference in perspective.

Now that we have the two plates lined up, we need to create a rotoshape to "split" between the combined b2/b1 plate and the newly created bg miniature plate. It should be noted that we are only using the floor, side wall, and upper wall of the bg miniature. This plate will be "under" the b2/b1 combo so split accordingly.

LedgeShards and BrokenWindow Renders

Figure 15.161 A combination of "broken window" and ledge shards' renders. © LUCASFILM LTD.

Ledge shards and broken window Plan

1. Add the different ledgeShards passes together.
2. Color correct the ledgeShards to the color temperature of the room/set.
3. Add grain to the ledgeShards, and Add them to the combined b2/b1/bg composite.
4. Add the different brokenWindow passes together.
5. Color correct the brokenWindow pieces to the color temperature of the room/set.

6. Reposition/duplicate the brokenWindow pieces to stay in-frame.

7. Add grain to the brokenWindow pieces. Place them Over the composite.

In the sequence that our shot is a part of, Mace and Palpatine are locked in a duel to the death. Things have a tendency to get broken which is what happened to the window in an earlier shot. This means that we need to add glass shards and glass pieces to the window opening.

Since this is a "locked off" shot with no camera movement, we can save time by rendering out and using a single frame. The bonus is that we don't have to worry about any scintillating/sizzling artifacts that small glass pieces sometime produce.

Most renders these days produce multiple passes that are Added together to achieve the final RGBA image. As mentioned in the Traffic section, this allows us maximum flexibility to color correct and manipulate the image. In this case, we have only separate RGBA and Spec (specular) renders for both the ledgeShards and brokenWindow renders.

The ledgeShards and ledgeShardsSpec renders must be added together. We also need to color correct the shards slightly darker so as not to attract too much attention to them. The same applies to the brokenWindow and brokenWindowSpec renders though these will need a little bit more comp "love." Color correction using simple rotoshapes to isolate different areas of the same render needs to be done to broken-Window pieces on the ledge and pieces on the floor.

Both renders will need the same sort of grain that we previously matched to the b2 plate applied. It is important that the added grain only resides within the matte[9] of the ledgeShards and brokenWindow pieces. Failure to do so means we would be adding extra grain to the entire composite, which would be "bad."

Now that we have our prepped renders, we need to Add them to the composite. The ledgeShards are meant to be Added to the composite which means we have to make sure we remove or kill the alpha channel if it has one. The brokenWindow pieces are placed Over the composite and therefore should have an alpha channel. We "may" have to bump up or Brighten the alpha channel only to make sure the pieces are visible.

Note: We will be repositioning the entire shot at the end so that the action is more centered and the composite more balanced. This will obviously affect what will be seen in the final image. Using a rotoshape we can isolate and move (or even duplicate) pieces of the glass fragments so that they will be visible with the new framing, and we can clear out any brokenWindow pieces that fall in undesirable locations.

[9] If a rendered element does not have an alpha channel, you may have to create one by using a luminance key or a mix of different color channels.

Effects

Now that we have our basic foreground and background elements in place, it's time to put on the finishing touches. The exciting bits that give the shot its energy and "electricity."

Lightsaber

Figure 15.162 The final color-corrected and blurred lightsaber.[10] © LUCASFILM LTD.

Lightsaber Plan

1. Create a rotoshape of the "standard" six-pointed lightsaber matte animated to match the on-set prop stick. (We'll create four different lightsaber elements from the same matte.)
2. Create the "core" element. Color correct it off-white.
3. Create the "core glow" element. Color correct, blur, undulate in brightness.
4. Create the "glow" element. Color correct it to be purple; blur; undulate in brightness.
5. Create the "big glow" element. Color Correct it to be purple and blur *more.*
6. Screen all the lightsaber elements together.
7. Add grain to the lightsaber elements. Use a lumakey to constrain.
8. Add the "final" lightsaber to the composite.
9. Create glows and interactive light to be applied to the combined b2, b1, and bg miniature sets.

While prop sticks are nice, no "duel to the death" would be complete without the requisite lightsabers. In a previous shot, Master Jedi Mace Windu has unceremoniously relieved Palpatine of his lightsaber and he must now rely on his powers from the Dark Side, lightning.

Lightsabers (and lightning for that matter, which we'll look at next), start as simple black-and-white single-channel matte images. We need to create and animate a

[10] For these next few layers we've chosen frames from a different time point in the shot in order to better show off the element's characteristics.

rotoshape using the on-set prop lightsaber hilt and stick as reference. Having put together more than a few lightsaber effects over the years, ILM has a few basic rules for their creation and animation:

1. The lightsaber rotoshape should contain three points at the tip and three points farther apart at the hilt.

2. The shape of the lightsaber should be longer and slightly wider than the on-set prop stick.

3. Lightsabers are *not* motion blurred. We must animate the shape of the rotoshape to match the "fan" of the motion-blurred prop stick in order to ensure that the whole region blows out to complete brightness. This means we need to turn moblur "off" for any lightsaber matte.

4. Lightsabers of yore were hand drawn, frame by frames, which is what gives them the "living" look and feel. In CG, this is achieved by procedurally animating multiple Brightness color corrections (see the curves at the end of this section).

Note: When creating the lightsaber rotoshape, it is important to move the "pivot point" of the shape to the base of the hilt. This makes animating the rotoshape orders of magnitude easier. Apply this concept to just about any object that has a well-defined point of rotation.

Figure 15.163 The color-corrected "core" rotoshape for the lightsaber. Notice that the pivot-point has been placed at the base of the hilt. © LUCASFILM LTD.

Figure 15.164 The slightly blurred, undulating "core glow." © LUCASFILM LTD.

Figure 15.165 The color-corrected, blurred "glow." © LUCASFILM LTD.

Figure 15.166 The color-corrected, blurred "BIG glow." © LUCASFILM LTD.

Once we have the animated rotoshape, we can *create the four different elements that are all derived from the same matte*. The first is simply color-corrected slightly off-white and will serve as the solid "core" of our lightsaber. The second is slightly blurred and brightened. An additional procedurally driven Brighten color correction is added to undulate the size and brightness of what will be the "core glow" element. The third will be color corrected to purple, blurred a bit more, and brightened three times as much (which makes the glow effect appear larger). As before, an additional animated brightness color correction is added to undulate the size and luminance of what will be the "glow" element. A final color-corrected, BIG blurred and triple-brightened color correction makes up the lightsaber's "BIG glow."

(a) (b)

Figure 15.167 (a) The Brightness curve for "core blur." (b) The Brightness curve for the "glow." © LUCASFILM LTD.

All four of the above elements are Screened together to create the "final" lightsaber. Once grain is added, the new lightsaber element can be Added to the comp.

Lightsabers should always be treated as photon-emitting objects. We can use the "final" lightsaber element and manipulate it to create an interactive light element to affect other objects in the scene. This can easily be achieved by, once again, *reusing* an element we have already created. By color correcting the final lightsaber, blurring the heck out of it and brightening it again, we get a new element that can used where appropriate. More on this in the next section.

It is important to note that an interactive light element of this sort can not only be added to another element to provide color and brightness, but it can also be used as a mask to drive a color correction (or any other effect). The wonderful thing about using an element to manipulate another is that you get changes in the manipulating element for free. This *procedural* matte means that mattes based on changing elements like sparks and lightning will automatically drive the same changes on the other elements.

Lightning Renders
Lightning Renders Plan

1. Combine each rendered lightning pass and create four different lightning elements.

2. Create the "core" element. Color correct it to be slightly off-white.

3. Create the "core glow." Color correct, blur, and give it an undulating brightness.

Figure 15.168 The combined color-corrected and blurred lightning renders. © LUCASFILM LTD.

4. Create the "glow." Color correct it to blue and blur it

5. Create the "big glow." Color correct it to blue and blur it *more.*

6. Add all the lightning elements together.

7. Add grain to the lightning elements. Create a lumakey to constrain where appropriate.

8. Add the "final" lightning to the composite.

9. Create lightning glows and interactive light to be applied to the combined b2, b1, and bg miniature sets.

Using our time as efficiently as possible means that we will spend less time *assembling* the comp and more time *polishing* it. Instead of reinventing the wheel, we are going to take the same setup we did in the section lightsaber and apply it to our lightning renders. With some minor tweaking we can finish off the lightning element and move on to the next one.

Figure 15.169 (a) Three separate lightning elements, one in each color channel, that will arc from the lightsaber. (b) Lightning elements that will emit from Emperor Palpatine's hands. © LUCASFILM LTD.

Speaking of working efficiently, you may notice that each of the lightning renders are very … shall we say … colorful. This was done on purpose and is an old compositing trick used to save space. If we view each of the red, green, and blue registers we will see *a separate lightning element in each channel.* In the comp, we can separate out each color channel and manipulate it individually if needed.

Once we have all of our passes color-corrected, blurred and added together, we can apply some grain and Add them to the composite.

Figure 15.170 (a) The color-corrected, blurred "glow." (b) The color-corrected, blurred "BIG glow." © LUCASFILM LTD.

Like we mentioned in the lightsaber section, we are going to need to create an interactive light lightning element. Fortunately for us, all the "heavy lifting" is done. We only need to take the "final" combined lightning element and manipulate it until we get the desired result. Using multiple brightness effects and large blurs will quickly get us to where we want to be. We can then use the matte from the combined b2/b1/bg plates to constrain our newly created interactive light element as shown below.

The lightning interactive element can then be Added to the rest of the composite. Again, the procedural nature of it means that where the lightning hits, we get realistic looking interactive light onto the surrounding objects. This goes a long way in making the audience *believe* in the power of the Dark Side.

Figure 15.171 (a) The interactive light element used to affect the surrounding areas. (b) The interactive light element premultiplied by the foreground's matte. Note that the effect is most noticeable around Mace's hand and on The Emperor's upraised arm. © LUCASFILM LTD.

Generic Elements

Generic Elements Plan

1. Add fast moving steam/smoke outside the window to increase drama.

2. Use the smoke element as a matte to "break up" our user-created interior lightning glows.

3. Add optional spark elements to lightning hits.

Figure 15.172 The generic smoke element. © LUCASFILM LTD.

There are few things in compositing that have a more *unifying effect* than adding in generic elements. These are often referred to as "practical" elements and can include smoke, steam, mist, rain, splashes, water, dust, fire, sparks, debris, and more. These generic elements are basically anything shot on-stage, sometimes for a specific shot or sequence of shots, sometimes as part of a facility-wide library of such elements. The more "real" elements we have in our composite, the more the audience *suspends their disbelief*. In our case, adding fast-moving steam that is flying from screen-left to right outside the window where the epic battle is taking place adds a sense of danger and excitement.

Generic elements do not have to be used literally. For example, we can also use a slow moving smoke element as a matte[11] to "break up" the lightsaber and lightning glows we created earlier. Using the smoke element shown in Figure 15.172 for example helps take the "CG Curse" off of our glows – it adds complexity, and makes the glows feel more "real."

It is important to note that there are many ways generic elements can be added to the comp depending on the desired effect. Some elements like sparks and lightning should be Added to a composite. As the name implies, this *adds* the value of the background and the foreground together and gives it more *punch*. Some should be Screened onto the comp. Screening an image brightens the darker areas of the background but leaves the brighter areas untouched. Finally, some elements like mist and fog should have an alpha channel so that they can be placed Over the background. Using an Over allows the background to be more realistically *occluded* by foreground generic elements. Take the time to experiment and see the difference between these commonly used layering techniques.

Final Assembly and Reframing

Final Assembly/Reframing Plan

1. Scale up and reposition entire comp based on layout reference.

2. Add camera shake.

[11] Many practical elements are shot over black. This makes it pretty easy to create a luminance key (matte) of the element. A common approach is to use the generic element as a matte and combine it with a super-blurred color image of the background. The nice thing about using this procedural technique is that you get the color of the background as well as all its associated lighting changes (if any) for FREE!

3. Add Grain if necessary.

4. Crop everything from 16:9 to 2.35.

Figure 15.173 The original (16:9) framing with the final (2.35) framing indicated by the yellow border. © LUCASFILM LTD.

As we mentioned in the beginning of this case-study, there was a decision made to re-frame the entire shot relative to the original framing, centering on the main characters and pushing in by a rather significant (20%!) amount. The Layout department would typically provide information about any shot modification of this sort and, in this case, Editorial also provided us with quick Avid composites that we could use for guidance.[12]

As with many of the other aspects of compositing that we have discussed, there are often several potential routes to the final result. In a perfect world we would have identified the necessary repositioning for the elements and the new shot framing *before* we started, which would have allowed us to do one reposition of the entire comp at the very end. But in this case the final layout for the shot changed multiple times, which is why each element was moved separately into place within the body of the comp.

Now that we have all this "extra" real estate to play with (extra pixels around all four sides of the image due to the push-in), we can add even more excitement/energy to the comp with some camera shake. Because of course there is no doubt that we would have had a hard time keeping the "camera" steady while filming the raw power of *The Dark Side* in action!

[12] An example of this can also be found on the DVD.

Generally we'll want to de-grain an image sequence *before* repositioning, especially if scaling takes place. This is because grain is the result of a photochemical process that happens when film is developed. Thus grain should never be scaled up or motion blurred – we want to *remove* it as much as possible, re-frame, and then re-introduce it at the appropriate levels at the end. (This is especially true when using a "still" frame as a background – there are few things that give away a composite more than "frozen" grain.)

Finally we need to crop the image to get to our final release format. Star Wars Episodes 1 to 3 were all shot HD – a 16:9 aspect ratio. The final aspect ratio is projected at the more dramatic film-widescreen 2.35:1 aspect ratio. The "extra" image that is in the original data needs to be cropped off to produce our final image size (as shown at the beginning of this case-study in Figure 15.139).

Summary

- Proper prior planning prevents problems.
- It's important to analyze all of the footage *before* starting the composite.
- Create a plan to fix what needs to be fixed and notify the various individuals/ departments involved.
- Remember that *we are recreating reality through the lens of a camera* ... that we need to analyze and replicate the various attributes of the camera and add them to our composite.
- Always have our "third eye" on image quality ... especially in terms of the edge detail.
- Constantly look for ways to *reuse* what we have done ... especially if we have several original elements that are similar (like bluescreens).
- Remember that *"once we have a matte, we're golden"* ... and that matte can be used to *affect* other elements in terms of the intensity of color correction, blurs, etc.
- Always look for *procedural* ways to do things ... but also develop a sense for when things can be done faster *manually*.
- Visualize and study the interplay of light and shadow in the shot ... picturing what it would look like *if you were actually there*.
- Constantly study the *real* world around you. Acquire reference footage of *real* things and use them to ground the composite in reality.

Digital Compositing Software: Tools and Features

The purpose of the list given in this appendix is twofold. First, if you are already working with compositing software, it may help you to identify and understand tools within that package which you were unfamiliar with. We have tried to list features that are common to a variety of different packages, and to give a brief description of each. A more detailed description of certain features and operators can be found throughout the body of this book.

Second, this list can be used as a guide for evaluating and comparing software that you have never used but possibly intend to purchase or recommend. Given the wide and expanding variety of digital compositing tools that are available, it can be difficult to make a reasonable comparison without having a common baseline to reference. Of course, not all compositing packages will have all the features listed here. Many packages may have additional features that are not listed here. Please understand that the presence or absence of certain features does not necessarily determine whether the package will be useful. Only by evaluating your specific needs can you determine whether a particular package is suitable to the task. You may even find that a combination of several different tools will be needed to cover all the possible scenarios that you need to address. In general, you shouldn't hesitate to pass over a poorly designed "all-in-one" package in favor of a group of well-designed packages that can be used in conjunction with one another effectively.

This appendix will try not only to list a number of different potential features, but also to give an idea about what a reasonably good implementation of that feature might include. Don't use this as a "yes or no" checklist, but instead try to examine the features of the package in question to understand how complete the implementation might be.

Finally, remember the importance of the overall design of the package's user interface. This is probably the most difficult component of a package to evaluate, since it

requires spending time with the product to understand the particular paradigm. It is something that cannot be dealt with in a simple features list, but absolutely should not be ignored. Chapter 9 goes into greater detail about certain features and methodologies that are relevant to this topic.

The categorization of the features in this list is rather arbitrary, as is the naming of the tools themselves. Some of the features described below are named fairly consistently throughout the industry but others vary wildly. Even (perhaps especially) the most common terms, such as "Brightness," will have a different underlying algorithm depending on the software used. If you are using this list to help evaluate the functionality of a particular piece of software, you may need to explore a little bit before you can accurately determine whether, and to what extent, the software in question supports a specific feature.

Remember too that many operators can be built as a combination of other operators. The list here consists primarily of tools that either cannot be built from other tools or are common enough to warrant inclusion. Most compositing systems will consolidate some of the operators that are mentioned here into larger operators that can perform multiple functions instead of providing them as individual "atomic" tools.

This chapter is also available online at **www.digitalcompositing.com** as a user-modifiable document. Feel free to contribute to the discussion on how your favorite compositing package implements specific tools and features.

Color Corrections

Although we will often refer to operations as taking place on each *pixel* in an image, in many cases the operation will actually be applied appropriately to each *channel* of that pixel.

On many systems certain color corrections can be applied not only to the entire image, but can also be limited so that they affect only to certain ranges of image brightness, generally broken into the categories of Shadows, Midtones, and Highlights.

In addition to the specific operations listed below, a good compositing system would ideally include the ability to use arbitrary mathematical expressions to manipulate color via a robust expression language.

Add: Add a constant value to each pixel in an image. Also known as "Lift." Sometimes known as "Brightness."

Brightness: Multiply the RGB channels of each pixel in an image by an equal, specific amount. Also known as "Exposure." Sometimes, however, "Brightness" refers to *adding* a specific value instead of multiplying.

Clamp: Clamp the value of each pixel in an image to be between a specific range. Values outside of this range will be forced to the limits of the new range.

Color-Space Conversions: The ability to convert images between various representations of color. These could include RGB, HSV, HLS, CMY, CMYK, etc.

Compress: Map a range of color values in an image into a new, smaller range.

Contrast: Modify the range/ratio of brightness values in an image. The midpoint of this contrast should be something that the user can control.

Divide: Divide the value of each pixel in an image by a constant value.

Expand: Map a range of color values in an image into a new, larger range.

Fade: Multiply the RGBA values of a four-channel image by an equal, specific amount.

Gamma: Modify the apparent brightness of an image by raising or lowering the mid-range tones of the image, typically by raising the value of every pixel to the power of 1 divided by the gamma value.

Histogram Equalization: Stretch the range of values in an image to fit as completely as possible between a given range, usually 0–1.

HSV Modifications: Modify an image based on its hue, saturation, and value.

Hue Rotation: Rotate the hue of an image through the color spectrum.

Invert: Invert the value of each pixel in an image, producing a negative of the image.

Look-up Table: Apply a user-defined table that specifies a particular mapping of input pixel values to output values.

Matte Divide: Divide the RGB channels of an image by its alpha channel.

Matte Multiply: Multiply the RGB channels of an image by its alpha channel.

Multiply: Multiply the value of each pixel in an image by a constant value.

Reorder: Shuffle the order of the channels in an image.

Saturation: Modify the saturation of an image.

Set: Set any channel or set of channels to a specific constant value.

Filters

Blur: Apply some type of blurring algorithm. The user should be able to choose different horizontal and vertical blur values.

Convolve: Convolve an image with an arbitrary filter. The size of the kernel should be user-definable as well.

Dilate: Increase the coverage of bright areas in the image, while decreasing the dark areas. Generally used primarily for mask manipulations.

Emboss: Create a new image that appears to have varying height based on the luminance values in the source image.

Erode: Decrease the coverage of bright areas in the image, while increasing the dark areas. Generally used primarily for mask manipulations.

Grain: Add simulated film grain to an image. You should either be able to specify a variety of parameters that describe grain characteristics (such as grain size, density, luminance and chrominance variance, etc.), to choose from a list of different film stocks that you wish to emulate, or to sample and mimic grain from an existing image.

Median: Replace the value of each pixel in an image by the median value of the neighboring pixels.

Radial Blur: Blur or smear an image radially about a certain point, ideally with control over the fall-off as a function of distance from the center point.

Sharpen: Apply some type of sharpening algorithm to enhance apparent edge detail. The user should be able to choose different horizontal and vertical sharpening values.

Smear: Smear an image in a certain direction by a certain amount. Often used to simulate motion blur.

Geometric Transformations and Warps

The system should support transformation in both a 2D and a 3D space and there should be support for a functional camera model within any 3D space.

Complex hierarchies of transformations should concatenate so as to ensure the highest quality results.

For any transformation, portions of an image that are moved out of frame should not be permanently cropped. Instead, the data should be available for use by subsequent transformations. Optionally, you should also be able to specify whether you wish any portion of the image that moves out of frame to wrap around and reenter the frame on the opposite side.

The user should be able to choose the type of filtering (resampling) that is used for many transformations. There are times when one may wish to choose different filtering along the vertical and horizontal axes.

Finally, for any animated geometric transformation, you should be able to choose whether or not the result is rendered with motion blur, and be able to control the extent of the motion blur that is applied.

In addition to the specific operations listed below, a good compositing system would ideally include the ability to use arbitrary mathematical expressions to manipulate transformations and warps via a robust expression language.

Crop: Remove a portion of an image that lies outside a specific boundary, either by specifying two corners that define a rectangular region or by specifying a single point and the resolution of the desired result.

Fit: Scale an image to fit within a given resolution, usually with the option of maintaining the aspect ratio of the original image.

Lens Distortions: Create or undo the distortion caused by a camera's lens. Ideally includes the ability to *analyze* the distortion of a lens by examining the curvature of objects that are believed to be straight.

Pan: Reposition an image within a given frame or in terms of its distance from camera.

Pin, Cornerpin: Distort an image by moving four arbitrary points within the image to four new positions.

Resize, Scale: Change an image's size by specifying a new resolution or a multiplier for the *x*- and *y*-axes.

Rotate: Rotate an image by specifying the center of rotation and the amount of rotation in any of the *x*-, *y*-, and *z*-axes.

Shear: Shear an image around a given point, specifying shear amounts for both the *x*- and *y*-axes.

Twirl: Distort an image by twirling it around a certain point.

Warp: Warp an image based on a control grid or a set of control splines.

Flip: Mirror the image around the *x*-axis.

Flop: Mirror the image around the *y*-axis.

Image Combination

The image-combination tools are described using the same conventions that were discussed in Chapter 5. Thus, A and B are considered the two source images. If there is a need to specify certain channels in an image explicitly, they will be indicated with subscripts; otherwise it is assumed that the operation will be performed on all four channels of an image equally. All images are assumed to be four-channel premultiplied images.

Add: Add two images together on a pixel-by-pixel basis (A + B).

Mix: Combine two images by using a weighted pixel average $(MV \times A) + [(1 - MV) \times B]$, where MV is the mixing value.

Atop: Place the foreground over the background, but only inside the background alpha. Thus, A atop B is really the same as $(A \text{ in } B_A)$ over B.

Reorder: Move specific channels between two different images.

Displace: Warp an image by using a second image to control the amount of warp at any given location.

In: Retain the foreground only within the background's matte. Thus, A in B is the same as $A \times B_A$.

Luminosity: A tool to modify the matte channel of a four-channel premultiplied image. Decreasing the matte channel gives the image a luminous look when it is placed over a background. Also known as the Opacity operator.

Max: Use the maximum value of the equivalent pixel location in the two source images.

Min: Use the minimum value of the equivalent pixel location in the two source images.

Multiply: Multiply one image by another image $(A \times B)$.

Out: Retain the foreground only outside of the background's matte. Thus, A out B (or "A held out by B") is the same as $A \times (1 - B_A)$.

Opacity: See Luminosity.

Over: Place the foreground over the background using the foreground alpha. A over B is the same as $A + [B \times (1 - A_A)]$.

Screen: Invert both images, multiply them together, and then invert the result. $1 - [(1 - A) \times (1 - B)]$.

Subtract: Subtract one image from another image $(A - B)$. It is useful to be able to choose to have the result of negative numbers in the resulting pixel become the absolute value of that result instead.

Under: Place the background under the foreground using the foreground alpha. Thus, A under B is the same as B over A.

Xor: Retain both source images only where their mattes do *not* overlap. $A \times (1 - B_A) + B \times (1 - A_A)$.

Z-Compositing: Choose the resulting pixel from either source image by comparing the Z-depth values for each image.

Field Controls

Interlace: Merge two images into a new image by choosing alternating lines from each image.

Deinterlace: Separate a single image into two new images, one containing only the even-numbered lines from the original image and one containing only the odd-numbered lines.

Swapfields: Switch the even- and odd-numbered lines in an image.

Matte Generation

Lumakey: Create a matte based on the luminance values in an image.

Chromakey: Create a matte based on a specific thresholded color in an image.

Difference Matting: Create a matte based on the differences between two images.

Specialized Keying Tools: Any of a number of proprietary tools for creating a matte for an object. These tools may rely on the fact that the object was shot in front of a uniformly colored background or may use other techniques, such as motion analysis, to determine the matte's location and transparency.

Timing and Animation

Keyframing: The ability to set specific "key" frames for a set of parameters and have the system create values for the in-between frames based on a variety of interpolation methods.

Procedural Animation: Animation that is driven by some sort of mathematical formula instead of specifically indicated by the user. This may be something as simple as a standard sine wave or as complex as a physically modeled wind simulation.

In addition to tools for dealing with the timing of animation parameters, there also needs to be tools for retiming actual image sequences. Typically these would include the ability to drop or duplicate frames, to average frames together, or to create completely new frames via optical flow techniques. There should also be the ability to perform the standard film/video conversions known as Pullup and Pulldown as described in Chapter 10.

Image Generation

Gradient: Create an image that contains horizontal, vertical, diagonal, or radial gradients between different colors.

Paint Tools: A broad category of possible features. An ideal group of paint tools would allow for procedural painting that can be applied to a sequence of images instead of just the one in question.

Shape Drawing: Create an image that contains user-defined shapes created via curves or polygons. The user should be able to control the color and transparency of the shapes and the softness of the edges.

Text: Create text with a user-specified font, color, size, orientation, and placement.

Texture/Patterns: An open-ended category that can include just about anything that might be used as imagery within a composite. Typically this could include things like a fractal cloud generator or a random noise image.

Particle system: Many compositing systems now include the ability to simulate a limited set of **natural phenomenon** (smoke, dust, rain, fire) via a set of procedural effects tools.

Tracking

Multiple Point: The ability to track several points at the same time.

Integration: Tracking information should be easily applicable to most geometric transformation tools, including Pan, Rotate, Scale, Pin, and Warp.

Subpixel Accuracy: The ability to accurately track features at greater than whole-pixel resolutions.

Stabilization: Diminish or remove camera movement in a plate. This can either be feature-based (choose a specific point and stabilize the plate based on the assumption that the point in question is unmoving) or through a more sophisticated analysis of the entire frame as it changes over time.

Camera Reconstruction: Analyze a sequence of images and derive the original camera move in 3D space that produced these images.

Control

You should be able to control and limit how a particular operator will be applied to an image. Various control methods include:

- The ability to restrict the operation so that it is only applied to specific channels of the image.
- The ability to restrict the operation so that it is only applied to the even-numbered or the odd-numbered scan lines of the image.
- The ability to specify a rectangular region of interest (ROI) outside of which the effect will not be applied.
- The ability to control the amount of the effect that will be applied, based on the grayscale values in an additional (separate or integrated) matte/mask image.
- The ability to limit the effect so that it will only be applied if it changes a given pixel by a user-specified threshold.

You should also be able to have some control over how the software uses the resources of the system on which it is running. This includes the ability to limit the amount of memory that the software will use, as well as having control over what disk space is used for any temporary image storage.

Other

Finally, there are a number of additional features that most compositing packages should support. These include the following:

Resolution Independence: The ability to translate compositing parameters that have been created to work on a sequence of images at a certain resolution to work with a sequence at a different resolution.

File Format Independence: Support for reading and writing a wide variety of image file formats, such as those listed in Appendix C.

Platform Independence: The ability of a given piece of software to run on a variety of different hardware platforms, often from different manufacturers.

Extensibility: The ability to add functionality to the package via the use of macros, plug-ins, and so forth.

Optimization: Automated tools that can analyze and optimize complex compositing scripts.

Scalability: The ability to create complex scripts that define large hierarchical compositing processes while still maintaining reasonable user interactivity.

Distributed Rendering: The ability to process a given compositing tree on multiple machines simultaneously. The work may be divided up so that different frames of the composite are sent to different machines or may even allow a specific frame to be broken into multiple segments, distributed, and then reassembled.

Internal Accuracy: The ability to process data at higher bit depths. Minimally 16 bits per channel but really there should be full support for a floating-point workflow that can maintain pixel values outside the range 0–1.

HDR support: Tools should be aware of high dynamic range images and behave appropriately when working with these images.

Proxy Support: The ability to use low-resolution stand-ins for the image/sequence in question, and the ability to prototype effects or scripts based on these proxies.

Graphics Hardware Acceleration: Many graphics subsystems can now perform a variety of compositing operations using onboard processing that is dedicated to specific imaging-related tasks. This sort of thing can significantly increase the interactivity of a compositing system.

Undo/Redo: A robust system for erasing or negating any changes that have recently been applied and then a way to reapply those changes if necessary. The best systems will maintain a complete list of recent actions, making it easier to see exactly what has occurred and allowing the user to undo multiple operations in a single step.

Script Organizational Tools: As compositing hierarchies grow more complex, it will become desirable to apply some sort of organization to the tree that is being shown to the user. Tools for this would include the ability of the user to select collapse segments of a script into a simpler representation, to hide portions of a script, to annotate areas in the tree and tools that help to layout the script in a visually comprehensible fashion.

Interoperability: As your compositing work will probably be done in an environment where there are a variety of software tools being used for other parts of the production process, any ability to transfer data more efficiently to and from these systems will be beneficial. This could include shared file types, data structures, and even plug-ins. Systems you may need to interact with would include editing tools, paint packages, 3D animation, lighting and rendering software, audio applications, etc.

Outside Resources: Finally, when choosing a compositing system, never underestimate the importance of having good documentation, both directly from the software's manufacturer and from independent third party publishers. Check on the availability of online forums or discussion groups. And generally an active community of users who are skilled in a particular application can prove invaluable, both when learning how to use a new piece of software and as an aid to finding employment with your new expertise.

Digital Image File Formats

Common Image File Formats

The following list is an overview of a few of the more common bitmapped image file formats that a digital compositing artist may encounter. It should not be considered a comprehensive list—there are hundreds of other methods to store images and more are constantly being defined. And even within the formats listed there are variations—the implementation standards are often poorly (or even contradictorily) defined and thus it is not at all uncommon to find that an image written into a specific file format by one system does not behave properly when read into another system.

Note that these are all single-frame file formats, as opposed to formats like Quicktime, which are designed to hold *sequences* of images.

Name	BMP or Bitmap Format
Extension	.bmp
Notes	Commonly used by the Microsoft Windows operating system and by programs that run on top of that. Supports lossless compression although more often than not the images are stored uncompressed.
Name	Cineon
Extension	.cin
Notes	The Cineon file format is actually a subset of the ANSI/SMPTE DPX file format featuring a fixed set of header information. Introduced prior to the formalization of DPX, it is still extremely common in the visual effects world. A more detailed description of this format is presented later in this chapter.
Name	DPX
Extension	.dpx
Notes	DPX is specified by the ANSI/SMPTE standard 268M-2004 and is probably the most popular file format used when capturing data from a film scanner.

Name	OpenEXR
Extension	.exr
Notes	OpenEXR is an Open Source file format initially developed by Industrial Light & Magic. A more detailed description of this format is presented later in this chapter.

Name	GIF
Extension	.gif
Notes	GIF (graphics interchange format) is a common format for use on the web. It features a limited color resolution but does allow for animated images.

Name	IFF, Interchange File Format
Extension	.iff
Notes	An abbreviation of Interchange File Format, IFF is a generalized structure for storing zand accessing files. The most common version of IFF in the visual-effects world is the one that Maya and Shake use as their native format.

Name	JPEG
Extensions	.jpeg, .jpg
Notes	A very common format for storing images, it features a lossy compression method that can dramatically reduce file sizes but is prone to visual artifacts.

Name	JPEG 2000
Extensions	.jpg2, .jp2
Notes	Jpeg2000 is the successor to the popular Jpeg format and allows for both lossy and lossless compression.

Name	PNG
Extension	.png
Notes	PNG (portable network graphics) was designed to replace the GIF file format for web use. It allows for lossless compression and bit depths up to 16 bits/channel.

Name	Photoshop
Extension	.psd
Notes	A proprietary format developed and used primarily by Adobe Photoshop, it includes support for many application-specific features such as layers.

Name	Tiff
Extensions	.tiff, .tif
Notes	TIFF (tagged image file format) is a very common and flexible file format that features a wide variety of implementations (although many packages only support a subset of these). Generally uses lossless compression.

The Cineon File Format

First introduced by Kodak as a part of an entire system (hardware and software) for dealing with film imagery in a digital fashion, the Cineon file format was designed specifically to store scanned film images in an efficient and high-quality fashion. Digital images can, of course, be stored in a variety of formats regardless of where the images originated but the Cineon format has a number of unique features that were

tuned to the film world (and specifically to the production pipeline for Kodak's dedicated system[1]).

Although the Cineon format is actually a subset of the DPX file format, it was formalized before DPX was completely described and gained widespread acceptance in the industry due primarily to the ubiquity of Cineon film scanners. We'll take a closer look at the Cineon format rather than the DPX format because there are fewer variations in how data can be represented, but effective use of either format requires a basic understanding of the information presented later.

While theoretically the Cineon format (like DPX) can support a variety of different configurations in terms of channels and bit depth, by far the most common use is as a three-channel RGB image with 10 bits of data used for each channel. The choice of 10 bits per channel was not arbitrary, but is tied closely to an analysis of how film works. To reduce the file size, as well as to fit into the 8-bit chunks that computers prefer, these three 10-bit channels are stored into a 32-bit structure. Since this is the only compression scheme that is used (other than the nonlinear color encoding that will be discussed in a moment), the file size of a Cineon image is predictable and based only on the resolution of the image itself. To compute the amount of disk space a Cineon image will consume, use the following formula:

$$\text{(X Resolution)} \times \text{(Y Resolution)}/250,000 = \text{File Size (in megabytes)}$$

For example, an image that is 1828 by 1556 will require about 11.377 megabytes on disk. There may be minor deviations from this formula, depending on the amount of information that is kept in the header of the file you are creating, but any major discrepancies will indicate that your image is probably not truly stored in the standard three-channel, 10 bits-per-channel Cineon format.

Before we go any further into the specifics of the Cineon format itself, there is a common misconception about it that should be addressed. Although discussions of this format usually focus on the specialized way the data is stored, in fact the structure of the Cineon file format is really not much different from most other image file formats. However, when Kodak first published the specifications for this format, it was as a part of their entry into the business of providing film scanning and recording services.

[1] Kodak's Cineon system (yes, the entire system was referred to as "Cineon," not just the file format) was really quite elegant and well thought-out, at least in terms of the way data passed through it. It provided an end-to-end pipeline that included a film scanner, a digital compositing workstation and a film recorder. All of the pieces worked nicely together and effectively insulated the compositing artist from the need to worry about color-space conversions at all. Unfortunately this was only true as long as you stayed entirely *within* their system. Not surprisingly most facilities choose to mix and match with other software, often compositing in packages other than Cineon, and consequently they were no longer working in a full color-managed workflow. And as a result every facility ended up developing their own color-space conversion pipeline for working with Cineon images and they all tended to be somewhat different. Which, ultimately, is why there (still) seems to be a great deal of confusion for how exactly one should work with Cineon images.

Consequently, not only did they need to describe the Cineon file format itself, they also formalized a specific color encoding that would be used when storing the images that were scanned into this format.

This color encoding is not really something that Kodak developed explicitly—rather it simply mimics the way that a film negative responds to light, in terms of the density of the developed negative compared with the light that reaches it (as we saw in Chapter 14). Thus, the nonlinear color representation that the Cineon file format uses is sometimes referred to as a **density space**. This response is logarithmic in nature, and so it is also (more commonly) referred to as a "logarithmic encoding" or even just **log space**. The characteristics of this color encoding were generally assumed to be a part of the Cineon format itself, and consequently the two became somewhat synonymous. But it is important to understand the distinction since there is effectively no way to *enforce* the storage of a particular color encoding into a given file. Thus, although an image that is stored in the Cineon format is *probably* represented in density space, there is no guarantee that this is the case. Many software packages will automatically perform the encoding when they write a Cineon file, but many packages will not. The same thing is true when reading a Cineon file—many software packages will automatically linearize the image, many will not. Ultimately, it is up to the compositing artist to understand exactly how the data that they are using is represented; otherwise, significant problems could result. For the rest of this discussion, we will operate under the assumption that the term "Cineon image" refers to an image that is also not only saved in the Cineon file format, but whose data is also encoded in the film density space as described by Kodak's Cineon file specification document.

Whenever we wish to digitize an image that was shot on film, we typically scan the original negative itself. There are really two reasons for using the negative instead of scanning a print from this negative. (And by "print" we're referring to the thing that you would actually project in a theater.) The first reason is in order to ensure that we have as sharp and grain-free an image as is possible. Obviously a print that is made from the original negative would be slightly inferior to the original, and thus less desirable for scanning. But a far more important reason why we scan the negative is because it contains a great deal more information than even a first-generation print. As, again, we discussed in Chapter 14, a piece of film negative can actually hold a much greater range of brightness values than a piece of print film. We want to bring all this information into the digital realm, and thus we must scan the negative, not a print.

At first glance, it may seem somewhat pointless to capture and keep all this additional data if the print that we will eventually be making is unable to display it. While it is true that the print itself may not be able to use the data, by this point in the book you're probably well aware that this additional data might prove crucially necessary as part of the intermediate digital compositing work we'll be doing. Therefore, the encoding method that is used to generate a Cineon image was designed to

keep as much of the data in the original negative as possible, while still storing this data efficiently.

For this reason, a Cineon file is often referred to as a "digital negative." This term occasionally generates some confusion, since a Cineon image doesn't *look* like a negative image when viewed. In reality, the final step that is performed on a scanned image before it is saved in the Cineon format is a simple digital inversion. Whites become blacks, colors become their complements, and, although no data is lost, the image is now much more comfortable and intuitive to work with.[2]

When Kodak set about defining the Cineon format they determined that it would require about 14 bits per channel to accurately represent this data if it was linearized, but if it was kept with the color representation that is natural for a piece of film negative, they could only use 10 bits per channel. It's effectively the same principle that we discussed in Chapter 14 when we saw how applying a gamma correction helps to preserve the accuracy of video imagery in areas where our eyes are most sensitive. And in the same fashion, we'll again almost certainly want to linearize the data before doing all but the most simple image manipulations to it. But exactly *how* this data should be linearized has proven to be the tricky part.

It's important to remember that the Cineon specification came about during a time when most compositing systems were very limited in the amount of data they could process in a timely fashion. Working in 8 bits per channel was at least as common as working in 16 bits per channel and as such Kodak described methods for converting the log color encoding that included both 8- and 16-bit methods.

More importantly, they really only documented methods for converting the imagery for the purposes of accurately *viewing* how it would look in a final print. They didn't actually describe the proper methodology for converting the data into a linear fashion in order to *work* on the imagery (because the Cineon compositing system did all of this internally, transparently to the user). And this, then, is probably the greatest source of confusion when dealing with Cineon imagery. Most of the compositing systems at that time didn't fully support any sort of color-managed workflow or even provide the capability to view imagery through a lookup. And so the typical workflow was to read the cineon file from disk and convert it into a color representation that "looked good" to the compositing artist (using Kodak's image-viewing instructions). Which meant that the linearization step was combined with a conversion that

[2] Incidentally, most scanning systems will give you the option of whether or not to compensate for the fact that the base color of a negative has an orange cast. This is done by determining the color of an unexposed area of the developed negative and then subtracting this characteristic color from the digital values that are produced when scanned. If this base correction is not applied, the scan will have a noticeable cyan tint—the orange becomes cyan when the values are digitally inverted. This is generally not a problem, since presumably you will be color correcting the image to match a reference clip anyway, and as long as you are still working with the original bit depth, you have more than enough room for such a correction.

made the images appear reasonably correct on a standard computer monitor. Which, as we learned in Chapter 14, meant that they would no longer be truly linear.

With all this in mind, let's look at the process in a bit more detail and try to describe a reasonably correct way to work with this file format using the typical set of controls that most compositing packages provide.

Cineon images should really be thought of as high-dynamic-range images that are stored with a nonlinear color representation. If we're planning to work in a 16-bit non-floating-point environment, there are really only two things we'll need to do—linearize the data and choose some subset of it to work with. Although most Cineon "Log to Lin" converters wrap these controls together into a single set, it's important to realize that they are indeed separate things. The true linearization portion of the process is usually just a single control that specifies the gamma characteristics of the negative that is being digitized and should almost always be left at its default setting.[3]

The other set of controls you will probably have access to will relate to choosing a white and black point out of the full range of data in order to map it to a range that you will be working with. As we've said, even though the negative is able to capture a wide range of brightness values, the final print that will be produced from such a negative will not have nearly as great a range. In particular, much of the detail in the brightest areas of the image will simply register as "white" when transferred from the negative to a positive print. The same thing is true, to a lesser extent, for the blacks of the image. Thus we theoretically can safely discard all values outside of that range as being unnecessary. In a scenario where we are working with a limited bit depth this might indeed make sense since then it would allow us to use our data most effectively. This was particularly necessary when working on compositing systems that could only process at 8 bits per channel. Such a small data space required us to work only with the data we absolutely needed for the final print.

For instance, if you are reasonably certain that you will not need to digitally "print down" the brightness of the image, much of the high-end detail will never be used. And so you could map Cineon values between[4] 90 and 685 into the range 0–255, which will result in an image that can be stored as an 8-bit file. Although this step reduces the precision, it is not nearly as severe a reduction as if we had mapped the full range 0–1023 into our 8-bit space. Usually there will be no visible artifacts that result from working with such images unless, as we mentioned, the need arises to decrease the brightness of the images by a great amount. If this is attempted, the truncated high end will become noticeable, and bright areas will appear clipped and artificial.

[3] On most systems the default value for this control is 0.6. And if your converter also includes a setting related to "Display Gamma," you need to find out where that should be set so that it doesn't introduce any nonlinearity back into the conversion.

[4] These numbers are usually given in the 10-bit range 0–1023, as is the standard practice when discussing Cineon images. If you want to convert them to floating-point numbers in the range 0–1, you will need to divide by 1023.

The only recourse at this point would be to return to the original 10-bit image and perform the brightness adjustment before truncating the data to 8 bits. This may or may not be a tremendous burden, depending on the situation.

You may occasionally see documentation that attempts to provide numerical values for what the black point or white point would be for a "standard" Cineon file. Typically, the numbers that are given place the black point at about 90 and the white point at about 685. But it is very dangerous to blindly assume that these numbers are always appropriate. They are based on the assumption that the film was exposed "normally," a nebulous concept at best. Cinematographers will often over- or under-expose a negative in order to achieve a specific effect, and thus there really is no such thing as a normal exposure. What's more, there may be steps performed when printing the negative onto a positive that also shift the brightness range. Thus, any default numbers for the white and black points should only be considered a starting point. The only way to truly determine what values will eventually be white or black on the print is to visually compare the digital image with an accurate sample, that is, a piece of film that has been developed and printed to properly represent the brightness and color balance that the director and the cinematographer desire for the shot. The white point and the black point, as well as any necessary color changes, can be applied to the digital data in order to duplicate this reference clip as closely as possible.

In practice, mapping a digital negative into an 8-bit space is generally a really bad idea. Why would you want to throw away precious imagery that you might need at some point later? If we have at least 16 bits per channel to work with, then we can probably choose a larger range of values from the original negative—or even the full range—instead. Choosing a larger range will affect the brightness of the linearized image if you're looking at it directly, but you should be viewing these images through a LUT anyway. So just make sure your viewer is properly calibrated to compensate for any workflow you set up on your system.

Nowadays, decoding a Cineon/DPX file into a larger 16-bit representation is considered by many to still be too much of a compromise. Even in this scenario (unless you choose a blackpoint of 0 and a whitepoint of 1024) you are throwing away data above your white point and below your black point. And thus it is becoming common to actually decode a Cineon file directly into a floating-point representation when you want to begin working on it. In this case your white point is still mapped to white at 1.0 but all the higher values now move into the realm of superwhite. And thus we are able to take advantage of the full range of values on the negative, effectively giving us a high-dynamic-range image.

Finally, it's worth noting that all of the common Cineon "log to linear" conversions are really just ballpark approximations that are based on some average values that Kodak determined after looking at a variety of different film stocks. These days, anybody that wants to work with their data in a truly linear scene-referred fashion will do a much more sophisticated characterization of the specific film stocks they

are working with and build custom LUTs that provide far more accurate conversions. As such the compositing artist would never need to be exposed to the typical white-point/blackpoint/ngamma/dgamma controls that were historically a part of most Cineon file readers.

The OpenEXR File Format

The OpenEXR file format was developed by Industrial Light & Magic (ILM) over the course of several years and was released to the public as open-source software in 2003. It was rapidly embraced by the visual effects industry and is now being used as a primary format at most large facilities. All of the major compositing software packages can now read and write the OpenEXR format as well.

Florian Kainz is one of the designers of the format and in October 2004 he presented the following paper at the SMPTE Technical Conference and Exhibition in Pasadena, California. In it he discusses not only the development and specifications of the OpenEXR format but also how it is used in production at ILM.

Using OpenEXR for Visual Effects Production

Abstract

OpenEXR is an open-source high-dynamic-range image file format that was developed by Industrial Light & Magic for use in digital visual effects production. This chapter briefly describes the file format and explains one of its most important features: the pixels in an image are stored as 16-bit or 32-bit floating-point numbers. The chapter describes how OpenEXR is used by ILM. It covers color management, why we avoid Cineon/DPX files, and how we handle real-time playback.

Introduction

Starting in 1999, Industrial Light & Magic, a visual effects production company, developed OpenEXR as a replacement for its proprietary 8-bit image file format. Our main requirement for a new file format was that it could store high-dynamic-range images with high color accuracy, but without dramatically increasing the size of image files. Other requirements included support for arbitrary image channels instead of just red, green, and blue; arbitrary metadata; and support for both scan-line-based and tiled image storage. In addition we wanted an easy-to-use C and C++ application programming interface for reading and writing image files. None of the existing image file formats that were considered fulfilled all our requirements, and we decided to develop a new format, which was eventually named OpenEXR.

Description of OpenEXR

The structure of an OpenEXR image file is fairly straightforward: a header contains metadata such as image resolution, what image channels are contained in the file, and how the image has been compressed. Metadata are stored as name-value pairs called "attributes." To store extra information such as colorimetric or process tracking data, application software can add its own attributes to the image header.

The header is followed by the actual pixels of the image. Pixels are stored either as horizontal scan lines or as rectangular tiles. Tiled files allow efficient random access to rectangular image regions. In addition, tiled files support storing multi-resolution images, which are useful for texture mapping during 3D rendering, or for quick zoom and pan operations on images with very high resolution.

An image file contains one or more image channels, for example, red, green, blue, alpha, depth, etc. Each channel has a type, which determines how the data are represented for each pixel in the channel. OpenEXR supports three channel types: 16-bit floating-point (HALF), 32-bit floating-point (FLOAT), and 32-bit unsigned integer (UINT).

HALF is the most commonly used data type. Its range and resolution are sufficient for most applications, and its small size, 2 bytes per pixel, keeps image files relatively short. FLOAT is used in cases where the range or resolution of HALF may not be enough; for example in-depth channels produced by 3D rendering software. UINT is intended for inherently discrete per-pixel data such as object identifiers.

To make reading and writing image files as easy as possible, and to avoid multiple incompatible or incomplete implementations, the OpenEXR format was developed together with an image file I/O software library that offers a convenient application programming interface. The source code for this library is the de-facto specification of the OpenEXR file format.

Floating-Point Pixels

Unlike most other image file formats, OpenEXR represents all per-pixel data that are conceptually continuous (for example, luminance, depth, or opacity) as 16-bit or 32-bit floating-point numbers. This has several advantages over storing integer data in the pixels: Floating-point numbers can represent a wide range of values with relatively few bits. Over most of this range, real numbers can be represented with an almost constant relative error. A wide range and constant relative error are desirable for high-dynamic-range color images [1]. Floating-point numbers can represent zero, negative numbers, denormalized numbers for gradual underflow near zero, infinities, and NaNs to indicate undefined or un-initialized values. Floating-point arithmetic is more convenient for image processing than integer arithmetic, and on modern computers floating-point computations are as fast as integer calculations.

Modern processors implement floating-point arithmetic according to the IEEE 754 standard, which specifies several different formats for floating-point numbers [2].

The smallest of those formats, single precision, requires 32 bits. Range and resolution of this 32-bit format are much larger than what is required for most image processing tasks. When a large number of images must be stored or processed, memory and disk space consumption tend to be an issue, making a floating-point data type with less than 32 bits desirable. 16 bits is the next smaller size that is "natural" for computers, so we decided to implement a 16-bit or half-precision floating-point data type.

To make conversion between 32-bit floating-point numbers and our new 16-bit HALF type as simple as possible, HALF was modeled after the IEEE-754 data types: "If the standard defined a 16-bit format, it would probably look like this." The main choice we had to make was how many bits to allocate for the exponent and the significand. (The significand is also known as the mantissa.) With 4, 5, and 6 exponent bits, the ratio of the largest to the smallest normalized number is roughly 10^4, 10^9, and 10^{19}, respectively. 10^4 is too small for many high-dynamic-range images, and 10^{19} is far more than what most applications need, so we chose 5 bits for the exponent. Allocating one more bit for the sign leaves 10 bits for the significand. With a 10-bit significand, real numbers are represented with a maximum relative error of about 5×10^{-4}, which is small enough to avoid visible quantization artifacts like contouring even after extensive image processing. In most cases 7 significand bits would be enough to avoid visible artifacts. The extra 3 bits keep rounding errors from accumulating too quickly during computations on HALF data.

New PC graphics cards developed by Nvidia, ATI and 3dlabs support frame buffers with 16-bit floating-point number formats that are identical or very similar to OpenEXR's HALF data type.

Compression

To keep image files small, OpenEXR supports several data compression methods. The default method, called PIZ, employs a lossless algorithm based on Haar wavelets. For 16-bit RGB images with film grain, PIZ typically achieves compression ratios around 2:1.

Converting RGB images to a luminance/chroma format with a full resolution luminance channel and two sub-sampled chroma channels increases the compression ratio to about 4:1. However, the conversion is lossy. Converting an RGB image to luminance/chroma format and back to RGB produces an image that is visually almost indistinguishable from the original, but the data stored in the pixels are not identical.

Pixar Animation Studios contributed a slightly lossy data compression method, called PXR24, to OpenEXR. PXR24 improves the compression ratio for FLOAT image channels by rounding the significand of 32-bit floating-point values to 15 bits. This eliminates the numbers' 8 least significant bits, which are difficult to compress because they are very noisy. For HALF data, PXR24 is lossless.

Open Source

In early 2003, after using and refining OpenEXR in production for two years, ILM released the file format as an open-source C++ library. Since the file format is useful for ILM, it should be equally useful for others. Making the source code for the file input and output library available under a royalty-free license should make it easy for others to integrate OpenEXR into their software. With enough software support, OpenEXR has the potential to become accepted by film and visual effects production companies as a high-quality image interchange file format. In part, this has already happened. OpenEXR is supported by a variety of application software packages, and several visual effects houses employ OpenEXR internally. Eventually, we hope to displace the Cineon/DPX file format.

How OpenEXR is Used at ILM

OpenEXR has become Industrial Light & Magic's main image file format. The large majority of image files throughout ILM's visual effects production pipeline are OpenEXR files. We use OpenEXR for all kinds of images—background plates, stage elements, 3D rendering—not just for typical high-dynamic-range applications like environment maps. Carrying as much image information as possible all the way through our production pipeline, and discarding bits only at the end when images are output to film or video, ensures the best possible quality for the final images.

OpenEXR's floating-point pixel formats are convenient for image processing and ILM's in-house software can operate directly on HALF and FLOAT images. The FLOAT pixel data type is directly supported by most computers' main processors. HALF data can be processed very quickly on modern workstation graphics cards that include direct hardware support for 16-bit floating-point numbers. Without a suitable graphics card, operations on HALF data can be performed on the main processor by converting to FLOAT and back as necessary. In addition, since there are only 2^{16} distinct HALF values, functions that take a single HALF argument can be implemented as LUTs. This can be used to accelerate image-processing operations such as color correction or exposure adjustment.

Color Management

The images in ILM's OpenEXR files live in a scene-referred linear-light working color space. For convenience, we use RGB primary and white point chromaticities that match Rec. ITU-R BT.709 [3]. Numbers in the red, green, and blue channels of the pixels are proportional to scene luminance values. (There is no "gamma.")

When images that were recorded on film or video, or with a digital camera, are converted to OpenEXR, we generate scene-referred images by reconstructing the relative luminance values that were present in the original scene. Within the limits imposed by the dynamic range and color gamut of the input media, the look of the scene-referred

OpenEXR image does not depend significantly on how an image was originally recorded.

3D computer graphics images are generated directly in scene-referred form. Internally, 3D renderers already work in a scene-referred color space. Red, green, and blue pixel values generated by the renderer are stored directly in OpenEXR files, without applying any gamma correction. Image processing and compositing occur in the scene-referred color space, producing new scene-referred image files. One can think of image processing and compositing as building a "virtual scene."

When we record our final images on film or video, we simulate the output that we would get if the virtual scene existed in reality and we recorded the scene with a film or video camera.

To preview an OpenEXR image file on a computer monitor, conceptually we simulate the image that will be seen on a screen when the file is recorded on film or video, and the resulting film print or video tape is shown in a theater. We then match the appearance of the theater screen on the computer monitor.

To simplify image interchange between different companies involved in the production of the visual effects for a movie, we are currently developing an open-source software library that implements ILM's color management scheme. For more information, see ref. [4].

Why not Cineon/DPX?

We do not use Cineon or DPX files in our pipeline, except for temporary files that are needed to communicate with film recorders and scanners that do not support other input and output formats.

The reasons for not using Cineon files are in part the same as the reasons for developing OpenEXR in the first place. For example, we often need a higher dynamic range than what is supported by Cineon, or we need image channels beyond red, green, and blue to store additional per-pixel information. (It should be noted that the DPX file format specification allows alpha and depth channels, as well as data formats with more than 10 bits per pixel per channel. In practice, software that reads and writes DPX files rarely implements those features.)

For ILM, another reason not to use Cineon files is the way images are typically encoded [5,6]: The data stored in the pixels represent "printing density"; the pixel values record how opaque camera original film stock has become due to exposure to light. The pixel values are inherently dependent on the type of film stock on which a scene was shot. This makes image processing unnecessarily difficult. For example, the standard "over" compositing operation is usually expressed as

$$composite = foreground + (1\text{-}alpha) \times background$$

This produces a correct result only if the pixel values stored in the foreground and background images are proportional to the luminance of the corresponding objects in the foreground and background scenes (and if the foreground has been premultiplied by alpha). With Cineon files, correctly compositing a foreground element shot on stock A over a background shot on stock B requires reconstructing scene luminance values. Also, in order to store the resulting composite image in a new Cineon file, scene luminance values must be converted back to printing density values, simulating how a particular film stock would "see" the composite scene.

With OpenEXR's scene-referred linear-light pixels, an "over" is always the same simple operation, no matter how the foreground and background images were originally created, or on what output medium the composite image will be recorded. Conversion between scene-referred pixels and representations specific to an input or output medium only happens when images are converted to or from OpenEXR.

Real-time Playback

For real-time playback of high-resolution image sequences, we preload the images and playback from main memory. So far, the OpenEXR file I/O library has not been optimized for real-time playback directly from disk. On a PC with a 3 GHz Pentium 4 processor, uncompressed RGB images with 2000 by 1000 pixels can be loaded from a local disk at about 10 frames per second. Compressed images are loaded at 3–4 frames per second.

The OpenEXR library places few restrictions on how the pixels of an image can be laid out in main memory. Application software describes the desired memory layout, and the library loads the image directly into the application's frame buffer. This may require reordering of the pixel data, conversion between pixel data types, and filling missing image channels with default values. In order to achieve maximum speed for real-time playback directly from disk, the library should probably implement a fast path for uncompressed files. If the layout of the data in the file matches the layout of the application's frame buffer, it should be possible to load images at a speed that is close to the maximum supported by the computer's file I/O system.

Since OpenEXR images are scene-referred, playback requires transforming the pixel colors to achieve the desired film or video look. If an image sequence is preloaded into main memory for playback, the color transformation can be applied at load time. In this case speed is not critical and the transformation can be implemented in software. If images are played back directly from disk, the color transformation must be very fast. With modern graphics cards, this can be done by implementing the transform as an OpenGL or Direct3D fragment shader.

Conclusion

The OpenEXR image file format was originally developed to maintain high image quality throughout ILM's visual effects production pipeline. The format's floating-point

pixels have a wider range and greater accuracy than film, video, or even special high-dynamic-range cameras, ensuring that the file format does not become a quality bottleneck. Occupying only 2 bytes per stored value, OpenEXR's 16-bit floating-point data type keeps image files relatively small. Data compression further reduces the size of the files. This makes it practical to use OpenEXR as a general-purpose file format, rather than a niche format for special high-dynamic-range applications.

ILM has released OpenEXR as open-source software and is actively supporting it. Since its release, the format has been adopted by several other production houses, and a growing number of commercial software packages can read and write OpenEXR files.

Like other image file formats currently used for film and visual effects production, OpenEXR lacks a commonly accepted color management method. We are currently developing an open-source software library that implements the color management method employed by ILM. By making this library available, we hope to increase use of OpenEXR as a standard image interchange format for film production.

References

G. Ward, "High Dynamic Range Image Encodings", http://www.anyhere.com/gward/hdrenc/hdr_encodings.html ANSI/IEEE 754, Binary Floating-Point Arithmetic Rec. ITU-R BT.709-3, Parameter Values for the HDTV Standards for Production and International Programme Exchange.

F. Kainz, "A Proposal for OpenEXR Color Management", http://www.openexr.com/OpenEXRColorManagement.pdf ANSI/SMPTE 268M-1994, Format for Digital Moving-Picture Exchange (DPX) SMPTE RP 180-1994, Spectral Conditions Defining Printing Density in Motion-Picture Negative and Intermediate Film.

OpenEXR was designed and implemented by Florian Kainz, Wojciech Jarosz, and Rod Bogart. The PIZ compression scheme is based on an algorithm by Christian Rouet. Josh Pines helped extend the PIZ algorithm for 16-bit and found optimizations for the float-to-half conversions. Drew Hess packaged and adapted ILM's internal source code for public release and maintains the OpenEXR software distribution. The PXR24 compression method is based on an algorithm written by Loren Carpenter at Pixar Animation Studios.

Additional information about the OpenEXR file format can be found at http://www.openexr.com.

Common Film and Video Formats

This appendix is provided as an additional source of information about some of the film and video formats that the typical compositor might encounter in the course of his or her daily work. It builds on the topics and discussions that were covered in Chapter 10, and you should read that chapter before attempting to decipher some of the information given here. Please note that, although sample resolutions are given for some of the analog formats discussed, these should be considered examples rather than standards. There may be many ways to digitize a given analog format and thus there is no guarantee that a specific digitization method will produce an image that is identical to what we have described.

Film

Although there have been a myriad of film formats developed over the years, some clear standards have emerged that can help to narrow our focus. Within this section, we give the basic dimensions for a range of formats, as well as a comparison of their relative sizes. For the 35 mm formats, this includes several of the more prevalent framings. In addition, we give some examples of what the resolution and file size might be like for these framings and formats.

Figure C.1 diagrams the sizes for the major 35 mm film formats. These formats are shown to scale, with the precise measurements given in Table C.1. If you take the time to examine the measurements that are given in this table, you may find that certain scanning resolutions do not have exactly the same aspect ratio as the negative that is used to capture that format. These minor discrepancies are related to the way the scanner is constructed, and can mostly be ignored.

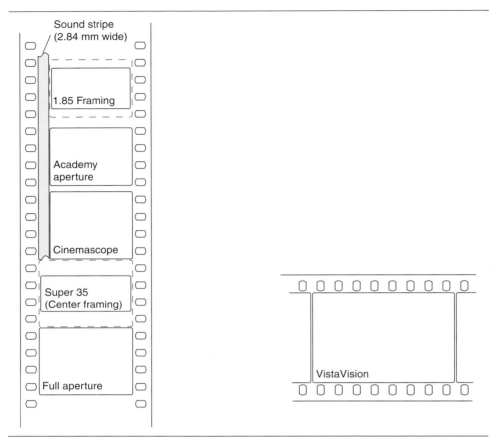

Figure C.1 35 mm film format framing.

Keep in mind that the aspect ratio for any given format will not necessarily be preserved when the image is projected. For instance, the Cinemascope negative (after taking into account the anamorphic squeeze) has an aspect ratio of 2.36:1, but is always projected with a mask that produces a 2.35:1 image.

Figure C.2 and Table C.2 compare the relative areas of the negatives used to capture the listed formats. For instance, an IMAX negative is approximately 10.55 times larger than the size of the negative used for standard Academy framing.

Scanning Resolutions and File Sizes

As mentioned in Chapter 10, a film scanner can be built to work at any resolution, and since the negative is an analog medium, there is no bias to sample it at any particular resolution. Theoretically, any correlation between the resolution of the digital

Table C.1 *Common Film Formats*

Format	Width	Height	Area	Aspect ratio
16 mm	0.404" 10.26 mm	0.295" 7.49 mm	0.119" 76.86 mm	1.37
Super 16	0.493" 12.52 mm	0.292" 7.42 mm	0.144" 92.84 mm	1.69
Academy aperture	0.864" 21.94 mm	0.630" 16.00 mm	0.544" 351.04 mm	1.37
Full aperture	0.980" 24.89 mm	0.735" 18.67 mm	0.720" 464.53 mm	1.33
1.85 framing	0.825" 20.95 mm	0.446" 11.33 mm	0.368" 237.29 mm	1.85
Super 35*	0.945" 24.00 mm	0.394" 10.01 mm	0.372" 240.12 mm	2.35
Cinemascope	0.864" 21.94 mm	0.732" 18.59 mm	0.632" 407.87 mm	2.35
VistaVision (8-perf)	1.485" 37.71 mm	0.991" 25.17 mm	1.472" 949.07 mm	1.5
65 mm (5-perf)	2.066" 52.47 mm	0.906" 23.01 mm	1.872" 1207.13 mm	2.28
IMAX	2.772" 70.39 mm	2.072" 52.62 mm	5.744" 3704.07 mm	1.33

*These figures describe Super 35 as composed for 2.35 projection, the most common use of this format.

image and the original negative is more or less arbitrary. In practice, however, certain common sizes have emerged, generally reflecting what was initially defined by early Kodak Cineon film scanners. The examples given in Table C.3 are all based on specifications from that system, but be sure to check the specifics of the system that you are using for the most accurate information.

The "full" mode reflects the image that was produced when the Kodak scanner ran at its maximum resolution (scanning at about 167 pixels per millimeter, or 4233 pixels per inch). Most people choose to work with resolutions that are less heavy—often exactly half of the full resolution of which the scanner is capable. Thus, a "half" resolution is also given. More modern scanners are capable of greater accuracy now and there may be situations where this is called for. There is, for instance, a visible advantage to scanning at 4 K and then downsampling to 2 K versus scanning directly at 2 K.

Since the Cineon format is such a predictable, as well as common, method for storing film images, we have also given an approximate file size for these scanned images if

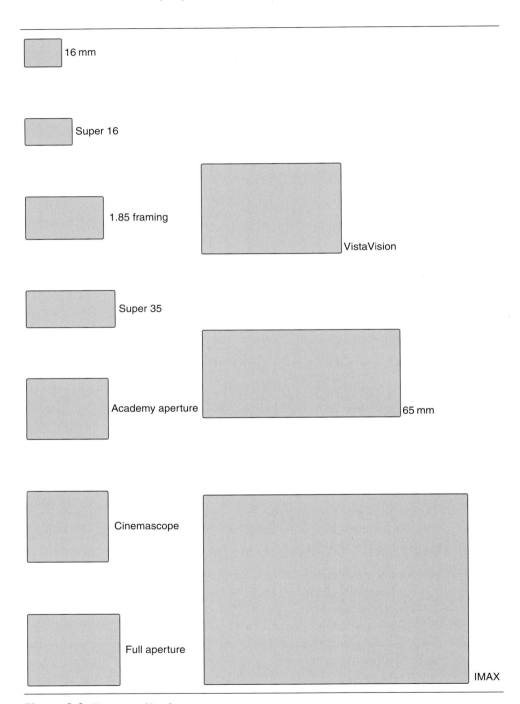

Figure C.2 Common film formats.

Table C.2 *Relative Negative Sizes*

	16mm	Super 16	1.85	Super 35	Academy	Cinemascope	Full aperture	VistaVision	65mm	IMAX
16mm	1.00	0.83	0.32	0.32	0.22	0.19	0.17	0.08	0.06	0.02
Super 16	1.21	1.00	0.39	0.39	0.26	0.23	0.20	0.10	0.08	0.03
1.85	3.09	2.56	1.00	0.99	0.68	0.58	0.51	0.25	0.20	0.06
Super 35	3.12	2.59	1.01	1.00	0.68	0.59	0.52	0.25	0.20	0.06
Academy	4.57	3.78	1.48	1.46	1.00	0.86	0.76	0.37	0.29	0.09
Cinema scope	5.31	4.39	1.72	1.70	1.16	1.00	0.88	4.43	0.34	0.11
Full aperture	6.04	5.00	1.96	1.93	1.32	1.14	1.00	0.49	0.38	0.13
VistaVision	12.35	10.22	4.00	3.95	2.70	2.33	2.04	1.00	0.79	0.26
65mm	15.71	13.00	5.09	5.03	3.44	2.96	2.60	1.27	1.00	0.33
IMAX	48.19	39.90	15.61	15.43	10.55	9.08	7.97	3.90	3.07	1.00

Table C.3 *Typical Scanning Resolution and File Sizes*

Format		Horizontal resolution	Vertical resolution	File size (MB) (Cineon format)
Full aperture	Full	4096	3112	51
	Half	2048	1556	13
Academy aperture	Full	3656	2664	39
	Half	1828	1332	10
Cinemascope	Full	3656	3112	45
	Half	1828	1556	11
VistaVision	Full	6144	4096	101
	Half	3072	2048	25

they are stored as Cineon files. As mentioned in Appendix B, these estimates will only be accurate for 10-bit, 3-channel Cineon files or for DPX files using the same storage method.

Digital Cinema Projection

The Digital Cinema Initiative (DCI) is a consortium of vendors and studios that was formed to establish standards for the digital *projection* of images in theaters. To quote from DCI's *Digital Cinema System Specification V1.0* about the Digital Cinema Distribution Master (DCDM):

The DCDM shall provide an image structure container that consists of either a 2 K (2048 × 1080) or 4 K (4096 × 2160) image file … It is expected that the image structure shall use one of the two containers such that either the horizontal or vertical resolution is filled. For example, a 4 K image file with a 2.39:1 aspect ratio would require an image structure of 4096 × 1714, therefore filling the horizontal resolution of the 4 K container.

Thus for the two most common film release formats (aspect ratios) we would have the resolutions shown in Table C.4.

Table C.4 *Digital Cinema Resolutions*

	Digital cinema 4 K	Digital cinema 2 K
1.85	3996 × 2160	1998 × 1080
2.35	4096 × 1714	2048 × 858

Video

There is a broad spectrum of technologies that could be grouped into the category of "video" and new formats are being introduced constantly. Rather than try to chase

any of these specifically, we'll confine our discussion to some basic concepts and terms centered around standards for broadcast (rather than acquisition) as at least these standards move somewhat less rapidly.

Broadcast television has effectively transitioned to a pure digital transmission method. Attempts were made during the development of a worldwide digital television standard (DTV) to avoid the variety of region-specific formats that existed with analog television (NTSC, PAL, SECAM) but unfortunately it appears that several different standards have again emerged. Specifically, there is the ATSC system in the U.S., the DVB system in Europe and the ISDB system in Japan. Other regions have tended to adopt one of these systems—as of the writing of this book the majority seem to be leaning towards DVB. And, unlike the relative format stability that we saw in the past with analog video, these standards are almost certain to evolve much more quickly. Already there are other formats showing up—for instance, DVB has diverged into one system for cable transmission and another for terrestrial or satellite broadcast.

And while it would indeed have been nice and elegant if there was a single table of allowable resolutions available for digital television that could be reproduced in this book, unfortunately this isn't the case. Even the standards proposed by organizations like ATSC are not being universally adopted by all broadcasters and different standards exist (for instance) between cable and satellite broadcast, or between production and broadcast formats. Fortunately the basic resolutions, aspect ratios, and frame rates of these various standards are reasonably convergent, which is really all most compositors will need to deal with.

Aspect Ratios

In general the aspect ratio for DTV is standardizing around 16:9. This widescreen format is closer to what is found in theatrical presentation and requires less modification of feature-film imagery when it is converted for television broadcast. To maintain compatibility with older material, there are still several formats that feature the 4:3 aspect ratio of analog broadcast television.

Generally DTV was designed with square pixels in mind—a high definition format at 1920 by 1080 pixels has exactly a 16:9 aspect ratio and a standard definition image of 640 by 480 has exactly a 4:3 ratio. Some format specifications still require squeezed pixels (for instance, one of the ATSC standards specifies 704 × 480 with a 10:11 pixel aspect ratio to produce an image that has a 4:3 aspect ratio) but in practice these are rarely used.

Resolutions

Typical horizontal resolutions are 1920, 1280, 720, 704, and 640. Vertical resolutions range from 1080 at the high end down to 480 at the low. At this point, the most common

DTV resolutions are: 1920 × 1080, 1280 × 720, 1024 × 576, 768 × 576, 704 × 480, and 640 × 480, using a variety of frame rates and interlacing modes.

Interlacing

Interlaced formats are still used with digital television. This is generally done to make the best use of bandwidth, as interlaced footage can obviously be sent at twice the speed as progressive.

Frame Rates

The set of possible frame rates remains largely the same as with analog television, although the list has grown to include the 24 fps from the film world. Thus we have 25 and 30 fps for progressive formats and 50 and 60 fps for interlaced.

By convention, DTV formats are usually referred to by their vertical resolution, interlacing mode and (sometimes) frame rate. Thus, 1080i is actually a 1920×1080 interlaced image and if you're in the U.S. it's probably running at 30 fps. 720p24 is progressively scanned 1280 × 720 image running at 24 fps.

Of course the technology will continue to evolve, so there will almost certainly be new, higher resolution formats emerging regularly. As of the writing of this book, NHK Japan has already proposed (and demonstrated) a standard for Ultra High Definition Video or UHDV which features a resolution of 7680 × 4320 pixels, displayed at a frame rate of 60 fps.

In the meantime, distribution of content will undoubtedly continue to shift away from broadcast or cable towards the more general-purpose capabilities of the Internet. This in turn will allow for a proliferation of new formats, determined only by the limitations of the software used to encode and decode this data and the bandwidth available to transmit it.

Bibliography

You've probably never read an introduction to a bibliography before. If you're like me, you hardly have ever read the bibliography itself, dismissing it as nothing but a few pages of densely packed text at the back of the book that might be useful to a researcher somewhere but certainly is not something worth spending a lot of time on. Which is part of the reason I wanted to write an introduction to this, so I can try to convince you to really make use of these pages. You'll notice that this isn't a terribly large bibliography. Instead of trying to impress you with the number of sources I consulted while writing this book, I thought I'd try to list those few books (and magazines) that I found to be really worthwhile. In effect, I weeded out all the crap so you don't have to. You can thank me later. If you really want a huge list of further references on all the various topics covered in this book, go to the library, or get some of the books I've listed below and read *their* bibliographies.

This list is not intended to be a recommendation of the "if you only own one book on this subject" sort. Far from it, since I can make absolutely no claims for having surveyed the literature nearly that broadly. If you find a better book on any of the subjects listed, let me know. In the meantime, be assured that the books that are listed are worth reading and owning. All of these books, as well as several additional recommendations, can be found via links on the **www.digitalcompositing.com** website.

American Cinematographer Manual, 9th ed.

ISBN: 0935578242

This is the bible for cinematographers and camera operators. Discusses cameras, film, lenses, filters, and a number of special techniques, from underwater cinematography to ultraviolet photography to stereoscopic technologies. There is also a companion volume, the American Cinematographer Video Manual that deals with many of the same issues from a video and television perspective.

Rogers, Pauline B. *The Art of Visual Effects: Interviews on the Tools of the Trade.*

ISBN: 0240803752

Interviews with a variety of well-known visual effects supervisors.

Adams, Ansel. *The Camera.*

ISBN: 0821221841

Adams, Ansel. *The Negative.*

ISBN: 0821221868

Adams, Ansel. *The Print.*

ISBN: 0821221876

There are so many books out there on photography and the camera that it would probably take a separate book to list them all. Some of them are excellent, many are not. But if you have to recommend a book on the subject, who can complain if you mention one written by Ansel Adams, quite possibly the most famous photographer ever. His justifiably classic book *The Camera* (as well as the companion volumes *The Negative* and *The Print*) is available as a reasonably priced, high-quality paperback and should be easily locatable. He discusses the science of the camera as well as the art. Yes, these are all discussing "pre digital" technology, but there's plenty to be learned here! Buy these books to look at the pictures, if nothing else, but I hope you'll read them and then be inspired to actually go out and take some photos yourself.

Lynch, David K., and Livingston, William. *Color and Light in Nature.*

ISBN: 0521775043

There are a number of good books about how light behaves in the natural environment but this one is reasonably technical without being heavy and is particularly well-illustrated.

Konigsberg, Ira. *The Complete Film Dictionary.*

ISBN: 0140513930

If you work in the film business, or want to, or just like to know about the (often intentionally arcane) terminology that is used by film professionals, you must get a copy of Konigsberg's book. It has everything from specific technical details about camera equipment to comprehensive essays on various film genres. A great reference, and a lot of fun to just poke around in.

Wright, Steve. *Digital Compositing for Film and Video.*

ISBN: 0240804554

Steve goes into great detail on many practical digital compositing techniques, from keying to color-correction, and provides an excellent companion to the book you're now holding.

Allen, Damian, and Connor, Brian. *Encyclopedia of Visual Effects.*

ISBN: 0321303342

A huge collection of tips and techniques related to visual-effects creation. Even the introduction is worth reading!

Reinhard, Erik, Ward, Greg, Pattanaik, Sumanta, and Debevec, Paul. *High Dynamic Range Imaging: Acquisition, Display, and Image-Based Lighting*, 1st ed.
ISBN: 0125852630

Written by the leading researchers in the field of HDR imaging, this book is extremely complete in its coverage of the subject.

Vaz, Mark Cotta, and Barron, Craig. *The Invisible Art: The Legends of Movie Matte Painting.*
ISBN: 081184515X

A great look at the history of the matte painting, with all kinds of classic images.

Rock, Irvin. *Perception.*
ISBN: 0716750015

This book covers a huge range of issues relating to how the human eye and brain are able to perceive the world. It also gives a number of examples of how to fool the eye/brain into thinking that it sees something that it doesn't. This information is useful more often than you might think.

Brugioni, Dino A. *Photo Fakery: The History and Techniques of Photographic Deception and Manipulation.*
ISBN: 1574881663

This one is both fun and a bit chilling. Looks at the historical use of photographic manipulations, touching on everything from communist propaganda to the Kennedy assassination.

Perisic, Zoran. *Visual Effects Cinematography.*
ISBN: 0240803515

Goes into far more detail about the process of photographing visual effects elements than what was covered in Chapter 12.

Goulekas, Karen. *Visual Effects in a Digital World.*
ISBN: 0122937856

Karen's massive dictionary of visual effects terms contains over 7000 entries and a good number of illustrations. Even if you've been in the industry for a long time, I guarantee that you'll be able to learn a few new things (or relearn a few old things) after thumbing through this book.

Finally, there are a number of other references that are worth considering. The conference proceedings from the yearly SIGGRAPH conferences (www.siggraph.org) will usually have a variety of technical papers that touch on digital compositing techniques. The classic paper by Porter and Duff was presented for the 1984 session of this conference:

Porter, Thomas, and Duff, Tom. *Compositing Digital Images. Computer Graphics* 18, no. 3 (July 1984): 253–259. Proceedings of SIGGRAPH '84.

There is also a fine magazine named *Cinefex* (www.cinefex.com) that has been covering feature-film visual effects for over a decade now. Every issue will provide you with a number of discussions about how digital compositing techniques are being used in the real world. As a bonus, you'll also learn about model making, pyrotechnics, and makeup effects.

Glossary

This glossary is intended to be a practical guide to words commonly used in the digital compositing field. It includes not only well-defined technical terms but also a number of colloquialisms that are often used within the industry. As mentioned in the introduction to this book, digital compositing is still a fairly new, volatile field. As such, any attempt to define the terminology that is in use within this discipline risks rapid obsolescence. What's more, many terms used in the digital compositing world can be rather ambiguous, or at least very context dependent. This is due in no small part to the fact that digital compositing is a mesh of so many different disciplines. Terms from the fields of traditional animation, computer animation, image processing, photography, computer science (both hardware and software), art, special effects, visual effects, electronics, optics, physics, film, television, video games, and multimedia have all become a part of the digital compositing lexicon. We have attempted to give some idea of how multiple-definition terms might be interpreted depending on the situation in which they are used.

If you regularly work with digital compositing software, you may find that there are a number of specific compositing operators that are not mentioned within this glossary. This omission is due to the extreme variability within the industry between different software vendors when choosing a name for a particular operation. Appendix A provides a list of typical features that are found in a compositing package, including a number of the common operators. Consequently, if you have come across a term in everyday use that is not found in this glossary, you may wish to check that appendix as well. Of course, your best bet is probably to check the manual for the particular software that is being discussed.

You will find that many entries will need to resort to the use of other digital compositing terms in their definitions. In most cases, if there is a word within a given definition that is also defined elsewhere in this glossary, that word is printed in bold. The exceptions to this rule are those words (such as "digital" or "color") that are used so often that it would be cumbersome to note their every occurrence.

A

Academy aperture A specific 35mm film framing. See Appendix C for more details.

Academy leader The standardized length of film attached by the lab at the head and tail of **release prints** that meets the standards specified by the **Academy of Motion Picture Arts and Sciences (AMPAS)**. The leader contains a countdown running from 8 to a single frame of 2, which is accompanied by a pop on the soundtrack.

Academy of Motion Picture Arts and Sciences (AMPAS) The professional organization that includes branches for almost every area of filmmaking and encourages continued artistic and technical research and development in the industry.

ACM Abbreviation for **Association for Computing Machinery**.

ACM SIGGRAPH See **SIGGRAPH**.

acquisition format A term used to describe the film format used to **capture** the images. For example, **Cinemascope** and **Super 35** are often used to capture images when the desired delivery format is **2.35:1**.

active region The portion of a video signal that is used for actual image information, as opposed to blanking, closed-captioning, time code, etc.

affine Any linear **geometric transformation** including pan, rotate, scale, and shear.

AIFF Audio Interchange File Format. A standard **file format** for storing audio data.

algorithm A procedure or set of instructions for solving a problem or accomplishing a particular goal.

aliasing An artifact that is due to limited **resolution**.

alpha channel The portion of a four-channel image that is used to store transparency information.

ambient light For **computer graphics**, a directionless light source that uniformly distributes light in all directions, illuminating objects equally regardless of their surface orientation. CG ambient lighting is used as an inexpensive way to simulate the indirect illumination that occurs in the real world when light bounces off of other objects in the environment.

ambient occlusion A CG shading method that uses a type of **global illumination** to better compute self-shadowing of objects. Often used in compositing as part of a **multiple-pass rendering** workflow.

American Cinematographer Manual A manual, published by the **American Society of Cinematographers**, that is considered to be the industry "Bible" for **Cinematographer**s, as well as anyone involved in the field. See Bibliography.

American Society of Cinematographers (ASC) The nonprofit organization dedicated to the continued advancement of the art of cinematography through technical and artistic growth. See also **British Society of Cinematographers (BSC), Canadian Society of Cinematographers (CSC)**.

anaglyph A **stereoscopic image** that requires the use of **anaglyph glasses** to view properly.

anaglyph glasses A type of **3D glasses** that uses two different lens colors, usually red and blue to control the images that are seen by each eye in a **stereoscopic image**. See also **flicker glasses, polarized glasses**.

analog Information/data that is continuously variable, without discrete steps or quantization. As opposed to **digital**.

anamorphic format A film format characterized by the fact that the image captured on the negative is horizontally squeezed by the use of a special lens. It is later unsqueezed at projection time by the appropriate amount. For most 35 mm feature-film work, the standard anamorphic format produces a 2.35:1 aspect ratio when projected. See **Cinemascope, Panavision,** and Appendix C for more details.

anamorphic lens A lens that changes the width-to-height relationship of the original image. The most common anamorphic camera lenses in film work compress the horizontal axis by 50%. See **Cinemascope**.

anamorphic Any distorted image that can be undistorted to restore it to its original format.

animated Having characteristics that change over time.

animatic A rough animation that gives some idea about the timing of a sequence. Essentially a moving **storyboard**.

animation Moving imagery that is created on a frame-by-frame basis. This may be accomplished via the use of computers or with more traditional **cel animation** techniques.

animator A person responsible for producing **animations**.

anisotropic Having properties (such as color or reflectivity) that differ based on the direction of measurement.

answer print The first **print** from the lab containing synchronized image and sound and which has had all the scenes color balanced.

antialiasing Techniques used to mitigate the artifacts caused by a lack of sufficient **resolution**.

aperture (1) In a lens, the size of the opening that light passes through (usually given in terms of its **f-stop** or **t-stop**). (2) In a camera body, the mask opening that defines the area of film that will be exposed on each frame. (3) In a projector, the mask opening that defines the area of the frame that will be projected.

apparent motion The natural ability of the eye to perceive motion in a series of images that are played back quickly enough. See also **persistence of vision**.

articulate matte A **matte** whose shape changes over time and which is designed to accurately follow the contours of the object to which it corresponds.

artifact A (usually undesirable) item in an image that is a side effect of the process used to generate or modify that image.

ASA rating A standard numerical rating for specifying a film's sensitivity to light. "ASA" refers to the American Standards Association, now known as the American

National Standards Institute, or ANSI. Many manufacturers now use their own specific **exposure index** instead. See also **DIN rating, ISO index**.

ASC Manual See **American Cinematographer's Manual**.

ASCII Abbreviation for American Standard for Computer Information Interchange. A very common alphanumeric text interchange format. The term is used colloquially to refer to data that is stored in a text format that doesn't require a special program to decode and is usually somewhat comprehensible to a human reader.

aspect ratio A single number that is the result of dividing the width of an image by its height. The units used to measure the width and height are irrelevant, since they will cancel when divided together to give a unitless result. See also **pixel aspect ratio**.

Association for Computing Machinery An organization, founded in 1947, that is the world's first educational and scientific computing society. **SIGGRAPH** is one of the many special interest groups within the ACM.

atmosphere A **depth cue** that causes objects to decrease in contrast as they move into the distance.

B

background In a composite, the bottom element over which all others are added. In general, the background makes up the majority of the image.

backing color The color of the uniform background that is used when shooting an element for **traveling matte** extraction.

BAFTA Abbreviation for the **British Academy of Film and Television Arts**

banding An artifact that appears in areas of a color gradient where the lack of sufficient color resolution causes noticeable bands instead of a smooth transition. Also known as **contouring.** See also **Mach banding**.

barrel distortion Distortion of a lens that causes straight lines to bend away from the center of the image.

base The transparent material (usually cellulose acetate) on which emulsions are applied to make photographic film. Note that it is generally not completely transparent, but rather has a slight characteristic color that may need to be compensated for when scanning.

batch compositing A method of compositing that entails the creation of a script or set of instructions that will be executed at a later time, without the need for a **graphical user interface**

beauty pass (1) In **multiple pass photography**, the pass of the object that contains the most color and detail, as compared with the **matte pass, reflection pass**, or

shadow pass. Also called the **color pass**. (2) In **multiple pass rendering**, the **CG element** that contains the most color and detail information. See also **shadow pass, reflection pass, matte pass, light pass**.

BG Abbreviation for **background**.

bicubic interpolation A method of **interpolation** based on an average of the 16 nearest neighbors. See also **linear interpolation, bilinear interpolation**.

bilinear interpolation A method of **interpolation** based on an average of the four nearest neighbors. See also **linear interpolation, bicubic interpolation**.

bit depth A way of specifying the **color resolution** in an image by measuring the number of bits devoted to each **component** of the pixels in the image.

bit The basic unit for representing data in a digital environment. A bit can have only two different values: 0 or 1.

bit-mapped image An image that consists of a rectangular, two-dimensional array of **pixels**. The standard method for representing an image in a digital format.

black point (1) On a piece of film, the measured density in the area of greatest opacity. (2) In a digital image, the numerical value that corresponds to the darkest area that will be represented when the image is eventually viewed in its final form.

bleach bypass A general term used to describe a number of film processing techniques offered by various labs, in which the bleaching function done during normal processing is partially or completely skipped as a means of increasing **contrast** and reducing **saturation**. Also called **ENR**.

blue spill Any contamination of the foreground subject by light reflected from the **bluescreen** in front of which it is placed. See also **spill, green spill**.

bluescreen photography The process of photographing an object in front of a bluescreen with the intention of extracting a **matte** for that object using various keying and/or color-difference techniques.

bluescreen (1) Commonly used as a generic term that refers to **bluescreen photography** or any similar process, which may use other colors as well as blue. (2) Literally, a screen of some sort of blue material that is suspended behind an object for which we wish to extract a **matte**. Ideally, the bluescreen appears to the camera as a completely uniform blue field.

bounce light Light that is reflected or "bounced" off other objects in a scene before it reaches the subject.

box filter A specific digital **filter** that is often used when **resampling** a digital image. The box filter is fast, but fairly low quality.

British Academy of Film and Television Arts (BAFTA) The British version of the American **Academy of Motion Picture Arts and Sciences (AMPAS)**.

British Society of Cinematographers (BSC) The British version of the **American Society of Cinematographers (ASC)**. See also **Canadian Society of Cinematographers (CSC)**.

burn-in Photographic double exposure of an element over a previously exposed piece of film.

C

camera aperture A specific 35 mm film framing, also known as **full aperture.** See Appendix C for more details.

camera mapping A **CG** technique in which an image is projected from the **camera** onto a **3D object**. This technique is useful for recreating a simulation of a 3D environment using 2D photographic elements. Also called **projection mapping**.

Canadian Society of Cinematographers (CSC) The British version of the **American Society of Cinematographers (ASC)**. See also **British Society of Cinematographers (BSC)**.

CBB Abbreviation for "**Could Be Better**". When a shot has a few minor technical or aesthetic adjustments to be made, but the delivery date is close at hand, this term is used to **final** a shot with the caveat that it will be improved at a later date if time and budget permit. Due to tight deadline and budget constraints, most of these CBBs never make it back into production and end up in the final cut of the movie.

CC Abbreviation for **color correction**.

CCD Abbreviation for charge-coupled device, a light-sensitive semiconductor that is often used in scanners and video cameras to capture an image.

cel animation **Animation** that is the result of sequences of images drawn on individual clear acetate cels. Many aspects of traditional cel animation are now being supplemented by digital techniques.

center extraction A term used to describe any process, such as masking or cropping, that is used to extract the centered portion of the original image to produce the final viewing format.

CG Abbreviation for **computer graphics (CG)**.

CG feature Any feature film created entirely with **computer-generated imagery**.

CG Supervisor Abbreviation for **Computer Graphics Supervisor**.

CGI See **computer-generated imagery**.

channel For a given image, the sub-image that is composed only of the values from a single **component** of each pixel.

characteristic curve A curve that plots the relationship between light falling on a piece of film and the resulting density of the developed image.

chroma-keying A **keying** technique that allows one to separate an object from its background based on colors that are unique to either the foreground or background.

chromatic aberration An image **artifact** that is caused by the fact that different wavelengths of light are bent by slightly different amounts as they pass through a lens. The artifact is usually seen as a color shift along sharply delineated edges in an image.

chromatic resolution Another term for **color resolution.**

chrominance The color portion of a video signal, carrying the **hue** and **saturation** values. See also **luminance.**

Cinemascope An **anamorphic** film format that produces an image with an aspect ratio of 2.35:1. Although Cinemascope (or CinemaScope) was originally a specific process developed by 20th Century Fox in the 1950s, it has become a generic term for the 2.35 anamorphic format. The most common lenses used for this purpose today are produced by **Panavision**. See Appendix C for more details.

Cinematographer An individual who is experienced in the art of capturing images on **camera**. The main Cinematographer for a film is the **Director of Photography**.

Cineon A specific image file format used most often in film compositing work. See Appendix B.

circle of confusion The size of the circle to which an idealized point will diverge when the lens is focused at different depths. Used as a way to measure the focus of a lens.

clean plate A **plate** that differs from the primary plate only in that it does not contain the subject(s) in the frame.

clip A small piece of film, often "clipped" from a longer shot, that can be used as a reference for color, lighting, etc.

clipping The process (intentional or otherwise) whereby data above or below a certain threshold is removed or lost. With digital images, this usually translates to colors outside a specific range.

clone In **digital paint**, a method of copying information from one region of an image to another.

cloud tank A large water-filled glass enclosure that is used to create clouds and other atmospheric effects. The clouds are usually produced by injecting some opaque liquid (such as white paint) into the water.

CLUT Abbreviation for **color lookup table**.

CMY Cyan, magenta, and yellow. The three complementary colors, or a method of specifying the colors in an image based on a mix of these three components.

color bars Standard test patterns used in video to determine the quality of a video signal. Color bars consist of equal-width bars representing black, white, red, green, blue, yellow, cyan, and magenta. These colors are generally represented at 75 percent of their pure value.

color contamination A term used to describe a **backing color**, such as **bluescreen** or **greenscreen**, that is contaminated with one of the other primary colors. Color contamination can make the job of **matte extraction** much more difficult.

color correction Any process that alters the perceived color balance of an image.

color difference method A compositing technique that utilizes the difference in color between the different channels of an image in order to extract a **matte.** The technique relies on the subject being photographed in front of a uniformly colored background, such as a **bluescreen**.

color lookup table A **lookup table** that is specifically designed to modify color.

color management A global term used to describe the process of producing consistent color across a range of software and devices.

color resolution The amount of data allocated for specifying the value of an individual color in an image. See also **bit depth**.

color space Any method for representing the color in an image. Usually based on certain components such as RGB, HSV, etc.

color temperature A method of specifying color based on an absolute temperature scale, degrees Kelvin (K). The color is equivalent to the color of light that would be emitted if a pure black object were heated to that temperature. Higher color temperatures are more blue, lower temperatures are more red.

color timer A person who adjusts the scene-to-scene color **continuity** when preparing the final print of a film.

color timing The color balance of a particular image or scene, or the process of color correcting and balancing that image or scene.

color wedge A series of images that feature incremental alterations in the color of a certain element (or sometimes the entire frame) for the purpose of choosing a final value for the color of that element.

complementary color The color that results when the primary color is subtracted from white.

complementary matte The matte that results when the primary matte is inverted.

component video Video signal in which various aspects of color such as luminance and chrominance are maintained separately.

component One of the elements that is used to define the color of a pixel. In most digital images, the pixel color is specified in terms of its red, green, and blue components.

composite video Video signal in which the color elements are all combined (encoded) into a single signal.

compositing engine Within a package used for compositing, the code that is responsible for the actual image processing operations, in contrast to other code that may deal with the user interface, file input/output, etc.

Compositing Supervisor The individual responsible for the aesthetic and technical supervision of all the digital composites created for a project. The Compositing Supervisor leads a team of **Compositors**.

compositing The manipulated combination of at least two source images to produce an integrated result.

Compositor A person who creates composites.

compression ratio The ratio of the data sizes between the uncompressed element and the compressed equivalent.

computer graphics An image or images created or manipulated with the aid of a computer.

Computer Graphics Supervisor The person responsible for determining the aesthetic and technical solutions, software selections, and overall **pipeline** for the **3D** work on a project.

conform The process of matching raw, original footage with some edited version of that footage.

computer-generated imagery An image or images created or manipulated with the aid of a computer. Often used to refer specifically to 3D computer animation, although it is really a much broader term.

contact shadow A shadow that is cast from one object when it is in direct contact with another object, as opposed to a shadow that is cast on a distant surface.

continuity The smooth flow of action or events from one shot or scene to the next, without any indication that the different shots/scenes may have been photographed at different times or processed differently.

contouring An **artifact** that results from not having enough **color resolution** to properly represent a color gradient. See also **Mach banding**.

contrast The ratio of the brightest tones in an image to the darkest.

control points The specific points that are interpreted to define the shape of a curve.

convolution filter A matrix of numbers used to control the weighted averaging performed in a **convolve** operation. Sometimes also referred to as the **convolution mask**.

convolution kernel The group of pixels that will be considered when performing a **convolve** operation. Generally we are only worried about the size of the kernel,

which is usually a square matrix with an odd number of elements in each dimension. The most common kernel size is 3 × 3. Occasionally the term is used as a synonym for the **convolution filter.**

convolution mask See **convolution filter.**

convolve An image processing operation that involves the specialized averaging of a neighborhood of pixels using a **convolution filter.** Also known as a **spatial convolution.**

cool A non-exact term that is used to describe an image that is biased toward the blue portion of the spectrum.

CPU Abbreviation for central processing unit, the computational heart of a computer.

crawling An undesirable **artifact** characterized by edges that do not remain stable over time.

creature shop Any facility that creates prosthetics, animatronics, puppets, robotics, and creatures for use in a film.

cropping The removal (intentionally or otherwise) of part of an image that is outside a specific boundary.

C-scope Abbreviation for **Cinemascope.**

cukaloris Panel with irregular holes cut in it to project patterned shadows onto a subject. Also known as a **kukaloris,** cuke, or cookie.

cursor A graphical marker, usually controlled by a device such as a mouse or a tablet, that is used to point to a position or object on a computer's display.

curve editor Any **graphical user interface (GUI)** module which allows the user to create and modify **curve**s.

D

D1 format A digital **component video** format. D1 is considered to be a nearly lossless format, although it does use **4:2:2 compression.**

D2 format A digital **composite video** format. D2 is a lower quality than **D1,** but is also significantly less expensive.

D5 format A digital **component video** format. D5 is considered to be of the same quality as **D1,** and also has provisions for storing **HDTV**-format imagery.

dailies Imagery produced during the previous day's work, or a meeting to view this work.

day for night The process of shooting footage in daylight conditions with the intention of eventually presenting it as a nighttime scene. It may involve a combination of photographic, lighting and digital postprocessing techniques.

decimation The process of throwing away unnecessary information when reducing the size of an image.

deinterlace The process of separating the two **fields** that make up a video image into two distinct images.

densitometer Instrument used to measure the optical density of a piece of processed film.

density space A **nonlinear color** representation that is based on the density of a piece of developed negative relative to the amount of light that reached it.

depth channel Another term for the **Z-channel**.

depth cue Information that helps to determine the distance of an object from the camera.

depth of field The depth of field of a specific lens is the range of acceptable focus in front of and behind the primary focus setting. It is a function not only of the specific lens used but also of the distance from the lens to the primary focal plane, and of the chosen aperture. Larger apertures will narrow the depth of field; smaller apertures will increase it.

depth of focus A term that is often improperly used when one wishes to refer to the **depth of field**. Depth of focus is a specific term for the point *behind* the lens (inside the camera body) where a piece of film should be placed so that the image will be properly focused.

desaturation A term to describe the removal or loss of color in an image. A completely desaturated image would consist only of shades of gray.

detail generator An adjustment available on some video cameras that introduces additional **sharpening** into the captured image.

digital intermediate See **digital intermediate**.

difference matte A **matte** created by subtracting an image in which the subject *is* present from an otherwise identical image in which it is *not* present.

diffusion An effect, caused by **atmosphere** or special **filters** placed on the lens, that is characterized by a scattering of light, elevated dark areas, and an overall softer look.

digital A method of representing data via discrete, well-defined samples. As opposed to **analog**.

digital artist Any artist who creates and manipulates images digitally. The term Digital Artist encompasses both 2D and 3D Artists and can be synonymous with the various titles used, such as CG Artist, Technical Director (TD), Compositor, Matte Painter, Character Animator, etc.

digital compositing The digitally manipulated combination of at least two source images to produce an integrated result.

Digital Effects Supervisor The individual responsible for the creation of all the digital effects work required for a production. The DFX Sup supervises the work of the **CG Supervisor** and the **Compositing Supervisor** and reports directly to the **Visual Effects Supervisor**.

digital intermediate A high quality digital version of a film which is used to finalize all color balancing issues.

digitization The process of sampling any analog subject to produce a digital representation. Within the field of digital compositing, usually refers to the process of converting a video or film source to digital information.

dilation An image processing technique that results in brighter areas of the image increasing in size and darker areas decreasing. See also **erosion**.

DIN rating A standard numerical rating for specifying a film's sensitivity to light. "DIN" is an abbreviation for Deutsche Industrie Norm (German Industry Standard). Many manufacturers now use their own specific **exposure index** instead. See also **ASA rating, ISO index**.

Dirac filter Another name for the **impulse filter**.

Director The person with the primary responsibility for overseeing the creative aspects of a project or production.

dissolve A specific **transition effect** in which one scene gradually fades out at the same time that a second scene fades in. Halfway through a linear dissolve the image will be a 50% mix of both scenes.

dither A method for representing more colors than would normally be available with a given **palette**. Dithering uses combinations of colored pixels and relies on the fact that the human eye will average them together and interpret the result as a new intermediate color.

D-max See **maximum density**.

D-min See **minimum density**.

DOD Abbreviation for **domain of definition**.

DOF Abbreviation for **depth of field**.

domain of definition A (usually rectangular) region that defines the maximum boundaries of useful information in an image. Generally, everything outside of the DOD will have a value of 0 in all channels of the image. The DOD is usually determined automatically, as opposed to a **region of interest**.

dots per inch A common method for measuring spatial resolution in the print industry. The horizontal and vertical scales are assumed to be equal, unless specified otherwise.

double exposure In the optical world, a double exposure is accomplished by exposing two different images onto a single negative. The result is a mixture of the two images. In the digital world, this effect is accomplished by mathematically averaging the two images.

double framing The process of duplicating and repeating every frame in an image sequence. The result is a new image sequence that appears to be moving at half the original speed. Also known as double printing.

DPI Abbreviation for **dots per inch**.

DPX A specific image file format. See Appendix B.

drop frame Video footage in which two frames are dropped every minute except the tenth. It is used to compensate for the fact that time code works at exactly 30 frames per second but NTSC video runs at only 29.97 **fps**.

dubbing The process of making a copy of a videotape.

dust busting The term used to describe the process of removing dirt and scratches from scanned imagery.

DVE An abbreviation for digital video effect, this usually refers to any of a number of **geometric transformations** that are typically performed by specialized real-time video equipment. Examples of a DVE move include animated pans, rotations, or flips, as well as various hardware-specific effects such as page turns or customized wipes.

DX Abbreviation for **double exposure**.

dynamic range (1) The range of brightness values in a scene or an image, from brightest to darkest, often expressed as a ratio. (2) In a digital image, the total number of different colors in the image.

dynamic resolution Another term for **color resolution**.

E

edge detection An algorithm used to enhance or isolate transition areas, or "edges," in an image.

edge matte A specialized **matte** that includes only the outlines or borders of an object.

edge numbers Sequential numbers printed along the edge of a piece of film (outside of the perforations) by the manufacturer to help identify particular frames.

edge quality A term used to describe the characteristics of the edges of an **element** that has been matted into a scene.

editing The process of assembling shots and scenes into a final product, making decisions about their length and ordering.

effects animation A term that is usually used to refer to elements that were created via **cel animation** or digital **rotoscoping** techniques but are not character related. Common examples include sparks, lightning, or smoke.

effects filter Any of a number of different optical **filters** that can introduce **diffusion, flares,** glows, etc. Dangerous when shooting **bluescreen** elements.

EI Abbreviation for **exposure index**.

eight-perf A nickname for the **VistaVision** film format that comes from the fact that each VistaVision frame has eight **perforations** along each edge.

8-bit image In the **visual-effects** world, this term typically refers to any image containing 8 bits of color information per **channel**.

8 mm film A narrow-**gauge** film that contains 74 frames per foot. See Appendix C for more details.

element A discrete image or sequence of images that will be added to a composite.

emulsion The light-sensitive material that is applied to a transparent **base** to create photographic film.

encoder (1) A piece of video equipment that combines a **component video** signal into a **composite video** signal. (2) A generalized term used to refer to a number of different data capture devices, usually ones that convert measurements into digital data.

ENR See **bleach bypass**.

erosion An image processing technique that results in darker areas of the image increasing in size and brighter areas decreasing. See also **dilation**.

E-split See **exposure split**.

exposure index A standardized, but manufacturer-specific, numerical rating system for specifying a film's sensitivity to light. There are also several industry-standard systems in use, including the **ASA rating**, the **ISO index**, and the **DIN rating**. To make it even more interesting, many manufacturers will specify a rating for both daylight lighting and tungsten lighting.

exposure latitude Amount of over-or underexposure a given type of film can tolerate and still produce acceptable results.

exposure split A simple **split-screen** shot in which multiple exposures of a given scene are combined in order to bring areas of widely divergent brightness into the same shot. Also known as an **E-split**.

exposure wedge A series of images that feature incremental alterations in the exposure (brightness) of a certain element (or sometimes the entire frame) for the purpose of choosing a final value for the exposure of that element.

EXR See **OpenEXR**

F

fade Decreasing the brightness of an image over time, eventually resulting in a black image.

fast Fourier transform An algorithm for converting an image so that it is represented in terms of the magnitude and phase of the various frequencies that make up the image. Yes, there *is* a regular Fourier transform, but nobody uses it because it's not … fast.

FFT Abbreviation for **fast Fourier transform**.

FG Abbreviation for **foreground**.

field chart A method of dividing an image into a grid so that certain areas of the frame can be specified by grid coordinates.

field dominance The order in which the fields in an interlaced image are displayed. Essentially, whether the even or the odd field is displayed first for any given frame.

field of view The range of a scene that will be captured by a specific camera. FOV is usually measured as the number of horizontal degrees (out of 360), although a vertical field of view is also a valid measurement.

field (1) An image composed of either the even or odd scan lines of a video image. Two fields played sequentially will make up a video frame. (2) A unit of measure on a **field chart**.

file format A standardized description of how a piece of data (such as an image) is to be stored.

film gauge The width of a particular film stock, i.e., 16 mm, 35 mm, etc.

film recorder A device that is capable of transferring digital images to a piece of film negative.

film recording The process of transferring digital images to a piece of film negative via the use of a **film recorder**.

film speed A very context-dependent term that may refer to (1) the rate that film is moving through a camera or a projector (24 frames per second in normal feature-film work) or to (2) the light sensitivity of the film itself. Slow-speed film is less light sensitive; high-speed film is more sensitive.

film weave Irregular horizontal movement (generally undesirable) of a piece of film as it moves through a camera or projector.

filter (1) A translucent material that is placed in front of a light or camera to modify the color that is transmitted. Certain of these optical filters may also be designed to introduce specific artifacts, such as **diffusion, flares**, etc. (2) Any of a number of algorithms used within the computer for sampling an image. Different filters can be used when transforming an image, and can result in differing amounts of

sharpness or artifacts. (3) The process of using either of the aforementioned types of filters.

final The term given to a composite shot once it is considered complete and has been approved by the appropriate decision makers.

"fix it in post" A phrase commonly used when time and/or conditions prohibit the ability to shoot a scene exactly as intended. Rather than delaying the production, a decision is made to shoot as quickly as possible and correct any problems during **post production**, usually using visual effects techniques.

fixed matte As opposed to a **traveling matte**, a fixed matte will not change position or shape during the shot.

flare Any of a number of effects that will show up on an image as the result of a light source shining directly into the lens of a camera.

flashing Flashing is an optical process whereby unprocessed negative is exposed to a small amount of light for the purpose of reducing the contrast or saturation of the scene that will eventually be photographed with that film. In the digital realm, flashing is the application of any number of nonspecific techniques to produce similar results. An image that appears to suffer from some of these characteristics is often referred to as appearing "flashed."

flat lens Another term for a **spherical lens**. Sometimes also used as a relative term for measuring the distortion and exposure variance of any lens.

flat Another term for low **contrast**.

flicker glasses A type of **3D glasses** that uses an electronic shutter to block the light reaching each eye independently. By syncing the glasses to the projection device, alternate stereo pairs can be presented to the viewer in a fashion that simulates a stereoscopic scene. See also **polarized glasses, anaglyph glasses**.

flip A simple geometric transform in which an image is mirrored about the X-axis so that it is now upside-down. This process is different from merely rotating the image 180 degrees.

float A number defined with **floating-point** precision.

floating-point A term used to describe a number in which no fixed number of digits must be used before or after a decimal point to describe a number, meaning that the decimal point can "float."

flop A simple geometric transform in which an image is mirrored about the Y-axis.

focal length A measure of the magnification power of a given lens, based on the distance from the center of the lens to the film. Also known as simply the "length" of a lens. A longer focal length will produce greater magnification than a shorter length.

focus (1) To adjust a lens so that the image it produces is as sharp as possible. (2) The point in space behind a lens where this sharpness occurs.

folding The process of consolidating discrete mathematical operations into a single function.

forced perspective A technique used to create the illusion of increased depth in a scene by building more distant objects at a smaller scale than normal.

foreground Usually the primary element to be added to a composite and placed over the **background**. Often, there may be several foreground elements in a composite.

format (1) The size, resolution, aspect ratio, etc. for a given image. (2) The **file format** for a given image. (3) The physical medium (such as film, video, etc.) used to capture or display an image sequence. (4) A multitude of additional variations and subcategories of the first three definitions.

four-perf A nickname for the standard 35 mm film format that refers to the fact that each frame spans four pairs of **perforations**.

four-point track A type of **2D tracking** in which four points are selected from a sequence of images to extract an approximation of an object's movement relative to the camera. Allows for **corner pinning** techniques.

4:1:1 compression A method of encoding the data needed to represent an image by sampling **Y** (**luminance**) for every pixel but removing every other **UV** (**chroma**) pixel in both the horizontal and vertical directions.

4:2:2 compression A method of encoding the data needed to represent an image by sampling **Y** (**luminance**) for every pixel but removing every other **UV** (**chroma**) pixel in the horizontal direction.

4:4:4 compression A method of encoding the data needed to represent an image by sampling **Y** (**luminance**) and **UV** (**chroma**) for every pixel in the image.

4 K resolution A general term referring to any digital image containing an X **resolution** of approximately 4096 **pixels**. The actual dimensions of a 2 K image depends on the **aspect ratio** of the imagery. A common 4K resolution used in **visual effects** when working with **full aperture** framing is 4096 × 3112.

FOV Abbreviation for **field of view**.

fps Abbreviation for **frames per second**. See **frame rate**.

fractal compression A **lossy** image-compression algorithm that is based on repeated use of scaled and rotated pixel patterns.

frame rate The rate at which sequences of images are captured or displayed. The frame rate is usually measured in frames per second, or **fps**.

frame A single image that is usually part of a group designed to be viewed as a moving sequence.

freeze frame A single frame that is held for a duration of time.

freeze The process of stopping the action. In digital compositing, this is usually accomplished by repeating the same frame for a duration of time.

fringing An **artifact** of the matting process in which a foreground element has a noticeable (usually bright) outline.

f-stop A measurement of the **aperture** of a lens.

full aperture A specific 35 mm film framing, also known as **camera aperture.** See Appendix C for more details.

G

gamma (1) In film, a measure of the contrast of an image or emulsion, based on the slope of the straight-line portion of the **characteristic curve.** (2) An adjustment applied to a video monitor to compensate for its nonlinear response to a signal. (3) A digital effect used to modify the apparent brightness of an image.

gamut The range of colors that any given device or format is able to display or represent.

garbage matte A rough, simple **matte** that isolates unwanted elements from the primary element in an image.

gauge See **film gauge.**

Gaussian blur A specific method for blurring an image based on a **Gaussian filter.**

Gaussian filter A specific digital **filter** that is often used when resampling an image.

gel Abbreviation for gelatin filter, a flexible colored optical **filter.**

generation loss The loss of quality of an image due to repeated duplication. Generation loss is significantly reduced and in some cases completely eliminated when dealing with digital images.

geometric transformation An effect that causes some or all of the pixels in a given image to change their current location. Such effects include **translation, rotation, scaling, warping,** and various specialized distortion effects.

GIF Graphics Interchange Format, a specific image file format. See Appendix B.

global illumination A general term used to describe the modeling of all the reflected and transmitted light that originates from every surface in a scene.

G-matte Abbreviation for **garbage matte.**

gobo See **cukaloris.**

grading Another term for **color timing,** used primarily in Great Britain.

grain The individual particles of silver halide in a piece of film that capture an image when exposed to light. Because the distribution and sensitivity of these particles

are not uniform, they are perceived (particularly when projected) as causing a noticeable graininess. Different film stocks will have different visual grain characteristics.

graphical user interface A **user interface** that utilizes images and other graphical elements to simplify the process of interacting with the software. Also known as the "look and feel" of the software.

gray card A card (gray) usually designed to reflect about 18% of the light that strikes it; used as a reference for measuring exposure. **grayscale image:** A completely **desaturated** image, with no color, only shades of gray.

greenscreen Identical in use and concept to a **bluescreen** (only it's green).

green spill Any contamination of the foreground subject by light reflected from the **greenscreen** in front of which it is placed. See also **spill, blue spill**.

GUI Abbreviation for **graphical user interface**.

H

handles Extra frames at the beginning and end of a shot that are not intended for use in the final shot but are included in the composite in case the shot's length changes slightly.

HD resolution A general term referring to any digital image that contains the **spatial resolution** of one of the **HDTV** standards. 1920 × 1080 is the most common of these.

HDR See **High Dynamic Range.**

HDTV High-definition television. A television standard with significantly greater spatial resolution than standard **NTSC, PAL**, or **SECAM**.

Hermite curve A specific type of **spline curve** that allows for explicit control over the curve's tangent at every **control point**.

high dynamic range Related to imagery or devices that can deal with a larger than normal **dynamic range**.

high-pass filter A **spatial filter** that enhances high-frequency detail. It is used as a method for **sharpening** an image.

histogram A graphical representation of the distribution (usually frequency of occurrence) of a particular characteristic of the pixels in an image.

histogram equalization: An **image processing** technique that adjusts the contrast in an image so that it fits into a certain range.

histogram sliding: Equivalent to adding a certain number to the values of every pixel in an image.

histogram stretching: Equivalent to multiplying the values of every pixel in an image by a certain amount.

HLS: Hue, luminance , and saturation . A method of specifying the colors in an image based on a mix of these three components.

hold To stop the action by using the same frame repeatedly.

hold-out matte A **matte** used to prevent a foreground element from completely obscuring an object in the background plate.

hot A nonexact term for describing an image that is too bright. Completely unrelated to the terms **warm** and **cool**.

HSB Hue, saturation, and brightness. A method of specifying the colors in an image based on a mix of these three components.

HSI Hue, saturation, and intensity. A method of specifying the colors in an image based on a mix of these three components.

HSL Hue, saturation, and lightness. A method of specifying the colors in an image based on a mix of these three components.

HSV hue, saturation, and value. A method of specifying the colors in an image based on a mix of these three components.

hue A specific color from the color spectrum, disregarding its **saturation** or **value**.

Huffman coding A **lossless** image-compression scheme. See also **run-length encoding, JPEG, MPEG**.

I

ICC Abbreviation for **International Color Consortium**.

ILM See **Industrial Light and Magic**.

image processing The use of various tools and algorithms to modify digital images within a computer.

IMAX A proprietary film capture/projection process that uses an extremely large-format negative.

impulse filter A specific digital **filter** that is often used when **resampling** a digital image. It is considered to be the lowest-quality, highest-speed filter in common use. Also known as the **Dirac filter** or the **nearest-neighbor filter**.

in-betweening The process of **interpolating** between the **keyframes** of an animation sequence.

in-camera effects **Visual effects** that are accomplished solely during principle photography, involving no additional postproduction.

indexed color A method of storing image data, in which the value of the pixel refers to an entry in a table of available colors instead of a numerical specification of the color itself.

Industrial Light and Magic A pioneering visual effects company that was the first to widely use digital compositing in feature-film work.

interactive lighting Lighting in a scene that changes over time and responds to the activity within the environment.

interframe coding The process used in **MPEG** encoding whereby intermediate images in a sequence are defined by their deviation from specific keyframes.

interlacing The technique used to produce video images whereby two alternating **field** images are displayed in rapid sequence so that they appear to produce a complete **frame**.

Intermediate General term used for copies (not necessarily first-generation) of the **original negative**, which can be used as the source for duplicate copies. See **interpositive, internegative**.

internal accuracy The measurement of the precision or **bit depth** that a software package uses to represent and modify image data.

International Color Consortium The organization established for the purpose of standardizing **color management** across different platforms.

internegative (IN) Short for **intermediate negative**, a copy made from the **interpositive** through **printing** and **developing**.

interocular distance The spacing between the eyes, usually referring to the human average of about 2½ inches; an important factor for the production of **stereoscopic imagery**.

interpolation The process of using certain rules or formulas to derive new data based on a set of existing data. See also **bicubic interpolation, bilinear interpolation, linear interpolation**.

interpositive (IP) Short for **intermediate positive**, a **positive print** made from the **original negative** for use in making **internegatives**.

ISO index A standard numerical rating for specifying a film's sensitivity to light. "ISO" refers to the International Standards Organization. The **ISO Index** actually incorporates both the American **ASA rating** and the European **DIN rating**. Many manufacturers now use their own specific **exposure index** instead. See also **ASA rating, DIN rating**.

J

JPEG A (typically **lossy**) compression technique, or a specific image format that utilizes this technique. "JPEG" is an abbreviation for the Joint Photographic Experts Group.

K

kernel The group of pixels that will be considered when performing some kind of spatial filtering. See also **convolution kernel**.

key (1) Another name for a **matte**. (2) The process of extracting a subject from its background by isolating it with its own matte and **compositing** it over a new background.

Keycode numbers See **edge numbers**.

Keykode A specific form of **edge numbers** that was introduced by Kodak.

keyer A device or operation used for **matte extraction** or **keying**.

keyframe animation The process of creating animation using **keyframes**.

keyframe Any frame in which a particular aspect of an item (its size, location, color, etc.) is specifically defined. The non-keyframe frames will then contain **interpolated** values.

keyframing Another term for **keyframe animation.**

keying The process of algorithmically extracting an object from its background and combining it with a different background.

Keylight The trade name of a **color difference keyer** developed by Computer Film Company (CFC).

keystoning, keystone distortion A geometric distortion resulting when a rectangular plane is projected or photographed at an angle not perpendicular to the axis of the lens. The result is that the rectangle becomes trapezoidal.

kukaloris See **cukaloris**.

L

large format camera Any camera designed to use wide-**gauge** films, such as **65 mm film**.

large format film Generally, referring to any film larger than the standard **35 mm film** format.

latent image The invisible image that exists on an exposed piece of negative which has not yet been developed.

layering operation A global term referring to any **compositing** operation that integrates one **element** with another element based on their **alpha channels** or **RGB values**.

lens artifact Any **artifact**, such as a **lens flare** or **chromatic aberration**, that appears in an image as a result of the **lens assembly**.

lens assembly Referring to the set of specially matched lenses that are assembled to form a single lens component in a standard camera lens.

lens flare An **artifact** of a bright light shining directly into the lens assembly of a camera.

letterboxing A method for displaying images that preserves the **aspect ratio** of the film as it was originally shot, using black to specify areas outside of the original frame.

light pass (1) In **multiple-pass photography**, the pass of individual lights striking the subject, such as the **key** or **fill**, for later use in **compositing**. (2) In **multiple-pass rendering**, the **CG element** that represents the effects of a particular **light** striking the **object**. See also **shadow pass, reflection pass, matte pass, beauty pass**.

lighting reference A **stand-in** object that can be used to judge the lighting in a scene.

linear color space A **color space** in which the relationship between a pixel's digital value and its visual brightness remains constant (linear) across the full **gamut** of black to white.

linear encoding A method of converting the colors from the input image to an output image in an evenly distributed, linear way. Also referred to as linear mapping. See **linear color space, nonlinear color space**.

linear interpolation A method of interpolation that is based on the average of the two nearest neighbors. See also bicubic interpolation, bilinear interpolation.

linear space See **linear color space**.

locked-off camera A camera whose position and lens settings do not change over the duration of the shot.

log space An abbreviation for **logarithmic color space**, a **nonlinear color space** whose conversion function is similar to the curve produced by the logarithmic equation.

long lens A relative term, in contrast to a **short lens**. Also known as a **telephoto lens**.

look-up table An array of values used to convert data from an input value to a new output value. See **color look-up table**.

lossless compression A method of compressing and storing a digital image in such a fashion that the original image can be completely reconstructed without any data loss.

lossy compression A method of compressing and storing a digital image in such a fashion that it is impossible to perfectly reconstruct the original image.

low-pass filter A **spatial filter** that removes high-frequency detail. It is used as a method for blurring an image.

luma-keying A matte-extraction technique that uses the **luminance** values in the image.

luminance In common usage, synonymous with brightness. In the **HSL** color space, luminance is the weighted average of the red, green, and blue components.

LUT Abbreviation for **look-up table**.

LZW compression A **lossless** compression method that finds repeated patterns in blocks of pixels in an image. Variations of LZW compression are used in a number of image file formats, including **GIF** and **TIFF**. "LZW" stands for Lempel-Ziv-Welch.

M

Macbeth chart An industry standard test chart made up of square color and gray patches.

Mach banding An optical illusion (named after the physicist Ernst Mach) in which the eye perceives emphasized edges in areas of color transition. This illusion causes the eye to be more sensitive to **contouring** artifacts.

macro (1) In the digital world, a combination of functions or effects that are grouped together to create a new effect. (2) A specialized lens that is capable of focusing at an extremely close distance to the subject.

mask An image used to selectively restrict or modify certain image processing operations on another image, or the process of doing so.

matchmove The process of extracting the camera move from a live action plate in order to duplicate it in a CG environment. A matchmove is often created by hand as opposed to **3D tracking** in which special software is used to help automate the process.

matte channel Another name for **alpha channel**.

matte An image used to define or control the transparency of another image. See also **articulate matte, complementary matte, difference matte, edge matte, fixed matte, garbage matte, G-matte, hold-out matte, rotoscoped matte, static matte, traveling matte**.

matte channel Another name for the **alpha channel** in a four-channel image.

matte extraction Any process used to create a **matte**.

matte line An artifact of the matting process wherein a foreground element has a noticeable outline.

matte painting A hand-painted image, usually intended to be photorealistic, that is combined with live-action footage.

matte pass (1) In **multiple-pass photography**, a pass that is lit in some high-contrast fashion so that it can be used as a **matte** during **compositing**. (2) In **multiple-pass rendering**, a separate **render** of the **alpha channel** of one of the objects in the scene for use during compositing. See also **beauty pass, reflection pass, matte pass, light pass**.

maximum density The point of exposure at which additional light (on the negative) will no longer affect the resulting image. The definitions of maximum and **minimum density** would be reversed if you were speaking of print (reversal) film instead of negative. Also known as **D-max**.

median filter A specialized **spatial filter** that removes pixel anomalies by determining the median value in a group of neighboring pixels.

minimum density The point of exposure just below the amount needed (on the negative) to start affecting the resulting image. The definitions of minimum and **maximum density** would be reversed if you were speaking of print (reversal) film instead of negative. Also known as **D-min**.

Mitchell filter A specific digital **filter** that is often used when **resampling** a digital image. The Mitchell filter is particularly well suited to **transforming** images into a higher resolution than they were originally.

moco Abbreviation for **motion control**.

monochrome An image that contains only a single hue, and the only variation is in the luminance of that hue. Typically, a monochrome image consists only of shades of gray.

morphing A process in which two image sequences are **warped** so that key features align as closely as possible and then a selective **dissolve** is applied to transition from the first sequence to the second. The result should be a seamless transformation between the two sequences.

motion artifact A general term describing all forms of image artifacts due to motion, such as **strobing** or **wagon wheeling**.

motion blur An artifact caused by the fact that a camera's shutter is open for a finite duration as it captures an image. Any object that is moving during that time will appear blurred along the path that it was traveling.

motion control A method of using computer-controlled mechanisms to drive an object's movement so that it is continuously repeatable.

motion-control camera A camera whose position, orientation, and lens settings are **motion controlled**.

motion graphics Animated graphic imagery that is done primarily to achieve a specific visual design rather than to produce photorealistic images.

MPEG A (typically **lossy**) compression technique specifically designed to deal with sequences of images, or the format of the images produced by this technique. "MPEG" is an abbreviation for the Moving Pictures Experts Group.

multimedia A broad categorization that generally refers to some method of displaying information using sound and imagery simultaneously.

multiplane compositing A technique that simulates a moving camera by automatically translating the different layers in a composite by an amount that is appropriate to their intended distance from this camera. Layers that are intended to appear farther away are moved by a smaller amount than layers that are intended to be nearer, producing a simulated **parallax** effect.

multiple-pass photography Any filming in which multiple exposures of the same subject are filmed, generally with different lighting setups. If the camera is moving then it must be **motion controlled** to ensure accurate alignment between passes. Typical passes might include a **beauty pass, shadow pass, matte pass**, and **reflection pass**.

multiple-pass rendering A technique in which a 3D object or scene is rendered in a series of separate images, each with different lighting or rendering characteristics. Typical passes might include **color, shadow, reflection, key light, fill light, backlight**. See also **multiple-pass photography**.

N

naming conventions The standardized names that are used within a facility to differentiate the various elements and files that are stored on disk for a project.

ND filter See **neutral density filter**.

nearest-neighbor filter Another term for the **impulse filter**.

neutral density filter An optical **filter** that is designed to reduce the intensity of the light passing through it without affecting the color of the light.

Newton's rings An artifact, usually seen in optical printing, characterized by circular moiré patterns that appear in the image.

NG Abbreviation for "no good."

node view A view, available in most compositing software, that shows the hierarchical structure of the image-processing operations that will be used to generate a final composite.

nonlinear color space A **color space** in which the relationship between a pixel's digital value and its visual brightness does not remain constant (linear) across the full **gamut** of black to white.

nonlinear encoding A method of converting the colors from the input image to an output image in a nonlinear way. See **linear color space, nonlinear color space**.

nonlinear editing Editing that does not require that the sequence be worked on sequentially.

nonsquare pixel A pixel whose width is not the same size as its height. The ratio of width to height is measured in terms of a **pixel aspect ratio**.

normalized value A digital value that has been converted to fall within a specific range. With digital compositing, this is usually the range of 0 to 1.

NTSC National Television Systems Committee. Refers not only to the committee itself, but also to the standard that they established for color television in the United States and other countries. It carries 525 lines of information, played back at a rate of approximately 30 frames per second (actually 29.97). Due to its unreliable color reproduction ability, the initials are often said to stand for "Never The Same Color" or "Never Twice the Same Color."

O

off-line compositing Another term for **batch compositing**.

Omnimax A proprietary film capture/projection process that uses the same large-format negative as the **IMAX** process but is designed for projection on the interior of a dome-shaped screen.

O-Neg Abbreviation for **original negative**.

one-point track A type of **2D tracking** in which a single point is selected in a sequence of images to extract an approximation of an object's movement relative to the camera. Tracking a single point only allows for translational movements.

1 K resolution A general term referring to any digital image containing an X resolution of approximately 1024 pixels. The actual dimensions of the 1 K image depends on the **aspect ratio** of the imagery.

on-line compositing A method of compositing that uses a highly interactive hardware/software combination to quickly provide the results of every compositing operation. Distinguished from an **off-line** or **batch compositing** system.

opaque The characteristic of an image that causes it to fully obscure any image that is behind it. Opaque is the opposite of **transparent**.

OpenEXR A specific image file format designed for use with high dynamic range imagery. See Appendix B.

optical compositing The process of using an optical printer to produce composite imagery.

optical flow analysis A method for procedurally determining the movement of objects in a sequence of images by examining the movement of smaller blocks of pixels within the image.

optical printer A device used to combine one or more different film elements and rephotograph them onto a new piece of film.

original negative The first-generation negative that captured the original image directly from the scene. Later duplicates of this negative are known as intermediate negatives **or internegatives.**

orthographic view A view of a 3D scene rendered without any perspective – objects appear to be the same size regardless of their distance from camera.

overcrank Running a **camera** at a faster speed than the intended projection rate, resulting in projected footage that appears to move slower than normal. Footage shot at a faster-than-normal rate is said to have been shot overcranked. See also **slow motion**.

oversampling Sampling data at a higher-than-normal resolution in order to mitigate sampling errors or inaccuracies from uncharacteristic data.

P

paint software A program that allows the artist to "paint" directly onto an image in the computer using a device such as a **tablet** or a mouse.

paintbox Usually used in the video postproduction world as a generic term for a variety of paint and compositing devices.

PAL Phase alternation by line. A standard for color television found in many European, African, and Asian countries. It carries 625 lines of resolution, played back at a rate of 25 frames per second.

palette The range of colors available for use in any particular application. A system that uses eight bits per channel would have a palette of over 16 million colors.

pan and scan A technique that is used to convert images shot with a **widescreen** film process to a less expansive video format. It generally involves selectively cropping the image to fit into the new frame, arbitrarily choosing what portions of the image are unnecessary.

pan and tile A technique in which a series of images of a scene are stitched together to create a larger panoramic view of the scene.

Panavision (1) A manufacturer of motion picture lenses and cameras. (2) The trade name for a specific wide screen process and lenses developed by the Panavision company. It is an anamorphic format that produces an image with a 2.35:1 aspect ratio. See also **anamorphic format, Cinemascope**.

Pantone Matching System (PMS) A color identification standard used in print work that contains over 3,000 different colors. Many computer graphics programs allow the user to select colors based on their PMS number.

parallax The perceptual difference in an object's location or spatial relationship when seen from different vantage points.

particle system A 3D computer graphics technique that is used to create a large number of objects that obey well-defined behavioral rules. Useful not only for controlling multitudes of discrete objects such as asteroids or flocks of birds, but also as a tool for creating natural phenomena such as fire or smoke.

perf Abbreviation for **perforation**.

perforation One of the sprocket holes that runs along the edges of a piece of film. They are used to guide the film reliably through the camera.

persistence of vision The characteristic of the human eye that allows it to continue to perceive an image for a fraction of a second after it disappears.

perspective compensation The use of a two-dimensional **geometric transformation** to correct a 3D discrepancy.

perspective A term relating to the size and depth relationships of the objects in a scene.

photogrammetry A method in which textured 3D geometry is created based on the analysis of multiple 2D images taken from different viewpoints.

photorealism A global term used to describe CG images that cannot be distinguished from objects or scenes in the real world.

picture element See **pixel**.

pincushion distortion A type of **lens distortion** in which straight lines are bent inward toward the center of an image. See also **barrel distortion**.

pipeline A well-defined set of processes for achieving a certain result.

pixel Originally an abbreviation for "picture element," although the term "pixel" is generally considered to be a true word nowadays. A digital image is composed of a rectangular array of individual colored points. Each one of these points is referred to as a pixel.

pixel analyzer A tool available in most **compositing** and **paint packages** that allows the user to point the mouse over an area of pixels in order to get the specific or average color values for that portion of the image.

pixel aspect ratio The width of a given pixel divided by its height. A number of image representation methods do not use pixels that have an equivalent width and height. The pixel aspect ratio is independent of a particular image's **aspect ratio**. See also **nonsquare pixels**.

plate A piece of original photography that is intended to be used as an **element** in a composite.

playback speed The rate (usually measured in frames per second) at which a sequence of images is displayed.

polarized glasses 3D glasses that use polarizing filters to differentiate between the images sent to the right and left eyes in stereo films. See also **flicker glasses, anaglyph glasses**.

post house A facility where the **postproduction** work takes place.

post move Referring to any move added to a plate via image transformations performed in compositing, as opposed to shooting the scene with the desired camera move.

posterization An effect applied to an image that intentionally causes **banding.**

postproduction Work done once principle photography has been completed.

practical effects Effects that are accomplished "live," without any postproduction. Practical effects include explosions, artificial rain, smoke, etc.

precomp Abbreviation for **preliminary composite**.

preliminary composite Any intermediate imagery that is produced during the digital compositing process that can be saved and used as a new source element.

premultiplied image An image whose red, green, and blue **channels** have been multiplied by a **matte**. Usually this matte is stored as the **alpha channel** of this image.

preproduction Any planning, testing, or initial design that is done before actual production begins.

Primatte A proprietary **chroma-keying** tool that can be used to extract a **matte** from an image shot in front of a uniform backing.

prime lens A camera lens with a fixed focal length, as opposed to a zoom lens, which has a variable focal length.

print A positive image that is suitable for viewing directly or for projection. Generally produced from an original or an intermediate negative.

procedural paint A specialized form of **paint software** that can actually apply brush strokes and other paint processes over a sequence of images instead of just a single frame. Parameters for these painting effects can usually be animated as well.

processing (1) The time spent by the computer as it computes any instructions that it has been given. (2) At a photo laboratory, the process of developing and printing a piece of film.

producer Administrative head of a project. Responsible for budget, schedule, etc.

production sense The near-mythical ability of an experienced digital artist to decide on the proper course of action when creating a visual effects shot.

progressive scan A method of displaying an image that does not rely on **interlacing.**

projection speed The **playback speed** for projected imagery.

proxy A scaled-down image that is used as a stand-in for a higher-resolution original.

pull a matte The process of creating a **matte** for an object, usually through **keying** techniques.

pulldown Shorthand for **3:2 pulldown**.

pullup Shorthand for **3:2 pullup**.

Q

quantization The process of assigning discrete digital values to samples taken from a continuous analog data set.

quantization artifact A term generally used to refer to a visually noticeable artifact of the **quantization** process.

quantizing Colloquial term for a **quantization artifact**.

R

raw stock Unexposed, unprocessed film.

real-time (1) Displaying a sequence of images at the same speed as they will be viewed in their final form. (2) Computational processing that appears to be nearly instantaneous.

rear projection A compositing process in which the previously photographed background scene is projected onto a large translucent screen from behind while the foreground action takes place. The composite is thus considered an **in-camera effect**.

record One of the red, green, or blue color-sensitive layers in a piece of film. Thus, the "blue record" is equivalent to a digital image's blue **channel**.

region of interest A (usually rectangular) region that is determined by the user in order to limit certain calculations. See also **domain of definition**.

release print A print of a movie that will be sent to theaters for display. A release print is several generations removed from the original negative.

render farm A group of computers that is set up as a place to submit 2D or 3D processes for noninteractive computation.

render queue The list of tasks waiting to be processed on a **render farm**.

render The process of creating a synthetic image from a 3D dataset.

RenderMan Specialized **rendering** software offered by Pixar, Inc.

repo See **reposition**.

reposition The process of adjusting the placement of an **element** within the frame.

resampling The process of reading previously **sampled** data for the purpose of converting or modifying it.

resolution independence The characteristic of a software package that allows the user to easily work with and move between an arbitrary number of different **resolutions**.

resolution The amount of data that is used to capture an image. The term is typically used to refer specifically to the **spatial resolution** of a digital image. See also **color resolution, temporal resolution**.

RGB Red, green, and blue. The three primary colors, or a method of specifying the colors in an image based on a mix of these three components.

RGBA Red, green, blue and alpha, grouped as a single unit.

ride film A location-based entertainment that features a film whose camera movements are synchronized with some sort of moving seat or platform.

ringing A visual **artifact**, often caused by excessive **sharpening**, that is characterized by overemphasized transitions between bright and dark areas in an image.

RLA A specific image file format. See Appendix B.

ROI Abbreviation for **region of interest**. Also used in the financial world as an abbreviation for Return On Investment, something your employer is probably worrying about right now.

rotation A **geometric transformation** that changes the orientation of an image relative to a certain axis.

roto Abbreviation for **rotoscope**.

rotoscope Originally the name of a device patented in 1917 by Max Fleischer to aid in **cel animation.** Now used as a general term for the process of creating imagery or mattes on a frame-by-frame basis by hand.

rotoscoped matte A **matte** created via **rotoscoping** techniques.

RP Abbreviation for **rear projection**.

RTFM Abbreviation for "read the manual" (sort of), a suggestion that is often given when someone asks a question instead of taking the time to look it up themselves.

run-length encoding A **lossless** compression scheme that consolidates sequences of identical pixels into a single data representation.

rushes Another term for **dailies**, used primarily in Great Britain.

S

sampling (1) The process of reading a signal at specific time increments. see also **digitization**. (2) The process of reading the color value from a pixel or a group of pixels.

saturation The brilliance or purity of a given color. The difference between a pastel and a pure color is the amount of saturation.

scaling A **geometric transformation** that changes the size of an image, usually without changing its location or orientation.

scan line A single horizontal row of pixels in a digital image.

scanner A device for **digitizing** film, print material, etc.

scene (1) The image captured by a camera. (2) A collection of shots that share a common setting or theme.

scene-referred An image that has a direct, well-defined mapping between the colors in the image and the colors in the original scene.

scope (1) Abbreviation for any **anamorphic** processes, such as **Cinemascope, Techniscope,** Superscope. (2) Shorthand for video scope, a **waveform monitor**.

screen left The left side of the screen or image from the viewpoint of the viewer. Opposite of **screen right**.

screen resolution The number of horizontal and vertical pixels that a given display device is capable of showing. This should be independent of the resolution that the system is capable of processing.

screen right The right side of the screen or image from the viewpoint of the viewer. Opposite of **screen left**.

script A **program** written in a scripting language, including the language used by a compositing package to describe the set of image processing operations to be applied to a set of images.

SDK Abbreviation for **software developer's kit**.

SECAM Officially this is an acronym for *séquentiel couleur à mémoire*, but most English speakers use the translation "sequential color and memory." A standard for color television used in France and a few African and Eastern European nations. It carries 625 lines of resolution, played back at a rate of 25 frames per second.

seed A number that is fed into a program or algorithm to produce a random number. The same seed will result in the same random numbers and therefore can provide for repeatable iterations.

sequence (1) A collection of images designed to be played sequentially. (2) A group of related **scenes** in a film, usually set in the same time and/or location.

server A computer that is shared over a network by several users.

70 mm film The widest-**gauge** film format, featuring twice the width of standard **35 mm film**. See also **IMAX**. See Appendix C for more details.

SFX Often used as an abbreviation for **special effects**, although sound effects people will dispute this usage.

sharpening The process of applying an algorithm that emphasizes the edges in an image. The result is an image that appears to have increased **sharpness**.

sharpness The visual sense of the abruptness of an edge.

short lens A relative term, in contrast to a **long lens**. Also known as a **wide-angle lens.**

shot An unbroken continuous image **sequence**.

Showscan A proprietary film capture/projection process that is characterized by a large-format negative and a playback speed of 60 frames per second.

shutter angle The part of a motion picture camera that determines how long a given area of film will be exposed to a scene. Most cameras have the ability to adjust their shutter angle. A larger shutter angle will result in increased **motion blur** on moving objects.

shutter speed The amount of time that a camera will spend capturing an individual image.

SIGGRAPH The Special Interest Group for Graphics, a subgroup under the **Association for Computing Machinery**, and the major organization for graphics professionals. Also, the annual conference sponsored by this group, which features a large number of courses, seminars, and some really big parties.

sinc filter A specific digital **filter** that is often used when **resampling** a digital image. The sinc filter is particularly well suited to **transforming** images into a lower resolution than they were originally.

16-bit image In the **visual effects** world, this term typically refers to any image containing 16 bits of color information per **channel**.

16 mm film A film format with a **gauge** of 16 mm that carries only two **perforations** along each frame and contains 40 frames per foot. Because the **captured** image area is significantly smaller than that of **35 mm film**, this film format is rarely used for visual effects work. However, 16 mm is still occasionally used for documentaries and television commercials. See Appendix C for more details.

65 mm film A popular **wide-screen** format that contains five perforations per frame (hence, the nickname **5-perf**). The 65 mm acquisition negative is usually printed onto **70 mm film** stock for release. See Appendix C for more details.

skip frames A method of speeding up the motion of a sequence of images by removing selected (usually regularly spaced) frames. Also known as skip printing.

slate Information about a particular shot that is placed at the head of the shot, before the actual image begins.

slop comp, slap comp A very rough initial composite that is usually used to test or visualize basic element relationships.

slow-motion Any technique that is used to slow down the motion of objects in a scene. It may involve filming at a faster speed than the intended projection speed or it may involve some postprocessing technique. l.

slow-mo Abbreviation for **slow motion.**

SMPTE Society of Motion Picture and Television Engineers.

Sobel filter A specific type of **edge detection** algorithm.

software developer's kit A programming interface that accompanies many software packages. It is provided as a means of writing additional plug ins and standalone programs to extend the capabilities of that software package.

solarization An effect that is produced when a range of brightness within an image is inverted. Can be used to mimic an optical effect that occurs with extreme overexposure.

spatial aliasing An **artifact** that is due to limited **spatial resolution**.

spatial convolution See **convolve**.

spatial filter A method of sampling and modifying the data in an image by looking at pixel groups.

spatial resolution A measurement of the amount of data used to capture an image. In a digital image, spatial resolution is usually specified by giving the X and Y dimensions of the image as measured in **pixels**.

special effects A term used to encompass both **practical effects** and **visual effects**.

special visual effects See **visual effects**.

spherical lens A lens that does not change the apparent width-to-height relationship of the scene being photographed. This is in contrast to an **anamorphic lens**.

spill Any light in a scene that strikes an object it was not intended to illuminate. See also **blue spill, green spill**.

spill suppression Any process that removes or neutralizes undesirable **spill** from an object.

spline curve A continuous smooth curve defined by a certain number of **control points**.

split-screen A basic composite in which two elements are combined using a simple matte with little or no articulation.

sprite General term for a (usually small) 2D element that is animated within a larger scene. Often used in conjunction with a **particle system**.

square pixel A **pixel** with equal X and Y dimensions.

squeezed image An image that has been **anamorphically** compressed.

stabilization The process of removing bounce or jitter from a sequence of images.

staircasing A **spatial aliasing artifact** in which a line or edge appears jagged, like the profile of a staircase, instead of smooth. Also **stairstepping**.

stand-in A reference object photographed in a particular scene that can later be used to help match the color and lighting of any new elements that will be added to that scene.

static image An image that contains no motion.

static matte Another term for a **fixed matte**.

steadiness An image sequence in which the individual frames are stable relative to each other and do not suffer from any frame-to-frame jitter or bounce.

steady test A test to determine if a camera or the imagery shot with that camera is steady.

stereoscopic image Imagery that is designed to send a different image to each observer's left and right eyes, thereby producing a sense of depth.

stereoscopic pair A pair of images (one for each eye) that comprise a **stereoscopic image**.

stochastic sampling A random or semirandom sampling of a data set. Used for **antialiasing, motion blur**, etc.

stock General term for motion picture film, or the specific manufacturer, manufacturer's product code, or rating of that film.

stop A way of measuring exposure that traces back to the different **f-stop** settings available on any given lens. F-stops on a lens are calibrated so that each successive stop will give twice the exposure. Thus, "increase the brightness by one stop" means to double the brightness; "decrease by two stops" would result in one-fourth the original brightness.

stop-motion animation An animation technique that involves photographing miniature objects or characters a frame at a time, changing the pose or position of the object between each frame. The result, when played back at normal speed, is of a continuously animating object.

storyboard A sequence of drawings that shows the intended action in a scene. Used as a visualization tool before the scene is shot.

strobing A rhythmic flicker in a moving image. Often due to a lack of motion-blur when dealing with synthetic images.

Subpixel Any technique that works at a resolution of greater than a single pixel, usually accomplished by making slight weighted corrections to several surrounding pixels.

Super 16 mm film A **16 mm film** that uses an image area that extends beyond the sound track of normal **16 mm film**. It is a single-**perforation** film that extends the image area out to where the second row of **perfs** would normally be. Also called single-perf. See Appendix C for more details.

Super 35 mm film The "Super 35" format is a 35 mm film that uses the **full aperture** of the negative to capture its images. Super 35 can be used for a number of different **formats** that use the full aperture framing, but it is most commonly used

for films that intend to be projected with a 2.35:1 **aspect ratio**. Also referred to as **Super Techniscope, Super 1.85**, **Super 2.35**. See Appendix C for more details.

Super 8 See **Super 8 mm film**.

Super 8 mm film A narrow **gauge** film that contains one **perforation** along each side and runs 72 frames per foot. See Appendix C for more details.

Super Techniscope Another name for **Super 35**.

super Abbreviation for **superimpose**.

superblack Any brightness level that drops below the normal representation of black for a given image or device. In video, superblack levels may be used for keying.

superimpose To place one image on top of another, usually with some transparency involved.

Superscope An early **anamorphic** format that uses the full width of the **35 mm film** area and is cropped top and bottom for a 2:1 **aspect ratio** during projection. See also **Cinemascope, Techniscope**.

superwhite Any brightness level that rises above the normal representation of white for a given image or device.

surface normal A vector that is perpendicular to a surface at a specific point on the surface. In compositing, **multi-pass rendering** will often include a surface-normal pass.

T

tablet A user-input device that provides a greater amount of control than the traditional computer mouse. Generally used in conjunction with a special pen.

tail slate **Slate** information that is recorded at the end of the shot instead of the beginning. Generally only used in live-action photography; the slate information is filmed upside-down, to distinguish it from a normal slate.

take When a particular shot is photographed multiple times in order to achieve a desired result, each time is referred to as a "take." This concept extends to digital compositing, where each test that is sent to film or video is usually kept track of by a "take number."

TARGA A specific image file format. See Appendix B.

Technical Assistant (TA) An individual who is responsible for much of the basic data-wrangling within a facility, often handling file backups, etc.

Technical Director (TD) An individual responsible for ensuring that the technical aspects of a digital shot are addressed. Generally considered to be a subset of **Digital Artist** with particular technical skills.

Techniscope A system designed to produce 35 mm **anamorphic** prints from 35 mm negatives using an image area that is approximately half the height of regular 35 mm images using a special camera. The negative image area is then stretched to normal height and projected at an **aspect ratio** of **2.35:1**. See also **Cinemascope, Superscope**.

Telecine A device for rapidly converting motion picture film into a video format. A telecine device is much faster than a film **scanner**, but will produce lower-quality results.

telephoto lens Any lens that has a longer-than-normal **focal length.** For a 35 mm camera, a focal length of 50 mm is considered normal, since it reasonably duplicates the magnification of a human eye.

temp comp See **temporary composite**.

temporal aliasing An **artifact** that is due to limited **temporal resolution**.

temporal resolution A measurement of the amount of data used to capture a sequence of images. Temporal resolution is usually specified by giving the number of frames per second used to capture the sequence.

temporal relating somehow to time or something that changes over time.

temporary composite A rough composite produced for a number of different reasons, usually to better judge the spatial and color relationships of the elements in a scene so that they can be modified to produce a **final** composite.

10-bit image In the **visual-effects** world, this term typically refers to any image containing 10 bits of color information per **channel**. The most widely used 10-bit image **format** used in **visual effects work** is the **Cineon file format**.

TGA See **TARGA**.

35 mm film 35 mm is the most common film format used in professional moviemaking. Each **frame** contains a **gauge** of 35 mm and four **perforation**s (thus, its nickname **4-perf**) and there are 16 frames per foot. The **sound stripe** runs along the left side of the film between the perforations and the image. See Appendix C for more details.

32-bit image In the **visual-effects** world, this term typically refers to any image containing 32 bits of color information per **channel**. At this **bit-depth** the channels are usually stored with a floating-point data representation and a 32 bit-per-channel image is thus also referred to as a **float** image.

3:2 pulldown Usually synonymous with **2:3 pulldown**.

3:2 pullup Usually synonymous with **2:3 pullup**.

3D Shorthand for three-dimensional. Having characteristics in 3 different dimensions, most often width, height and depth.

3D film (1) A general term referring to a film created entirely with 3D **computer graphics**. (2) Often used as another term for a stereoscopic film.

3D glasses Specially designed glasses that are worn to view **stereoscopic imagery**. See also **anaglyph glasses, polarized glasses, flicker glasses**.

3D graphics **Computer graphics** that involves the creation of three-dimensional models within the computer.

3D motion blur **Motion blur** that is calculated for a CG scene as it is rendered, as opposed to applying **2D motion blur** as a postprocess.

3D tracking Unlike **2D tracking**, 3D tracking is intended to recreate the full 3D movement of the camera that photographed a particular scene (or, less commonly, the full 3D movement of an object in the scene). See also **match move**,

3-perf A technique used to maximize the use of raw film stock in **1.85 formats** so that almost no film is wasted. Most cameras use a **4-perf** pulldown that creates a lot of unused film between the captured images, whereas a 3-perf pulldown positions the captured images closer together.

TIFF Tagged Image File Format, a specific image file format. See Appendix B.

timecode An electronic indexing method used with video tapes. Time code is measured in hours, minutes, seconds, and frames.

timeline graph A graph that represents the temporal relationships between objects or data.

timing (1) A general term referring to how a particular event or object moves or evolves over a period of time. (2) See **color timing**.

tracking The process of determining the movement of objects in a scene (relative to the camera) by analyzing the captured footage of that scene. See **2D tracking, 3D tracking**.

tracking markers Another term for **witness points**.

transformation Usually referring to a **geometric transformation**.

transition effect A method for moving from one **scene** to the next. See also **wipe, dissolve**.

translation A **geometric transformation** that refers only to a change in position, without a change in scale or rotation.

translucent A term that refers to something that is partially **transparent**; usually implies some additional image distortion, such as blurring.

transparent The characteristic of an image that allows other images that are behind it to still be partially visible. Transparent is the opposite of **opaque**.

traveling matte Any **matte** that changes over time, as opposed to a **static matte**.

t-stop A measurement of the **aperture** of a lens that also takes into account the amount of light lost when passing through the lens elements themselves.

two-point track A type of **2D tracking** in which two points are selected from a **sequence** of images to extract an approximation of an object's movement relative to the camera. Allows for the determination of rotation and scale as well as basic translation. See **one-point track, four-point track**.

2.35 format Pronounced "two-three-five format," 2.35 is a widely used **aspect ratio** for film. It can also be written as 2.35:1, which means that the image is 2.35 times as wide as it is high. **Cinemascope** and **Super 35** are most commonly used as the acquisition format to acquire this **widescreen** format. See Appendix C for more details.

2.5D ($2^1/_2$ D) Pronounced "two-and-a-half D," A general term for techniques that use 2D imagery in a 3D environment to give the illusion of a true 3D scene.

2:3 pulldown Pronounced as "two-three pulldown." A method for converting 24-fps film to 30-fps video. Also called **3:2 pulldown, pulldown**.

2:3 pullup Pronounced as "two-three pullup." A method for converting 30-fps video to 24-fps film. Also called a **3:2 pullup, pullup**.

2D graphics **Computer graphics** that does not use any three-dimensional information and thus involves no explicit depth information.

2D motion blur **Motion blur** that is added as a **post process** to moving objects in an image.

2D Shorthand for two-dimensional. Containing information in only two dimensions (generally width and height) without any sense of depth.

2D tracking The process of determining the motion of objects in a scene relative to the camera. The data derived by a 2D track is dependent on the number of **points** tracked. See **3D tracking, one-point track, two-point track, four-point track**.

2 K resolution A general term referring to any digital image containing an X **resolution** of approximately 2048 **pixels**. The actual dimensions of a 2 K image depends on the **aspect ratio** of the imagery. A common 2 K resolution used in **visual effects** when working with **full aperture** framing is 2048 × 1556.

2-perf Nickname for **16 mm film** because it carries only two **perforations** for each frame.

U

Ultimatte A proprietary tool based on the **color difference method** that can be used to extract a matte from an image shot in front of a uniform backing.

undercrank Running a camera at a lower speed than the intended projection rate, resulting in projected footage that appears to move faster than normal. Footage shot at a slower-than-normal rate is said to have been shot undercranked.

underscan The adjustment on a video monitor that increases the viewable height and width of the image area so that the edges of the display can be seen.

unpremultiplied image An image whose red, green, and blue **channels** have not been multiplied by an alpha channel.

unpremultiply To redivide the **RGB channels** of an image by its own **alpha channel**. Opposite of **premultiply**. See **unpremultiplied image**.

unsharp masking A particular technique used to **sharpen** an image that involves subtracting a slightly blurred image from the original. Used not only in the digital realm but also as a photographic technique.

user interface The portion of a computer program that deals specifically with how the user interacts with the software. See also **graphical user interface**.

V

value In the **HSV** color space, the value equals the maximum of the red, green, and blue components.

vaporware A product that does not yet exist, but is nevertheless being promised for delivery.

vectorscope A device used to view the **chrominance** portion of a **video signal**. Radial distance from the center of the display represents **saturation** (chrominance amplitude), and the counterclockwise or clockwise angular distance represents the **hue** (chrominance **phase**). See also **waveform monitor**.

VFX Abbreviation for **visual effects**.

vignetting A camera or lens artifact characterized by a darkening of the image in the corners of the frame.

visible spectrum The range of colors between ultraviolet and infrared that is visible to the human eye.

VistaVision (or Vistavision) A specialized 35 mm film format that runs the film through the camera horizontally instead of vertically and is able to capture more than twice the resolution of a standard 35 mm frame. Generally only used for **visual effects** work nowadays. See Appendix C for more details. Also known as **eight-perf**.

visual effects A broad term that refers to just about anything that cannot be captured using standard photographic techniques. Visual effects can be accomplished **in-camera** or via a number of different **optical** or digital **post-production** processes. Visual effects are a subcategory of **special effects**.

Visual Effects Director of Photography The individual responsible for photographing any elements that will be used in visual effects production.

Visual Effects Producer The individual responsible for the administrative side of visual effects production.

Visual Effects Supervisor The individual responsible for the organizational and administrative side of visual effects production.

W

wagon wheeling An **image artifact** caused when a rotating object (like a wheel) appears to be moving at the wrong speed or in the wrong direction relative to the object to which it is attached. This is a **temporal aliasing artifact**.

warm A nonexact term used to describe an image that is biased toward the red portion of the spectrum.

warping engine Within a package used for compositing, the code that is responsible for any **geometric transformations**.

warping A geometric, per-pixel distortion of an image, often based on some kind of spline-or grid-based control.

waveform monitor A device primarily used to measure the luminance of a video signal with respect to time. Also called a **scope**. See also **vectorscope**.

wavelet A method of representing an image based on frequency information. Used as the basis for certain compression techniques.

weave See film weave.

wedge See **color wedge, exposure wedge**.

white balance The calibration of a camera for accurate color capture or of an image for accurate color display based on specific **lighting** conditions.

white point (1) On a piece of film, the measured density in the area of least opacity. (2) In a digital image, the numerical value that corresponds to the brightest area that will be represented when the image is eventually viewed in its final form.

wide-angle lens Any lens that has a smaller-than-normal **focal length**. For a 35 mm camera, a focal length of 50 mm is considered normal, since it reasonably duplicates the magnification of a human eye.

widescreen A generic term that usually refers to any image with an **aspect ratio** greater than 1.33:1.

wipe A specific **transition effect** in which one scene is horizontally or vertically revealed to replace another scene.

wire removal A generic term for the process of using digital painting or compositing techniques to remove undesirable wires, rigs, or harnesses that were needed to aid certain stunts or **practical effects**.

witness points Specific objects placed into a scene that can later be analyzed to determine the movement and configuration of the camera that photographed the shot using **tracking** techniques. Also known as **tracking markers**.

working resolution The resolution of the images that will be produced by any given compositing process.

X

x An abbreviation used to denote a **frame**. "24x" denotes 24 frames.

x-**axis** Generally the horizontal axis.

Y

Y-depth image A specialized image that uses the brightness of each pixel to specify the height of that pixel relative to some reference ground plane. See **Z-depth image**.

y-**axis** Generally the vertical axis.

YIQ A color space used for **NTSC** television, in which the brightness (Y), orange-cyan (I), and green-magenta (Q) components are encoded together.

YUV A **color space** in which **Y** represents the **luminance** and **U** and **V** represent the **chrominance** of an image or video.

Z

z-**axis** The axis perpendicular to the *x*-**axis** and the *y*-**axis**, and consequently the axis that is used to represent depth.

Z-buffer Another term for a **Z-depth image**.

Z-channel A **Z-depth image** that is integrated with a color image as an additional **channel**.

Z-depth compositing Compositing images together with the use of a **Z-buffer** to determine their relative depths, or distances from the camera.

Z-depth image A specialized image that uses the brightness of each pixel to specify the relative depth for each pixel in the corresponding RGB image. This depth may be measured relative to some arbitrary fixed point in space or relative to the virtual camera that is being used to capture the scene.

zoom (1) In a real camera, to increase the **focal length** of the camera's lens, magnifying a portion of the scene. (2) With digital images, to increase the scale of a portion of an image in order to duplicate the effect of a camera zoom.

Index